A SHORT HISTORY OF THE OTTOMAN EMPIRE

A SHORT HISTORY OF THE OTTOMAN EMPIRE

RENÉE WORRINGER

UNIVERSITY OF TORONTO PRESS
Toronto Buffalo London

© University of Toronto Press 2021
Toronto Buffalo London
utorontopress.com
Printed in Canada

ISBN 978-1-4426-0042-3 (cloth) ISBN 978-1-4426-0044-7 (EPUB)
ISBN 978-1-4426-0041-6 (paper) ISBN 978-1-4426-0043-0 (PDF)

Library and Archives Canada Cataloguing in Publication

Title: A short history of the Ottoman Empire / Renée Worringer.
Names: Worringer, Renée, author.
Description: Includes bibliographical references and index.
Identifiers: Canadiana (print) 20200344315 | Canadiana (ebook) 20200344366 |
 ISBN 9781442600416 (softcover) | ISBN 9781442600423 (hardcover) |
 ISBN 9781442600447 (EPUB) | ISBN 9781442600430 (PDF)
Subjects: LCSH: Turkey – History – Ottoman Empire, 1288–1918.
Classification: LCC DR486 .W67 2021 | DDC 956/.015 – dc23

We welcome comments and suggestions regarding any aspect of our publications – please feel free to contact us at news@utorontopress.com or visit us at utorontopress.com.

Every effort has been made to contact copyright holders; in the event of an error or omission, please notify the publisher.

University of Toronto Press acknowledges the financial assistance to its publishing program of the Canada Council for the Arts and the Ontario Arts Council, an agency of the Government of Ontario.

Canada Council for the Arts / Conseil des Arts du Canada

ONTARIO ARTS COUNCIL
CONSEIL DES ARTS DE L'ONTARIO
an Ontario government agency
un organisme du gouvernement de l'Ontario

Funded by the Government of Canada / Financé par le gouvernement du Canada Canadä

FSC
www.fsc.org
MIX
Paper from responsible sources
FSC® C016245

CONTENTS

List of Maps • vi

List of Figures • vii

List of Genealogical Charts • ix

Abbreviations, Dates, and Glossary • x

Acknowledgments • xi

PREFACE • 3

CHAPTER ONE Introduction • 11

CHAPTER TWO The Early Ottoman Synthesis: Inheritors of Multiple
 Traditions • 23

CHAPTER THREE The Ottoman Emirate: Consolidating Power, Evolving
 Strategies • 47

CHAPTER FOUR Ottoman Interregnum and Revival • 71

CHAPTER FIVE Becoming an Empire: Tools of State • 99

CHAPTER SIX Reaching Imperial Heights: Sixteenth-Century Ottoman
 Empire • 127

CHAPTER SEVEN Life in the Ottoman Empire • 159

CHAPTER EIGHT An Empire Changing: The Balance of Power at Home and
 Abroad • 183

CHAPTER NINE Late Seventeenth-Century Ottoman Disruptions,
 Eighteenth-Century Intrusions and Exchanges • 211

CHAPTER TEN The "Long" Nineteenth Century: Reform, Change, and
 the Rise of Nationalism • 239

CHAPTER ELEVEN At Empire's End • 275

CHAPTER TWELVE The Empire at War • 309

CHAPTER THIRTEEN Epilogue: Ottoman Legacies and Turkey's Ghosts • 345

Glossary • 355

Credits • 361

Index • 367

MAPS

0.1 Ottoman Empire • 6
2.1 Turkic Migrations • 24
2.2 The Umayyad Caliphate • 27
2.3 The Abbasid Caliphate, *c.* Tenth Century • 28
2.4 The Great Seljuk Empire • 32
2.5 The Byzantines and Seljuks of Rûm • 33
2.6 The Mongol Empire • 34
2.7 Early Ottoman Territory and the Byzantine Frontier • 38
3.1 Ottoman Expansion in Anatolia and the Balkans • 48
4.1 Ottoman Balkans and Anatolia during the Civil War, 1402–13 • 73
4.2 Constantinople *c.* Fifteenth Century • 80
4.3 Sultan Mehmed II's Empire by 1481 • 94
5.1 Ottoman Expansion as a World Empire • 115
5.2 The Safavid Empire in Persia, *c.* 1630 • 118
6.1 Ottomans among the European Empires, *c.*1551 • 128
6.2 Ottomans among the "Gunpowder" (Muslim) Empires, *c.* Sixteenth Century • 129
6.3 The Ottoman Empire in the Reign of Süleyman the Magnificent, *c.*1566 • 136
9.1 Ottoman Podolia and Surrounding Empires, Seventeenth Century • 214
9.2 Losses along the Danube • 216
10.1 Ottoman Empire, 1795, on the Eve of Napoleon's Egypt Invasion • 243
10.2 Wahhabi Conquest and Conversion, Early Nineteenth Century • 247
10.3 Crimean War (1853–6) • 267
10.4 Refugees Entering Ottoman Lands, *c.*1850s–60s • 268
11.1 Ottoman Losses, 1878–1912 • 283
11.2 Flow of Muslim Refugees after 1877–8 War • 285
12.1 Ottoman Losses of Territory • 310
12.2 Balkan Wars, 1912–13 • 311
12.3 The Ottoman Empire in World War I • 320
12.4 Ethnic Groups in the Six Ottoman *Vilayets*, 1912 • 323
12.5 Deportation Routes and Massacre Sites • 330
12.6 The Sykes-Picot Agreement, 1916 • 335
12.7 Treaty of Sèvres • 339
12.8 Turkish War of Independence, 1919–22 • 340
13.1 Mortality in Anatolia, 1912–22 • 352
13.2 Demographic Change in Anatolia's Population, 1912–22, by Religion • 353

FIGURES

0.1 Children's Book, *People of Different Countries* (1837) • 8

0.2 *The Lustful Turk: Scenes in the Harem of an Eastern Potentate* (1828?) • 9

2.1 Artist Erol Deneç's *The Dream of Osman Gazi* (2011) • 36

2.2 Bursa, the Emir Sultan Mosque • 40

3.1 The Battle at Nicopolis, 1396 • 50

3.2 Ottoman *Tuğs* • 53

3.3 Turkish Tiles, Two Different Tile Designs • 58

3.4 Ottoman *Sipahi*s, Sixteenth Century • 60

3.5 "Janissary Recruitment in the Balkans," from Arif Çelebi's *Süleymannâme*, Sixteenth Century • 62

3.6 "Reception of İbrahim Paşa" (1527), from the *Süleymannâme*, Sixteenth Century • 64

3.7 Janissaries Carrying Copper Cauldrons • 65

3.8 Süleyman's Janissaries, Sixteenth-Century Miniature • 66

3.9 "Mehterhâne" from *Surname-i Vehbi* (1720) • 67

4.1 Fifteenth-Century Sketch of a Bronze Statue of Byzantine Emperor Justinian • 79

4.2 Rumeli Hisarı • 81

4.3 Aya Sofya, Exterior • 82

4.4 Aya Sofya, Interior • 83

4.5 Galata Tower, Pera, *c.*1900 • 84

4.6 Aerial View of Topkapı Palace • 85

4.7 Sultan Mehmed II and Gennadius Scholarius, Greek Orthodox Patriarch • 89

4.8 Sultan Mehmed II by Italian Artist Gentile Bellini, *c.*1480 • 95

4.9 Sultan Mehmed II by Nakkaş Sinan Bey, End of Fifteenth Century • 95

5.1 Vlach/Romanian Shepherd • 101

5.2 "Vlad the Impaler and Turkish Envoys" by Romanian Painter Theodor Aman, Nineteenth Century • 104

5.3 Ottoman *Wagenburg* and *Tabur* Formation, from Fifteenth-Century Engraving • 110

5.4 Ottoman Galley or *Kadırga* from a Miniature Painting • 112

5.5 *Göke* (1495), the Flagship of Ottoman Admiral Kemal Reis • 113

5.6 The *Kızılbaş* with Shah İsmail • 117

5.7 Fresco, *Battle of Çaldiran against Ottoman Sultan Selim I, 1514*, Chehel Sotoun, Isfahan • 122

6.1 Portrait of Ottoman Sultan Süleyman • 130

6.2 Süleyman the Magnificent Marching with Army in Nahçivan (in Today's Azerbaijan), 1554 • 134

6.3 Ottoman *Grand Vezir* Sokollu Mehmed Pasha Helping the Ailing
 Sultan Süleyman while on Campaign • 135
6.4 Barbarossa, Ottoman Grand Admiral of Süleyman the Magnificent • 143
6.5 Scholars and Artists Meeting to Collaborate on a Manuscript
 during Selim II's Reign (r.1566–74) • 145
6.6 The Funeral Procession of Sultan Süleyman, *c.*1566 • 146
6.7 Portrait of Roxelana (*c.* Sixteenth Century) • 149
7.1 Central Room of a Male Bathhouse (*Hamam*) • 164
7.2 An Ottoman Coffeehouse • 165
7.3 Leggings-Makers Guild • 166
7.4 Mevlevi Whirling Dervishes *Sema* Ceremony, Galata *c.*1870 • 167
7.5 Shepherdesses Resting, Late 1870s • 169
7.6 Holy Caravan on Its Way to Mecca for Hajj after Leaving Damascus,
 *c.*1860–1900 • 170
7.7 Ottoman Sultan Selim I "the Grim" (r.1512–20) Hunting with
 Hounds and Falcons • 172
7.8 Ottoman Army Camel Corps Moves to Beersheva, *c.*1915 • 174
7.9 Bedouin in Iraq with Falcon and Saluki Sighthounds • 175
7.10 Ottoman Family Portrait, *c.*1890 • 176
7.11 Dancing *Köçek* with Tambourine, Late Nineteenth Century • 177
7.12 Ottoman Cemetery with Carved Headstones of Members of the
 Askeri Class • 179
8.1 The Battle of Lepanto, 1571 • 186
8.2 The Selimiye Mosque, Edirne • 187
8.3 Mehmed Sokullu Bridge over the Drina River, Bosnia • 188
8.4 Sultan Mehmed III Returning from the Siege of Eğer, 1595–6 • 194
8.5 The Blue Mosque, Sultanahmet, Istanbul • 201
8.6 Sabbetai Zvi Crowned as the Messiah, Seventeenth Century • 207
9.1 Fortress of Kamianets-Podilskyi, Ukraine • 214
9.2 Battle of Kahlenberg, Siege of Vienna, 1683 • 217
9.3 *Battle of Zenta* (Present-Day Serbia), 1697 • 219
9.4 Sa'adabad Palace and Garden Scene • 227
9.5 Ottoman Miniature Artist Levni, Illustrated Account of Sultan
 Ahmed III's Festival of 1720 • 228
9.6 Shepherds and Butchers Guild in Procession, 1720 Circumcision
 Festival of Sultan Ahmed III's Sons • 229
10.1 Sultan Selim III and Officials Observing New Order Troops
 (*Nizâm-ı Cedid*), *c.*1806 • 242
10.2 *Battle of the Pyramids*, 1798 • 245
10.3 Mehmed Ali Pasha in Egypt • 249
10.4 Ottoman Sultan Mahmud II in Western Garb • 251

10.5 *Grateful Hellas*, 1858 • 252
10.6 Sultan Mahmud II's "Triumphant Soldiers of Muhammad" (*Asâkir-i Mansure-i Muhammediye*) • 253
10.7 Ottoman Imperial University (Now Istanbul University) • 266
11.1 The "Sick Man of Europe" Being Dismembered • 276
11.2 Constantinople *c.*1890s • 278
11.3 Ottoman Parliament, Depicted in *The Graphic* (April 7, 1877) • 281
11.4 Muslim Refugees in the Aya Sofya Mosque after 1877–8 War • 284
11.5 Sultan Abdülhamid II (r.1876–1909) • 286
11.6 Kurdish *Hamidiye* Unit • 289
11.7 Postcard Commemorating the Young Turk Revolution, 1908 • 293
11.8 Palestinians Celebrating the Revolution in 1908 • 294
11.9 Japanese Admiral Tōgō, Hero of the Russo-Japanese War • 296
11.10 Street Dogs in Constantinople • 303
11.11 Street Dogs Relocated to Hayırsız Ada (Sivri Island) in the Marmara Sea • 304
12.1 Enver Pasha • 313
12.2 Cemal Pasha • 313
12.3 Mehmed Talaat Pasha • 314
12.4 *Sharif* Husayn of Mecca, Nineteenth Century • 315
12.5 Australian 9th and 10th Battalions, Mena Camp, Near Pyramids with Kangaroo, the Regiment Mascot • 317
12.6 Ottoman Soldiers on the Gallipoli Peninsula in 1915 • 321
12.7 Irfan Orga, at the War College, 1928 • 324
12.8 Armenians in Cattle Cars • 328
12.9 Armenians Marched through Harput to a Prison in Nearby Mezire by Armed Turkish Soldiers, 1915 • 329
12.10 The Armenian Genocide • 332
12.11 Prince Faysal and Lawrence at Guweria during the Arab Revolt • 336
12.12 Burning of Smyrna (Izmir), September 1922 • 341
12.13 Smyrna Dock, 1922 • 341
12.14 Mustafa Kemal Atatürk • 342

GENEALOGICAL CHARTS

0.1 The Ottoman Dynastic Family Tree • 1
4.1 Ottoman Sultan Bayezid I's Five Sons Competing for the Throne • 72
8.1 Ottoman Sultans and Their *Valide Sultans* • 202

ABBREVIATIONS, DATES, AND GLOSSARY

ABBREVIATIONS

The following abbreviations are commonly used in this book:

- *c.* circa. Used in dates to mean they are approximate.
- ~ Used to suggest that the date is contentious or unknown.
- b. date of birth
- d. date of death
- r. regnant dates

DATE CONVENTIONS

All dates are BCE (Before Common Era) or CE (Common Era).

GLOSSARY

The glossary, located at the end of this book, includes definitions of Ottoman Turkish, Turkish, and Arabic words, in English.

ACKNOWLEDGMENTS

The writing of this Ottoman undergraduate textbook was a challenging yet enlightening undertaking for me from start to finish. As an Ottoman historian whose previous research focused on late Ottoman intellectual history, the development of nationalism in the empire among Turks and Arabs, and their desire to achieve modernity, I quickly recognized my shortcomings. I had crept into the field through several "back doors" – from interest in the modern Middle East, in naïve hopes of seeing a just resolution to the Palestinian-Israeli conflict; from an initial study of Arabic and Hebrew languages for that purpose, before realizing the need to look further back in time than the twentieth century to understand that conflict, which led me to Turkish and Ottoman languages and nineteenth-century history; from a year of living in Damascus, Syria; and from years spent living and working in Japan before grad school, which pulled my eventual research in Ottoman history to an exploration of Ottoman-Japanese relationships, both concrete and abstract. Writing this book has been my way of expanding my "Ottoman horizons." A broader perspective opened up for me in Ottoman studies, thanks to the ever-increasing pool of scholarship by an ever-multiplying cadre of talented Ottomanists: from the history of early Ottoman conquests into the Balkans to the nature of the Danube River as both lifeblood of important eastern European cities and a marker of frontiers between imperial foes at different times; from the evolution of dynastic politics and the ruling Ottoman class to the changes in Ottoman war tactics and technology; from tolerant coexistence among ethnoreligious Ottoman peoples on the one hand to virulent nationalist divisions in the empire on the other.

Imperial rivalries, the differing methods of Ottoman provincial administration in far-flung border regions, the daily life of Ottoman subjects and the role of non-human animals in the empire, as often voiceless, yet significant agents of history, are just some of the many topics toward which I give a nod here. To the many Ottomanist colleagues and peers whose works I devoured in order to present to students clearer glimpses into the richness of the Ottoman Empire's history, I am humbly grateful.

It is inevitable that there will be critics who will not like this book – for not exploring this event's significance or that person's contributions to Ottoman history in more detail, or for not sufficiently producing enough innovative themes or narratives. That is the risk of writing a general textbook. There are those who argue an introduction to the emergence of Islamic civilization and its various dynasties should not be included in an Ottoman history, for do European historians always include a summary of pre-modern Christendom before moving on to modern histories of European nation-states? Is it merely an Orientalist trope, an assumption that the Ottoman Empire can be understood as nothing other than another Muslim state that rose and fell?

I argue (and my experience with my students has reinforced this point, including their direct testimonies saying exactly this) that, for a textbook to be an effective tool for teaching an undergraduate course on the Ottoman Empire to students who typically have little to no knowledge of the Islamic Middle East, nor of Central Asia, an introduction

to these regions and their diverse peoples and histories is an absolutely necessary first step to introducing them to the world of the Ottomans. And after all, the Ottomans learned who they were and eventually began to write about themselves as inheritors of traditions that harken back to earlier Islamic empires, in their chronicles, their record-keeping, and their relations with minorities. So in that spirit, students should learn who the Ottomans understood themselves to be.

In any case, if this textbook is not groundbreaking for the information it provides to Ottoman specialists, in my opinion it will still be a welcome addition to the field, as a comprehensive text introducing students to a rich and sometimes overlooked history of an empire that left an indelible mark on the world. European histories often omit the presence and actions of the Ottoman Empire in their narratives; my intention in this book for students is to replace that error with a story that incorporates the Ottoman Empire into its proper Eurasian context, as an empire at the crossroads of seas, continents, and cultures.

The list of those who enabled me in this endeavor must start with my editor at the University of Toronto Press, Natalie Fingerhut, who first asked me if I would be interested in such a project several years ago. Her constant enthusiasm, support, and feedback for my manuscript, especially when my overindulgence in maps and images pushed resources to the limit (!), motivated me to constantly rethink how to best captivate the undergraduate reading audience. Judith Earnshaw's keen set of eyes to oversee the accompanying artwork has made the final result a visually stunning textbook that makes the narrative come alive. Former graduate students of mine, Haley Wilson and Anne Vermeyden were research assistants who assisted me in exploring the vast amount of sources and visual aids now available to the Ottomanist across period and region. Marie Puddister did an excellent job rendering specific maps for me, which was no easy task when trying to capture the expansions and contractions of often-contested Ottoman territory over time. My colleagues in the History Department at the University of Guelph, who have made my academic life richer from their knowledge and observations as well as from their friendship and the supportive environment they foster, generously read and commented on some of the early drafts of the first chapters, and their guidance was immeasurable. Sabbatical leave and a course release from the History Department moved the project along. I can also thank students in my Ottoman history courses at Guelph in 2017 and 2019/2020 who read and reviewed chapters of the manuscript. Their honest critiques of the material as undergraduates allowed my test drive of it to sometimes confirm what I thought needed to be in and, at other times, to be excised from the final textbook. The College of Arts generously provided travel funds for me to attend a conference at the University of Zadar in Croatia in 2016 entitled "Negotiating Limits between Early Modern Sovereignties: Venetian Dalmatia and Ottoman Bosnia Fifteenth–Eighteenth Centuries." The willingness of Karen-edis Barzman and Palmira Brummett to allow me to engage with the many Italian and Croatian scholars in this setting and to enjoy a field trip to the actual physical border sites of the Venetian and Ottoman empires did more to educate me in the complexities of the Ottoman Balkans than I could have grasped otherwise.

I have been so fortunate to benefit from the expertise of a pioneer in our field, Virginia Aksan, who has become a supportive friend and a most generous Ottomanist mentor for me. She took the time to read and comment on most of the first draft of the manuscript, broadening my understanding of Ottoman military history and posing the hard questions regarding the history of empires in the early modern and modern periods. Mark Stein, my longtime "big brother" from grad school days, also perused the draft version to give me useful feedback before final submission. Victor Ostapchuk at the University of Toronto has become a friend and fellow Ottomanist colleague with whom I have gained a clearer recognition of the importance of the Black Sea region and its loss by the Ottomans; University of Toronto Ottoman Seminars have been a way for me to liaise with other Ottomanists in the area, as have GLOW (Great Lakes Ottomanist Workshop) meetings. Cengiz Kırlı expanded how I viewed Ottoman coffeehouse culture, and more recently he provided a more nuanced analysis of the *Tanzîmât* reform era beyond simply one of ethnonational conflict, to one including legal issues with Ottoman society's definition of corruption and how justice was negotiated with the state. Amila Buturović, Walter Denny, Evren Altınkaş, and Tony Toth provided consultation or images for the book. To the three anonymous reviewers for the University of Toronto Press I owe a tremendous debt. Whoever you are, I thank you for taking the time to put the manuscript under an Ottomanist microscope and commenting extensively, constructively: your efforts made the final manuscript so much more precise and meaningful in terms of the depth of content, readability, and the suggestions for further reading that I had occasionally missed.

Without the sustained friendship of Nick Miniaci (who regularly passed on useful sources in German for me), Fraser Telford, Sara Wilmshurst, and Robin Watson, all brilliant historians and writers who have encouraged me, made me contemplate the meaning of what I write and why it is important to impart history to students, I would not have sustained the personal momentum to finish this book.

Finally, my greatest ally in surviving the academic world is Stephen Rowell, my partner in having a life on the farm, beyond the world of the Ottomans, though he is always game to explore Ottoman history in our travels. For his willingness to drive hours to see a fortress in Croatia, or an Ottoman battle site or preserved *tekke* in Hungary, or an Ottoman-era bridge in Bosnia, for his calmness when my computer glitches cause me to panic, and his patience when I have none, I can never underestimate his hand in completing this project. I dedicate this work to him.

And to my current "wolf pack," Arrow, Gem, and Khan, you remind me in the simplest way of how to step away from work and be in the moment. You make me wish at times that humanity could be a bit more like canines. Thank you for the many study breaks spent throwing Frisbees and herding sheep with you.

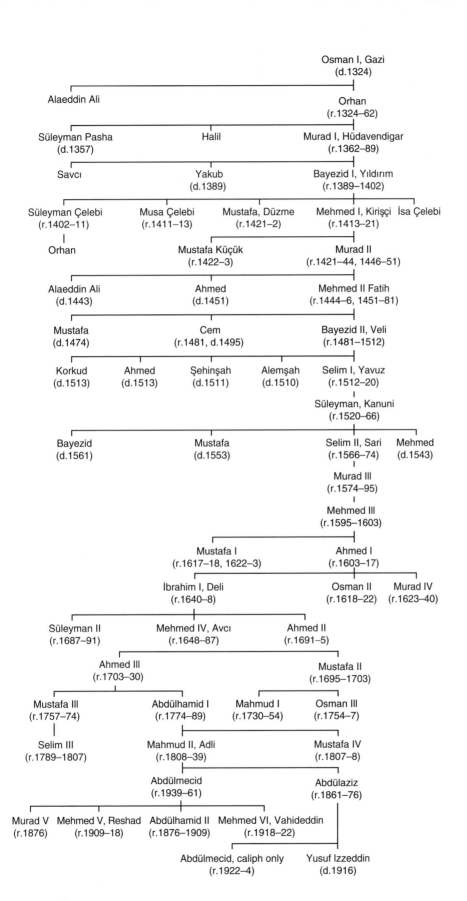

Genealogy 0.1 The Ottoman Dynastic Family Tree.

PREFACE

What is a nation?

A nation is a people many of whom speak the same tongue, who have similar customs and morals, and who are subject to the laws of a government. For example, Turks and Arabs are nations, because each of them has a language, blood (ties), customs, and history.

What does the Ottoman nation mean?

The Ottoman nation is a body created by the incorporation of various peoples such as Turks, Arabs, Albanians, Kurds, Armenians, Greeks, Bulgarians, and Jews ... who possess different religions and nationalities.

How is it that these peoples who have different languages, religions, and faiths are called the Ottoman nation? ...

Although these peoples have different languages of their own their official language is the same. It is the Ottoman (Turkish) language.

Does the difference of religion and faith hinder the creation of a nation?

No, it cannot hinder the creation of a nation, because the question of religion and faith is a matter of the next world. In the affairs of this world, however, individuals cannot abandon their interests, and those who have common aims should unite....[1]

− Ottoman Committee of Union and Progress (CUP)
party propaganda, 1910

Essentially the Turk is a bully and a coward; he is brave as a lion when things are going his way, but cringing, abject, and nerveless when reverses are overwhelming him. And now that the fortunes of war were apparently favouring the empire, I began to see an entirely new Turk unfolding before my eyes. The hesitating and fearful Ottoman, feeling his way cautiously amid the mazes of European diplomacy, and seeking opportunities to find an advantage for himself in the divided counsels of the European powers, gave place to an understanding, almost dashing figure, proud and assertive, determined to live his own life and absolutely contemptuous of his Christian foes. I was really witnessing a remarkable development in race psychology – an almost classical instance of reversion to type. The ragged, unkempt Turk of the twentieth century was vanishing and in his place was appearing the Turk of the fourteenth and the fifteenth, the Turk who had swept out of his Asiatic fastnesses, conquered all the powerful peoples in his way, and founded in Asia, Africa, and Europe one of the most extensive empires that history has known. If we are properly to appreciate this new Talaat and Enver and the events which now took place, we must understand the Turk who, under Osman and his successors, exercised this mighty but devastating influence in the world. We must realize that the basic fact underlying the Turkish mentality is its utter contempt for all other races. A fairly insane pride is the element that largely explains this strange human species. The common term applied by the Turk to the Christian is "dog," and in his estimation this is no mere rhetorical figure; he actually looks upon his European neighbours as far less worthy of consideration than his own domestic animals. "My son," an old Turk once said, "do you see that herd of swine? Some are white, some are black, some are large, some are small – they differ from each other in some respects, but they are all swine. So it is with Christians. Be not deceived, my son. These Christians may wear fine clothes, their women may be beautiful to look upon; their skins are white and splendid; many of them are very intelligent and they build wonderful cities and create what seem to be great states. But remember that underneath all this dazzling exterior they are all the same – they are all swine."[2]

– Henry Morgenthau, American Ambassador
to the Ottoman Empire, 1913–16

The question of "who were the Ottomans" has become a multilayered query over the last hundred years. During World War I, scholars, government officials, and military officers on the Allied side tried to answer the question with a few books written about this "mysterious" empire which entered the war on the side of the Central Powers. With the founding of the Turkish Republic in 1923, as well as the establishment of many new countries across the Balkans, the Middle East, and North Africa, the Ottoman Empire seemed to disappear from the horizon of history, until resurrected by academics in Turkey, Europe, and North America from the 1930s onward. They answered the question of who the Ottomans were

in a range of ways that often conflicted with one another and created historiographical dilemmas in determining the origins and motivations of the first Ottomans. The semblance of a consensus today is that the question of who the Ottomans were is complex due to several factors: the dearth of reliable early sources; the lengthy span of time the Ottoman Empire existed, so that the empire of the first 300 years of its existence varied dramatically from the empire of the latter 300 years; the vast expanse of territories absorbed into Ottoman lands over time incorporated an ethnically and religiously diverse population, further complicating the question of who was called Ottoman (Map 0.1).

Even today, defining the Ottomans seems to be a mystery: when I first started teaching Ottoman history in Australia, many of my students could not answer this question. So I asked them, "Do you know what Gallipoli is?" They responded that of course, the 1915 Allied Gallipoli Campaign of World War I was famous for the Australia-New Zealand Army Corps (ANZAC forces) fighting the enemy at close range in trenches. It was a horribly failed operation designed originally by Britain and France to seize control of the strategic Dardanelles waterway leading to Constantinople, in an effort to deal the Central Powers an early blow in the war, and it gave the two Commonwealth colonies, Australia and New Zealand, their first real sense of a national identity set apart from that of Britain. To the students' embarrassed surprise, I reminded them that the enemy on the other side to which they referred were indeed, the Ottomans, who successfully defended the Dardanelles Straits for eight months with a tremendous loss of life on both sides.

Perhaps students cannot be blamed for this omission in their understanding of history. The Ottoman Empire was a formidable force involved in European politics and commerce almost since its inception as a frontier principality, or *beylik*, named for Osman, the eponymous founder of this emirate, situated between the Byzantines and the Seljuk Turks of Rûm in Anatolia at the turn of the fourteenth century ("Ottoman" is the corrupted West European pronunciation of "Osman"). Yet it often does not receive more than cursory mention in the narratives of medieval and early modern Europe, a carryover from centuries of Orientalist scholarship influencing Western thinking about the civilizations of Asia that has been hard to overcome. The early scholars of "the Orient," whether this is understood as the ancient Near East, the Holy Land, or Asia more generally, called themselves "Orientalists." They were specialists in the studies of the (often dead) languages and past civilizations of these regions. As primarily biblical scholars, they also shaped often flawed, wildly exaggerated, or incomplete perspectives on Islamic cultures and on Muslims. This neglect is being remedied today, but it speaks to the larger issue of the complicated relationship between Christendom and Islam over the centuries, which was exacerbated by nineteenth-century colonial legacies, and which has, I would argue, endured to the present: demonstrated in the many current misunderstandings between what we often call in very monolithic terms, "the West" and "the Islamic world." Until very recently in fact, the Ottoman Empire was known only as either Europe's Muslim enemy, when in reality it was not always a hostile relationship, or as the "Sick Man of Europe" from the mid-nineteenth century, when it was considered by European and Russian empires to be on the verge of collapse and ripe for partition. This "Eastern Question" of how

HOLY ROMAN EMPIRE
(Habsburgs)

FRANCE

Vienna •

Esztergom •
Budapest •
Szigetvár •
• Mohacs

HUNGARY

TRANSYLVANIA

POLAND-
LITHUANIA

RIGHT-BA
UKRAINE

PODOLIA

Dniester R.

MOLDAVIA

C

Venice

Corsica

**PAPAL
STATES**

NAPLES

SPAIN

Sardinia

Sava R.

Belgrade •
Sarajevo •
• Ragusa

WALLACHIA

Danube R.

• Sofia

RUMELIA

Salonika •

Edirne •

Constan

• Bursa

• Izmir

Rhode

Sicily

Algiers •

Tunis •

ALGIERS

MOROCCO

TUNIS

Tripoli •

TRIPOLI

Crete

Mediterranean Sea

E

Growth of the Ottoman Empire

Ottoman Empire and vassals, 1512

Conquests of Selim I, 1512–20

Conquests of Süleyman I, 1520–66

Ottoman conquests, 1566–1699

Austrian Habsburg possessions

Spanish Habsburg possessions

Venetian Republic and possessions

Map 0.1 Ottoman Empire.

RUSSIAN EMPIRE

Ural R.

...ANATE

Azov

Don R.

Volga R.

Astrakhan

Kaffa

CIRCASSIA

Tiflis

Caspian Sea

...ea

...inop

Trebizond

Kars

Baku

Amasya

Erzurum

Lake Van

Van

...a

Diyarbekir

Tabriz

SYRIA

Mosul

Aleppo

Tigris R.

Tehran

...s

Damascus

MESOPOTAMIA

Baghdad

Isfahan

Jerusalem

Euphrates R.

Basra

SAFAVID EMPIRE

Persian Gulf

Gombrun
to Portugal 1551

HIJAZ

Red Sea

Muscat
to Portugal 1551

Medina

ARABIAN
PENINSULA

OMAN

Mecca

Suakin

Massava

San'a

Aden

ETHIOPIA

Gulf of Aden

0 500 km

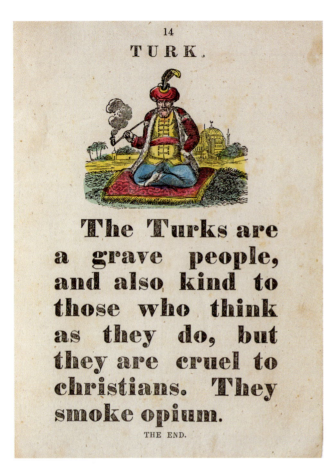

14

TURK.

The Turks are a grave people, and also kind to those who think as they do, but they are cruel to christians. They smoke opium.

THE END.

to prop up or divide up the Ottoman Empire pervaded European geopolitical thought in the modern era, though the Ottoman Empire survived another seventy years, till the end of World War I.

Stereotypes of the "Terrible Turk," as lingering vestiges of earlier attitudes about "Moslems" and "Saracens" from the medieval Christian world, prevailed in the West in later eras, contributing to the neglect of accurate historical research on the Ottomans. Turks were labeled decadent opium-eaters and addicts by Western authors and expatriates (Figure 0.1).[3] The Orientalist construction of the harem in Western art and literature as the playpen of Oriental despots, their den of eroticism full of enslaved women to be ravished as the sultans desired, was propagated mainly by European men who never set foot in this inner sanctum and so would not know the more mundane realities. Lady Mary Wortley Montagu (b.1689–d.1762), writer, traveler, and wife of an eighteenth-century British ambassador stationed in Constantinople in 1716, was perhaps the first foreigner to author a real-life glimpse into harem life due to her friendships with Ottoman women and access to their private quarters and *hamams*, which she recounted in her *The Turkish Embassy Letters* (1763). But European mens' fantasies spawned images of "the Lustful Turk" – the actual title of a soft-porn-type erotic novel originally published in 1828 that became immensely popular reading material in the climate of socially repressed nineteenth-century Victorian England and that went through several printings due to high demand (Figure 0.2). Described as "faithfully and vividly depicting in a series of letters from a young and beautiful English lady to her friend in England the full particulars of her ravishment and of her complete abandonment to all the salacious tastes of the Turks, the whole being described with that zest and simplicity which always gives guarantee of authenticity,"[4] the tales conjured up fantasies of Western women captured, kidnapped, and forced into the harems of oversexed Muslim rulers who eventually succumbed to the wishes of their captors, until, in one story for example, a jealous Greek slave-girl wrought the ultimate revenge upon her captor-lover: castration. *The Lustful Turk* provides more insight into Victorian-era England's sexual repression than of Ottoman society and history.

In addition, the image of the "cruel and immoral Turk" emerged in the nineteenth-century press and in the imaginations of Europeans who were made aware of the plight of various Christian minorities in the Ottoman Empire amid the turmoil of nationalist awakenings that soured relations between Muslim and non-Muslim, state and society, and spilled over into atrocities at times committed by both sides against one another. Virtually erasing the previous centuries of any pattern of Ottoman coexistence between Muslim and

non-Muslim communities, the effects of this violent period at the end of the empire had historiographical implications for the post-Ottoman Balkans. Newly emerging nation-states in this former Ottoman heartland typically drafted nationalist histories demonizing the Ottoman Empire, portraying it as "the Ottoman Turkish yoke of oppression" that had smothered separatist aspirations of non-Muslim and/or non-Turk peoples for centuries, until it was finally lifted and independence achieved through nationalist unity against the Muslim Turks.

Similarly, the destruction of the Ottoman Armenian population of the empire during and directly after World War I, either through government-directed massacres or by forced deportations in what became death marches for the majority of the Armenians in Anatolia, who suffered starvation, disease, and attacks from various sectors of society – military, paramilitary, and civilian – became an ongoing conflict over historical events and historiography that is still hotly debated today. The government of the Turkish Republic continues to deny the violent acts committed between 1915 and 1918 as an Ottoman state-initiated genocide, and instead deems this tragedy just a consequence of wartime mobilization, violent separatist rebellion, and the chaos of imperial demise. American and European diplomats, missionaries, and other foreign expatriate personnel personally witnessed atrocities, but their memoir accounts, like that of the American ambassador to the Ottoman Empire from 1913 to 1916, Henry Morgenthau, presented above, are often littered with racist anti-Turk, anti-Muslim sentiments that negatively affected

Figure 0.2 *The Lustful Turk: Scenes in the Harem of an Eastern Potentate* (1828?). Artist: Anonymous.

post-war perceptions of the Ottoman Turks, while at the same time allowing Turkey the perfect reason to discount these sources as biased, Orientalist stereotypes, and to continue to reject categorizing events as a genocide. Newly employed sources by various scholars of the late Ottoman period, however, have revealed more irrefutable details of the Ottoman state's role in the systematic orchestration to empty Anatolia of its non-Turk, non-Muslim population, and collaborative efforts by Turkish, Armenian, and Western researchers are painting a fuller picture of the turbulent events surrounding the demise of the empire and their devastating effects on Ottoman society as a whole.

Additionally, revisionist historians of late Ottoman and early Turkish Republican history are increasingly challenging Turkey's "official" histories and re-examining its Ottoman past, either that concerning the Armenians, or that of the powerful nationalist story of modern Turkey's emergence in which all other narratives had been suppressed but the secular, Atatürk-centric version. It is in part due to the profound influence of Mustafa Kemal Atatürk, the Ottoman military officer and hero at Gallipoli who famously told his troops, "I don't order you to fight, I order you to die," who then commanded the remnants

of the Ottoman army in resisting European intentions to parcel off Anatolia through the Treaty of Sèvres in the aftermath of the world war, and who became the first president of the newly founded Turkish Republic in 1923. Turkish nationalist history and the many reforms implemented during Atatürk's tenure as president were a successful attempt to erase the Islamic, Ottoman past, and most recently the empire's ruinous defeat in World War I. In its place a pre-Islamic, secular Turkic identity to be proud of was promoted, in a bid to create a new, modern nation oriented toward Europe instead of the Middle East (it also omitted Islamist movements, Kurdish identity, etc.). But Ottoman history is now being resuscitated in all its richness and depth, without the baggage of mid-twentieth-century nationalist agendas.

So how then do we approach Ottoman history? Who were the Ottomans? Let us first tackle a few characteristics of the Ottoman studies field, the historiography and debates, the periodization, the themes concerning the Ottomans and their empire, before delving into the second question more thoroughly in subsequent chapters.

NOTES

1 *Hayye-ale-l-felâh: Osmanlı İttihad ve Terakki Cemiyeti'nin Kardaşlarına Hediyesi* [Salonica, 1910], 3–5, 9; translated by M. Şükrü Hanioğlu in *Preparation for a Revolution: The Young Turks, 1902–1908* (New York: Oxford University Press, 2001), 301.

2 Henry Morgenthau, *Ambassador Morgenthau's Story* (Michigan: Wayne State University Press, 2003), 191–2; originally published by Doubleday, Page, & Company, 1918.

3 My former student Daniel Attrell drew attention to Western views of the Ottoman Turks as opium addicts in his undergraduate paper, "*Somnium Orientis*: The Mystique of Eastern Drug Cultures and the Western Imagination" (unpublished paper, 2011).

4 Anonymous, *The Lustful Turk: Scenes in the Harem of an Eastern Potentate* (repr., Herefordshire, UK: Wordsworth Classic Erotica, 1997), 49.

SELECTED READINGS

Akçam, Taner. *From Empire to Republic: Turkish Nationalism and the Armenian Genocide*. New York: Zed Books, 2004.

Akçam, Taner. *The Young Turks' Crime Against Humanity: The Armenian Genocide and Ethnic Cleansing in the Ottoman Empire*. Princeton, Princeton University Press, 2012.

Lockman, Zachary. *Contending Visions of the Middle East: The History and Politics of Orientalism*. 2nd ed. New York: Cambridge University Press, 2010.

McCarthy, Justin. *The Turk in America: The Creation of an Enduring Prejudice*. Salt Lake City: University of Utah Press, 2010.

Montagu, Lady Mary Wortley. *The Turkish Embassy Letters*, edited by Teresa Heffernan & Daniel O'Quinn. Peterborough: Broadview, 2012.

ONE

INTRODUCTION

AN INTRODUCTION TO OTTOMAN HISTORIOGRAPHY

A brief discussion of how Ottoman studies evolved is a useful starting point for exploring the history of the Ottoman Empire. Proceeding from Europe's earlier Orientalist tradition concerning "the East," the Ottoman Empire became an empire "without its own history."[1] With perhaps the exceptions of *Present State of the Ottoman Empire* (1670) written by British diplomat and translator Paul Rycaut (b.1629–d.1700), and later the multivolume German *History of the Ottoman Empire* (published *c.*1827–35, translated to French 1840) by Austrian Orientalist, historian, and diplomat stationed in the Austrian embassy Joseph von Hammer-Purgstall (b.1774–d.1856), most studies of the Ottomans written in Europe or the West tended to rely only upon European sources to provide the narrative. No knowledge of Ottoman language was deemed necessary for its study (can you imagine only using German sources to write French history?!). Thus the predispositions; the biases toward Islam, Muslims, Turks, and Arabs; and the omission of sources emerging from within the Ottoman Empire itself, or from its close Asian neighbors and rivals, typically led to historiography rife with prejudiced ideas: the Ottomans only succeeded because of the Christian minorities' impact on the ruling class, for example. The logical conclusion drawn from this premise by late eighteenth- and early nineteenth-century historians, such as the Englishman Edward Gibbon (b.1737–d.1794), and Albert Lybyer (b.1876–d.1949), an American writing just before the outbreak of World War I when the Ottoman Turks were on the opposing side, was that the empire devolved once Muslim administrators predominated. Or that the early Ottoman raiding forces were comprised of fanatical Muslims, bent merely on "Holy War" to spread the faith, through forced conversion if necessary. This "*gazi* thesis," a term coined by Austrian scholar Paul Wittek in the 1930s, not only ignored tribal warriors' motives of material gain through plunder and slaves in this retrospective projection back in time, but it also assumed the Turkic nomads on the frontier, many of whom were recent Muslim converts, practiced a more orthodox form of Islam than was probably the case. Turkish sociologist M. Fuad Köprülü (b.1890–d.1966) challenged

Wittek's interpretation in the 1930s, founding the study of Turcology in the process, and influencing later scholars with his emphasis on the Central Asian heritage of the Ottomans.

Many contemporary Ottoman historians argue for a more refined and nuanced understanding of the prevalent frontier-raiding culture of this early Ottoman period. They have revised the *gazi* narrative of early Ottoman origins, noting the heterodox nature of Islam in the Anatolian frontier due to the persistence of Turco-Mongol shamanistic traditions as well as Sufi (Islamic mystical) influences among the Turks on the Byzantine border in Anatolia. Pointing out how the Islamic Middle East had fragmented into mini-states after Mongol conquest, when Europe of the fourteenth century had suffered from wars and popular uprisings among its many political disruptions (e.g., the Hundred Years War), from demographic collapse due to famines and disease, and from religious upheavals, the time had been right for the intrusion of these "Ottomans" onto the scene, and before long, into Europe, as a new tribal nomadic group from the east. The Ottoman *beylik* emerged in this particularly elastic space as a kind of "Wild West," with its tribal, pastoral nomadic practices melded into previous Perso-Seljuk, Islamic patterns of authority around the turn of the fourteenth century, creating an entity quite innovative, flexible, pragmatic, and thus long lived: an Ottoman principality that would, in subsequent centuries, embrace a more orthodox, Sunni Islamic ideology fueling expansion as it evolved into a state and world empire.

Another historiographical consideration is the issue of periodization of the Ottoman Empire. Traditional scholarship on the Ottomans tended to follow earlier Western (Orientalist) patterns of study in which empires were understood simplistically to rise and fall as British historian Edward Gibbon had described in his six-volume *Decline and Fall of the Roman Empire* published in the eighteenth century. Thus Ottoman beginnings around 1300 were understood to crescendo up to the late sixteenth century, particularly with the rule of Sultan Süleyman the Magnificent (r.1520–66), during which Ottoman institutions burgeoned with personnel, successful conquests brought the empire to its height (or so it was perceived), and Ottoman law was codified to harmonize with Islamic *Shari'a* law (in Turkish, *şeriat*). And from the late sixteenth century onwards, posited historians H.A.R. Gibb and Harold Bowen in their *Islamic Society and the West* (Vol. I published in 1950; Vol. II in 1957), the Ottoman Empire sunk into what scholars came to call the "paradigm of decline." Future chapters will deconstruct this so-called decline, but suffice it to say here that the cyclical nature of territorial, military, and economic expansions and contractions in the latter centuries of the empire that were ignored by earlier Ottomanists have now been properly incorporated into Ottoman history by scholars who have revised the narrative and periodization accordingly. They concur that there was a "rise" of an Ottoman principality into a state from the late thirteenth/early fourteenth century to the late sixteenth century; they see the sixteenth century as a formative era with the "institutionalization of empire." The post-sixteenth century Ottoman Empire went through continuous transformation as the polity had to adapt to new domestic and international circumstances; "decline" is too simplistic an explanation of late Ottoman history.

Decentralization in the empire was a consequence of the attempts to manage a vast territorial expanse amid changes in the dynastic household and succession, the dissemination of firearms in the empire, the alteration of global trade patterns, and other factors. This was followed by an effort at Ottoman recentralization in order to reassert control over resources and people in response to the fluctuation between the empire's growth and contractions. In addition to these political, economic, and social changes, the effects of climatic and environmental factors, including the "Little Ice Age" starting in the 1590s and continuing into the early decades of the seventeenth century, and the spread of disease, all are given a proper place in Ottoman history by revisionist environmental historians. These conditions affected people, agricultural production, the management of livestock, and thus ultimately the ability to provision the cities and the armies on campaign.

Recent scholarship has also demanded a reconsideration of how to describe peripheral areas of the Ottoman Empire that abutted other empires or cultural zones, describing them alternatively as "frontiers" or "borderlands." The terms are not interchangeable, as the term *frontier* denotes an area on the "outer edge of a society" where the "savage, the unknown" exists and "divides one society from another."[2] Borderlands, in contrast, are integrative and emphasize similarities between peoples; there is "overlap and blend," so that these dynamic regions consist of peoples who interact and coexist in economic and social frameworks. For Ottomanist scholars, these distinctions can be applied to areas of the Ottoman Empire in different places at different times. For example, the Ottoman *beylik*'s location, adjacent to Byzantine lands in Anatolia, and the interaction of both Muslims and Christians across it, resembled the current theoretical conception of a borderland. For Ottomans themselves, especially those governing from the center once the principality became an imperial state with a capital, what was a "borderland" often became understood as a "frontier." The Mediterranean Sea, a conduit for commerce, was more borderland than frontier between empires. The Venetian-Habsburg-Ottoman juncture in the Slavic region of today's modern Croatia, Bosnia, and Serbia of the fifteenth to eighteenth centuries could be viewed alternatively as a frontier or a borderland, depending upon one's perspective. Wars to control territory and people perhaps overshadowed the more cooperative interactions between empires and fluid relations between the inhabitants of a region whose daily lives reflected connectedness through trade and culture, despite their differences in faith and/or ethnicity. Distinguishing borders as either frontiers or borderlands depends in large part upon whether evidence exists indicating how the ruling elite or the general population would have understood it. For purposes of this book, sometimes the word *frontier* is used to simply denote the idea of a demarcation between empires. At other times a frontier reflects a specific historical context: when an Ottoman Sultan or his administration's view was of a provincial region needing pacification of its local recalcitrant inhabitants, such as settling tribal groups, or as a front in war with European or Russian "infidels" (non-Muslims), or with Safavid "heretics" (Shi'ites), who were viewed negatively, for example. *Borderland* denotes the theoretical construct of a region perhaps divided imperially, yet with a tendency toward diversity, economic activity across borders, and cultural-social fluidity among local populations.

SOURCES OF OTTOMAN HISTORY

Contributing to the preliminary portrayal of Ottoman origins and Ottoman rise to prominence was the dilemma of available early sources, a problem that illustrates a larger quandary for the discipline of history in general, as well as the trajectory of Ottoman history influenced by those first scholars mentioned previously. Empires founded initially by nomadic tribespeople often create a predicament because nomads typically do not start to write about themselves until they begin to settle down, and a realization sets in that their legitimacy or their legacy must be preserved. Nomads often recognize this need about one hundred or so years after the establishment of a polity, so that early sources are scarce, or unreliable at best. Historians may come to depend on sources by "others" – rival powers, vanquished enemies, or conquered peoples – which likely have their own agendas. Ottoman sources concerning the principality's early history may also be skewed by being drafted retrospectively, with specific purposes in mind. For example, among one genre of Ottoman sources, that is, Ottoman chronicles, the authors who produced these narrative accounts glorifying the Ottoman dynasty as victors provide but one perspective; early chronicles sometimes included legendary, almost mythical feats that also detract from their historicity.

Between the fifteenth and sixteenth centuries, there is no doubt the Ottomans were actively promoting their imperial ascendency through chroniclers: scribes, *medrese* teachers (*müderris*), tutors of princes, and their associate artists who produced illustrated manuscripts. Although there was a *şehnameci* (court historian) in the sixteenth century who drafted poetic histories in Persian, by the late seventeenth century, the Ottomans had thoroughly acknowledged the importance of the historical record. A more formal, appointed position called a *vakanüvis* – an official court historian – was created in the Ottoman Empire to draft its history; author Mustafa Na'ima (b.1655–d.1716) was the first *vakanüvis* appointee, and the last, Abdurrahman Şeref (b.1853–d.1925), served in this capacity from 1908 until his death. To lend legitimacy and continuity to their Ottoman chronicles, many authors followed the approaches of previous Islamic historians and began their manuscripts with pre-Islamic human history, then surveyed Islamic empires that preceded the Ottomans before proceeding to narrate the Ottoman story. In honor of their tradition, and to familiarize readers with what came before the Ottomans, the present volume will also begin with an overview of pre-Ottoman and Islamic history.

Besides the many Ottoman manuscripts, books, and documents located in various libraries and archives such as those in Topkapı Palace, another pool of sources crucial to the study of Ottoman history are government records housed in the Ottoman Prime and Foreign Ministry Archives in Istanbul. There are millions of documents preserved here and in other sites – financial records such as tax registers and cadastral surveys, tax farm records, *evkâf* (pious endowment) registers, official sultanic decrees, *fetva* (legal pronouncement) collections, complaint petitions and responses, internal communications between Ottoman bureaucratic offices of the state, between the Ottoman administrative center and provincial authorities, diplomatic correspondence with foreign powers, etc. – all across time and

place of the empire. The sheer volume of Ottoman government-produced archival sources left behind by the ruling class has generated a tendency in Ottoman history for decades to focus primarily upon a "view from the center" – that is, a very capital-centric political history, at the expense of other perspectives, such as Ottoman provincial histories, or those of non-elite, non-state actors, or non-textual sources (i.e., art, architecture, numismatics, photographs), which may be more reflective of sociocultural life in the empire. This has now changed: judicial and Islamic legal court records, called *kadı* registers, which pertain to property ownership, crime, and family life, among other things, are located in court buildings of district centers and so are spread across former Ottoman lands. They add a fuller picture of Ottoman life while balancing elite and non-elite perspectives as well as Ottoman history from the provincial point of view. Privately held archives and memoirs, non-Ottoman sources such as travel accounts or foreign diplomatic sources, domestic and foreign newspapers in later centuries, all comprise other possible sources for writing Ottoman history and integrating it more thoroughly into European, Asian, and world histories. The list of potential sources of Ottoman history is seemingly endless and not fully tapped yet.

As one result of the broader employment of various sources, recently women and gender have become prominent subfields of Ottoman history. Scholars have now deciphered how to approach these topics when, for example, many of the textual sources, whether narrative Ottoman chronicles, or archival Ottoman government documents, seemed to have been rather silent when it came to women and their agency. Prominent Ottoman women in the dynastic households of the sultans often played important roles behind the scenes as political power brokers, regents, and advisors in the palace, and there are some records indicating this influence. Depending upon the origin of the source, their actions were interpreted at the time positively, as assisting in Ottoman rule while knowing their subordinate position, or negatively, as nefarious, scheming women, interfering in politics. In Ottoman society at large, however, royal womens' influence was expressed mainly through charitable giving and funding of buildings or foundations to serve the public good – mosques, hospitals, fountains, and the like, rather than leaving behind any textual evidence.

For sources reflecting non-royal Ottoman womens' agency, researchers had to look in other directions. Ottoman court records have provided a unique perspective on how women in the Ottoman Empire lived, owned property, managed businesses, accumulated wealth, and played important roles in Ottoman society. These court records contain a variety of information that can help piece together Ottoman womens' lives. Marriage, divorce, and inheritance records inform researchers of womens' domestic existence and possessions; female slaves sometimes took their fight for emancipation to the courts; disputes over property argued in court cases paint a picture of how women used the courts to claim their rights. As a consequence of scholars' efforts to pursue these avenues of research, we now have a more nuanced view of Ottoman society as a whole.

In light of the vast reservoir of sources for Ottoman history mentioned above, a historiographical issue to consider as a potential obstacle to the study of Ottoman history and

defining the Ottomans is language: Ottoman Turkish is now a dead vernacular, but was once the official language of the imperial ruling elites, or the *askeri* class of the empire. Evolving out of a synthesis of Turkish, Persian, and Arabic vocabulary and syntax, and written in a modified Arabic script that appeared in various styles depending upon the type of text (e.g., a manuscript chronicle, a financial document, an imperial decree, etc.) and the century in which it was written, the ability to communicate in this language was a marker of elite status in the Ottoman Empire. It reflected one's knowledge of what can be called the "Ottoman way" – the education and connections necessary to guarantee a position (directly or indirectly) within the state's governing apparatus. The *re'aya*, however – the predominantly illiterate, non-ruling classes of the peasantry, merchants, tradespeople, and artisans, those who paid taxes to support the state and its *askeri* class – continued to speak in their local languages, and were what the *askeri* would consider "country bumpkins."

This high Ottoman language developed over time, transforming in parallel with the empire's evolution, so that early Ottoman Turkish language was heavily infused with Persian words and constructs; as the empire expanded to include Arab lands and population, and as the Ottomans came to practice a form of Islam more orthodox in its expression, Arabic vocabulary and concepts also increasingly made their way into Ottoman Turkish. Even the terms *askeri* and *re'aya* have roots in Arabo-Islamic parlance that make their direct translation unmeaningful without knowledge of Islamic history: *asker* is the Arabic word for army or soldier, implying the military origins of the Ottoman state's emergence; *re'aya* is a Qur'anic term meaning "the flock," with its religious implications of the prophetic "shepherd" guiding, and having custodianship over, his charges (*re'aya* from the eighteenth-century Ottoman Empire onwards typically meant the Christian tax-paying population only). What all of this means for the student of Ottoman history then becomes more obvious: to be able to pour over Ottoman archival documents, or to read the chronicles left behind by those past Ottoman (often court) historians, or to examine the newspapers published in the last century of the empire's existence, the Ottomanist needs to learn not just Ottoman Turkish, which requires a knowledge of modern Turkish language, but, depending upon one's period of expertise, a substantial background in Persian and Arabic languages as well, and a familiarity with various Ottoman stylistic scripts.

Nonetheless, the field of Ottoman studies is now flourishing due to the persistence of scholars facing the linguistic and other challenges to their craft – the Ottoman archives in Turkey are open and available, and, unlike many other places in the Middle East and North Africa today, scholarly inquiry can continue, unhindered by current wars that have destroyed lives, antiquities, archives, and libraries in the countries that had previously been Ottoman provinces before World War I. Ottomanists with a knowledge of multiple languages are piecing together more thorough narratives of this empire's rich historical tapestry using Ottoman Turkish, Arabic, Armenian, Greek, etc. as well as European (western and eastern), Middle Eastern, North African, and Asian sources. The Ottoman Empire is being explored from the perspectives of similarities and intersections with other societies of the world in new and exciting ways, including comparisons with empire-building processes occurring in various geographic regions as they dealt with the same

sorts of issues. Discussions of Muslim and non-Muslim relations are now shifting away from the extreme categories of "pure tolerance" versus "persecution and forced conversion," to a more nuanced approach that recognizes the Ottoman ability to successfully "manage difference" at times (but at other times not) and to achieve coexistence among its mosaic of ethnoreligious peoples comprising the Ottoman polity. Rather than viewing Ottoman society as rigidly segregated between Muslims and non-Muslims, scholars have unearthed the evidence of considerable mingling, whether in the early stages of the principality's emergence on the frontier as fellow raiders, for example, or in the marketplace, or due to patterns of social mobility within the Ottoman class structure and the role of conversion and imperial service in that process. As previously mentioned, gender relations have also been re-examined in the Ottoman context, dispelling the former views of women in Islamic societies as powerless and completely isolated within the walls of the harem. Efforts are finally being made to properly integrate Ottoman history into European studies; as evidence, more university history departments than ever before have at least one Ottomanist in their faculty, engaging in an academic dialogue across empires and civilizations rather than compartmentalizing history into a simple binary of "Islam and the West."

Before delving more deeply into the question of Ottoman origins and tracing the Ottoman ascent from principality on the Anatolian frontier to world empire, we must first emphasize what is the most striking feature of the Ottoman Empire's existence, and that which made possible Ottoman imperial success and longevity: Ottoman flexibility and pragmatism in administering what would become a vast territorial expanse – in an empire comprised of such ethnoreligious, socioeconomic, and ecological diversity. This Ottoman flexibility created a certain synergy, a synthesis of disparate influences to create something wholly new and enduring as an imperial entity. As mentioned earlier, the Ottoman propensity to generally accept and manage difference, notable from the *beylik*'s inception, its inclusiveness toward anyone willing to serve the Ottoman interest, was its greatest achievement, and, in many ways, not ever similarly replicated elsewhere.

The Ottomans were able to establish and maintain a vast empire not merely through war, conquest, and force, but with a governing approach that, for the most part, involved both a keen recognition of how to rule so as not to alienate provincial subjects too severely (though this did occur), while also possessing the ability to find local mediators from the population willing to cooperate with the state, particularly in outlying provincial areas. And conversely, when the Ottomans stopped exhibiting this flexibility, when the Ottoman state's lack of adaptability manifested amid challenges from the outside world and domestically from within, the empire's dissolution and ultimate collapse ensued. Ottoman pragmatic openness toward religious heterodoxy in the pre-modern period transitioned to a more rigid policy of Sunni Muslim orthodoxy by the sixteenth century and after (with few exceptions until the secular Young Turk regime of the twentieth century), although non-Muslims still fared relatively well in the empire until its violent wartime end. Earlier centuries of Ottoman military innovativeness bogged down in the early modern era as warfare technology evolved and the Ottomans failed to adjust fast enough (though they did eventually); this in the face of binding international agreements that dragged them into

catastrophic economic circumstances and devastating wars. But even so, it was not until having to counter the emergence of nationalism internally in the nineteenth and early twentieth centuries that the Ottoman responses to international pressures and internal crises were perhaps less innovative, more reactive in nature, and often more brutal and authoritarian in their execution of policies. Given the dramatically changed world of the modern era, with its global colonial strife and territorial interventions perpetrated mainly by European and Russian powers, perhaps the Ottomans had no room to maneuver, no possibility for their pattern of flexibility and pragmatism to endure. This is the final question the student of Ottoman history should ponder.

CHAPTER OUTLINE

This illustrated narrative of the Ottoman Empire will start with a survey of some elements of pre-Ottoman history that affected the emergence of the later Ottoman state in significant ways. Chapter 2 presents an overview of the Central Asian origins of the Turks, a brief summary of the rise of Islam and the Muslim empires in the region of the Middle East, the Turks' entrance into this pre-modern setting, and the establishment of a small principality in Anatolia at the turn of the fourteenth century by a Turk named Osman, founder of what later became the Ottoman Empire.

Chapter 3 explores some of the features that evolved over time and underpinned the Ottoman dynasty's ability to establish, maintain, and legitimize political power in the region – whether through Ottoman dynastic succession, the slave-recruit system modified from earlier Islamic precedents, or the methods of provincial conquest and administration. The explanations of these early institutions and practices may stray slightly beyond the chapter's chronological outline in order to demonstrate their change over time. Chapter 4 returns to the chronology where Chapter 3 left off – the early fifteenth century. This chapter traces the first major Ottoman crisis of rulership, as well as the tools of empire developing before and after the siege of Constantinople in 1453, which laid the foundations for the Ottomans to assert themselves as a full-fledged global power by the sixteenth century, the subject of Chapter 5. Chapter 5 covers the increasingly complex world of the sixteenth century in terms of managing what was becoming a vast territorial, ethnoreligiously diverse Ottoman Empire, and engaging with European Christian and fellow Muslim powers in war and in trade. Chapter 6 expands upon these themes through the era of several sultans, including the famous Süleyman the Magnificent, whose reign saw the alteration of dynastic succession practices and the immeasurable transformation of the empire through the process of institutionalization.

Chapter 7 breaks slightly with the chronological format to present information on everyday life for people in the Ottoman Empire, elite and non-elite, as well as a view of some understudied historical actors – non-human animals in Ottoman society. Chapters 8 and 9 re-engage with political history where it intersects with social history – on

the advent of climate disasters interconnecting with wars and rebellions as the empire witnessed the transformative turn of the seventeenth century, for example. These chapters explore seventeenth-century crises leading to the empire's eventual unraveling in the twentieth century, as well as the cultural contacts between Europe, the Ottoman Empire, and Asia in the early modern era. The cyclical nature of expansion and contraction of Ottoman territory, economy, and political authority due to a changed world, both internationally and internally, was in part the consequence of Europe's "Age of Discovery" and the subsequent rise of European imperial empires bent on colonial conquest and military supremacy. Various other issues illuminate the causes of domestic unrest the Ottomans suffered at home, such as the further alteration of Ottoman succession, or changes in the character of the ruling Ottoman elite. As is recounted in Chapter 10, Ottoman reforms in response to crises, often referred to as "defensive modernization," began in the latter decade of the eighteenth century, a process that continued amid the emergence of separatist nationalist movements in the "long" nineteenth century, along with the influx of Muslim refugees from former Ottoman lands, which affected Muslim/non-Muslim relations in tragic ways. Dramatic changes to Ottoman daily life in the empire's final century ensued due to many factors, including the introduction of modern technologies, drastic reforms to the Ottoman sociopolitical system and the attraction to new organizing ideologies, new identities leading to sectarian violence, and European military and fiscal interventions: all are the subjects of Chapter 11. These crises culminate in the Ottoman Empire's continuous wars of the twentieth century, from the Balkan Wars to World War I, all of which serve as the backdrop to the violence of the Arab Revolt, the Armenian genocide, and the destruction of the Ottoman Empire discussed in Chapter 12. On the heels of World War I came the Turkish War of Independence and the establishment of the Turkish Republic in 1923, events not lacking in social trauma for all who survived the wartime mobilization, and leaving behind in the aftermath some unfinished business where identity was concerned. The epilogue (Chapter 13) sums up some of these issues: the legacies of the Ottoman Empire in the world; historical and contemporary relations between Muslim Turks and non-Muslim minorities in and outside Turkey today (e.g., Greeks, Armenians); the ongoing strife with the mainly Sunni Kurds and the Shi'i *Alevi* Turks in the country; the tensions between secular and Islamist sectors of the population; and modern Turkey's place in the world today, in a region still plagued by instability and interstate hostilities.

NOTES

1 See Eric R. Wolf, *Europe and the People without History* (Berkeley: University of California Press, 1982) for the distinction between Europeans (West) and "Others."

2 Linda T. Darling, "The Mediterranean as a Borderland," *Review of Middle East Studies* 46, no. 1 (Summer 2012): 54–5.

SELECTED READINGS

Aksan, Virginia H. *Ottomans and Europeans: Contacts and Conflicts*. Istanbul: The Isis Press, 2004.

Aksan, Virginia H. "What's Up in Ottoman Studies." *Journal of the Ottoman and Turkish Studies Association* 1, no. 1–2 (2014): 3–21.

Aksan, Virginia H., and Daniel Goffman, eds. *The Early Modern Ottomans: Remapping the Empire*. Cambridge: Cambridge University Press, 2007.

Barkey, Karen. *Empire of Difference: The Ottomans in Comparative Perspective*. New York: Cambridge University Press, 2008.

Cahen, Claude. *Pre-Ottoman Turkey: A General Survey of the Material and Spiritual Culture and History, c.1071–1330*. New York: Taplinger Publishing Company, 1968.

Dale, Stephen F. *The Muslim Empires of the Ottomans, Safavids, and Mughals*. Cambridge: Cambridge University Press, 2010.

Darling, Linda T. "The Mediterranean as a Borderland." *Review of Middle East Studies* 46, no. 1 (Summer 2012): 54–63.

Faroqhi, Suraiya. *Approaching Ottoman History: An Introduction to the Sources*. Cambridge University Press, 1999.

Finkel, Caroline. *Osman's Dream: The Story of the Ottoman Empire, 1300–1923*. London: John Murray, 2005.

Gibb, H.A.R., and Harold Bowen. *Islamic Society and the West*. 2 vols. Oxford: Oxford University Press, 1957.

Gibbon, Edward. *The History of The Decline and Fall of the Roman Empire*. Vol. 2, chap. 64. London: Strahan & Cadell, 1781.

Goffman, Daniel. *The Ottoman Empire and Early Modern Europe*. Cambridge: Cambridge University Press, 2002.

Greene, Molly. "The Ottoman Experience." *Daedalus* 134, no. 2 (Spring 2005): 88–99.

Imber, Colin. *The Ottoman Empire: 1300–1481*. Istanbul: The Isis Press, 1990.

İnalcık, Halil. *The Ottoman Empire: The Classical Age, 1300–1600*. London: The Trinity Press, 1973.

Itzkowitz, Norman. "Eighteenth Century Ottoman Realities." *Studia Islamica* 16 (1962): 73–94.

Itzkowitz, Norman. *Ottoman Empire and Islamic Tradition*. Chicago: University of Chicago, 1972.

Kafadar, Cemal. *Between Two Worlds: The Construction of the Ottoman State*. Berkeley: University of California Press, 1995.

Köprülü, Mehmed Fuad. *Islam in Anatolia after the Turkish Invasion*. Salt Lake City: University of Utah Press, 1993.

Köprülü, Mehmed Fuad. *The Seljuks of Anatolia*. Salt Lake City: University of Utah Press, 1992.

Lewis, Bernard. *Istanbul and the Civilization of the Ottoman Empire*. Norman: University of Oklahoma Press, 1963.

Lindner, Rudi Paul. *Nomads and Ottomans in Medieval Anatolia*. Bloomington, IN: Research Institute for Inner Asian Studies, 1983.

Lowry, Heath W. *The Nature of the Early Ottoman State*. New York: State University of New York Press, 2003.

Lybyer, Albert Howe. *The Government of the Ottoman Empire in the Time of Suleiman the Magnificent*. Cambridge: Harvard University Press, 1913.

Mikhail, Alan. *Nature and Empire in Ottoman Egypt: An Environmental History*. New York: Cambridge University Press, 2011.

Peirce, Leslie. *The Imperial Harem: Women and Sovereignty in the Ottoman Empire*. New York: Oxford University Press, 1993.

Peirce, Leslie. *Morality Tales: Law and Gender in the Ottoman Court of Aintab*. Berkeley: University of California Press, 2003.

Pitcher, Donald Edgar. *An Historical Geography of the Ottoman Empire*. Leiden: E.J. Brill, 1972.

Quataert, Donald. *The Ottoman Empire 1700–1922*. New York: Cambridge University Press, 2000.

Quataert, Donald. "Ottoman History Writing at the Crossroads." In *Turkish Studies in the United States*, edited by Donald Quataert and Sabri Sayari, 15–30. Bloomington: Indiana University Press, 2003.

Streusand, Douglas E. *Islamic Gunpowder Empires: Ottomans, Safavids, and Mughals*. Boulder, CO: Westview Press, 2010.

University of Chicago. *Historians of the Ottoman Empire*. (Website initiated in 2003). https://ottomanhistorians.uchicago.edu/en. (Online bio-bibliographical reference on all of the historians who lived and produced within geographical limits of the Ottoman Empire, covering works of history primarily in Turkish, but also in Arabic, Persian, Armenian, Greek, and other languages.)

Vryonis, Speros. *The Decline of Medieval Hellenism in Asia Minor and the Process of Islamization from the Eleventh through the Fifteenth Century*. Berkeley: University of California Press, 1971.

Vryonis, Speros. *Studies on Byzantium, Seljuks, and Ottomans: Reprinted Studies*. Malibu, CA: Undena Publications, 1981.

White, Sam. *The Climate of Rebellion in the Early Modern Ottoman Empire*. New York: Cambridge University Press, 2011.

Wittek, Paul. *The Rise of the Ottoman Empire*. Reprint, London: The Royal Asiatic Society of Great Britain and Ireland, 1958.

TWO

THE EARLY OTTOMAN SYNTHESIS: INHERITORS OF MULTIPLE TRADITIONS

WHO ARE THE TURKS?

This Ottoman flexibility could be said to have been borne of the cultural encounters to which the Ottomans were exposed from early on – but who were the progenitors of these Ottomans? Before discussing the emergence of the Ottoman principality in Anatolia and contributions to Islamic civilization, we must consider the pre-Islamic identity of those who would found it – the Turks. Who were these "Turks"? According to historians, the peoples of Inner Asia, both Indo-European and Turco-Mongol, had a history of equestrian and pastoral nomadic existence for millennia, which brought them into contact with ancient Chinese empires. The terrain of Central Asia varied between steppe grasslands and desert areas, a forest zone, and mountain chains separating it from South Asia, making a nomadic tribal social organization, horse-breeding, and the migration of these groups cyclically between summer and winter pastures for their horses, sheep, goats, camels, cattle, and yaks the basis of their existence. Nomads tended to be resistant to central authority and depended upon one another for survival; life was lived in round portable tents – *yurt*s. Agricultural and more urban settlements existed in a symbiotic relationship between nomads and sedentarists in a market context, though settled peoples could also be the target of raiding.

As a nomadic people without much written history, scholars have relied upon Chinese annals from the late seventh century CE (compiled from earlier Chinese texts, now lost) to tell us about the Turkic tribal confederations that the Chinese called the *Tu-chüeh* (or *Türkî*, anglicized pronunciation as "Turkey"), a word whose original meaning was "combat helmet," describing the shape of the mountainous Altai region from where it was believed these nomads had originated (Map 2.1). The genealogical tradition passed down orally traces Turkic origins back to a semi-fictional chieftain, Oğuz Khan, who was said to have had two wives, three sons from each wife, and four branches of descendants from each son, to make a total of twenty-four Oğuz tribes who migrated eastwards and westwards. This Oğuz Khan later figured

Map 2.1 Turkic Migrations.

into Muslim Turco-Mongol literature as an ancestral hero and founder whose descendants established various dynasties across the region. For the Chinese, *Tu-chüeh* did not necessarily connote an ethnicity the way "Turkic" does today, but rather a social descriptor: these were barbaric raiders who wrought havoc on Chinese empires and could not be controlled.

The oral Turkic folk traditions relayed from Chinese sources are quite informative. The *Wu-Sun*, a nomadic (Altaic-Turkic or Indo-European?) people in northwestern China who migrated between several areas around the third century BCE to the fourth century CE (circa the Han period), had an origin myth similar to that of Rome – their ruler was said to have been abandoned as a child after his father had been killed, but was suckled by a she-wolf and fed by a crow. Several Central Asian Turkic peoples, including the Uyghurs of East Turkestan and the Huns, have origin myths claiming their ancestors were descended from wolves, the wolf being a popular totem among nomadic tribes whose predatory and migratory lifestyle and social organization in many ways resembled the survival tactics of a wolf pack. According to the Chinese accounts of Turkic origin mythology, one branch of the Turkic *Xiongnu* tribe named *A-Shih-Na*, who had migrated west in late third to early second

century BCE, were attacked, and everyone was killed but a ten-year-old boy whose feet were cut off; a she-wolf found him, nursed him, and eventually mated with him to have ten sons, one of whom assumed the clan name of *Ashina* and founded a dynasty in the sixth century CE. This Central Asian empire, divided between eastern and western khanates, was called the *Köktürks* or *Göktürks*, reflecting the shamanistic beliefs of this clan, as their name means "Blue Turks," or "Sky Turks," a reference to the celestial Turco-Mongol sky god *Tanrı* or *Tenggri* who divinely empowered them in their destiny to rule. In the eighth century the Göktürks erected stone monuments in Mongolia conveying the fortunes and failures of these Oğuz Turk descendants in what are called the Orkhon Inscriptions (carved in Chinese and in an Old Turkic script, alphabetic yet runic) and the Tonyukuk Inscription (in Old Turkic).

Eventually the Göktürk Empire was absorbed into another Turkic khanate, the Uyghurs, in the eighth century. The Uyghurs preserved some of their shamanistic beliefs (particularly of a blue wolf as a guide who led them in battle); however, as a consequence of being situated along the Silk Road, the Uyghurs were exposed to and practiced various religious traditions such as Buddhism, Manichaeism, and Nestorian Christianity. In addition, their strategic location and the influences of Persian and Chinese cultures ushered in a more settled and commercialist lifestyle for the Uyghurs, as well as a written language. Other Turkic tribal groups continued their pastoral nomadic existence, one of whom, the Kırghız, overthrew the Uyghurs by the ninth century CE, dispersing them to other areas of Central Asia, where they eventually converted to Islam as well (by around the tenth century). Wolf iconography and mythology would endure among some Turco-Mongol peoples as part of their cultural identity throughout the centuries and up until today, though it disappeared from other later Turkic societies such as the Seljuk Turks of the eleventh century; for the Ottomans, it would only reappear in the last decades of the empire as a symbol of Turkish national and military might.

Demographic pressures from Mongol peoples further east, the eventual weakening and collapse of the Uyghur Khanate around 840 CE, and the need to find new grazing pastures for livestock and new settled regions to raid enticed other tribes of the Oğuz lineage to migrate westwards by the late eighth century, into areas such as Transoxiana (beyond the Amu Darya or Oxus River, what is today parts of Turkmenistan, Uzbekistan, Kyrgyzstan, Kazakhstan, and Tajikistan). Some of these Oğuz tribes began to convert to Islam along the way, some time in the early ninth to tenth century, upon coming into contact with the Islamic state that had already expanded out of Arabia and into Byzantine lands, across Persia, and into Central Asia. One branch of the Oğuz called the Kınık tribe converted to Islam after its leader, Seljuk, did so around the late tenth century (*c.*985 CE). His descendants established control in Samarkand and Bukhara and migrated further, into Khurasan to engage in raids called *gaza* upon the local population there. From here, these Seljuk Turks expanded their power base in the eleventh century and came into deeper contact with more established Islamic societies in a cultural encounter that melded their Turkic, nomadic steppe customs with a more settled tradition of imperial rulership, translated mainly through the medium of Perso-Islamic traditions. This intersection of Turkic peoples and Islamic civilization to which we now turn is a portion of the pre-Ottoman story underpinning the later Ottoman flexibility to adapt.

ISLAMIC BEGINNINGS

The founding of Islam in Mecca by the Prophet Muhammad occurred around the early seventh century. His migration to Medina in 622 CE with a fledgling Muslim community marked the beginning of the Islamic *hijri* calendar. After the Prophet's death in 632 CE, the rapid expansion of Muslim armies out of the Arabian Peninsula and into the Byzantine and Sassanian Persian empires had irreversible consequences for the region as a whole. The pattern of cultural assimilation set by ancient Near East civilizations continued unabated in the Islamic centuries to follow. The caliphs, or "successors," who led the Muslim community politically and spiritually after 632 CE presided over conquests that significantly reduced Byzantine territory, including the loss of Damascus (636 CE) and the prized city of Judaism and Christianity, Jerusalem (637 CE). Egypt fell under Muslim control by 641 CE. Sassanian Persia's capital of Ctesiphon was occupied by Arab forces in 637 CE, opening Persia to the Arab conquerors who ultimately destroyed the Sassanian Empire as they extended their reach across the Iranian Plateau. After the caliphate had become a hereditary Arab state with the ascent of the Umayyad dynasty (r.661–750), centered in Damascus, Arab Muslim armies surged into Central Asia in the early eighth century. They battled Turkic and Indo-European tribes in Transoxiana while also ranging across North Africa to the shores of the Atlantic, crossing Gibraltar into the Iberian Peninsula by 711 CE (Map 2.2). The Umayyads in the Levant tried unsuccessfully several times to conquer Byzantine Constantinople. The Umayyads in Damascus were overthrown in 750 CE, but the dynasty managed to endure by eventually establishing a Muslim caliphate in al-Andalus (Islamic Spain) after 930 CE that witnessed a rich and thriving culture underpinned by Judaic, Christian, and Muslim coexistence.

The Prophet Muhammad's death in 632 CE had initiated a communal dispute over leadership that would not take on religious doctrinal characteristics until later. The majority of the fledgling Muslim *umma* (the "community of believers"), later known as *Sunni*s, adhered to the idea that a successor (not another prophet, for there could be no other according to Islam) should be chosen from among Muhammad's Quraysh tribe by the elders of the community. A minority, however, called *Shi'a*, believed that Muhammad had actually designated a successor to his political, military, and spiritual (in prayer) leadership: a member of his family, that designate being Ali, his cousin and son-in-law by marriage to his daughter Fatima. As Ali was passed over as caliph in favor of first Abu Bakr, then Umar, and then Uthman, before he was finally chosen to lead, animosities between those in disagreement about the succession process led ultimately to not only the assassinations of Uthman and Ali, but also to the fracturing of the Islamic community into a Sunni majority and a Shi'i minority in later centuries. The latter splintered further into Shi'a subsects as Shi'ite religious doctrine and the understanding of the imamate (the Shi'ite conception of Islamic leadership) came to be more rigidly defined in later decades. Initial bloody rebellions against the Sunni Umayyads by Shi'a and others led to upheavals resulting in the Abbasid Revolution ousting the Umayyads in 750 CE, eventually giving way to a more quietist Shi'ite attitude about non-interference in worldly politics in Sunni lands until the fifteenth century. There were exceptions, such as the establishment of the Ismaili Shi'ite Fatimid dynasty in Egypt in the tenth to twelfth centuries. The Sunni-Shi'i divide would

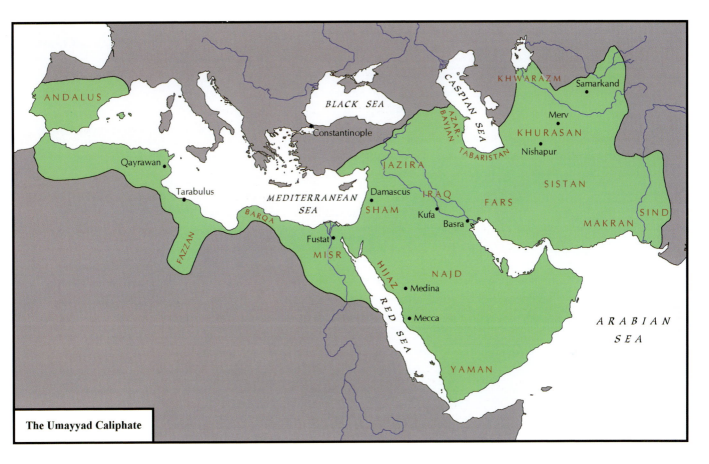

The Umayyad Caliphate

Map 2.2 The Umayyad Caliphate.

fester and ultimately crystallize as an imperial conflict disguised as a religious and ideological one between the later Sunni Ottoman Empire and Shi'ite Safavid Persia, resulting in numerous lengthy wars between the sixteenth and eighteenth centuries.

The Sunni Abbasid dynasty (r.750 ~ 1258) that overthrew the Umayyads reigned mainly from their new capital further east, Baghdad on the Tigris River, continuing the trend toward an assimilative Islamic civilization that absorbed and adapted the cultures of those with whom the Abbasids came into contact (Map 2.3). They also continued to penetrate Central Asia through conquest, bringing the Abbasid armies into contact with China at the Battle of Talas (751 CE) in which Muslim forces defeated the T'ang; thus Islam in this way began to be introduced to the local peoples of the area. But one could argue this Islamization process was actually a two-way street, as a coincident "Turkish influx into the Islamic world" happening in several stages:

> The first phase began in the ninth century, when unconverted Turkic nomads, captured in border raids, were used as slave-soldiers in Baghdad or elsewhere in the Middle East. Converted to Islam and assimilated culturally, they created no lasting Turkic presence in the Middle East. The second phase began in the tenth century, when a minor ruling clan from Transoxania, the Seljuks, converted to Islam and migrated into Iran to seek its fortune. So began the remarkable career of the Turks as empire builders in the Islamic Middle East.... The third phase in forming a Turkish presence inside the Middle East,

Map 2.3 The Abbasid Caliphate,
c. Tenth Century.

that of creating a Turkish literary culture to go with the Turkish demographic presence, would have to wait nearly until the Ottomans' rise in the fourteenth century.[1]

ISLAMIC "*GHULAM* SYSTEM" AND "*MAMLUK*" SLAVERY

Earlier precedents concerning slavery would influence later Ottoman practice, thus a brief overview of Islamic slavery is necessary here. Domestic slavery had existed in the Middle East since pre-Islamic eras, and Islamic societies often enslaved Africans for domestic or hard labor use. The *ghulam* system originally referred to both those freeborn and enslaved servants of the Abbasid caliphs who had personal ties of loyalty to him. According to Islamic legal precedent, Muslims could not be enslaved by other Muslims, nor could non-Muslims in the *Dar al-Islam*, the "Abode of Peace," understood to be the realm in which Islamic or *Shari'a* law was in force. In other words, those who were *dhimmi*s (non-Muslim "Peoples of the Book") who had accepted subordination to the Muslim sovereign and demonstrated this through the payment of a special tax called the *jizya*, as well as abiding by various other stipulations regulating non-Muslim appearance and behavior, were then granted protection of their lives and property, and a measure of communal autonomy. They could not legally be enslaved.

Therefore slaves in Islamic societies were usually drawn from outside Muslim lands, among non-Muslims from the *Dar al-Harb*, the "Abode of War," foreign territory not conquered, where Islamic law was not in force, and where non-Muslims had not submitted to Muslim rule.[2] This meant slaves were acquired as captives in war or purchased in slave markets; once in Islamic lands, they could be bought and sold, inherited, or serve as gifts within the *Dar al-Islam*. A Muslim ruler's entitlement to one-fifth of the plunder in raids dated back to the precedent set during the Prophet Muhammad's lifetime concerning movable property taken in war; captives fell into this category.

The Abbasid Caliph al-Muʿtaṣim (r.833–842), in need of a military force loyal to him alone to relieve his dependence upon rebellious Arab tribal units, adapted the earlier Mesopotamian practice of forming slave armies. Impressed with Turkic horsemanship and martial abilities in combat, particularly as mounted archers, al-Muʿtaṣim's trained slave soldiers, called *mamluks* ("that which is possessed"), were predominantly non-Muslim, pagan Turks captured in battle or bought in slave markets in Central Asia. The Arabic sources indicate the *mamluk* slaves in this period to have numbered somewhere between 20,000 and 70,000, with the caliphal body-guard numbering around 10,000. This form of slavery allowed for a level of social mobility that carried Turkic peoples far beyond mere caliphal servitude; these forces were trained, educated, converted to Islam, subsequently manumitted (considered freed), and allowed households of their own, though their status, service, loyalty, and very lives remained in the hands of their master, the caliph. Later Islamic dynasties continued to utilize such slave armies. Muslim dynasties whose founders were Turkic military commanders (*amirs/emirs*) of slave origins even emerged in the Middle East and North Africa across regions of the Abbasid realm, and functioned autonomously (e.g., the Tulunids in Egypt, *c.*868–905; the Ghaznavids in Eastern Iran, Afghanistan, and northwestern India, *c.*977–1186; the Mamluk Sultanate in Egypt, *c.*1250–*c.*1517, named specifically for its founder as a former Turkic slave commander). They created for themselves a symbiotic relationship by which they ostensibly carried out the wishes and policies of the Abbasid caliph in Baghdad, and in return, they possessed regional military and economic control, the caliph recognizing their authority by bestowing the title of *sultan* upon them. In time the Abbasid Empire would fragment into a multiplicity of these emirates, increasingly stripping the Sunni caliph of any actual authority beyond spiritual, relegating him to the status of a Muslim figurehead. As a symptom of this Abbasid political impotence, not only was command on the ground in the region of Iraq held by Twelver Shi'i *Buyids*, a dynastic power in the tenth century who virtually held the Abbasid caliph under house arrest, but other fully independent rival claimants to the caliphate would emerge, as mentioned earlier, in Umayyad Spain as well as in Shi'i Fatimid Egypt.

THE ISLAMIC CULTURAL MILIEU

The Abbasids sought out knowledge from manuscripts acquired from Byzantium, Persia, India, and China and translated at the "*Bayt al-Hikma*," an institute established in Baghdad by an enlightened and inquisitive Abbasid caliph. Scholars were welcome here: Sunni Islamic

law was elaborated upon; philosophy flourished, as did other arts and sciences – mathematics, astronomy, medicine, agricultural production, etc. Knowledge and commercial exchange became the priorities of the Abbasids; Venice was among their early trading partners in the Mediterranean. This period of the "High Caliphate" was marked also by the significant influence of Persian culture, which survived, despite the destruction of the Sassanian realm, due to the entry of many Persian bureaucrats and scholars into the Abbasid fold, thus driving Islamic cultural efflorescence and impacting later Muslim dynastic empires. This early tendency toward assimilating knowledge and culture of other civilizations was a pattern that continued in subsequent empires in the Islamic Middle East, including that of the later Ottomans.

Often assumed to be a purely Persian theory of political power that made its way into Islamic civilization, the "Circle of Justice," as it came to be called in Ottoman literature of the sixteenth century, was actually yet another influence of ancient Near Eastern empires – the Sumerian, Babylonian, and Assyrian – which merged nicely with ancient Persian empires' notions of divine sanction for their monarchies (such as the Achaemenids and the later Sassanians). The basic presumption of this theory centers around the possession of power and authority only so long as justice and prosperity are maintained in the realm, since a ruler must have an army to support this power and protect the domain. Soldiers must be paid, therefore the treasury must be full; this is only possible if the people are satisfied and pay their taxes to provide revenue for the state. Later empires further transformed the ancient Mesopotamian and Persian interpretations of this political theory. Islamic scholars defined rulership in terms of the Circle of Justice merged with Qur'anic precepts concerning social justice and the maintenance of authority on the one hand and normative customs on the other. In the ninth century the Persian Muslim scholar Ibn Qutayba wrote that "there can be no government without men, no men without money, no money without prosperity, and no prosperity without justice and good government."[3] The ruler may have been absolutist, but had to be benevolent, seeing to the needs of the people, hearing their grievances. These principles of the Circle of Justice persisted into the Ottoman era to come, underpinning Ottoman political thought for centuries.

THE MEDIEVAL "NEIGHBORHOOD": ANATOLIA AND THE MIDDLE EAST

The Roman Emperor Diocletian (r.286–305) had instituted a tetrarchy administratively dividing the Roman Empire into eastern and western halves in the third century and moved his capital to Nicomedia (İzmit) in Asia Minor. Constantine, the first Christian emperor, ruled in the early fourth century from the new eastern capital, Byzantium, renaming it Constantinople – in a Greek-speaking part of the eastern Mediterranean, where Eastern Orthodox Christianity had taken root. By 395 CE the empire was permanently divided into the Western Roman Empire, which suffered invasions by Germanic peoples and only survived until 476 CE, and an Eastern Byzantine Empire, which endured until 1453.

The Seljuk Turks in Khurasan at the turn of the eleventh century, having already converted to Sunni Islam a generation before, defeated other bordering Muslim dynastic states such as

the Ghaznavids in 1040 CE at the Battle of Dandankan near Merv. This opened the Iranian plateau to the Seljuks as a gateway into the Islamic heartlands, and into Anatolia – including the Kingdom of Armenia and Byzantine territory. At the "invitation" of the Abbasid caliph, and likely due to a Seljuk offer to free the pilgrimage route to Mecca and Medina from Ismaili Fatimid control, a Seljuk army reached and eventually "liberated" the Abbasid caliph in Baghdad from the Shi'i *Buyid* Amirs in 1055 CE. The Abbasid caliph bestowed the title of sultan on the Seljuks, implying their investiture with temporal political power and recognizing them as the legitimate sultanate carrying out the will of the caliph. Raiding into Anatolia was already being carried out by Turkmen tribes, but the Seljuks now mobilized a *gazi* force and sacked the Armenian capital, Ani (1064 CE), before confronting a Byzantine army led by Emperor Romanus IV at the Battle of Manzikert in 1071 CE; the Seljuk Turks were victorious and imposed an annual tribute upon the Byzantines. With the Seljuk defeat of Byzantine forces, Anatolia was opened to more Turkic migrations by tribes seeking plunder and pastures in the agriculturally rich, mainly Christian Asia Minor. Seljuk rule precipitated the eventual Turkification and Islamization of Asia Minor, creating the cultural and political environment that made possible the rise of the Ottomans in the thirteenth century.

The Seljuks' reign as the temporal power across the central Islamic lands endured for over a century; in a fashion typical of Turco-Mongol patterns of rule, members of the Seljuk family shared power, apportioning off areas of their expanding territorial gains into appanages to be governed as part of what became the Great Seljuk Empire (Map 2.4). Ultimately this style of succession would lead to the dynasty's inevitable breakup, as the various branches of the Seljuks began to squabble with one another over territory and resources. Though they generally relinquished much of their nomadic heritage for a more settled Persianate and Islamic lifestyle, they continued to rely upon Turkish tribesmen as mounted archers by drawing from local tribes or Turkic nomads who continued to flow westwards into their territories, as support for the heavier siege-style forces and weaponry they now employed in warfare. The high Perso-Islamic culture marking their apogee in the eleventh century under Sultan Malik-Shah (r. 1072–92) was centered in Isfahan.

By the twelfth century, the eastern lands of the Great Seljuk Empire had suffered upheaval and political fragmentation, assisted by the rise of the *Khwarazmshahs*, a Persianate Sunni Muslim dynasty of Turkic *mamluk* origin and former vassal of the Seljuks in Khurasan and Transoxiana in the late eleventh century, which reached their height by the end of the twelfth century. The Byzantine-Seljuk frontier region in Anatolia came to possess the only surviving Seljuks when dynastic struggles caused the collapse of the Great Seljuk Sultanate. Only this Seljuk Sultanate of "Rûm" (Rûm from "Rome"), with its seat eventually at Konya (the former Byzantine Iconium), was left intact, rising to prominence when the Great Seljuk state began its downfall at the end of the twelfth century (Map 2.5). The Islamic Middle East could be said to have been divided already by the mid-tenth century into the Persianate zone of these various eastern dynasties who utilized Persian as their language of administration and high culture, and the Arabo-Islamicate zone of Syria, Iraq, the Arabian Peninsula, Egypt, and North Africa. Sharing a border with the Byzantine Empire, the Seljuks of Rûm, as *gazi* warriors, perpetuated a rather heterodox form of the Sunni faith in Anatolia, mediated by a Turco-Persian understanding of Islam that involved the founding of mystical Sufi orders.

The Great Seljuk Empire
at the Death of Malikshah
1092

Map 2.4 The Great Seljuk Empire.

The political environment of the region out of which the Ottoman principality appeared has to be understood within the broader context of two other foreign interventions that caused some redefinition of cultures and imperial territorial boundaries – the Crusades and the Mongol irruption. The Crusades themselves were only locally influential in the Middle East: Latin Christendom's desire to reclaim the Holy Land was satisfied only in the First Crusade with their violent sack of Jerusalem in 1099 CE. Future crusades were more a nuisance than a serious threat to Islamic lands, and the crusader kingdoms merely established their control along the coastal Mediterranean region while in many ways adapting themselves to the indigenous civilization around them. The western European crusaders' devastating sack of Byzantine Constantinople in 1204 CE during the Fourth Crusade, with Venetian assistance, had more significance for the future of Byzantium, as the city never fully recovered from the destruction and depopulation even after Byzantine restoration to the throne there in 1261

Map 2.5 The Byzantines and Seljuks of Rûm.

CE. Permanently weakened and in many ways a hollowed-out city after this, Constantinople would be an easier target for the Turks in future centuries. Profiting from this event, Venice would henceforth dominate much of the sea-trade in the eastern Mediterranean. In addition, Byzantine rivals to the west, the Slavic Balkan kingdoms of Bulgaria and Serbia for example, were now in a better position to challenge Byzantine hegemony.

The Crusades did, however, help to generate local Muslim resistance to their intrusion, in part triggering the rise of *Salah ad-Din* (Saladin) as a military and political hero, renowned in both Islamic and Western history for his just behavior. Saladin's victories over the crusaders not only secured Jerusalem for Muslims in 1187 CE, but also redrew the imperial map when he was able to supplant Shi'i Fatimid rule in Egypt with his own, establishing the Sunni *Ayyubid* dynasty there and in Syria. Though relatively short lived, the Ayyubids were replaced by a dynasty borne of their Turkic *mamluk* slave commander, Baybars, and was thus named the Mamluk Sultanate (r.1260 ~1517). The Mamluks of Egypt became the custodians of Arabo-centric Islamic culture, of the Sunni orthodoxy and many of its scholars, and in concrete terms, of the holy cities of Islam – Mecca, Medina, and Jerusalem. They would also become the front line of defense in the Levant against the other dramatic foreign invasion into the Muslim Middle East – the Mongol onslaught of the thirteenth century.

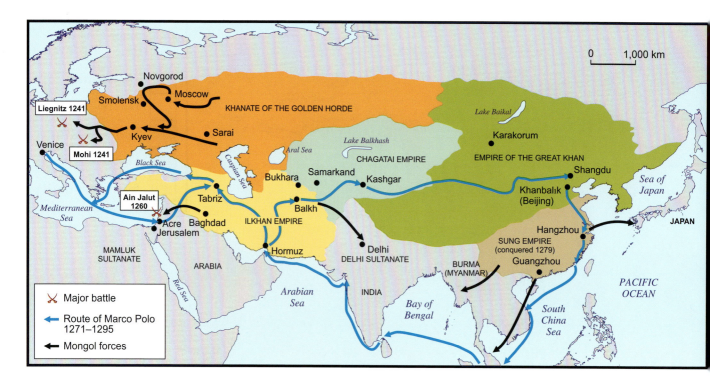

Map 2.6 The Mongol Empire.

The first Mongol raids into the Middle East led by Chingghis Khan in the early decades of the thirteenth century occurred after a provocation by the *Khwarazmshah*, and did not reach much further into the Islamic world than areas of Persia and the Caucasus. But the campaign led by his grandson Batu from 1236 to 1242 CE, which subdued part of eastern Europe and Russia in 1241 CE, and that of another grandson, Hülegü, across the Islamic Middle East in the 1250s, had much more transformative and long-lasting consequences overall than did the crusades or Chingghis Khan's earlier intrusion. Despite a diplomatic offer at first by the Mongol Great Khan in Karakorum for the Seljuks of Rûm to submit, a Mongol general, Baiju, under orders from Batu, defeated the Seljuks of Rûm in a battle at Kösedağ in eastern Anatolia (south of Giresun on the Black Sea) in 1243 CE, making the Seljuks initially subordinate in the form of annual tribute to Batu's Mongol domain, later known as the Golden Horde or the Kıpçak Khanate. But once Hülegü's forces were dispatched into the Middle East, destroying the *Nizari* ("Assassins") stronghold at Alamut in 1256, sacking Baghdad violently in 1258, and executing the Abbasid caliph, Hülegü assumed sovereignty over the Seljuks of Rûm in the name of the Great Khan. Tribute and Seljuk service would come to be directed through this branch of the Mongols called the Ilkhanids, the dynasty established by Hülegü and carried on by his descendants who governed this appanage from Tabriz, its eventual capital.

The westward Mongol advance of forces led by Hülegü's general, a Nestorian Christian of the Turkic Naimans named Kitbuqa, would be halted at Ayn Jalut in Palestine by the Mamluks in 1260 CE, though subsequent Mongol Ilkhanid-Mamluk "hot" and "cold" wars occurred. An Abbasid prince who had fled the carnage in Baghdad sought refuge in Cairo, so that the Mamluk Sultanate could now claim to be the protector of the Muslim caliphs, an assertion that would later figure into Ottoman designs on conquering Egypt in the sixteenth

century, as would its position as gateway to the Indian Ocean spice trade. Equally significant for the Islamic world, despite the eventual conversion to Islam and Persianization of the Ilkhanid Mongols in the late thirteenth century, the Islamic Middle East was now more definitively divided between cultural zones. The Arabo-Islamic, Mamluk realm was a center of Arabic learning and servitor of the holy cities of Mecca and Medina (as the *Khadim al-Haramayn al-Sharifayn*, "Servant of the Two Holy Cities"); a vast Perso-Islamic, Turco-Mongol civilization assimilated Persian, Turkic, and Mongol influences from further east, even as far as from Central Asia, into the existing Islamic milieu. This political and cultural division would have repercussions for Turkic principalities that arose on the Seljuk-Byzantine border concerning their social, administrative, and military practices. These "fiefdoms," or Turkic *beyliks*, of which the Ottomans were one, were assumed to have been subordinated to the Seljuks of Rûm. But they were actually more independent and possessed more loyalty toward Ilkhanid Mongol overlordship, above that of the Seljuks (Map 2.6).

THE HOUSE OF OSMAN

> When he captured Karaca Hısar, [many of] the houses in the city were left empty. And many people came from the Germiyan province and other provinces. They asked Osman Gazi to provide them with homes. So Osman Gazi gave homes to them. And it wasn't long before the city began to flourish. And they converted its numerous churches into mosques. And they even set up a market.[4]
>
> *– Fifteenth-century Ottoman chronicle describing*
> *Osman's first conquest in 1288*

The border between the Byzantine Empire and Seljuks of Rûm lay in Anatolia, with its diverse mix of Armenian, Greek, and Jewish as well as Arab and Kurdish peoples inhabiting the landscape. Historians of this era have, with much difficulty, tried to pinpoint the arrival of other Turkic tribes who migrated westwards in search of new settlements to raid, additional lush pastures to graze their flocks, and cultivable land. The dearth of early, reliable sources pertaining to the timing and composition of this influx of Turks, and the historiographical dilemma of trusting later fifteenth-century Ottoman chronicles (with their particularistic and semi-mythical projections back in time, such as Osman's dream – see box and Figure 2.1) to piece together Ottoman geneological origins, has caused early Ottoman history to be a story shrouded in much legend and speculation. But it is believed that some time in the mid-thirteenth century, probably around the 1240s or 1250s, a branch of the Oğuz Turks, a clan of the Kayı tribe, the supposed forefathers of the Ottomans, moved into Asia Minor, coinciding with or happening just after Mongol raids into Anatolia (there is debate as to whether a certain Süleymanshah was Osman's grandfather). These Turks made their way toward the border with the Byzantine Empire and settled in a fortuitous location southeast of Byzantine Nicaea (modern İznik) called Söğüt, at the end of the thirteenth century.

OSMAN'S DREAM

Osman Ghazi prayed (for new raids against the Christians) and briefly wept (for fallen comrades). Then sleep won him over, so he lay down and rested. He saw that among (his acquaintances) was a highly esteemed sheykh, whose many miracles were well-known and whom all the people followed. They called him a dervish, but his dervish qualities were deep within him. He possessed much in the way of worldly goods, comforts, and sheep. He also had both students and knowledge. His guest house was never vacant and Osman Ghazi himself used to come from time to time and be a guest of this holy man. As Osman Ghazi

Figure 2.1 Artist Erol Deneç's *The Dream of Osman Gazi* (2011). Oil on canvas.

slept he saw that a moon arose from the holy man's breast and came to sink in Ghazi's breast. A tree then sprouted from his navel, and its shade compassed the world. Beneath this shade there were mountains, and streams flowed forth from the foot of each mountain. Some people drank from these running waters, others watered gardens, while yet others caused fountains to flow. (When Osman awoke he went and) told the story to the sheykh, who said,

"Osman, my son, congratulations, for God has given the imperial office to you and your descendants, and my daughter Malkhun shall be your wife." He married them forthwith and gave his daughter to Osman Ghazi.[5]

Is this kind of legend characteristic of emerging dynasties in the medieval era a tool for legitimating rule? What do the various elements of the story illustrate?

About the earlier ancestors of Osman, the eponymous founder of the Ottoman *beylik* in western Anatolia, we have little definite evidence other than two coins minted that describe "Osman son of Ertuğrul" on them. Later Ottoman chronicles cannot be firmly relied upon, as they often cannot be corroborated and sometimes contain fabrications deliberately disseminated for effect, such as intimating Ottoman linkage to certain heroic figures in Muslim history, or to Noah's son Japheth. However, they can be used with discretion to establish certain logical conclusions: for example, some chronicles describe Osman's father as having received pasture rights around the area of Söğüt from the Seljuks of Rûm, with regular transhumance of wintering livestock in a valley that runs between Bilecik and Eskişehir, and summer pasturing in a mountainous area around Domaniç (Map 2.7).

One pattern of nomadic tribal leadership tends to manifest as what has been called elective chieftaincy – not based necessarily upon one's age, but on experience and what could be called nomadic charisma – courage, generosity, prowess in battle, and other such qualities of leadership in a tribal zone. Several fifteenth-century Ottoman chroniclers (Aşıkpaşazade, Mahmud Beyati, Yazıcıoğlu Ali) indicate Osman was chosen as tribal chief because of his reputation for fairness and justice. This, and leading raids in this area, gained him followers, both Muslim and Christian. However, recurring tribal rivalries ensued between Osman and the powerful Turkic Muslim principality to the south, Germiyan, over territory and over Germiyan's ill-treatment of non-Muslims friendly with Osman. Germiyan had been established already in the late thirteenth century and was once closely linked to the Seljuks; it would be a troublesome and uncooperative *beylik* for the Ottomans in the future. And there were many other Turkic *beyliks* in Anatolia as well: among them, Karesi, Saruhan, Aydın, Menteşe, and Teke *beyliks* were economically and culturally influenced by their coastal positions, and all arose some time around or just after the turn of the fourteenth century (see Chapter 3, Map 3.1).

The principalities in the Anatolian hinterland were more directly affected by Seljuk and Mongol rule – Hamid enjoyed a coastal trade; Karaman was an established *beylik* as

Map 2.7 Early Ottoman Territory and the Byzantine Frontier.

of the last quarter of the thirteenth century and occupied the former Rûm Seljuk capital of Konya by 1327. The Karamanids would be a greater thorn in the Ottoman side in the next century and a half, reluctant to submit, resistant to Ottoman demands, and often outright rebellious. When the Seljuks and Mongols were able to exert their authority in Anatolia (c. eleventh to fourteenth centuries), however, the power distribution of vassals (those who accepted an overlord to whom they were often required to pay some sort of tribute) flowed west from the traditional Mongol capital at Karakorum (and eventually from the later capital of Khanbalık), the site of the Great Khan, to the Ilkhanid Mongol realm centered at Tabriz, down to the Seljuk Turks of Rûm, who to varying degrees were able to demand vassalage and service from the Turkish *beyli*ks on the Byzantine border. It seems Osman was acting somewhat more autonomously by around 1299 CE.

The Byzantine Greek historian Georgius Pachymeres (b.1242–d.1310) recounts Osman's role as leading a Turkish force and defeating the Byzantine army in 1302 at the Battle of Bapheus in Bithynia, at a place called Koyunhisar, in the region around İzmit (Byzantine Nicomedia) and İznik (Byzantine Nicaea). Pachymeres describes how heavy spring rains and flooding of the Sakarya River had wrought havoc upon crops among Bithynian agriculturalists and on Osman's tribal herds, so that the nomads' predation and victory over the Byzantines resulted in local capitulation to Osman in order to preserve lands and livelihoods, as well as to receive sufficient grain allotments. Even the Catalan Company mercenaries from the faraway Kingdom of Aragon who were hired by the Byzantines as a fighting force

to challenge Osman's growing power in the area were less interested in curbing this growth than seeking their own fortunes elsewhere and abandoned Byzantine territory. By roughly 1308 CE the Byzantine city of Bursa was paying tribute to Osman Bey, the surrounding countryside was in his possession, and before long Bursa came under a lengthy blockade. Already Osman's tribe had begun the shift from a pastoral-nomadic lifestyle to one of settlement, since the area under their control was more suited for the cultivation of crops.

Though Osman died in 1324 CE, his son Orhan (r. 1324–62 CE), who became the next leader of the emirate, did succeed in the conquest of Bursa in 1326 CE, making it the first urban "Ottoman capital" (Figure 2.2). As such, an administrative apparatus emerged in Bursa during Orhan's tenure. Ottoman coins were minted here (*sikka* – an indication of Muslim sovereignty), religious institutions and architecture would begin to dot the Bursa skyline (mosques and *medrese*s – Islamic schools – appeared in Bithynia) and some scholars from the more powerful and prestigious Mamluk Sultanate (religious and otherwise) migrated to this new center. The emirate expanded – in 1331 CE İznik (Nicaea) came under Ottoman control. When the Muslim traveler Ibn Battuta passed through Anatolia in 1331, he described Orhan's rule as

> one of the greatest, richest, and most extensive ... commanding the greatest army of all the Turkoman kings. His practice is, constantly to be visiting his fortresses and districts, and to be inquiring into their circumstances. It is said that he never remained a month in any one place. His father had conquered the city of Burūsa [Bursa], and had besieged that of Yaznīk [Iznik], nearly twenty years, but did not take it; after this his son besieged it for twelve years and took it.
>
> In this place [Bursa] I met him; he received me very respectfully, and provided me with a considerable number of dirhems [a word derived from the Greek *drachma* for an Ottoman unit of weight and currency]. I next went to Yaznīk.[6]

Following the transition in battle tactics started by Osman, Orhan shifted reliance only upon archers mounted on horseback to the additional use of infantry, or *yaya*s, his private guard, who wore white caps called *ak börk* (several Ottoman chroniclers relate that other tribal leaders' retinue apparently wore red caps).

By 1337 CE, Orhan had taken Nicomedia (İzmit) despite Byzantine tribute paid to preclude its loss, and the Ottoman march westward continued, absorbing the Karesi *beylik* on the northwest coast of Anatolia some time in the 1340s. This put Orhan's forces at a crucial location to cross the Dardanelles Straits into Europe. Ottoman presence in the Aegean had also begun to be felt. Orhan's conquests employed a pragmatic approach toward Byzantine politics that yielded results and set a precedent for the later Ottoman pattern in a moment when they were still not the most prominent Turkic *beylik* in western Anatolia: direct involvement in European power struggles, backing one side or another as other maritime *beylik*s were preoccupied with crusaders. Having battled the Byzantine Kantakouzenos faction's army previously, Orhan's forces now supported them and supplied troops against their rival Byzantine faction for the throne, the Palaeologos, in 1346; the alliance was sealed

Figure 2.2 Bursa, the Emir Sultan Mosque.

in a fashion typical of emergent empires – through marriage, in this case Orhan's marriage to Princess Theodora, the daughter of John Kantakouzenos. Once John VI Kantakouzenos was on the Byzantine throne, Orhan's son Süleyman gained possession of a fortress at Tzympe, on the Thracian side of the Dardanelles in 1352. Orhan had signed a treaty with Genoa during war with Venice over the Italians' competition for the Black Sea trade; the Genoese transported the Ottoman forces across the straits. As luck would have it, an earthquake struck the area and damaged the city walls of Gallipoli in 1354, allowing him to occupy and use it as a foothold from which his forces could conduct an expansion further into Thrace.

To the east, Orhan's territory now stretched to Ankara in central Anatolia. Orhan died in 1362, his son Süleyman having predeceased him, and his young son Halil having been taken hostage by Genoese mercenaries. Murad I, the third son of Orhan, would succeed his father and establish a more permanent presence in Edirne in Thrace by 1369. The Turks were firmly in Europe.

ISLAM AND NON-MUSLIMS ON THE ANATOLIAN-BALKAN FRONTIER

The emergence of the Ottoman *beylik* on the border between European and Byzantine Christian powers and other Muslim, Turkic principalities inevitably brings to the surface a host of questions and debates that are complicated further by the nature of early Ottoman historiography and the various interpretations of the extant sources by current scholars. Since the early twentieth century Ottomanists have been wrestling with issues such as

the motivations for the Ottoman Turks' conquests in Anatolia and the Balkans, the question of Muslim and non-Muslim relations during the Ottoman rise to preeminence in the fourteenth century, and the form of Islam (i.e., the degree of orthodoxy, or lack thereof) practiced by these recent converts to the faith. Rather than revisiting in detail the many secondary sources in Ottoman studies that have deconstructed certain myths of Ottoman history, a recap of the historiographical conclusions should suffice. As a response to the Lybyer and Gibbon theses mentioned in the introduction, Mehmed Fuad Köprülü, the founder of modern Turcology in the Turkish Republic, published his series of 1930s lectures at the Sorbonne, promoting the idea of nomadic expansion as Turkic and nationalist heritage. In response, Paul Wittek published his 1937 lectures at the University of London in which he elaborated upon his "*gazi* thesis," arguing that there was a zealous religious motivation for expansion on the frontier – that of Islamic "warriors for the faith" combatting Christian infidels.

Subsequent revisions and a more nuanced view of the early Ottomans have emerged since this 1930s debate; Ottomanist scholars now generally concur that the Turkic nomads who migrated to Anatolia were recent converts to Islam whose animist, Central Asian traditions had not yet disappeared. In other words, as relative newcomers to the faith, the form of Islam Turkic nomads embraced was rather heterodox in nature, and heavily influenced by Sufism – Islamic mysticism that seeks out truth and unity with the divine through a very direct and personal experience with God.

Sufism often involved ritualistic practices, as opposed to emphasis on a more literal, textual understanding of the faith. Islam here was a synthesis of Ottoman experiences with Sufi teachings and guidance and their pre-Islamic practices. Sufi wandering dervishes (*baba*s) accompanied the raiders, interpreted their dreams, told their fortunes, inspired them in battle with the belief that the Prophet Muhammad himself was in their midst, and perhaps enticed non-Muslims into the fold. Their rituals easily assimilated with the culture of the local Christians who joined in the cause. This form of syncretic Islam suited the kind of "Wild West" borderland in Anatolia occupied by both Muslims and non-Muslims, as it was compatible with those whose desire was to conduct raids for booty, slaves, and territorial control, and whose identity revolved more strongly around a certain warrior ethos – that of courage and prowess in battle, honor, fairness and justice, generosity and hospitality – than any rigid religious agenda. Turkic nomads were often directed to the frontier by the more sedentarized and orthodox Muslim sovereigns in the hinterlands such as the Seljuks who did not want "God's Unruly Friends"[7] – unorthodox Sufis – assisting uncontrollable tribal warriors in disrupting their Seljuk realm.

The lack of concrete evidence to respond definitively to the issues of intent and ideology among early frontiersmen stems from several factors. First, as was already mentioned, nomadic societies frequently do not leave textual or written sources behind. Once an amount of sedentarization occurred, a self-awareness that the Ottoman dynastic story must be recorded for posterity emerged, their imperial rule needing legitimation through narrative means such as chronicles produced through patronage by court historians. As a consequence, there are two main types of sources available to the historian

of the early Ottoman era: either the contemporaneous sources concerning the early Ottomans that were typically those drafted by others – by those peoples who had been conquered by the Ottomans or their rivals for power and territory (i.e., the Byzantine Greek Pachymeres on Osman; the Karamanid historian Şikari), or else Ottoman chronicles that were for the most part from a century or more later, narrating the stories of Osman, Orhan, and Murad I's rise to prominence (i.e., Ahmedi's *İskendername*; Aşıkpaşazade's *Tevârih-i Âl-i Osman*).

In all of these situations, projections onto the historical record by the author(s) and their particular circumstances colored the veracity of their accounts. Those vanquished might have less favorable perspectives on their conquerors, or they might have attempted flattery to gain status. The Ottoman chronicles we have for this period were actually written in the fifteenth century, a time when religiosity among the Ottomans was changing substantially, yet fifteenth-century Islamic religious ideology among the Ottomans was projected back upon the fourteenth-century principality. Successful Ottoman expansion had also altered their self-perception and position in Europe and Anatolia. No longer merely one among several *beylik*s vying for supremacy, the Ottomans had annexed or absorbed several of the others. They now asserted themselves in the fifteenth-century chronicles as having long been protectors of the Islamic faith, fighting on the frontier against infidel Christians, rather than as a fledgling principality seeking out allies wherever they could be found, Muslim or non-Muslim, as was the case in the fourteenth century.

Second, the language used to describe the Ottomans conducting raids and conquests also changed over time, muddying the contemporary understanding of past events. Early sources and evidence frequently referred to them as *akıncılar*, loosely translated as "those who flow over an area" (from the Turkish verb, *akmak*, meaning "to flow"). Those participating in these raids and conquests were often Christians who either remained true to their faith or who eventually chose to convert to Islam. The term *gazi* itself evolved over time to carry a more specific meaning of a "warrior for the faith of Islam" once the Ottoman principality attracted Muslim scholars from Islamic heartlands (e.g., the Mamluk realm or Timurid Persia in the fourteenth century) who lent their orthodoxy to Ottoman frontier culture, and the principality became a state, an empire, and ultimately the custodian of Sunni Islam in later centuries. Subsequent Ottoman chronicles retrospectively (and rather inaccurately) attributed this conservative character to the early Ottomans. But "Osman Gazi" and "Orhan Gazi," as they have been called, were not likely motived by religious fervor. In other words, *gazi* in the fourteenth century meant something different from *gazi* in the fifteenth century and beyond.

Third, we have a tendency to view frontier zones in history through the lens of our modern world, so that ethnoreligious differences between peoples at that time are believed to be insurmountable obstacles to cooperation. But here Ottoman flexibility was apparent from the *beylik*'s inception, as has already been shown through their early involvement with the Byzantines. Rather than an orthodoxy demanding that *gazi*s be "warriors for the faith" conducting a *jihad*, or "Holy War" against non-Muslim infidels (possibly attributed to Seljuk-era entanglements with crusaders and Byzantines or to Mamluk scholastic

influences), what occurred in this borderland was the banding together of tribal and mercenary fighters for the common Ottoman cause of seeking plunder. Definitions of this early Ottoman frontier ethos have been described as a "predatory confederacy,"[8] or a "brokerage across networks,"[9] both of which imply the participation of a variety of actors in a raiding culture that was inclusive, and not defined by a strict religiosity at the outset.

This brokerage allowed some accommodation between Christians and Muslims in a shared quest to control resources and territory. Köse Mihal, a Byzantine administrator in Bithynia and early convert to Islam, became a companion of Osman and negotiated on his behalf to gain the support of local Christians; Gazi Evrenos was a Christian chieftain and another convert to Islam, perhaps of Spanish Catalan background, who accompanied Osman in early raids, and later crossed the Dardanelles with Orhan's forces to conquer areas of Macedonia. This early Ottoman latitudinarian attitude also better explains the Ottoman turn east into Anatolia soon after Orhan's early conquests in the Balkans. The seizure of fellow Muslim principalities could not be easily justified as an ideologically driven *jihad* in the name of expanding the lands of Islam when the target was fellow Turkic Muslim brethren. Instead, the Ottomans chose to be pragmatic in their choice of friends and foes when it came to raiding and conquest.

NOTES

1 Carter V. Findley, *The Turks in World History* (New York: Oxford University Press, 2005), 66.

2 A third classification in the understanding of global divisions among some Islamic legal schools, often overlooked, was the *Dar al-Ahd*, the "Abode of the Pact" in which temporary truces and agreements were made between Muslim and non-Muslim powers, i.e., the Islamic *umma* and a Christian power such as the Byzantines, to facilitate commerce, access to pilgrimage sites, etc.

3 Ibn Qutayba, *Uyūn al-akhbār*, i, 2, 5–11, 110–11, quoted in Bernard Lewis, ed., *Islam: From the Prophet Muhammad to the Capture of Constantinople*, vol. 1, *Politics and War* (New York: Oxford University Press, 1987), 185.

4 Aşıkpaşa-zâde, *Tevarih-i Âl-i Osman* [History of the Ottoman Dynasty], ed. Nihal Atsız, in *Osmanlı Tarihleri* (Istanbul 1945), 102–3, translated in Bogdan Murgescu and Halil Berktay, eds., *The Ottoman Empire Workbook 1* (Thessaloniki: Center for Democracy and Reconciliation in Southeast Europe, 2009), 38.

5 This dream quoted from Rudi Paul Lindner, *Nomads and Ottomans in Medieval Anatolia* (Bloomington, IN: Research Institute for Inner Asian Studies, 1983), 37, which he translated from *Die Altosmanische Chronik des Aşıkpaşazade, herausgegeben von Friedrich Giese* (Leipzig, 1929), 9–11. Lindner points out in a footnote the play on words of "hilal" (crescent moon) and "helal" (wife) in the legend.

6 From *The Travels of Ibn Battuta in the Near East, Asia & Africa 1325–1354*, trans. and ed. by Rev. Samuel Lee (New York: Dover Publications, Inc., 2004), 73–4.

7 Ahmet T. Karamustafa, *God's Unruly Friends: Dervish Groups in the Islamic Later Middle Period 1200–1550* (Salt Lake City: University of Utah Press, 1994).

8 Heath W. Lowry, *The Nature of the Early Ottoman State* (New York: State University of New York Press, 2003).

9 Karen Barkey, *Empire of Difference: The Ottomans in Comparative Perspective* (New York: Cambridge University Press, 2008).

SELECTED READINGS

Barkey, Karen. *Empire of Difference: The Ottomans in Comparative Perspective*. New York: Cambridge University Press, 2008.

Başan, Aziz. *The Great Seljuqs: A History*. New York: Routledge, 2010.

Beckwith, Christopher I. *The Tibetan Empire in Central Asia: A History of the Struggle for Great Power among Tibetans, Turks, Arabs and Chinese during the Early Middle Ages*. Princeton: Princeton University Press, 1993.

Bınbaş, İlker Evrım. "Oğuz Khan Narratives." Encyclopædia Iranica. Last modified April 15, 2010. http://www.iranicaonline.org/articles/oguz-khan-narratives.

Cahen, Claude. *The Formation of Turkey*. London: Longman, 2001.

Clauson, Sir Gerard. "Turks and Wolves." *Studia Orientalia* 28, no. 2 (Helsinki, 1964): 2–22.

Darling, Linda T. *A History of Social Justice and Political Power in the Middle East: The Circle of Justice from Mesopotamia to Globalization*. New York: Routledge, 2013.

Darling, Linda T. "The Vicegerent of God, from Him We Expect Rain": The Incorporation of the Pre-Islamic State in Early Islamic Political Culture." *The Journal of the American Oriental Society* 134, no. 3 (July–September 2014): 407–29.

Deweese, Devin. *Islamization and Native Religion in the Golden Horde: Baba Tükles and Conversion to Islam in Historical and Epic Tradition*. University Park, PA: Penn State University Press, 1994.

Esin, Emel. *A History of Pre-Islamic and Early Islamic Turkish Culture*. Istanbul: Ünal Matbaası, 1980.

Findley, Carter V. *The Turks in World History*. New York: Oxford University Press, 2005.

Finkel, Caroline. *Osman's Dream: The Story of the Ottoman Empire, 1300–1923*. London: John Murray, 2005.

Freely, John. *Storm on Horseback: The Seljuk Warriors of Turkey*. New York: I.B. Tauris, 2008.

Fodor, Pál. "Ottoman Warfare, 1300–1453." In *Byzantium to Turkey 1071–1453*, edited by Kate Fleet, 192–226. Vol. 1 of *The Cambridge History of Turkey*. New York: Cambridge University Press, 2009.

Goffman, Daniel. *The Ottoman Empire and Early Modern Europe*. Cambridge: Cambridge University Press, 2002.

Golden, Peter. *Central Asia in World History*. Oxford: Oxford University Press, 2011.

Imber, Colin. *The Ottoman Empire 1300–1481*. Istanbul: The Isis Press, 1990.

Imber, Colin. *The Ottoman Empire 1300–1650: The Structure of Power*. New York: Palgrave MacMillan, 2002.

Itzkowitz, Norman. *Ottoman Empire and Islamic Tradition*. Chicago: University of Chicago Press, 1972.

Jila, Namu. "Myths and Traditional Beliefs about the Wolf and the Crow in Central Asia: Examples from the Turkic Wu-Sun and the Mongols." *Asia Folklore Studies* 65 (2006): 161–77.

Julien, Stanislas, trans. *Documents historiques sur les Tou-kioue (Turcs)*. Paris: Imprimerie nationale, 1877.

Kafadar, Cemal. *Between Two Worlds: The Construction of the Ottoman State*. Berkeley: University of California Press, 1995.

Karamustafa, Ahmet T. *God's Unruly Friends: Dervish Groups in the Islamic Later Middle Period 1200–1550*. Salt Lake City: University of Utah Press, 1994.

Köprülü, Mehmed Fuad. *The Origins of the Ottoman Empire*. Edited and translated by Gary Leiser. New York: State University of New York Press, 1992. First published 1935 by Editions de Boccard, Pairs, under the title of *Origines de l'Empire Ottoman*.

Lee, Rev. Samuel, trans. and ed. *The Travels of Ibn Battuta in the Near East, Asia & Africa 1325–1354*. New York: Dover Publications, Inc., 2004. First published 1829 by The Oriental Translation Committee, London, under the title *The Travels of Ibn Batūta*, translated from the Abridged Arabic Manuscript Copies preserved in the Public Library of Cambridge.

Lindner, Rudi Paul. "Anatolia 1300–1451." In *Byzantium to Turkey 1071–1453*, edited by Kate Fleet, 102–37. Vol. 1 of *The Cambridge History of Turkey*. New York: Cambridge University Press, 2009.

Lindner, Rudi Paul. *Explorations in Ottoman Prehistory*. Ann Arbor: University of Michigan Press, 2007.

Lindner, Rudi Paul. *Nomads and Ottomans in Medieval Anatolia*. Bloomington, IN: Research Institute for Inner Asian Studies, 1983.

Lowry, Heath W. *The Nature of the Early Ottoman State*. New York: State University of New York Press, 2003.

Melville, Charles. "Anatolia under the Mongols." In *Byzantium to Turkey 1071–1453*, edited by Kate Fleet, 51–101. Vol. 1 of *The Cambridge History of Turkey*. New York: Cambridge University Press, 2009.

Morgan, David. *The Mongols*. 2nd ed. Oxford: Blackwell Publishing, 2007.

Murgescu, Bogdan, and Halil Berktay, eds. *The Ottoman Empire Workbook 1*. Thessaloniki: Center for Democracy and Reconciliation in Southeast Europe, 2009.

Muslu, Cihan Yüksel. *The Ottomans and Mamluks: Imperial Diplomacy and Warfare in the Islamic World*. New York: I.B. Tauris, 2014.

Parker, E.H. "The Early Turks (From the CHOU SHU)." *The China Review, or Notes & Queries on the Far East* 24, no. 3 (1899): 120–30.

Peacock, A.C.S. *The Great Seljuk Empire*. Edinburgh: Edinburgh University Press, 2015.

Pulleyblank, E.G. "The Wu-sun and Sakas and the Yüeh-chih Migration." *Bulletin of the School of Oriental and African Studies, University of London* 33, no. 1 (1970, In Honour of Sir Harold Bailey): 154–60.

Roux, Jean-Paul. *La religion des Turcs et des Mongols*. Paris: Payot, 1984.

Sicker, Martin. *The Islamic World in Ascendancy: From the Arab Conquests to the Siege of Vienna*. Westport, CT: Greenwood Publishing Group, 2000.

Sinor, Denis. "The Legendary Origin of the Türks." In *Folklorica: Festschrift for Felix J. Oinas*, edited by Felix J. Oinas et al., 223–57. Uralic and Altaic Series 141. Bloomington, IN: Sinor Research Institute for Inner Asian Studies, 1982.

Soucek, Svat. *A History of Inner Asia*. Cambridge: Cambridge University Press, 2000.

Sourdel, D., C.E. Bosworth, P. Hardy, and Halil İnalcık. "Ghulām." *Encyclopaedia of Islam*, edited by P. Bearman, Th. Bianquis, C.E. Bosworth, E. van Donzel, W.P. Heinrichs. 2nd ed. Brill, 2012. https://doi.org/10.1163/1573-3912_islam_COM_0237.

Sulaiman, Äsäd. *Uyghur Totem Mädäniyeti* [Uyghur Totem Culture]. Beijing: n.p., 2001.

Tang, Li. "A History of Uighur Religious Conversions (5th–16th Centuries)." Asia Research Institute, National University of Singapore, Working Paper Series, no. 44 (June 2005).

Wei, Cuiyi, and Karl W. Luckert, eds. *Uyghur Stories from Along the Silk Road*. (Lanham, MD: University Press of America, 1998.

Wei Shou. "Gaoche Zhuan (History of the Highwheels)." In *Wei Shu (History of the Wei Dynasty)*. Orig. ed. 551–554 CE. Beijing, n.p., 1983, 103:2307.

Wittek, Paul. *The Rise of the Ottoman Empire*. London: The Royal Asiatic Society of Great Britain, 1938.

Worringer, Renée. "Shepherd's Enemy or Aşina, Böri, Börte Činō, and Bozkurt?: Wolf as Menace, Wolf as Mythical…," *Society & Animals* 24 (2016), 556–73.

THREE

THE OTTOMAN EMIRATE: CONSOLIDATING POWER, EVOLVING STRATEGIES

The Ottoman principality's adaptability to new circumstances as the needs arose is reflected in the development of socioeconomic and political arrangements over time that allowed the frontier *beylik* to grow into a powerful emirate by the early fifteenth century (Map 3.1). How and with whom they made alliances is just one example of Ottoman flexibility to be explored in this chapter; another is the Ottoman succession system which, though ruthless, ultimately preserved the stability and longevity of the dynasty. The varied ways in which provincial areas were managed depended upon earlier precedents already in place as well as innovating new methods when required. Modifications were made to the customary practice of Islamic *mamluk* slavery to suit Ottoman needs. These are all indicative of the Ottoman principality's ability to adjust as it expanded and transformed – all in a world around the Ottomans that was not static either, but was constantly in transition.

SOME CHRONOLOGY TO 1402

After Orhan's death, the leadership of the emirate under Murad I (r.1362–89) and his son Bayezid I (r.1389–1402) were formative periods for many of the features of the later Ottoman state. With Murad I's possession of Edirne in the late 1360s and only a brief loss of Gallipoli to the Byzantines in 1366 (formally ceded back to Ottoman control around 1377) that did not impede Ottoman advances into Thrace, Edirne eventually became a second Ottoman capital from which to stage campaigns in Europe. Murad I's annexation of Turkic Muslim territory in Anatolia and his expansion in both directions was legitimated through various means: though portrayed in later Ottoman chronicles as acquired through marital alliance, purchase, or a

Map 3.1 Ottoman Expansion in Anatolia and the Balkans.

willing offer of allegiance by the *bey* of a particular principality, Murad I likely acquired much of his *beylik*'s adjacent Turkic Muslim neighbors' lands in Anatolia through force and conquest. Balkan conquests were initially conducted through a more cautious imposition of vassalage. Southern Bulgaria was subdued and made a vassal. Macedonia was the next target: in 1371 a small Turkish force routed a Serbian army at the Maritsa River. Salonika (Thessalonika) was put under Ottoman siege by 1372 and overcome by 1387. Sultan Murad I's son Bayezid I, however, would embrace direct annexation of territories in both the Balkans and Anatolia. Rumelia, as the European Balkans were called, soon became an integral part of Ottoman domains from the late fourteenth century until the last decades of the empire in the twentieth century.

Ottoman expansion both east and west initiated a dilemma from Murad I's era that would be a constant in Ottoman history from this moment – the need to avoid conflict on both flanks at the same time, and the difficulty in preserving sovereignty on one side of Ottoman lands when involved in war or conquest on the other (the same imperial dilemma

would trouble the later Habsburgs, Prussia/Germany, Safavid Persia, and the Romanovs). Dating the precise years of Ottoman rule is made more difficult by the frequent tendency for vassals in the early decades of the conquests to rescind their loyalty, refuse to pay tribute and supply troops, or to rebel when the opportunity arose, only to be subdued again by the Ottomans later. In 1387 not only did Murad I campaign in the east against the troublesome Karamanids in southern central Anatolia, but his forces also pushed further west toward Serbia in 1388 after an earlier setback. In 1389 the Ottomans fought a victorious battle against Serbian Prince Lazar's army at Kosovo-Polje in which both sides had costly losses, including each of their leaders, Lazar and Murad I; the Serbian loss at Kosovo has continued to figure into Serbian nationalist thought into the modern day.

Once Murad I's son, Bayezid I, assumed his father's position while still on the battlefield, he came to be known as "Yıldırım Bayezid," or Bayezid the Thunderbolt, for the rapidity with which he moved back and forth, carrying out campaigns on eastern and western borders to expand Ottoman territory or to subjugate rebellious tribal leaders, one of whom was, again, the Karamanids in the late 1390s. Before this, Bayezid I and his forces annexed the Turkic principalities in western Anatolia, which granted the Ottomans better access to trade routes through Aegean coastal ports and which began to threaten Venetian dominance in commerce. They retook areas of Bulgaria that had seemingly rescinded their vassalage, and pushed into Greece, which raised alarm in Venetian outposts and port cities along the Aegean and Dalmatian coasts. The Ottomans blockaded Byzantine Constantinople, their unreliable vassal, and around 1394 a fortress called *Anadolu Hisarı* was erected on the Asian side of the Bosphorus Straits that divided the city between European and Asian continents.

Bayezid I led raids into Wallachia (modern Romania). His bold actions managed to create enemy alliances on both sides of the Ottoman emirate. In the west, a crusade initiated by King Sigismund of Hungary, whose Balkan domains were being intruded upon by the Ottomans, was supported by the Byzantines, Venetians, and French and English knights. Confronted in battle at Nicopolis in 1396, these enemies on one side were routed by Bayezid I's army (Figure 3.1). While on the other Ottoman flank, the outcome was dramatically different: his campaigns against emirates in eastern Anatolia brought him into conflict with a powerful Turco-Mongol Muslim rival out of Central Asia whose incursions west had panicked Christian and Muslim sovereigns alike – Timur, or Tamerlane (d.1405). Bayezid I's forces met Timur's at the Battle of Ankara in 1402. Many of Bayezid I's Ottoman fighters switched sides or fled, except for a Serbian contingent and his Janissary (slave recruit soldier) bodyguard. Sultan Bayezid I's dramatic defeat and humiliating capture by Timur put an end to his reign. Bayezid I died in captivity, several sons were held hostage in Samarkand, and Timur reinstated the authority of the Turkic principalities in Anatolia that had been subdued by the Ottomans in a bid to reassert the Turco-Mongol appanage-style structure once more in the region. A much reduced Ottoman principality in Anatolia and the Balkans, divided according to Timur's wishes between two other sons of Bayezid I, ushered in a period of civil war between Ottoman brothers and uncertainty as to the continued existence of the Ottoman state – in what is called the "Ottoman Interregnum" of 1402–13.

Figure 3.1 The Battle at Nicopolis, 1396.

ALLIANCE-BUILDING AND LEGITIMACY

When the Ottomans were merely one of many Turkic emirates in Anatolia and could not yet act from a position of superiority, marital alliances were an additional way of securing warriors to support raids, to expand territorial control, and to gain legitimacy. Osman Bey's dream claiming his marriage to the daughter of Sheykh Edebali for example, would have provided a linkage to the *Vefaiyye* Sufi order in the Bilecik region, giving Osman not only the sanction to rule by a prominent dervish and influential figure in a local *ahi* (a fraternal trade guild), but also a connection to this Sufi master that could be traced back to the order's eleventh-century founder in Baghdad, who in turn traced his spiritual lineage all the way back to the Prophet Muhammad. For later Ottoman chroniclers in a cultural setting in which spiritual transmission of knowledge was considered relevant, propagation of this lineage was an Islamic justification for the dynasty's right to rule. However, a *vakf* (pious endowment) document from Orhan's time indicates his mother was actually not, as the legend claimed, Edebali's daughter, but in fact the daughter of a Seljuk *vezir* (administrator); this marriage would have provided Osman and his son Orhan a form of legitimacy on the ground as the "rightful successors" of Seljuk rule in Anatolia at the time. Orhan's marriage to the Byzantine princess Theodora in 1346 allowed for cooperation with the Kantakouzenos clan which eventually yielded the Ottomans a foothold in Thrace; the rival Byzantine Palaeologus faction attempted later to create an alliance through marriage of John Palaeologus's daughter Irene to Orhan's young son Halil, though this marriage did not secure the relationship since Halil did not assume control of the emirate after his father's death – his brother Murad I did. By this time perhaps Orhan also began to see less political benefit in such a pact.

Murad I is believed to have annexed part of Germiyan principality through a marital arrangement between his son Bayezid and a Germiyan princess. Murad I himself married the sister of John III Shishman, the Tsar of the north central part of the Bulgarian Kingdom, making him a strategic, if at times unreliable, vassal. After Kosovo, Bayezid I solidified Serbian vassalage with the deceased Lazar's son and successor, Stephen Lazarević, by marrying his sister. Marital alliances were contracted mainly for political purposes, particularly when the fledgling Ottoman *beylik* was not yet strong enough to fully assert its authority over other domains. Holding vassals' sons hostage at Ottoman court was another strategy used to elicit loyalty, with some success.

The practice of alliance-building through sultans' marriages into rival households fell into relative disuse in the mid-fifteenth century once the Ottomans had subdued their Anatolian neighbors. Daughters of the sultans had also been married to foreign Muslim powers to create strategic allies or vassals in this era, though again by the mid-fifteenth century, with changes to the dynasty's imperial administration of its provinces, Ottoman princesses were married instead to members of the Ottoman ruling elite to preserve wealth and power internally, and to tie them in loyalty and service to the royal family. Since the Ottomans had also shifted to a system of concubinage to reproduce heirs for dynastic succession (to be explained shortly), sultanic marriages became relatively obsolete until resurrected in the sixteenth century.

There were other ways to try to establish legitimacy over the Turkic Muslim emirates in Anatolia as well as with Christian marcher lords, those regional frontier commanders of military forces in the Balkans who possessed political clout. Their cooperation was essential to Ottoman expansion. They participated in raids with the Ottomans already in the fourteenth century, some of whom converted to Islam. Toward the end of Murad I's tenure in the 1380s the title of sultan, a term that had been bestowed upon the Seljuks by the Abbasid caliphs and was now implying Sunni Muslim sanction for Ottoman rulership, was first used to describe the leader of the Ottoman principality in place of *emir* or *malik* (the Arabic word for king). The Turco-Mongol term *khan* seems not to have appeared in Ottoman parlance until the reign of Mehmed I (r.1413–21). Bayezid I (r.1389–1402) solicited the Abbasid "shadow caliph" in Mamluk Egypt to be granted the title of *Sultan-î Rûm*, which was formerly the designation reserved for the Seljuk sultan.

In the fifteenth century, attempts to link the Ottomans to the Seljuk regime that had previously governed much of Anatolia were projected back in time, including the stories of the land grant in Söğüt by a Seljuk sultan Alaeddin to Osman's father Ertuğrul, the sending of Turkic symbols of authority such as a drum, a sword (said to be that of the third Muslim caliph, Uthman), and a "robe of honor" to Osman, or of a horsetail standard (*Tuğ*), a Turco-Mongol symbol of sovereignty and call to campaign (Figure 3.2). These symbols were intended to legitimate Osman as the Seljuk heir to the sultanate in the absence of a Seljuk prince, all of which invested the Ottomans with political power and made war an acceptable action against fellow Turkic principalities who did not recognize Ottoman overlordship. Later, the number of Ottoman horsetails one possessed, which preceded one on campaign, marked a campsite, and were posted outside one's tent, became a sign of status: the sultan had seven to nine; the *grand vezir*, five; a *vezir*, three; *beylerbeyi* (an Ottoman provincial governor-general), two; *sancakbeyi* (an Ottoman official governing a sub-province), one. After the conquest of Constantinople in 1453, horsetails were planted on the hills above, either on the European side (Belgrade Gate) or the Asian side (Scutari Hill) to indicate the direction planned for a coming campaign.

In addition, genealogical chains were eventually drawn up by later Ottoman court historians, depending upon the circumstances encountered or the audience for the genealogy. To appeal to both Muslims and Christians in Ottoman service on the basis of a shared spiritual connection to early Abrahamic, monotheistic traditions, they would claim at one moment that Oğuz Khan, the founder of Osman's Turkic ancestral tribe, was a descendant of Noah through Japheth, while other Turkic ancestors were linked to David, Solomon, and Jesus, as prophets preceding Muhammad who were part of the Muslim tradition as well as that of Christianity. After Timur's victory temporarily subordinated the Ottomans and reinstated Turco-Mongol rule in Anatolia in 1402 through the reassertion of the Turkic principalities' autonomy, future Ottoman sultans strived to more emphatically link themselves to the Abrahamic tradition through fabricated claims of descent of Osman from a Companion of the Prophet, as a way to reclaim legitimacy over other Muslim powers.

As the Ottoman principality matured into a state and absorbed more lands and peoples in Europe and the Middle East, further tools of legitimacy adapted from Arabo-Islamic, Persianate, Turco-Mongol, and Byzantine traditions would be pragmatically assimilated

into the dynasty's claims to govern, through their practices and titulature. The earlier Central Asian Karakhanid Khanate's advice to rulers by a Turkic author of the eleventh century entitled the *Kutadgu Bilig* (*Wisdom of Royal Glory*) influenced Central Asian Turks in their understanding of the need for justice to create prosperity and stability; its guidance was very subtly absorbed into later Ottoman thinking about how to bring about a just realm. Persian administrators in the Seljuk state had already further propagated the Arabo-Persian principles behind an Islamized Circle of Justice and the need to adhere to *şeriat* law in Anatolia, which impacted the Ottoman principality as it sought ways to legitimate its expanding reach. Ahmedî's *İskendername*, an Ottoman chronicle of the early fifteenth century, confirms that the Ottomans promoted themselves as a "people of justice" in order to proclaim their legitimacy as rulers. The frontier ethos of a courageous warrior leader not greedy for material wealth, but honest and fair, generous and concerned for the welfare of the *re'aya*, his flock, was to be demonstrated through "feeding and clothing his people," providing feasts and hearing grievances, all

Figure 3.2 Ottoman *Tuğs*.

in contrast to the obvious injustices committed by the "derelict" Byzantines. The building of mosques, *medreses*, and *imarets* (soup kitchen/hostel/hospital complexes) to serve, impress, and co-opt the local population similarly assisted in Ottoman management of new conquests. The Ottoman praxis of justice would become more developed and formalized once Sultan Mehmed II (r.1444–6, 1451–81) was able to enact his vision of an Ottoman world empire, in part by establishing a system of imperial legal proclamations (*kânûnnâmes*) to clearly establish law and justice. But early on the merging by the Ottomans of Turco-Mongol customs (i.e., the familial sharing of power) with Islamic ideals circulating in Anatolia such as the Arabic *bay'a*, or oath of allegiance, the notion of a Circle of Justice, or the *shûra*, the Muslim consultation among elders, produced a flexible means of appealing to the various inhabitants of Asia Minor to support their bid for power as just and legitimate overlords.

SHIFTING SUCCESSION, OPEN SUCCESSION, REPRODUCTIVE POLITICS

The process of dynastic succession among the Ottomans has been called open succession. Ottoman succession evolved in this early period with a few characteristics that reflect the melding of particular circumstances in Anatolia with a version of Turco-Mongol succession

Jumping ahead in time to illustrate the evolution of dynastic practice, first, during the early half of the sixteenth century, Sultan Süleyman "the Magnificent" (r.1520–66) as he is known in the West, broke with the established tradition by marrying his concubine, the famous slave girl, Roxelana. Renamed Hürrem, she further broke with reproductive custom by having several sons. Second, in the second half of the sixteenth century, Sultan Murad III (r.1574–95) was the last sultan to dispatch a son, Mehmed III, to the countryside for practical administrative and military experience, while the other sons remained in the palace. From this era onwards, the heirs apparent had no household in a provincial posting. They did not leave the Ottoman palace, but were literally held prisoner in the capital (Constantinople from 1453), living an isolated existence behind the walls of Topkapı in the *kafes* (nicknamed "the cage") – separate apartments of the palace that allowed little contact with the outside world. Their mother, the other heirs apparent, their mothers, and a host of imperial servants all interested in supporting one familial faction or another also lived within the confines of Topkapı. The princes were not allowed to father children until and unless they became sultan. Official fratricide had lapsed at this point; power was contestable within the imperial household, all members of whom were resident in the palace.

Ultimately the alteration in the conditions around Ottoman succession led to the emergence of the seniority principle, so that the eldest living Ottoman male in the dynasty, and not necessarily a son, ascended the throne. This pattern of Ottoman succession appeared first after the reign of Sultan Ahmet I (r.1603–17), when his brother, Mustafa I, succeeded him, and it lasted until the empire's demise. The incompetence of some of the later sultans and the misfortunes of the Ottoman Empire in the post-sixteenth century have often been attributed to the confinement of the dynastic family, as it resulted in the lack of practical experience in governing and military affairs among heirs apparent. Some Ottoman princes suffered from mental illness and alcoholism. In addition, the political intrigues at court caused by the various familial factions and their supporters vying for power had the effect at times of causing the untimely demise of capable *grand vezir*s and other palace officials involved in advising a sultan and in decision-making on behalf of the empire. About this more will be said later.

EARLY PROVINCIAL ADMINISTRATION AND THE *TIMAR*-HOLDING *SIPAHI* CAVALRY

A fundamental institution of the Ottoman military and administration emerged out of early expansion into the Balkans and Anatolia based upon mounted raids by *akıncı*s who took control of the countryside, blockading urban centers until they capitulated. As a method of conquest, the Ottomans absorbed the local customs already in place while adapting their land management system to suit their needs. Practices in existence in one region were often left intact, modified only as the Ottomans saw fit, and varied dramatically from how another region might be administered once it was conquered (e.g., the

Balkans and western Anatolia, from the fourteenth century onwards, versus the Arab lands seized in the sixteenth century). As had been practiced in the frontiers of eastern Europe and Anatolia previously by the Byzantines and the Seljuks respectively, warriors were often on continuous duty, and thus were granted control over territory through a kind of prebendal right (direct collection of revenue from the territory) as a way to support themselves. Unlike European feudalism however, the horseman receiving such a land grant was still strongly bound by an amount of centralized constraint by the *bey* or sultan.

When the Ottomans expanded their territory, provinces were formed in an ad hoc manner, with family members or close associates initially assuming territorial and military control (Anatolia), or local lords left in place (mainly Rumelia and parts of Anatolia). The territorial-administrative nomenclature up to the fifteenth century was rather fluid, reflecting this Ottoman provincial flexibility, though a clearer terminology indicating the hierarchical provincial administrative structure stabilized by the mid-sixteenth century. Early Ottoman district governors were called *sancakbeyi*s, the meaning of which originated from the word *sancak*, which meant a standard or banner bestowed upon a commander to symbolize investiture with political and military power, and under which the receiving lord's forces would fight. The first *sancakbeyi*s were dispatched even before more definitive and senior posts were created, probably at the end of Orhan's reign (1362) or during that of Sultan Murad I (~1389).

According to historian Aşıkpaşazade's chronicle, it was Murad I who first used the term *beylerbeyi* (governor-general) for the senior position overseeing *sancakbeyi*s, to describe his commander in Europe (Rumelia), Lala Şahin. The Rumelia *beylerbeyi*'s residence and thus the provincial seat came to be established in Sofia (Bulgaria). A *vilayet* (or *beylerbeylik*) of Anadolu (Anatolia) soon followed, with a residence and seat in central Anatolia, first at Ankara and later at Kütahya, an area famous for its hand-painted Turkish tiles with traditional colors and the tulip (*lale*) design (Figure 3.3). A more formal kind of larger province (a *vilayet* or *beylerbeylik*) appears from the sources to have been established under Sultan Bayezid I (r.1389–1402), with this *beylerbeyi* now "governor-general" of Rumelia (Europe) in charge of keeping order, dispensing justice, managing land revenue grants and auxiliary forces in his territory, and providing and commanding military troops in battle who fought as a unit for the sultan. A *beylerbeyi* received the high rank of an Ottoman political or military official, called *pasha*. These first two provinces, Rumelia and Anatolia, were initially the most militarily significant, though a third, less important *vilayet* of Rûm was established by one of Bayezid I's surviving sons, Mehmed I (r.1413–21), in northern central Anatolia in the early fifteenth century with a residence at Amasya. The Ottomans reused Amasya castle, built by a Pontus king in the second to first centuries BCE, which was strategically situated in the mountains above the Black Sea coast on the banks of the Yeşil River. Another *beylerbeylik* was established in the mid-fifteenth century with the subordination of Karaman, its seat at historic Konya.

As the Ottomans increased their territorial holdings, they adjusted the provinces accordingly, reorganizing and increasing their number based upon practical and strategic need. *Vilayet*s were divided into more sub-provincial *sancak*s. From around the end of Sultan

Figure 3.3 Turkish Tiles, Two Different Tile Designs.

Bayezid I's reign (1402) onwards, provincial appointments of individuals of slave origins, trained and made loyal to the Ottoman sultan and state (to be discussed shortly), in these core areas gradually started to displace the local tribal leaders who had become vassals by paying tribute and/or providing troops. Ottoman family members would later be replaced in the provinces by these individuals of slave origins as well. The appointments by the Ottoman central authority to provincial positions became more frequent and numerous, with *sancak*s further subdivided into smaller judicial districts called *kaza*s, of various sizes (with a town and surrounding villages with between 3,000 and 20,000 people), in which a Muslim *kadı* (judge) presided over legal and other affairs, both religious and secular, and was assisted by additional staff. *Kaza*s were further divided into smaller administrative units called *nahiye*s. A *sancakbeyi*'s posting usually lasted less than three years, and frequently provincial district governors were rotated to different *sancak*s to discourage their ability to build up local autonomy in one place.

Nonetheless, some outlying or more remote regions of the Balkans, eastern Anatolia, and later the Arab and North African lands in the sixteenth century continued to be administered by rather autonomous local lords whose early service to the Ottomans allowed them hereditary status as district governors and whose livelihood was based upon prebendal right. Tribes and nomads, a persistent feature of Ottoman lands until the empire's end, continued to play important roles – assisting in expanding territorial control on frontiers: Albanians on the European front, Tatar horsemen in the north, autonomous Sunni Kurdish chieftains and their tribes who often came to be relied upon to pacify eastern borders in the seventeenth century, and Arab Bedouin who secured more inaccessible areas to the south. The Ottoman provincial system varied as territorial acquisitions increased and fluctuated over time; it adhered to a general rule of flexibility and accommodation with local custom while attempts at centralizing and standardizing Ottoman provincial administration occurred at different times over the centuries.

For the Ottomans, another element of the provincial structure was the formation of a standing cavalry or *sipahi* force, developed around the end of the fourteenth century.

Sipahi cavalrymen were granted *timar*s, a word (Persian in origin meaning "care," in the sense of nourishment[3]) to describe the allotment of land a *sipahi* oversaw once a cadastral survey had been conducted to establish the potential revenue generated by its use. The initial *timar* lands were granted to marcher lords, both Christian and Muslim. The size of the *timar* often varied, based upon their service to the Ottoman ruler or their courage and prowess in battle. The highest ranking *timar*-holders were Muslim. The land itself, often having been farmed by the peasantry for generations, would be considered *miri*, or state (sultanic) land, owned by neither peasantry nor *sipahi*. The peasants remained on the land and had the ancestral right to continue to farm it; the *sipahi* resided there and was granted a portion of this *timar* called a *çift* for his own use (*çift* meant pair, referring to a plot of land equivalent to what a pair of oxen could plow, or about 20–30 acres). The *sipahi* collected tax revenue from the peasants for himself to live on (as well as certain services, such as requiring them to work a number of days on his personal *çift*), and therefore he did not demand a salary from the state treasury. The *sipahi*s, in collaboration with the provincial district governor, the *sancakbeyi* (or *mir-i liva*, a newer military title for this position), who also had military forces at his disposal, would assist in keeping order and protecting the territory when not at war. When called up for campaign by the sultan, however, the *sipahi*s were duty-bound to appear, along with predetermined numbers of personnel, munitions, weaponry, and provisions to contribute to the war effort, based upon their *timar* revenue. Usually a proportion of *sipahi*s were left in place on their *timar*s to preserve order in a *sancak* while the rest were obligated to appear when called up, all of whom would be commanded in combat by the *sancakbeyi*. Failure to show up for a campaign could cause the *sipahi* to be dispossessed of his *timar* and therefore his livelihood; an impressive performance in battle could lead to favorable treatment and thus, the expansion of one's *timar*-holdings, regardless of one's faith as Christian or Muslim. *Timar*s were inheritable, as was the status of *sipahi*, but as the descendants of original non-Muslim *timar*-holders converted to Islam, and as the state increasingly granted *timar*s to individuals of slave origins, the religious composition of the *sipahi* class became overwhelmingly Muslim by the sixteenth century (Figure 3.4).

As a type of late medieval knight, *sipahi* weaponry consisted of various kinds of coats of mail depending upon rank and *timar*-revenue, a bow and arrows, a javelin and shield, and usually a curved saber. Their horses were lighter stock of the steppe tradition rather than heavy European war horses, allowing for greater mobility in their battle tactics. The eventual introduction of firearms into the Ottoman fighting force did not change their methods much, because not only was it difficult to use these firearms when mounted, but the *sipahi* cavalrymen, as an elite corps, considered firearms to be beneath them. By the end of the fourteenth century the *sipahi* cavalry was "the backbone of the provincial army and of the whole Ottoman military organization."[4] Actual statistics are unreliable, but estimates are 10,000–15,000 *sipahi* cavalrymen were available from Rumeli and Anadolu for imperial campaign in the 1430s–40s; another source claims that in 1475 there were 22,000 *timar*-holding *sipahi*s in Rumelia and 17,000 in Anatolia.[5]

Figure 3.4 Ottoman *Sipahi*s, Sixteenth Century.

KAPIKULU SLAVES: THE *DEVŞIRME* SYSTEM AND THE JANISSARY CORPS

Murad I's tenure as sultan coincided with changes to the Ottoman *beylik* that shaped what would become the *askeri*, or ruling class, for centuries to come. Though initially the extended Ottoman family governed conquered areas, as Ottoman dynastic rule evolved, only the sons accompanied by their entourages were assigned provincial domains in central Anatolia. Other areas into which Ottoman control was slowly being extended created conditions for the use of military forces and administrators who came not from tribal lords nor local *bey*s who could be disloyal vassals at any opportunity, but instead from the use of a political slave elite called *kapıkulu* ("slaves of the Porte"), incorporated into the Ottoman ruling class for these purposes. The Ottomans inherited the basic pattern of Islamic *mamluk* slavery established in the ninth century that was continuing to be used by later Muslim dynasties; a similar form of slavery had been a common feature in the Byzantine Empire as well. But unlike the other form of traditional slavery (called *'abd* – a more familiar kind of domestic, labor slavery), *mamluk* or administrative-military slavery allowed an individual the opportunity for social mobility and elevated status through service, merit, and ambition. Over time they could even establish their own slave households. The Ottomans eventually modified the Islamic system of slave recruitment to fit their particular needs in a way that could have been considered a transgression against Islamic law.

The earliest details of the Ottoman acquisition of slaves, including when precisely this was first carried out, are somewhat sketchy. Scholars now believe the Ottomans likely adopted their early methods of obtaining slaves from the practices already in existence by local *bey*s in the area. Ottoman historians claiming this first occurred during Murad I's time indicate that these slaves were captives in raids on Christian settlements; one-fifth of the prisoners of war (called *pencik*) were given to Murad I as a kind of levy, to employ as infantrymen. Regular raids to acquire captives as slaves in the Christian

Balkans continued during Sultan Bayezid I's reign in the late fourteenth century and after. Regulations decreed by the state in the fifteenth century in the form of a register ensured any captives unaccounted for, such as runaways or missing slaves, would be found, so that no unauthorized activities occurred. The slave raids in Rumelia apparently ceased somewhere around the mid- to late sixteenth century with the establishment of the Kingdom of Hungary as Ottoman territory; after this, captives for slave purposes generally came through Crimean Tatar raiding among Christian Slavs in Russia, Ukraine, Poland, and the Caucasus, and through the acquisition of African slaves from the sub-Sahara. Eunuchs, or castrated slaves, were usually acquired from outside Muslim lands, as the procedure itself was considered unlawful according to Islamic jurisprudence. The constant demand for eunuchs as slaves who could be trusted to serve in the sultan's inner sanctum, however, likely overrode this prohibition, and there were known to be occasional volunteers who, if they survived the surgery, became immensely powerful at court.

To gain more slave recruits who would serve in the Ottoman palace and court, as Ottoman infantry called the "Janissary Corps" (*yeni çeri*, or "new troops"), or in a division of the military slave cavalry (of which there were six units), the Ottomans devised a second method of enslavement, the "collection," or levy, called *devşirme* in Ottoman Turkish. Several European Christian sources indicate this collection was already being carried out in the late fourteenth century in the Balkans, perhaps rather sporadically, depending upon the Ottoman need for foot soldiers to supplement the freeborn peasant *yaya*s. The *devşirme* levy came to be rather rigidly regulated over time, though it still fluctuated according to the needs of the Ottomans to replenish their ranks. Several extant sources – a memoir written by a Serbian Janissary who served from 1453 to 1463, Konstantin Mihailović (b.1435–d.1501), an early sixteenth-century sultanic decree (*fermân*), and an early seventeenth-century anonymous text by a former Janissary – illustrated the rather explicit guidelines for the levy. Generally speaking, and with some inconsistencies in sources, a periodic draft of young males taken from non-Muslim communities residing in Ottoman lands would be carried out approximately every three to seven years in alternating provincial areas by local Ottoman officials. The ratio was of one boy levied for every forty households.

When an imperial order went out, a village for example would be required to bring forth all eligible males of a certain age, somewhere between eight and twenty years old, but preferably around twelve to fourteen years. Their fathers and the priests who had to produce the baptismal register also appeared, so that the boys could be inspected and chosen by Ottoman officials based upon particular verifiable criteria such as age, their physical characteristics, and family background, etc. (Figure 3.5) The anonymous *The Laws of the Janissaries*, though written in 1606, explains in detail the measures used for selection: only sons of a family could not be taken, nor could orphans; boys with any defects or health issues; boys too short or too tall; sons of townsmen, craftsmen, village headmen, shepherds; or boys who were married. Certain ethnoreligious groups also were not levied: not Turks, Jews, Armenians, or Georgians and not Hungarians or Croatians in the north beyond Belgrade. When the *devşirme* was extended to areas of Anatolia, some regions were exempt. Finally Arabs were never taken, and Christian communities who provided other

کسی را که باشد دل و فر بلند
نیشه بود از یکی بی نیاز
کنون شاه را در سر هر سپاه
چنین است قانون فرخنده فال

که سازد به خط بر از دریا
روان کی کند صاحب و قار
کند همره او و فرخنده یک
زبد نوازش بی نیک

کلهای سرخ و قبای آل
فراوان تر از سبز بر نهال
گل گون سغر لاله ها دسته
چو گل بنه بر سم اند دخت

اگر دو بگر دو لایت تمام
ستاند ز زر خانه نیک غلام
پولاد کلایی نه بر سرش
چو غنچه قبای کند در برش

military service in provincial areas (such as guarding bridges, or working in mines) were not subject to the levy. Typically the recruits were of Greek, Serbian, Albanian, Bulgarian, Hungarian, or Russian extraction.

According to Islamic law *dhimmi*s fell under a protected status, and this practice of enslaving them should have been considered illegal. But from the Ottoman state's perspective it was merely a levy on the non-Muslim *re'aya* who technically had submitted to the sultan and were his subjects. It was also a method to prevent the development of a (Turkish) military aristocracy that would be hereditary, at least at the outset. The only Muslim community from whom members were drafted by the *devşirme* were Bosnian Muslims after the Ottomans annexed Bosnia in 1463 during Mehmed II's reign. The narrative of its conquest claims Bosnians requested permission to be included in the levy as a form of special privilege in return for their voluntary subordination and immediate conversion to Islam; they were not drafted into the Janissary Corps as combat soldiers, but only became palace servants or tended and guarded the palace gardens.

Those youths chosen were grouped into "flocks" of 100–200, their details were recorded in registers to prevent corruption by profiteering and to locate any recruits lost along the way, and they were then transported on foot and under guard to the Ottoman capital for further examination and evaluation by Ottoman officials. The *aga* of the Janissaries (the high commander of the Janissary Corps), and his subordinates, the *aga* of Rumelia and the *aga* of Anatolia also oversaw their circumcision and conversion to Islam. Those boys deemed to be the most intelligent and best-looking were separated off to be educated in the palace school, to serve in other capacities around the palace (e.g., as pages, called *iç oğlans*) or for other officials, all under the strict discipline and supervision by *ak agas* – the white eunuchs. The boys were provided with rigorous training for years in the fields of administration, military strategy, martial and cultural arts (religion, languages, sciences, music, etc.) which could allow them, within this meritocracy and based upon their aptitudes, to reach the highest echelons of power within the Ottoman Empire. In fact most Ottoman *grand vezir*s by the sixteenth century were of these slave origins, whereas before this many had been of Christian or Muslim descent, but often from elite backgrounds in former dynasties.

The many positions to be occupied by these recruits who were among these first selected ranged from those categorized as part of the "Inner Service," such as being direct attendants upon the sultan in all aspects of his daily life, or in specific duties such as the sultan's sword-bearer and his stirrup-holder. The second selection round placed those chosen into the "Outer Service." They carried out many functions around and outside the court, or those tasks connected to the outside world, much of which was militarily related: many of the Janissary officers, including the *aga* of the Janissaries, the highest-ranking Janissary official who served on the Imperial Council, or the standard-bearer for example. Those who managed the Sultan's stables and hunting animals (horses, hounds, and falcons) and maintained the animals' care, the palace chefs and tasters, couriers for foreign correspondence, the gardeners, and members of the six *kapıkulu* cavalry divisions, were all part of the Outer Service. In all of these posts occupied by *kapıkulu* slave recruits, status was understood in a clear hierarchy demarcated by title, dress, and headgear. Illustrated here in a miniature

Figure 3.5 (facing page)
"Janissary Recruitment in the Balkans," from Arif Çelebi's *Süleymannâme*, Sixteenth Century.

Figure 3.6 "Reception of İbrahim Paşa" (1527), from the *Süleymannâme*, Sixteenth Century.

(Figure 3.6) are the stylized dress and somber demeanor of various Ottoman *kapıkulu* "slaves of the Porte," as well as, prostrated before the sultan to kiss the hem of his *kaftan*, İbrahim Paşa, a Greek slave from Venice-held Parga who became friend, confidante, and *grand vezir* of Süleyman in the sixteenth century. Behind him are two other *vezir*s, likely of slave origin; to the sultan's left are two *iç oğlan*s (unbearded); two attendants in the doorway in red headgear are *has oda ağa*s (personal servants); two *kapıcı*s (palace guards) stand at attention in the courtyard.

The rest of the *devşirme* recruits were sent to work for Turkish farmers in Anatolia for seven to eight years to accustom them to hard labor and for them to learn Turkish language and the tenets of Islam. They were annually inspected by officials each year before being recalled at some point to join the ranks of beardless Janissary novices in white-pointed headgear (*acemi oğlan*s), where they received a wage, lived in novice military barracks, endured more rigid discipline and training, and worked as state laborers for a few more years. *The Laws of the Janissaries* described how novices' labor included transporting firewood to the palace or snow from the mountains on vessels to the royal icehouse; serving on vessels transporting troops across the Bosphorus Straits; working as palace cooks and tending to laundry; maintaining the palace gardens; apprenticing in the Ottoman dockyards; or laboring as builders and blacksmiths. They were eventually called up to fill the various ranks of the Janissary Corps as the need arose – as infantry, armorers, gunners and bombadiers, as fortress guards in strategic provincial locations, etc., all to serve in the sultan's disciplined military machine on campaign as the first professional standing army in Europe.

The Janissaries established camaraderie as soldiers who lived, ate, and fought together (Figure 3.7). Their lives were defined by a sartorial code, a culture of rituals surrounding discipline during warfare and in peacetime, and an esteemed status as part of the *askeri* class who did not pay taxes, but protected the sultan and his domains. Originally they were the sultan's private guard, called *yoldaşlar*. As the Janissary numbers increased, their military roles expanded, though the sultan still retained a unit of archers who marched ahead of him on campaign as a personal bodyguard, similar to the old Turco-Mongol tradition of retainers made up of close companions and volunteers (called in old Turkic *böri* or in Mongolian as *nökör*, known as "wolves"). A more formal organization of the Janissaries evolved over time as their numbers swelled, with Janissary troops divided into several corps or *ocaklar* ("hearths") further organized into regiments (*orta*s) of various sizes that functioned

Figure 3.7 Janissaries Carrying Copper Cauldrons Used to Bring Food from the Palace Kitchens to the Barracks, with Regimental Spoon. Each *orta* had its own cauldron for feeding its members and was also carried on campaign.

in tandem with other forces of the Ottoman military. The sources vary, but generally the number of Janissaries during Murad I's reign is estimated to have been only about 2,000 (at Kosovo); during Sultan Mehmed II's era (1451–81), roughly 5,000–10,000; by the mid-1500s, almost 13,000; and during the seventeenth century it fluctuated between about 49,000 and 54,000,[6] when by this point the *devşirme* levy was being abandoned and most Janissaries were freeborn (Muslims). By the mid-eighteenth century estimates are of over 100,000.

Their many ranks were expressed as important roles related to traditional communal living in this brotherhood, while simultaneously reflecting both the needs of the sultan (e.g., his water-bearer), and the sultan's obligation to "feed" his charges. The colonel or commander of a regiment was called the *çorbacı* ("soup maker") and wore a soup ladle "as his badge, proudly worn but never wielded,"[7] and as a symbol of "humility toward the Sultan."[8] Below him ranked the *aşçı başı*, or actual "chief cook" in the barracks, who ensured the troops were properly fed, but also dispensed firm discipline when necessary. The Janissaries were to live in the barracks when not on campaign; they were not to marry; they were not to engage in any commercial activities. They were not to grow beards, the facial hair of free men, but only moustaches, to indicate their status, though their increasing political power by the fifteenth century and after allowed them to defy many of these restrictions (Figure 3.8). The distinctive white flap of their headgear, adorned with feathers or other ornamentation depending upon rank, was said to imitate the sleeve of the mystic Hajji Bektaş, their Sufi patron saint whom, according to one legend, it was believed had blessed them with a touch of his hand (though impossible given he had died some one hundred years before the establishment of

Figure 3.8 Süleyman's Janissaries, Sixteenth-Century Miniature.

the Janissary institution). *Bektaşi* dervishes and Muslim imams (prayer-leaders) were attached to each division to assist in the spiritual motivations of the corps.

The Janissary Corps was initially armed with bows and marched as a center guard flanked by cavalry. Once gunpowder weapons were adopted by the Ottomans, they were the first to use firearms, and did so with organized firing tactics and devastating results. Their initial encounters with this technology were likely with their Hungarian enemies in the Balkans in the 1380s; Venetian traders eventually supplied arms to the Ottomans via Ragusa (Dubrovnik). Serbian vassal contingents would have used this weaponry as well as did later Bosnian foes. Sultan Bayezid I was known to have used cannons against Karaman, and the use of firearms during his sieges of Constantinople in 1394 and 1402 has also been documented. Handguns called *tüfenk* – a kind of matchlock arquebus – were used in small numbers by the 1440s; Janissaries were outfitted with the more advanced, larger, and more powerful matchlock muskets in the late sixteenth century, and flintlock muskets as well as light firearms were also part of the Janissary arsenal. The Ottoman fighting force was accompanied on campaign by the Janissary *mehter* band(s), which was designed to instill fear in the adversary and to inspire the troops for ceaseless battle with its rumblings of drums, horns, and other percussion (Figure 3.9); this Ottoman invention of the military band was borrowed into European armies later. When not on campaign, the *mehter* band played daily in the Ottoman capital either to honor the sultan or to mark the beginnings or endings of certain prayer times.

Questions often arise as to the loyalty of the *kapıkulu* elites and the Janissary Corps toward their dynastic Ottoman masters. As youth pulled from their families and pressed into service, what kept them from resisting, rebelling, escaping back to their birthplaces rather than serving in the palace, where, as such youths, they were required to live in complete silence in the presence of Ottoman dignitaries, casting their gaze downward at all times to show submission? Or being forced into labor in the countryside for a period of years? What kept them from rejecting conversion to Islam, or refusing to serve as Janissaries whose only duty was to exist for military campaign? Did they truly lose their connection to their non-Muslim communities and their heritage? First, the high level of organization in this *devşirme* system precluded the possibility of a significant number of escapees. Second, once removed from their families, a new life and new culture was established for them at an impressionable age, guided by persuasive mentors and strict discipline, and one which could provide tremendous cohesion for them as part of the ruling class, as well as socioeconomic and political benefits for those lucky enough to go into palace service. Additionally, evidence suggests that many Ottoman officials of *kapıkulu*

origins were not completely severed from their roots, but rather maintained some level of contact, and even on occasion managed to provide favors to their original communities such as establishing endowments for them (e.g., a fountain, or bridge, in the village). Third, the Sufi form of Islam adhered to by the Janissaries, the thirteenth-century *Bektaşi* order founded by Hajji Bektaş, was unorthodox in its rituals and beliefs (or lack thereof), combining reverence for Ali and the twelve imams (usually associated with Shi'ism) with other Islamic and Christian elements in a way that likely appealed to those "displaced" by the *devşirme* experience who needed the fraternity provided by a Sufi mystical ideology.

Loyalty to the sultan and Ottoman state among the Janissaries did not remain stable forever, however, nor did the *devşirme* institution survive throughout the empire's lifespan. In later centuries the discipline and rigor associated with the Janissary Corps was replaced with fear and loathing. The *devşirme* fell into disuse after the 1660s, and so no new recruits for this system were forthcoming from among *dhimmi* youths. Yet the corps numbers expanded exponentially as the strict guidelines for recruitment were ignored, reaching

Figure 3.9 "Mehterhâne" from *Surname-i vehbi* (1720).

numbers unsustainable for the Ottoman state. In those earlier centuries the Janissaries were not to marry, not to engage in any trades or businesses, but to live for war: only to serve the empire on campaign as the most powerful soldiery Europe had ever seen (or perhaps to be stationed in the countryside to guard fortresses and bridges, or to act as the state's police and firefighters in urban areas), or else to retreat to their barracks. But as the ability of the sultan and his state to enforce discipline and regulate the corps dissipated, Janissaries married, engaged in commerce, had children, and the system became corrupted as they found ways for their Muslim offspring to inherit their positions, many of whom never actually served as soldiers. As a salaried class, the burgeoning Janissary Corps of later centuries placed a huge burden on the Ottoman state treasury. Usually paid quarterly, they could and did also demand imperial bonuses before heading out on campaign, they could refuse to fight, and they extorted bribes from the local population, even setting fires they would refuse to put out without being paid money. It has been said that they started to "frighten everyone but the enemy" by the seventeenth century because of their tendency to flee the battlefield. At home in the capital, when one heard the loud clank of their copper soup cauldrons being overturned, symbolizing their refusal to eat the sultan's rations, it meant a Janissary political rebellion was on the horizon. They deposed more than one sultan in the latter centuries of the empire's existence, and executed at least one (Osman II, r.1618–22).

Ottoman institutions and organizational patterns – dynastic succession, military and civil administration, etc. – did not appear overnight. They evolved over time as needs arose to maintain the territories and manage the peoples that increasingly came under Ottoman rule. Perhaps one of the more unique aspects of this rising empire was its acceptance of and reliance upon mobility, inherent from the *beylik*'s outset and perpetuated as Ottoman territory expanded over the centuries. Whether the sultan himself on campaign, or his armies, his warrior horsemen and the accompanying provisions, or the tribes who regularly traversed the landscape with their livestock to seek out summer and winter pastures, mobility was an essential characteristic of Ottoman life for many. There was a certain flexibility in the Ottomans retaining its usefulness as a means to exert control over provincial zones, unless efforts to sedentarize troublesome nomads was deemed more necessary (which occurred sometimes from the fifteenth century onwards). Openness to innovative methods and technology together set the Ottomans on a path to successful conquest: the expansion of Osman's principality of the fourteenth century resulted in an imperial state by the fifteenth century, and an empire posing a serious challenge to the powers of Europe by the sixteenth century.

NOTES

1 *Qur'an*, al-Nisa' 4:3.
2 From Halil İnalcık, *The Ottoman Empire: The Classical Age 1300–1600* (London: The Trinity Press), 59.
3 Pál Fodor, "Ottoman Warfare, 1300–1453," In *Byzantium to Turkey 1071–1453*, ed. Kate Fleet, vol. 1 of *The Cambridge History of Turkey* (New York: Cambridge University Press, 2009), 195.

4 Fodor, "Ottoman Warfare," 199.

5 İnalcık, *The Ottoman Empire*, 108. See also note 1 on page 230, from Franz Babinger, *Die Aufzeichnungen des Genuesen Jacopo-de-Promontorio über den Osmanenstaat um 1475* (1956).

6 Gábor Ágoston, *Guns for the Sultan: Military Power and the Weapons Industry in the Ottoman Empire* (New York: Cambridge University Press, 2005), 26.

7 Godfrey Goodwin, *The Janissaries* (London: Saqi Books, 1997), 70.

8 Ernest Tucker, "Janissary," in *Europe, 1450 to 1789: Encyclopedia of the Early Modern World*, last updated May 31, 2020, http://www.encyclopedia.com/doc/1G2-3404900568.html.

SELECTED READINGS

Ágoston, Gábor. *Guns for the Sultan: Military Power and the Weapons Industry in the Ottoman Empire*. New York: Cambridge University Press, 2005.

Ágoston, Gábor, and Bruce Masters. *Encyclopedia of the Ottoman Empire*. New York: Facts on File, 2009.

Akgündüz, Ahmed, and Said Öztürk. *Ottoman History: Misperceptions and Truths*. Rotterdam, The Netherlands: IUR Press, 2011.

Anonymous. *The Laws of the Janissaries (Kavanin-i yeniçeriyan)*. 1606.

Clot, André. *Suleiman the Magnificent*. London: Saqi Books, 2005.

Darling, Linda T. *A History of Social Justice and Political Power in the Middle East: The Circle of Justice from Mesopotamia to Globalization*. New York: Routledge, 2013.

Feldman, W. "Mehter." In *Encyclopaedia of Islam*, edited by P. Bearman, Th. Bianquis, C.E. Bosworth, E. van Donzel, W.P. Heinrichs. 2nd ed. Brill, 2012. https://doi.org/10.1163/1573-3912_islam_SIM_5149.

Finkel, Caroline. *Osman's Dream: The Story of the Ottoman Empire, 1300–1923*. London: John Murray, 2005.

Fodor, Pál. "Ottoman Warfare, 1300–1453." In *Byzantium to Turkey 1071–1453*, edited by Kate Fleet, 192–226. Vol. 1 of *The Cambridge History of Turkey*. New York: Cambridge University Press, 2009.

Goffman, Daniel. *The Ottoman Empire and Early Modern Europe*. Cambridge: Cambridge University Press, 2002.

Goodwin, Godfrey. *The Janissaries*. London: Saqi Books, 1997.

Hathaway, Jane. *A Tale of Two Factions: Myth, Memory, and Identity in Ottoman Egypt and Yemen*. New York: State University of New York Press, 2012.

Imber, Colin. *The Ottoman Empire 1300–1650: The Structure of Power*. New York: Palgrave MacMillan, 2002.

İnalcık, Halil. *The Ottoman Empire: The Classical Age 1300–1600*. London: The Trinity Press, 1973.

İnalcık, Halil. "Ottoman Methods of Conquest." *Studia Islamica* 2 (1954), 103–29.

İnalcık, Halil. "The Ottoman Succession and its Relation to the Turkish Concept of Sovereignty." In *The Middle East and the Balkans under the Ottoman Empire: Essays on Economy and Society*, edited by Halil İnalcık, 37–69. Bloomington: Indiana University Turkish Studies 9, 1993.

Kasaba, Reşat. *A Moveable Empire: Ottoman Nomads, Migrants, and Refugees*. Seattle: University of Washington Press, 2009.

Kastritsis, Dimitris. *The Sons of Bayezid: Empire-Building and Representation in the Ottoman Civil War 1402–1413*. Leiden: E.J. Brill, 2007.

Genealogy 4.1 Ottoman Sultan Bayezid I's Five Sons Competing for the Throne.

Savcı

Yakub
(d.1389)

Bayezid I, Yıldırım
(r.1389–1402)

Süleyman Çelebi
(r.1402–11)

Musa Çelebi
(r.1411–13)

Mustafa, Düzme
(r.1421–2)

Mehmed I, Kirişçi
(r.1413–21) İsa Çelebi

Persianate-centric Timurid state fragmented over succession struggles in the fifteenth century and could not sustain its demands for Ottoman vassalage for long. Eventually overrun by the Karakoyunlus from the west and the Central Asian Üzbeks rising in the east, a later surviving Timurid heir, Babur, fled south, where he founded the long-lived Mughal dynasty in India in 1526.

Prince Mehmed could be said to have demonstrated ruthless Ottoman pragmatism in the face of a house divided. He established his Anatolian power base first at Amasya before moving on to Bursa, dislodging his brother, Prince İsa, there, and, as was depicted in a later miniature painting, having himself enthroned by his supporters as Sultan Mehmed I in 1403, though his authority as sultan was not universally recognized. The civil war between brothers raged on. Prince Süleyman, in Edirne, had assumed control of Rumelia, and eventually killed Prince İsa. Just as the Turkic principalities in Anatolia seized the opportunity to reassert their independence, Byzantine and Balkan vassals of the Ottomans also saw the possibility to free themselves of Ottoman domination. Prince Süleyman was compelled to grant them autonomy to gain stability on the European front in order to turn his attention toward taking Anatolia from Mehmed. By the Treaty of Gallipoli signed in 1403 with Süleyman, the Byzantines were freed from Ottoman vassalage and tribute, and regained some territory; Serbia, however, retained their lands on condition of paying tribute and providing military support; and Venice secured its commercial privileges.

Prince Süleyman advanced into Anatolia, ruling both areas for a time, forcing Prince Mehmed to retreat east to Tokat in 1404. Prince Musa, Bayezid's son captured with him in 1402, had been released by Timur in 1403 and was held by Mehmed, who released him in 1409 to assist in attacking Süleyman via Wallachia. Musa occupied Edirne and reached all the way to Gallipoli. Süleyman returned to Rumelia and, failing to balance his rule between raiding marcher lords and powers wanting peace and stability in order to facilitate trade, was killed by Musa in 1410. Musa ruled for about two years until Balkan "allies" (including Gazi Evrenos Bey)[1] and forces from the Dulkadir emirate in Anatolia chose to support Mehmed I's bid for power over that of Prince Musa, and in 1413 Musa was killed during the Battle of Çamurlu (south of Sofia, Bulgaria). Violent as this family struggle was, it was the solution for an Ottoman house divided. The interregnum and civil war had brought the principality to the brink of extinction; Ottoman adaptability during a critical moment came in the form of a fratricidal war that ultimately provided the opportunity to reconstruct Ottoman authority – as well as hone Ottoman skills in dealing with tribal politics and communities demanding autonomy. Osman's *beylik* would survive.

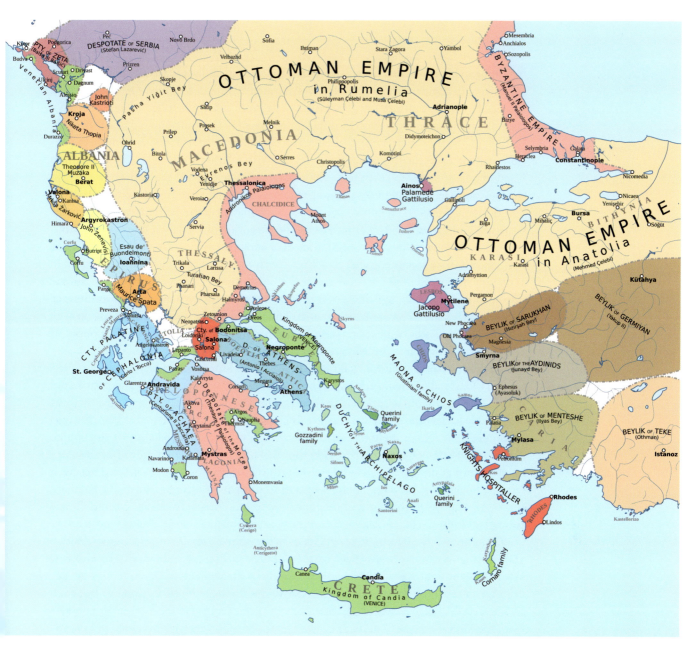

VASSALS, VENICE, AND VEXING REBELS

Map 4.1 Ottoman Balkans and Anatolia during the Civil War, 1402–13.

Although the Ottoman sultanate was now in Mehmed I's hands, further challenges to his reassertion of Ottoman authority continued from various directions. First and foremost was the need to re-subordinate the Turkic principalities that had been reinstated by Timur, with the most problematic of them, the Karamanids, defeated in 1415. They would continue to take advantage whenever Ottoman attention turned westwards, in a bid to regain lost Karamanid territory. Another brother, a "false" Prince Mustafa, supposedly also captured

by Timur and later released from Samarkand, appeared in Wallachia accompanied by forces supporting his claim to the throne. He was defeated by Sultan Mehmed I in 1416 and held hostage by the Byzantines until Mehmed I's death in 1421, when he was released from custody in Thessalonika to stir up trouble for Mehmed I's son and potential heir, Murad II.

One of the most persistent challenges to Ottoman territorial and economic expansion westward was their imperial rival, Venice, with whom they forged a set of relations based upon a complicated combination of pragmatic coexistence and a shared interest in the flow of trade, interspersed with semi-regular wars that interrupted this fragile balance. The Venetians had taken control of most of Dalmatia on the Adriatic coast from the Croatian-Hungarian nobility in 1409 (with the exception of Ragusa [Dubrovnik], which became an Ottoman tributary in 1458), with their administrative seat at Zadar (Zara). Sultan Mehmed I's naval forces engaged in a brief confrontation with Venice in the Aegean in 1416, which resulted in the destruction of the Ottoman fleet (see Chapter 5 for the early Ottoman navy), but an agreement was reached between the two powers concerning the release of prisoners and trade arrangements. This would not be the last confrontation with Venice; in fact another eight wars with Venice occurred over the course of the reigns of eleven Ottoman sultans! But Mehmed I's problems continued elsewhere.

In addition to the political challenges to Sultan Mehmed I's authority from brothers, foreign rivals, and resistant principalities, in 1416 a major two-pronged rebellion broke out in the Dobruja area of Bulgaria and in the Aegean coast of Anatolia, led respectively by the charismatic leaders Sheikh Bedreddin (a learned Muslim scholar appointed as Prince Musa's chief military judge for about two years when Musa controlled Rumelia) and former pupils Börklüje Mustafa and dervish Torlak Hu Kemal. These revolts were triggered by the chaos of the interregnum and by local frustrations in these areas, but they possessed syncretic Islamic, millenarian leanings due to the mystical preachings of their leaders. In Rumelia, migration of peoples in and out of the region caused conflicts between agriculturalists and pastoral nomads, and Sultan Mehmed I's dispossessing local lords of their land grants when he assumed power in the Balkans inflamed them. In the Aegean area of Anatolia, a poor Muslim and Christian peasantry was swayed by the call for equality and resistance to landholding elites. Both movements had inspired people to rebel with demands of communal ownership of property, and both were eventually put down: Sheikh Bedreddin was apprehended, taken to Serres (in Ottoman Macedonia), tried, convicted, and hanged in the marketplace in 1420; Börklüje Mustafa was very publicly crucified, and his followers were executed in Ephesus. The Ottoman state took a dim view of impoverished dervishes after this, hanging Torlak Hu Kemal and massacring members of his order in the Manisa/Smyrna region of Anatolia.

Sultan Mehmed I died shortly thereafter in 1421 after a fall from a horse. His son, Murad II, eventually assumed the Ottoman throne in Bursa around the age of twenty. He thwarted the ambitions of both his uncle, the "false" Mustafa who had claimed power briefly from Edirne and had support in Rumelia, as well as his thirteen-year-old brother, "Little Mustafa," whom Murad II had strangled in the ensuing succession struggle. Sultan Murad II (r.1421–44, 1446–51) would see the recovery of Anatolian lands lost to Timur in 1402, with the exception of Karaman. Through ceaseless campaigns in the Balkans, Murad II either subdued vassals who waivered in their Ottoman loyalties, or he seized control of more territory: a

THE EPIC OF SHEIK BEDREDDIN BY NÂZIM HIKMET

Nâzım Hikmet Ran (b.1902–d.1963) was a Turkish poet, playwright, and novelist who spent much of his life imprisoned by the Turkish Republic for his revolutionary communist views. His poetry is renowned for its celebration of the lives of the peasantry and commoners in the countryside. Hikmet's *Epic of Sheik Bedreddin*, published in 1936, reflects the poet's idealization of Sheikh Bedreddin and his rebellion against the Ottoman state in the early fifteenth century as an expression of leftist, socialist inclinations being persecuted by the state. Below is an excerpt.[2]

On the divan, Bursa silk in green-
branching red boughs;
a blue garden of Kutahya tiles on the
wall;
wine in silver pitchers,
and lambs in copper pots roasted golden
brown.
Strangling his own brother with a
bowstring
– anointing himself with a gold bowl of
his brother's blood –
Sultan Mehmet had ascended the throne
and was sovereign.
Mehmet was sovereign,
but in the land of Osman
the wind was a fruitless cry, a death-song.
The peasants' work done by the light of
their eyes
and by the sweat of their brows
was a fief.
The cracked water jugs were dry –
at the springs, horsemen stood twisting
their mustaches.
On the roads, a traveler could hear the
wail of men without land
and land without men.

And as foaming horses neighed and swords
clashed
outside the castle door where all
roads led,
the market place was in chaos,
the guilds had lost faith in their
masters.
In short, there was a sovereign, a fief, a
wind, a wail. [...]
[...] "The fire in my heart
has burst into flame
and is mounting daily.
Were my heart wrought iron, it could not
resist,
it would melt ...
I will come out now and declare myself!
Men of the land, we will conquer the
land.
And proving the power of knowledge
and the mystery of Oneness,
we'll abolish the laws of nations and
religions ..." [...]
We heard: "That the people might be
freed of their suffering
and the earth's flesh be made pure
as a fifteen-year-old boy's,
the landowners have been slaughtered
wholesale
and the lords' fiefdoms made public land."
[...]
Bedreddin's braves faced the Prince's army
like the last work of this earth.
With flowing white robes,
bare heads,
bare feet, and bare swords ...
A great battle took place.
Turkish peasants from Aydin,
Greek sailors from Chios,
Jewish tradesmen,

Mustafa's ten thousand heretical comrades
plunged into the forest of enemies like ten
 thousand axes.
The ranks of green-and-red flags,
inlaid shields,
 and bronze helmets
were torn apart,
but when the day descended into night in
 pouring rain,
the ten thousand were two thousand. [...]
They were defeated.
The victors wiped their bloody swords
 on the flowing white robes
 of the defeated.
And the earth brothers had worked all
 together
like a song sung together
was ripped up
 by the hooves of horses bred in the
 Edirné palace. [...]
 At the center,
straight as a sword stuck in the ground,
 the old man.
Facing him, the Sultan.
They looked at each other.
It was the Sultan's wish

that, before finishing off this incarnation
 of blasphemy,
before giving the word to the hangman,
the court should exercise its skills
and dispose of the matter properly. [...]
They turned to Bedreddin.
They said, "You talk now."
They said, "Explain your heresy."
Bedreddin
looked out through the archway:
sunlight,
the branches of a tree turning green in the
 yard,
and a brook carving stones.
Bedreddin smiled.
His eyes lit up,
 and he spoke:
"Since we lost this time,
words avail not.
Don't draw it out.
Since the sentence is mine,
give it – so I may seal it ..." [...]
The rain hisses.
In Serrai's market place,
across from the coppersmith's,
Bedreddin hangs from a tree.

lengthy blockade starting in 1422 to retake Salonika (which the Byzantines had ceded to Venice) forced its eventual capitulation by 1430. Serbia, caught between status as a vassal for the Ottomans and pressures from King Sigismund of Hungary, drew the Ottomans and Hungary into direct conflict, causing a full Ottoman annexation of Serbia by 1439. Ottoman advances further into southern Greece and Albania in 1430 threatened Venetian possessions there, and ultimately Venice was forced to pay tribute to the Ottomans after an Ottoman *sancak* was established in 1431 (see Map 5.1; green areas depict Ottoman territories lost in 1402 and finally regained by Sultan Murad II).

 Sultan Murad II's Ottoman campaigns to expand further into southeastern Europe had repercussions. Aggrieved Christian powers in the Balkans – Venice, Serbia, King Vladislav of Poland/Hungary, and the Byzantines hoped to liberate the Balkans from Ottoman control. In an effort to facilitate cooperation among the European powers, the Byzantine emperor

capitulated and accepted (temporarily) a union of the Greek Orthodox church with that of the Latin Catholic papacy in 1439 with the Council of Ferrera-Florence, a controversial move to end the doctrinal schism, although this inflamed both the Byzantine orthodox clergy as well as the Byzantine population at large. With the additional assistance of (once again), the Karamanids, who could attack the Ottomans from the east, Hungary's military commander János (John) Hunyadi, was encouraged and financially supported to embark on the "Long Campaign" against the Ottomans in 1443, in order to push Ottoman forces out of areas of Serbia and Bulgaria and in hopes of ousting them from Europe completely. Sultan Murad II first led an army in Anatolia to subdue the forces of emir Ibrahim of Karaman in spring of 1443, before he crossed back to confront the Hungarian army. After an Ottoman retreat in early 1444, Sultan Murad II then sued for peace; Hungarian, Polish, and Serbian envoys were sent to Edirne to negotiate terms, and in June of 1444 a ten-year truce was agreed upon by Sultan Murad II with the Treaty of Edirne. It seems that, believing the Ottoman realm to have acquired peace and stability, and, as some historians have speculated, having become exhausted by war and overcome with grief at the death of his favorite son, Alaeddin, Sultan Murad II did the unthinkable: he abdicated the Ottoman throne in Edirne in the summer of 1444 in favor of his twelve-year-old son, Prince Mehmed II, who had been provincially posted in Manisa (near Smyrna/Izmir) near the Aegean coast in Anatolia. Seeing this unprecedented move by an Ottoman sultan as a sign of weakness, the pope absolved the Christian powers of their oath to the Ottomans in August 1444 (though Serbia remained in the treaty) and sanctioned the anti-Ottoman crusade. Called out of retirement, Murad II commanded Ottoman forces at Varna (on the Black Sea coast of Bulgaria). Hungarian military superiority on the field should have decided the battle, but the death of the Hungarian king was the determining factor; the Ottomans secured victory, the battle ending in November 1444.

Young Sultan Mehmed II had only reigned for about two years when further crises in Edirne led Murad II to be recalled to the throne as sultan in 1446. There he remained sultan, quelling rebellions of vassals in the Balkans for the next several years, including Hunyadi's Hungarian cavalry forces, who campaigned again in 1448 in Kosovo-Polje and were routed by Ottoman *sipahi*s. Sultan Murad II's campaigns to stabilize the empire after such turmoil had established the possibility for a grander Ottoman future. Byzantine Constantinople, on the other hand, would no longer be able to resist the Ottoman onslaught from this moment onwards. With Murad II's death in 1451, his son Mehmed II again ascended the Ottoman throne, at age nineteen, now a wiser, more seasoned sultan, and one with a more ambitious vision: he would reign for thirty years, and lay the foundations for the world empire to come.

IMPERIAL VISION: FATIH MEHMED II

The riddle of the Red Apple during Ottoman Sultan Mehmed II's reign:

> And the Emperor ordered a great rug to be brought as an example and to be spread out before them, and in the centre he had an apple placed, and he gave them the following

riddle, saying: "Can any of you pick up that apple without stepping on the rug?" And they reckoned among themselves, thinking about how that could be, and none of them could get the trick until the Emperor himself, having stepped up to the rug, took the rug in both hands and rolled it before him, proceeding behind it; and so he got the apple and put the rug back down as it had been before. And the Emperor said to the lords: "It is better to torment the *kaury (giaur)* [*gavur* = infidel, Christian] little by little than to invade their land all at once. For we are so insecure that if we had a small setback there, then all our lands that we have conquered from the kaury would be against us and rebel".... And so they all praised his speech and the Emperor's example.[3]

The Ottoman conquest of Byzantine Constantinople in 1453 by Sultan Mehmed II has only recently been recast as a new chapter in world history – as the successful Ottoman regeneration of this city after the siege, and the beginning of the early modern era, instead of the more cynical European perspective: the fall of Western civilization. In fact the Fourth Latin Crusade which reached Constantinople in 1204 had already initiated the dwindling power and wealth of the Byzantine Empire long before the Ottoman siege. They sacked and looted the Byzantine city, forcing the imperial dynasty out of power until 1261, when the Palaeologus emperors were able to return to Constantinople. The Byzantines then ruled a feeble empire from a city much reduced in population and less the envy of the world as a jewel in the east. Nonetheless, this city, with its strategic location, situated at the crossroads of the two continents of Europe and Asia, and on the shores of several waterways linking the Mediterranean to the Black Sea, had been the target of countless invasions many times before. Its city walls were fortifications that seemed impenetrable. As early as the seventh century, Muslim Arab armies had tried unsuccessfully to fulfill a tradition, a *hadith* attributed to the Prophet Muhammad: "Verily you shall conquer Constantinople. What a wonderful leader will that leader be, and what a wonderful army will that army be!" Subsequent Muslim attempts to conquer Constantinople had failed, including several by Sultan Mehmed II's Ottoman predecessors.

Both the legend from classical antiquity of Alexander the Great's grasping an apple of gold seized from lands he conquered to symbolize his possession of the world, as well as Central Asian Turkic folklore, came to be employed as metaphors for future Ottoman campaigns: the "Red Apple," *kızıl elma* in Turkish, dates back to the Oğuz Turks and reflected their belief in a red or golden orb as representing a place somewhere west, to be reached and conquered in the future. It was a symbol of victory, of world domination, of unification by the Turks, and typically would become associated with a particular city or a building within it (the final location of the "Golden Apple," as it was also sometimes called, would be where the Turks would find their end at the hands of Christians – a point conveniently omitted by not ever making a final western endpoint to the conquests). Constantinople came to be understood as the "Red Apple" because of the statue on a seventy-meter high pillar of the Roman Emperor Justinian (who ruled the Roman Empire from this eastern capital, 527–65 CE), on horseback with a golden orb in hand, which was located outside the city's famed Byzantine Hagia Sophia Church (Figure 4.1).

The statue was later destroyed after the Ottoman conquest in 1453, though reports of remnants of it seen in places here and there by visitors to the city attest to its existence. And as the Ottomans set their sights further west into Europe, so moved the *kızıl elma* – understood variously as Rome, and particularly the papal St. Peter's Basilica in the Vatican, with its high rounded dome the symbol of Christendom. Later, when the Ottomans were either in competition or all-out war with the Habsburgs and their Holy Roman emperors, the Red Apple became Vienna, represented by St. Stephen's Cathedral.

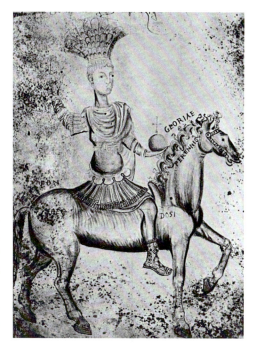

Figure 4.1 Fifteenth-Century Sketch of a Bronze Statue of Byzantine Emperor Justinian.

When young Mehmed II returned to the Ottoman throne upon the death of his father in 1451, he was older, more experienced, and had ambitious designs that included fulfilling the Islamic prophesy of conquest and seizing the *kızıl elma*. Sultan Mehmed II had a broad-reaching imperial mindset – the Ottoman state in his eyes was destined to be a world empire that would inherit Roman/Byzantine and Greek imperial status, with him as its preeminent commander, the Ottoman sultan khan. Roman caesars, Byzantine emperors, and Alexander the Great were his exemplars. But, like the riddle of the Red Apple introduced at the beginning of this chapter, he proceeded carefully, so as to "roll up the carpet" with the least amount of antagonism. After dealing with a challenge to his claim to Ottoman rule by killing his remaining brother, he temporarily pacified borders, renewing treaties with powers in the Balkans (Serbia and Hungary), as well as with Venice; he made certain the principalities in Anatolia would not stir up conflict on the eastern Ottoman border. He had paid his Byzantine vassals in Constantinople ransom to hold a pretender/family relation, an uncle Orhan, hostage there, indefinitely; when they threatened to release Orhan, this became the pretext for him to besiege Constantinople.

THE SIEGE OF CONSTANTINOPLE

Siege preparations began in earnest in 1452 with the construction of a fortress on the European side of the Bosphorus Straits at its narrowest point (Map 4.2), situated directly across from Anadolu Hisarı, which had been built by his ancestor Sultan Bayezid I on the Asian side during his blockade of the Byzantine city. The impressive three-towered fortress went up in record time – in about four months – with each of his three ministers (*vezirs*) responsible for the construction of one tower, the healthy competition of which likely sped up progress toward its completion. Once finished, Rumeli Hisarı (Figure 4.2), the "Rumelian Castle" or as it was known then, *Boğaz kesen* – "Cutter of the Strait" or "throat cutter" – was now armed with a cannon mounted on the tower facing the water in order to restrict resupply of grain and other provisions to Constantinople coming from the Black Sea. A Hungarian cannon founder named Urban had deserted Byzantine service and

Map 4.2 Constantinople *c.* Fifteenth Century.

went to work for the Ottomans, making this large armament. Any Genoese or Venetian ships attempting to avoid paying the Ottoman toll and running the blockade could be sunk. The threat was real, for a Venetian ship that attempted to do so was hit by cannon fire, sunk, the captain and crew captured, the captain impaled, and the crew beheaded.

The Genoese trading colony at Pera (Galata) across from Byzantine Constantinople was in peril. Genoa sent galleys and personnel as aid to the Byzantines, under the command of Giovanni Giustiniani Longo. Venice supplied meager naval support and word from the pope – that help would only be forthcoming from Latin Christendom provided the Emperor Constantine promised the pope a more serious union by the Eastern Orthodox Church. Though a union was sworn, the Byzantine Greek populace rioted in the streets and many low-level clergy overwhelmingly rejected the call, led by the learned monk George Scholarius, later known as Gennadius Scholarius. Byzantine historian Doukas alleges it was the Byzantine Grand Duke Notaras himself that claimed "better the turban of the Turk in Constantinople than the tiara of the Pope" – and the Byzantines left in the city could only watch and pray as the Ottoman forces amassed for the assault.

The Hungarian cannon-founder Urban served Sultan Mehmed II again, casting the largest cannon yet, on the spot where eventually the Byzantine walls that had withstood countless onslaughts would be breached by the Ottomans around the Gate of St. Romanus, after camping before these walls in a fifty-four-day siege in 1453. It was the first large-scale use of gunpowder warfare by the Ottomans. Smaller cannons, mangonels,

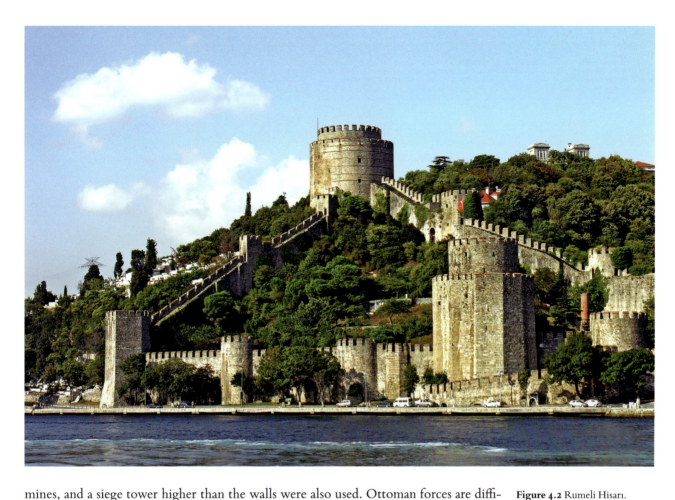

mines, and a siege tower higher than the walls were also used. Ottoman forces are diffi- **Figure 4.2** Rumeli Hisarı.
cult to count, but Latin and Byzantine sources put the number at a perhaps exaggerated
figure of 160,000; Byzantine and Latin auxiliary forces who defended the city were esti-
mated at less than 10,000; the city's population was likely only around 45,000. It has been
argued that Latin Christians (i.e., Venetians, Genoese, etc.) did not allow the Byzantines
to surrender, in order to be able to negotiate better terms for themselves in the aftermath.
The three layers of interconnected Byzantine Theodosian city walls, separated by ditches
and moats, caused a lengthy siege, as did a boom of heavy chain floated by large wood
blocks that cut off Ottoman access into the Golden Horn. Not to be deterred, however,
Sultan Mehmed II deployed his naval forces in the Bosphorus, and in a daring maneuver,
dragged some seventy-two galley ships up the hills of Pera-Galata using greased pulleys
and logs, launching them on the other side in the Golden Horn, as well as using a pontoon
bridge from Galata to the old city to convey the troops across. The Orthodox masses gath-
ered in Hagia Sophia to pray as the city walls gave way and their city fell to the Ottomans.
The Byzantine Emperor Constantine was killed in battle.

Sultan Mehmed II entered the city on horseback in the afternoon after the Ottoman
forces had taken the city and were exercising their right to three days of looting, pillaging,
and enslaving the vanquished following a victory. He went directly to the Hagia Sophia

Figure 4.3 Aya Sofya, Exterior.

Church, stopped a soldier who was destroying the marble floor by stating that plunder and prisoners were the troops' to take, but that the buildings and the city itself now belonged to him, Mehmed the Conqueror, or "*Fatih Mehmed*," as he came to be known. He reined in the looting after the first day and had the church proclaimed the mosque of Aya Sofya – architecturally adding the minarets later (Figures 4.3 and 4.4). This would be the start of the remaking of Constantinople into an Ottoman and Islamic capital. Though the name *Konstantiniyye* was still used up to the early twentieth century by Ottomans (and Constantinople by Europeans) to describe the city – it was also dubbed Istanbul (from the Greek *Is tin polin* = "to the city") – and sometimes further nicknamed "Islambol" ("abounding with Islam"). Loukas Notaras, the high-ranking Byzantine official who had been captured was originally granted clemency. He was executed shortly thereafter, for political expediency, either because of intrigues by others envious of his wealth, or as punishment for his possibly fraudulent actions, but not before the sultan chastised him verbally for the Byzantine refusal to surrender, which in the sultan's eyes could have prevented the destruction to people and property that followed. Two days after the Ottoman victory, the Genoese colony in Galata (Pera) across the Golden Horn surrendered to try to preserve their privileged, autonomous trading outpost. Fatih Mehmed II

chose to seize Genoese Pera and especially its cannon foundry anyway, making it a permanent Ottoman installation, although Galata (Figure 4.5) remained the locale in Istanbul for mainly Latin merchants, officials, and other foreigners, their residences and eventually their diplomatic missions.

Figure 4.4 Aya Sofya, Interior.

CONSTRUCTING AN OTTOMAN CAPITAL

There is a legend, now disregarded by most historians as fiction, that during a low point in the siege, Mehmed II's spiritual guide, the sheikh Akşemseddin miraculously discovered the tomb of Ayyub al-Ansari, a Companion of the Prophet Muhammad who had supposedly been killed during an Arab siege of Constantinople in the late seventh century. While the

Figure 4.5 Galata Tower, Pera, *c.*1900. Symbol of a lengthy European presence in the Beyoğlu district of Istanbul.

story may have proved to be mere myth, one of Mehmed II's significant building projects in his new capital was a direct result of the belief in this location on the Golden Horn to be sacred, and a sign of Muslim prophesy come to fruition. He had a mosque complex built on the site, which is today the district called *Eyüp*, after the Muslim hero Ayyub. An Ottoman tradition developed later for a new sultan's ascension ceremonial to commence here. The ritual consisted of the Ottoman heir apparent's procession to *Eyüp*, where he was girded with a belt and the sword of Osman. The procession then returned to Constantinople with him on horseback, past the Janissary barracks, where the new sultan was given a goblet of sherbet, which he drank, then filled it with gold coins which he tossed to the Janissaries, who shouted "*kızıl elma'da görüşürüz!*" ("We meet again in the Red Apple!") as a promise of future campaigns against Christian Europe by the newly enthroned sultan.

In anticipation of recreating a prosperous imperial city worthy once again of the world's envy, Mehmed II set about repopulating and (re)building. Repopulating Istanbul would be facilitated through both invitation and force, of Christians (Latins, Armenians, and Greeks), Jews, and Muslims from various areas, in order to generate commerce and a flourishing urban culture. Merchants, tradespeople, those who had something to offer Mehmed II and his capital, were tempted to migrate from the Balkans or from Anatolia to Istanbul, with promises of tax exemptions or homes (either to entice Byzantine Greeks to return, or to newcomers who could occupy recently vacated houses). Some came simply to find a better life there. Other communities were forcibly uprooted and relocated in the city to provide whatever services they could offer to improve Istanbul. New neighborhoods were established in the city, populated by the influx of new subjects who would need residences, mosques, markets, *hamam*s (baths), and other urban structures that increasingly dotted the Istanbul skyline. Building projects demonstrated to the observer that the Ottoman Empire was no longer a petty principality, but a Muslim world empire, abounding in wealth, prestige, and culture.

Between 1457 and 1458 his first palace, later called the "Old Palace," was built on the site where Istanbul University is today, in the district of Bayezid. In 1458 the fortress called *Yedikule*, or "Seven Towers," where later foreign dignitaries were often imprisoned during wartime (and where at least one sultan was executed) was erected by adding additional towers to the Theodosian Walls. In 1459 construction began on what would become the preeminent Ottoman seat of power – Topkapı Palace, built on the site of Byzantium ruins. It was literally a city within the city, surrounded by miles of walls, each gate leading into another courtyard of the Ottoman state's powerful inner sanctum, the Treasury, the Council Chamber (*Divan*), the Audience Hall, the private quarters of the sultan and the harem, etc. Subsequent Ottoman sultans would continually add more buildings and halls

to the original Topkapı complex, making it the maze-like mammoth structure it is today (Figure 4.6). The construction of the famous covered Grand Bazaar (*Kapalı Çarşı*), finished in 1460–1, was done in typical Middle Eastern *bedestan* style, a centrally located commercial building with a maze of streets and alleys housing hundreds of shops in the district of Fatih. Sultan Mehmed II also had the Fatih Mosque complex built over the ruins of the Byzantine Church of the Holy Apostles between 1463 and 1470. His patronage attracted Muslim theologians to the Ottoman capital from further afield.

Many of what we can call long-lasting imperial practices and policies of the Ottoman Empire were established during Sultan Mehmed II's reign, as he made Constantinople his permanent political capital. Bursa still maintained a certain symbolic significance as the first Ottoman capital as well as a commercial center for the empire; several Ottoman sultans were entombed there, illustrating the city's importance as the dynasty's imperial birthplace. Edirne not only served as a welcome respite in summer and a second capital city, but also as an important staging area from which to launch new military campaigns into Europe. Istanbul was now becoming a thriving marketplace, situated as it was along several land and sea trade routes with goods and slaves flowing in and out, from Muscovy and Persia to North Africa and Europe. As such, Fatih Mehmed II granted some early trade concessions to a few of the Italian states in a continuation of commercial relations Venice and Genoa had enjoyed with previous Muslim rulers and the Ottomans.

THE CAPITULATIONS: PART I

A seminal feature of Ottoman commercial involvement in the world were the agreements known as *Capitulations*. The Capitulations were commercial privileges granted to foreign trading partners as part of the Ottoman sovereign's responsibility to provide for his flock and ensure there would be no shortages in his domains. These privileges were bestowed upon outside powers from a position of Ottoman strength and superiority vis-à-vis European empires. Originally developed in the pre-Ottoman era by Islamic empires offering certain "exemptions" called *imtiyâzât*, they were based upon the notion of *amân* – the special dispensation by a Muslim ruler for a non-Muslim(s) to enter and/or reside in the *Dâr al-Islam* (Muslim lands) and be guaranteed safety and security of one's life and property for a period of time without falling under the category of *dhimmi*, which would have required the payment of the *jizya* tax.[4] The Ottoman manifestation of this principle, the "Capitulations" (from the Latin meaning "to draw up chapters"), afforded commercial benefits such as lower tariffs to foreigners who agreed to "the promise of friendship and good will," in the form of an agreement binding upon both parties called an *ahdname*, which granted

foreigners the equivalent of this *amân*, security or safe passage. The actual written document, issued by the Ottoman sultan himself, was a certificate called a *berat*, and would require renewal upon the ascension of a new sultan. According to precedent, a foreign agent who remained in Ottoman lands more than ten years would then revert to the status of *dhimmi*, with its *jizya* obligations – though the Ottomans often did not enforce this requirement. The granting of Capitulatory privilege varied between those given to individual foreign merchants seeking such an opportunity, and those bestowed upon a European empire whose emissary (i.e., ambassador or consul) represented their overall commercial interests at the Ottoman court.

Whereas the first such commercial privileges to Venice were granted by Seljuk sultans in the thirteenth century, the Ottomans first granted Capitulations to the Genoese in the mid-fourteenth century, with whom they already had good relations, before extending them to Venice. Wars with Venice did not appear to interrupt Ottoman-Venetian trade substantially. Venetian privileges were typically renewed by subsequent sultans, including Süleyman I, and beyond.

Capitulations, or *imtiyâzât*, were granted to foreign powers by the sultan and allowed them lower customs duty and tariff rates, as well as the ability to travel within Ottoman lands to freely conduct this trade. Such concessions were contained in written pledges by the sultan, called *ahdname*s, the actual treaty agreements themselves between foreign powers and the Ottoman state. As a consequence of the Ottoman sense of a ruler's responsibility to "feed the people" as part of the guarantee of a just realm, these treaties allowed a kind of "favored nation status" to outside powers that was bestowed upon them by a benevolent sultan who wanted to ensure the provisioning of his empire. What would become a

regular Ottoman policy of bestowing Capitulatory privileges upon foreign parties when the Ottomans were powerful, became, in later centuries, a political and economic liability for the empire when they could no longer determine the terms of the treaties – when these Capitulations became an imposition because they were interpreted and exploited by European recipients to the detriment of the Ottomans.

Fratricide as part of the Ottoman open succession process had already been in use for almost a century when Sultan Mehmed II institutionalized the sanction of brothers executing brothers through a formal *kânûnnâme*, or legal code. *Kânûn*s, or dynastic laws, were legal decrees pertaining to the governing of the empire, often based upon custom. *Kânûnnâme*s were collections of these legal statutes that dealt with aspects of Ottoman administration that were not covered in religious, or *şeriat* law, and were meant to supplement it. Centralizing laws and policies related to the Ottoman state's administration were publicly promulgated by Fatih Mehmed II. These included laws dictating several areas of currency and fiscal management, land tenure and taxation, crime (including *zina* – illicit sexual acts, and *kazf* – the false accusation of such), laws organizing the hierarchy of the *ulema* (religious class), etc. His first criminal code applied to all Muslims and non-Muslims (except where *zina* and *kazf* were concerned); taxation laws dealt with Muslims and non-Muslims separately. Ottoman laws were not static, but were continually modified and amended when a new sultan ascended the throne, or when needed, in flexible fashion. Sultan Mehmed II is credited with initially centralizing imperial legal tendencies that were built upon by his successors.

Other practices demonstrated the Ottoman shift to an imperial realm of world-class power. Court rituals and etiquette such as the pilgrimage to *Eyüp* for enthronement ceremonies mentioned previously is merely one example. Topkapı Palace provided sultanic seclusion, as Ottoman sovereigns would increasingly withdraw from public view, only appearing a few times per year during religious holidays or when departing on campaign. Grievances from the public would still be heard, though by statesmen who then presented these petitions to the sultan. Political marriages to solidify alliances with external powers were replaced with marriages of high officials in the Ottoman state to members of the sultan's family. Growing reliance upon slave recruits in the administration and the ranks of the military required the *devşirme* levy to be extended beyond the Balkans, into areas of eastern Anatolia, though still among non-Muslims. The ranks of the Janissary Corps swelled: from a few thousand, the number of Janissaries rose to around 12,000 by 1473, all of whom received their salaries quarterly (see also Chapter 3). Feared as the fierce, formidable military arm of Sultan Mehmed II's empire threatening Europe's eastern frontiers, they were the first standing army in Europe since the Roman era, likely influencing the later development of similar standing armies in the West. The Janissaries were also becoming a powerful entity at home who would act according to their group interests. They would make both financial and political demands of the Ottoman dynasty that had far-reaching repercussions in future centuries – including the fate of several later Ottoman sultans.

COMMUNAL RELATIONS, OR EVOLUTION OF THE "*MILLET* SYSTEM"

The effective Ottoman management of its non-Muslim population was built upon previous Islamic precedent whereby non-Muslims who had accepted the Muslim sovereign, *dhimmis*, would be allowed a level of communal autonomy by the state and protection by Muslim armies provided they paid the *jizya*, they remained loyal, they adhered to certain cultural regulations spelled out by previous Islamic rulers, and they did not assist the Muslim sovereign's enemies. The Ottomans built on this practice in a very flexible manner. The *jizya* or head tax on non-Muslim communities in a particular village or town was usually calculated and paid communally, with regular recalculation due to births and deaths; some exemptions were allowed under certain circumstances (e.g., physical disabilities of members of a community). In return, non-Muslims falling under Ottoman rule would be granted the ability to continue to worship in their faith, run their own schools, and operate their own religious courts. They were not to bear arms, but protection would be afforded to them. Many non-Muslims flourished economically due to this laissez-faire approach that allowed them to pursue commerce, trades, and positions of influence among the Ottoman ruling elite. Of particular note was the Ottoman allowance for what has been called "a culture of difference not sameness" in the pre-nineteenth century.[5] In other words, to be part of a non-Muslim religious group, Christian or Jewish, was permissible in Ottoman society. Difference was recognized and managed through specific taxation and sumptuary laws, but this acknowledgment of difference did not compel the Ottoman state to attempt to alter, assimilate, or otherwise forcibly change non-Muslim identities or status, at least up until the nineteenth century. In fact, the Ottoman state accepted this difference by actively utilizing non-Muslim linkages with Europe in trade and diplomacy in order to benefit the Ottoman Empire as a whole: Greek Orthodox, Jewish, and Armenian merchants provided the Ottomans with commercial agents whose networks made the Ottoman state rivals with Venice.

More recent scholarship has refuted the notion that Sultan Mehmed II introduced a very rigid structure of non-Muslim communal management called the "*millet* system." Nonetheless, there is evidence of a rather informal set of arrangements put in place after the conquest of Constantinople in 1453, with alterations to the arrangements over time and place, which resulted in a rather successful method of dealing with non-Muslims in the Ottoman midst. The very word, *millet*, is a Qur'anic term generally meaning religion, confession, or rite that over time came to describe various non-Muslim ethnoreligious communities in the empire, such as the *millet-i Rûm* (Greek Orthodox Christians), *millet-i Yahudî* (Jews), and the *millet-i Ermenî* (Armenian Orthodox Christians). In fact the term *millet* was only first used by the Ottomans to describe these communities at the end of the seventeenth century, and not regularly until the nineteenth. Research on religious confessional groups in the Ottoman Empire has revealed the exaggerated understanding of this *millet* system in earlier sources, which had previously resulted in scholars

retrospectively inflating the influence and responsibilities of the heads of Greek Orthodox, Jewish, and Armenian communities upon their sects than was originally the case after the conquest. As intermediaries between the Ottoman authorities and their respective non-Muslim communities, it was simplistically assumed that these leaders represented all members of the group at all times, but the reality was more complicated. Typical of the pragmatic Ottoman approach to governing, policies were forged over time; their main purposes were to benefit from the skills, resources, and the socioeconomic and political connections possessed by members of non-Muslim populations to guarantee the smooth, unhindered collection of tax revenue from them.

Figure 4.7 Sultan Mehmed II and Gennadius Scholarius, Greek Orthodox Patriarch.

How did this communal management evolve? The Ottomans already had many non-Muslims in the territories they controlled and so certain arrangements with these communities were already in place. In 1453 the Byzantine emperor was dead, and the Byzantine civil official, Grand Duke Loukas Notaras, had been executed by order of the sultan days later. Fatih Mehmed II chose to appoint the Greek Orthodox theologian and philosopher, Gennadius Scholarius, as the patriarch of the Greek Orthodox Church in Constantinople about six months later, in 1454 (Figure 4.7). As head of the Ecumenical Patriarchate, Gennadius and his successors, mainly drawn from the wealthy Feneriot Greek merchants residing in the capital, became influential members of the ruling class, though they could not claim to represent all of the Ottoman Empire's Orthodox subjects since other patriarchs in other regions of Anatolia and in the Balkans (and eventually in the Arab provinces as well after the sixteenth-century conquest) still retained their local leadership positions. It was not until roughly the eighteenth century that the various archbishoprics and metropolitans across the diverse Orthodox sect, the largest of the non-Muslim communities in the empire, which included not just ethnic Greeks but also Slavs and Arabs, were subordinated to the patriarchate in Constantinople. The Greek Orthodox Christians in Ottoman lands, the population of which was concentrated in the capital, in areas of modern Greece and Macedonia, as well as in Anatolia around areas of Izmir, Trebizond, and Cappadocia, would serve the Ottoman state as a cadre of foreign service personnel up to the nineteenth century, as they had the multilingual skills and commercial links to Europe to facilitate diplomacy and trade.

Prior to the conquest of Constantinople, Jewish communities were already enjoying the benefits of living under Ottoman rule that were a marked improvement over the experiences of persecution in the Byzantine Empire, or ghettoization, persecution, and even expulsion from Europe taking place in the pre-modern era. A letter from

Rabbi Isaac Zarfati/Yitzhak Tzarfati encouraging Jewish emigration to Ottoman lands attests to this difference. The Jewish community's relationship to the Ottoman authorities changed as the composition and location of the Jewish population varied, so that describing it as a singular *"millet"* is not accurate. Jews in Byzantine and Slavic Balkan lands before the conquest of Constantinople resided in the Byzantine capital and in various towns such as Bursa and Salonika, where local rabbis looked after their affairs amid a general Jewish tendency toward social interactions not based upon direction from a clerical hierarchy. With Ottoman expansion into these areas, Jews migrated or were relocated to the second Ottoman capital of Edirne, where a Jewish population divided by sect (Rabbinate and Karaite) was already in existence. Once Constantinople was conquered, Jews from Balkan and Anatolian towns were relocated to the new Ottoman capital as part of the repopulation effort, where they engaged in commerce, customs regulation, and running the Ottoman mints.

To administrate this Jewish community in the city that was now rather diverse, a rabbi, Crete-born Moses Capsali, was appointed as a functionary to ensure the extraction of the poll tax from his community and to oversee legal affairs. It is not clear whether his status as an Ottoman intermediary went much beyond the Ottoman capital, and even there, it appears that the Karaite Jewish sect paid their taxes independently, but he served as the chief rabbi for over forty years, until his death in around 1496. Thus he would have witnessed the start of a further influx of Jews into Ottoman territory who were being expelled from Spain due to the Christian Reconquista (culminating in the conquest of Granada in 1492). Sephardic Jews from the Iberian Peninsula were for the most part welcomed into Ottoman lands (mainly in provincial centers and not Istanbul) between 1492 and 1512, for what they could contribute to the empire. They altered the demography once more. Subsequent successors to the office of the grand rabbi in Istanbul seem to have lost their status (perhaps a consequence of the Jewish community's diverse composition making it difficult to choose one representative?) and their involvement in fiscal affairs, though they remained important in matters of Judaic law. Financial and administrative duties fell upon various Jewish individuals more personally connected to the Ottoman court – influential commercial agents, tax farmers, and physicians who could intervene on behalf of their community. Jewish relations with the central Ottoman authority evolved into more decentralized interactions by local communities. As an example, Salonika, half of whose population would be Jewish by the mid-sixteenth century due to European immigration, established a municipal council comprised of the many congregations in the city as its representative to the Ottomans.

The Armenian population of Anatolia had its origins in the ancient Armenian Kingdom and the later Armenian Kingdom of Cilicia (*c.*1199–1375), which survived the westward Seljuk Turkic migrations described in Chapter 2. By the time of the Ottoman rise to prominence, the Armenians had already become dispersed across Byzantine urban centers and in the Anatolian countryside, as well as in the Crimea, Central Europe, Persia, and the Arab Middle East, with the Armenian Church's various local prelates (high-ranking

"ISAAC ZARFATI TO THE JEWS OF SUAVIA, THE RHINELAND, STYRIA, MORAVIA, AND HUNGARY"

The following text comes from a mid-fifteenth-century letter (1454?) from a French-born Jew residing in Edirne, Rabbi Yitzhak Tzarfati (Isaac Zarfati), inviting his Jewish co-religionists in Christendom to immigrate to the Ottoman Empire.

I have heard of the afflictions, more bitter than death, that have befallen our brethren in Germany – of the tyrannical laws, the compulsory baptisms and the banishments, which are of daily occurrence. I am told that when they flee from one place a yet harder fate befalls them in another. I hear an insolent people raising its voice in fury against a faithful remnant living among them; I see its hand uplifted to smite my brethren. On all sides I learn of anguish of soul and torment of body; of daily exactions levied by merciless oppressors. The clergy and the monks, false priests that they are, rise up against the unhappy people of God and say: "Let us pursue them even unto destruction; let the name of Israel be no more known among men." They imagine that their faith is in danger because the Jews in Jerusalem might, peradventure, buy the Church of the Sepulchre. For this reason they have made a law that every Jew found upon a Christian ship bound for the East shall be flung into the sea. [Zarfati alludes here to the Bull of Pope Martin V forbidding the seafaring republics of Venice and Ancona to convey Jews to the Holy Land under pain of excommunication]. Alas! How evil are the people of God in Germany entreated; how sad is their strength departed! They are driven hither and thither, and they are pursued even unto death. The sword of the oppressor ever hangs over their heads; they are flung into the devouring flames, into swift-flowing rivers and foul swamps.

Brothers and teachers, friends and acquaintances! I, Isaac Zarfati, though I spring from a French stock, yet I was born in Germany, and sat there at the feet of my esteemed teachers. I proclaim to you that Turkey is a land wherein nothing is lacking, and where, if you will, all shall yet be well with you. The way to the Holy Land lies open to you through Turkey. Is it not better for you to live under Muslims than under Christians? Here every man may dwell at peace under his own vine and fig tree. [I Kings 4:25; Isa. 36:16; Mic. 4:4; Zech. 3:10]. Here you are allowed to wear the most precious garments. In Christendom, on the contrary, you dare not even venture to clothe your children in red or in blue, according to your taste, without exposing them to the insult of being beaten black and blue, or kicked green and red, and therefore are ye condemned to go about meanly clad in sad colored raiment. All your days are full of sorrow, even the Sabbaths and the times appointed for feasting. Strangers enjoy your goods, and, therefore, of what profit is the wealth of your rich men? They hoard it but to their own sorrow, and in a day it is lost to them forever. Ye call your riches your own – alas, they belong to them! They bring false accusations against you. They respect neither age nor wisdom; and though they gave you a pledge

sealed sixty-fold, yet would they break it. They continually lay double punishment upon you, a death of torment and confiscation of goods. They prohibit teaching in your schools; they break in upon you during your hours of prayer; and they forbid you to work or conduct your business on Christian feast days....

And now, seeing all these things, O Israel, wherefore sleepest thou? Arise! And leave this accursed land forever! [Ps. 44:23].[6]

clergy) and Armenian cultural heritage providing the loose links among these communities. A socioeconomic class divide between the more urbane Armenian communities and the rural Armenian peasantry emerged over time as well. After Mehmed II's assault on Constantinople, Armenians were also brought to the new Ottoman capital, where they became prominent actors in Ottoman trade and finance. Sources indicate that the Ottomans recognized the Armenians as a religious community before 1453, and that an Armenian named Yovakim was appointed in the late 1430s as an archbishop, though his jurisdiction was rather limited, around Bursa and near Byzantine Constantinople. It is believed that he was brought to Constantinople by Sultan Mehmed II in 1461. Other bishops and prelates occupied positions among Armenian communities in areas that would fall under Ottoman suzerainty up to and after the 1453 conquest, so that the Armenian Patriarchate in Constantinople was not immediately an overarching authority for the entire Armenian millet. Communities in and outside Ottoman lands were overseen by other Armenian patriarchs in Ejmiacin and Sis (near Yerevan in modern Armenia), Akhdamar (on Akdamar Island, Lake Van, Turkey), and Jerusalem. By the seventeenth century, however, the patriarchate in Constantinople had extended its reach over Armenian communities in Rumelia and parts of Anatolia. By the eighteenth century, it had emerged as the preeminent representative of Ottoman Armenians, amid much conflict with the other patriarchates and due also to the rising prominence of well-connected Armenians in the capital who used their influence, positions, and wealth to benefit themselves and the Armenian population.

An Ottoman tax register from 1478 indicates the population of Constantinople (excluding those exempt from taxation, i.e., members of the ruling class – the dynastic household, the military, the bureaucracy, and the religious class) was approximately 100,000 people. An estimate excluding the population of Galata provides the ethno-religious breakdown inside the walled city of Constantinople as follows: Muslim 60 per cent; Greek 21.5 per cent; Jewish 11 per cent; Caffan (Genoese) 2 per cent; Armenian 2.6 per cent; Karamanlı 2.79 per cent; Gypsy 0.2 per cent, while other estimates put the Greek and Armenian percentages slightly higher, and the Jewish figure slightly lower. Inside walled Galata, the figures put Greek households at 39 per cent; Armenians 4 per cent; Catholic/Latin 22 per cent; Muslim 35 per cent.[7] The demography and composition of Constantinople, Galata, and many of its newly established neighborhoods fluctuated over the centuries due to emigration and immigration of peoples, the effects

of earthquakes, disease, famine, and war. But according to population figures, Istanbul continued to expand its population – to over 500,000 by the mid-sixteenth century, making it the largest city in Europe at the time.

OTTOMAN AUTHORITY RECLAIMED

The Ottoman Empire over which Fatih Mehmed II presided now had control over trade in and out of the Black Sea, influence in the Aegean, and in the Mediterranean. He clearly intended to expand this hegemony further east and west. In 1455 the Genoese colonies were besieged in the Aegean by Mehmed II's growing naval forces, which were made possible by his establishment of a dockyard in the Golden Horn after the conquest (in addition to the Gallipoli yard). The Byzantine Greek Empire of Trebizond on the Anatolian coast of the Black Sea was made a vassal by 1456, the same year in which Mehmed II repeated the failure of his father, Sultan Murad II, by engaging in a failed siege of the strategic city of Belgrade in a push deeper into the Balkans. His ambitions were directed toward both eastern and western conquests: either due to Trebizond's reluctance to pay the proper tribute, or because of its location as an eastern Black Sea port that served as a trading gateway for rival Uzun Hasan's Akkoyunlu tribal confederation centered in Tabriz, Sultan Mehmed II chose to conduct a joint army and naval siege in 1461 that brought an end to the last Byzantine outpost with Trebizond's downfall. Uzun Hasan and the Akkoyunlu had become an eastern problem when they took possession of Karaman and could then encroach on Ottoman territory in eastern Anatolia. Attempting to create a two-front conflict for the Ottomans, Uzun Hasan offered assistance to Venice against the Ottomans when the Ottoman-Venetian War ensued in 1463. Venice and its dominance over Mediterranean trade were being challenged by the Ottoman rise as a naval and commercial sea power. Venetian ports and possessions in the Adriatic Sea were threatened in particular when Sultan Mehmed II's forces were able to annex Bosnia and Herzegovina in 1463, presaging the war that then lasted until 1479. Albania fell under Ottoman control (see Chapter 5); Venetian Negroponte in Greece was taken by sea conquest in 1470. Venice itself was an object of raids. Uzun Hasan's threats to repeat Timur's actions against the Ottomans intensified, and by 1472 war with the Akkoyunlu over Karaman was inevitable. The conflict lasted until 1473, with Ottoman gunpowder technology determining the ultimate victory. Karaman and its tribal leaders were incorporated into the Ottoman military to pacify the region once and for all. Sultan Mehmed II's annexation of Latin ports such as Genoese Caffa in Crimea followed shortly thereafter, in 1475; the Tatars of the Crimean Khanate assumed vassalage in 1478.

Once these eastern frontiers – the crucial Black Sea outposts and Karaman – were subordinated, and Venice had sued for peace, Sultan Mehmed II could turn Ottoman designs on some new European targets, to the next "Red Apple" in the west, which

Map 4.3 Sultan Mehmed II's Empire by 1481.

some interpret to mean Fatih Mehmed II's eyes were on Rome. A failed siege of Rhodes in 1480 to quell the piracy of the Knights Hospitallers of St. John who preyed upon Ottoman shipping in the eastern Mediterranean and Aegean seas was followed up by a landing of Ottoman forces at Otranto, on the "heel of the boot" of Italy. Captured rapidly by an Ottoman naval force led by Admiral Gedik Ahmed Pasha in 1480, Christian reinforcements from Italy and Hungary retook Otranto in 1481 when the admiral withdrew his forces after Mehmed II's death, and his son Bayezid II's preoccupation with securing the throne.

Sultan Mehmed II had died on a last campaign in 1481, seemingly headed east, not west. He viewed himself as a Roman caesar, a rival to Latin claims of Holy Roman

emperor. He had personally led eighteen campaigns to extend Ottoman dominion. He now possessed and had retooled Rome's successor, the Byzantine realm, as his Ottoman Empire (Map 4.3). His imperial titulature, inscribed in gilded Arabic calligraphy atop the Imperial Gate to the first courtyard of Topkapı in 1478, reflected the confident attitude of the conquering sultan:

> The Sultan of Two Continents and the Emperor of the Two Seas, the Shadow of God in this world and the next, the favourite of God on the Two Horizons [East and West], the Monarch of the Terraqueous Orb, the Conqueror of the Castle of Constantinople, the Father of Conquest Sultan Mehmed Khan, son of Sultan Murad Khan, son of Sultan Mehmed Khan, may God make eternal his empire and exalt his residence above the brightest stars of the firmament.[8]

So did his commissioning the Italian artist Gentile Bellini for a portrait (Figure 4.8), befitting for a world-class monarch – the three crowns pictured represent Rumelia, Anatolia, and Trebizond. Mehmed II was intrigued by Western (Renaissance and classical) arts, sciences, history, and political ideas; he patronized Greek scholars and collected Greek manuscripts as well as Byzantine relics. An Ottoman portrait of Sultan Mehmed II from the fifteenth century by Nakkaş Sinan Bey resembled European artistic style (Figure 4.9), though he sits cross-legged to indicate his status as a Central Asian emperor-khan, smelling a rose and clutching a handkerchief, a Turkic symbol of authority.

Had it not been for Ottoman flexibility to adjust to the near-fatal circumstances wrought by Timur's defeat of Bayezid I and Timur's subordination of the sultan's sons, had the open succession system not propelled Mehmed I to ultimate victory, and had his son Murad II not acted strategically and decisively when needed to reassert Ottoman control over territory or to seize more lands through war, perhaps Sultan Mehmed II would not have been able to successfully besiege Constantinople. Ottoman adaptability to the dire situation faced in the early fifteenth century had yielded results yet again through at times ruthless, and sometimes unorthodox, political and military choices. Fatih Mehmed II's achievements on campaign, and his transformation of certain aspects of Ottoman state and society, set the stage for the conquests to come, and for the Ottoman imperial might that would manifest in the sixteenth century under his descendants, culminating in his great grandson, Sultan Süleyman the Magnificent, Europe's ultimate contender for the title of Holy Roman emperor.

Figure 4.8 Sultan Mehmed II by Italian Artist Gentile Bellini, *c.*1480.

Figure 4.9 Sultan Mehmed II by Nakkaş Sinan Bey, End of Fifteenth Century.

NOTES

1 There is a degree of mythology around Gazi Evrenos Bey as an early convert to Islam who participated with Osman and Orhan in conquests as well as having been involved in the later civil war between princes. He is said to have been born in 1288 and died in 1417, implying he lived 129 years! It is more likely that the deeds of Gazi Evrenos Bey and his descendants have been collapsed into the story of a single person by that name, especially given that they were an elite family who maintained their privileged position with the Ottomans.

2 Nazim Hikmet, excerpts from "The Epic of Sheik Bedreddin," translated by Randy Blasing and Mutlu Konuk, from Poems of Nazim Hikmet. Copyright © 1994, 2002 by Randy Blasing and Mutlu Konuk. Reprinted by permission of Persea Books, Inc (New York), www.perseabooks.com. All rights reserved.

3 Konstantin Mihailović, *Memoirs of a Janissary*, trans. Benjamin Stolz, notes Svat Soucek (Ann Arbor: Joint Committee on Eastern Europe, American Council of Learned Societies, by the Department of Slavic Languages and Literatures, University of Michigan, 1975), 145–7.

4 See J. Wansbrough, Halil İnalcık, A.K.S. Lambton, and G. Baer, "Imtiyâzât," in *Encyclopaedia of Islam*, eds. P. Bearman, Th. Bianquis, C.E. Bosworth, E. van Donzel, W.P. Heinrichs, 2nd ed. (Brill, 2012), https://doi.org/10.1163/1573-3912_islam_COM_0371.

5 Aron Rodrigue, "Difference and Tolerance in the Ottoman Empire: Interview with Aron Rodrigue," by Nancy Reynolds, *Stanford Electronic Humanities Review* 5, no. 1 (Spring 1996): 81–92, https://web.stanford.edu/group/SHR/5-1/text/rodrigue.html.

6 Translation in Franz Kobler, ed., *Letters of Jews through the Ages*, vol. 1, *From Biblical Times to the Renaissance: A Self-Portrait of the Jewish People* (London: Ararat Publishing Society, 1953), 283–5. Reprint excerpt in Bernard Lewis, *The Jews of Islam* (Princeton: Princeton University Press, 1984), 135–6.

7 Fariba Zarinebaf, *Crime and Punishment in Istanbul 1700–1800* (Berkeley: University of California Press, 2011), 38–9.

8 Gülrü Necipoğlu, *Architecture, Ceremonial, and Power: The Topkapı Palace in the Fifteenth and Sixteenth Centuries* (Cambridge, MA: The MIT Press, 1991), 34–6.

SELECTED READINGS

Babinger, Franz. *Mehmed the Conqueror and His Time*. Edited by William C. Hickman. Translated by Ralph Manheim. Princeton: Princeton University Press, 1978.

Bardakjian, Kevork B. "The Rise of the Armenian Patriarchate of Constantinople." In *The Central Lands*, edited by Benjamin Braude and Bernard Lewis, 89–100. Vol. 1 of *Christians and Jews in the Ottoman Empire*. New York: Holmes & Meier Publishers, Inc., 1982.

Braude, Benjamin. "Foundation Myths of the *Millet* System." In *The Central Lands*, edited by Benjamin Braude and Bernard Lewis, 69–88. Vol. 1 of *Christians and Jews in the Ottoman Empire*. New York: Holmes & Meier Publishers, Inc., 1982.

Dennis, George T. "The Byzantine-Turkish Treaty of 1403." In *Byzantium and the Franks 1350–1420*, 72–88. London: Variorum, 1982.

Epstein, Mark A. "The Leadership of the Ottoman Jews in the Fifteenth and Sixteenth Centuries." In *The Central Lands*, edited by Benjamin Braude and Bernard Lewis, 101–15. Vol. 1 of *Christians and Jews in the Ottoman Empire*. New York: Holmes & Meier Publishers, Inc., 1982.

Fodor, Pál. "Ottoman Warfare, 1300–1453." In *Byzantium to Turkey 1071–1453*, edited by Kate Fleet, 192–226. Vol. 1 of *The Cambridge History of Turkey*. New York: Cambridge University Press, 2009.

Fodor, Pál. *In Quest of the Golden Apple: Imperial Ideology, Politics, and Military Administration in the Ottoman Empire*. Istanbul: The Isis Press, 2000.

Gondicas, Dimitri, and Charles Issawi, eds. *Ottoman Greeks in the Age of Nationalism: Politics, Economy, and Society in the Nineteenth Century*. Princeton: Darwin Press, 1999.

Hooper, Paul Lovell. *Forced Population Transfers in Early Ottoman Imperial Strategy: A Comparative Approach*. Bachelor's Senior Thesis, Princeton University Department of Near Eastern Studies, 2003.

Hovanissian, Richard G., ed. *Foreign Domination to Statehood: The Fifteenth Century to the Twentieth Century*. Vol. 2 of *The Armenian People: From Ancient to Modern Times*. New York: St. Martin's Press, 1997.

Imber, Colin. *The Crusade of Varna, 1443–45*. Aldershot, England: Ashgate, 2006.

Kastritsis, Dimitris. "The Şeyh Bedreddin Uprising in the Context of the Ottoman Civil War of 1402–1413." *Political Initiatives "From the Bottom Up" in the Ottoman Empire: Halcyon Days in Crete 7*, edited by Antonis Anastasopoulos, 221–38. Rethymnon: University of Crete Press, 2012.

Konortas, Paraskevas. "From Tâ'ife to Millet: Ottoman Terms for the Ottoman Greek Orthodox Community." In *Ottoman Greeks in the Age of Nationalism: Politics, Economy, and Society in the Nineteenth Century*, edited by Dimitri Gondicas and Charles Issawi, 169–79. Princeton: Darwin Press, 1999.

Kritovoulos. *History of Mehmed the Conqueror*. Westport, CT: Greenwood Press, 1970.

Levy, Avigdor, ed. *The Jews of the Ottoman Empire*. Princeton: The Darwin Press, 1994.

Levy, Avigdor. *Jews, Turks, Ottomans: A Shared History, Fifteenth through the Twentieth Century*. New York: Syracuse University Press, 2002.

Lewis, Bernard. *The Jews of Islam*. Princeton: Princeton University Press, 1984.

Masters, Bruce. *Christians and Jews in the Ottoman Arab World: The Roots of Sectarianism*. Cambridge: Cambridge University Press, 2001.

Necipoğlu, Gülru. *Architecture, Ceremonial, and Power: The Topkapı Palace in the Fifteenth and Sixteenth Centuries*. Cambridge, MA: The MIT Press, 1991.

Özdemir, Fatih. "Kızıl Elma'yı Arayan Üç Yazar: Ömer Seyfettin, Ziya Gökalp, Ragıp Şevki Yeşim." *Turkish Studies International Periodical for the Languages, Literature and History of Turkish or Turkic 3*, no. 5 (Fall 2008): 503–15.

Parry, V.J. "La manière de Combattre." In *War, Technology and Society in the Middle East*, edited by V.J. Parry & M.E. Yapp, 218–56. Oxford: Oxford University Press, 1975.

Peirce, Leslie. "Domesticating Sexuality: Harem Culture in Ottoman Imperial Law." In *Harem Histories: Envisioning Places and Living Spaces*, edited by Marilyn Booth, 104–35. Durham: Duke University Press, 2010.

Petrović, Djurdjica. "Firearms in the Balkans on the Eve of and after the Ottoman Conquests of the Fourteenth and Fifteenth Centuries." In *War, Technology and Society in the Middle East*, edited by V.J. Parry & M.E. Yapp, 164–94. Oxford: Oxford University Press, 1975.

Pitcher, Donald Edgar. *An Historical Geography of the Ottoman Empire*. Leiden: E.J. Brill, 1972.

Rodrigue, Aron. "Difference and Tolerance in the Ottoman Empire: Interview with Aron Rodrigue." By Nancy Reynolds. *Stanford Electronic Humanities Review* 5, no. 1 (Spring 1996): 81–92. https://web.stanford.edu/group/SHR/5-1/text/rodrigue.html.

Runciman, Steven. *The Fall of Constantinople 1453*. Cambridge: Cambridge University Press, 1965.

Salgırlı, Saygın. "The Rebellion of 1416: Recontextualizing an Ottoman Social Movement." *Journal of the Economic and Social History of the Orient* 55 (2012): 32–73.

Tursun Beg. *The History of Mehmed the Conqueror*. Translated by Halil İnalcık and Rhoads Murphey. Minneapolis: Bibliotheca Islamica, 1978.

Zarinebaf, Fariba. *Crime and Punishment in Istanbul 1700–1800*. Berkeley: University of California Press, 2011.

FIVE

BECOMING AN EMPIRE: TOOLS OF STATE

After the turbulent interregnum and Sultan Murad II's reclamation of territories lost during that civil war, his son Sultan Mehmed II's conquest of Constantinople in 1453 ultimately laid the foundations for the world-class Ottoman Empire to come. This consolidation of the Ottoman principality's power consisted of establishing, repopulating, and rebuilding the capital of Constantinople; adopting a practical means of managing non-Muslims, which elicited their loyalty by providing communal autonomy; and formulating the basis of an Ottoman legal code. A flexible means of ruling over provincial lands through resettlement and local intermediaries as vassals depending upon their location and relationship to the dynasty was worked out. Mehmed II's fifteenth-century reign also witnessed a continuation of expanding Ottoman army and naval forces as well as improving warfare technology. There was more dynastic, familial strife between Mehmed II's sons after his passing, which ushered in a new phase in Ottoman-European relations. But by the sixteenth century, the Ottomans would be able to seize their place on the global stage as an empire whose reach penetrated deep into Europe, the Middle East, North Africa, and into the Indian Ocean. Europe would soon experience the most ominous challenges yet.

DEALING WITH THE UNRULY: SÜRGÜN OR "RESETTLEMENT"

Part of the Ottoman pragmatic strategy to manage conquered territory was through a policy of forced resettlement – called *sürgün*, which the Ottomans carried out frequently in the Balkans and Anatolia, starting from Orhan's era in the fourteenth century. *Yürüks*, nomadic (mainly Turkmen) tribespeople who had not relinquished their pastoral nomadic lifestyle for a more settled agricultural existence, both migrated into the Balkans voluntarily and were relocated in sizable numbers by the Ottoman state to areas in Macedonia,

Thessaly, Thrace, Bulgaria, and as far west as Bosnia, to repopulate underpopulated areas and create more heavily Muslim areas through immigration and the conversion of locals. Besides engaging in animal husbandry and other economic functions, they could serve as a counterweight to revolts by locals resentful of Ottoman rule. Resettling Turkmen, Tatars, and Kurds from areas of Anatolia additionally removed potentially rebellious tribal and unorthodox dervish elements in eastern lands who often resisted central authority, and placed them in Christian regions to assist in the further conquest and Islamization of the Balkans. Even so, *Yürüks* were often not that loyal to a centralizing Ottoman state in comparison to Balkan Christians in this early era, who in many cases were more amenable to imperial rule due to their previous experience, and because of the Ottoman tendency toward granting communal autonomy. Nonetheless, by the late fifteenth and early sixteenth centuries the Muslim population in the Balkans consisted in part of semi-nomadic Turk descendants of earlier (late fourteenth to early fifteenth century) migrations, and heterodox groups such as *Abdal Rûm* (later *Alevi-Bektaşi*) dervishes of both migrant and pre-Ottoman Balkan origins.

Various Christian populations in the Balkans were also uprooted and resettled in Anatolia, some as early as the late fourteenth century. As was mentioned earlier, Muslim, Christian, and Jewish communities were transplanted in large numbers after the conquest of Constantinople in the mid-fifteenth century when Sultan Mehmed II's desire to remake the city as a worthy imperial capital for the Ottoman state set in motion his repopulation of the city to reinvigorate its economy. His use of *sürgün* was one major peak of this resettlement policy during the empire's lifespan.

Sürgün, whether forced or combined with enticements, continued to be employed by the Ottomans at times in the fifteenth and sixteenth centuries, for roughly the same purposes. Vlach shepherds from areas of southern Serbia moved north with their flocks into deserted areas after Ottoman confrontations with Hungary in the late fifteenth century, and their migration continued into Bosnia. In southwest Bosnia on the Dalmatian border, Herzegovina became a *sancak* in 1470 and was added to the Bosnian *sancak* in 1483. Most Vlach pastoralists of Slavic descent there were Orthodox Christian and eventually "Serbianized" (some were Catholic; some Vlachs converted to Islam in the 1530s, especially in Herzegovina); they migrated westwards with their flocks as the Ottomans pushed into Venetian Dalmatia and later into Habsburg territories in the sixteenth century. The Ottoman state also settled them there to secure newly conquered areas. Peasant agricultural lands were sometimes then converted into grazing areas for the Vlachs' animals. Vlachs also served as frontier guards or auxiliary military forces.

MANAGING CONQUEST: VASSALS AND *VOIVODES*

As the Ottoman state's use of *sürgün* and their political and fiscal relationship with the Vlachs illustrates, the Ottomans employed various pragmatic methods to most efficiently

WHO WERE THE VLACHS?

The term *Vlach* has caused some confusion: early assessments by some historians were that Vlachs were originally Latin-speaking peoples from Wallachia or the Black Sea region who moved into Slavic areas. Others argue that Vlach was an ethnoreligious term to describe only Orthodox Serbian tribal pastoralists (Figure 5.1). The Venetian term used, "Morlacchi" (Morlachs), or "Black Vlachs," was applied rather broadly to Christian Slavic pastoralists who migrated from inland toward the Dalmatian coast.

Ottoman records, however, have revealed the granting of a particular administrative-fiscal status to those the state categorized as Vlachs. They were a separate group receiving certain tax exemptions not based upon ethnic or religious affiliations, but upon their transhumant lifestyle and their particular usefulness to the empire in

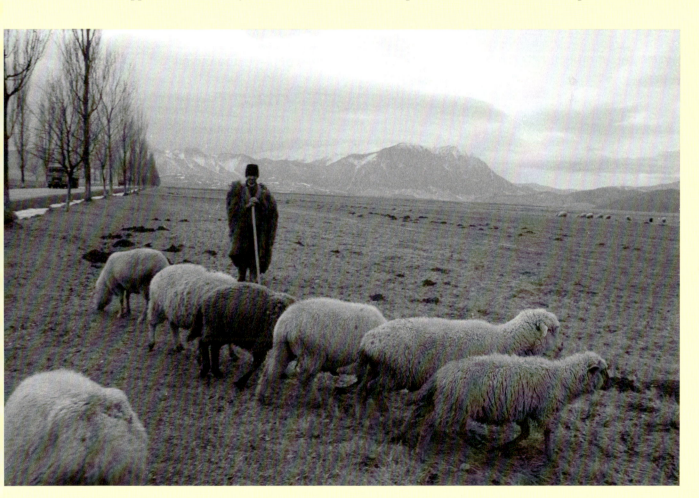

Figure 5.1 Vlach/Romanian Shepherd.

expanding territorial control that set them apart from the regular tax-paying *re'aya* peasant class. In typical pragmatic Ottoman manner, the state provided incentives for Vlach colonization in borderlands: Vlachs who migrated into newly conquered border areas continued to receive a special Vlach status, with its lower tax rate (called *filuri*). As a further sign of Ottoman recognition of Vlach loyalty through settling recently acquired territories, they were granted privileges not given to other Christians. Vlach elites were granted *timar*s or allowed to build new Orthodox churches for example. However, for Ottoman Vlachs who had settled and assimilated into the local Serbo-Slavic population in more established Ottoman territories, their communal status was revised by the Ottoman authorities, their privileged position was abolished, and they were categorized as *re'aya*, with the commensurate tax obligations, by roughly the 1520s.

Although Vlach identity had been defined by the Ottoman state largely in terms of their socioeconomic and military usefulness, from the later sixteenth century onward, settled Vlachs were ethnoreligiously redefined as a segment of the Orthodox Serbian peasantry, and taxed accordingly. By the early seventeenth century, the term "Vlach" appears to have fallen into disuse in Ottoman records, coinciding with Ottoman provincial military forces having become increasingly comprised of Muslims. Various sources also indicate that many of the famed *Uskok* militias causing trouble (Habsburg Croatian irregular units who conducted guerilla warfare against the Ottomans on land and sea along the eastern Adriatic) were of Vlach origin – Ottoman subjects who, perhaps due to their tax privileges being abrogated in the sixteenth century, chose to flee across the border to Venetian or Habsburg territories, from where they raided back into Ottoman Balkan lands.

manage territory as their reach expanded. Sometimes they drew upon previous mechanisms, relying upon local elites already in place as their vassals. At other times, they designed new ways to preserve stability and maximize tax revenue by complete absorption of territory and rule through appointed officials. In some areas of the Balkans, such as Wallachia, Moldavia, and Transylvania (today's modern Romania), territory was frequently contested between the Ottomans and Hungary, or sometimes with Poland-Lithuania. Here the Ottomans initially relied upon *voivode*s there as their vassals – a kind of local Christian warlord, the equivalent of a duke, who originally served the Hungarians as military governors and who typically adhered to whichever overlord, the Hungarian king or the Ottoman sultan, could grant them the most autonomy. The Ottomans demanded the *voivode* pay tributary taxes to the Ottoman treasury and assist on campaigns. They were frequently compelled to leave family members in the Ottoman capital as hostages to ensure loyalty. These *voivode*s were usually chosen by the *boyar*s, or local aristocracy, with the sultan's sanction. Centuries later, after Ottoman military success in the Prut River campaign against Russia in 1711, the Ottomans adopted the practice of appointing Greek

Christian governors to administer these "Danubian Principalities" semi-autonomously instead, until the Greek War of Independence began in 1821.

In some cases reliance upon locally chosen *voivodes* proved to be a successful and enduring arrangement with a family who inherited the *voivodate*, but there were also incidents of these provincially appointed vassals who turned on Ottoman authority when it seemed possible to carve out rulership independent of Ottoman subordination. The Ottomans adapted their methods according to provincial need and when the region in question was acquired. For example, Sultan Bayezid I conducted some raids into Wallachia in the late fourteenth century and compelled the Wallachian *voivode* to pay taxes in 1394. Occasionally the Ottoman center collected taxes from this region, but Wallachia reverted to autonomy during the interregnum when the Ottoman principality was in the turmoil of civil war between brothers. It was not until the early fifteenth century that Wallachia came more firmly under Ottoman control – around 1417.

Moldavia first paid taxes to the Ottomans in 1377, but also asserted its independence during the Ottoman Interregnum. The Moldavian *voivodes* intermittently paid tribute to the Ottomans or rebelled with Hungarian or Polish support, provoking Sultan Mehmed II to invade and ransack the territory in 1476 (see Map 4.3 for conquests of Bosnia, Venetian Dalmatia, the Principalities, and the Crimean Khanate). It was not until 1484, however, that his successor, Ottoman Sultan Bayezid II (r.1481–1512) forced Moldavia to pay regular tribute.

The Hungarian *voivodate* of Transylvania (or *Erdel*) became a vassal of the Ottomans only in the sixteenth century. The principality was the source of wars between Hungary and the Ottomans as it played one sovereign against another. It was permanently occupied by Habsburg forces in the seventeenth century.

In another famous instance of a vassal turning on Ottoman authority, an Albanian named Skanderbeg (George Kastrioti, b.1405–d.1468), born of a noble family whose father paid tribute to the Ottoman sultan and who was held hostage in Edirne, converted to Islam after several revolts against Ottoman authority in Albania in the 1430s. He served as a vassal until 1443, when he abandoned his Ottoman overlords during the attempted crusade against them. He reverted to Christianity, and eventually battled the Ottomans until his death in Krujë, Albania, in 1468.

Coincident with Skanderbeg's reversion to Christianity and subsequent revolt was the refusal by the king of Bosnia, an Ottoman vassal since roughly the 1420s, to pay tribute in 1461, which provoked Sultan Mehmed II's invasion and conquest of Bosnia in 1463. The *sancak* of Bosnia was created in the same year – thus creating the fluid borderland between Venetian Dalmatia and Ottoman Bosnia in which the local Slavic populations, Croatian, Serbian, Vlach, and (recently converted) Bosnian Muslim, cooperated with or resisted these imperial overlords at differing times. The Ottomans faced Venetian opposition to their control of Albania, triggering war from 1463 to 1479, which ultimately resulted in Venice's loss of Negroponte, and Venetian holdings in Albania and Greece. The Ottoman thrust into this area was multifaceted: first, in the rugged, mountainous terrain of Albania, the local populations provided a convenient source of manpower;

A REBELLIOUS *VOIVODE*: VLAD III DRAKUL, THE "HORROR OF DRACULA"

A noble named Vlad II Drakul (Dracul) became *voivode* of Wallachia in 1436, and as was often the practice, he was required to send sons to the Ottoman court. Two of his sons, Vlad III (Figure 5.2) and his younger brother Radu, were sent to Sultan Murad II in 1442 as hostages

Figure 5.2 "Vlad the Impaler and Turkish Envoys" by Romanian Painter Theodor Aman, Nineteenth Century.

to guarantee the loyalty of their father. In 1448 after their father's assassination, Vlad III Drakul (b.1431–d.1476) claimed the Wallachian *voivodate* with Ottoman support. Also known as Vlad the Impaler (or Lord Dracula in modern fantasy-horror), he was famous for impaling domestic and foreign enemies on wood stakes and leaving their corpses hanging to intimidate oncoming foes.

Vlad III was soon overthrown locally. He reclaimed the position after an eight-year struggle, from 1456 to 1462. Refusing to pay Ottoman tribute in 1459, Ottoman envoys dispatched to have an audience with him were said to have been killed by him – by nailing their turbans to their heads when they would not lift their headgear to him in respect.[1] This further incurred the wrath of Sultan Mehmed II (r.1444–6, 1451–81), who sent a sizable army into Wallachia in 1462. Though Vlad III's tactics resulted in some early battle victories, ultimately his forces were defeated by the Ottoman army, and his own brother Radu, commanding an Ottoman Janissary force, played a role in this. Radu was rewarded by the sultan with the title of Bey of Wallachia. Vlad III Drakul was captured and imprisoned by Hungarian King Matthias I for a period of years, released, and attempted to retake Wallachia by force in 1475, but was killed in 1476, the circumstances of which are still rather shrouded in mystery.

clans served as provincial Ottoman buffer forces against adversaries when the boundaries between empires here were not yet rigidly set. Second, Albania was also a location from which to draw more *devşirme* recruits, many of whom enjoyed a newfound opportunity for social mobility and status as members of the Ottoman ruling elite – Albania provided many of the *grand vezir*s for the Ottoman state in subsequent centuries. Ottoman rule here led to large-scale conversion to Islam by the local Albanian population late in the seventeenth century, with pockets of ethnic Albanians remaining Christian. Third, its fertile lowlands and pastures for livestock meant the region could supply agricultural produce for Ottoman provisioning of its capital and for the military. In that regard also, Ragusa (Dubrovnik) became an official Ottoman protectorate as of 1481 and a major port for Ottoman commerce. And last, the Ottomans recognized the strategic position of the Morea (southern Greece) for domination of the eastern Mediterranean. As a foothold from which to combat the piracy rampant in the Adriatic and Aegean, they could control and protect the vital sea trade routes into Istanbul.

The Ottoman capture of the Crimea and their relationship to the Crimean khans there varied from Ottoman administration of other provincial possessions, occurring as it did, after the dramatic conquest of Byzantine Constantinople in 1453, and because of the Turco-Mongol genealogical lineage of the Crimean Tatars. As a breakaway khanate in the early fifteenth century from the Mongol Golden Horde of the Russian steppes and the Turkic Kıpçaks, the Crimean khans claimed direct ancestry from Chingghis Khan. Their livelihood consisted of agricultural production, pastoral livestock management, raiding, and taxes they collected from the Genoese trading outposts on the Black

Sea coast of southern Crimea, which supplied grain and other goods to Byzantine Constantinople. Power struggles at court among the Crimean Tatars were capitalized upon by the Ottomans, who sent a naval fleet in 1475 and occupied Genoese Caffa, some other coastal ports, and henceforth proclaimed an Ottoman *sancak* of "Kaffa." The Tatars thereafter became Ottoman vassals. They sent family members as hostages to the Ottoman court. By the end of the sixteenth century their skilled horsemen often served as Ottoman front guards and light cavalry on campaign, harassing the enemy ahead of the advancing Ottoman military. The Tatars supplied the Ottoman slave trade through their raiding into Slavic Christian (Russian, Polish, Ukrainian) territories. And, by virtue of their Mongol heritage, they received subsidies and stipends from the Ottoman treasury rather than being compelled to pay annual tribute. Most significantly, the Crimean Tatars were actually considered by some in the Ottoman ruling class to be possible heirs to the throne, in the unlikely event of the Ottoman dynasty finding itself without an heir.

A glance at the map of Fatih Mehmed II's Ottoman Empire in 1481 (see Chapter 4, Map 4.3) reveals an early stage of what one historian has called the later Ottoman "Northern Arc"[2] – the empire's attention to this fluid "front line" in eastern Europe that endured and expanded northward as well as deeper into Europe over the centuries. Drawing a line from Greece and Albania in the southwest, this "Northern Arc" extended upward into Bosnia, then to Wallachia, and then northeastward to the Crimean Khanate by 1475. Moldavia (modern Romania and Moldova) paid regular tribute after 1484 under Mehmed II's successor, Bayezid II (r.1481–1512). The Ottoman "Northern Arc" would continue to be the Ottomans' (very lucrative) primary imperial and military focus; they controlled three quarters of the Black Sea coast by Bayezid II's reign, and by the mid-sixteenth century had pushed the frontier into Hungary and Bessarabia (eastern Moldavia). Neither what is called the "Southern Tier" – the Levant, Arabia, North Africa, and Egypt, with its Indian Ocean trade network, all currently still Mamluk domains at this time – nor the post-Timurid east, with its unyielding Akkoyunlu Turkmen led by Uzun Hasan whom Mehmed II defeated in a campaign in 1473, were yet serious Ottoman priorities. Until the late fifteenth century, the Mamluk Sultanate was still a more powerful Muslim state than the Ottomans; while Mamluks and Ottomans were both political rivals and trading partners, the Karamanids and other eastern Anatolian principalities often regarded the Mamluks as a more formidable, loyalty-inspiring sultanate. The Ottoman-Mamluk balance of power in the region was changing, however.

"FAMILY STRIFE" AND EUROPEAN INVOLVEMENT: BAYEZID II (r.1481–1512) AND CEM

Ottoman succession struggles had not ceased with the death of Sultan Fatih Mehmed II in 1481. The competition to seize the Ottoman throne between two sons, Bayezid,

who had been posted in the provincial hub of Amasya, and Cem (pronounced "Jem"), in Konya, escalated into a lengthy drama of around fourteen years that involved European powers and threatened the stability of the Ottoman realm in a way reminiscent of the interregnum era. It was a tragic story of maneuvering among *vezirs* at the Ottoman court, failed battles, secret alliances, and geopolitical deal-making that ultimately resulted in Bayezid II's reign as sultan and the permanent captivity and exile of Cem – a drama that also captivated European literary audiences in the fifteenth century and up to today. This was perhaps a significant moment of mutual realization: Europe took notice of and realized it could play a role in affecting Ottoman internal political struggles; the immense wealth of the Ottomans was evident to Europeans who used the opportunity to extort the Ottoman Empire. For the sultans, they could effectively use Europe to assist in consolidating power and silencing pretenders to the throne.

Bayezid II had reached the capital first in 1481, and had Janissary support for his accession after a gift of bonus money, an act that soon became the tradition for future sultans ascending the throne. Cem's power and forces lay in his provincial region of Karaman in southeastern Anatolia. Despite his initial success in seizing Bursa, Cem and a close ring of supporters were eventually driven out and back to Karaman, and from there, he sought refuge briefly in the Mamluk Sultanate before returning to Anatolia. Seemingly in an attempt to generate assistance against Bayezid II in Rumelia, a decision was made to sail to the island of Rhodes, where the Knights Hospitallers of St. John had guaranteed Cem and his entourage safe passage, though in reality he became a prisoner. After remaining in Rhodes for a month, they were taken to Italy and on to Nice, arriving in 1482.

Cem soon became a pawn in European politics, as the Knights Hospitallers established a secret agreement with Bayezid II that they would hold Cem hostage there for a yearly fee. He was moved frequently from place to place. The French King Charles III was persuaded by Pope Innocent VIII to have the Knights Hospitallers hand Cem over to the Vatican as a way to mobilize a crusade against the Ottomans. In the end, however, Cem merely came to be used instead as leverage against the Ottoman sultan – in 1490 Bayezid II agreed to pay the pope a staggering 40,000 gold ducats annually, along with a few Christian relics held in Constantinople since the conquest in 1453, to hold him hostage. As the French king marched into Rome in 1494, he demanded Cem be surrendered to him before his forces moved on to Naples with Cem in their custody. It appeared as though France, armed with the disenfranchised brother, might actually continue its march all the way to the Ottoman capital. But Cem died several days after arriving in Naples and the French eventually withdrew. In one last exchange over Cem, a squabble over his corpse ensued when Bayezid II insisted it be sent back to Constantinople for identification and resorted to threats against the peace with Naples if demands were not met. Cem, an erudite poet and prince, said to have been his father's favorite for the throne, had been in captivity from roughly 1482 until his death in 1495. His body was finally laid to rest in Bursa in 1499.

BATTLE FORMATIONS, WEAPONS, AND SIEGE TACTICS

Ottoman military organization evolved over time as the principality increased its territorial possessions and as both gunpowder technology and modes of warfare changed. Early conquests have been described as cutting off towns and fortresses through control of the countryside by raiders on horseback maintaining a blockade until surrender was the only option. As the Ottomans developed a field army during Orhan and Murad I's eras in the fourteenth century, the mounted archers, the *akıncıs*, continued to conduct border raids and feigned retreats under the command of their Rumelian or Anatolian lords' direction, ahead of the more formal (and very soon more numerous) Ottoman *timar*-holding *sipahi* cavalrymen who were required to appear on campaign when called.

By Bayezid I's reign in the late fourteenth century, blockades of cities and castles were accompanied by siege tactics using batteries, mangonels, trebuchets, towers to allow the scaling of walls, and mining (digging cavities under the city walls and using fire and/or gunpowder in the chambers to collapse them and the walls above). Vassals were obligated to provide forces, both mounted and foot soldiers. The Janissaries, who began as a contingent of the sultan's bodyguards (see also Chapter 3), typically occupied a position in the center of the Ottoman forces, in front of the sultan. They would be flanked on either side by the six *kapıkulu* cavalry divisions, with the mainstay of the Ottoman force, the *sipahi* cavalry, on the outer wings of the formation, as well as the "*deli*" mounted raiders to lure the enemy into the foot soldiers' ranks: by the fifteenth century the Ottomans were conducting a very well-documented levy of infantrymen called *azabs*, from the local peasantry – about one from every twenty households – who would be drafted and paid for their services on campaign. They marched at the head of the Ottoman military or behind; they were expendable conscripts who carried a bow, sword, shield, axe, or lance. In addition, *yaya* foot soldiers and *müsellem* (tax-exempt peasant volunteer) cavalry were unpaid personnel who were granted lands to farm in return for service on campaign when called and were typically in non-fighting roles, from spying and information gathering, to repairing roads and bridges, to managing the provisions on campaign, to transporting weaponry, etc.

The *sipahi*s used a variety of weaponry, from bows to short swords, depending upon what they could muster when called on campaign. The Janissaries used recurved bows and arrows early on, and were centrally supplied with weaponry. They would become the backbone of the Ottoman field army in time, once they began to use firearms in battle on a large scale in the early sixteenth century. Ottoman military historians generally agree that though gunpowder technology from China was familiar to the Mongols of the thirteenth century, the introduction of this technology to the Ottomans actually came via Ottoman encounters with European armies in the Balkans. The production of gunpowder weaponry in Venice and Ragusa (Dubrovnik) on the Dalmatian coast in the fourteenth century was a consequence of Venetian-Hungarian conflicts; this technology easily made its way into Bosnia, and eventually into Serbia as well, by the last decades of the fourteenth century. The Ottomans adopted the use of gunpowder technology soon after,

using smaller cannons for several sieges by the early fifteenth century, as well as for field artillery. But as early as the end of the fourteenth century they had already developed an artillery corps of professional cannoneers (*topçu*s) who were remunerated through *timar*s. And by the third decade of the fifteenth century, Ottoman artillery was often comprised of larger, heavier cannon cast on the spot, with experienced cannon-makers of Italian, French, German, and Hungarian origin. Murad II's alliance with the Genoese (*c.*1421) has been credited with this transfer of large cannon technology to the Ottomans, which continued to be effective until the sixteenth century, when warfare changed and the big, immovable cannons became less practical and were replaced by smaller, more mobile siege artillery. Sappers, or combat engineers, dug the trenches for moving the artillery into place. By the mid-fifteenth century they used mortars fired over city walls, and wrought-iron cannons gave way to bronze.

During the Battle of Varna in 1444, the Ottomans captured and then soon adopted the Hungarian *wagenburg*, described as "… a defensive arrangement of 'war wagons' chained together, wheel to wheel … manned with cross-bowmen and hand-gunners … protected by heavy wooden shielding and by light artillery against cavalry assault."[3] The Ottomans quickly became adept at the use of this *wagenburg* tactic, arranged in a camp-style called *tabur* (Figure 5.3), which was extremely effective against their foes on the battlefield in the sixteenth century, including in Ottoman Sultan Selim I's (r.1512–20) victory over the Safavids in Persia in 1514. Ottoman Sultan Selim I's victory proclamation and an account from 1541 by the Renaissance littérateur, Paolo Giovio (b.1483–d.1552), who served the papacy, described the Ottoman conquest of the Mamluk Sultanate in 1516–17 as involving three hundred gun carts carrying cannons in front of about 10,000 infantrymen – some armed with arquebuses – likely Janissaries.

The first Janissaries to use handheld firearms (a matchlock long gun called *tüfenk*) probably did so during Murad II's campaigns in the mid-fifteenth century (see also Chapter 3). They gained a reputation as excellent marksmen, which persisted when firearms overwhelmingly became the weapon of the Janissaries by the mid-sixteenth century. The larger musket was introduced to the Janissary Corps by Sultan Murad III (r.1574–95). Janissary training was rigorous, with target practice several times each week. Either kneeling or standing in battle, they fired in rows at the enemy with devastating results. By the seventeenth century, as the effectiveness of the Janissary Corps on the battlefield gradually began to wane (due to factors explored in later chapters), the Ottoman government opted to deal with the deterioration of this fighting force in part by hiring, or conscripting, armed infantry from among the *re'aya* – the peasantry, called *sekban*s, or *levend*s. The Ottomans ended up relying to a large extent upon these *sekban*s to boost their numbers in the field, many of whom were dispossessed yet armed vagabonds and bandits who could be absorbed into the Ottoman military as mercenary fighters when necessary. The *re'aya*, as members of the ruled and not the ruling class, had historically not been allowed to bear weapons. But the diffusion of firearms among the population of the empire from around the sixteenth century onwards became impossible to control.

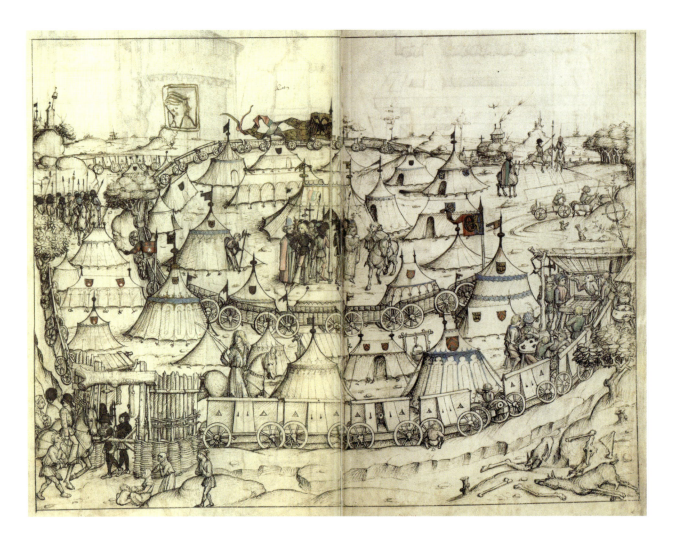

Figure 5.3 Ottoman *Wagenburg* and *Tabur* Formation, from Fifteenth-Century Engraving.

EARLY OTTOMAN NAVAL FORCES

The Central Asian nomadic roots of the Turks who established the Ottoman *beylik* in the fourteenth century created an assumption about the Ottomans as merely a land-based power. This premise has only recently been revised by Ottoman historians who more precisely describe the Ottoman state as an amphibious world-power, challenging the idea that the Ottomans only developed a navy because of foreign (e.g., Greek, Italian) expertise. This is not to deny the impact of the cultural encounter between the Turks who migrated into Anatolia and the local Christian populations who already possessed the knowledge and experience of the seas. The sources do indicate that Greek mercenaries assisted Turks in Anatolia who conducted piracy in the Aegean Sea during the Seljuk era, and this shared raiding at sea continued with the Turkic principalities that formed in Anatolia along the coastal regions. But again Ottoman pragmatism governed the direction of their imperial emergence. Previously a rather Eurocentric historiographical view was of the Ottoman navy as an accidental phenomenon: as if Ottoman presence at sea only occurred when a

sixteenth-century Ottoman sultan, Süleyman the Magnificent, incorporated North African corsair Khayr ad-Din Barbaros, or "Barbarossa," into the Ottoman state and bestowed the title *kapudan pasha* (*kapudan-i derya*, "captain of the seas") or admiral, upon him in 1533. Ottoman recognition that a naval force was necessary to their continued territorial expansion as well as to protection of their valuable trade routes actually occurred earlier than the sixteenth century. These concerns were the Ottoman motivations for the extensive efforts to become a formidable power at sea.

Once the Ottomans were in control of Gallipoli, Sultan Murad I (r.1362–89), recognizing the need for naval power, retained a few ships there. Its strategic location became a base from which the Ottomans could control trade through the Dardanelles Straits, into the Marmara Sea, onward to Constantinople, and the Bosphorus Straits leading into the Black Sea. In fact, after the Ottoman conquest of the Aydın and Menteşe *beylik*s on the south Aegean coast by Sultan Bayezid I in the early 1390s, a small Ottoman naval force developed, assisted by some Byzantine, Greek, and Genoese naval expertise absorbed into the Ottoman principality. Venetian shipbuilding and technology was setting the standard in the Mediterranean and was also influential in the emergence of Ottoman naval power. By Sultan Bayezid I's reign, Gallipoli had become a permanent dockyard, and he was said to have had a Mediterranean fleet from around 1392 of some seventeen ships at his disposal (and up to forty or sixty by 1402). The Ottoman dockyard at Gallipoli, with its permanent and temporary laborers, many (though not all) of whom were foreigners, remained the largest shipyard until the sixteenth century, when the Golden Horn Arsenal in Constantinople, which had been a Genoese facility until the fifteenth-century Ottoman conquest, surpassed it.

Ottoman sea battles resembled their battle tactics on land – they attacked coastal shipping ports, and naval forces blockaded port cities to cut off outside assistance, avoiding when possible open battles at sea. Many of their early fifteenth-century naval battles were with Venice, who had dominated the eastern Mediterranean. The long, oared galleys (Figure 5.4) had single masts and were low in the water, which made them poor in rough seas and set them at a disadvantage against the higher-gunneled Venetian galleons when they tried to board for hand-to-hand combat.

The seamen aboard the Ottoman galleys were of various origins. Foreign renegades often served the Ottomans as naval support, as piracy was a "non-national" pastime in the Mediterranean and Aegean of anyone well-versed in the art of raiding for profit. Convicted criminals and captives served as Ottoman oarsmen. Initially *azabs* or *levends* recruited from among the *re'aya* were also used as oarsmen, drafted as an Ottoman levy in various regions at a rate of one out of every twenty-three houses (later as a more intense need arose to provision Ottoman naval personnel, the rate increased to one out of fifteen, then to one out of seven or eight). The local community from which a levy recruit hailed were responsible to pay the recruit's wages. *Azab*s were later armed with arquebuses. By the sixteenth century, musket-bearing fleet combatants were drawn from the *timar*-holding cavalrymen and the Janissaries, as well as the *azab*s or *levend*s, and often no experience at sea was necessary to be dispatched to serve in a naval capacity, officer or otherwise. Other seamen and corsairs

Figure 5.4 Ottoman Galley or *Kadırga* from a Miniature Painting. Zaporozhian Cossacks in chaika boats attacking Ottoman galleys or *kadırgas* in the Black Sea.

experienced in Mediterranean privateering became indispensable to Ottoman naval activities from the sixteenth century, with Barbarossa perhaps the most famous of these mercenaries turned Ottoman naval heroes.

The use of artillery aboard Ottoman ships was adopted in the fifteenth century. Prior to this, the main tactic at sea was ramming and boarding the enemy ships. The smaller, lighter galleys could only fire artillery from the bow, and when the larger, heavier galleasses were developed, which could fire from broadside, artillery was decisive. Ottoman ships were also used to transport cannonballs for field battles. After Sultan Mehmed II's conquest of Constantinople in 1453, he had a large fleet constructed at the Gallipoli dockyard, based upon Venetian designs common in the Mediterranean. The build-up of Ottoman naval capabilities continued in earnest under Mehmed II's successors, particularly his son Sultan Bayezid II (r.1481–1512). The Ottoman-Venetian war of 1499–1502 over control of the Morea (southern Greece) pitted the fleet commanded by Ottoman naval commander Kemal Reis (Figure 5.5) against the ships of the Venetian Antonio Grimani. In the first wartime use of cannons aboard ships, Grimani was captured and the Ottomans subsequently defeated Venice, compelling an armistice in which the Ottomans acquired more territory. Sultan Bayezid II commanded an extensive naval reorganization and increase in ship numbers in 1502.

The Mediterranean fleet – including Aegean squadrons, defended shipping lanes and guarded the transport of grain from Greece to the Dardanelles, as well as the Mediterranean Sea route from Egypt. In addition, timber for shipbuilding, which had to be transported to the dockyards, came from Anatolia and was in good supply until the late seventeenth to early eighteenth century; the fabric for sails came from Greece, Aegean Anatolia, and sometimes Aleppo or Egypt in the sixteenth century. Ropes and riggings in the sixteenth century were made mainly of hemp, which originated from the west Black Sea and Bulgarian coasts, and from Samsun on the Anatolian coast of the Black Sea. Supplying the materials for the Ottoman naval yards as well as provisioning the empire generally required multiple Ottoman fleets that typically operated independently of one another in the sixteenth century. Until Barbarossa became *kapudan pasha*, usually the *sancakbeyi* of Gallipoli commanded the fleet, but with the advent of several fleets in various locations, the admirals came to be appointed from among the *kapıkulu* slave recruit ranks – particularly

from those educated in the palace school, and not necessarily having had previous experience at sea.

OTTOMAN DIPLOMACY, NAVAL POWER, FRIENDS AND ENEMIES, CHRISTIAN AND MUSLIM

The first decades of the sixteenth century and "Levantine diplomacy" during the Age of Discovery (roughly the fifteenth to eighteenth centuries) have been defined by four main features: the development of the Ottoman navy, the decline of Mamluk power in Egypt and Syria, the rise of the Safavids in Persia, and Portuguese naval expansion.[4] Ottoman seapower was enhanced at this time mainly to combat corsairs (such as the Knights of Rhodes) conducting piracy against Ottoman shipping, to transport provisions to Constantinople and the military on campaign, or to defend the coasts. But Sultan Bayezid II's retooling and expansion of naval forces at the turn of the sixteenth century (at the end of the

Figure 5.5 *Göke* (1495), the Flagship of Ottoman Admiral Kemal Reis.

conflict with Venice), and that of his successors, must be understood as part of a flexible and broad system of making alliances, seeking control of trade networks, and confronting rivalries on an imperial scale in which the Ottomans became the nexus – the most central, and the most resilient of powers, connected to both Christian and Islamic worlds.

The global context in which Ottoman naval ascendancy occurred must also take into consideration several factors dramatically affecting the international order: the Reconquista that resulted in the fall of Granada in 1492 and the expulsion of the Moors and Jews (many of whom relocated to areas of the Ottoman Empire). The Habsburg rise in Austria, and also in Spain (through marriage) in the late fifteenth century, coupled with Spain's newfound seapower, began the discovery of the New World, the economic and political effects of which reverberated in Europe. The Portuguese Vasco da Gama's circumnavigation of the African Cape of Good Hope in 1497 brought the Portuguese into the Indian Ocean spice trade by 1498 and threatened the Mamluk role there and in the Red Sea. At the Mamluk-Portuguese Battle of Diu in 1509, combined naval assistance from the Ottomans, Gujaratis, and Venetians failed to thwart the establishment of a Portuguese stronghold on the subcontinent; Goa became a Portuguese port and viceroyalty capital by 1510. These events would all solidify Ottoman ambitions to become a preeminent seapower.

Sultan Bayezid II had initiated a fresh chapter in Ottoman diplomacy in the late fifteenth century in an adept manner. Not only were the secret agreements regarding Cem's captivity

negotiated through a new policy of dispatching Ottoman emissaries to European powers, but negotiations were conducted individually with each state, which gave the Ottomans the flexibility to maneuver among them as political need arose. Clearly the Ottomans had been players in European politics since the days of involvement with contenders for the Byzantine throne and the early conquests into southeastern Europe. But Bayezid II astutely recognized the potential gain in exploiting rivalries between Christian states for the benefit of his empire, a pattern that would repeat itself in subsequent centuries. The contest with Cem had also reignited tensions between the Ottoman state and tribes in Karaman as well as with a few of the principalities in eastern Anatolia who still did not fully acknowledge Ottoman suzerainty. In addition, Mamluk Sultan Qa'it Bay had provided refuge to Cem, and hostilities were brewing between the two Muslim states. Both sides rather unsuccessfully attempted to court European (mainly Italian city-states) assistance against the other; the Ottoman-Mamluk War that started in 1485 ended in a stalemate and eventually agreed-upon boundaries by 1491. With the southern Ottoman border temporarily pacified, Bayezid II renewed the push west toward the Adriatic coast, attacking Venetian outposts in a third Ottoman-Venetian War that began in 1499 as a combined land and sea effort. This campaign prompted new resistance among anti-Ottoman forces – a diplomatic alliance between Venice, the papacy, and the Kingdom of Hungary to battle against the Ottomans until 1502. Venice sued for peace in 1503, having lost some of its territories in southern Greece; Venice unofficially became a tribute-paying vassal of the Ottomans to preserve its merchants' abilities to trade in and through Ottoman lands and the eastern Mediterranean.

Bayezid II's successor, Sultan Selim I (r. 1512–20), had global ambitions that also clearly included the recognition of seapower as a major component to Ottoman expansion to deal with recently founded Shi'i Safavid Persia on the Ottomans' eastern flank, the conquest of the Mamluk Sultanate, and Portuguese seafaring competition in the Indian Ocean. At the beginning of the sixteenth century only Venice, the Ottomans, and the Knights of Rhodes had Mediterranean fleets. Sixteenth-century Ottoman expansion of naval forces included the establishment of additional shipyards to compliment the expansion of the Ottoman state into an empire that reached new boundaries in Europe, the Middle East, North Africa, and the Indian Ocean (Map 5.1). Permanent dockyards were founded at İzmit in the Marmara Sea, at Sinop on the north Anatolian coast of the Black Sea, at Suez in the Red Sea, and at Basra in southern Iraq. The Ottomans eventually used river fleets to transport troops, livestock, ordnance, and equipment, one of which was on the Danube, anchored at Buda, and another at the confluence with the Sava, stationed at Belgrade. Conquest of the Mamluk Sultanate in Egypt in 1517 and the subsequent inheritance of some southern sea trade routes created the need for a fleet to carry out this trade, to continue the flow of goods from Egypt to Constantinople, to provision the empire's cities as well as its regular military campaigns, and to facilitate the pilgrimage routes in Arabia. The Egyptian ports of Alexandria (for the eastern Mediterranean) and Suez (as a base for the Red Sea and Indian Ocean fleets) flourished as economic and naval hubs. An Ottoman fleet was stationed at Bab al Mandeb (the southwestern corner of Yemen across

Map 5.1 Ottoman Expansion as a World Empire.

Legend:

Ottoman Empire in 1451 (First Conquered)
- 1281-1362
- 1362-1389
- 1389-1402
- 1402-1451

Ottoman Expansion From
- 1451-1512
- 1512-1520
- 1520-1566
- 1566-1683

from Djibouti) at the mouth of the Red Sea in the sixteenth century but it was short lived. By the late seventeenth century Ottoman galleons were replacing their oared galleys as the preeminent fighting vessels.

THE SAFAVID "HERESY"

After establishing a peace with Venice, Ottoman attention turned to the troublesome Turkic tribespeople in eastern Anatolia, the *kızılbaş*, or "redheads," who adhered to a more

esoteric, Sufi practice of Islam and who tended to resist central authority as a general rule. Named for their red headgear with twelve folds to honor the line of twelve Shi'a imams beginning with Ali, their allegiance, both spiritual and eventually militarily as well, was to the emerging Safavid dynasty in Persia under the leadership of Shah Ismail, on the Ottomans' eastern flank. The Safavi Sufi order had been established in Ardabil, northern Iran near the Caspian coast, by a Shaykh Ṣafī ad-Dīn (b.1252–d.1334). What was ostensibly a Sunni-oriented Sufi order transformed over time into a rather militant, anti-Sunni sect with Shi'a leanings, whose antipathy toward Ottoman authority moving into the area erupted around the mid-fifteenth century, headed by Ismail's grandfather Junayd, and then by his father, Shaykh Haydar Ṣafawī. After defeating the Shirvan Shah in 1500, in 1501 the teenaged Ismail led an army to seize Tabriz in Azerbaijan, unseating the tribal Akkoyunlu tribal dynasty there and founding a new state by 1502 that relied upon resistance to Ottoman expansion among its Turkmen tribal *kızılbaş* elements for military support (Figure 5.6).

Shah Ismail's Safavid state was a theocratic one, at least at the outset. Safavid doctrine would claim Ismail was the reincarnation of Imam Ali, or Jesus; a god-like status was accorded to him, implying the return of the Hidden Twelfth Imam, the Mahdi, was at hand to unseat the illegitimate usurpers of power that had reigned in his absence (such as the Ottomans). It was at this time that predominantly Sunni Persia was beginning to be converted to Shi'ism. First, the local clergy was forced to renounce their Sunni leanings by cursing the names of the first three caliphs. The Persian populace eventually acquiesced as well. Shah Ismail, armed with his ideology and his *kızılbaş* army, was able to occupy Baghdad by 1508. The Safavid state (Map 5.2) faced a similar dilemma of a two-front war, with the Ottomans on one side, and the Sunni Turkic Khanate of Bukhara, the Üzbek Shaybanids, on their eastern flank. The Üzbeks invaded Safavid territory unsuccessfully in 1510, and again in 1512, defeating the Safavids.

Ottoman Sultan Bayezid II appeared to have a concerned but conciliatory attitude toward the Safavid state now abutting his eastern borders. Succession struggles amongst his sons while he was still alive, his son Prince Selim's aggressively anti-Safavid posture toward what he considered a dynasty promoting heretical faith, and a serious rebellion in southwest Anatolia led by an unorthodox Turkman spiritual leader called Şahkulu ("servant of the Shah") who was influenced by Safavid Shi'ite ideology, were all threatening Ottoman stability in Anatolia. The rebellion was ultimately put down in 1511 by Bayezid II's favorite son, Prince Ahmed, and Şahkulu was killed, leaving his Shi'a followers to flee and meld back into the countryside. They did not disappear, but would reemerge as a continual destabilizing force on the eastern Ottoman frontier.

Prince Selim, meanwhile, had his sights set on the Ottoman throne: he demanded a provincial posting in Rumelia (on the Danube, at Semendere southeast of Belgrade) and challenged his father militarily in Thrace. Backed by the powerful Janissaries and believing his father, Sultan Bayezid II, to be too inactive against the pro-Safavid *kızılbaş*, Selim had his father deposed in 1512 – the first such incident of deposition (though more Janissary-inspired oustings of sultans were to come in future reigns). Bayezid II died shortly thereafter; Selim's remaining brothers, Korkud and Ahmed, were captured and he had them

Figure 5.6 The *Kızılbaş* with Shah İsmail.

Map 5.2 The Safavid Empire in Persia, *c.*1630.

strangled. The nickname, Yavuz Selim, or "Selim the Grim," for the new Ottoman Sultan Selim I (r.1512–20) was an apt one for the man who ruthlessly oversaw the first dynastic overthrow in a succession struggle to occur during the father's lifetime. He now turned his full attention more vehemently to the Muslim powers in the east and south – first, the Shi'ite Safavid state under Shah Ismail, and then to the Mamluk Sultanate.

Sultan Selim I's recognition of the intricate network of political and trade alliances dictated his actions in establishing the Ottoman Empire as the superior power of the sixteenth century; his Muslim rivals helped to stimulate the eventual orthodox Sunni Islamization of the Ottoman Empire. Pacifying his western frontiers on land and sea through renewing agreements with Venice and Poland, and forcing an entente with Hungary, the Ottomans took advantage of the somewhat weaker state of the Mamluks to also renew their alliance for the moment. He then turned his attention on the Safavids,

whom he considered not only a challenge to Ottoman legitimacy and authority, but as heretics and infidels for their Shi'ite beliefs – grounds for war. Flowery letters between Ottoman Sultan Selim I and Safavid Shah Ismail reveal a visceral contempt on the part of Selim I for his eastern adversary, whereas Shah Ismail's poetic writings expose a more ethereal tone of indifference to Ottoman condemnation.

Like his father before him, Sultan Selim I's hostilities toward the unruly *kızılbaş* resulted in the first action – sealing the border with the Safavid state to both rid Anatolia of its "heretic" Shi'a Turkmans through arrest and massacre and to create an economic embargo against the Safavid silk trade. The semi-nomadic pastoralist Kurdish tribes inhabiting areas around Diyarbakir, Van, and Şahrizor (Mosul) assisted Selim I in his battles with these *kızılbaş* Turkmen. He forcibly deported Persian merchants from Bursa to where they could be monitored in Istanbul. Yavuz Selim I then led the Ottoman campaign forces to Çaldıran, northwest of Tabriz, where they met Shah Ismail's Safavid mounted contingents in 1514. With almost evenly matched armies numerically, and Kurds again present with Selim I, the battle resulted in a dramatic Safavid defeat due to superior Ottoman gunpowder technology – muskets and cannons – skillfully employed by the Janissaries, though both sides endured heavy casualties (Figure 5.7). Shah Ismail's requests for peace with the Ottomans were rebuffed, his envoys to the Ottomans treated harshly. He attempted to appeal to Venice for support, but the Venetians had no intention of jeopardizing their trade relations and security with the Ottoman Empire by reneging on their current agreement. The Ottomans occupied Tabriz for a period but could not maintain their hold on the Safavid capital.

Shah Ismail's prestige as a godlike imam, the Mahdi, and head of the Safavid state diminished greatly after this defeat, necessitating the reconciliation of *kızılbaş* mysticism with Safavid twelver Shi'i orthodoxy. The Sufi-oriented, shamanistic *kızılbaş* tribesmen had to be "tamed," redirected somewhat, in their service to the Safavids. This occurred gradually, in large part due to the migration to Safavid Persia of a more scholastic Arab Shi'ite *ulema* (hailing primarily from Jabal 'Amil in Syria) who could provide the realm with a more orthodox creed of twelver Shi'ism. These 'Amilis, as they were called, aspired to link Shi'ism to Safavid imperial sovereignty in order to overcome their marginalized Shi'i status of the past and to become an overt, official faith. Shi'a communities as well as their *ulema* in some Sunni areas of the Middle East migrated to their new Shi'a home in Safavid Persia to further propagate the faith during the reign of Shah Ismail, who died in 1524, and that of his son Shah Tahmasp (r. 1524–76). It was at this time that Safavid society in Persia overwhelmingly converted to Shi'ism, and the ritual cursing (of the names of the first three caliphs before Ali) to publicly demonstrate a rejection of Sunni political leadership and orthodoxy pervaded.

The Safavids and their *kızılbaş* adherents in Anatolia would remain a thorn in the Ottoman side for centuries. During imperial conflict between them in the first half of the sixteenth century under sultans Selim I and his son Süleyman (r. 1520–66), additional efforts to employ *sürgün* tactics as an administrative means to suppress revolts were conducted against Anatolian *kızılbaş* by relocating them to the Balkans. Some migrated there voluntarily, in hopes of finding a safe haven within Ottoman territory (they are understood as *Alevi-Bektaşi* Turkmen today). In 1639 a treaty ended the Ottoman-Safavid War of 1623–39

"LETTERS FROM SELÎM AND ISMÂ'ÎL" (c.1514)[5]

Sultan Selim seemingly sent three letters to Shah Ismail, and Shah Ismail answered with one, before the Battle of Çaldıran in which Shah Ismail's Safavid army was defeated. Sultan Selim had already attacked *kızılbaş* supporters of Ismail's claims to be the Shi'ite imam returned in eastern Anatolia. Selim used his Ottoman heritage, his campaigns in the name of the faith, and quotes from the Qur'an in his letters to legitimate his claims as the rightful leader of Muslims while condemning the heresy of the followers of the Sufi Shaykh Safavi – in other words, Shah Ismail and his Safavid followers. Shah Ismail's response bears an air of confident indifference as he quotes Persian poetry and warns against an Ottoman attempt to bring down the house of Ali and its Safavid inheritors.

Selîm to Ismâ'îl:

This missive which is stamped with the seal of victory ... has been graciously issued by our most glorious majesty – we who are the Caliph of God Most High in this world, far and wide ... slayer of the wicked and the infidel, guardian of the noble and the pious; the warrior in the Path, the defender of the Faith; the champion, the conqueror; the lion, son and grandson of the lion; stand-bearer of justice and righteousness, Sultân Selîm Shâh, son of Sultân Bayezîd, son of Sultân Muhammad Khân – and is addressed to the ruler of the kingdom of the Persians, the possessor of the land of tyranny and perversion, the captain of the vicious, the chief of the malicious, the usurping Darius of the time, the malevolent Zahhâk of the age, the peer of Cain, Prince Ismâ'îl.... We, the instrument of Divine Will, shall hold in force upon the earth both the commandments and prohibitions of Divine Law as well as the provisions of royal proclamations....

It has been heard repeatedly that you have subjected the upright community of Muhammad ... to your devious will, that you have undermined the firm foundation of the Faith, that you have unfurled the banner of oppression in the cause of aggression, that you no longer uphold the commandments and prohibitions of the Divine Law, that you have incited your abominable Shi'i faction to unsanctified sexual union and to the shedding of innocent blood ... the Sunnî community agree that the ancient obligation of extirpation, extermination, and expulsion of evil innovation must be the aim of our exalted aspiration.... But should you turn your countenance of submission to ... our angelic threshold ... should you take up a course of repentance ... and return to the sublime straight path of the Sunna of Muhammad ... should you consider your lands and their people part of the well-protected Ottoman state, then shall you be granted our royal favor and our imperial patronage. On the other hand, if your evil, seditious habits have become a part of your nature ... Then, with the support and assistance of God, I will crown the head of every gallows tree with the head of a crown-wearing Sûfî and clear that faction from the face of the earth....

Ismâ'îl to Selîm:

May his godly majesty, the refuge of Islâm, the might of the kingdom, he upon whom God looks with favor, the champion of the sultanate

and of the state, the hero of the faith and of the earth, Sultân Selîm Shâh ... accept this affectionate greeting and this friendly letter, considering it a token of our good will.... Your honored letters ... their contents, although indicative of hostility, are stated with boldness and vigor. The latter gives us much enjoyment and pleasure, but we are ignorant of the reason for the former. In the time of your late blessed father ... complete concord and friendship was shown on both sides.... Thus, now, the cause of your resentment and displeasure yet remains unknown. If political necessity has compelled you on this course, then may your problems soon be solved.

Dispute may fire words to such a heat
That ancient houses be consumed in
 flames.

... We have always loved the *ghâzî*-titled Ottoman house and we do not wish the outbreak of sedition and turmoil once again as in the time of Tîmûr.

Why should we then take umbrage at these provocations? We shall not.

The mutual hostility of kings is verily an ancient rite. Should one hold the bride of worldly rule too close, His lips those of the radiant sword will kiss.

... we have now dispatched our honored personal companion and servant Shâh Qulî Âghâ ... may he soon arrive so that with assistance from above the mysteries concealed behind a veil of fate might be disclosed ... we now prepare provisions and our troops for the coming campaign.

In all friendship we say do what you will.

Bitter experience has taught that in this world of trial He who falls upon the house of 'Alî always falls.

... When war becomes inevitable, hesitation and delay must be set aside, and one must think on that which is to come. Farewell.

and divided the Caucasus region roughly between them. The Safavid state collapsed in 1722, to be replaced temporarily by Sunni tribal Afghans before Nadir Shah, the leader of the Turkman Afshar tribe allied with the Safavids, proclaimed himself shah in 1736 after the deposition of the last Safavid Shah Abbas III (r. 1732–6).

THE MAMLUK SULTANATE, THE "SOUTHERN TIER"

Sultan Selim I's decision to look covetously south toward the Mamluk Sultanate had wide-ranging and dramatic effects upon the trajectory of Ottoman expansion in terms of the empire's economic reach, territorial extent, cultural orientation, and demographic composition. The fortunate geographic location of Mamluk Egypt, as a crossroads between the southern seas, the Indian Ocean, and the Mediterranean, allowed for its domination of rich trade routes. Safavid appeals to the Mamluks for support against the Ottomans had

Figure 5.7 Fresco, *Battle of Çaldiran against Ottoman Sultan Selim I, 1514*, Chehel Sotoun, Isfahan.

gone unheeded; the Mamluk sultan had been unwilling to assist the Ottomans against the Safavids in 1514. Combined with misinformation about Safavid intentions to conduct an incursion into the border zone with Mamluk Syria, Selim I had his pretext for invading Mamluk territory next. Ottoman and Mamluk military forces met at Marj Dabiq near Aleppo in 1516, and again, though forces were numerically relatively equal, Mamluk reliance upon cavalry and a lack of muskets and cannons proved to be their downfall against the Ottoman military machine. The last Mamluk sultan, Qansuh al-Ghawri, was killed in battle. The Ottomans continued their march southward, and Damascus, historic seat of the seventh- to eighth-century Muslim Umayyad dynasty, surrendered. Jerusalem was occupied, and the campaign proceeded to Mamluk Cairo, which was conquered in 1517 with much difficulty. Many Mamluks were massacred, and Ottoman governors would now be appointed and dispatched to maintain order in Egypt from 1517 until Napoleon's invasion

of Ottoman Egypt in 1798. The province was administered as a large tax farm. Several of the powerful Mamluk *emirs* who remained were incorporated into an Ottoman garrison comprised of a mix of Janissary soldiers, Mamluks of various ethnicities (Turk, Circassian, etc.) or their children, and Arabs. They served in the "Circassian Corps," one of seven corps organized by İbrahim Pasha, the governor of Egypt who had been dispatched to Cairo by Sultan Süleyman in 1524 to replace a previously appointed governor. These Mamluk *emirs* preserved their households' status by assuming the office of *sancakbeyi*, and they sometimes rivaled the authority of the Ottoman governor. However, Ottoman-Mamluk military strength in Egypt was no match for Napoleon's army in 1798.

Control of the Red Sea and the spice trade now fell to the Ottomans, whose geographic centrality and commercial links to Venice, Ragusa (Dubrovnik), and others in Europe made for very profitable shipping of spices from the East, while also triggering direct conflict in the Indian Ocean with the Portuguese. It has been argued that Selim I's capture of Egypt in 1517 initiated an Ottoman quest for geographic and strategic knowledge of the Indian Ocean (from available Muslim and European cartographic sources), with the aim of projecting Ottoman power and prestige as the preeminent Islamic state among local Muslim sultanates, while also hoping to counter both Portuguese presence and later, Mughal sovereignty in the region, during Sultan Süleyman's reign. The cartographic works of the famous Ottoman sea commander, Piri Reis, first appeared under the patronage of Selim I, coinciding with the sultan's initiation of contact with the ruler of Gujarat in an attempt to find Indian Ocean trading partners and allies against the Portuguese. But the Ottomans were never able to successfully breach Portuguese control of the trade beyond the peripheral zones of the Red Sea and Hormuz. The Gujarati port city of Diu had already played host to a "*Rûmi*" community – Turkish-speaking Ottoman Muslim merchants, but the majority of the merchants engaged in this trade were locals. Nevertheless, the Ottoman Empire now stretched from southeastern Europe to the Arabian Peninsula, and possessed economic and cultural influence that might have extended further east than delineated territorial borders would indicate, through networks of tribal clientage, trade, and Ottoman self-promotion as the premier Muslim sovereigns.

The Ottoman state, which had been mainly comprised of a Christian population from its inception on the Byzantine border, was now transformed into an Islamic Ottoman Empire par excellence after Sultan Selim I's conquests, with Muslims outnumbering non-Muslims. The Ottomans now inherited certain roles and obligations with their absorption of the Mamluk realm. The Mamluk Sultanate had been the custodians of the high Arabo-Islamicate culture founded by previous dynasties since the Mamluks halted the Mongol invasion westward in 1260. An Abbasid prince claiming the caliphal bloodline had resided in Cairo under Mamluk protection; his descendants were (falsely) rumored to have been hauled back to Istanbul as a means to maintain the prestige of the Ottomans as the symbolic keepers of caliphal authority, a status Sultan Selim I's son and successor Süleyman would embrace more directly in the mid-sixteenth century by assuming the title personally. Al-Azhar was located in Cairo, a center of Islamic learning founded by the Fatimids, though it had long since become orthodox Sunni in its doctrinal orientation. The Mamluk dynasty, though Turkic in ethnicity, had presided over predominantly Arab populations in Egypt and Syria,

the majority of whom were Sunni Muslim, and were now Ottoman subjects. The Mamluks had held the keys to the holy cities of Islam – Mecca and Medina – which required them to maintain and provide safe passage on the pilgrimage route; the Ottoman governor of Egypt was now responsible for this task. Jerusalem, the third holiest site in Islam and a city with significant meaning for the Abrahamic faiths of Judaism, Christianity, and Islam, had also been under Mamluk control. Responsibility for the upkeep of the various religious sites in these cities and the maintenance of the annual traditions of the hajj now passed to the Ottomans, though no Ottoman sultan would ever make the pilgrimage himself.

Sultan Selim I and his empire would have a new legitimacy for future sultans: as the guardians of Sunni Islam against the Safavid Shi'a heresy in the East, and as holy warriors against infidel Christian Europe. With his conquests Ottoman Sultan Selim I had created the "Southern Tier" that would, in future centuries, also extend south to coastal East Africa, and across North Africa, becoming the site of countless competitions and wars with colonial empires for economic dominance that would endure into the nineteenth century. Selim I's final legacies were first, his instructions to the *ulema* to sanction continuing war against the Safavids, and second, the good fortune left to his son, Süleyman, as the sole heir to the throne. Without any surviving brothers to mount a challenge to his ascension to the Ottoman sultanate, in 1520 the new young Sultan Süleyman was at the head of a vast imperial enterprise that spanned several continents and seemed to know no limits.

NOTES

1 Franz Babinger, *Mehmed the Conqueror and His Time*, ed. William C. Hickman, trans. Ralph Manheim (Princeton: Princeton University Press, 1978), 203.

2 From 1700~, in Virginia H. Aksan, *Ottoman Wars 1700–1870: An Empire Besieged* (London: Pearson Longman, 2007), 6.

3 Gábor Ágoston, *Guns for the Sultan: Military Power and the Weapons Industry in the Ottoman Empire* (New York: Cambridge University Press, 2005), 19.

4 Palmira Brummett, *Ottoman Seapower and Levantine Diplomacy in the Age of Discovery* (New York: State University of New York Press, 1994), 23.

5 Excerpted from William H. McNeill and Marilyn Robinson-Waldman, eds., *The Islamic World* (Chicago: University of Chicago Press, 1973), 337–44, and trans. John Woods, from Z. Sabitiyân, ed., *Asnâd va nâmehâye tarîkhî va ijtimâiyye dowreye safavîyye* (Tehran: Ibn-i Sinâ, 1964), 112–17. Reprinted by permission of John Woods.

SELECTED READINGS

Abisaab, Rula. *Converting Persia: Shia Islam and the Safavid Empire, 1501–1736*. London: I.B. Tauris, 2005.
Ágoston, Gábor. "Firearms and Military Adaptation: The Ottomans and the European Military Revolution, 1450–1800." *Journal of World History* 25, no. 1 (March 2014): 85–124.

Ágoston, Gábor. *Guns for the Sultan: Military Power and the Weapons Industry in the Ottoman Empire.* New York: Cambridge University Press, 2005.

Ágoston, Gábor, and Bruce Masters. *Encyclopedia of the Ottoman Empire.* New York: Facts on File, 2009.

Aksan, Virginia H. *Ottoman Wars 1700–1870: An Empire Besieged.* London: Pearson Longman, 2007.

Antov, Nikolay. "The Ottoman State and Semi-Nomadic Groups along the Danubian Serhad (Frontier Zone) in the Late 15th and the First Half of the 16th Century: Challenges and Policies." *Hungarian Studies* 27, no. 2 (December 2013): 219–35.

Antov, Nikolay. *The Ottoman "Wild West": The Balkan Frontier in the Fifteenth and Sixteenth Centuries.* New York: Cambridge University Press, 2017.

Babinger, Franz. *Mehmed the Conqueror and His Time.* Edited by William C. Hickman. Translated by Ralph Mannheim. Princeton: Princeton University Press, 1978.

Barzman, Karen-edis. *The Limits of Identity: Early Modern Venice, Dalmatia, and the Representation of Difference.* Leiden: E.J. Brill, 2017.

Bracewell, Catherine W. *The Uskoks of Senj: Piracy, Banditry, and Holy War in the Sixteenth-Century Adriatic.* Ithaca, NY: Cornell University Press, 1992.

Brummett, Palmira. "The Ottomans as a World Power: What We Don't Know about Ottoman Sea-Power." *Oriente Moderno.* The Ottomans and the Sea, n.s., anno 20 (81), no. 1 (2001): 1–21.

Brummett, Palmira. *Ottoman Seapower and Levantine Diplomacy in the Age of Discovery.* New York: State University of New York Press, 1994.

Casale, Giancarlo. *The Ottoman Age of Exploration.* New York: Oxford University Press, 2010.

Collins, J.D. "The Military Organization and Tactics of the Crimean Tatars during the Sixteenth and Seventeeth Centuries." In *War, Technology and Society in the Middle East*, edited by V.J. Parry and M.E. Yapp, 257–76. Oxford: Oxford University Press, 1975.

Fleet, Kate. "Early Turkish Naval Activities." In *Oriente Moderno.* The Ottomans and the Sea, n.s., anno 20 (81), no. 1, (2001): 129–38.

Hathaway, Jane. *The Arab Lands under Ottoman Rule, 1516–1800.* London: Pearson Education, Ltd., 2008.

Imber, Colin. *The Ottoman Empire 1300–1650: The Structure of Power.* New York: Palgrave MacMillan, 2002.

İnalcık, Halil. "The Rise of Turcoman Maritime Principalities in Anatolia, Byzantium, and the Crusades." In *The Middle East and the Balkans under the Ottoman Empire: Essays on Economy and Society*, 309–41. Bloomington: Indiana University Turkish Studies and Turkish Ministry of Culture Joint Series 9, 1993.

İnalcık, Halil. "The Socio-Political Effects of the Diffusion of Fire-arms in the Middle East." In *War, Technology and Society in the Middle East*, edited by V.J. Parry & M.E. Yapp, 195–217. Oxford: Oxford University Press, 1975.

İnalcık, Halil. "The Yürüks: Their Origins, Expansion and Economic Role." In *The Middle East and the Balkans under the Ottoman Empire: Essays on Economy and Society*, 97–136. Bloomington: Indiana University Turkish Studies, 1993.

Kursar, Vjeran. "Being an Ottoman Vlach: On Vlach Identity(ies), Role and Status in Western Parts of the Ottoman Balkans (15th–18th Centuries)." *Ankara Üniversitesi Osmanlı Tarihi Araştırma ve Uygulama Merkezi Dergisi* [Journal of the Center for Ottoman Studies, Ankara University] 34 (September 2013): 115–61.

McNeill, William H., and Marilyn Robinson-Waldman, eds. *The Islamic World*. Chicago: University of Chicago Press, 1973.

Minawi, Mostafa. *The Ottoman Scramble for Africa: Empire and Diplomacy in the Sahara and the Hijaz*. Stanford: Stanford University Press, 2016.

Murphey, Rhoads. *Ottoman Warfare 1500–1700*. New Jersey: Rutgers University Press, 1999.

Petry, Carl F. *Protectors or Praetorians?: The Last Mamluk Sultans and Egypt's Waning As a Great Power*. Albany: State University of New York Press, 1994.

Soucek, Svat. "About the Ottoman Age of Exploration." *Archivum Ottomanicum* 27 (2010): 313–42.

Yılmaz, Hüseyin. *Caliphate Redefined: The Mystical Turn in Ottoman Political Thought*. Princeton: Princeton University Press, 2018.

Winter, Michael. "Turks, Arabs and Mamluks in the Army of Ottoman Egypt." *Wiener Zeitschrift für die Kunde des Morgenlandes* 72 (1980): 97–122.

Zarinebaf, Fariba. *Crime and Punishment in Istanbul 1700–1800*. (Berkeley: University of California Press, 2010.

SIX

REACHING IMPERIAL HEIGHTS: SIXTEENTH-CENTURY OTTOMAN EMPIRE

"THE GRAND TURK": SÜLEYMAN THE MAGNIFICENT, SÜLEYMAN THE LAWGIVER (*KÂNÛNÎ*)

Süleyman I's enthronement as Ottoman sultan in 1520 at age twenty-five came during the century marked by the rise of early modern dynastic states with powerful, charismatic rulers the world over whose empires were often at odds with one another (Maps 6.1 and 6.2). Süleyman's reign of forty-six years (r.1520–66) intersected with many of them. In addition to Sultan Süleyman, the early decades of the sixteenth century played host to Muslim sovereigns like Shah Ismail and his notable Safavid descendants (i.e., Shah Tahmasp, r.1524–76), the Timurid Babur (founder of the Mughal dynasty in the subcontinent, 1526), and the Üzbek Shaybanid khans of Central Asia, all of whom presided over the Islamic "Gunpowder Empires," so named because their use of gunpowder technology in battles made them the most formidable powers in the world at the time. In the West, the reigns of two prominent English Tudors, King Henry VIII (r.1509–47) and his daughter Queen Elizabeth I (r.1558–1603), overlapped at each end of Süleyman's era on the Ottoman throne. The Habsburg dynasty's Charles V was elected Holy Roman emperor in 1519, with his brother Ferdinand I overseeing the Austrian possessions (eventually including Hungary) by 1521, and his son Philip II, those of Spain by the 1540s. Their rival, the king of France, Francis I (r.1515–47), would become a useful Ottoman ally against the Habsburgs. Once Habsburg and Ottoman empires abutted one another in the Balkans, a Venetian-Habsburg-Ottoman nexus in Dalmatia (the Croatian coast of the Adriatic) became a frequent hotspot of shifting alliances, tacit agreements, and territorial disputes. The rise of Muscovy under Ivan III (d.1505) would later be thought of as the "Third Rome" under his grandson Ivan IV "the Terrible" (r.1547–84); known as the

Map 6.1 Ottomans among the European Empires, c.1551.

Tsardom of Russia in the mid-sixteenth century, by the eighteenth century the Russian Empire became the most threatening enemy to the Ottoman Empire.

In this age of imperial rivals, the newly enthroned young Ottoman Sultan Süleyman I, known as Süleyman "the Magnificent" in the West, would ultimately preside over an empire transformed. Historians point out the institutionalization of the Ottoman Empire during Süleyman I's lengthy tenure, whether concerning the emergence of an expansive hierarchy of administrative and palace offices, the further development of the army and naval forces, the continuing organization of fiscal and taxation regulation (including tax farms), management of provincial areas of the empire, or the elaboration of imperial rituals and ceremonies to enhance the dynasty's symbolic authority. Sultan Mehmed II before him had already established and consolidated many of the foundations of the central Ottoman administration after the conquest of Constantinople through the promulgation of a legal code or *kânûnnâme* defining institutions and offices of the empire. Süleyman's reign was a continuation of this trend. In time Ottoman palace and administrative posts would become a substantial bureaucracy with an enlarged scribal chancery and record-keeping offices. The character of the Ottoman administration would eventually become further central-ized in a peculiar way that ultimately led to the diffusion of political authority to the class

of Ottoman ruling elite, and to fiscal decentralization. Süleyman's reign stands out as a moment of changes in the administration of the empire through the dramatic expansion of the *askeri* class, all of which must be understood as part of an ongoing process of the dynasty's imperial sedentarization.

Upon ascending the Ottoman throne, Süleyman I carried out several actions to legitimate his reign and demonstrate power to his late father's *vezir*s (many of whom had remained in office), to his Ottoman subjects, and to the empire's adversaries in the Christian West who may have thought the sultan young, inexperienced, and at a vulnerable moment. These actions included the display of justice in the realm, as well as conquests. With the death of his father in 1520, Süleyman reversed some of Selim I's rigid policies to illustrate his intention to be a just and benevolent ruler over a prosperous empire, fulfilling the obligations embodied in the Circle of Justice. Recognizing the effects of the Safavid silk embargo on the Ottoman economy, he released Iranian silk merchants who had been arrested or deported, and compensated them if needed. He insisted upon fair behavior from his officials, dismissing or executing those found to be extorting the Ottoman populace. The codification of Ottoman law that had begun under his ancestor, Sultan Mehmed II, peaked with Süleyman I and jurisprudent Ebu Su'ud's initiative to compile and reconcile administrative Ottoman *kânûn*s (administrative legal decrees) with the *şeriat* (Islamic law), so that the two forms of law, secular and religious, would have no legal contradictions. For this achievement, Süleyman I became known in the Muslim world as *kânûnî*, "the lawgiver."

Map 6.2 Ottomans among the "Gunpowder" (Muslim) Empires, *c.* Sixteenth Century.

SÜLEYMAN THE MAGNIFICENT: DEPICTING THE DYNASTY THROUGH COURT PATRONAGE

Figure 6.1 Portrait of Ottoman Sultan Süleyman.

Sultan Süleyman is pictured here (Figure 6.1) as a young man in a posthumously drafted 1579 manuscript entitled *Şemâ'ilnâme*[1] written by court historian Lokman and illustrated by renowned miniature artist Nakkaş Osman, under the patronage of *Grand Vezir* Sokollu Mehmed Pasha. The manuscript appeared in several versions about twelve years after Süleyman's death. As a dynastic history of Osman's house including portraits of each sultan, the treatise included discussions of the various sultans' reigns, and the portraits were intended to demonstrate continuity of the dynasty while also revealing a sultan's character based upon his physical appearance. Ottoman contact and rivalries with both Venice and France seem to have inspired the Ottomans to produce this style of illustrated account. The sixteenth century was a moment in which monarchs in the world acted much the same, had the same grand strategies for ruling over large empires, and had a level of respect and esteem for one another's royal prestige. Certainly the Europeans were impressed with (and fearful of) the standing armies and opulent wealth of the Ottomans.

SULTAN SÜLEYMAN'S MANY CAMPAIGNS

Süleyman's reign fell within a significant portion of the tenth century in the Islamic calendar, during which many individual personalities altered the course of Ottoman history – whether Süleyman himself; his *grand vezir*s; his concubine and wife, Hürrem; the corsair and Ottoman naval admiral (*kapudan pasha*) Barbarossa; the famous architect Sinan Pasha; the talented cartographer and naval commander, Piri Reis; the sultan's religious head, *Şeyhül-İslâm* Ebu Su'ud; or foreign figures such as the Habsburg Holy Roman Emperor Charles V, or Martin Luther, founder of the Christian Reformation movement. But the Ottoman Empire of the sixteenth century must also be understood as rising to global prominence as an empire interconnected with more regions of the world, with more cultures and rival powers, on both land and sea, and at further distances than had occurred previously. Nonetheless, Süleyman's successes were a continuation of his predecessors' achievements. Ottoman conquests must be understood in this light – as a means to territorial expansion and thus access to resources and revenue through control of trade routes, and not simply "*jihads* for the faith" against infidels, even as the empire embraced a more orthodox Sunni religious ideology promoted by the elite. In this regard, a chronology of conquests undertaken from the beginning of Süleyman's assumption of the throne until his last campaign illuminate the Ottomans' global reach.

Sultan Süleyman ordered or personally led a series of conquests that eventually brought his empire to its furthest territorial height to date, though there would be expansions and contractions along frontier zones in subsequent centuries. Contrary to the misleading view that the Ottoman Empire only expanded into Europe via land, Ottoman rivalries with European empires before, during, and after Süleyman's reign occurred frequently on both land and sea – with Venice and the Austrian Habsburgs in southeastern Europe, the Adriatic, and the eastern Mediterranean; with the Spanish Habsburgs in the western Mediterranean; and with the Portuguese in the Red Sea and the Indian Ocean. His empire now began the offensive in a two-pronged land and sea strategy of westward expansion.

The first in a series of military acts was the successful Ottoman siege of Belgrade in 1521, a strategic outpost on the Hungarian front that had eluded previous sultans. The Christian population of Belgrade was deported to the outskirts of Constantinople (called the Belgrade Forest today) to establish the city as an Ottoman *sancak*. From this initial conquest into the heart of the Balkans, the Ottomans could launch further assaults west. Shortly thereafter, in 1522, his forces besieged the Knights Hospitallers of St. John on the island of Rhodes, who had been harassing Ottoman ships in the eastern Mediterranean and, until now, also had been unassailable. The use of miners and artillery eventually shifted the battle in favor of the Ottoman army after a stalemate had endured for about six months: the Knights Hospitaller surrendered, with favorable terms granted to those civilians who remained and accepted Ottoman rule. The Knights Hospitallers evacuated Rhodes and relocated via Venetian Crete to Sicily, and eventually were granted Malta in 1530 by Holy Roman Emperor and King of Spain Charles V, as a means to protect the Habsburg southern frontier from pirates.

The Belgrade conquest had made possible the next land assault further into Hungarian territory, with the Battle of Mohács in 1526, in which the Hungarian forces were outnumbered by the Ottoman Janissary army and cannons. Perhaps the most significant result of this Ottoman victory was the hostilities it put in motion: the Hungarian king having been killed, Croatian-Hungarian submission to the Habsburgs occurred when Habsburg Archduke Ferdinand was elected king of Hungary (the northern and western areas). This brought the Ottomans into what would be direct, sustained conflict with the Habsburg Empire in the region of Hungary. A pro-Ottoman king had also been elected and made resident in Buda once Süleyman's forces seized the city in 1529; Süleyman and his army then continued on to Vienna, where they tried unsuccessfully to defeat the Austrian Habsburgs in a poorly planned siege in late 1529 in which wet autumn weather determined the Ottoman retreat for the season.

The Ottoman client king in Buda, John Szapolyai, governed eastern Hungary as the center of a new Ottoman province (*vilayet*), called Budin, until his death in 1540. In 1541, his infant son John II Sigismund and Hungarian mother Isabella were received by Süleyman in his tent as tribute-paying vassals; the child was confirmed on the throne, with Isabella as regent. In 1541 the Ottomans occupied Buda to resist Habsburg pressures and appointed a *beylerbeyi* to govern central Hungary. Süleyman then officially annexed eastern Hungary as a vassal Ottoman principality called Erdel (Transylvania). Hungary, now an Ottoman possession, became the site of numerous wars between Habsburg and Ottoman empires throughout the late sixteenth century, beyond Süleyman's death in 1566, and up to the late seventeenth century.

The truce between the two powers in 1547 was temporary and required the Habsburgs to pay annual tribute to the Ottomans. Further skirmishes and a sustained war (from 1593 to 1606) eventually resulted in the lapsing of Habsburg tributary responsibility. But conflict in Hungary between the two empires in Süleyman's lifetime was exacerbated by the advent of the Reformation: after Martin Luther's Ninety-five Theses of 1517 indicting the Catholic Church mobilized the Protestant movement and attracted Hungarian nobles into the Protestant fold, the Ottomans adeptly seized upon an opportune moment to support them against their mutual Catholic, imperial foe. Collaborating with the Protestants in Hungary allowed for Ottoman rule there, if somewhat precarious, for almost 150 years.

Struggles with Venice continued over dominance in the Mediterranean. In 1537 the Ottomans besieged and captured the strategic fortress of Klis, located high above the Venetian port of Spalato (Split) on the Dalmatian coast, north of the Ottoman tributary of Ragusa (Dubrovnik). It had been defended by a Croatian feudal lord, Petar Kružić, and a Slavic *Uskok* militia. When Kružić was captured and beheaded, the *Uskok* forces retreated to the Habsburg port of Senj further north on the coast, from where they could continue to harass Ottoman shipping at sea and raid into Ottoman territory. The fortress at Klis was the administrative center (*Kilis sancağı*) of the Ottoman province of Bosnia for a century – part of the border demarcation between (Latin and Catholic) Venetian Dalmatia and Ottoman Bosnia. The local Slavic population (Catholic, Orthodox, and Muslim) was sandwiched in between, and (Catholic) Habsburg pressure was exerted from the north. From

1537 to 1539 the Ottomans were able to push further into Venetian possessions, acquiring more of the Peloponnesus and Aegean islands.

Süleyman's ambition as a world emperor was not just directed against Christian European "infidel" rivals to the west, however. Competition with the Portuguese over the Indian Ocean spice trade resulted in naval conflicts off the Gujarati coast of the Indian subcontinent, the Horn of Africa and coastal East Africa, and the Red Sea in the 1530s, which continued until Sultan Süleyman's death in 1566. Although annexation of the southern Arabian peninsula – Yemen – had technically been achieved with Selim I's conquest of the Mamluk Sultanate, İbrahim Pasha (soon-to-be Süleyman's *grand vezir*) recognized while governing Egypt that to break the Portuguese blockade on the Red Sea and challenge Portuguese interests in the Arabian (Persian) Gulf and Indian Ocean, the local *emirs* and tribes in Yemen who resisted any central control had to be subdued and Yemen conquered. This the Ottomans did after a naval offensive in 1525–7. But due to infighting among Ottoman commanders and a willingness on the part of locals to collaborate with the Portuguese when convenient, it did not become an official Ottoman province until after the seizure of Aden in 1538. The Egyptian governor, with a Suez fleet under his command, took control of Yemen in 1539, though the Ottomans were not able to maintain a firm hold over Yemen permanently – a major rebellion occurred in 1567. The sultan of Gujarat, already in conflict with the Mughal Emperor Humayun, had made a plea for Ottoman assistance to oust the Portuguese from the region in 1536; an unsuccessful Ottoman naval offensive on Diu took place in 1538. The Ottomans may have hoped to assume a prominent position in the Indian Ocean as a supreme Muslim power in the eyes of local dynasts, but what occurred was just a formal détente between the Portuguese and the Ottomans, albeit with explicit conditions for trade imposed on each party. The Ottomans ultimately could not maintain their imperial reach much beyond control of the holy cities in Arabia: war with the Portuguese continued before long in the 1540s, resulting in a second failed Ottoman siege of Diu in 1546, failure to take Hormuz in 1552, and failure at Muscat in 1554. The Ottomans did establish the province of Habesh (Eritrea) on the African coast around 1555; a request from the sultanate of Aceh for Ottoman artillery to use against the Portuguese in 1562 resulted in merely a symbolic dispatch of Ottoman personnel and military equipment in 1568, and not much else.

Sultan Süleyman and İbrahim Pasha's desires to seize commercial hegemony for the Ottomans in the east dovetailed with their ideological motivations. Now the custodians of Sunni Orthodox Islam, on the Ottomans' eastern flank was the "heretical" Shi'ite Safavid Empire, with their unruly *kızılbaş* Turkic tribesmen still stirring up trouble in eastern Anatolia. The Ottoman Empire had a religious duty as defenders of Sunni Islam to combat this heresy and imperial challenge militarily when feasible – in consideration of the fact that conducting wars on eastern and western frontiers simultaneously was not strategic. Having calmed the Hungarian front after 1529, Süleyman's army captured Baghdad in 1534 in the "campaign of the two Iraqs"; several times the Safavid capital of Tabriz was seized temporarily (the Safavids eventually chose to relocate their center to Isfahan around 1598). Basra became an Ottoman province by 1546. Another Ottoman-Safavid war

Figure 6.2 Süleyman the Magnificent Marching with Army in Nahçivan (Southeast of Yerevan, in Today's Azerbaijan), Summer 1554. Note the Crimean Tatar "deli scout" in the foreground.

in 1548–9 and yet another in 1553–5 (Figure 6.2) yielded Ottoman gains in eastern Anatolia, the western Caucasus, and in Mesopotamia.

Ottoman relations with Muscovy based upon mutually beneficial trade and joint opposition to the Poland-Lithuanian Commonwealth did not immediately suffer after Ivan IV became the Russian tsar in 1547. The Crimean Tatars' tributary relationship with the Ottomans and Tatar raids into Ruthenian territory also did not initially sour Ottoman-Muscovy interactions (Ruthenians were eastern Slavic peoples in today's Belarus, Ukraine, and Russia called Rus' who adhered to either the Eastern Orthodox or Greek Catholic Christian rites). As trading partners overland or via the Black Sea, which had effectively become an "Ottoman lake" by 1484, a stabilized borderland relatively free of piracy led to lucrative commerce involving silks and spices exported by the Ottomans, while slaves, furs, agricultural products, raw materials, etc. were imported from the north to Ottoman lands by Crimean, Genoese, and other merchants. Ivan IV seized the khanates of Kazan and Astrakhan, however, in the 1550s; the Ukrainian and Russian Zaporozhian and Don Cossacks, eastern Slavic Christians who formed militia-type communities in regions north of the Black Sea, started conducting more sea raids on the Crimean Khanate and into Ottoman territories using their longboats in the latter part of the sixteenth century, foreshadowing the adversarial relationship to come between the Ottoman and Russian empires from the seventeenth century onward, and ultimately the decline of Ottoman power in the Black Sea. But Süleyman generally enjoyed a northern frontier that was mutually beneficial to the Ottomans and Muscovy.

Figure 6.3 Ottoman *Grand Vezir* Sokollu Mehmed Pasha Helping the Ailing Sultan Süleyman while on Campaign. Lokman's *Zafarname*, 1579.

In an effort to establish Ottoman dominance over the eastern Mediterranean and combat the Knights Hospitallers of St. John in Malta who were using North African Tripoli from which to raid Ottoman shipping, the Ottomans attacked and seized the fortress in 1551. Malta was quite literally the gateway to penetrating the western Mediterranean, which could then facilitate Süleyman's push further into Europe, and the decision was made for the island to be an Ottoman target. The Knights Hospitallers, however, resisted the siege successfully in 1565; this Ottoman failure was perhaps the foreshadowing of later Mediterranean setbacks to come. There would be subsequent Ottoman defeats in wars, losses of territory, some temporary, some permanent, and some Ottoman retrenchment from the seventeenth century onward. But Kânûnî Sultan Süleyman died on campaign in Szigetvár, Hungary, in 1566, having led most of the campaigns personally (Figure 6.3). Seemingly on a campaign aimed again at the conquest of Vienna, his army succeeded in conquering the heavily fortified, moat-surrounded, multichambered Hungarian town and fortress there in the autumn of 1566, though he did not live to see it – he died in his tent

The Ottoman Empire in the Reign of
Süleyman the Magnificent, 1566

Map 6.3 The Ottoman Empire in the Reign of Süleyman the Magnificent, *c.*1566.

the day before the battle was won by his unknowing Janissaries, his death kept secret by *Grand Vezir* Sokollu Mehmed Pasha in order to maintain troop morale.

Building on his predecessors' military and imperial successes, Süleyman had pushed the territorial boundaries of the Ottoman Empire to what seemed to be its outermost limits by the end of his reign (Map 6.3). His empire engaged fellow powers in commerce and conflict, coming into contact with cultures from the Russian steppe and eastern Europe, to North and East Africa, the Arab Middle East and the Persian frontier, to as far away as southeast Asia, who viewed the sultan and his empire alternatively as the greatest military threat, or as a Muslim sovereign par excellence. The sheer magnitude of the Ottoman territorial expanse by the sixteenth century and the manpower and resources required to maintain control over peoples, revenues, and trade routes, the stunning ability of the Ottomans to be able to move or transport whole communities, military forces and supplies, natural resources,

livestock and foodstuffs across the empire as needs arose, should leave one in awe of this polity. The Ottoman Empire has been labeled a "provisioning organism" because of its highly adaptive and flexible nature, and the ability of the Ottomans to mobilize what was needed at any time or place in order to survive internal calamities as well as wartime exigencies. How was this provisioning system maintained in the sixteenth century and beyond?

STRUCTURES OF EMPIRE AND OTTOMAN GOVERNANCE

The Ottoman state apparatus that developed in the sixteenth century required ministerial and military positions to be increasingly occupied by non-Muslim *devşirme* slave recruits who were educated, Islamized, and moved up the Ottoman ranks usually through a meritocratic system. These talented, ambitious and often ruthless individuals frequently became connected to the dynastic state through marriage and patronage, the combination of which could yield personal power and financial gain as well as vulnerability to political intrigues. Ottoman pragmatism and flexibility was again at work: the early Ottoman pattern of forging marital alliances with outside powers for political benefit when the dynasty was less secure in power was now carried out internally, to link these new Ottoman elites to the dynastic household. Such marriages could legitimate elites' roles in governing, but created at times lethal competition among them for the sultan's favor, thus helping him to curb their potential to challenge his preeminent authority. For example, several of Sultan Süleyman's *grand vezir*s and their close connections to the dynasty fit this description of the ruling elite: İbrahim Pasha (*grand vezir*, 1523–36), friend, advisor, and confidante to the sultan, was entrusted with serious affairs of state from the moment of his assumption to the office. He was later strangled on the sultan's order, seemingly due in part to intrigues by rivals at court. Rüstem Pasha, another powerful *grand vezir* with a lengthy tenure (1544–53; 1555–61), interrupted once after being implicated in the execution of Süleyman's son Mustafa, married Süleyman's daughter Princess Mihrimah; he was recalled to serve again and amassed property and wealth empire-wide. Sokollu Mehmed Pasha (*grand vezir*, 1565–79) outlived Süleyman, continued to serve as *grand vezir* for his son Sultan Selim II and grandson Sultan Murad III, married into the dynasty as well, and extended his elite status to a network of family members who continued to occupy prominent posts in the Ottoman central government and in the provinces.

Sultan Mehmed II had previously formalized the tradition of a consultative body for sultans seeking advice on various affairs into an Imperial Council, or *Divan-i Hümayun*. Originally established as a forum for deliberating financial and taxation issues as well as hearing petitions and dispensing justice along the lines of the Circle of Justice, sultans initially participated in these meetings. After Mehmed II, and particularly from Süleyman I's reign, sultans tended not to attend the council, but listened secretly from a window overlooking the *Divan* as issues of empire were debated and discussed, creating distance between ruler and ruled that contributed to the increasingly mysterious aura around sultans. The majority of the officials in attendance by the sixteenth century were Muslim converts of

PROS AND CONS OF BECOMING AN OTTOMAN RULING ELITE: PARGALI İBRAHIM PASHA (b.1493–d.1536)

The career of İbrahim Pasha started humbly. Born of Christian parents in Parga, Greece, under the rule of the Republic of Venice, as a young boy he was stolen by pirates who sold him into the Ottoman slave recruit system. He ended up a childhood comrade in the household of Prince Süleyman in Manisa and was educated for the palace service. This friendship and connection to him was rewarded upon Süleyman's accession to the throne with not just direct and private access to the sultan and a palace of his own, but with the promotion to Head Falconer and, in 1523, to the prestigious and very powerful position as *grand vezir*, followed also by the post of *beylerbeyi* of Rumelia. Such direct advancement from palace service to these posts was unprecedented and drew resentment from rivals at court. He was married to a woman with connections to the Ottoman governing elite in an elaborate public celebration designed to demonstrate his new status as well as the sultan's imperial grandeur. Despite being integrated into the Ottoman elite, he maintained ties to his familial roots.

Dispatched in 1524 to Egypt to suppress a revolt by a disgruntled former *vezir* and current governor Ahmed Pasha, İbrahim Pasha is credited with administrative reorganization of the rich province of Egypt in 1525, with its geographic centrality along important trade routes. He also promoted the cartographical work of Piri Reis, and the efforts of other corsairs as tools to combat Portuguese operations in the Indian Ocean and incursions into the Red Sea (through the short-lived Ottoman control of Yemen). He accompanied Süleyman on campaign as commander of the Ottoman army in Hungary in 1526 and in the failed Vienna campaign of 1529. Turning east to the Safavids, under his command the Ottomans captured Tabriz in 1534, and Baghdad surrendered shortly thereafter. Back in Istanbul by 1536, he represented the Ottoman position while negotiating an economic and political agreement with the French (the Capitulations; see also Chapters 4, 8, and 9) that allowed for cooperation against the Habsburgs.

İbrahim's rapid rise to power and execution by order of his patron, the sultan, illustrates both the diffusion of dynastic authority to elites beyond the imperial family, and the benefits and risks involved in participating in Ottoman ruling circles as a servant of empire. His unabashed ambition, training, and skills both in governing and in diplomacy led to tremendous wealth and political power, yet made him vulnerable to sultanic distrust and intrigues at court which cost him his life. Having made arrogant claims rivaling the sultan himself while on the "campaign of the two Iraqs," he was later strangled in his bedchamber in Topkapı Palace in 1536 and buried in an unmarked grave. İbrahim Pasha, who had been nicknamed "Makbul" – "the favored one," later became known as "Maktul" – "the executed." Political rivals, Sultan Süleyman's *haseki* (favorite concubine) and then wife, Hürrem Sultan, and İbrahim's own ambition have all been implicated in his demise.

SOKOLLU MEHMED PASHA
(b. 1505–d. 1579)

Sokollu Mehmed Pasha also emerged as a teenaged *devşirme* recruit from a Serbian Orthodox family of some standing in Bosnia, but personified an Ottoman servant rising through the ranks to the ruling elite through meritocratic means, with an intellectual curiosity and astuteness in governing that helped to make Ottoman universal sovereignty known across imperial boundaries, and over the reigns of three consecutive Ottoman sultans. Educated in Edirne Palace and then brought to Topkapı, he was believed to have been in the Iraq campaigns before returning to serve in the interior treasury and eventually in various posts for Sultan Süleyman, as his valet-de-chambre, groom, stirrup-holder, and sword-bearer. In the 1540s his service shifted to the outer palace, as chief taster and head imperial guard. In 1546 after the death of Ottoman Admiral Barbarossa, Sokollu Mehmed Pasha assumed the position of *kapudan pasha* in more of an administrative and logistical sense, whereas the famed corsair, Turgut Reis, carried out naval operations. By 1549 Mehmed had been made *beylerbeyi* (governor-general) of Rumelia, and field marshal in Rumelia commanding troops in the Transylvania campaign to reassert the sultan's sovereignty amid Habsburg resistance. By 1554 he was in the east to continue the war against the Safavids, his distinguished service earning him the position of third *vezir* in the Imperial *Divan*. When conflict between Süleyman's sons Bayezid and Selim appeared imminent while the sultan was still alive, he charged Sokollu Mehmed Pasha with seeking conciliation between the two. When this was not possible, Süleyman backed Selim with

an army commanded by Sokollu Mehmed Pasha, who ingratiated himself to the future Sultan Selim II (r. 1566–74), even gaining the hand in marriage of Selim II's daughter Ismihan Sultan in 1562. With the death of *Grand Vezir* Semiz Ali Pasha, Sokollu Mehmed Pasha assumed the office of *grand vezir* in 1565, a position he would hold until his assassination in 1579 (there are conflicting theories as to the motive of the knife-wielding assailant).

Sokollu Mehmed Pasha served sultans Süleyman (d. 1566), Selim II (r. 1566–74), and Murad III (r. 1574–95), whether as a military planner (rather than combatant), a master negotiator with foreign adversaries and allies, or as an administrator balancing his supporters against court rivals. He amassed great personal wealth through his various tributary arrangements with Rumelian principalities, with Venice, etc. He governed quite successfully – maintaining order by reliance upon a network of his relatives and loyal servants placed in provincial and palace administration positions. For example, when the ailing Süleyman died on campaign in Szigetvár, Hungary in 1566, to maintain stability (and to guarantee his political position with the future sultan), Sokollu Mehmed Pasha concealed his death with the help of several associates until Selim II could get to Istanbul to be declared the next sultan. Hiding his death from the troops until Selim II met the army in Belgrade included having his secretary, Feridun, draft orders in Süleyman's name and having a servant impersonate the sultan riding in the carriage.

A visionary in terms of projecting Ottoman imperial power domestically and abroad and in

innovative strategies for expanding the empire, he commissioned many mosque complexes, *medreses*, and palaces, often drawing on the expertise of the famous Ottoman architect of the day, Sinan. His engineering plans typically possessed multiple purposes: his design for a canal connecting the Mediterranean and the Red Sea to more easily facilitate trade while providing the ability to mount more substantive naval challenges to the Portuguese never materialized (though the Suez Canal was finally opened in 1869). Nor did the canal between the Don and Volga rivers, which was hoped would assist in retaking areas lost to the Russian tsar, making possible another flank on the Safavids, and possibly facilitating local Muslim pilgrims undertaking the hajj, materialize in 1569. After the Ottoman seizure of Cyprus from Venice in 1571

and the disastrous sinking of the Ottoman navy at Lepanto shortly thereafter, Sokollu Mehmed Pasha directed fiscal policy to make possible the rebuilding of the Ottoman fleet within a year, as a show of resiliency and power to Europe.

After the passing of Sokollu Mehmed Pasha in 1579, the office of the *grand vezir* became less influential in the administration of the empire for a period of time (seventy-five to eighty years), with a virtual rotating door of *grand vezirs* in and out of office, until revived under an influential family, the Köprülüs. Meanwhile other members of the Imperial Council (the *Divan*), the *şeyhül-islâm*, as well as palace favorites (e.g., *valide sultan* [queen mother], *haseki* [favorite concubine], and *kızlar ağası* [chief black eunuch]) all became more powerful figures at court in decision-making.

slave (*kul*) origins: the "men of the sword," or those involved in political and military affairs, which consisted of the *grand vezir*, who was the sultan's second in command; on occasion, the *beylerbeyi* (governor-general) of Rumelia, who was the commander of the *sipahi* cavalry; and the commander of the Janissaries and other lesser ministers (*vezirs*), who assisted the *grand vezir*, who were added to the *Divan* over time. The "men of the pen" in attendance, or the administrators or bureaucrats, included the *başdefterdar* (the chief finance minister overseeing the Treasury and his underlings) and the *nişancı* (head of the imperial chancery). The *reis ul-küttab* (chief of the scribes responsible for administrative orders, correspondence, etc.) attended to assist in *Divan* affairs. As the empire's domains grew larger, with more and more provincial possessions to survey and manage, the bureaucratic class of record-keepers and scribes expanded numerically in the sixteenth century with the increase in the chancery's duties (supervision of *timar* grants, drafting the sultan's law codes, diplomatic correspondence) and the administration of fiscal-taxation issues (including an increase in the number of treasuries across the empire). Bureaucratic career paths entailed gaining a specialized expertise through years of service as a protégé mentored by more senior official(s) in one or the other of these Ottoman offices.

The *ulema* or religious class was represented in the *Divan* by the two *kadiaskers* (military judges for Rumelia and Anatolia, respectively). The *ulema* were, unlike the other members of the *Divan*, not of slave-recruit origins, but were freeborn Muslims. Almost

from the Ottoman *beylik*'s inception the Ottoman sultans had established Islamic courts across the territories they controlled; these courts were staffed with judges (*kadıs* or *kazıs*) appointed, dispatched, and in government service as part of the state. Governing locally in conjunction with *timar*-holding *sipahi*s and provincial governors, judges' roles were to "define property rights and subjects' obligations, and maintain communal peace" – in short, to apply Ottoman law that often "accommodated the legal practices and cultures they encountered."[2] These men were educated in *medrese*s and executed Islamic law according to the Hanafi school's methodology, which guided Ottoman society generally in matters of religious obligations and rituals, family (marriage, inheritance, etc.), and contracts, for example. Where Islamic *şeriat* law was ambiguous or lacking, in areas not explicitly covered in the Qur'an – concerning criminal law, land tenure, and taxation, the Ottoman state then had to continue to decree and codify secular laws, which often also incorporated customary law or practices inherited as the Ottomans expanded into new regions and governed over larger, more diverse populations. A hierarchy of judicial positions developed in the smaller courts within provinces of the empire to apply these laws and document records in court registers (*sicil*s) as Ottoman territories grew, with the two *kadiasker*s responsible for overseeing the judges ranked below them in Rumelia and Anatolia, respectively.

Sultan Süleyman built upon and clarified the *kânûnnâme*s promulgated by the previous three sultans some time in the 1540s, formulating a seminal imperial legal code to regulate Ottoman society as a whole that endured with few alterations (mainly to do with taxation) until the late seventeenth century. He expanded the position of the *şeyhül-islâm* (*shaykh al-Islam*), who ultimately emerged as the highest-ranking member of this religious class. *Şeyhül-İslâm* was originally a title for an Islamic jurisprudent of the *ulema*, who was also known as a *müfti*. Unlike *kadıs* (judges), *müfti*s, or Islamic jurisprudents, were not initially appointed officials, but rather were learned members of the *ulema* class whose opinions were respected and binding. They produced legal pronouncements called *fetva*s, which were sought after by sultans and judges alike to assist in their deliberations. What occurred between the fifteenth and sixteenth centuries was an evolution of Ottoman judiciary offices: from Murad II's reign, the *şeyhül-islâm* connoted an official title; by the early sixteenth century the *şeyhül-islâm* held a professorship at Bayezid II's *medrese*, he supervised sultanic *vakf*s, and oversaw *ulema* appointments such as those of judges and teachers. Additionally, Ottoman *müfti*s were incorporated into the state bureaucracy. A hierarchy of *müfti*s came to be presided over by the *grand müfti* in Istanbul. Sultan Süleyman appointed Ebu Su'ud (b.1490–d.1574), the *kadiasker* in Rumelia, as *grand müfti* of Istanbul in 1545, and ultimately the post was merged and became synonymous with the office of the *şeyhül-islâm*, the highest religious legal authority in the Ottoman Empire until the twentieth century.

The *şeyhül-islâm* held tremendous power because he affirmed the sultan's authority, but owed his status in large part to his appointment by the sultan (thus his dismissal or execution could be possible as well). In Sultan Süleyman's reign, he and Ebu Su'ud were responsible for reconciling Ottoman *kânûn* and *şeriat* law, thus the sultan's nickname "the lawgiver." Their harmonizing of the law code was part of the overall centralization process

at work in the capital that solidified the Sunni orthodoxy as official Ottoman religious doctrine and guaranteed Ottoman law and justice throughout the realm.

Sultan Süleyman, recognizing that the further development of naval forces had become an imperative due to the growing importance of the Ottoman navy for conquests and guarding commercial interests in the Mediterranean, made another modification to the governing offices of the empire. In 1534 Süleyman enlarged the Imperial *Divan* by adding a successful North African pirateer or corsair operating out of Algiers, after bestowing the title of *kapudan pasha*, or naval grand admiral, upon him. Named Hayrettin Barbaros – more commonly known as Barbarossa – a name from the Italian "Barba-Rossa," or "Redbeard," he was also rewarded with islands to govern in the Aegean, including Rhodes. Ottoman naval forces under Barbarossa conquered Tunis in 1534; though it was taken by the Habsburgs a year later, Barbarossa defeated the Holy League in 1538. Tunis, due to its strategic location as a gateway into the western Mediterranean (like Malta), continued to be a site of Ottoman-Habsburg naval battles with control of the port flipping back and forth between the two from 1569 to 1574. Ottoman competition with the Habsburgs and the Knights Hospitallers based on Malta in the eastern Mediterranean over control of Tripoli on the North African coast continued after Barbarossa's death in 1546, and into the 1560s.

PROJECTING OTTOMAN PRESTIGE

Sultan Süleyman, his *vezir*s and advisors all keenly recognized the need to project Ottoman power and authority to European empires as well as to Muslims in the world, both within Ottoman lands and to those further afield, something Sultan Mehmed II before him had also clearly understood. Süleyman extended the reach of Ottoman prestige in several ways: first, in combination with the elaboration of imperial rituals and ceremonies to enhance the dynasty's symbolic authority, sultans increasingly retreated from public view as austere monarchs, except when attending Friday prayers, or leaving or returning from campaign. Ottoman wealth and greatness was expressed through lavish public celebrations and feasts to mark special occasions, such as *Grand Vezir* İbrahim Pasha's marriage to the daughter of an elite family, or festivals in honor of the marriages of Ottoman princesses and the circumcision of princes. Second, Süleyman's chief architect, Mimar Sinan Pasha, constructed mosques as masterpieces that dotted the Ottoman skyline across the empire in stunning displays of Ottoman power even after Süleyman's death.

Third, for both European and Muslim audiences, Sultan Süleyman assumed more titles to emphasize his status as supreme Muslim sultan and world emperor. By the end of the fifteenth century Ottoman sultans already claimed to be "the best of *ghazi*s and of fighters in the Holy War"; his father Sultan Selim I had assumed the title of "Servitor of the Two Holy Sanctuaries" and protector of the pilgrimage route, and had the Prophet's relics sent to Constantinople, seeing himself as possessor of the "exalted caliphate" after the conquest of the Mamluk Sultanate, as Ottoman chroniclers Neşrî, Kemalpaşazade, and İdris all described. The local custodian of Mecca and Medina, the *sharif* of Mecca acknowledged

BARBARY CORSAIRS, OTTOMAN ADMIRALS

The "Barbary Coast" of North Africa, named for the Berber influences at work there, became famous for its pirates who raided Christian ships and the coasts of Spain and Italy for plunder and slaves. Experienced sailors Oruç Reis and his brother Hızır (later known as) Hayrettin Barbaros (Figure 6.4), born to an Ottoman *sipahi* on Ottoman Midilli Island (Lesbos, Greece, today) in the 1470s, gained much of his early privateering in the eastern Mediterranean combatting the Knights Hospitallers, who harassed Ottoman shipping, on the island of Rhodes. At one point Oruç was captured and imprisoned for about three years by the Knights.

The brothers found their way eventually to North Africa, conducting operations from Algiers after they had ousted the Spanish, and Oruç ruled rather independently as the sultan of Algiers until accepting formal Ottoman overlordship in 1517 when Algiers became an Ottoman *sancak* (province); Oruç then assumed the title of *beylerbeyi* (governor-general) of the western Mediterranean. Ottoman pragmatism was at work again: the Ottoman state recognized the benefits of incorporating these seasoned pirates into the more formal Ottoman naval forces that had been established closer to the Ottoman imperial center, as a way to extend Ottoman reach at sea and occupy the enemy ships of Spain in the western Mediterranean with able Ottoman seamen and corsairs.

Oruç Reis was killed fighting the Spanish at Tlemcen in 1518, and Hayrettin then assumed his titles and position in Algiers, inheriting the nickname "Barbarossa." He continued piracy and raiding against Europe in his wide-ranging sea battles primarily against the Spanish Habsburgs, ultimately being summoned to Constantinople in 1533 by Ottoman Sultan Süleyman to receive distinction as *kapudan-i derya*, or grand admiral of the Ottoman Navy. Barbarossa sent an envoy to the king of France, and the French concluded an alliance with Ottoman Sultan Süleyman to cooperate against the Habsburgs; a joint naval force with the French in 1543 allowed them to capture Nice, and the Ottoman fleet wintered in Toulon the same year. Hayrettin Barbaros died in Constantinople in 1546 but had dictated his memoirs before he died.

Figure 6.4 Barbarossa, Ottoman Grand Admiral of Süleyman the Magnificent. Painted by Nigari, sixteenth century.

in a letter that Süleyman now occupied "the seat of the Sublime Sultanate and the dignity of the Great Caliphate" upon his accession to the Ottoman throne. Süleyman's response in 1526 to a request of assistance from Francis I against the Austrian house after the French king had been captured and imprisoned by the Holy Roman Emperor Charles V at the battle of Pavia, Italy, in 1525, illustrates Süleyman's embrace of more grandiose titles and his view of the French king as a lesser sovereign:

> I, who am the sultan of sultans, the sovereign of sovereigns, the dispenser of crowns to the monarchs of the globe, shadow of god upon earth, the sultan and Padishah of the White Sea [Mediterranean] and the Black Sea, of Rumelia, Anatolia, Karamania and the land of Rum, of Zulkadir, Diyarbakir, Kurdistan, Azerbaijan, Persia, Damascus, Aleppo, Cairo, Mecca, Medina, Jerusalem, of all Arabia, of the Yemen and those other lands which my noble forefathers and my glorious ancestors – may God brighten their tombs! – conquered by the force of their arms and which my august majesty has likewise conquered with my flaming sword and victorious blade, I, Sultan Süleyman Khan, son of Sultan Selim, son of Sultan Bayezid, to thee, who art Francis, king of the province of France....[3]

Early in his reign he embraced the notion of being a *sahib-kıran* – a prophesied "universal ruler" of sorts that would usher in the coming of the apocalyptic Day of Judgement for Muslims – a prophesy which originated with interpretations of the Book of Daniel and that was indicative of a spiritually turbulent time in Christendom as well, when millenarian movements cropped up in many regions of the world. As the Ottoman state acquired a more orthodox Sunni Muslim character, Süleyman's titles reflected the dualistic nature of his claims, directed at both his subjects and to foreign powers, to appeal to Muslims as "the lawgiver," and to subordinate Europeans, as an inscription from 1538 illustrates:

> I am a slave of God and I am the master in this world.... God's virtue and Muhammed's miracles are my companions. I am Suleyman and my name is being read in the prayers in the holy cities of Islam. I launched fleets in the Mediterranean on the part of Franks in Maghreb as well as in the Indian Ocean. I am the Shah of Baghdad and Iraq, Caesar of the Roman lands and the Sultan of Egypt. I took the land and crown of the Hungarian king and granted it to one of my humble slaves.[4]

The rivalry with the Habsburg monarchs over who was the true inheritor of Greek and Roman civilizations and thus could be designated "Holy Roman emperor" was expressed in titles, deeds, and dress. Correspondence with Ferdinand and Charles V reflected Süleyman's claim to be "master of the lands of the Roman Caesars and Alexander the Great."[5] *Grand Vezir* İbrahim Pasha commissioned Venetian artisans to make a gold, four-tiered crowned helmet with pearls and diamonds for Sultan Süleyman in 1532 which resembled Habsburg and papal headgear; a bejeweled sceptre and throne were also delivered, neither of which

Figure 6.5 Scholars and Artists Meeting to Collaborate on a Manuscript during Selim II's Reign (r.1566–74).

had been seen before in the court of Ottoman sultans, and Süleyman was reportedly seen sporting a "papal-style tiara" and turban when proceeding on horseback while in view of Habsburg enemies, all of which art comprised an "iconography of power."[6] His *grand vezir*, Lutfi Pasha (1539–41), further encouraged the notion of Ottoman possession of the Islamic Caliphate by the will of God, and Ebu Su'ud drew up the *Kânûnnâme* of Buda 1541 in which the sultan was described as the "Inheritor of the Great Caliphate … Possessor of the exalted Imamate, Protector of the Sanctuary of the Two Respected Holy Places."[7] By the 1550s Süleyman had fully resurrected the idea of a leader of all Muslims, a custodian of the holy cities of Islam, combatting the infidels of Europe, claiming to be the "Caliph of the Whole World" or "Caliph of all Muslims in the World."[8] In these latter years of his reign, a more somber and pious tone prevailed in his titles and portraiture. At the behest of his *şeyhül-islâm*, the inscription on the gate of the Süleymaniye Mosque complex finished in 1557 reads:

> This slave of God, powerful with God's power and his mighty deputy on the Earth, standing by the commands of the Quran and for the execution of them all over the world, master of all lands, and the shadow of God over all nations, Sultan over all the Sultans in the lands of Arabs and Persians, the propagator of the Sultanic laws, the tenth Sultan among the Ottoman Khakans, Sultan, son of Sultan, Sultan Suleyman Khan….[9]

And finally, the rich collection of Ottoman miniature paintings such as those seen in previous chapters are from sixteenth-century manuscripts commissioned by Ottoman

Figure 6.6 (following pages) The Funeral Procession of Sultan Süleyman, *c.*1566. From Lokman's *Zafarname*, Istanbul, 1579.

Sultan Süleyman I and his immediate successors who recognized the importance of patronizing the arts for imperial benefit – by depicting Ottoman history to legitimate the dynasty in perpetuity. Building on the previous Islamic tradition of miniature painting that had developed among Muslim dynasties in the Middle period (roughly tenth to fifteenth centuries), adhering to Persianate culture such as the Seljuks, Ilkhanids, and Timurids, Ottoman Sultan Mehmed II had established an imperial scriptorium, or *nakkaşhane*, in Constantinople after the conquest in 1453. It housed various craftsmen and artists who collaborated to produce illustrated manuscripts. Increasingly Ottoman miniature painting emphasized major victories and achievements of the patron-sultan rather than the legends and feats of rulers in the past, in order to legitimate and project Ottoman dynastic power. Portraiture mimicking European artists' renderings had also become a significant aspect of rulership; from Mehmed II's era sultans had employed both Ottoman and western artists for this task. Sultan Selim I's defeat of the Safavids in 1514 resulted in many of the craftsmen from eastern lands with expertise in Persianate miniature painting to either be brought or migrated to the Ottoman capital to serve the sultans. But the pinnacle of miniature painting to represent the preeminent and universal authority of the Ottoman dynasty happened with Sultan Süleyman I and his immediate successors in the sixteenth century. Around the 1540s he created the post of *şehnameci*, or official court historian, who was responsible for organizing and drafting illuminated manuscripts in Persian, with a team of artists who collaborated on the final book creation (Figure 6.5). The Turkic nomads of Central Asia – and typically nomads had an oral culture and so did not become aware of the need to write their dynasty's history for a few hundred years – had settled down and established an imperial world empire, the Ottoman Empire. In recognition of their achievements, colorfully detailed, illustrated chronicles were produced to tell the Ottoman story. Even Sultan Süleyman's death was beautifully recounted in the annals of Ottoman illustrated manuscripts (Figure 6.6).

DISRUPTION IN SUCCESSION

Sultan Süleyman's personal choices initiated radical changes in Ottoman dynastic reproductive politics – ultimately altering the succession system forever when, in an unheard of action, he married his concubine. The daughter of a Ruthenian priest of Ukrainian, Polish, or Russian descent in Rohatyn (in today's western Ukraine), Alexandra Lisovska (b. 1505), or "Roxelana" as she is known in the West (for her Ruthenian roots), was kidnapped in a raid by Crimean Tatars and sold into slavery, taken to Constantinople, and eventually ended up in the harem of Süleyman (Figure 6.7). She converted to Islam, and bore him a son named Mehmed in 1521. Reportedly they had fallen deeply in love, she assumed the name Hürrem, and soon became his *haseki*, the chief consort. Letters of poetry between the sultan and Hürrem when he was away on campaign attest to their devotion. She displaced Mahidevran (known also as Gülbahar), his previous *haseki* and mother of his

son Mustafa, whom he then sent to Manisa. Breaking with tradition, Hürrem Sultan and Süleyman married at some point. Contrary to former reproductive restrictions placed on concubines, as his wife, she had at least four more sons and a daughter, Mihrimah. Also contrary to the open succession system developed earlier, she remained in the capital, first in the Old Palace, then relocated to Topkapı permanently, where she played a major role not just as the sultan's advisor and confidante, but sometimes also engaged in foreign correspondence on behalf of Süleyman. As was typical of Ottoman dynastic women, her power was expressed outside the palace through commissioning the building of charitable works (*vakfs*) locally in Istanbul, as well as further afield, in Edirne, and at the holy sites in Mecca and Medina. Rumors abound of her intrigues at court leading to the deaths of opponents, and to a rather negative view of her overall. Reportedly jealous of İbrahim Pasha's closeness to the sultan and his support for a rival concubine's son Mustafa as heir to the throne, Hürrem Sultan has been implicated in İbrahim's fall from grace and ultimate execution at Süleyman's order. The subsequent execution of Mahidevran's son Prince Mustafa in 1553, again at the order of the sultan after rumored accusations of his intention to overthrow his father, is also often blamed on Hürrem Sultan's plotting with her son-in-law and *Grand Vezir* Rüstem Pasha for one of her own sons to inherit the throne instead. She died in 1558 and did not witness the mortal struggle between her own two remaining sons, Bayezid (killed in 1562) and Selim II, the less capable of the two, who would become the next sultan.

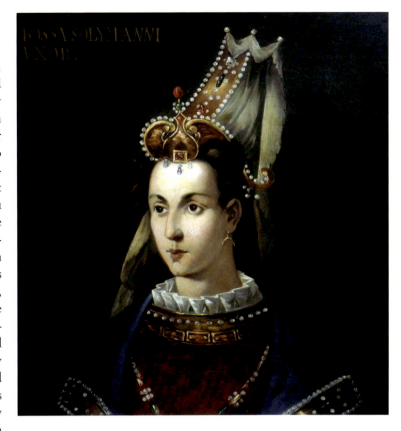

Figure 6.7 Portrait of Roxelana (*c.* Sixteenth Century). Artist: Anonymous.

From this moment on, the Ottoman open succession system ceased to be the rigid management of heirs that it once was – the *haseki*, the favorite, often bore multiple sons for the sultan, and while competition between sons did not cease, after Sultan Murad III's reign (r. 1574–95), princes were no longer being dispatched to the countryside to gain administrative and military experience. Competition over succession in the dynastic household took place within Topkapı Palace, between a queen mother (*valide sultan*), the mothers of princes, the sons, and their respective supporters, in a period that was pejoratively labeled "The Sultanate of the Women." The heirs apparent were increasingly isolated in the palace, devoid of the opportunities to gain knowledge and skills in the outside world that would assist in governing the empire, and subject to both the perils of palace intrigues and personal problems (mental illness, alcoholism, etc.). The succession system would suffer

VAKFS: PIOUS ENDOWMENTS

An institution Islamic in origin and varied in type, prolific in the empire, and of great benefit to Ottoman society in daily life as well as to the administration, was the pious endowment or *vakf* (in Turkish; plural *evkâf*; from the Arabic *waqf*). A *vakf* was a permanent religious endowment, a kind of fiscal trust, typically set up for immovable property in perpetuity, the income from which was to be used for charitable purposes and the public good. The person owning such a property would donate it for a particular purpose, either while still alive, or upon the death of the founder. The property donated could be cultivable land, an orchard perhaps, bathhouses (*hamams*), or some shops (*bazaar*).

As an act of personal piety, a gift to God which benefitted the people, this property served public welfare and was administered either by a person or persons independent of the Ottoman state government, protected by members of the religious *ulema* class, or possibly administered by the *ulema* themselves. As such, revenue generated on the *vakf* property by the goods or services provided was used to maintain the property's upkeep and pay any salaries or other costs required to keep it functioning. This revenue was tax free, and the Ottoman state could not seize it upon the death of the founder. Some of the many examples of *vakf*s to benefit society were lands used to house Sufi lodges (*tekke/zaviye*), libraries (*kütüphane*), orphanages (*yetimhane*), mosque complexes (*külliye*) that might include a school (*medrese*) or a soup kitchen (*imaret*), caravanserai inns/hostels (*khan*), hospitals (*darül-şifa*), or even water fountains (*çeşme*) or a bridge (*köprü*) over a river.

"Sultanic *vakf*s" were the prerogative of the dynastic family; that is, those done to honor religious sites (e.g., the Dome of the Rock in Jerusalem, the *Harameyn*, meaning the two holy sanctuaries of Mecca and Medina, which contain the mosques with the Ka'aba in the former, and the Prophet Muhammad's tomb in the latter), or to develop urban areas. Many Ottoman royal women endowed properties as a show of dynastic power. Pasha households whose patriarch had been originally of slave recruit origins were known to endow properties later in their lives, establishing them in their birthplace to serve the community from which they came. By the eighteenth century it was possible for anyone to establish *vakf*s. In addition, *evkâf* sometimes became corrupted so that the income from them was funneled back to the founder or the founder's heirs directly – because it was non-taxable and non-confiscatable, *vakf*s led to a degree of financial decentralization in the empire. A controversy emerged surrounding the extension of this notion of the pious endowment in the Ottoman Empire to "cash *vakf*s," the lending out of monies from the *vakf*'s operation at interest to fund services for the public good. Usually considered against Islamic law, as it was considered a form of usury, it was made permissible through an Islamic legal decree in 1548.

While initially founded to provide services for the general welfare, the *vakf* also furthered interests of the Ottoman state. In more peripheral or remote areas of the empire, allowing the founding of *vakf*s by individuals was a means of establishing much needed institutions or infrastructure across an empire whose border regions were far from Constantinople and were often difficult for the authorities to manage. *Vakf*s could provide the central state with an outpost, a means of provincial security, as well as supplying provisions for the frontiers if the state could not secure the resources directly.

from a less capable pool of heirs apparent after this, with few exceptions, and shifted to the seniority principle by the early seventeenth century, when ascension to the Ottoman throne passed to the eldest living male relative.

FROM CENTER TO PROVINCES

Provincial organization evolved into a flexible yet interlocking hierarchy of positions, with financial and political linkages back to the imperial center. Administration of and military command in provincial areas more distant from the capital were slowly shifting from family members and local marcher lords to appointed officials who had initially been drafted in the *devşirme*, trained by means of the *kapıkulu* system, and rotated through various provincial postings on a semi-regular basis, to prevent, it was thought, accumulating too much power and prestige locally – though it still occurred. Often the *kadı* served all the functions of scribe, tax office, and judge in a locale. The appointment of a governor and chief judge was the general pattern of rule in the Arab provinces between the sixteenth and eighteenth centuries. But Ottoman pragmatism in governing the provinces was evident, and often developed in a rather ad hoc manner, in accordance with local circumstances. Ottoman rule has been described as "an enduring imperial style" that had two essential features:

> First, the empire possessed an extraordinary ability to find those few local residents who were willing and able to keep vast territories friendly to the House of Osman. Second, the Ottoman imperial administration had an uncanny knack for going into a newly conquered area and figuring out how things were done there. Having read the local landscape, it would adjust imperial rule accordingly. In short, the extraordinary sensitivity of the Ottoman elite to local conditions allowed them to build an empire across three continents that endured for many centuries.[10]

Appointing officials to provincial outposts to establish and maintain linkages with amenable and prestigious local notables (i.e., tribal chieftains, heads of wealthy families, *sharifs*, prominent Sufi shaykhs, merchants with trade networks, etc.) willing to cooperate with the Ottoman state when it suited their interests to do so, had a kind of stabilizing influence upon remote regions of the empire. This would manifest as the predominant Ottoman strategy for provincial management by the end of the sixteenth century, and it continued sometimes even into the nineteenth. Dynasties of governors with local roots emerged in Baghdad (of *mamluk* origins), Damascus (the al-'Azm family), and Mosul (Jalili family) for example, who collaborated with the Ottoman state as a Sunni Muslim elite guaranteeing stability. To secure the Ottoman-Safavid frontier as a kind of buffer zone, particularly after Selim I's campaign against the Shi'i

Safavids and their *kızılbaş* sympathizers, Kurdish tribes comprised a kind of confederation of emirates in eastern Anatolia who were recognized by the central authority as the autonomous principalities there, with their tribal heads, *mir*s, granted hereditary leadership status by the sultan in the sixteenth century. Many were converted into Kurdish fiscally defined *sancak*s over time; some of these were later attached to larger provincial *vilayet*s to subordinate them, though the more territorially remote regions were left to function quite independent of the central state until the seventeenth century and sometimes beyond. Center-periphery relations in what was considered historic Kurdistan in eastern Anatolia was managed with a seemingly implicit understanding of mutual cooperation, loyalty to the state, and tribal autonomy, though if and when a revolt by Kurds did occur, the Ottoman state could and did suppress them and replaced the *mir* with a more amenable family member.

In North Africa, from the late sixteenth century to the eighteenth, Ottoman authority was tenuous at best. Ottoman employ of corsairs like Hayrettin Barbaros led in most cases to autonomously governed provinces by Janissaries (or other appointed officials who eventually put down roots locally), local North Africans of Muslim or Jewish descent, Bedouin, and European adventurers or renegades, former slaves, or converts from Christianity, who all established ruling households and competed for power and wealth. By the late nineteenth century these Ottoman provinces came under significant foreign pressure and colonial interventions, literally snatching from Ottoman hands the opportunity to recentralize and rule more directly. In Algiers, a Regency (autonomous rule in the name of the Ottoman Sultan by appointed individuals who extended their control over that region of coastal North Africa) was created from roughly 1515 first by the Barbaros brothers, with ongoing competition with the Spanish for it until 1580, and afterwards by other semi-independent pashas. By 1711 *dey*s (Ottoman title for the provincial ruler of a Regency) of Ottoman origins were appointed for three-year terms and held the Regency as *timar* lands, then as tax farms; with Ottoman sanction, *dey*s ruled in alliance with Janissaries, until the French invasion and beginning of Algeria's colonization by France in 1830. Tunis, captured briefly by Barbarossa in 1534, was lost to the Habsburgs and local rule was re-established in 1535; the Ottomans and Habsburgs competed for control over Tunis until in 1574. Ottoman rule was then reasserted and remained for several centuries as the autonomously governed province of *Ifrikiya* by a *dey* or governor appointed from Istanbul, until French occupation ensued in 1881. Tripoli (in Libya), mentioned previously, was besieged by the Ottomans in 1551 to combat the Knights Hospitallers of Malta pirating Ottoman shipping; Tripoli, though also semi-independent when a Janissary garrison founded their own regime, eventually had more direct Ottoman authority restored around 1835, and remained part of the Ottoman Empire until 1911, when Italy invaded in hopes of resurrecting an Italian "Roman" empire.

Some historians have argued, contrary to the stereotypical view of the Ottomans as merely militaristic and enslaving toward its empire's inhabitants in the countryside, that the Ottoman hand in provincial regions was at times too light compared to the centralization

of European empires, allowing too much autonomy to be able to preserve control – so that when the sultan and central authorities attempted to reform and recentralize the empire in the nineteenth century, the battle with recalcitrant locals had already been lost. Perhaps this analysis is rather superficial, given the changed world to come in the nineteenth century. As an example of Ottoman provincial flexibility amid changing circumstances, the Kurdish emirates that arose in the region between Ottoman and Safavid empires in eastern Anatolia in the sixteenth century were seen as early as Sultan Selim I's reign as a useful buffer provided they promised allegiance to the Ottoman state. Aware of their important position and location, the Kurds pledged loyalty to the Ottomans in return for the kind of privileges sometimes granted to non-Muslim *emirs* in the Balkans – tax exemptions or avoidance of conscription; in the Kurds' case, *istimalet* status: inherited rights to Kurdish emirate lands and autonomy. This would not really change until the political situation shifted with turmoil in, and a weakening of, Persia in the mid-1800s, Ottoman preoccupation with Russian dangers elsewhere (and Russian influence in Iran), and European support for non-Muslims in eastern Anatolia. By 1846 a *vilayet* of Kurdistan was officially declared in an Ottoman imperial order (*irade*) intended to dismantle the emirates and to bring the region under direct Ottoman control through various means: appointing regional notables as provincial officials to exert authority over the Kurds, suppressing rebellions militarily, exiling troublesome Kurdish leaders, yet granting privileged status to the *vilayet* and its inhabitants. The Kurds would no longer need to be used by the Ottoman state against Iranian dynasties, but to pacify non-Muslims in the area resisting Ottoman authority and where there was perhaps European backing. Ottoman policy here was pragmatic above all, allowing a preservation of governance at least until 1915.

During Süleyman's reign, modifications were made to regulating land tenure taxation known as the *iltizâm* system, which had likely come into use during Sultan Mehmed II's time. Earlier Islamic empires had already developed a land management scheme – the *ikta'* system – in which the right to collection of taxes was auctioned off to an individual (usually from the military) who then paid the state treasury a predetermined amount in advance and who could keep any surplus as profit. The Ottomans generally assumed this practice in conquered areas where it already existed. A *mukataa* in the Ottoman period was a tax farm, the tax revenue of which was generated from sources other than from crown lands (i.e., commodities, etc.). Similar to the *ikta'*, the right to *mukataa* collection was bid on, the amount was paid to the treasury in advance, and profits were pocketed by the holder of the right. *Timars* could potentially include revenues from a *mukataa*. To this was added the Ottoman *iltizâm* system: *iltizâm* referred to tax revenues collected from certain levies or from imperial lands; according to several studies on Ottoman tax farms, Sultan Süleyman's alteration granted the Ottoman Imperial Treasury the ability to add "military fiefs which it seized to the original Imperial domains, and also farmed out the new revenues it acquired."[11] Again public auction was the method for distributing these tax farms. This was a binding contract enacted for a one-to-three-year period, although settlement with the state occurred annually. Pre-determined revenues were to be paid to

the state treasury. Those *mültezim*s, the individuals given the lease to collect such taxes, were considered government officials whose bid had to be guaranteed by a banker or moneylender; no military obligation was required of them.

In the following century further revision of Ottoman fiscal administration was enacted amid several crises (to be discussed in subsequent chapters) requiring drastic measures. In 1695 lifetime tax farms were granted to generate quick cash for the Ottoman Treasury. This policy, called the *malikâne* system, dramatically augmented the long-term positive and negative effects of political and economic decentralization of the empire: designed to curb the abuses inherent in earlier tax farm contracts, holders of *malikâne*s accumulated massive wealth, much of which often did not flow back into the Ottoman Treasury.

DYNASTIC UPHEAVAL BEGINS

As a result of the change in the succession system, the next competition for the Ottoman throne among princes started before Süleyman I's death, between him and Hürrem's two remaining sons, Bayezid and Selim. Mahidevran's son Prince Mustafa had been executed previously at the sultan's order (court intrigue likely what caused Süleyman to believe Mustafa planned to usurp the throne); two other sons had also died earlier. Distrusting Bayezid's intentions as well, the sultan supported the faction around Selim in the princes' confrontation at Konya. Bayezid eventually fled the field and accepted an offer of asylum from the "heretical" Ottoman enemy, the Safavid Shah Tahmasp, perhaps Bayezid's most unforgivable action that sealed his fate. Selim had him murdered in the Persian capital in 1562. *Grand Vezir* Sokollu Pasha's ability to keep secret Süleyman's passing at Szigetvár in 1566 until the surviving heir apparent arrived at Constantinople cleared the way for the accession of Sultan Selim II (r.1566–74), a sultan less capable and very unlike his campaigning father. "Selim the Sot," as he was nicknamed, would spend far more time in the palace than sultans previously had, a patron of the arts who left the wars and Ottoman governance to his trusted *grand vezir* and military commanders.

Typically the enthronement ceremony (*cülüs töreni*) of a new sultan took place in Constantinople with a particular set of rituals that involved the donning of some of the Islamic relics kept in Topkapı Palace, certain Ottoman officials giving their oath of allegiance (the Islamic *bay'a*) – a kiss on the hand or prostration to the floor – and uttering blessings, followed by public pronouncements of the new reign and the sultan's name being read in the Friday prayer. Usually the previous sultan's funeral would also be held afterwards on the same day. But Süleyman had died in Hungary, creating some complicated circumstances. Just after his enthronement, Selim II visited the shrine at *Eyüp* (as was tradition before embarking on a campaign) before departing to meet the troops in Belgrade, creating what would henceforth become part of all subsequent sultans' accession ceremonies – after having taken a boat across to the Golden Horn and riding horseback to the mosque complex at *Eyüp* in a symbolic procession, seeking the saint's blessing and

(by Ahmed I's era *c.*1603) being girded with the symbolic "sword of Osman." For Selim II, another enthronement ceremony was held in Belgrade, but it was recounted that he had violated protocols, including the public statement requiring him to promise the Janissaries accession bonuses and offices, followed by monetary distribution. And upon return to the capital, the Janissaries mutinied, demanding their due of the new sultan until they were paid. This action by the rebellious Janissaries would foreshadow the troubled times ahead for Ottoman sultans who would increasingly be beholden to Janissary approval in order to remain on the throne. The Janissaries would become, especially by the seventeenth century, a kind of corporate body with their own group interests to demand and preserve, violently if necessary.

NOTES

1 Hazine 1563, folio 61a, Topkapı Palace Museum.

2 Kaya Şahin, "From Frontier Principality to Early Modern Empire," in *Routledge History of the Renaissance*, ed. William Caferro (New York: Routledge, 2017), 324.

3 Letter of 14 February 1526, National Museum of France, MS or Suppl. turc 822.

4 Halil İnalcık, "State and Ideology under Sultan Süleyman I," in *The Middle East and the Balkans under the Ottoman Empire: Essays on Economy and Society* (Bloomington: Indiana University Turkish Studies, 1993), 79.

5 İnalcık, "State and Ideology," 79.

6 Gülru Necipoğlu, "Süleymân the Magnificent and the Representation of Power in the Context of Ottoman-Habsburg-Papal Rivalry," in *Süleymân the Second and His Time*, eds. Halil İnalcıl and Cemal Kafadar (Istanbul: ISIS Press, 1993), 170.

7 Halil İnalcik, "The Rise of the Ottoman Empire," in *The Cambridge History of Islam*, eds. P.M. Holt, Ann K.S. Lambton, and Bernard Lewis (Cambridge: Cambridge University Press, 1977), 1A:321.

8 İnalcık, "State and Ideology," 80.

9 İnalcık, "State and Ideology," 78.

10 Molly Greene, "The Ottoman Experience," *Daedalus* 134, no. 2 (Spring 2005): 88–9.

11 Fatma Müge Göçek, "Mültezim," in *Encyclopaedia of Islam*, https://doi.org/10.1163/1573-3912 _islam_SIM_5492.

SELECTED READINGS

Ágoston, Gábor, and Bruce Masters. "Sokollu Family." *Encyclopedia of the Ottoman Empire*, 534–6. New York: Facts on File, 2009.

Atçıl, Abdurrahman. *Scholars and Sultans in the Early Modern Ottoman Empire*. New York: Cambridge University Press, 2017.

Brummet, Palmira. "The Ottomans as a World Power: What We Don't Know about Ottoman Sea-Power," *Oriente Moderno*. The Ottomans and the Sea, n.s., anno 20 (81), no. 1 (2001): 1–21.

Brummett, Palmira. *Ottoman Seapower and Levantine Diplomacy in the Age of Discovery*. Albany: State University of New York Press, 1994.

Casale, Giancarlo. *The Ottoman Age of Exploration*. New York: Oxford University Press, 2010.

Çelebi, Arif. *Süleymannâme (The Illustrated History of Süleyman the Magnificent)*, edited by Esin Atıl. New York: Harry N. Abrams, Inc., 1986.

Darling, Linda T. *Revenue-Raising and Legitimacy: Tax Collection and Finance Administration in the Ottoman Empire 1560–1660*. Leiden: E.J. Brill, 1996.

Eppel, Michael. "The Kurdish Emirates: Obstacles or Precursors to Kurdish Nationalism?" In *Routledge Handbook on the Kurds*, edited by Michael L. Gunter, 37–47. London: Routledge, 2018. https://www.routledgehandbooks.com/doi/10.4324/9781315627427-4.

Ergin, Nina, Christoph Neumann, and Amy Singer, eds. *Feeding People, Feeding Power: Imarets in the Ottoman Empire*. Istanbul: Eren Books, 2007.

Fetvacı, Emine. *Picturing History at the Ottoman Court*. Bloomington: Indiana University Press, 2013.

Fleischer, Cornell H. "The Lawgiver as Messiah: The Making of the Imperial Image in the Reign of Süleyman." In *Soliman le Magnifique et Son Temps: Actes du Colloque de Paris, Galeries Nationales du Grand Paliais, 7–10 Mars*, edited by Gilles Veinstein, 159–77. La Documentation Française, 1992.

Fleischer, Cornell H. "A Mediterranean Apocalypse: Prophecies of Empire in the Fifteenth and Sixteenth Centuries." *Journal of the Economic and Social History of the Orient* 61 (2018): 18–90.

Fuccaro, Nelida. "The Ottoman Frontier in Kurdistan in the Sixteenth and Seventeenth Centuries." In *The Ottoman World*, edited by Christine Woodhead, 237–50. New York: Routledge, 2011.

Greene, Molly. "The Ottoman Experience." *Daedalus* 134, no. 2 (Spring 2005): 88–99.

Imber, Colin. *The Ottoman Empire, 1300–1650: The Structure of Power*. New York: Palgrave MacMillan, 2002.

İnalcık, Halil, ed. "The India Trade." In *An Economic and Social History of the Ottoman Empire*, edited by Halil İnalcık, with Donald Quataert, 315–63. Cambridge: Cambridge University Press, 1997.

İnalcik, Halil. "The Rise of the Ottoman Empire." In *The Cambridge History of Islam*, edited by P. Holt, A. Lambton, B. Lewis, 320–1. Cambridge: Cambridge University Press, 1977.

İnalcık, Halil. "State and Ideology under Sultan Süleyman I." In *The Middle East and the Balkans under the Ottoman Empire: Essays on Economy and Society*, 70–94. Bloomington: Indiana University Turkish Studies, 1993.

İnalcık, Halil, and Cemal Kafadar, eds. *Süleymân the Second and His Time*. Istanbul: The Isis Press, 1993.

Isom-Verhaaren, Christine. *Allies with the Infidel: The Ottoman and French Alliance in the Sixteenth Century*. London: I.B. Tauris, 2011.

Kunt, Metin, and Christine Woodhead, eds. *Süleyman the Magnificent and His Age: The Ottoman Empire in the Early Modern World*. New York: Longman, 1995.

Masters, Bruce. *The Arabs of the Ottoman Empire, 1516–1918: A Social and Cultural History*. New York: Cambridge University Press, 2013.

Matthee, Rudolph P. *The Politics of Trade in Safavid Iran: Silk for Silver, 1600–1730*. Cambridge: Cambridge University Press, 1999.

Müge Göçek, Fatma. "Mültezim." In *Encyclopaedia of Islam*, edited by P. Bearman, Th. Bianquis, C.E. Bosworth, E. van Donzel, W.P. Heinrichs. 2nd ed. Brill, 2012. https://doi.org/10.1163/1573-3912_islam_SIM_5492.

Necipoğlu, Gülru. "Süleymân the Magnificent and the Representation of Power in the Context of Ottoman-Habsburg-Papal Rivalry." In *Süleymân the Second and His Time*, edited by Halil İnalcık and Cemal Kafadar, 163–94. Istanbul: The Isis Press, 1993.

Ostapchuk, Victor. "The Human Landscape of the Ottoman Black Sea in the Face of the Cossack Naval Raids." *Oriente Moderno*. The Ottomans and the Sea, n.s., anno 20 (81), no. 1, (2001): 23–95.

Özoğlu, Hakan. *Kurdish Notables and the Ottoman State: Evolving Identities, Competing Loyalties, and Shifting Boundaries*. Albany: State University of New York Press, 2004.

Peirce, Leslie P. *Empress of the East: How a European Slave Girl Became Queen of the Ottoman Empire*. New York: Basic Books, 2017.

Peirce, Leslie P. *The Imperial Harem: Women and Sovereignty in the Ottoman Empire*. New York: Oxford University Press, 1993.

Şahin, Kaya. *Empire and Power in the Reign of Süleyman: Narrating the Sixteenth-Century Ottoman World*. New York: Cambridge University Press, 2013.

Şahin, Kaya. "From Frontier Principality to Early Modern Empire." In *Routledge History of the Renaissance*, edited by William Caferro, 321–36. New York: Routledge, 2017.

Setton, Kenneth M. *The Fifteenth Century*. Vol. 2 of *The Papacy and the Levant (1204–1571)*. Philadelphia: The American Philosophical Society, 1978.

Shuval, Tal. "The Peripheralizatio of the Ottoman Algerian Elite." In *The Ottoman World*, edited by Christine Woodhead, 264–75. New York: Routledge, 2011.

Turan, Ebru. "The Marriage of İbrahim Pasha (ca. 1495–1536): The Rise of Sultan Süleyman's Favorite to the Grand Vizierate and the Politics of the Elites in the Early Sixteenth Century Ottoman Empire." *Turcica* 41 (2009): 3–36.

Veinstein, G., "Soḳollu Meḥmed Pasha." In *Encyclopaedia of Islam*, edited by P. Bearman, Th. Bianquis, C.E. Bosworth, E. van Donzel, W.P. Heinrichs. 2nd ed. Brill, 2012. https://doi.org/10.1163/1573-3912_islam_SIM_7090.

White, Sam. *The Climate of Rebellion in the Early Ottoman Empire*. New York: Cambridge University Press, 2011.

SEVEN

LIFE IN THE OTTOMAN EMPIRE

In an empire as territorially vast, as geographically and ethnoreligiously diverse, and as long-lived as the Ottoman Empire had become, with the porosity of its boundaries and the variations in social, commercial, and economic organization over time and place, describing daily life in Ottoman lands is a daunting task that will always be incomplete. This is due to several factors: omitting certain experiences and phenomena might be due to a lack of extant sources on the topic. Or perhaps there are sources not yet unearthed that may shed light on a subject in the future but have not, as of now, been discovered. Or perhaps it is due to the desire to avoid making massive generalizations about life in the Ottoman Empire that are inapplicable because of changes over time. For example, life among subjects in the pre-modern empire versus the rather fluidly defined early modern or modern Ottoman contexts could all have similarities and continuities, or be very different, as local circumstances and/or the world changed. Such disparities may also have existed depending upon which part of the Ottoman Empire one is discussing at a particular moment in time, that is, agricultural methods across Ottoman lands varied depending upon climate; food preparation and diet depended upon availability of particular foodstuffs; culture and customs differed depending upon the ethnoreligious makeup of an area, one's class or occupational distinctions, etc. The extent to which the central Ottoman state was able to exert its authority over a region also affected the daily lives of people.

In addition, there are differences between settled Ottoman urban life, and that of daily existence in rural areas. The Ottoman domain as it expanded was comprised of a countryside containing settled populations in small towns and villages, as well as pastoral nomads still practicing transhumant migrations with their flocks, seeking out suitable grazing pastures. Their disparate everyday lives, whether sedentary, urban, agricultural, or nomadic and tribal, were nonetheless intertwined through symbiotic commercial exchange as well as through competition over resources. In any case, their lives could clearly differ from the experiences of the Ottoman dynasty and its palace elite households, especially as the small principality evolved into a bureaucratic state and global empire replete with rituals befitting imperial grandeur. Ottoman court life, some of which was explored previously, took place

as it did in imperial capitals and palaces (Bursa, Edirne, and eventually Constantinople) or while sultans were on campaign. Some public ceremonial aspects of this elite Ottoman court life were observed by the general urban population with awe or dismay. But their everyday lives as Ottoman subjects were more routine, and usually more mundane. Both urban and rural Ottoman subjects often merely lived in hopes of an existence not destroyed through natural disasters, wars, disease, starvation, or other catastrophic circumstances, many of which began to be experienced by the vast and diverse Ottoman populace more severely starting in the late sixteenth century. The state's demands on the general population in financial and/or human terms at this time exacerbated their suffering.

While there are ample sources to inform an understanding of daily urban life in the Ottoman Empire, defining the everyday experiences of people living a rural existence can be more difficult to ascertain. In larger cities such as Constantinople, or in other urban areas in which the Ottoman administration as well as European ambassadors, diplomats, or commercial agents and expatriates had a presence, Ottoman archival documents, chronicles by court historians, Islamic court (*şeriyye mahkemesi*) records (*sicil*s) and by the nineteenth-century civil (*nizamiye*) court records, foreign or domestic memoirs (most of which start in the late fifteenth century and flourished in the sixteenth to seventeenth centuries and beyond), and newspapers by the nineteenth century, can paint a rich picture of Ottoman urban life. In the Ottoman countryside, however, sources can sometimes become more difficult to locate, though the same types of sources listed above sometimes also yield results. Among the most famous accounts of travel through Ottoman lands is the *Book of Travels* (*Seyahatname*) by Evliya Çelebi (b.1611–d.1682), a multitalented, Istanbul-born Turk who received an Islamic education before being attached to retinues of provincial pashas and traveling across the empire to satisfy his wanderlust. His *Book of Travels* is a collection of ten books that are described as "a vast panorama of the Ottoman world in the mid-seventeenth century" when "... the Ottoman state was still a great imperial power – geographically it was at the height of its glory – although cracks and strains were evident."[1] From it and other sources, one may gain a perspective on Ottoman peoples inhabiting both urban and rural settings in the empire in a particular moment in time.

OTTOMAN IDENTITIES, PUBLIC SPACES, AND SOCIAL GROUPINGS

Distinctions between Muslims and non-Muslims in the Ottoman Empire were sometimes adhered to and at other times ignored. The Ottoman state distinguished between various ethnoreligious communities by recognizing them as *millet*s (see Chapter 4); there were also some social conventions separating communities that were enforced, as Evliya Çelebi's travelogue described. For example, the *hamam*, or bathhouse, was a social space in urban areas for all classes, but baths were used on different days by people of different

EVLIYA ÇELEBI'S *BOOK OF TRAVELS* (*SEYAHATNAME*) (SEVENTEENTH CENTURY), DESCRIBING DISTRICTS OF CONSTANTINOPLE AND ANKARA

CIRCUMFERENCE OF THE WALLED TOWN OF GALATA[2]

This city has eighteen Muslim quarters, seventy quarters of Greek infidels, three of cranky Franks, one of Jews, and two of Armenians. No infidels reside in the first castle, and none at all in the second castle as far as the Arab mosque – the inhabitants of the quarter possess a noble rescript from Mehmed the conqueror according to which no infidel is allowed in.... The majority of these inhabitants are grief-stricken Mudejars[3] who came from Spain, driven out by the infidels.... Aside from these two castles, the two walled areas of Galata as far as Tophane are filled with Franks of the Seven Kings (i.e., from the Habsburg Empire) and other Christians. According to the land survey of Murad (IV) Khan, there are 200,000 infidels and 64,000 Muslims. May God preserve it.

There are seventy Churches. First, the Church of the Organ belonging to France.... Near it is the Venetian church.... The Greeks have ?[4] churches. They have one hospital according to their false claim. The Armenians have three churches. And the Jews have two synagogues. But the Jews are always in fear of these infidels (i.e., Christians).

As for the infidel quarters, they are patrolled day and night, because they have girded their loins for rebellions more than once, and many of them were put to the sword.

THE MANNERS AND CUSTOMS OF THE INHABITANTS OF GALATA

The people of Galata are in ? categories: the first are sailors, the second merchants, the third craftsmen of various sorts, and the fourth are joiners and caulkers. Most of them wear clothing of Cezayir (the Aegean archipelago) {because they are mainly marines....}

The Greeks are tavern-keepers. The Armenians are sellers of pressed meat (*pastırma*) and wealthy merchants. The Jews are intermediaries in the marketplace. The Jewish boys are male prostitutes – there is no more despised group of catamites than they.

THE PRAISEWORTHY FOOD AND DRINK OF THE CITY OF GALATA

First is the fine white Mudejar *francala* bread. The thousands of colored candies, flavored with musk and ambergris and worthy of a padishah, in the glass jars at the confectioners' market are found nowhere else, unless it be paradise-centered Damascus. The Mudejar also sell spiced sweetmeats topped with decorative leaves and spiced ring-bread (*simit*).

Among the artisans are sellers of compasses and watches, cut-crystal lenses and hourglasses, and infidel apothecaries.

As for drinks, in the taverns ... are sold various notorious forbidden ruby-dripping wines, including *misket* (from Bulgaria) and wines from Ancona, Syracuse, Mudanya, Erdemir, and Bozcaada

(Tenedos). When I pass through that wicked locale and see hundreds of downtrodden tavern-slaves lying in the highway ... and inquire about their wretched state, some put forth this verse:

> I am so drunk I do not know
> What is worldly or divine.
> Who am I? Who is the cup-bearer?
> What is the crimson
> wine?...

This city, because of its delightful climate, is famous for its darling boys and girls. Its blessings are abundant for rich and poor alike. All the people are impertinent lovers, of dervish temperament.

They are famous for their salons in wintertime.

THE PLEASURE PARK AND RESORT LODGE OF WORLD-ADORNING KAĞITHANE

It is a promenade famous among travellers in Arabia and Persia, India and Yemen and Ethiopia. The Turkish poets have penned the praises of its air and water. It is a delightful river that flows through the valleys of Levendçiftlik near the Bosphorus. Fullers wash their turbans and shirts and trousers without need for soap – after two rinses the garments come out fresh as a white rose.... On holidays, thousands of old and young lovers come to this place to flirt with one another and go out in caiques and ferries....

DESCRIPTION OF THE LAND OF SELASIL ("CHAINS"), THE INVINCIBLE FORTRESS OF ANKARA, THE PROSPEROUS WALLED CITY OF ENGÜRÜ[5]

Within the castle are 600 pretty houses, with no orchards or gardens. The ancient mosque of ? is located there, converted from a church ages ago. All the houses and public buildings are covered with pure clay. In short, this citadel is noteworthy from the point of view of its construction and of its architecture.

As to the lower town, in the year ?, from fear of the Celalis, Cenabi Ahmed Pasha (Beylerbey of Anatolia and governor of Ankara, d.1561), with the help of the people of the province, built a strong single-layered wall around it.... There are a total of seventy-six prayer niches of which ? are Friday mosques.... There are eighteen dervish convents with prayer-niches. The most flourishing is that of Haci Bayram Veli with over 300 mystics who have wasted their bodies with divine love. Their sheikh, Koca Abdurrahman Efendi, is considered to possess the miraculous graces of a saint, and one whose prayers are accepted by God....

Then in Ankara is the convent of his majesty Mawlana Jalaladdin Rumi.... There are ? medreses.... There are three schools of Prophetic Hadith. There are 180 elementary schools. There are ? public baths.... These are delightful baths with invigorating atmosphere. There are also 200 private baths, according to the boast of the notables of the province.

There are seventy great and lofty palaces with their orchards and gardens – delightful mansions with layer on layer of walls, all of which are brick, however, not stone. Also none of the public buildings in this city has a tiled roof but rather all are covered with pure clay. And all the houses are made of brick, since the Ankara brick is famous and hard as granite.... It is a great city, with 6,066 flourishing houses made of brick. There are ? *hans* of merchants. The rest are small guest houses.

There are 200 fountains.... There are 2,000 shops and an ornate bedestan ... very crowded and prosperous. The coffee shops and barber shops are

also famously crowded. All the sultanic markets and all the major roads in the quarters are paved end to end with pure white stones....

True, this is Anatolia and the province consists mainly of Turkish peasants; still, one finds writers and authors, Koran interpreters and experts in Hadith, and Koran reciters who chant it with proper enunciation. And there are over 2,000 mature and clever boys and girls who have memorised the Koran....

faiths as a means of segregation. Men and women were also segregated when enjoying *hamam*s (Figure 7.1) as places to socialize. Nonetheless, it was not as though the different communal groups did not engage with one another. To the contrary, there were plenty of interactions between them in urban settings, especially in shared public spaces where people (Muslims and non-Muslims, genders) mixed freely – e.g., on streets, during commercial dealings in the marketplace, in manufacturing areas, during festivals or other celebrations, enjoying leisure activities, etc. Barber shops were a social gathering place for men in cities. In the last decades of the empire, Muslim and non-Muslim men would have mixed to an extent also in military units.

The coffee-drinking culture that emerged with the introduction of the substance to the empire starting around the fifteenth century created a microcosm of Ottoman society that could bring men of different ages and backgrounds together – the coffeehouse (until recently, cafés were the prerogative of men only). Coffee had been introduced into Yemen from Ethiopia where it originated, as part of the Red Sea trade of the fifteenth century, and was rumored to have been used by Sufi dervishes in their rituals. Once its use spread in Arabia, efforts were made by the religious class in Mecca to ban its use by declaring coffee an illegal intoxicant according to Islamic law (*c.*1511), yet this "innovation" was brought by pilgrims returning from Mecca to Egypt (where it was said to be a fad among students at al-Azhar University!), Syria, and Anatolia. Once the Ottomans conquered Mamluk Egypt in 1517, it was not long before, according to sources, coffee arrived to Constantinople in 1543. The government could not control popular enthusiasm for imbibing it. The coffee trade soon proved so lucrative that the Ottoman authorities decided merely to prohibit by decree all but a state monopoly on coffee-roasting. Realizing the profitability of coffee as a source of tax revenue, the Ottoman state relaxed its position further. The ports of Aden and Mocha in Yemen soon became important export centers for coffee, and Yemen supplanted Ethiopia in coffee production. Two Syrian Arab entrepreneurs opened the first coffeehouse in Constantinople around 1554, and several European sources claim that "by the time of Selim II (r.1566–74) and Murad III (r.1574–95) there were about six hundred coffeehouses in Istanbul; they were situated in the most important parts of the city"[6] (Figure 7.2). Europeans, having been introduced to coffee in Cairo, Aleppo, and Constantinople, soon brought the invention to Europe, with the first cafés in Venice by around 1615 and in other Italian cities by 1645. In 1635 the Ottomans lost control of Yemen

Figure 7.1 Central Room of a Male Bathhouse (*Hamam*).

and its coffee production to the local Zaydi Qasimid Imamate, but coffee continued to be exported worldwide.

Episodes of crackdowns banning the drinking of coffee occasionally occurred during periods of moral austerity. It seems the first attempt at a ban was during Selim II's reign in the early 1580s, with more strict actions taken when conservative *Kadizadeli* attitudes (see Chapter 8) prevailed at court during the later reigns of Murad IV (the closure of coffeehouses *c.*1633) and of Mehmed IV in the later seventeenth century. These bans were usually short-lived, not universally accepted, and ineffective against coffee's popularity. And when tobacco was imported from the Americas in 1609, it quickly became another feature of Ottoman living, a pastime associated with coffee-drinking (the Turkish verb is the same for "to drink" and "to smoke": *içmek*). Tobacco was initially a medicinal treatment but by the early seventeenth century recreational smoking with pipes or *nargileh*s (*hookah*s) became another widespread phenomenon, and the Ottomans were growing their own tobacco in areas of Anatolia, the Balkans (Macedonia), and northern Syria by the turn of the eighteenth century. From its inception the coffeehouse was a social space in which to enjoy the drink, socialize, gossip, play backgammon, listen to poetry readings or experience the tradition of storytellers recounting the feats of past Islamic rulers. *Karagöz* shadow puppet theater, with its sometimes lewd and promiscuous storylines, was popular here. Janissaries frequented these cafés and even owned many of them. They

also came to own taverns (*meyhanes*) which, while often in the districts housing foreigners and non-Muslims, served wine or a fermented alcoholic drink and had their share of Muslim customers, as Evliya Çelebi recounted. Opium dens also cropped up in urban areas as a somewhat more clandestine social space to gather and feed one's addiction. The consumption of tea, though known in the sixteenth century, did not really become popular in the Ottoman Empire until the late nineteenth century.

Ottoman cities developed along similar lines to previous Islamic Middle Eastern urban centers so that residential quarters (*mahalles*) often tended to have an ethnoreligious character. A Christian residential quarter would emerge around the church at which the community congregated; a Jewish community lived near the synagogue; Muslims lived near their congregational mosque. These boundaries were not fixed nor impermeable by people from a different community. Nor were minority communities "ghettoized" the way in which Jews were cordoned off in Europe. Living quarters emerged out of convenience and preference – chain migration caused people to relocate to urban areas and settle near others of their community. Over time, a residential quarter or even a city could shift from being dominated by one community to another – especially due to large-scale migrations to and from areas, among other factors (e.g., after Murad II's conquest in 1430, Salonika transformed from a Christian city to a Muslim one; Jews became the majority in Salonika by the early sixteenth century).

Figure 7.2 An Ottoman Coffeehouse.

Galata, which had been primarily non-Muslim as a Latin Genoese outpost up to, during, and immediately after Sultan Mehmed II's conquest of Constantinople, was a hub for foreign merchants and eventually became the residence for many non-Muslim European dignitaries and ambassadors. Despite its architecture and businesses catering to non-Muslim demands (including taverns and coffeehouses), over time the demography of this quarter of Istanbul shifted to a mainly Muslim population. The houses in cities such as Istanbul were often two-story and generally tended to be made of wood, which made neighborhoods and whole quarters of cities vulnerable to the ravages of fires, which often occurred after earthquakes, forcing relocations. The repair or building of non-Muslim structures was often scrutinized.

Apart from the simple distinctions between *askeri* (ruling) and *re'aya* (subject) classes, as the empire became more diverse socioeconomically, identities in Ottoman society became

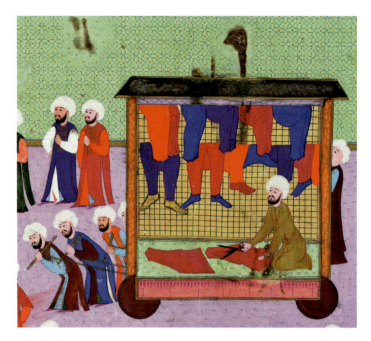

Figure 7.3 Leggings-Makers Guild.

more complex so that an individual may have had a multiplicity of overlapping identifications. This layered identity in Ottoman society affected one's daily life. One could be a member of a particular ethnoreligious community and would be visually recognizable due to sartorial regulations dictating what colors, styles, accessories, and headgear were permissible for non-Muslims, for example. Typically clothing and headgear indicated one's religious sect and ethnicity, place of origin, one's occupation and/or class. Clothing regulations were sometimes strictly enforced, such as during the upswing in conservative Muslim *Kadizadeli* mentality at court. At other times rules were relaxed, or even completely ignored.

The economic organization of tradespeople into the many Ottoman guilds (Figure 7.3) in existence in the empire created distinct affiliations between fellow guild members. Working in the same occupational group allowed guilds some strength in numbers when collectively bargaining for some autonomy. Religious sect was not necessarily relevant to the guilds, though sometimes a guild came to be dominated by a particular ethnoreligious community.

Unlike in Europe where certain ethnoreligious groups were actively restricted from some professions, in the Ottoman Empire some positions were merely incidentally occupied by particular ethnoreligious groups: multilingual Greek Orthodox Christians were often the *dragoman*s – the translators and interpreters for foreign diplomats stationed in Ottoman lands. Once Ottoman diplomatic missions were established in European capitals, Greeks frequently served the Ottoman state as foreign dignitaries, until after Greek independence in 1830, when Armenians (and Muslims) later assumed this function. Starting in the early eighteenth century, the Greek Orthodox *millet* supplied the governors for Ottoman Wallachia and Moldavia from among the Greek elite of Constantinople's Fener district. Armenian elites in Constantinople were the bankers and moneylenders to pasha households; a prominent Armenian family ran the Ottoman munitions plant. Non-Muslims such as Armenians and Jews possessed trade networks linking the Ottoman economy to their respective diaspora communities further afield – Armenian dominance in the silk industry (among others) connected Ottoman and Safavid worlds this way; the Jewish communities in the Ottoman Empire created commercial links with their counterparts in Europe. Jewish physicians were often attached to the Ottoman court to serve the sultan or his *vezir*s.

Membership in a specific Sufi sect was another form of identity shared between individuals. Some Sufi orders could include both men and women but all were exclusively Muslim. Each order centered around a founding shaykh who was revered as a kind of saint. The Sufi lodge would typically contain the tomb of the original founder, living quarters

for the current Sufi master and disciples, and the lodge provided a space for performing certain ceremonies and rituals specific to that order. The Janissaries had a particular affiliation with *Bektaşi* Sufism, a popular order among the peasantry in Anatolia and the Balkans, and distinguishable by their axes and talismans. There were other orders – the famous *Mevlevi* "Whirling Dervishes" founded by Jalal al-Din Rumi, embraced by many Ottoman ruling elite, was famous for its aesthetics (Figure 7.4). The more religiously conservative *Naqshbandiyya* order was preferred by some Ottoman sultans. Members of the same guild may or may not also have been connected through engaging in the same Sufi rituals.

Tribal groups in the Anatolian, Arab, and Balkan countrysides of the empire formed another type of identity. Many pastoral nomads engaged in transhumance – the regular migration of these tribes with their horses, sheep, goats, cattle, and camels to summer and winter pastures, respectively. Their grazing lands, viewed as a hereditary right, were officially or unofficially recognized by the Ottoman authorities. There were tribes who were horse drovers. Some tribes weaved very sought-after carpets and kilims. Some crafted

Figure 7.4 Mevlevi Whirling Dervishes *Sema* Ceremony, Galata *c.* 1870.

bows and/or arrows that were delivered to the state. They were a rural labor force, as lumbermen and mine workers; they provided transportation and served as auxiliaries; they traded in wood and charcoal. Some combined pastoralism with subsistence agriculture. According to one historian,

> it is rather misleading to consider the nomads only in their activities which were disruptive to the settled societies. Apart from their supplying cities with animal products, their economic activities included marginal agriculture, weaving for market (felt, carpets), transport services, and supplying labor for other sectors of society. The nomad contribution to the economy as a whole was of vital importance.[7]

Some of their economic contributions to the empire earned them tax exemptions. But increasingly the Ottoman state, in its desire to increase its revenues, wanted to settle and contain nomads to shift them more fully over to cultivation (called *iskân*, "pacification"), as a means of control, and to increase economic output through their settled production (agriculture, mines, etc.) and the taxes the state could levy. Attempts to change their lifestyle in this way, or to relocate tribes, particularly in the nineteenth century, often resulted in resistance and serious rebellions in the countryside. For the pastoral nomads whose livelihood relied upon their livestock (Figure 7.5), life was more tenuous, and could have a dramatic effect on the empire as a whole in difficult seasons – droughts, harsh winters, disease, all led to the death of their animals, and to a perilous cycle of requiring the slaughter of their animals for their own subsistence, lessening the size of the flock and its ability to reproduce in sufficient numbers the following year. This effect in turn rippled through the Ottoman Empire's provisioning of urban centers and armies.

Those Turkmen, Kurdish, or Arab tribal nomads who had migrated or were forcibly resettled (*sürgün*) to western Anatolia or the Balkans were originally called *Yürüks* by the Ottoman administration to distinguish them from Christian and Tatar nomads in Rumelia and the Turkmen and Kurdish tribes in eastern Anatolia and the Caucasus. Eventually the term came to more generally mean "nomad," and within this category used by the Ottoman chancery can be discerned many sub-tribal, or smaller nomadic clans, many of whom were named for the economic functions they carried out in the Ottoman lands they inhabited. Shepherds with a valuable knowledge of animal husbandry were part of an elaborate system of sheep provisioning used in the Danube region called the *celep-keşan* system. Shepherds were subcontracted by government-appointed overseers (*celep*s), who were typically wealthy locals from sheep-raising areas. The shepherds raised their flocks, provided and delivered "on the hoof" to the agreed-upon destinations the large numbers of sheep requisitioned by the Ottoman administration to provision its empire. The *celep*s guaranteed the number of head to be delivered to Istanbul, then sold them at an official market price (*narh*) set by the Ottoman state on goods and services. Istanbul was the central destination for the sheep, from where they would either be pastured until needed, or sent on to butchers (contracted, and sometimes pressed into this service in this occupation) throughout the city – supplying armies and the capital were the priority.

This system requisitioned most sheep from the southern Danube region in the Balkans, but demand was also met from the principalities (Moldavia, Wallachia), the Crimea, and Anatolia (in times of shortage).

Figure 7.5 Shepherdesses Resting, Late 1870s.

NON-HUMAN ANIMALS IN OTTOMAN LIFE

Though non-human animals are often neglected in the historical narratives of empires, they played significant roles in Ottoman life, whether in service to the sultan, his palace and dynasty, for the maintenance of the Ottoman Empire's military and its economy, or for the general functioning of Ottoman society in daily life. Non-human animals in the Ottoman Empire could, to an extent, be divided into a hierarchy of status and care mimicking the division between human classes of the *askeri* and the *re'aya*. Those non-human animals that served the dynasty and palace, such as those employed in many sultans' favorite pastime – hunting – or those deemed "exotics," such as lions, elephants, leopards, etc. given as gifts, or "collected" as a demonstration of wealth and power, were honored and cared for with the utmost diligence and attention. A camel carried the all-important

Figure 7.6 Holy Caravan on Its Way to Mecca for Hajj after Leaving Damascus, with Soldiers, Dignitaries, and Camel Carrying the Sultanic Palanquin (*Mahmal*), *c.*1860–1900.

ceremonial palanquin (*mahmal*, made of embroidered fabrics) for the Muslim hajj caravan from Damascus to Mecca, that symbolized the authority of the Ottoman sultan (Figure 7.6). For non-human animals used merely as "engines," as a type of labor force in the daily functioning of the empire, as pack animals and transportation vehicles, as farm animals, as "street-cleaners," or as a source of food and/or clothing (hides or wool), their lives were considerably harder. And yet the latter category of non-human animals in many ways had a greater impact on the empire's existence overall. Any changes to conditions affecting the lives of these non-human animals upon which the empire relied, reverberated more strongly in Ottoman society as a whole. Natural disasters and radical fluctuations in climate, the effects of wartime mobilization, or of technical modernization, could all dramatically alter non-human animals' existence, thereby creating knock-on effects in society that led to further crises.

The "royal hunt" was a tradition that dated back to pre-Islamic Eurasian empires and continued into Islamic dynasties up through the Ottoman era, though the sultans of the last centuries of the empire seem to have lost enthusiasm for the sport. For earlier Ottoman sultans, hunting expeditions were enjoyed in lands set aside as preserves or parks for this purpose in many regions of the empire, with lodges built to accommodate the needs of

the hunt, and various prey animals to be hunted were often stocked, fed, and watered. The environs of Edirne was a favorite, and doubled as a summer retreat. The wild animals to be hunted could be deer, gazelle, antelope, wild goats or sheep, wild boar, jackals, wolves, rabbits, or a variety of birds. The Ottoman tradition derived from precedents set by earlier empires, including Turco-Mongol hunts that were designed to hone one's skills in battle – and in fact raiding formations and battle tactics often mimicked hunting patterns of surrounding prey while feigning an escape route into which they were driven before seizing upon the trapped animals.

Ottoman royal hunts inherited what has been described as the use of "animal assistants" for the hunt in ancient Egypt, Mesopotamia, Persia, and Eurasia, whether domesticated animals whose artificial selection and total existence was dependent upon human control and used to fulfill human needs (e.g., dogs, horses), or "tamed" animals, those which were never domesticated but "reconditioned to hunt under a measure of human control" – raptors (birds of prey), and cheetahs (in Egypt, Mesopotamia, and Eurasia) for example.[8] The Ottomans wholeheartedly embraced falconry, the use of different falcons, hawks, eagles, and even owls in the hunt. Widespread in many parts of the world, falconry was also likely Mesopotamian in origin. It flourished in Persia and Eurasia, and with the coming of Islam, the Arabs also expanded its use. From these beginnings, the Ottomans practiced "hound and hawk on horseback" hunting customs that were often depicted in miniatures accompanying manuscript chronicles. The "chase" style of the hunt was of two types: the first involved the mounted sultan, his retinue of officers who were responsible for the training of greyhound-type sighthounds, and the young slave recruits on foot who held the dogs until they were released to chase down their prey. The sighthounds were often used for hares and mastiff-type dogs were used to chase down larger wild animals. In the second "falconry" style of the hunt, the sultan was accompanied by his hunting party of various palace ranks: the master of the hounds with spaniel-type dogs assisting in tracking and flushing birds and the numerous falconers who released the falcons and hawks to hunt down the prey. Either dogs or falcons would catch, or wound, or attack and kill the prey, or prey would be killed with the sultan's weapons (or both together) (Figure 7.7).

In the Ottoman hunting expeditions, these animal assistants themselves held a tremendous amount of prestige. Horses had been a prominent feature of pre-Ottoman Turkic life on the steppes of Asia, and horse culture continued to run deep in Ottoman life – horses were still a respected and irreplaceable non-human animal, a major means of transportation and Ottoman military power, as well as the sultan's vehicle for the hunt. Horses were often received by the sultan as valuable gifts, as tribute, or taken as booty; horses were given by the sultan as imperial gifts to other sovereigns. Depictions abound of the sultan mounted upon his prized steed in miniatures recounting hunts, campaigns, and other royal ceremonies. The palace offices associated with the imperial stables were of high rank, reflecting the centrality of the horse. Between 1880 and 1893, the well-known photographer

Abdullah Fréres even photographed Arabian stallions, mares, and foals belonging to Sultan Abdülhamid II's Imperial Stables in official portraits.

The imperial hounds and the birds of prey used for the Ottoman royal hunt were no less worthy of prestige. Dogs in pre-Islamic Persia had been very highly regarded and used for hunting. With the coming of Islam, Muslim attitudes about dogs as ritually unclean diminished their status somewhat, though dogs with jobs – hunting, herding, and guarding to assist humanity – were considered acceptable to maintain. Recent scholarship examining medieval legal texts illustrates that some Islamic jurists were known to have refuted the uncleanliness argument. Certainly the Ottoman dynasty adhered to those positions and cherished their hunting hounds, which were bred, trained, fed, and very well cared for, again by slave recruits occupying the office of the Keeper of the Hounds and a retinue of subordinates who saw to the imperial dogs' every need, including veterinary care. Similarly, the Chief Falconer was a palace position of high status, and the sultan's birds of prey, whether captured in the wild, or bred and raised in Ottoman aviaries (a more difficult task, as birds of prey are not easily reproduced in captivity), received unrivaled care and training from the aviary's servants.

The imperial non-human animals of the Ottoman Empire were accorded special status that paralleled the elite class of their *askeri* masters, whereas the existence of other non-human animals coexisting in Ottoman society was similar to the general rigors and hardship of *re'aya* life. Non-human animals used as a labor force or as transportation – again horses, but also donkeys and mules, oxen, water buffalo, and of course, camels – may or may not have been treated mercifully by their human masters. They carried the military personnel, equipment, and war materiel on campaign (Figure 7.8); they transported provisions and merchants' goods; they pulled carts; they ploughed fields; they turned grain threshers, mills, and water wheels. Their roles would change and their numbers would decrease in the nineteenth century with the shift to human labor in cities and improvements in technology.

Non-human animals – livestock and work animals – were also property, a source of wealth for peasants and agriculturalists. The Ottoman Empire's vast demand for hundreds of thousands of sheep to provision armies on campaign and people in cities annually relied upon guaranteed numbers of livestock head to be delivered on a regular basis. Shepherds delivered these requisitions to be used for meat and other products including hides for clothing. Meat from sheep was the luxury regularly enjoyed only by the palace, elites, and Janissary and other ranks of the Ottoman military; in times of shortages, goat meat was the substitute. Meat in general was a rarity for the masses whose diet was more dependent upon fruits, vegetables, and grains. Nonetheless, meat was not the only commodity; these non-human animals yielded produce without losing their lives as well, such as milk, cheese, butterfat, and yogurt. Sheep produced wool and mohair goats produced their famous Angora (Ankara) wool, both of which were integral to the Ottoman textile economy. Silkworms were cultivated to produce silks for Ottoman consumption, an industry dominated by Armenians in Persia but linked to Ottoman Armenian merchants (furs to trim the collars of Ottoman sultans' and his

Figure 7.8 Ottoman Army Camel Corps Moves to Beersheva, *c.*1915.

ministers' silk and woolen caftans were usually imported from Russia). These non-human animals could be said to lead a more precarious position in Ottoman daily life than those of the imperial household and palace, as their station in life was reminiscent of non-elites. Non-royal hounds were sighthounds used by Bedouin in desert areas for hunting (sometimes accompanied by raptors) (Figure 7.9); livestock guardian-type dogs ambled along with a shepherd and his flock, guarding against predators.

LIVING, LOVING, LEARNING, DYING: THE NON-ELITE EXPERIENCE

Family and marriage, sexuality, children, healthcare, and the end of life – these are all mere glimpses into stages of daily life for the *re'aya* – the subjects of the Ottoman Empire. By no means is this an exhaustive exploration of the lived experience in Ottoman society. But mentioning a few features of what could be characterized as "average peoples' lifespans"

under Ottoman rule enriches the picture of how life was similar to, or differed from, lives of palace elites.

As a general tendency, the extended family, often consisting of three generations, could be said to be the norm in non-elite Ottoman households up until the nineteenth century. In urban areas other relatives likely lived nearby, in the same *mahalle* (local neighborhood). The purposes of marriage were to establish households, connect families, and raise children. As a result, the woman's role in reproduction and in managing the affairs of the family made her position in the household extremely important. Despite this, the understanding of gender in Muslim societies was such that women were seen as the imperfect version of males in terms of body, and because they were understood to emanate from one type in this way, the ambiguity implicit in this mere physical difference had to be blocked, demarcated by social boundaries to avoid potential problems. Insistence on veiling, men growing beards, and spatial segregation in certain public places (mosques, *hamam*s, etc.) all served this purpose. Changes in Ottoman womens' roles in the modern era became more obvious by the nineteenth century with cultural trends of westernization, government-sponsored reform initiatives promoting modernization, and legal reforms that resulted in women becoming more visible in public, enjoying more freedom to move around, or as participants in the work-force, for example.

Figure 7.9 Bedouin in Iraq with Falcon and Saluki Sighthounds.

In spite of the fact that Qur'anic law permitted a Muslim man to marry up to four wives at one time and to have relations with slaves (with some stipulations, such as treating all spouses equally that, if truly followed, would make polygamy impossible), polygamy in fact was relatively rare in Ottoman society. Among other things, the financial burdens it created were prohibitive. Contrary to the eroticized harem imagery so prolific in nineteenth-century photography staged in most cases by European photographers, Ottoman families often looked more like the familiar nuclear or extended household. Plenty of Ottoman families such as this one would sit for portraits done by professional photographers (Figure 7.10).

In the typical marriage agreement, a dowry (*mahr*) was usually paid by the groom to the bride – to be for her only, as economic security in case of divorce or her husband's death. Half would be paid during the wedding itself, with the other half to be delivered after divorce or death. The agreement of the groom and bride was to be recorded in court registers, and the state attempted to define *mahr* amounts officially for classes, based upon ability to pay. Of course irregularities in or failures to adhere to this arrangement could happen that worked to the detriment of the woman's financial and social well-being, but

Figure 7.10 Ottoman Family Portrait, *c.*1890.

a system was put in place. Court records clearly illustrate the ability of Ottoman women to own property, and to use the courts to have their grievances heard and to enforce their claims when called for. Judges (*kadıs*) determined the outcomes, and judges were male.

The ambiguity of gender explains some aspects of sexuality in the Ottoman Empire. Pre-Islamic attitudes relating to older men's interest in pre-pubescent, facially hairless boys was not considered immoral behavior. With the coming of Islam, some Sufi rituals and poetry involved such relationships, as they were understood to connect to a spiritual journey to find unity with God. Scholars have determined that in Ottoman society there was an understanding of three genders and two sexualities, with Ottoman sources illustrating the view that men, women, and boys were three distinct genders; sexuality was based accordingly upon "penetrator" and "penetrated" rather than on a male/female difference.[9] The famous Ottoman poet Ahmed Nedim (b.1681–d.1730) was known for his lyrical odes to beardless boys, such as this verse: "The learned are all enamored of boys, not one remains who female love enjoys."[10] In Ottoman palace culture, cross-dressing boys performed as entertainers called *köçek*s (Figure 7.11). Homoerotic sexuality between adult males was acceptable if carried out discreetly, and if it did not interfere with eventual marriage and family life. However, Sultan Selim I's *kânûnnâme* of the early sixteenth century categorized the crime of *zina* (juridically understood to be various forms of illicit sexual relations) to

include victimization of both boys and girls. By Süleyman's time, his *kânûn-nâme* characterized homoerotic sex and sodomy by the sodomizer as *zina* crimes punishable by fines and bastinado strokes, though it was still not criminally immoral conduct if one was the passive participant.

Ironically at the same time that homosexuality in the Ottoman Empire was officially, though briefly, decriminalized in 1858 as a part of the *Tanzîmât* legal reforms (based on the French code), the European Orientalist attitudes about the Ottomans as barbaric and uncivilized, which had proliferated in the eighteenth and nineteenth centuries, forced a kind of reconstruction of Ottoman sexuality and a rejection of this "immorality" of past attitudes in favor of very orthodox, conservative views toward sex and sexuality generally. Homosexual relations were relegated to the shadows as shameful behaviors in the modern era. More severe legal interpretations of sexuality requiring punishment included both homosexual and heterosexual relationships that were considered illicit. However, though adulterous relations outside of marriage were officially illegal behaviors, they were not usually as severely punished in Ottoman society as current extremist attitudes would have one believe. Islamic laws were in place requiring substantial, almost impossible proof (four male eyewitnesses to the actual adulterous act), which was difficult to acquire; wrongful accusations could lead to punishment of the false accuser. Stoning men or women for the offense was not prescribed in the Qur'an (Qur'an 24:2, "give each of them 100 lashes"), but a controversial interpretation of a *hadith* suggests stoning; house arrest for a woman proven to have committed adultery was more usual.

Figure 7.11 Dancing *Köçek* with Tambourine, Late Nineteenth Century.

Besides fines and lashes, another typical punishment (if any) for various crimes, sexual or other, was dispatch to the galleys for a length of time. This was the usual sentence after conviction of a repeat offender for some crimes, including several forms of theft. Prisons and prison terms were generally a nineteenth-century innovation. Prostitution, both male and female, was a reality in Ottoman cities such as Istanbul. It was tacitly tolerated by the authorities as long as it was relatively discreet, with prostitutes working on the streets, in taverns, in brothels, and even using houses or other meeting spots for clients. Even after the slave trade was officially abolished in the Ottoman Empire in the late nineteenth century (*c.*1890), slave concubines could still be purchased in the markets and treated similarly by wealthier individuals who thus avoided the negative stigma attached to prostitution. Slavery would not truly cease until after the founding of the Turkish Republic in 1923.

Children's schooling typically took place in urban centers and varied depending upon their ethnoreligious community, class, and means. For non-elite Muslim families, primary education for children from approximately age five and older was typically provided by schools called *mektep-i sıbyan*s, which taught fundamental lessons – to read, write, compute basic arithmetic, and learn and memorize Qur'anic verses and the tenets of Islam. These schools could be in buildings erected specifically for this purpose, in mosque complexes

or in the mosque itself, in libraries of officials, or even in Sufi lodges. They were funded privately, by *vakf* endowment in cities and villages. In earlier centuries there was no formal curricula and all students of various ages sat and learned together. These *mektep*s were generally for boys only. Some girls had access to rudimentary education in small schools attached to mosques, though for the most part, they only had access to education if their families were of a certain status. Girls and women in the palace reached the highest educational levels: there are records of daughters of *ulema* who were taught at home by their fathers, and some families hired private tutors. The teachers in the primary schools may have merely been literate, or may have had a *medrese* education and/or been members of the *ulema* attached to the local mosque. Instruction placed a heavy emphasis on memorization.

Those young students who showed promise at the *mektep* level could attend the next level of education at *medrese*s – religious schools that originated as educational institutions in earlier pre-Ottoman Islamic empires, the most recent of which were those in Seljuk Anatolia. The first Ottoman *medrese* was founded in 1331 in Iznik. *Medrese*s, also typically established by a *vakf*, were founded in urban centers across the Ottoman Empire between the fourteenth and sixteenth centuries, with most in Constantinople. The first Ottoman *medrese*s drew upon the corpus of religious expertise of *ulema* from other areas of the Muslim world, such as scholars from the centers of learning in Mamluk Egypt and Syria, and in Persia and Turkestan. In order to train those who would eventually become elites serving the Ottoman state, *medrese* students continued their studies with religious subjects including *fiqh* (Islamic jurisprudence), as well as calligraphy, linguistics (i.e., Arabic grammar), and sciences such as medicine, astronomy, physics, mathematics, etc., continuing the pattern of earlier Islamic empires. A hierarchy of *medrese* levels was established after Mehmed II's conquest of Constantinople, but contemporary sources indicated a deterioration in the *medrese* education system in the late sixteenth to early seventeenth centuries, in tandem with the empire's other socioeconomic and political problems.

Medicine and medical care in the Ottoman Empire inherited traditions from a variety of cultures, whether from the ancient Greek, Persian, and Turkic practices, or the later medical advances that occurred in pre-Ottoman, medieval Islamic empires. Ottoman physicians recorded their observations from direct experience, which also contributed to the pool of medical knowledge. The Swiss Renaissance physician Paracelsus (b.1493–d.1541) and his medical chemistry, which employed the use of minerals and drugs to correct imbalances, caused Ottoman pharmacology to gain traction a century later. The medical expertise later imported to the empire by immigrant physicians from Jewish communities who fled the Iberian Peninsula in the fifteenth and sixteenth centuries after the Reconquista also informed Ottoman medicine. Like earlier Islamic precedent, Ottoman provision for healthcare early on was charity based. *Vakf* endowments established not only *medrese*s that offered medical instruction to students, but hospitals (*darül-şifa*) for free treatment and care needed by the general population as well.

The overall picture of Ottoman medicine has been described as one of "Galenic humoralism, folkloristic medicine, and religious medicine."[11] When possible, the emphasis in treating patients was on preventive care, rather than on invasive procedures. In other words,

Ottoman medicine relied upon several forms of diagnosis and treatment: first, institutional medicine, that is, the procedures according to medical treatises compiled in previous centuries, was carried out in the hospital or clinic by trained physicians educated in *medreses*. Because of a general shortage of trained physicians, however, it also involved folk healers' treatments of various ailments and diseases, resembling modern holistic medicine, which focused upon correcting any imbalance among body, mind, and environment, and

Figure 7.12 Ottoman Cemetery with Carved Headstones of Members of the *Askeri* Class.

delivering compassionate care and a quick recovery if at all possible. Religious superstition and belief in magical remedies could come into conflict with medical analysis. With disease and high mortality rates being ceaseless conditions in Ottoman lands, the idea of sickness was often understood as a manifestation of evil, or as punishment for straying from the path of righteousness. This required God's intervention as the ultimate healer, and/or a purification of some sort in order to recover. In fact, the Ottoman merging of medicine with religion was reflected in hospital design in which hospitals were physically connected to mosques, with religious functionaries often spiritually involved in the treatment process, which differed from the more secular approaches to medicine undertaken by earlier Islamic empires. People sometimes also tried to flee from disease or illness, with varying degrees of success.

At the end of life in the Ottoman Empire, funerals and commemorative ceremonies varied in scale depending upon one's status in life. Muslim traditions upon one's death were similar in that the body of the deceased was typically washed, wrapped in a shroud, taken to a mosque for funerary prayers and rites, then buried in a grave, to await Judgment Day's arrival. But the similarities ended there: funeral processions for members of the Ottoman dynasty, for example, could be public spectacles full of mourning. Elaborate tombs or mausoleums were often erected over the burial sites for Ottoman sultans, their royal concubines or wives, and other elites, in contrast to the larger cemeteries located outside the city walls for burials of the more anonymous masses of Ottoman subjects. Small graveyards within cities can still be seen around mosques in which religious or other prominent individuals were buried; carved headstones with Qur'anic verse or prayers engraved on them have the shape of the individual's headgear atop the stone to indicate the person's socio-economic class and profession – whether the sultan's royal turban, the religious turbans of the *ulema*, the military headgear of the various Ottoman military officers, or that of Ottoman palace officials and administrative *vezir*s (Figure 7.12). *Askeri* and *re'aya* distinctions followed Ottomans to their final resting places.

NOTES

1 Robert Dankoff, trans. and commentary, *The Intimate Life of an Ottoman Statesman Melek Ahmed Pasha (1588–1622): As Portrayed in Evliya Çelebi's Book of Travels (Seyahat-name)* (New York: State University of New York Press, 1991), 4.

2 Robert Dankoff and Sooyong Kim, eds. and trans., *An Ottoman Traveller: Selections from the Book of Travels of Evliya Çelebi* (London: Eland Publishing, Ltd., 2010), 18–22. Reprinted by permission of Eland Publishing Ltd. Translation and Commentary © Robert Dankoff & Sooyong Kim.

3 Mudejar is the word denoting Moors (Muslims) of al-Andalus who had initially remained in Spain after the Reconquista but did not convert to Christianity. They were eventually expelled between the late fifteenth to early sixteenth century and many ended up in the Ottoman Empire.

4 Wherever there is a question mark in the excerpt, Evliya Çelebi had left a blank space, as though to fill in information later as he acquired it.

5 Dankoff and Kim, *An Ottoman Traveller*, 74–6.

6 Uğur Kömeçoğlu, "The Publicness and Sociabilities of the Ottoman Coffeehouse," *Javnost* 12, no. 2 (January 2005): 8; Mouradgea d'Ohsson, *Tableau general de L'Empire othoman*, vol. 4, part I (Paris: L'lmprimerie de Monsieur,1791), 79 and Philip Sylvestre Dufour, *Traitez nouveaux et curieux du Café, du Thé, et du Chocolate: Ouvrage également necessaire aux Medecins, Lá tous ceux qui aiment leur santé* (Lyon: Jean Girin & B. Riviere, 1685), 38.

7 Halil İnalcık, "The Yürüks: Their Origins, Expansion and Economic Role," in *The Middle East and the Balkans under the Ottoman Empire: Essays on Economy and Society* (Bloomington: Indiana University Turkish Studies, 1993), 99.

8 Thomas T. Allsen, *The Royal Hunt in Eurasian History* (Philadelphia: University of Pennsylvania Press, 2006), 52.

9 İrvin Cemil Schick, "What Ottoman Erotica Teaches Us about Sexual Pluralism," *Aeon*, March 23, 2018, https://aeon.co/ideas/what-ottoman-erotica-teaches-us-about-sexual-pluralism.

10 E.J.W. Gibb, trans., *A History of Ottoman Poetry* (London: Luzac and Co., 1905), 4:56, quoted in Stephen O. Murray, "Homosexuality in the Ottoman Empire," *Historical Reflections/Réflexions Historiques* 33, no. 1, Eighteenth-Century Homosexuality in Global Perspective (Spring 2007): 105.

11 Miri Shefer-Mossensohn, *Ottoman Medicine: Healing and Medical Institutions, 1500–1700* (Albany: State University of New York Press, 2009), 12.

SELECTED READINGS

Allsen, Thomas T. *The Royal Hunt in Eurasian History*. Philadelphia: University of Pennsylvania Press, 2006.

Andrews, Walter, and Mehmet Kalpaklı. *The Age of the Beloveds: Love and the Beloved in Early Modern Ottoman and European Culture and Society*. Durham: Duke University Press, 2004.

Borromeo, Elisabetta. "The Ottomans and Hunting According to Julien Bordier's Travelogue." In *Animals and People in the Ottoman Empire*, edited by Suraiya Faroqhi, 219–33. Istanbul: Eren, 2010.

Boyar, Ebru, and Kate Fleet. *A Social History of Ottoman Istanbul*. Cambridge: Cambridge University Press, 2010.

Buturović, Amila. *Carved in Stone, Etched in Memory: Death, Tombstones and Commemoration in Bosnian Islam since c.1500*. New York: Routledge, 2015.

Dankoff, Robert, trans. and commentary. *The Intimate Life of an Ottoman Statesman Melek Ahmed Pasha (1588–1622): As Portrayed in Evliya Çelebi's Book of Travels (Seyahat-name)*. New York: State University of New York Press, 1991.

Dankoff, Robert, and Sooyong Kim, eds. and trans. *An Ottoman Traveler: Selections from the Book of Travels of Evliya Çelebi*. London: Eland Publishing, Ltd., 2010.

Dubin, Alan, and Cem Behar. *Istanbul Households: Marriage, Family and Fertility, 1880–1940*. New York: Cambridge University Press, 1991.

Faroqhi, Suraiya. *Towns and Townsmen in Ottoman Anatolia: Trade, Crafts, and Food Production in an Urban Setting, 1520–1650*. Cambridge: Cambridge University Press, 1984.

Faroqhi, Suraiya, ed. *Animals and People in the Ottoman Empire*. Istanbul: Eren, 2010.

Faroqhi, Suraiya. *Subjects of the Sultan: Culture and Daily Life in the Ottoman Empire*. New York: I.B. Tauris, 2000.

Faroqhi, Suraiya. *Travel and Artisans in the Ottoman Empire: Employment and Mobility in the Early Modern Era*. New York: I.B. Tauris, 2014.

Greenwood, Antony. "Istanbul's meat provisioning: A study of the *Celepkeşan* system." PhD diss., University of Chicago, 1988.

Grehan, James. "Smoking and 'Early Modern' Sociability: The Great Tobacco Debate in the Ottoman Middle East (Seventeenth to Eighteenth Centuries)." *The American Historical Review* 111, no. 5 (December 2006): 1352–77.

Hattox, Ralph S. *Coffee and Coffeehouses: The Origins of a Social Beverage in the Medieval Near East*. Seattle: University of Washington Press, 1988.

Howard, Douglas A. *A History of the Ottoman Empire*. New York: Cambridge University Press, 2017.

İhsanoğlu, Ekmeleddin. *The Madrasas of the Ottoman Empire*. Manchester: Foundation for Science Technology and Civilization, April 2004. https://www.muslimheritage.com/uploads/madrasas.pdf.

İnalcık, Halil. "The Yürüks: Their Origins, Expansion and Economic Role." In *The Middle East and the Balkans under the Ottoman Empire: Essays on Economy and Society*, 97–136. Bloomington: Indiana University Turkish Studies, 1993.

İnalcık, Halil, Suraiya Faroqhi, Bruce McGowan, Donald Quataert, and Sevket Pamuk, eds. *An Economic and Social History of the Ottoman Empire*. 2 vols. New York: Cambridge University Press, 1994.

Kia, Mehrdad. *Daily Life in the Ottoman Empire*. Westport, CT: Greenwood Press, 2011.

Kömeçoğlu, Uğur. "The Publicness and Sociabilities of the Ottoman Coffeehouse." *Javnost* 12, no. 2 (January 2005): 5–22.

Mazower, Mark. *Salonika, City of Ghosts: Christians, Muslims and Jews 1430–1950*. New York: Vintage Books, 2004.

Micklewright, Nancy. "Domestic Interiors in Photography from the Late Ottoman World." In *Harem Histories: Envisioning Places and Living Spaces*, edited by Marilyn Booth, 239–60. Durham: Duke University Press, 2010.

Mikhail, Alan. *The Animal in Ottoman Egypt*. New York: Oxford University Press, 2014.

Mikhail, Alan. "Animals as Property in Early Modern Ottoman Egypt." *Journal of the Economic and Social History of the Orient* 53 (2010): 621–52.

Mikhail, Alan. "Unleashing the Beast: Animals, Energy, and the Economy of Labor in Ottoman Egypt." *The American Historical Review* 118, no. 2 (2013): 317–48.

Murphey, Rhoads. "Ottoman Medicine and Transculturalism from the Sixteenth through the Eighteenth Century." *Bulletin of the History of Medicine* 66, no. 3 (Fall 1992): 376–403.

Murray, Stephen O. "Homosexuality in the Ottoman Empire." *Historical Reflections/Réflexions Historiques* 33, no. 1, Eighteenth-Century Homosexuality in Global Perspective (Spring 2007): 101–16.

Peirce, Leslie P. *The Imperial Harem: Women and Sovereignty in the Ottoman Empire.* New York: Oxford University Press, 1993.

Sajdi, Dana. *Ottoman Tulips, Ottoman Coffee: Leisure and Lifestyle in the Eighteenth Century.* New York: I.B. Tauris, 2007.

Schick, İrvin Cemil. "What Ottoman Erotica Teaches Us about Sexual Pluralism." *Aeon,* March 23, 2018. https://aeon.co/ideas/what-ottoman-erotica-teaches-us-about-sexual-pluralism.

Shefer-Mossensohn, Miri. *Ottoman Medicine: Healing and Medical Institutions, 1500–1700.* Albany: State University of New York Press, 2009.

Shields, Sarah. "Sheep, Nomads and Merchants in Nineteenth-Century Mosul: Creating Transformations in an Ottoman Society." *Journal of Social History* 5, no. 4 (Summer 1992): 773–89.

Um, Nancy. *The Merchant Houses of Mocha: Trade and Architecture in an Indian Ocean Port, Publications on the Near East.* Seattle, WA: University of Washington Press, 2009.

Yıldırım, Onur. "Ottoman Guilds in the Early Modern Era." *International Review of Social History* 53, Supplement 16 (December 2008): 73–93.

Zarinebaf, Fariba. *Crime and Punishment in Istanbul 1700–1800.* Berkeley: University of California Press, 2010.

Ze'evi, Dror. "Hiding Sexuality: The Disappearance of Sexual Discourse in the Late Ottoman Middle East." *Social Analysis: The International Journal of Social and Cultural Practice* 49, no. 2 (Summer 2005): 34–53.

Zilfi, Madeline C. *Women and Slavery in the Late Ottoman Empire.* New York: Cambridge University Press, 2010.

EIGHT

AN EMPIRE CHANGING: THE BALANCE OF POWER AT HOME AND ABROAD

GLOBAL REORDERING AND THE OTTOMAN POSITION

While many of the patterns of daily life described previously remained relatively unchanged, there were some dramatic transformations and changes both domestically in the empire and in the world – politically, economically, climatically – that would define the early modern era for the Ottomans. Selim II's reign (r.1566–74) and those who followed witnessed the continuity of some patterns in Ottoman state and society, though glimmers of trouble were on the horizon as early as the late sixteenth century, which would stretch Ottoman flexibility to adapt to circumstances to its limit. The Janissary challenge to sultanic authority upon Selim II's ascension has already been mentioned (see Chapter 6). The enlarged borders of the empire now presented new threats to Ottoman sovereignty in peripheral areas that strained the military provisioning machine, especially when forced to pivot between adversaries in the Balkans, Persia, soon Muscovy/Russia (extending the Northern Arc), and again the Portuguese in the Indian Ocean (attempting an extension of the Southern Tier). The Ottoman imperial thrust into the Mediterranean and the competition it provoked with Venice and Habsburg Spain was limited in part by the empire's reliance in the western Mediterranean upon the fleet at Algiers, manned by corsairs likely more interested in harassing European shipping than volunteering for combat. By the 1580s, competition in the Mediterranean region between Spain and the Ottomans had stabilized: the Ottomans were more preoccupied with the Northern Arc and Persian wars; more significantly perhaps, Spain had reoriented its attention toward New World exploration, driven by European competition. The Age of Discovery that had begun in the late fifteenth century led to the establishment of new trade routes globally, and a European hunger for new sources of raw materials and export markets that would continue unabated. The reorganization of the world economic system that ensued had a direct impact upon Ottoman relations with other states and empires, whether through treaty-making, confrontation, or the Capitulations.

WORLD SYSTEMS THEORY AND THE CAPITULATIONS: PART II

The effects of what social scientist Immanuel Wallerstein defined as the "modern world system" could be felt in the Ottoman Empire as it became incorporated into a revolutionary new global economic order. According to this paradigm, various factors in the pre- and early modern era caused an economic restructuring into a capitalist economy first dominated by Europe. Agricultural production in Europe's feudalist societies had diminished due to climatic changes and epidemics (among other things). The Age of Exploration ushered in the discovery of the New World in 1492; new trade routes were discovered after the Portuguese circumnavigated the African continent and reached India in 1498. The fiscal balance changed with the influx of silver to Europe, which caused global inflation that also affected the Ottoman economy negatively. Starting in the sixteenth century, this new capitalist system would create what Wallerstein describes as an international division of labor.

According to his theory, regions of the world are categorized as part of the "core," those countries or empires in northwestern Europe (Britain, France, and Holland initially) that first developed manufacturing capability due to centralized government that could direct commerce and thus embark upon a quest to seek out new sources of raw materials and shape the structure of the new economic system. Their resource markets were to be found in those regions called the "periphery" or "semi-periphery" – regions to be colonized by the core countries so that resources could be extracted, imported to the core, manufactured, and exported back to the colonies or countries as finished goods, thus making economy and imperialism work in tandem. These peripheries were assumed to be without the same ability to direct the world economy using force, and were relegated to the status of colony and/or export market. Areas of the periphery and semi-periphery were incorporated into the system at different times, at different rates, and, in many cases, piecemeal if the region was large (e.g., the Ottoman Empire, Latin America, the Indian subcontinent). The core could expropriate their resources using unequal trade arrangements.

For the Ottomans, the Capitulations signed with foreign powers eventually facilitated this process: in 1536 *Grand Vezir* İbrahim Pasha negotiated a Capitulation with France, a draft treaty which, due to İbrahim's execution, did not get ratified by Süleyman. A more formal treaty understood to be between equal powers was soon established between the two empires in the same year. Capitulations with Poland were granted in 1553. Capitulatory privilege was finally granted with France in 1569, three years after Süleyman's death, with the English and several other European trading partners in 1580, and with the Dutch in 1612. French and English Capitulations of the sixteenth century initiated fierce competition between them over trade in the Levant. English and Dutch Capitulations reflected more extensive involvement of these two naval powers in the Mediterranean Sea, which was previously the domain of Italian city-states and the Ottomans. Full Capitulatory privilege was not extended to Habsburg merchants traveling to Ottoman lands until 1718. Although Russian merchants had been trading in the Ottoman Empire from the fifteenth century onwards, official Capitulations similar to those granted to France and England were not granted until 1783, with the annexation of Crimea.

The Ottoman-Habsburg Treaty of Edirne in 1568 ended hostilities in Hungary for a quarter of a century, granted Ottoman control of Transylvania, and required the Habsburgs to pay an annual tribute to the Ottomans (see Map 0.1). Other peripheral areas of the vast Ottoman domains, however, were sites of conflict: tensions with Muscovy (which became the Tsardom of Russia under Ivan III, *c.*1547) was beginning to simmer in the north. A Zaydi tribal rebellion broke out in Yemen, an integral region for conducting the spice trade, which took three years to quell. *Grand Vezir* Sokollu Pasha had an ambitious vision for Ottoman authority amid these crises. In the absence of an effective sultan (Selim II) in 1568, his plan to exert and extend Ottoman influence included first, his unsuccessful Suez Canal project to connect the Mediterranean and Red seas as a means not only to facilitate commerce but to get ships, troops, and supplies transported to the south, whether to combat upstarts in Arabia, or the Portuguese. Second, during the Ottoman campaign of 1569, after Ivan IV had seized the khanates of Kazan and Astrakhan in 1556, Sokollu spearheaded the failed Don-Volga rivers engineering project (northwest of Astrakhan) to connect the two waterways by digging a canal that would make possible the dispatch of the Black Sea fleet directly to the Caspian Sea. In the event of another conflict with the Safavids, the proposed canal was also thought to be a way to more rapidly move campaign forces than overland through the Caucasus. The canal came to naught however, and the campaign was a failure. And third, an Ottoman contingent was sent to help the rebellious Moriscos in the War of the Alpujarras (*c.*1568–71). These Muslims in the mountainous Granada region of Andalusian Spain who had been forcibly converted to Catholicism by the Castilian regime were in revolt. Promises of assistance against the Portuguese were made to people in other far-flung regions as well – the Persian Gulf, East Africa, and the sultan of Aceh.

Other influential individuals at the Ottoman court, however, swayed the decision instead for a naval campaign in the Mediterranean to seize Cyprus, which provoked war with Venice, backed by Habsburg Spain and the papacy, from 1570 to 1573. Frustrated by the failure to take Malta in 1565, the Ottomans had resigned themselves to consolidating their control over the eastern Mediterranean and reducing Christian piracy, which operated from Cyprus and disrupted Ottoman shipping to and from Egypt. The Ottomans captured the island in 1571 and made it a new site for resettlement (*sürgün*) and exile. But the Holy League – the Papal States under Pope Pius V, Habsburg Spain, and Catholic maritime powers such as the Republic of Genoa, Venice, Saxony, and the Knights Hospitallers of Malta (the Holy League excluded France) – formed to try to break Ottoman control over the eastern Mediterranean. They united temporarily against the Ottoman navy and used the new class of ship, the Venetian galleass with its cannons, to inflict a dramatic naval defeat. The Ottoman fleet was sunk at Lepanto in the Gulf of Corinth in 1571 at the hands of Spanish naval commander Don Juan de Austria, illegitimate son of Holy Roman Emperor Charles V and half-brother to King Philip II of Spain (Figure 8.1). The victory caused exaltation in Europe, believing that the Ottomans were no longer invincible and that total defeat of the Ottoman scourge was at hand.

Nonetheless, a year later, to the dismay of the Holy League, the *grand vezir*'s wish to see a completely rebuilt Ottoman fleet had been achieved. The naval war went on with less

Figure 8.1 The Battle of Lepanto, 1571.

well-trained Ottoman personnel but no shortage of Ottoman naval successes. In 1574, the Ottomans were able to seize Tunis from the Spanish Habsburgs, after a protracted competition that had gone on for decades and during which Tunis changed hands numerous times since Barbarossa first captured it in 1535. Sultan Selim II died that same year, but the grand mosque in Edirne bearing his name, the *Selimiye* – a masterpiece constructed by the famous architect Mimar Sinan, with the diameter of its dome larger than that of the Aya Sofya and the four spear-like minarets the tallest in Turkey today – was not finished until after his death (Figure 8.2). From this moment in the late sixteenth century, Ottoman overreach in several far-flung directions began to hinder the empire's ability to flexibly confront the challenges to its sovereignty and internal stability.

Selim II's eldest son, Murad III (r.1574–95), ascended the throne after the execution of his young brothers. Like his father, he was also less interested in ruling and spent much of his time in the palace while his ministers governed. Murad III's reign was a tumultuous era, much of which would affect the dynastic household, its ability to assert authority, and the empire's economic stability. Early in his reign it appeared that the Ottomans' European front would be quiet. After the Cyprus war with Venice, official borders were demarcated by 1576 near the Dalmatian fortress at Novigrad (in present-day Croatia), the Venetian frontline of defense against Ottomans in the 1520s after Ottoman victory at Mohács in 1526. In 1580 Bosnia became an Ottoman *beylerleylik* with enlarged territory that included parts of Slavonia, Dalmatia, and forward districts of Serbia, resulting in the migration of mainly Orthodox Christian (Serbo-Croatian) Vlach/Morlach sheep-raisers into the area. A truce with the Spanish Habsburgs over control of the western Mediterranean and North Africa further lessened demands on the Ottoman navy. But, as was seemingly habitual,

Figure 8.2 (facing page) The Selimiye Mosque, Edirne.

MASTER ARCHITECT, MIMAR KOCA SINAN (b.1490–d.1588)

Often considered the father of classical Ottoman architecture, Sinan was a product of the *devşirme* levy. The Christian son of a stonemason, he was converted to Islam and drafted into the Janissary Corps in 1512. Distinguishing himself initially while on military campaign by engineering projects such as bridges and aquaducts, he was eventually appointed chief royal architect. He is credited with designing over 300 structures across the Ottoman Empire in his lifetime – mosques, *medreses*, *hamams*, *imarets*, hospitals, caravansarais, palaces, mausoleums, etc. His most famous architectural achievements were the Süleymaniye Mosque complex in Istanbul commissioned by Sultan Süleyman himself (built between 1550 and 1557), which was influenced by the Byzantine Hagia Sophia architectural design, and the Selimiye Mosque in Edirne (Figure 8.2), which he considered his masterpiece, built between 1569 and 1575. The dome of this mosque is higher than that of the Hagia Sophia/Aya Sofya. Mimar Sinan also designed the Mehmed Sokullu Bridge over the Drina River in Višegrad, Bosnia (Figure 8.3), on order from the *grand vezir*, who hailed from the area and desired to keep "the solemn promise of his heart." It was built between 1571 and 1577.

Figure 8.3 Mehmed Sokullu Bridge over the Drina River, Bosnia.

the eastern frontier with the Safavids again heated up with an Ottoman offensive to take the Caucasus starting in 1578, perhaps triggered also by Ivan IV's push into Central Asia. A prolonged war in the east, the first phase of which lasted until 1590, gained the Ottomans the Safavid capital, Tabriz, and Tiflis, but the difficulty of maintaining supply lines over rugged terrain made the territorial gains a costly endeavor without much return. An Üzbek attack on the Safavids' eastern flank assisted the Ottomans in forcing the Safavids to accept a peace. It did not last, as hostilities reignited with the Safavids a little over a decade later.

SULTANIC SPECTACLE AND PALACE DYNAMICS

As another rather sedentary sultan, Murad III preferred life in the palace to personally campaigning. But in anticipation of the looming Islamic millennium, which would come to pass in 1591–2, the expectation of this sultan's reign demanded expenditures on elaborate celebrations to represent the empire's immense wealth to both the public and foreign observers alike. In the shadow of the costly stalemate against the Safavids that was ongoing in the 1580s, perhaps a public spectacle to distract from such Ottoman imperial setbacks was thought to be in order. In addition to the two annual *Bayram* celebrations marking the end of Ramadan and the Feast of the Sacrifice, respectively, in 1582, on the occasion of his son Prince Mehmed's circumcision, an extravagant public festival that lasted for fifty-two days and nights was held at the Hippodrome in Constantinople, the preparations for which commenced a year ahead of time. The many guilds of Istanbul exhibited their wares in public processions; musicians, dancers, athletes – all performed. Throughout the festival, fireworks were set off at night. An illustrated festivity manuscript book describing each day's events was produced by court artisans to commemorate this lavish affair. The sultan also decided to honor the Prophet Muhammad's birthday, called *Mevlid*, starting in 1588, with an officially decreed court celebration.

The Ottoman succession system that had proved so successful as a pragmatic means of producing capable, if ruthless, leadership, had already been altered by Süleyman and Hürrem's matrimonial choice in earlier decades with consequences for the dynasty. Murad III was the last sultan to dispatch a son to the countryside to administer the provinces. After his reign, the heirs apparent would no longer gain necessary military, political, and administrative experience in provincial postings, but would remain in the palace with their mothers and associates, under a kind of house arrest, until the death of the sultan initiated the succession of one of them. This change had several significant consequences for the empire: first, a trend toward less capable sultans related directly to this policy. Second, in place of princes, power disseminated from the royal household to appointed officials who were rotated around the empire, or to provincial elites with connections to the political center, to maintain order in the provinces. Many profited greatly from their local posting, especially the fiscal and political autonomy it provided them. Third, with the dynastic household now resident in Topkapı Palace, intrigues at court became endemic as factions

emerged around various formidable figures. *Vezirs* vied with one another for the sultan's favor, or for the backing of a particular concubine or one of her sons. The chief black eunuch, the *kızlar ağası*, became extremely powerful at court in this era, controlling the finances of the holy cities of Mecca and Medina among other responsibilities. He and the *şeyhül-islâm* ultimately overshadowed the importance of the *grand vezir* for the sultan for a time. The endorsement of the most powerful woman in the harem, the queen mother (the *valide sultan*) who resided in the palace, was often sought after not only by individuals at court, but by foreign dignitaries who recognized her tremendous influence as well. The harem had increased dramatically in size due to the sheer number of personnel required to maintain it and serve its many residents; rivalries between concubines could and did turn deadly. With the death of a sultan, women of his harem, the *haseki* (chief consort) or wife, typically retired to the Old Palace, where she continued to receive the stipend allotted to her during her tenure as a favorite. If the *valide sultan* outlived her son, she too would usually retire there, though the famous Kösem Sultan was the exception to the rule. As was the funerary tradition, the sultan and his favorite would often be buried side by side in his mausoleum to honor them both.

Mehmed III (r.1595–1603), the eldest of Murad III's sons, seized the throne upon his father's death. Famously recounted by horrified witnesses, the sight of the coffins of his nineteen young brothers carried out of the palace, many of them small children whom he had had strangled, was viewed as particularly heartless fratricidal succession. Following on the heels of his father having had nine brothers executed, it caused much shock and consternation among the general population as to the barbarity of such a succession process. Whether or not the public response to Mehmed III's decision to adhere to this ruthless action caused the eventual lapsing of fratricide as official Ottoman policy is unclear. But from his son Ahmed I's era as sultan (r.1603–17), crown princes were confined to the palace, not sent to provinces, and not usually executed as part of the succession process (though it occurred for other reasons). As outward signs of subordination, they were not allowed to grow a beard, nor father children until and unless they became sultan. Only ascending the throne could free them from life in the *kafes* ("the cage") to participate in ruling the empire and producing a royal heir. For many crown princes, it was a life of mental illness, alcoholism, and relative isolation.

WAR, CLIMATE, REBELLION

The first obvious failures of Ottoman flexibility were laid bare around the turn of the seventeenth century with a series of interrelated crises that caused tremendous hardship for the general population, financial strain on the empire, and internal turmoil within the Ottoman dynasty: wars on several fronts, radical climate fluctuations, and devastating rebellions in the countryside. In 1593, toward the end of Murad III's tenure as sultan, war with the Habsburgs was reignited by what started as raids back and forth on

HASEKI (FAVORITE CONSORT) AND *VALIDE SULTAN* (QUEEN MOTHER) IN THE OTTOMAN PALACE

Nurbanu Sultan (b.1525?–d.1583), likely of Venetian or Greek origin, was Sultan Selim II's *haseki* and legal wife who was the first to use the title *valide sultan* when her son, Murad III, ascended the throne in 1574. She was said to be quite predisposed toward Venice when advising the sultan on policy; she corresponded with other foreign governments as well. She was succeeded by Murad III's *haseki*, Safiye Sultan, upon the accession to the throne of their son, Mehmed III, in 1595. Safiye was also a very powerful *valide sultan* who served as regent and advisor for her son until her death in 1619.

Becoming *valide sultan* apparently relied upon having been a *haseki*, but the post of *haseki* eventually lost its significance some time after Mehmed III's reign, unless one's son became the sultan. As historian Leslie Peirce describes, when "princes lost access to public adulthood, their mothers lost *their* public roles as well ... a result of the general anonymity of the dynastic family once it was gathered into the imperial palace.... With the princes' loss of stature came the anonymity of their mothers."[1] The largest stipend, charitable giving, and public building by dynastic women were henceforth mainly the preserves of the queen mother. These changes paralleled the Ottoman succession system's shift toward the seniority principle by the early seventeenth century, during which time the position of *valide sultan* was occupied by the formidable Kösem Sultan.

Also known as Mâh-Peyker Sultan, Kösem Sultan was born a Greek Orthodox Christian named Anastasia *c.*1590 on an island in Aegean, bought as a slave, entered Ahmed I's (r.1603–17) harem as a teenager, converted to Islam, and became his *haseki*. As *valide sultan*, she served twenty-eight years as powerful regent to two sons, Murad IV (r.1623–40) and İbrahim (r.1640–8), and to her grandson Mehmed IV (r.1648–87) when his mother, Turhan (Sultan İbrahim's *haseki*) was considered too young and inexperienced.

Some attribute the shift away from the fratricidal open succession system to her actions to spare a family member – though at a later time she privately condoned the deposition of her own son İbrahim when his disastrous reign threatened the dynasty and the empire's survival. However, young Turhan, in a rivalry with Kösem Sultan over the post of *valide sultan*, collaborated with the chief black eunuch to foment a palace revolt. In a troubled era of fiscal and other crises in the empire, factions united against Kösem and murdered her in 1651. The derogatory term "Sultanate of the Women," used to describe this era of palace intrigues in the sixteenth and seventeenth centuries, ignored circumstances in which the dynasty was compelled to adjust and transition into a seniority succession system. The phrase has since fallen into disuse due to its misogynous implications.

the European frontier in Hungary-Croatia in which fortresses were taken and lost several times. The Habsburgs refused to pay tribute as per previous agreements and a full-scale Ottoman campaign was launched, just three years after a peace had been agreed upon with the Safavids. The Ottoman-Habsburg war lasted thirteen years. Habsburg-inspired revolts of Ottoman vassals in Transylvania, Wallachia, and Moldavia further fueled the Ottoman offensive. Known as "the Long War," it continued through Mehmed III's reign and into that of his son and heir, Sultan Ahmed I (r.1603–17), ultimately ending with few tangible achievements. In 1596, Sultan Mehmed III, the first sultan to campaign with his army since Süleyman, returned home to Istanbul from the siege of Eğer in Hungary amid much pomp and circumstance (Figure 8.4), though overall the war ended in a stalemate only after his death, with enormous losses on both sides. A peace treaty was signed in 1606. But before that, in 1603, the Ottomans' worst war scenario had come to pass: while still in conflict with the Habsburgs, war on their eastern front with the Safavids had restarted when the tenuous peace treaty broke down and Shah Abbas (the fifth Safavid Shah, r.1588–1629) retook Tabriz. The Ottomans were besieged by war on both flanks of the empire, stretching resources and resolve to the limit. The conflict with the Safavids continued to 1618 – it was a cycle of wars that would continue into the seventeenth century.

A perfect storm had brewed in the late sixteenth century: dynastic politics at court and the factionalism developing in the late sixteenth century caused poor decision-making. The effects of the influx of New World silver on the Ottomans and the choice to debase the coinage in the mid-1580s had deleterious economic consequences for members of the ruling class. The burden of wartime mobilization first on the European front, followed by another war on the Safavid front that was fought simultaneously for a few years, all sparked a devastating series of rebellions across the empire. The Janissaries revolted over the coin debasement. The changes in wartime tactics and technology, including the shift toward siege warfare and defensive anti-cannon fortresses meant the Ottoman cavalry was less useful now, and foot soldiers were needed for the long, drawn-out campaigns. The Ottomans began drafting irregular, militia-type personnel from the peasantry to serve on the battlefield starting in the 1590s. These *sekban*s, as they were called, were first employed in the Habsburg Long War. They were called up on a short recruitment and paid. Some carried firearms (muskets). They were resented by the Ottoman Janissaries and military forces of the ruling elite, those of *devşirme* recruit origins, the "men of the sword," who alone had been permitted to carry arms until now.

The effects of climate and natural disasters (including earthquakes and fires) had not been considered as factors in the turmoil besetting the Ottoman Empire until recent studies unearthed what has been called "Ottoman imperial ecology"[2] and the Ottoman state's ability to provision according to its needs by moving around people, resources, crops, livestock, minerals, etc. Ideologically this provisioning adhered to the Ottoman understanding of the ruler's responsibility to provide for the populace and ensure there would be no shortages anywhere. The Ottoman provisioning system was very successful in feeding its urban populations and armies on campaign with supplies of grain from Egypt and the Black Sea ports, and sheep from the Balkans, the Crimea, and southern and

eastern Anatolia. Timber went to the shipyards in Constantinople, Basra, and Suez from areas of Anatolia and the Black Sea coast. Saltpeter necessary for making gunpowder and other metals and resources for munitions production were not just acquired from outside powers, but were also available and produced locally in Ottoman lands. As effective as their system of provisioning was, it was also fragile, due to the distances involved in transport from one region of the empire to another, and the modes of transport employed. Piracy when shipping across waterways was always a concern. Sheep were transported by shepherds "on the hoof," which would seem relatively secure and problem-free.

However, several features of fifteenth- to sixteenth-century Ottoman Anatolia increased the potential for the empire's management of its peoples and provisioning to break down. First, the Ottoman "core" – identified as the eastern/central Balkans and central/western Anatolia – and the Levant area were the regions of the fastest population growth, whose agricultural taxes were the most significant for the state. Superior Ottoman political and military power over Europe in the fifteenth and sixteenth centuries caused a noticeable population increase in these heartlands, creating more demands on agricultural production and land use, initiating tensions between those tilling lands for crop production and those using pastures for grazing livestock. Second, by the 1560s and up to the 1580s, incessant war as well as natural disasters were the backdrop for late and post-Süleymanic rule. Erratic weather in 1561, 1565, 1570, and 1585 cycled between terrible droughts and wet weather causing flooding; these conditions exacerbated the famines, epidemics, and banditry that had become a regular part of life in the empire's core.

And then, in the early 1590s, the "Little Ice Age" weather pattern that affected the world occurred, and nowhere worse than around the eastern Mediterranean and Ottoman lands. Unprecedented cold and the longest drought in 600 years, followed by harsh, wet, snowy winters and flooding spring seasons coincided with the Habsburg wars, making the campaign in the Balkans extremely grueling, and the demands to provision the military during this lengthy campaign arduous. The Hungarian Danube was recorded as having frozen over on occasion, and campaigning armies having marched across the ice; such an event would have impeded Danube fleets efficiently resupplying armies or transporting soldiers. Ottoman core territories suffered the worst of these climatic effects, which continued into the first decades of the seventeenth century. Such harsh weather conditions led ultimately to the dislocation of people, famine, the spread of plague, the death of livestock due to disease and starvation, and dramatic population decrease. The ensuing *Celali* rebellions, so named after a mutinous spiritual leader earlier in the sixteenth century and centered specifically in Anatolia, were not religiously inspired. They coincided with the effects of traumatic weather patterns, causing people in the Anatolian countryside to flock to cities for refuge and survival. Urban crowding in turn caused an upswing in epidemics due to unsanitary conditions. In 1621 the Bosphorus Straits actually froze over, affecting resupply routes and causing the suffering of the population in the capital, as recounted by a contemporary Ottoman chronicler (and corroborated by other witnesses):

Figure 8.4 Sultan Mehmed III Returning from the Siege of Eğer, 1595–6.

In the year 1030 (1620 AD) there was such a cold that the Istanbul Bosphorus froze, and without ships many men crossed over the ice to Üsküdar, Galata, and Kasımpaşa on foot. In that same city some men froze from the severe cold and died. The earth was covered in snow.

Famine invaded, and the man who could get any bread for a *dirhem* counted himself lucky. The reason for this terrible famine was that once the sea froze, the İskender Bosphorus along Yöros castle was closed and no ship could come from the Black Sea. With no ship coming to the neighborhood of Istanbul from the Mediterranean either, no one was capable of getting provisions to Istanbul.[3]

Historians still disagree about the root cause of these many rebellions in the Anatolian countryside that broke out in the 1590s and wrought havoc on the provinces and populace for decades – whether it was due to wartime mobilization or demobilization. Was it the dissemination of firearms from the sixteenth century on that had occurred among the peasantry? Was it that those who were called up as *sekban*s were away on campaign, allowing for outlaw brigands to prey upon those left behind, their properties unguarded? Or was it the consequence of these *sekban*s returning from the front, armed, with no options but to turn to banditry to survive? In any case, the *Celali* rebellions were seemingly the consequence of several factors: a demographic increase straining the land and resources of the provinces, unemployment, wartime upheaval, climatic disturbances, and economic hardship felt by the peasantry and other sectors of Ottoman society. The Imperial Council had ordered burdensome irregular wartime taxes in cash or in kind to assist in funding campaigns when the state was in extraordinary financial circumstances, called *avarız-i divaniyye* (collected regularly from the eighteenth century). The *ocaklık* system – the demand on villages for labor at times in nearby industries supporting wartime mobilization or to guard strategic facilities (e.g., saltpeter mines, bridges, etc.) – had reached a moment of unbearable hardship for the *re'aya*. Provincial notables, *sipahi*s, and Janissaries (locally stationed, who often acquired land revenue rights called *çiftlik*s) participated in revolts over the Ottoman central authorities' decision to impinge on their autonomy, or to alter their provincial *timariot* or *çiftlik*-holding revenue arrangements to compensate for the economic drain on the treasury that wartime was costing.

A major *Celali* rebellion broke out in Karaman against the Ottoman authorities requisitioning sheep from that province around 1596 (or 1598, sources vary) and it coincided with an earthquake in Anatolia. Its leader had somewhere between 20,000 and 30,000 local armed men ravaging the countryside; the Ottoman state, unable to quell the violence militarily after several years, offered that rebel a governorship in north-central Anatolia (Çorum). Other political rebellions against Ottoman provincial officials had flared in North Africa, Egypt, and Syria. Ultimately the Ottoman state, in an effort to find a tenable and pragmatic solution to the violent unrest in the countryside during war with the Safavids, chose to negotiate with some *Celali* rebels, incorporating their leaders and renegade armies into the administrative and/or military apparatus as a way to adapt, to pacify these forces, and to restore order to the empire, though stability would only be temporary. The governor

of Aleppo with lengthy familial ties to the area, Canbulatoğlu Ali Pasha, led a *Celali* rebellion in cooperation with the Druze *Emir* Fakhr ad-Din Ma'an II in Mt. Lebanon while other *Celali* leaders challenged the Ottoman authorities in Baghdad, Harput, and areas of eastern and southern Anatolia, their forces often numbering between 30,000 and 70,000 armed *sekban*s. Sometimes buying off their commanders with administrative offices in the ruling hierarchy, the Ottoman state was offered cooperation and mercenaries as militia units in exchange. However, the Ottomans would eventually choose to resort to brutal suppression to restore order and Ottoman authority – Canbulatoğlu was executed in 1610 (although his family members continued to occupy government posts). Many *Celali*s were killed in that first decade of the seventeenth century, though the rampaging in the countryside still continued.

The *Celali* rebellions may have started in response to the conditions described earlier, and to oppressive taxation practices in the face of Ottoman state demands to fill the treasury. But it devolved into marauding by renegade militias and mercenary gangs who preyed upon commoners, killing them, seizing their land, possessions, and animals in the worst of times. The combination – weather and lawlessness – was brutal for the Ottoman peasantry, the consequences of which soon also affected the political and economic well-being of the empire as a whole for decades to come, through depopulation and the interruption of revenue to the center. Another phase of rebellions in the mid-seventeenth century, coinciding with dynastic crises at court, and the persistence of climate fluctuations until the early 1700s meant a slow recovery in Ottoman lands. Life in the Ottoman Empire for most subjects was made more dismal and unbearable due to the consequences of dynastic upheaval, wars, rebellions, and radical climatic changes. Ottoman flexibility that had proved so successful in dealing with the circumstances of earlier centuries was dramatically challenged from the late sixteenth century into the seventeenth. Could the Ottomans retrench and adjust to the new realities they faced, and salvage the empire in this critical moment?

OTTOMAN "DECLINE"?

Ottoman historiography until recently viewed the lifespan of the Ottoman Empire as a linear progression in which the post-Süleymanic centuries were merely a slow and inevitable decline. Plenty of revisions to this simplistic understanding of Ottoman history have now been put forth that take into account the many factors causing such a transformation of the empire in the early modern era. Nonetheless, the perception of something having gone awry after Süleyman's reign was not just manufactured out of thin air by modern historians entrenched in Orientalist thinking. The view that something was going terribly wrong in the Ottoman Empire actually emanated from several contemporaries, from various vantage points, both within and outside the empire. Some members of the scribal class of the Ottoman state, the bureaucrats and littérateurs who had become Ottoman by

were rampant in Ottoman political institutions, implying that sultans had no respect for their subjects or their property, whereas European kingdoms did.

This shift in European perceptions of the Ottomans from positive to negative reflects the changing world of the early modern era that could more accurately be termed a multi-dimensional transformation of the Ottoman Empire. This transformation was required in the new global political and economic climate in which European empires had now become more demarcated. They had gained confidence, wealth, power, and colonies as the Renaissance paved the way for the eighteenth-century European Enlightenment. Meanwhile, the Ottomans were managing a vast, well-established, multiethnic and multi-religious empire with its own trajectory of changing patterns at court, in the cities, and in provincial areas, all while suffering natural disasters, costly wars resulting in less return overall, violent rebellions, changing trade routes, and disruptive inflation caused by the reordering of the world economy. Less capable sultans, intrigues at court, and a high dynastic turnover of sultans has been aptly described as part of a process to redefine the understanding of the sultanate in this era. The Ottomans were no longer guaranteed a regular yield of territory, resources, and increased revenue through successful campaigns that expanded the empire's domains. Combined with the sheer distances to border areas straining supply lines, the mass mobilization of people, resources, and livestock necessary to supply campaigns, the changes in fiscal policies to accommodate urgent needs, the start of Ottoman reverses in Europe, and wars in the east against the Safavids, the seventeenth and eighteenth centuries became an era of exacerbated pressures complicating the ability of the ruling elite to effectively govern. A tendency toward political and economic decentralization, away from the Ottoman center and toward the provinces, resulted. Given all of these travails, Ottoman survival for several hundred more years indicates not "decline," but retrenchment and adaptability to changing circumstances, the hallmark of Ottoman imperial existence.

SEVENTEENTH-CENTURY CHAOS AND RENEWAL: *KADIZADELI* CONSERVATISM, SPIRITUAL MILLENARIANISM, THE KÖPRÜLÜ *GRAND VEZIRS*

A few sultans of the seventeenth century seemed aware of the need to regenerate the image of a powerful warrior-sultan resembling Süleyman after several generations of more sedentary Ottoman rulers had come to pass. Sultan Ahmed I (r. 1603–17), who did not campaign himself, presided over the continuation of the disruptive *Celali* rebellions and the suppression of this first phase of revolts around 1609 with his *Grand Vezir* "Kuyucu" Murad Pasha (known as "Grave-Digger," he occupied the post between 1606 and 1611). Ahmed I also witnessed the conclusion of the Long War with the Habsburgs in 1606, and renewed war with the Safavids from 1603 that lasted throughout his reign and would not end until 1618, in yet another mere temporary cessation of hostilities. Nonetheless, his

stunning mosque complex, built in the heart of the Ottoman capital in a district appro-priately named Sultanahmet, and known today as the Blue Mosque (Figure 8.5), was an expression of Ottoman authority despite its funding not having derived from a truly successful Habsburg war.

It is with Ahmed I's death at a young age (twenty-seven years) that a profound modi-fication to Ottoman dynastic succession occurred amid what has been described as an "Ottoman tragedy."[5] First, fratricide lapsed as an official policy. Ahmed I's mentally ill younger brother Mustafa I assumed the throne in 1617. Mustafa I had been spared frat-ricidal execution, perhaps due to the traumatic effects of their father's reign before him when Mehmed III (r.1595–1603) had had his nineteen brothers executed. Or perhaps it was because Ahmed I had not yet fathered a son at that time of his accession, so there was as yet no other heir to the Ottoman throne. In any case, the seniority principle in which the eldest male member of the Ottoman dynasty would ascend the throne soon became the pattern for future Ottoman rule, along with the abandonment of princes assuming provincial postings, but only after some pandemonium at court in the transi-tion involving Ahmed I's *haseki* Kösem Sultan (mentioned earlier). She had much to do with orchestrating succession when he died to secure power as a future queen mother

Figure 8.5 The Blue Mosque, Sultanahmet, Istanbul. Commenced in 1609, finished in 1617.

Genealogy 8.1 Ottoman Sultans and Their *Valide Sultans*.

Ayşe Fatma Mahmud ? = = = = MEHMED III = = = = *Handan*
 (r.1617–18) (r.1595–1603) (r.1603–5)
 (r.1622–3)

 MUSTAFA I *Kösem* = = = = AHMED I = = = = Mahfıruz
 (r.1617–18) (r.1623–51) (r.1603–17)
 (r.1622–3)

MURAD IV Ayşe Fatma Handan Kasım OSMAN II
(r.1623–40) (r.1618–22)

 Turhan = = = = IBRAHIM = = = = *Dilaşub* = = = = Muazzez
 (r.1651–83) (r.1640–8) (r.1687–9)

Gülnüş = = = = MEHMED IV SÜLEYMAN II AHMED II
(r.1695–1715) (r.1648–87) (r.1687–91) (r.1691–5)

(Genealogy 8.1). In fact, the positions of *valide sultan* and chief black eunuch (*kızlar ağası*) of the harem became quite notable in this affair. After only a few months, when it became apparent to the sultan's associates and the general public that Mustafa I suffered from insanity, a palace coup engineered by powerful individuals at court (including the chief black eunuch) deposed Mustafa I in 1618 in favor of Ahmed I's now teenaged son Osman II ("Genç" or "Young" Osman, fourteen years old, r.1618–22), whose mother was Mahfıruz. Unusually, she was not allowed to reside in Topkapı as *valide sultan* upon her son Osman II becoming sultan in 1618, precluding him from a significant source of support within the palace, though Kösem was said to be fond of him. Nor did he have a *haseki*. When Osman II chose to marry, it was to the daughter of a prestigious family, which upset the Ottoman tradition of producing heirs with concubine women of unknown or unassuming origins.

In addition, to command the prestige of the sultanate after the coup by reinvigorating the notion of a *gazi* sultan leading forces in war, Osman II chose to embark upon a foolish campaign in 1621 against the Poland-Lithuania Commonwealth that lasted until early 1622 and ended in Ottoman retreat, with Janissaries angered by Osman II's command and actions. His public appearances caused further opposition. As distrust between Osman II and his slave recruits grew, back in Constantinople, rumors flew: of Osman II's execution of his brother Prince Mehmed, a resort to fratricide which now upset many; of plans to replace his personal Janissary guard and others with *sekban* irregulars, thus recruiting a whole new military; of him going on pilgrimage to Mecca as a

pretext to moving the throne out of Istanbul (perhaps to Bursa, Damascus, or Cairo). The Janissaries mutinied, executed his palace supporters, placed Mustafa I back on the throne, and took Osman II to *Yedikule* (the Seven Towers Fortress built into the city walls) where he was strangled. It was a terribly disturbing event: the first episode of regicide in Ottoman history.

Another year and a half later, in 1623, those who had made Mustafa I sultan a second time deposed him once he was again deemed mentally unfit to rule. He was then replaced on the throne by Murad IV (r.1623–40), the eleven-year-old son of Ahmed I and Kösem Sultan. She served as regent when she became queen mother, running affairs from the palace for her young son from 1623 to 1632 as well as for another son, İbrahim, who succeeded his brother in 1640 when Murad IV had no heir. "Deli" ("Crazy") İbrahim I (r.1640–8) was nicknamed for his unstable mental health and erratic behavior; he was ultimately also deposed and executed in 1648. His son, Mehmed IV (r.1648–87) was placed on the throne, a mere child at age six. Kösem Sultan remained regent for the first few years of his reign, until his mother, Turhan Sultan, and those around her conspired and murdered Kösem Sultan after a state coin debasement policy attributed to her and a maidservant was enacted that resulted in a tradesmens' rebellion in 1651. The turbulence at court over dynastic succession did not really stabilize until the early eighteenth century.

Administering the now very diverse agrarian Ottoman Empire, the vastness of which presented a myriad of political, social, and economic challenges in the seventeenth century, was taking its toll. Another wave of *Celali* rebellions, the first of which was led in 1623 by the governor of eastern Anatolia in Erzurum, *beylerbeyi* Abaza Mehmed Pasha, was followed by others across Anatolia; Sultan Murad IV (r.1623–40) had been able to stabilize the empire with some reforms and a reassessment of land grants despite revolts of these mercenaries attacking the Janissaries in a political rivalry between them. As before, some rebels were rewarded with governing posts and *sekban* soldiers were absorbed into the military. Nonetheless, rebellions across Anatolia continued throughout the seventeenth century when the Ottomans were at war, exacerbating chaos and fiscal crisis. War with the Safavids had restarted; though a protracted conflict from 1624 to 1639, it led to the Ottoman loss (and recovery) of Baghdad, ultimately setting a clearer boundary between the two empires, with the Caucasus region divided between Ottoman control over western Armenia and Georgia, and Safavid sovereignty over Azerbaijan and eastern Armenia. The Ottoman hold on Arabia had loosened, and after the Zaydi rebellion in 1635, the Ottomans were expelled and completely lost Yemen. Trouble with the Cossacks in the Black Sea region from the early 1600s resulted in the Ottomans' slow loss of control over ports in the Black Sea. These early seventeenth-century territorial constraints provided the backdrop for further unsettled dynastic politics at court.

Responses to the ongoing chaos in the capital – an empty treasury, Janissary and *sipahi* conflicts and rebellions, factionalism from the 1620s and 1630s onwards boiling over between Albanians and Bosnians who had come to dominate the Ottoman ruling establishment versus slave recruits of Caucasian origins, widespread corruption and the selling of offices, and the draining conflicts in borderlands of the empire – manifested in several

forms. Sultan Murad IV was uneasy about the possibility of others among the ruling elite seizing power and he reacted with both curiosity and decisiveness: wandering the city incognito with his chief black eunuch, he gauged the mood of the capital; those whom he considered a threat, including brothers, several *vezir*s, and the *şeyhül-islâm*, he had executed. Often in times of crisis in Islamic polities, a demand for the state or society to return to the "true path of Islam" from which they had strayed, the Sunna of the Prophet Muhammad and the *Rashidūn* (the first four caliphs after Muhammad's death), is made by more conservative Muslims. This was one of those moments. Murad IV not only enacted certain reforms to reassert control and stabilize the empire, but he began to adhere to the ideas of a puritanical spiritual movement that emerged in Constantinople starting around 1631. The *Kadizadeli* movement, as it was called, enforced a rigid interpretation of Islam. Based upon the earlier teachings of a scholar named İmam Birgivi (d.1573), who challenged what he saw as moral corruption (even disagreeing with Sultan Süleyman I's *şeyhül-islâm*, Ebu Su'ud, over the issue of cash *vakfs*), another Muslim scholar named Kadizade Mehmed Efendi (d.1635) began to write treatises in the 1620s and 1630s. He was influenced additionally by the writings of medieval Muslim scholar Ibn Taymiyya (b.1263–d.1328), whose commentaries reflected the concern over the fate of Islamic society at the hands of the conquering Mongols in the thirteenth century. Kadizade Mehmed Efendi had been a member of a Sufi order before eventually rejecting its practices as deviating from the true path. He explicated how Sultan Murad IV should correct the moral abuses of Ottoman society through strict adherence to the tenets of the Qur'an and the Sunna. This included reining in the Janissaries, who were viewed as not only politically corrupt but, as a consequence of their connections to the heterodox *Bektaşi* Sufi order, morally bankrupt. In an attempt to purify society and restrict the activities of the increasingly "immoral" Janissaries, Sultan Murad IV embarked on a program of "renewal": he prohibited visits to saints' graves, seen as a heretical Sufi practice; sumptuary laws (codes of dress for non-Muslims) were strictly enforced; and he banned coffee and alcohol, closing down the coffeehouses and taverns where these "offenses" took place and which were believed to be dens of immorality and Janissary sedition. Ironically, Murad IV died prematurely at age twenty-seven due to complications from excessive alcohol consumption (cirrhosis)!

The *kadizadeli*s were not just acting on moral impulses, however. Many of them were charismatic preachers from the east who were excluded from prestigious *medrese* and judicial positions within the Ottoman religious *ulema* class, and were expressing their frustrations. After roughly the 1550s, these *ilmiye* ("men of religion") positions had generally become the preserve of those educated and employed in the *medrese*s of major cities, while marginalizing those from the provinces. By the end of the seventeenth century, the well-connected sons whose family or household allowed them to become apprentices to more powerful office-holders were guaranteed a path to the top. This competition for high offices within the Ottoman elite would boil over at the turn of the eighteenth century when rebellion, dynastic turnover, and defeat in war provided the backdrop for more than just moral conservatism directed at society – it would result in a few violent episodes directed at the perceived transgressors within the elite (see Chapter 9).

The prolific scholar and polymath of the era known by the sobriquet Katip Çelebi (b.1609–d.1657), a member of the Ottoman intellectual elite influenced by Kadizade Mehmed Efendi himself, provided his own diagnoses of the need for a just and ideal Ottoman administration amid the many crises plaguing the empire. He assimilated pre- and early Ottoman philosophical, religious, and even medical understandings of political authority in his many treatises to provide a reiteration of the principles of the Circle of Justice as a template for good Ottoman imperial governance in the mid-seventeenth century. His search for remedies to sustain and preserve a natural order within the Ottoman polity was similar in genre to the "mirror for princes" advice authored not just by previous Ottoman bureaucrat-scholars, but also by Muslim scribal elites of earlier Islamic dynasties. However, he was also influenced by particular circumstances of the time, which included global rivalries among surrounding empires with competing universalist claims, provincial political and economic troubles, and in general the domestic social climate of the time.

A few short years after "Deli" İbrahim I (r.1640–8) had succeeded his brother Murad IV, the Ottomans, frustrated over piracy by Maltese corsairs, engaged in a war with Venice over the island of Crete which lasted twenty-five years, from 1645 to 1669. İbrahim I's unpredictable behavior and debauchery, the frequent appointment and dismissal of his officials, various climatic disasters, unabated brigandage in the countryside, and a bankrupt treasury came to a head with Venice blockading the Dardanelles Straits in 1648–9 during the war, cutting off supply lines to the forces at Crete and to the capital. The same year, 1648, was also when an earthquake hit Constantinople, affecting water supplies, causing rioting and ultimately the deposition of the sultan after a violent Janissary cavalry rebellion sparked the support of the *ulema* and general population. Unlike the untidy dethroning of Osman II previously, Sultan İbrahim I was overthrown in a palace coup engineered and sanctioned by his politically astute mother Kösem Sultan, with a religious *fetva* drafted by the *şeyhül-islâm* himself, legitimating the coup. Sultan İbrahim I was executed in a second regicide. His son Mehmed IV (r.1648–87) ascended the throne while the Candia War with Venice over Crete continued.

Sultan Mehmed IV spent most of his reign in Edirne, his favorite hunting ground, rather than in Istanbul, especially after a fire had damaged Topkapı Palace and forced a relocation to the older capital. He was known as *Avcı*, "The Hunter," due to his passion for pursuing this activity more than ruling his empire. Mehmed IV appeared content to permit his ministers to govern in his stead during most of his forty-year tenure as sultan, which allowed for the capable administration by members of the Albanian Köprülü family starting in 1656 with Köprülü Mehmed Pasha, a *kapıkulu* slave recruit whose distinguished service both provincially and in the capital was in various positions and offices during Murad IV's reign. Turhan Sultan, the *valide sultan* in the 1650s, had moved the office of the *grand vezir* out of the palace, which insulated it from intrigues and facilitated Köprülü Mehmed Pasha's eventual success in asserting *vezir*ial authority. Once he became *grand vezir*, he reined in *Kadizadeli* opposition to the establishment *ulema* through exile. Rebellious soldiers were executed, provincial rebellions were quelled, and a semblance of tranquility in the empire prevailed, all during the ongoing conflict with Venice over Crete. Köprülü Mehmed Pasha died in 1661 and for the first time, a son assumed the *grand vezir*ate directly

after his father: Köprülüzade Fazıl Ahmed Pasha served as *grand vezir* from 1661 to 1676. By 1665, indicative of the elevated authority of the Köprülü *vezir*s, the Imperial Council regularly met in the office of the *grand vezir* rather than in the palace.

Imperial troubles had been looming, however. In 1663, a demand was made of the Habsburgs to restart their payment of tribute to the Ottomans (which had been paid from Süleyman's time until the end of the Long War in 1606), which resulted in the Ottoman-Habsburg war led by *Grand Vezir* Köprülüzade Fazıl Ahmed Pasha. The Ottomans were defeated in 1664 at Mogersdorf, south of Vienna, but by terms of the treaty, they gained control over an area of Transylvania (in today's modern Slovakia). Putting an end to the Venetian war in 1669, the Ottomans now possessed Crete, which became an Ottoman province. Rich in agricultural produce, Crete remained Ottoman territory from this moment until 1913.

In the tumultuous mid-seventeenth-century Ottoman Empire, social tensions manifested as dramatically as military conflicts between empires. Another wave of *Kadizadeli* severity surfaced again in the empire around 1665 with the *grand vezir*'s reinvigoration of *Kadizadeli* conservatism – bans were again placed on the "immoral vices" of coffee, tobacco, alcohol, etc. for the public as a way to preserve order in the empire. Nonetheless, Köprülüzade Fazıl Ahmed Pasha reportedly indulged in some of them himself, dying in 1676 at the young age of forty-one from complications due to alcoholism. In the same year, 1665, a spiritual social rebellion against Ottoman authorities led by Jewish rabbi Sabbetai Zvi gained a substantial following and unnerved the empire with its potential for inciting political unrest and rebellion (Figure 8.6). Suppression of the movement was swift.

The Köprülü dynasty endured throughout, symptomatic of the rise of prominent pasha households (*kapılar*) in the capital whose families began to dominate administrative and military posts in the empire, and extended their wealth and influence into provincial areas as well. Another brother, Köprülüzade Fazıl Mustafa Pasha, also rose through the ranks of *vezir*s to eventually become a similarly capable *grand vezir* in 1689. He was killed in battle fighting the Habsburgs in the Balkans in 1691. This powerful and often effective household of *grand vezir*s and statesmen presided over Ottoman affairs until roughly the first decade of the eighteenth century. Early on, they oversaw finances and resettlement policies amid various calamities: the war with Venice, the recurring weather events around the Mediterranean, the repeated rebellions in Istanbul and in the countryside, and urban disasters like the severe drought in 1660 that led to fire in Constantinople and destroyed two-thirds of the city, followed by the usual famine and plague that accompanied events of this sort.

The global changes experienced by the Ottoman Empire in the late sixteenth century included demarcation of imperial borders through outcomes in war, the effects of the discovery of new international trade routes that had an inflationary impact on the Ottoman economy, and the climatic disruptions culminating in the Little Ice Age. These changes did not just provoke witnesses inside and outside the empire, Ottoman and foreign, to interpret critically what many of them labeled a deterioration of Ottoman state and society. They also fomented particular domestic responses to these challenges on the part of the

1665 SABBETAI ZVI MOVEMENT

Many of the rebellions besetting the Ottomans in the seventeenth century are described as that of the *Celali*s, or as political in nature, that is, revolts against Ottoman authority. The movement of Sabbetai Zvi (b.1626–d.1676) (Figure 8.6), a Jewish rabbi from Smyrna (Izmir), was spiritual in its character and became political in its expression. It had far-reaching side effects for Ottoman society. It occurred in a time wrought with millenarian, "renewal" movements in other places in the world. While still in Smyrna, around 1648, Sabbetai Zvi started proclaiming he was the Jewish Messiah, in a year associated with redemption of Israel by some Jews following a mystical sect. He was soon banished from Smyrna by fellow rabbis. He traveled to various Ottoman cities – Constantinople, Salonika, Cairo, and Jerusalem, to preach his messianic message. He cultivated a large following, reaching beyond Ottoman lands and into Europe. After declaring he would depose the sultan and establish himself as ruler, he returned to Constantinople in 1666, where he was imprisoned for a few months.

However, he continued to gain plenty of financial and spiritual support from his followers, as people sold their material possessions, awaiting the enthronement of the Messiah. The sultan and his *vezir*s, eager to disband this potential challenge to the morality and stability of the Ottoman state (no doubt during another wave of *Kadizadeli* rigidity), gave him the choice to either be impaled, or subject himself to a trial of his divinity in the form of a volley of arrows (in which should the archers miss, his divinity would be proven), or he could convert to Islam. As the story goes, he donned a turban and converted to Islam the following day, and was granted an Ottoman title and a salary by the sultan

Figure 8.6 Sabbetai Zvi Crowned as the Messiah, Seventeenth Century.

himself. Three hundred families who were his disciples also chose to follow in his footsteps and converted to Islam.

Known as *dönmes* (those who turned, "converts"), they were often believed to have only outwardly converted and become Muslim while still secretly practicing Judaism in private. In later centuries they were sometimes accused of fomenting conspiracies against the Ottoman state. Most of the *dönmes* relocated to Salonika, but in 1912 they moved to Anatolia after the city fell to Greece.

sultan and dynasty, the palace, and the ruling class in the capital, as well as from provincial elites and the peasantry in the countryside. Sultans perhaps uneasily attempted to impress upon subjects as well as European powers a sense of uninterrupted Ottoman glory and wealth through public festivals and displays of grandeur. But this could not alleviate the growing challenges, domestic and international, the Ottoman state continued to face into the seventeenth century. Amid disastrous wartime political and financial stresses, behind the scenes, dynastic succession was being altered.

Powerful individuals at court, with the backing of other groups (e.g., Janissaries, *ulema*) intervened in a climate of palace factionalism to oust sultans deemed unfit to rule, creating more turmoil. Confronting changes in warfare, the character of the Ottoman military was evolving from a slave recruit Janissary army to relying upon *sekban* militias, many of whom were loyal to autonomous provincial notables who were empowered enough at times to compel the Ottoman state to grant their demands for government posts, or else face *Celali* mercenary rebellions. The state's negotiation with *Celali*s eventually had to turn to violent suppression of the rebels, though management of provincial Ottoman regions remained an issue with recalcitrant actors until the end of the empire. Thus Ottoman internal responses to the dire circumstances of the mid-1600s should be described as the following: provincial rebellion and unrest to demonstrate dissatisfaction with the status quo; Islamic *Kadizadeli* conservatism undertaken by certain ruling elites as an expression of sociopolitical anxiety and marginalization, fearing usurpation of power but couched in a veneer of quelling moral transgressions; and, in a demonstration of the rising political power of elite households (*kapılar*) as dynastic authority receded, Köprülü *veziri*al recentralization of Empire – in an effort to adapt and manage flexibly the inevitable transformation of the Ottoman state in the seventeenth century.

NOTES

1 Leslie Peirce, *The Imperial Harem: Women and Sovereignty in the Ottoman Empire* (New York: Oxford University Press, 1993), 104.

2 Sam White, *The Climate of Rebellion in the Early Modern Ottoman Empire* (New York: Cambridge University Press, 2011), xi.

3 *Hasan Bey-Zâde Târîhî*, ed. Şevki Nezihi (Ankara: Türk Tarih Kurumu Basımevi, 2004), 928–9, quoted in White, *The Climate of Rebellion*, 124.

4 See George W. Forell, "Luther and the War against the Turks," *Church History* 14, no. 4 (December 1945): 256–71.

5 Gabriel Piterberg, *An Ottoman Tragedy: History and Historiography at Play* (Berkeley: University of California Press, 2003), 1.

SELECTED READINGS

Aksan, Virginia H. "Theoretical Ottomans." *History and Theory* 47 (2008): 109–22.

Atasoy, Nurhan. *1582 Surname-i Hümayün, An Imperial Celebration*. Istanbul: Koç Bank Publications, 1997. http://www.turkishculture.org/traditional-arts/miniatures/life-in-istanbul-785.htm.

Ayalon, Yaron. *Natural Disasters in the Ottoman Empire*. New York: Cambridge University Press, 2014.

Baer, Marc David. *The Dönme: Jewish Converts, Muslim Revolutionaries, and Secular Turks*. Stanford: Stanford University Press, 2010.

Barkey, Karen. *Bandits and Bureaucrats: The Ottoman Route to State Centralization*. Ithaca: Cornell University Press, 1994.

Barzman, Karen-edis. *The Limits of Identity: Early Modern Venice, Dalmatia, and the Representation of Difference*. Leiden: E.J. Brill, 2017.

Bulmuş, Birsen. *Plague, Quarantines and Geopolitics in the Ottoman Empire*. Edinburgh: Edinburgh University Press, 2012.

Casale, Giancarlo. *The Ottoman Age of Exploration*. New York: Oxford University Press, 2010.

Currie, James Muhammad Dawud. "Kadizadeli Ottoman Scholarship, Muhammad Ibn 'Abd al-Wahhâb, and the Rise of the Saudi State." *Journal of Islamic Studies* 26, no. 3 (2015): 265–88.

Darling, Linda T. *Revenue-Raising and Legitimacy: Tax Collection and Finance Administration in the Ottoman Empire, 1560–1660*. Leiden: E.J. Brill, 1996.

Dursteler, Eric R. *Venetians in Constantinople: Nation, Identity, and Coexistence in the Early Modern Mediterranean*. Baltimore: Johns Hopkins University Press, 2006.

Eldem, Edhem. "Capitulations and Western Trade." In *The Later Ottoman Empire, 1603–1839*, edited by Suraiya N. Faroqhi, 283–335. Vol. 3 of *The Cambridge History of Turkey*. New York: Cambridge University Press, 2006.

Erimtan, Can. "The Perception of Saadabad: 'The Tulip Age' and Ottoman-Safavid Rivalry." In *Ottoman Tulips, Ottoman Coffee: Leisure and Lifestyle in the Eighteenth Century*, edited by Dana Sajdi, 41–62. London: I.B. Tauris, 2007.

Ertuğ, Zeynep Tarım. "The Depiction of Ceremonies in Ottoman Miniatures: Historical Record or a Matter of Protocol?" In *Muqarnas: An Annual on the Visual Cultures of the Islamic World*, vol. 27, edited by Gülru Necipoğlu and Karen Leal, 251–75. Leiden: E.J. Brill, 2010. https://s3.us-east-1.amazonaws.com/media.archnet.org/system/publications/contents/9474/original/DTP101957.pdf?1396896599.

Faroqhi, Suraiya, and Arzu Öztürkmen, eds. *Celebration, Entertainment and Theatre in the Ottoman World*. Calcutta: Seagull Books, 2014.

Ferguson, Heather L. *The Proper Order of Things: Language, Power, and Law in Ottoman Administrative Discourses*. Stanford: Stanford University Press, 2018.

Finkel, Caroline. *Osman's Dream: The Story of the Ottoman Empire 1300–1923*. London: John Murray, 2005.

Fleischer, Cornell. *Bureaucrat and Intellectual in the Ottoman Empire: The Historian Mustafa Âli, 1541–1600*. Princeton: Princeton University Press, 1986.

Imber, Colin. *The Ottoman Empire, 1300–1650: The Structure of Power*. New York: Palgrave Macmillan, 2002.

İnalcık, Halil. "Military and Fiscal Transformation in the Ottoman Empire, 1600–1700." *Archivum Ottomanicum* 6 (1980): 283–337.

Kunt, I. Metin. *The Sultan's Servants: The Transformation of Ottoman Provincial Government, 1550–1650*. New York: Columbia University Press, 1983.

Necipoğlu, Gülru, and Karen Leal, eds. *Muqarnas: An Annual on the Visual Cultures of the Islamic World*. Vol. 27. Leiden: E.J. Brill, 2010. https://s3.us-east-1.amazonaws.com/media.archnet.org/system/publications/contents/9474/original/DTP101957.pdf?1396896599.

Özel, Oktay. "The Reign of Violence: The Celalis c.1550–1700." In *The Ottoman World*, edited by Christine Woodhead, 184–202. New York: Routledge, 2011.

Piterberg, Gabriel. *An Ottoman Tragedy: History and Historiography at Play*. Berkeley: University of California Press, 2003.

Sholem, Gershon. *Sabbatai Sevi: The Mystical Messiah, 1626–1676*. Princeton: Princeton University Press, 1973.

Valensi, Lucette. *The Birth of the Despot: Venice and the Sublime Porte*. Ithaca, NY: Cornell University Press, 2008.

Varlık, Nükhet. *Plague and Empire in the Early Modern Mediterranean World: The Ottoman Experience, 1347–1600*. New York: Cambridge University Press, 2015.

Wansbrough, J., Halil İnalcık, A.K.S. Lambton, and G. Baer. "Imtiyāzāt." In *Encyclopaedia of Islam*, edited by P. Bearman, Th. Bianquis, C.E. Bosworth, E. van Donzel, W.P. Heinrichs. 2nd ed. Brill, 2012. https://doi.org/10.1163/1573-3912_islam_COM_0371.

White, Sam. *The Climate of Rebellion in the Early Modern Ottoman Empire*. New York: Cambridge University Press, 2011.

White, Sam. "Rethinking Disease in Ottoman History." *International Journal of Middle East Studies* 42 (2010): 549–67.

NINE

LATE SEVENTEENTH-CENTURY OTTOMAN DISRUPTIONS, EIGHTEENTH-CENTURY INTRUSIONS AND EXCHANGES

The second half of the seventeenth century in the Ottoman Empire was in many ways more turbulent than the first, marked by the steady encroachment of European powers and forces of the Russian Empire militarily. This era was not without some Ottoman victories, but they paled in comparison to earlier conquests that had expanded Ottoman domains exponentially – the ruling class now needed to direct its energies toward administrating and defending what it possessed. While Ottoman flexibility was employed to accomplish governance domestically wherever possible, resisting European and Russian interventions in the empire, whether political, military, economic, or cultural, proved to be a very formidable task. The Ottoman military machine on campaign was still a significant threat on Europe's doorstep. But the tide seemed to be turning when perhaps the most famous chapter in the narrative of seventeenth-century foreign victories over the Ottomans occurred – the failed Ottoman siege of Habsburg Vienna in 1683, which set the imperial stage for further Ottoman territorial losses in Europe in subsequent decades. The Ottomans would recognize that other means than mere military might were required to survive in this changed world. Negotiations and diplomacy in the international arena would also be necessary, as well as finding innovative ways to manage provincial finances and peoples.

Focusing solely upon military victories and defeats, however, does not tell the whole story of late seventeenth- to eighteenth-century Ottoman relations with Europe. Economic interactions between the Ottoman Empire and foreign powers were still contingent upon earlier Capitulatory arrangements that would prove devastating to the Ottoman economy in the long run. Culturally speaking, past scholarship concentrating on this early modern

to modern period has emphasized the significance of the process of westernization among the Ottoman societal elites, particularly in the eighteenth century. While there is no denying the Western influences at work on Ottoman state and society that began here, it would be more accurate to describe it as an intersection of sorts that existed between the Ottomans of "the east" and Europe in "the west" – whether one speaks of art and architectural styles, music, or other expressions of culture. The flow of knowledge, of culture and technology, had for many centuries flowed generally from east to west; this was now a moment of shifting patterns that functioned more like a two-way street, though one could argue eventually science and technology would inevitably flow from west to east, starting in the Enlightenment. The Ottomans would look to the west as a yardstick for measuring modernity, although their modernizing gaze was not only cast upon European innovations, but toward reforms conducted by the Russian tsars in the eighteenth century and Meiji Japan in the nineteenth. In any case, Ottoman flexibility and pragmatism in governing an empire would have to rise to the challenges of the continuously changing global and domestic political orders.

TROUBLE IN THE NORTHERN ARC

Though the Ottomans had preserved the entente with the Polish-Lithuania Commonwealth up to a point, raiding by Cossacks along the Black Sea littoral had extended down as far as Ottoman settlements on the Bosphorus Straits, threatening Constantinople itself. The Ottomans, on the defensive, made a deal to support Ukrainian Cossacks against the Commonwealth, triggering a response from Poland and a declaration of war in 1671 (Map 9.1). Ottoman forces led by Sultan Mehmed IV and the *Grand Vezir* Köprülü Fazıl Ahmed Pasha temporarily gained the empire its furthest extent north, Podolia, in 1672, after a successful siege of the Kamenets Fortress (in today's Ukraine, southwest of Kyev, near the Moldova border) (Figure 9.1). They held Podolia until 1699.

Historians have questioned whether Ottoman preoccupation with expanding the European front against the Habsburgs and Venice rather than prioritizing the Black Sea and Russian steppe frontier as a core area to be rigorously defended ultimately assisted in the downfall of the Ottoman Empire. Sultan Mehmed IV's court had remained in Edirne, where he preferred to be, and closer to the sites of Habsburg and Venetian military confrontations. In the late seventeenth century this capital would prove important to overseeing post-1683 treaty arrangements with Europe; subsequent sultans maintained Edirne as their palace until 1703, though Istanbul remained officially the Ottoman capital. To the north, Muscovy had been a steady and beneficial Ottoman trade partner. But due to Cossack raids, conflicts in the Ukraine with both Poland and Muscovy, and Ottoman troubles with the Crimean khan, Muscovy (which had become the Tsardom of Russia by 1547 and the Russian Empire with Peter the Great in 1721) evolved into the Ottomans' greatest enemy from the late seventeenth century until the empire's end. Ottoman support for the

THE CAPITULATIONS: PART III

From their beginnings as Ottoman privileges bestowed upon foreign powers when the Ottomans were in a position of political and military strength in the sixteenth century, Capitulations evolved over time into a destructive force in the Ottoman Empire. As the power balance shifted internationally away from Ottoman supremacy and toward European hegemony, Western empires started to forcefully demand better commercial arrangements in their Capitulatory agreements, including lower tariffs, access to more markets, and, from the late seventeenth century, legal, extraterritorial privileges (in effect diplomatic immunity) for their respective foreign nationals on Ottoman soil. The effects of this new economic system, skewed in favor of foreign powers due to Capitulatory privileges, were being felt by the seventeenth and eighteenth centuries in Ottoman lands. The Ottomans were compelled to abide and unable to abrogate the detrimental arrangements; they reached a disastrous peak in the nineteenth century when local cottage industries were decimated by the effects of the Capitulations allowing European merchants tariff exemptions so that European goods flooded the Ottoman market.

Additionally, Capitulations were eventually manipulated to include some Ottoman *dhimmi*s, non-Muslim subjects of the empire linked to foreign governments either as actual translators and interpreters, *dragoman*s who also conducted business, or who were connected falsely through bribery, given foreign citizenship, and issued a *berat*, thus benefiting from advantageous trade concessions and avoiding payment of the *jizya*. Ottoman concern for maintaining its ability to provision the empire and allowing the flow of foreign commerce had, in latter centuries, led to these detrimental political and economic effects. Serious efforts to cancel the Capitulations in the nineteenth century were met with resistance by European powers; during World War I the sultan declared the abolition of the Capitulations to no avail; they were not completely abrogated until 1923. Historian Caroline Finkel describes the Capitulations best:

> The Ottomans favored a notional "command economy," in which their foremost responsibilities were to maximize the wealth in the treasury and prevent shortages in the marketplace – especially in Istanbul. Although this principle could only ever be partially implemented, the subordination of economic to political and social priorities which it implies serves to emphasize the different vision of their western trading partners, who seized any opportunity to increase economic activity and profits. These two economic views complemented each other to the ultimate disadvantage of the Ottomans who could not envision that the western states' eagerness to enter into capitulatory agreements with them would, in later centuries, work to the detriment of their own economic – and political – well-being.[1]

Map 9.1 Ottoman Podolia and Surrounding Empires, Seventeenth Century.

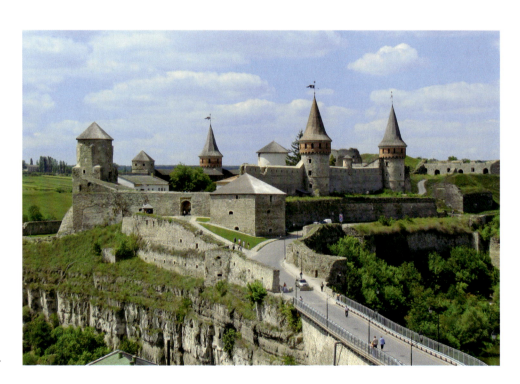

Figure 9.1 Fortress of Kamianets-Podilskyi, Ukraine.

Cossacks as another adversary against the Commonwealth (in addition to the Ottomans' traditional ally, the Crimean Tatars), had disturbed the balance between Poland-Lithuania and the Russian Tsardom in the long term. The effects of this disruption would be felt soon enough and be terribly costly for the Ottomans by the end of the seventeenth century.

The last decade of Mehmed IV's rule was defined by wars in the "Northern Arc": a war with Russia in 1677–8 over part of Ukraine, culminating in the very disastrous war starting in 1683 against what would, by 1684, become the Holy League – the Austrian Habsburgs, the papacy, Venice (in the Morean War, 1684–99, fought in the Peloponnesus and the Aegean Sea), Poland, and the Russian Tsardom, at a time when France and the Habsburgs had reached an entente. This war, often called the "Great Turkish War," continuing as it did until 1699, outlasted Mehmed IV, who died in 1693, and spanned the chaotic turnover of three more Ottoman sultans' brief reigns as well as those of several *grand vezir*s. Their failures on campaigns and in quelling domestic rebellions by various sectors of Ottoman society cost them their positions and/or their lives. But before Mehmed IV was overthrown by the military in a coup in 1687 that placed his brother, Süleyman II (r.1687–91) on the throne, a most humiliating Ottoman defeat occurred with their failure at the second major siege of Vienna in 1683.

THE SIEGE OF VIENNA 1683 AND RUINOUS AFTERMATH

There were several factors leading up to the siege of Vienna and Ottoman failure in 1683. Habsburg troubles had already been evident in the 1670s with Thököly's Middle Hungarian Principality and its Protestant Hungarian nobility. These vassals of the Ottomans, insurgents against their Catholic overlords due to Leopold I, the Holy Roman emperor (r.1658–1705), having ruled over Hungary and alienated them, declared their independence and Thököly their king. They sought support from either the French King Louis XIV (r.1643–1715) – the Habsburgs' enemy in the Thirty Years War (1618–48) – or from the sultan. Ottoman decision-makers, perhaps not taking into account the cessation of hostilities between France and the Habsburgs, viewed the Austrian Empire as at a vulnerable moment, considering it an opportunity to expand Ottoman territory westward. There was disagreement at court over how to proceed militarily, but Merzifonlu Kara Mustafa Pasha, *grand vezir* since 1676 (and son-in-law of the Köprülü forebear), persuaded Mehmed IV of the potential to proceed (Map 9.2).

The *grand vezir* was initially approved to command forces to acquire the fortress of Győr on the Habsburg-Ottoman frontier, about halfway between Buda and Vienna on the Danube River, on the pretext that the Habsburgs refused to give it as tribute to honor a previous treaty. In the spring of 1683 the sultan and elements of his military, the Janissaries, artillery, and cavalry all gathered in Belgrade for an assault, and the *grand vezir* led the campaign from there. But Kara Mustafa Pasha's greed pushed the army beyond Győr. Poor planning, lack of readiness for undertaking an extension of the campaign to Vienna, a

Map 9.2 Losses along the Danube.

city at a great distance in terms of military supply lines, and changes in modern-era siege warfare would be determining factors in the outcome. The difficulty of carrying out this attack on Vienna now that European warfare relied on defense and siege technology was missed: the Ottomans did not transport the heavy artillery needed to breach thick city and fortress walls. Conquering strongholds and towns along the way to facilitate the lengthy supply lines was a necessity that stretched manpower and resources. Once Ottoman forces encircled the walls of the city in the summer, sconces (trenches) and mining by Ottoman forces were somewhat effective against the defenders of Vienna. But at a critical moment,

Figure 9.2 Battle of Kahlenberg, Siege of Vienna, 1683.

Kara Mustafa Pasha's desire to hold back the army in hopes that Vienna would capitulate voluntarily would cost him the victory: if they surrendered, Ottoman forces would not be allowed to break through and pillage for themselves as was tradition; he would be able to seize more wealth for himself. Holding out for this possibility, relying upon poor intelligence reporting, and with relatively evenly matched forces between the Ottomans and the coalition of European forces that had united against them, the Ottoman military was routed (Figure 9.2). Kara Mustafa Pasha's delay had allowed for the cavalry of the victorious Jan III Sobieski, king of Poland (r. 1674–96) to reach the gates of Vienna and overrun the Ottoman encampment, capturing Ottoman equipment and tents. The Christian armies had halted the Ottoman advance at last. With a few exceptions in which temporary withdrawal and reconquest occurred, from this moment onwards, Ottoman sultans were forced to permanently withdraw from areas where they were defeated.

Kara Mustafa Pasha's failure at Vienna cost him his life – he was executed. The Ottoman war against the Holy League's members – another that had been organized by Pope Innocent XI and which included the Papal States, the Habsburgs, Venice (who wanted to reclaim territories), and Russia by 1686 – continued from 1684 to 1699, ultimately resulting in the loss of Buda, Esztergom on the Danube, and a large region of Hungary in 1686 to the Habsburgs, then Mohács in 1687, and a brief assault on the Crimea by Russia in 1689.

The debacle at Vienna contributed to the mutiny among the Ottoman military forces, turning militias, Janissaries, and cavalry regiments on one another in violent unrest and ultimately the military forced the deposition of Sultan Mehmed IV in 1687 in favor of his brother, Süleyman II (r.1687–91), who fearfully ascended the throne after a forty-year life of imprisonment in the palace. Mehmed IV was not executed but was left to retire in Edirne.

While the Ottoman Morean War in Greece with Venice continued, the Ottomans lost Belgrade temporarily in 1688 to the Habsburgs. The Ottomans were soon granted a moment of improved fortunes on the battlefield, however. In Europe the Bourbon-Habsburg dynastic rivalry resulted in the "Nine Years War" (1688–97) between Louis XIV of France and Austrian Holy Roman Emperor Leopold I over succession of the Spanish throne. Also called the War of the Grand Alliance, Habsburg energies (along with those of England, the Netherlands, the League of Augsburg, and the king of Sweden) were occupied with resisting French expansion when France's army invaded the Rhine. Sultan Süleyman II benefitted from this circumstance and led a campaign in 1689 to retake the crucial outpost and fortress of Belgrade, strategically situated at the junction of the Danube and Sava Rivers. The Ottomans succeeded in 1690, as well as seizing a few other strongholds. When Sultan Süleyman II died in 1691, Ottoman forces were on the front to defend Belgrade against another Habsburg offensive. His and Mehmed IV's brother, Ahmed II, who had also been confined to the palace for much of his life, was placed on the throne in Edirne. Ahmed II (r.1691–5) immediately presided over what amounted to another brief loss of Belgrade in 1691 before further battles amounted to retrenchment on two fronts, Belgrade and Transylvania, against the Habsburgs. Once the Ottomans regained their hold over Belgrade, it would last for the next twenty-seven years.

But continued fiscal difficulties required the Ottomans to institute some creative solutions. They attempted to implement *sürgün* policy to relocate and force the settling of tribal groups as a way to reinvigorate agriculture, in a policy designed for economic and demographic recovery, with only very limited success. The administration also needed to ease restrictions that had been placed on Balkan Christians as a way to generate stability amid the Habsburg challenge. An overhaul of the *jizya*, the poll tax on non-Muslims of the empire, was also undertaken around 1691, which had evolved into a disjointed assessment system of collective taxation on communities (villages or towns) in many areas. A reinstatement of the poll tax based upon individual adult males was enacted as a way to alleviate the burden on the Ottoman treasury. In a further revision of Ottoman fiscal policy at a very harrowing time of financial and military crises, the decision was made to redefine land administration and taxation schemes that would alter the Ottoman *timar* system and the military structure in future centuries: in 1695, the *iltizâm* system in which tax farms were typically assigned for a period of three years, was reordered as lifetime tax farms called *malikâne*. Though an effort to raise revenue more rapidly, it was a short-term fix with long-term consequences. It would chip away at the *sipahi* cavalry's *timar* holdings and give more political clout to provincial elites with connections to the *vezir*s and pashas in the capital who could affect the bidding on the *malikâne* lands.

Mehmed IV's son Mustafa II (r.1695–1703) succeeded Ahmed II as the Ottomans were still mired in war – on the Danube front to defend Belgrade, further north near Timișoara (in today's western Romania), and in the Morea with Venice. Coming on the heels of the Nine Years War's end in Europe, the Battle of Zenta (in present-day northern Serbia near the Hungarian-Romanian border) in 1697 sealed Ottoman fate in Hungary with a terrible rout: the outnumbered Habsburgs commanded by Prince Eugene of Savoy had caused the separation of Ottoman forces crossing the Tisa River and decimated their ranks, with many Ottoman soldiers drowning in the river (Figure 9.3). The Ottomans recognized they needed to negotiate an end to this war and accepted English and Dutch offers of mediation, though it would ultimately be a watershed in Ottoman relations with European powers. The Treaty of Karlowitz (1699) ended the Ottoman war with the Holy League and initiated new conditions for the empire in dealing with foreign empires from this time onwards: first, it meant official recognition of Ottoman loss of territory on paper, in official treaties and delineated by physical marking of borders with mounds and natural landmarks. These losses in 1699 consisted of ceding much of Hungary and Transylvania. To the Polish-Lithuanian Commonwealth went Podolia. Venice regained possessions in Dalmatia and the Peloponnesus when the Morean War concluded. The Russian Tsardom, now led by Peter the Great (r.1682–1725), was not Catholic and so not formally part of the league, but did accept a truce at Karlowitz. No longer a power accepting Ottoman superiority, and at the table as a fellow equal participant, Russia gained in prestige but not much in territory except Azov. Russia signed a separate peace with the Treaty of Constantinople in 1700. In the coming century, the Russian ascent as another global player would have serious repercussions for Ottoman-Russian relations.

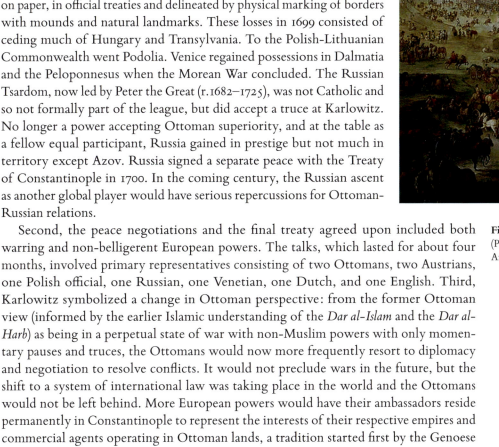

Second, the peace negotiations and the final treaty agreed upon included both warring and non-belligerent European powers. The talks, which lasted for about four months, involved primary representatives consisting of two Ottomans, two Austrians, one Polish official, one Russian, one Venetian, one Dutch, and one English. Third, Karlowitz symbolized a change in Ottoman perspective: from the former Ottoman view (informed by the earlier Islamic understanding of the *Dar al-Islam* and the *Dar al-Harb*) as being in a perpetual state of war with non-Muslim powers with only momentary pauses and truces, the Ottomans would now more frequently resort to diplomacy and negotiation to resolve conflicts. It would not preclude wars in the future, but the shift to a system of international law was taking place in the world and the Ottomans would not be left behind. More European powers would have their ambassadors reside permanently in Constantinople to represent the interests of their respective empires and commercial agents operating in Ottoman lands, a tradition started first by the Genoese

Figure 9.3 *Battle of Zenta* (Present-Day Serbia), 1697. Artist: Jacques-Ignace Parrocel.

and the Venetian *bailo*s. This too would have economic consequences for the Ottoman Empire, particularly as commercial rivalries in the Ottoman Levant between French and English agents heated up. And last, the Ottoman-Habsburg border in east-central Europe (Hungary/Transylvania) was now more firmly demarcated with Habsburg Austria the dominant power there. The Habsburgs thus retreated from the tri-imperial contest with the Ottomans and Russia.

THE "EDIRNE INCIDENT" AND A CHANGING ELITE

Since the mid-seventeenth century the Ottoman court had resided in Edirne, in part due to Sultan Mehmed IV's penchant for the hunting grounds there. The effects of the failed Vienna siege in 1683 and the continual strain of wars throughout the next fourteen years, followed by the detrimental terms of the Treaty of Karlowitz in 1699, and what was likely perceived as an absence of Ottoman authority by many in Constantinople, resulted in the "Edirne Incident" in 1703 in which Sultan Mustafa II was overthrown by a coalition of Janissaries, *ulema*, and pashas who demanded the heads of his officials – including the powerful *Şeyhül-İslâm* Feyzullah Efendi and the *grand vezir*. This incident was not simply a localized rebellion against a sultan, but rather reflects the complex political transformation occurring within the ruling Ottoman classes at the turn of the eighteenth century. The cessation of Ottoman territorial expansion necessitated the need for capable administrators. As the Ottoman dynasty was losing its monopoly on recruitment for manpower through the lapsing of the *devşirme* system, Ottoman meritocracy in the administration was faltering. Political power devolved from the sultan and diffused into pasha households (*kapılar*) who accumulated wealth and influence, and who came to be relied upon to fill the void, assuming and dominating elite positions in government. Sultan Mustafa II tried to neutralize the political power of these households and the corruption and manipulation of finances. He recalled his former childhood tutor from exile in Erzurum, Seyyid Feyzullah Efendi (b.1639–d.1703), a member of the *ulema* with significant positions under his father Sultan Mehmed IV, and appointed him immediately to the post of *şeyhül-islâm* in 1695. This maneuver, seen as leapfrogging over the traditional path to the position through seniority and service, combined with Feyzullah Efendi's immediate assumption of political roles within the administration that were deemed by contending elites to transgress the duties of the head of the religious establishment, drew ire from several factions – from other *ulema*, the Janissaries, other rival pasha households. Feyzullah Efendi alienated and angered ruling elites with his nepotism, appointing family members and pliable individuals to government posts in an exercise of political overreach. What began as an intra-elite protest transformed into a popular revolt of discontent in Istanbul as well. Sultan Mustafa II was deposed, not executed, but returned to where he had spent his childhood – confined in Topkapı Palace. His brother, Ahmed III, was placed on the throne in 1703, and the royal court moved back to Istanbul. The *grand vezir* too, Rami Mehmed Pasha, lost his

position, but not his head – unlike Feyzullah Efendi, who was very publicly humiliated and beheaded. Nonetheless, his household continued to occupy positions in the aftermath, illustrating the continuity of pasha households' access to Ottoman political and financial power from this moment.

The resiliency of the Ottoman dynasty amid crises in this way, one could argue, is reflected in the repetitive pattern of rebellion and overthrow of sultans without any new dynasty ever coming to power, and only ending with the demise of the empire altogether after World War I. The Ottoman dynasty had endured a tumultuous seventeenth century; the eighteenth century would bring additional crises including losses in wars, sultanic turnovers, and other problems, as well as a level of fiscal stability for a time and flourishing of cultural expression among the court and wealthy, powerful elites. But as always, when the deposition of a sultan did occur, another member of the Ottoman royal family was always placed on the throne.

The composition of the Janissary Corps, still a non-taxed sector of the *askeri* class in Ottoman society, had changed immensely by the end of the seventeenth century. The last recorded *devşirme* levy of slave recruit trainees occurred some time before 1700; they would no longer come from the drafting of boys from the Christian peasantry. What was already ensuing among this formerly elite military force of previous centuries was the corrupting of the meritocratic system. Janissary officers and/or those with access to political means and connections to the religious class were able to marry, have families, and enroll their Muslim children in the Janissary rosters who then inherited the position, salary, and benefits of their fathers. The registers of the eighteenth century swelled with those who had purchased such warrants; salaries of dead Janissaries were still being collected. Janissaries of a lesser rank with less access to such privilege, having to subsist on income that was often meager and sometimes not forthcoming due to financial strains on the treasury, became involved in businesses and trades, forming guild-like organizations. Evidence shows many Janissaries became the proprietors of taverns and coffeehouses, among other ventures. In effect they became a corporate body within Ottoman society who possessed and acted for their own political and commercial interests. They could and did demand the deposition of a sultan or the execution of an official. They began to have a reputation for extorting money from the general populace; as urban firefighters, they were known to start fires and refuse to extinguish them unless satisfactorily compensated. Their abilities as a crack fighting force were diminishing as the Ottomans, like other modern empires, increasingly shifted toward a military arrangement that relied upon conscripting soldiers from the general population or depending upon provincial notables with local militias for hire, to serve as conflicts arose. The Janissaries were more frequently derided because they were feared by everyone but the enemy. This shift in turn also influenced the effectiveness of Ottoman armies raised on an ad hoc basis who likely were less well trained, less prepared, and were less committed overall to enduring the adversities of war in the eighteenth century.

The demands of the war with the Holy League and effects of the Karlowitz Peace of 1699 were felt during Sultan Ahmed III's reign (r. 1703–30) in various ways. The

restructuring of the fiscal taxation system in 1695 by creating *malikânes* (life-time tax farms rather than those on three-year terms) was a way to rely upon extracting personal wealth from elites, and it did lead to financial stabilization for a period. These *malikânes* were dominated by the pasha households mainly in the capital who had access to the auctions either through earlier accumulated wealth, or by borrowing from other wealthy individuals who operated as moneylenders for the *malikâne* bidders. Most of these money-lenders were non-Muslim, and in the capital were mainly Armenian. In this way elites at the center could dominate provincial *malikânes*, though there were often prominent local families who could prevail over contracts in their area as well, contributing to what has been called a "push-pull" between the center and the peripheral, provincial areas of the empire. Tax farms allowed for some exertion of authority from the center. But, as was typical of the tendency toward Ottoman pragmatism in managing their lands based upon previous custom as well as on innovative strategies, there were still other dynamics in place that allowed for provincial autonomy. *Timar* grants allotted in some areas of the empire (such as the Balkans, Anatolia) still continued to provide a means of provincial administration. Their decline as a percentage of Ottoman revenues started by the mid-seventeenth century but they did last until the *Tanzîmât* era of the mid-nineteenth century. Tribal control still predominated in many regions (e.g., historic Kurdistan). A local upper class often emerged as beneficiaries of the flexible Ottoman political and fiscal system in areas further from the capital. Examples include heads of old, established families, made wealthy and prestigious through various means – through international trade networking, landownership, etc.; officials appointed from the center whose status in the community stemmed from wealth accumulated through commercial enterprises; members of the esteemed religious class with elevated status; or Janissaries stationed in a particular setting who put down roots and became distinguished locally (e.g., Egypt, Syria, Iraq). This fiscal evolution toward privatization in the empire started in the sixteenth century, but its dramatic effects became manifest in the seventeenth and eighteenth centuries and was indic-ative of Ottoman socioeconomic and political dynamism (as opposed to "decline"). In the so-called *ayan-emir* system, a term coined by the late historian Albert Hourani to describe provincial power-sharing by urban notables (*ayans*) and those put in place to support and protect the lands and their associated revenues accumulated from a region (*emirs*), prov-inces could develop into very autonomous, almost independent provincial areas (e.g., North African Algiers, Tripoli). The *ayans* and *emirs* might cooperate or be at odds with one another over financial and political control of their provincial area, depending upon the individual situation.

IMPOSING NEIGHBORS, EUROPE IS KNOCKING

The loss of most of Hungary in the late seventeenth century concentrated Ottoman atten-tion toward managing and defending the Danube region at all cost against Russian and

Habsburg advances. North of the Danube, Peter the Great (b.1672–d.1725) had become the sole tsar of Russia by 1696 and founded his capital, Petersburg, in 1703. He embarked on a modernization program based upon principles of the European Enlightenment that included increasing the size and improving the training of the Russian military. He engaged in the expansion of his empire at the expense of neighbors, which drew the Ottomans into conflict: Charles XII of Sweden (b.1682–d.1718) was afforded refuge in Ottoman territory after the Swedish defeat at the hands of Russia in the Battle of Poltava (1709); Russian demands to evict the Swedish king were met with an Ottoman refusal. In response, Russia threatened the Ottoman position in Moldavia by inducing cooperation from the Ottomans' vassal there, the Moldavian prince, who agreed to allow Russian military access to territory and fortresses. A brief Russo-Ottoman War (1710–11) followed, which ended in the defeat of Russian forces at the Prut River in Moldavia in 1711. As a consequence of this campaign, the Ottomans changed their policy concerning provincial administration of the Christian vassal states of Moldavia and Wallachia, which they now called the Danubian Principalities. Before 1711, the Ottoman government had appointed local, usually native Moldavian and Wallachian aristocrats as client *voivode*s to administer those provinces. As a new strategy to incorporate the principalities into the empire more definitively, securing the Danube region and preventing revolts in Moldavia and Wallachia, the Ottomans introduced the appointment of Greeks from elite families in the Fener district of Constantinople with more connections to the Ottoman state, as the principalities' local governors.

During the early years of Ahmed III's reign (r.1703–30), the Ottomans were also continually entangled with the Habsburgs over preserving Ottoman control of territory south of the Danube. In the eighteenth century conflicts with the Habsburgs, Venice, and Russia often resulted in temporary gains and sometimes permanent losses of territory, and usually nothing more than a costly stalemate (see box, Map 9.2). Though the Ottomans reclaimed some territory of the Peloponnesus from Venice in their second war in the Morea (1714–18), the Battle of Petrovaradin (in modern Serbia) in 1716–18 with the outnumbered Habsburg army commanded by General Prince Eugene of Savoy resulted in a decisive defeat and the Ottoman loss of Belgrade in 1717. The Treaty of Passarowitz of 1718 acknowledged these arrangements in which a peace was concluded after Habsburg-Ottoman and Venetian-Ottoman wars, and the Kingdom of Serbia retained the city; Belgrade, however, as a strategic forward position, would be regained by the Ottomans in 1739, after another Ottoman-Habsburg war and with the assistance of France at the negotiating table. French acumen extracted concessions from the Austrian Habsburgs and in so doing, was granted a permanent Ottoman *ahdname* (Capitulatory privilege) in 1740. The Ottomans lost and regained Belgrade yet again in another Ottoman-Habsburg conflict between 1788 and 1790. By the Treaty of Sistova in 1791, however, Belgrade would be formally maintained by the Ottomans until Serbian independence in 1878. Belgrade boasts a lengthy history of more than forty invasions over its entire history; many of them were at the hands of either the Austrian Habsburgs or the Ottoman Empire.

As a new means of interaction with Europe, the Ottomans were slowly accepting the redefinition of imperial boundaries as more permanent arrangements negotiated between

states, rather than as merely a temporary cessation of hostilities. Now on the defensive in the eighteenth century, the Ottomans often had to resort to diplomacy, which further transformed administrative positions in the *askeri* class. Ottoman officials blessed with the necessary negotiating skills made them at times more significant to resolving conflicts than military officers.

Architectural development at the capital followed need: the *grand vezir*'s residence had already become the site for Imperial Council (*Divan-i Hümayun*) meetings; from 1718, the *grand vezir*'s office found a permanent home in a building west of Topkapı Palace that was now called the Sublime Porte. This French term, the translation of *Bab-ı Alî*, meant roughly "High Gate," describing the gate of the sultan's palace from where previously decisions and decrees had been announced. As French had become the language of diplomacy, "Sublime Porte" or "Porte" now meant the Ottoman government, its various bureaucratic offices, ministers, and personnel.

Prior to the early eighteenth century European powers had posted ambassadors in the Ottoman Empire, but there were no permanent Ottoman representatives in European capitals. The Ottoman assumption of superior military might have meant diplomatic missions were reserved for the weaker power to provide, and any Ottoman emissaries dispatched to foreign lands were temporary, and expected to return home upon conclusion of their business. The Ottomans started dispatching personnel to Europe more frequently in the eighteenth century, and these emissaries, exposed to European culture and civilization, became the conduits for Western ideas and customs to seep into upper-class Ottoman life. In addition, the presence of Europeans in the Ottoman Empire had increased generally – not just ambassadors to the Ottomans resided in the cities of the empire, but also foreign merchants were now more visible in Ottoman urban areas, particularly French and British commercial agents. Sometimes there was no distinguishing between the foreign diplomat and the merchant, as many expatriates stationed in Ottoman lands made their commercial fortunes while operating as representatives of their government. European travelers, scholars, and pilgrims touring the "Holy Land," also became more frequent visitors to the empire.

The 1699 Treaty of Karlowitz initiated concerns over the management of Christian holy sites such as the Church of the Holy Sepulchre in Jerusalem and the Church of the Holy Nativity in Bethlehem – and competition was brewing between the French, who supported Catholics (Franciscans) for authority and upkeep of the sites, while Russia supported the Orthodox Church's priests. This increased rivalry between the French and Russian empires; having this localized dimension of antagonism in the "Holy Land" within the Ottoman Empire would have international repercussions in the next century. It was the genesis of what has come to be called the Eastern Question of the eighteenth century onwards: with the military setbacks and political turmoil of the Ottoman Empire starting in the late seventeenth century, the European "Great Powers" (including Russia) began to strategically ponder first, how to prop up a weakened Ottoman Empire so that the international, imperial balance of power would not be disrupted in favor of any one empire; and second, that in the event of Ottoman collapse, how its territories would be divided

up among Western empires (and Russia). This era witnessed the end of any possibility of a united Christian Europe acting against the Muslim Ottoman Empire – each European country or empire now acted in its own interests and often at the expense of others. Alliances would be formed between European powers, or between a European power and the Ottomans, depending upon need, to counter a European rival. The Ottomans had played this game of involvement in European politics since the inception of their empire, but now there was a more complex concert of powerful empires juggling for supremacy in the Ottoman "neighborhood."

For example, on the Ottomans' eastern frontier, in 1722 the Safavid Empire of Persia, an Ottoman adversary for centuries, collapsed after an invasion by Afghan forces, creating a new dynamic in the east that drew in the Russian Empire as well. In the chaos, Ottoman and Russian forces both occupied areas of northwest Persia. Russia's involvement in the Caucasus and its ambitions in the Black Sea led to the signing of a Habsburg-Russian mutual defense pact in 1726. Meanwhile, an Afshar Turkman named Nadir Khan managed to command military forces ostensibly to restore Safavid authority in Persia in 1729. With his forces he would eventually provoke war, seizing Tabriz from the Ottomans in 1730, which sparked a major rebellion in Istanbul (more about that shortly) and the deposition of Sultan Ahmed III in favor of his nephew Mahmud I (r.1730–54). In the midst of ongoing chaos at the Ottoman capital and frustrations over Crimean Tatar raiding into Ukraine and the Caucasus, Russia decided to seize the opportunity, first establishing an alliance with Nadir Khan in 1735 before issuing a declaration of war on the Ottomans in 1736 and invading the Crimea. In 1736 Nadir Khan ousted the last Safavid shah, assumed leadership for himself as Nadir Shah, king of Persia, and established the Afshar dynasty. The Ottoman-Persian conflict was settled with a treaty in 1736 that restored the imperial borders between the two that had been previously established in 1639. Hostilities reignited between the two Muslim empires in 1740. The military offensives by Nadir Shah and his forces in the 1740s in the Caucasus proved somewhat successful, but his occupation of Baghdad was temporary: he was forced to cede the latter back to Ottoman control. An Ottoman-Persian peace treaty signed in 1746 cemented Ottoman acceptance of Persia as a fellow Muslim empire. From this moment, Persia could still be an enemy in war, but no longer a heretic in the eyes of the Ottomans. In 1747 Nadir Shah was assassinated by his own troops; another tribal dynasty, the Zand, took control of Persia between 1751 and 1794, and Persia generally devolved into control by tribal warlords until the Turkmen Qajars were able to dominate and the first Qajari was officially crowned as shah of Persia in 1796 (the Qajar dynasty endured until 1925).

In this web of alliances and conflicts, Russia had been able to capture the Crimean Khanate capital of Bakhçesaray on the Black Sea in 1736 and gained more Black Sea access. But this war, which involved Persia and Russia, the Ottomans and the Habsburgs, ended in a stalemate by 1738. It was a disastrous mêlée for all, but beneficial for France, which had assisted the Ottomans in its conflict with the Habsburgs and gained the permanent renewal of French privilege in the Ottoman economy. Ultimately the Ottomans did regain Belgrade in 1739, albeit another temporary achievement, as was mentioned earlier. And

Russia began to further its claims over not just the Christian holy sites, but soon, over the Orthodox Christian populations of the Ottoman Empire. European and Russian pressure on the Ottomans emanated from several quarters: military conflicts on their borders, concessions at the negotiating table, and, increasingly, interventions on behalf of their Ottoman subjects when it suited imperial interests.

CULTURAL EXCHANGES: EIGHTEENTH-CENTURY OTTOMAN INTERSECTIONS

During Sultan Ahmed III's reign in the early eighteenth century, his restoration of the court to Constantinople stimulated the expression of imperial opulence and architectural development in the renewed capital. The Bosphorus Straits became a "royal thoroughfare" – the site of imperial processions aboard *caïque*s (wooden skiffs) and visible displays of wealth and splendor along the shores, as a reminder of Ottoman magnificence for both foreigners and the general population. Cultural changes emanated from the financial reforms that had afforded an Ottoman surplus and a period of economic stability. Fiscal policy created a chain reaction leading to what some twentieth-century Ottoman historians have called the "Tulip Age," or "*Lâle Devri*," from roughly 1718 to 1730, the latter half of Ahmed III's time on the throne.

The craze for tulips, for which the Ottoman era is named, was a symbol of sophisticated modern taste. Tulips originated in Central Asia and were first imported to the Netherlands from the Ottoman Empire in the mid-sixteenth century by a Viennese royal gardener; it seems to have coincided with the European importation of the Ottoman pastime of drinking coffee and the introduction of the café to Habsburg Austria and Europe. Dutch tulip-growing flourished from the late sixteenth century and tulip-breeding competitions began to occur there in the seventeenth century. Following suit in the eighteenth century, frequent tulip-breeding competitions were held in the Ottoman Empire among elites as an expression of this newfound refinement, with the sultan's chief florist and his panel of judges to assess the best cultivators. The tulip of the eighteenth century has been labeled a "transcultural commodity"[2] linking global societies and economies together from East to West, in a shared pattern of mass consumerism that crisscrossed the Mediterranean. In the Ottoman Empire this cultural exchange was reflected in the acquisition by the court and well-to-do society of a mix of Ottoman, European, and Asian luxury goods.

In this Tulip Era, displays of ostentatious consumption at court matching those in France were certainly exaggerated due to the overindulgence of the sultan, his retainers and officials, and his family, including his many sons and daughters (over thirty!?) in extravagant living. Marriages of princesses to elites – *damad*s (son-in-laws) – "bridegrooms" who gained further status through marriage, steadied the dynasty. *Damad*s engaged in policy-making while reaping the benefits of palace opulence. Lavish cultural expenditure at court went to architectural patronage – building Baroque palaces and pavilions, mosque

complexes, libraries to house and protect books from catastrophes such as fires, cultivation of lush gardens for aesthetic pleasure and royal gatherings, etc. Mansions called *yalı*s along the Bosphorus Straits served as stunning residences for members of the royal family and the elite. Extravagantly designed fountains proliferated across Istanbul, providing architectural beauty and the public availability of water, emulating the religious symbolism of a lush Paradise in the afterlife. The more austere classical Ottoman architectural style was forsaken in this time and place for more colorful, opulent artistry in building, such as the grandeur of Sa'adabad Palace built in 1722, constructed to imitate both French Versailles and Perso-Islamic palatial designs of the rival yet collapsing Safavids in Isfahan (Figure 9.4). It was a flexible incorporation of styles from both east and west.

Increasingly this promotion of consumption was extended beyond the elites to include the wider public and the Ottoman social hierarchy became more fluid. Women were becoming more visible outside their homes, enjoying leisure time in gardens, or attending the many public feasts and festivals being held on various occasions and holidays. Among the most famous demonstrations of the Ottoman court's displays of extravagance were Sultan Ahmed III's public ceremonies to honor the circumcision of his four sons in 1720. The celebration lasted fifteen days and nights, taking place at Okmeydanı and in waterside pavilions. Tents were set up there for the sultan, *grand vezir*, and other guests, and the water festival was viewed from gazebos along the shore. Acrobats, dancers, fireworks, and other displays occurred day and night (Figure 9.5). The many guilds also took part in the festivities, parading in a procession, displaying their skills and merchandise, and presenting gifts (Figure 9.6). The building of elegant homes by the wealthy was meant to mimic court

Figure 9.4 Sa'adabad Palace and Garden Scene.

Figure 9.5 Ottoman Miniature Artist Levni, Illustrated Account of Sultan Ahmed III's Festival of 1720.

behavior. The encouragement of flamboyant consumerism undertaken by the elite class to enhance their prestige was also a way for the sultan to place a fiscal burden upon elite Ottoman households, to rein in their newfound wealth and power at the center, much like the purpose of French King Louis XIV's conspicuous consumption at his court in Versailles in the mid-seventeenth century.

While this was the Tulip Era of cultural fluorescence, interest was not limited just to the acquisition of consumer goods or borrowed architectural styles from Europe. Other Western influences and technology would eventuate. During Sultan Ahmed III's reign, the first Ottoman study mission to Europe was dispatched in 1720, to Paris, and remained until 1721. Headed by Yirmisekiz Mehmed Çelebi Efendi (d. 1732), he was ostensibly sent as ambassador to Louis XV to inform the French that their request to conduct repairs on the Church of the Holy Sepulchre had been authorized. But he was actually dispatched for almost a year to study and report back to the sultan, especially concerning Western civilization and education, in order to discern what elements of Western culture might be suitable for the Ottoman Empire to adopt. His *Sefaretname-i Fransa* (*Travelogue of France*) is a record of these observations and experiences, and he was the first such conduit for westernization of Ottoman culture that made a permanent impact upon the empire.

Yirmisekiz Mehmed Çelebi Efendi's mission to France also had an impact upon French culture, however. There had already been a taste for the "exotic Orient" in Europe, with the latest fads in Louis XIV's era including "Chinoiserie" (Chinese ceramics and textiles, literature, etc.) as well as a dabbling in things Ottoman (art, architectural styles). By the eighteenth century and particularly after the Ottoman mission to Paris, it was no longer simply tulips and the Ottoman habit of drinking coffee that were trendy, but "Turquerie" of all sorts had become the rage – smoking tobacco in a Turkish pipe while donning

Figure 9.6 Shepherds and Butchers Guild in Procession, 1720 Circumcision Festival of Sultan Ahmed III's Sons.

a brightly colored Ottoman robe and turban; wearing a timepiece with Indo-Arabic numerals or decorative calligraphic inscriptions on it. The interest went beyond "alla Turca" fashion and food to include music: the percussion of the Janissary military *mehtar* band that had instilled fear in European armies in centuries past now influenced Western music and was introduced not only to European military bands such as France's by 1741, but played a role in Western opera performances, as did the operatic storylines that included tales of exoticized sultans and harems.

The flow of culture and technology from Europe to the Ottoman Empire would be enhanced further when a Hungarian convert to Islam named İbrahim Müteferrika established the first printing press with Arabic letters in Constantinople in 1727 (printing presses in Hebrew, Armenian, and Greek were already in existence there). While prohibited from printing any religious texts, his press allowed for the dissemination of printed books in Ottoman Turkish on non-religious subjects such as Turkish grammar, science, warfare, and history (Christian priests in the Arab provinces did print some religious texts for their congregations). Other European language presses were in operation in predominantly Christian areas of the empire (e.g., the Danubian Principalities), often due to the involvement of Christian priests. The Ottoman ban on religious printing would not be lifted until around 1803.

This early eighteenth-century Ottoman interaction with European culture would alter Ottoman state and society permanently and dramatically, whereas the Ottoman cultural impact on Europe was more ephemeral. Nonetheless, Ottoman westernization was not without its critics at home. When the Afshar king of Persia, Nadir Shah, seized Tabriz from the Ottomans in 1730, it became the pretext for expressing multiple grievances against the sultan and his *grand vezir*, İbrahim Pasha, causing unrest in the Ottoman capital and ultimately a mob rebellion. The poor Ottoman masses, suffering from the sultan's devaluation of currency, were further alienated from the ruling elites who had been busying themselves with their very extravagant palaces and festivals. To extract more revenue, the *grand vezir* taxed guilds more heavily, cut Janissary wages, and increased taxes on provincial elites. Conservative elements of the population such as the *ulema* disliked the intrusion of Western culture in Ottoman society. Later named the Patrona Halil Rebellion after an Albanian rebel who asserted himself as ringleader, Sultan Ahmed III was overthrown in favor of Mahmud I (r.1730–54), Mustafa II's son and the nephew of Ahmed III. The rebellion was eventually put down by the new sultan in 1731 and its participants bloodily disposed of, but not before the Sa'adabad Palace, so representative of the splendor of Ahmed III's Tulip Era, was destroyed.

LATE EIGHTEENTH-CENTURY DISRUPTIONS

Perhaps Voltaire's original version of *Candide* (published 1759) best captures the volatile political atmosphere of the mid-to-late eighteenth century in the world: a satire set against

a narrative of travel, in one scene the main character, Candide, dines with strangers on a ship heading to Constantinople after attending the Carnival of Venice. They are soon revealed to be dethroned kings: Ottoman Sultan Ahmed III, a Russian tsar, a pretender to the English throne, Polish kings, and the *elected* monarch of Corsica.

Added to the global disorder were some additional political "disruptions" affecting the Ottoman Empire: the aggressive Russian advance and expansion south and east; agitation in the Ottoman Arabian Peninsula by an extremist movement, the Wahhabis; the American and French revolutions; and Napoleon's invasion of Ottoman Egypt in 1798. The mid-eighteenth-century post–Tulip Era, from roughly the 1740s to the 1760s, had been one of relative peace for the Ottomans, leaving aside the brief conflict with Nadir Shah in Persia. However, international and internal circumstances demanded by the end of the eighteenth century that the sultan and the Porte had to recognize, if they had not already, the abso-lute necessity of adapting to this changed world of new technologies and new ideas by conducting reforms, mainly military in nature at first, that could defend and preserve the Ottoman realm. Were they late to the "military revolution" that had occurred in Europe up to the 1750s, this lag leaving them ill prepared for the wars to come? In any case, the late eighteenth-century recognition of the Ottoman need to adapt and reform militarily and eventually administratively to survive was a seminal moment in the Ottoman Empire that would eventually lead to the exploration of even more dramatic reforming ideologies in the mid-nineteenth century – liberalism, constitutionalism, nationalism.

Unrest at the capital prevailed during Mahmud I's time on the throne. The *Celali* rebel-lions of the late sixteenth and seventeenth centuries had been the condition mainly in the Anatolian countryside. By the 1740s, because of population increases in urban centers due in part to migration from rural areas, and despite the frequent outbreaks of disease, some rather violent uprisings plagued the Ottoman capital in addition to the continuation of heavily armed brigandage in the provinces. Devastating fires could and did ravage the cities. Wars and their aftermath, particularly in the Balkans, created refugees, resulting in urban flight and overcrowding. There were also polarizing currents at work during Sultan Mahmud I's reign, the brief tenure of his successor and brother, Osman III (r.1754–7), and of Osman III's successor, Mustafa III (r.1757–74), another of Ahmed III's sons. On the one hand, the stalemates and defeats in war indicated to some in ruling Ottoman circles that military reform of some sort was imperative, and that learning Western methods in this regard could be beneficial to the Ottomans. Perhaps the first to promote this idea was the Hungarian convert, İbrahim Müteferrika, who introduced the Arabic printing press, and who published a treatise on warfare to address this issue as early as 1730. Soon after, another European convert to Islam, the Frenchman Comte de Bonneval, came to the capital and made a fleeting effort on behalf of the sultan to modernize the army through improved training, but it came to naught. As the eighteenth century wore on, the Ottomans increas-ingly called upon provincial *ayan* households to raise and finance local militias (*levend*s) as their fighting forces when the remnants of the Janissary Corps and the *timariot* holders became almost completely unreliable, creating resentment among many of these elites toward central authorities for their burdensome fiscal demands.

VOLTAIRE'S *CANDIDE* (1759) CHAPTER XXVI

OF A SUPPER WHICH CANDIDE AND MARTIN TOOK WITH SIX STRANGERS, AND WHO THEY WERE[3]

The servants being all gone, the six strangers, with Candide and Martin, remained in a profound silence. At length Candide broke it. "Gentlemen," said he, "this is a very good joke indeed, but why should you all be kings? For me I own that neither Martin nor I is a king."

Cacambo's master then gravely answered in Italian: "I am not at all joking. My name is Achmet III. I was Grand Sultan many years. I dethroned my brother; my nephew dethroned me, my viziers were beheaded, and I am condemned to end my days in the old Seraglio. My nephew, the great Sultan Mahmoud, permits me to travel sometimes for my health, and I am come to spend the Carnival at Venice."

A young man who sat next to Achmet, spoke then as follows: "My name is Ivan [VI]. I was once Emperor of all the Russias, but was dethroned in my cradle. My parents were confined in prison and I was educated there; yet I am sometimes allowed to travel in company with persons who act as guards; and I am come to spend the Carnival at Venice."

The third said: "I am Charles Edward [Stuart], King of England; my father has resigned all his legal rights to me. I have fought in defense of them; and above eight hundred of my adherents have been hanged, drawn, and quartered. I have been confined in prison; I am going to Rome, to pay a visit to the King, my father, who was dethroned as well as myself and my grandfather, and I am come to spend the Carnival at Venice."

The fourth spoke thus in his turn: "I am the King of Poland [Augustus III]; the fortune of war has stripped me of my hereditary dominions; my father underwent the same vicissitudes; I resign myself to Providence in the same manner as Sultan Achmet, the Emperor Ivan, and King Charles Edward, whom God long preserve; and I am come to the Carnival at Venice."

The fifth said: "I am King of Poland [Stanisław Leszczyński] also; I have been twice dethroned; but Providence has given me another country, where I have done more good than all the Sarmatian kings were ever capable of doing on the banks of the Vistula; I resign myself likewise to Providence, and am come to pass the Carnival at Venice."

It was now the sixth monarch's turn to speak: "Gentlemen," said he, "I am not so great a prince as any of you; however, I am a king. I am Theodore, elected King of Corsica; I had the title of Majesty, and now I am scarcely treated as a gentleman. I have coined money, and now am not worth a farthing; I have had two secretaries of state, and now I have scarce a valet; I have seen myself on a throne, and I have seen myself upon straw in a common jail in London. I am afraid that I shall meet with the same treatment here though, like your majesties, I am come to see the Carnival at Venice."

The other five kings listened to this speech with generous compassion. Each of them gave twenty sequins to King Theodore to buy him clothes and linen; and Candide made him a present of a diamond worth two thousand sequins.

"Who can this private person be," said the five kings to one another, "who is able to give, and really has given, a hundred times as much as any of us?"

Just as they rose from table, in came four Serene Highnesses, who had also been stripped of their territories by the fortune of war, and were come to spend the Carnival at Venice. But Candide paid no regard to these newcomers, his thoughts were entirely employed on his voyage to Constantinople, in search of his beloved Cunegonde.

On the other hand, the cultural extravagance indulged in during Sultan Ahmed III's Tulip Era, and the transformation of Ottoman society that appeared to be occurring at court among the upper echelon elites, and among the general population (in differing ways) had prompted a reaction that was expressed as a demand for a more rigid religiosity. While the sultans of this latter eighteenth century returned to an embrace of Islamic morality by having sumptuary regulations enforced on non-Muslims and restrictions placed upon women, the undercurrent of foreign influences and continued consumerism did not simply vanish. The tension between these forces – of learning from Europe but resisting westernization through a resurgence of strict Islamic interpretation like that of the *kadizadeli*s of the previous century – was impossible to erase, especially as the outside world continued to change in terms of politics, global economy, and imperial exploration leading to the establishment of colonies by European powers.

The Ottomans needed more than military modernization – they needed allies against the rising power of the Russian Empire pressuring the Ottoman northern frontier. Russia and the Habsburgs had been kept busy with their wars against Prussia; Sultan Mustafa III was impressed enough with Frederick the Great of Prussia's military successes against them in the Seven Years War (1756–63) that negotiations were undertaken, yielding Capitulatory privileges for Prussia in the Ottoman Empire in 1761. Attempts at an Ottoman-Prussian alliance, however, escaped their grasp when Prussia, politically cornered by the Habsburgs, France, and Russia, was compelled to sign a defensive alliance in 1764 with Catherine the Great, who had ascended the throne to become empress of Russia in 1762. The Ottoman sultan declared war on Russia in 1768 over its occupation of an area in Podolia. But Janissary pay certificates, bartered and traded without giving the Ottoman military its necessary manpower, had afflicted the corps, forcing the recruitment of locally raised *levend* militias. Ottoman government figures are contradictory, but the empire's combined Janissary and militia forces assembled around the Danube basin were recorded as anywhere between 80,000 and 600,000 soldiers during 1768–74.[4] Of this number, somewhere around 100,000–150,000 were armed *levend*s from the Balkans and Anatolia who actually showed up to fight at the front during this war. Desertion was rampant. Russian forces attacked the Crimea in 1771, and diplomacy did not help the Ottomans to stave off the onslaught that consisted of more Habsburg, Prussian, and Russian cooperation. The former Ottoman vassal, the

Crimean khan, declared "independence" in 1772. In the aftermath, the term *levend* was even struck from Ottoman usage due to the blame for their abysmal failure in this campaign; a reform of the military was now more apparent than ever.

The six-year war ended in 1774 with the signing of the Treaty of Küçük Kaynarca in Bulgaria. The Ottoman sultan was acknowledged in it as the "Grand Caliph of Mahometanism" – a status that would be more broadly and publicly propagated as caliph of all Muslims globally in the late nineteenth century. Tatar political independence and territorial integrity was guaranteed in this treaty, though their allegiance to the Ottoman sultan as fellow Muslims was acknowledged. The Black Sea, however, had slipped from Ottoman grasp – Russia would now have commercial rights there, and control over some of its northeastern coast. Russia was given navigation rights through the straits to the Mediterranean and on the Danube. The Ottomans owed Russia a war indemnity and granted other provisions to Catherine the Great's empire – an embassy in Istanbul, and permission to build a Russian church of the Greek Orthodox rite in the Galata quarter of the Ottoman capital (in Beyoğlu; it never materialized). Most damaging to Ottoman sovereignty vis-à-vis its non-Muslim subjects, over whom Ottoman sultans had ruled as their protector since Mehmed II's conquest of 1453, Russia now claimed the right to indirect protection over Orthodox Christians in the Ottoman Empire by requiring that the Porte not expose "the Christian religion to the least oppression any more than its churches, and that no obstacle shall be opposed to the erection or repair of them; and also that the officiating ministers shall neither be oppressed nor insulted."[5] The actual treaty provisions were specific to the Greek Orthodox Christians but were interpreted more widely by Russia to mean the entire Orthodox population of the Ottoman Empire. The provisions would have irreversible and destructive effects upon the fabric of Ottoman society in the next century.

Sultan Mustafa III died in 1774 before the treaty signing took place, but his brother, Abdülhamid I (r.1774–89), who next ascended the throne, soon witnessed the annexation of the Crimea by Catherine the Great in 1783. The Crimean Khanate that had served for hundreds of years in a special capacity as an Ottoman vassal with honored Mongol lineage, the khanate which supplied the forward guard in campaigns, was now under Russian suzerainty. The Crimean khan himself eventually fled to Ottoman territory, was exiled to the island of Rhodes, and executed in 1787.

Catherine intended to achieve the dual agenda of her "southern policy" with the Russian war machine: access to warm-water ports and the restoration of a Greek empire. Russian attention was now on the Caucasus and establishing a protectorate over Georgia in 1785. Having already lost the Crimea, the dishonored Ottoman state now faced public outcry at the prospect of further losses in the Caucasus as well as resistance to yet another war. But negotiations were refused, and the Ottoman declaration of war came in 1787; the Austrian Habsburgs, now an Austro-Hungarian empire and a reluctant Russian ally, declared war on the Ottomans in 1788. An offer of mediation from the Triple Alliance of the moment – Britain, Prussia, and the United Provinces (the Dutch Republic) was rejected by Russia. When the fighting was over in 1791, the Treaty of Jassy (1792) meant

the Ottomans were resigned to the loss of Georgia to Russia, and Russia's permanent presence at Black Sea ports. As was mentioned earlier, Belgrade had been lost to the Habsburgs but was shortly returned to Ottoman control. Nonetheless, the Ottoman military was now in dire need of rebuilding after its staggering destruction during this conflict.

The Ottomans were on the cusp of a new era by the end of the eighteenth century – a modern world order linking empires through international trade, law, and diplomacy; imperial competition that relied upon innovative military technology and a new style of standing army; and binding treaties establishing permanent territorial borders. Despite the pressures of imperial conflicts on several fronts with the rising powers of Europe, of Russia, and of Persia, and internal disruptions to Ottoman political stability such as fiscal crises, a cycle of dynastic turnovers and the accompanying violence those engendered in the 1700s, the empire could not just be said to be "in decline." An Ottoman transformation was taking place, an adjustment to the changed world, and it would not be without setbacks and retreats, retrenchment and adaptation. The Ottomans survived to seek new approaches to dilemmas, and most significantly for the future, sultans and the Sublime Porte began to take an *active* interest in Western technology, political structures, and intellectual currents of thought as possible solutions to their problems, again the result of Ottoman imperial flexibility.

NOTES

1 Caroline Finkel, *Osman's Dream: The Story of the Ottoman Empire, 1300–1923* (London: John Murray, 2005), 72–3.

2 Ariel Salzmann, "The Age of Tulips: Confluence and Conflict in Early Modern Consumer Culture (1550–1730)," in *Consumption Studies and the History of the Ottoman Empire, 1550–1922: An Introduction*, ed. Donald Quataert (New York: State University of New York Press, 2000), 84.

3 Voltaire, *Candide* (New York: Boni and Liveright, Inc., 1918), 144–8. http://www.gutenberg.org/files/19942/19942-h/19942-h.htm#Page_142.

4 Virginia Aksan, "Whatever Happened to the Janissaries? Mobilization for the 1768–1774 Russo-Ottoman War," *War in History* 5, no. 1 (1998): 29.

5 Treaty of Küçük Kaynarca, Empire of Russia, Ottoman Empire, 1774, Article XVII: 2.

SELECTED READINGS

Abou-el-Haj, Rifa'at Ali. *The 1703 Rebellion and the Structure of Ottoman Politics*. Istanbul: Dutch Institute, 1984.

Abou-el-Haj, Rifa'at Ali. *Formation of the Modern State: The Ottoman Empire, Sixteenth to Eighteenth Centuries*. New York: Syracuse University Press, 1991.

Ágoston, Gábor. *Guns for the Sultan: Military Power and the Weapons Industry in the Ottoman Empire*. New York: Cambridge University Press, 2005.

Ágoston, Gábor. "Military Transformation in the Ottoman Empire and Russia, 1500–1800." *Kritika: Explorations in Russian and Eurasian History* 12, no. 2 (Spring 2011): 281–319.

Aksan, Virginia H. "An Ottoman Portrait of Frederick the Great." In *Ottomans and Europeans: Contacts and Conflicts*, 67–80. Istanbul: The Isis Press, 2004.

Aksan, Virginia H. *Ottoman Wars 1700–1870: An Empire Besieged*. London: Pearson Longman, 2007.

Aksan, Virginia H. "Whatever Happened to the Janissaries? Mobilization for the 1768–1774 Russo-Ottoman War." *War in History* 5, no. 1 (1998): 23–36.

Atıl, Esin. *Levni and the Surname: The Story of an Eighteenth-Century Ottoman Festival*. Istanbul: Koçbank, 1999.

Bowles, Edmund. "The Impact of Turkish Military Bands on European Court Festivals in the 17th and 18th Centuries." *Early Music* 34, no. 4 (November 2006): 553–9.

Faroqhi, Suraiya, and Arzu Öztürkmen, eds. *Celebration, Entertainment and Theatre in the Ottoman World*. Calcutta: Seagull Books, 2014.

Finkel, Caroline. *Osman's Dream: The Story of the Ottoman Empire 1300–1923*. London: John Murray, 2005.

Fleet, Kate, and Reşat Kasaba, eds. *The Later Ottoman Empire, 1603–1839*. Vol. 3 of *The Cambridge History of Turkey*. New York: Cambridge University Press, 2006.

Göçek, Fatma Müge. *East Encounters West: France and the Ottoman Empire in the Eighteenth Century*. New York: Oxford University Press, 1987.

Hamadeh, Shirine. "Ottoman Expressions of Early Modernity and the Inevitable Question of Westernization." *Journal of the Society of Architectural Historians* 63, no. 1 (2004): 32–51.

Hamadeh, Shirine. *The City's Pleasures: Istanbul in the Eighteenth Century*. Seattle: University of Washington Press, 2007.

Itzkowitz, Norman. "Eighteenth-Century Ottoman Realities." *Studia Islamica* 16 (1962): 73–94.

Kunt, Metin. "Ethnic-Regional (Cins) Solidarity in the Seventeenth-Century Ottoman Establishment." *International Journal of Middle Eastern Studies* 5 (1974): 233–9.

Mansel, Philip. *Constantinople: City of the World's Desire, 1453–1924*. New York: St. Martin's Griffin, 1996.

McGowan, Bruce. *Economic Life in Ottoman Europe: Taxation, Trade and the Struggle for Land, 1600–1800*. New York: Cambridge University Press, 2010.

Nizri, Michael. *Ottoman High Politics and the Ulema Household*. New York: Palgrave Macmillan, 2014.

Ostapchuk, Victor. "Cossack Ukraine In and Out of Ottoman Orbit, 1648–1681." In *The European Tributary States of the Ottoman Empire in the Sixteenth and Seventeenth Centuries*, edited by Gábor Kármán and Lovro Kunčević), 123–52. Leiden: E.J. Brill, 2013.

Quataert, Donald. *The Ottoman Empire, 1700–1922*. New York: Cambridge University Press, 2005.

Rempe, Martin. "Cultural Brokers in Uniform: The Global Rise of Military Musicians and Their Music." *Itinerario* 41, no. 2 (2017): 327–52.

Rice, Eric. "Representation of Janissary Music (Mehter) as Musical Exoticism in Western Compositions, 1670–1824." *Journal of Musicological Research* 19, no. 1 (1999): 41–88.

Salzmann, Ariel. "The Age of Tulips: Confluence and Conflict in Early Modern Consumer Culture (1550–1730)." In *Consumption Studies and the History of the Ottoman Empire, 1550–1922: An Introduction*, edited by Donald Quataert, 83–106. New York: State University of New York Press, 2000.

Salzmann, Ariel. "An Ancien Régime Revisited: "Privatization" and Political Economy in the Eighteenth-Century Ottoman Empire." *Politics and Society* 21, no. 4 (1993): 393–423.

Smiley, Will. *From Slaves to Prisoners of War: The Ottoman Empire, Russia, and International Law*. Oxford: Oxford University Press, 2018.

Tezcan, Baki. *The Second Ottoman Empire: Political and Social Transformation in the Early Modern World*. New York: Cambridge University Press, 2010.

"Treaty of Peace (Küçük Kaynarca), 1774." Great Britain *Parliamentary Papers* 72 (1854), 171–9. Available online through the National University of Singapore. "Empire in Asia: Document Archive." Last updated November 20, 2014. http://www.fas.nus.edu.sg/hist/eia/documents _archive/kucuk-kaynarca.php.

Zilfi, Madeline C. "Women and Society in the Tulip Era, 1718–1730." In *Women, the Family, and Divorce Laws in Islamic History*, edited by Amira El Azhary Sonbol, 290–303. Syracuse: Syracuse University Press, 1996.

TEN

THE "LONG" NINETEENTH CENTURY: REFORM, CHANGE, AND THE RISE OF NATIONALISM

The Ottoman territorial losses of the seventeenth and eighteenth centuries generated the question of the Ottoman Empire's ability to survive in the modern era from various quarters in Ottoman society. There was a sense within the empire that something had gone wrong for the Ottomans. War with the Austrian Habsburgs and the Russian Empire was still raging when Sultan Abdülhamid I died, and his nephew, Selim III (r.1789–1807) ascended the Ottoman throne. Sultan Selim III spearheaded the first attempt to respond with state-led reforms that focused primarily on the military, as this was seen as the most obvious weakness vis-à-vis European powers – defeat in war. Subsequent attempts at reform were again state-led and would focus on other institutions as well, whether fiscal, educational, political, societal, or the like, but as a general pattern, reforming ideas in the Ottoman Empire often emanated from the military sector first. The Ottomans had been very willing to absorb new technologies (such as the use of gunpowder) in earlier centuries. In the modern era there was at times a non-receptiveness to some technological innovations that perhaps, like China, stemmed from an Ottoman sense of self-sufficiency – as though the successes of the past and the structures in place that had guaranteed that outcome, were rather difficult to modify or change. The question remained: how did this come to pass? How did the balance of power shift in favor of European empires? A few spiritual renovation movements in peripheral areas of the empire (i.e., the Wahhabis in Arabia, to be discussed shortly) would soon issue a moral-religious challenge to the Ottomans, implying the sultans were not the rightful heads of a Muslim polity and that straying from the true path of Islam was the cause of failures. Europe viewed the Ottoman Empire as declining and capable of destruction; European empires' stars were on the ascent as they colonized more of neighboring Ottoman lands in Africa and Asia, and put pressure on the empire itself. How could the Ottoman Empire reform itself in order to stave off the onslaught of foreign powers, and how, it was asked, could the empire "catch up" with the West?

Ideas of the European Enlightenment had made their way to the Middle East. In the Ottoman Empire, it inspired a few eighteenth-century attempts at reform, some of which were at best merely trying to mimic Western methods in order to reorganize certain Ottoman institutions. The nineteenth century witnessed more dramatic and far-reaching reforms, with some successes. The Age of Reason had not just yielded the advent of rational science and secular thought. Their later corollaries – liberty, independence, the rule of law, constitutionalism, representative government and parliamentary assembly, the ideology of nationalism – manifested in the "Age of Revolutions" commenced by the American (1776) and French (1789) revolutions, which were equally influential in the next century. To varying degrees in the nineteenth century these intellectual currents informed the thinking of Ottoman elites, reformers, and activists, who viewed one or more of them as imperative for the empire's (or their ethnoreligious communities') survival. They also influenced reform-minded leaders in places like Morocco, Ottoman Tunisia, Ottoman Egypt under Mehmed Ali Pasha, the Qajars in Persia, and the Central Asian khanates (the latter were eventually crushed by Russia). Some individuals fully embraced a secular approach to society that rejected religious underpinnings, while others, identified by current historians as "Islamic modernists," were those who strived to reconcile the foundations of Islam with scientific principles as the best way to achieve lasting modernity. Among some Christian communities of the empire, their clergies played a significant role in encouraging nationalist consciousness. Christian missionary efforts stepped up to both convert the "unenlightened" – whether defined as Muslim or eastern Christian – or to support non-Muslims in their quest for self-rule.

The "long" nineteenth century is often demarcated as starting with Selim III's reign in 1789 or with the French invasion of Egypt in 1798, and concluding with the start of World War I in 1914. Framed on both ends of the time period by Ottoman conflict with European empires as well as by the impact of Western culture and politics on the empire, the "in-between" was the Ottomans' moment to seek innovative solutions to these many challenges. The tensions inherent in this era of reform and change are undeniable: between tradition and innovation, between monarchical, dynastic rule and constitutional, parliamentary government, between religiosity and secularism, between multireligious, multiethnic society and particularistic nationalist orientations, between Muslim and non-Muslim. The nineteenth century was a radical historical moment for the Ottoman Empire that most adversely and destructively confronted its pragmatism and flexibility in managing peoples, territories, and relationships with foreign powers.

"DEFENSIVE MODERNIZATION" BEGINS

Sultan Selim III came to the throne in 1789, a young man in his late twenties whose education and experience was in many ways quite different from his predecessors. Even during the years when he was restricted to the confines of Topkapı Palace, he had an

interest in decision-making by the Imperial Council, an awareness of the outside world, and the changes taking place that necessitated a new approach to governing the Ottoman Empire. He corresponded through letters with the French King Louis XVI regarding the Russian threat. Coming to the throne amid war and the recent French Revolution, the new young sultan sought the views of his statesmen on how to save the empire from more calamity by establishing a 200-person consultative assembly. The sultan read the reports they drafted in 1792 recommending reforms, mainly but not only military in nature; based upon European models, they were to be done without losing the Ottoman "Islamic essence." The subsequent reforms introduced by Sultan Selim III that would continue to be expanded upon throughout the following century are what historians call "defensive modernization" – that is, attempts to modernize the military and recentralize the governing administration through reforms adopted by the Ottoman state in self-defense against European military successes and/or threats. In the late eighteenth century, however, modernization was understood by some Ottoman elites around the sultan to be synonymous with "westernization" – absorbing the cultural attributes of European civilization. Encouraged by Ignatius Mouradgea d'Ohsson for example, the Ottoman-born Armenian scholar and *dragoman* (interpreter) for the Swedish Embassy, Selim III presided over a major importation of European ideas and styles, whether the architecture of palaces, the sultan's enthusiasm for Italian music, etc. The ban on religious printing was lifted in 1803. The association of modernization with westernization was a dilemma complicating Ottoman attempts at reform until the empire's demise in the twentieth century – and it is a question still being wrestled with today in many post-Ottoman Muslim societies.

Selim III's predecessor Sultan Abdülhamid I had already recognized the problems inherent in drafting rebellious *levend* militias from the provinces as armed forces in wars and abolished the practice. Selim III went further: in light of the Ottoman military's weak performances in the previous decades, he decided to introduce a completely new military corps called the *Nizâm-ı Cedid*, or "New Order." After setting up a treasury to fund this military endeavor in 1793, the revenues of which came from state-administered tax farms and government-seized *timar* lands, the New Order (Figure 10.1) was publicly announced in 1794. Because the *devşirme* levy had fallen into disuse over one hundred years earlier, Christians were no longer drafted into Janissary service; Muslim recruits were instead to be drawn from Anatolia and would receive modern military equipment and training along the lines of French and German standing armies. Imperial military and naval engineering schools were founded anew or existent schools were restructured and modern curricula introduced. By 1807 there were approximately 27,000 troops trained by some 600 foreign advisers from France, Britain, Sweden, and Austria in newly established schools conducting drills and instruction. Additional reforms followed the military one, including decrees aimed at reorganizing some of the political institutions of the empire and curbing the power of provincial notables in the countryside. Acknowledging the necessity of international diplomacy, in 1793 the first permanent Ottoman embassies were established in Europe. London was the first in 1793; others in Vienna, Berlin, and Paris followed shortly

Figure 10.1 Sultan Selim III and Officials Observing New Order Troops (*Nizâm-ı Cedid*), *c.*1806.

thereafter. Many of these diplomatic posts were filled by Ottoman Greeks, as was the translator for the Imperial *Divan*.

Perhaps Selim III's greatest error in an otherwise practical reform effort was his inability to recognize the opposition fomenting against the modernization strategy he was putting in place. His New Order Army, while still small in numbers in 1798, participated in one of the battles against Napoleon's invasion of Egypt (to be discussed shortly), defending Acre and repulsing the French force's advance towards Palestine in 1799. Building on this momentum, Selim III enacted a larger draft of Muslims for the New Order in Anatolia in 1802, and extended it to the Balkans in 1805. Those drafted by the latter conscription directive resisted and rebelled; general dissatisfaction in the empire was brewing. Selim III had been willing to allow for military duality to endure: the Janissary corps had not been abolished, but continued to exist in its corrupted, unruly state; they were resentful of this separate new military force who posed a challenge to their status, refusing to serve with them. Eventually a coalition formed of Janissaries, provincial notables unhappy with restrictions on their autonomy and finances, and the more conservative elements of the religious *ulema* class who disliked the reforms and the introduction of Western methods as an affront to Islam. They demanded Selim III disband the *Nizâm-ı Cedid*. Violent confrontation between New Order troops and Janissaries occurred in Edirne in 1806 (called the "Second Edirne Incident"), and Selim III acquiesced in 1807, sanctioning their disbandment. But rebellion had already

The Ottoman Empire in 1795

Map 10.1 Ottoman Empire, 1795, on the Eve of Napoleon's Egypt Invasion.

exploded beyond Edirne, to the capital, with riotous troops and conservative opposition demanding the execution of the reforming statesmen around him, and ultimately the deposition of the Ottoman sultan. He was deposed in 1807 and his cousin, Mustafa IV (r. 1807–8) was enthroned for a very brief period amid some ceremonials to cement his legitimacy. Selim III was placed under house arrest in Topkapı Palace. A powerful *ayan* (notable) and governor of Silistra from northeastern Bulgaria in command of the New Order on the Danube front during the Russian war, Mustafa Bayrakdar Pasha arrived with his forces in Istanbul in the summer of 1808 with the intention of reinstating Selim III to the throne. Mustafa IV's henchmen murdered Selim III in the harem, allowing Bayrakdar Pasha to have Sultan Mustafa IV condemned on traitorous grounds and deposed in favor of his young brother, Mahmud II (r. 1808–39). Mustafa Bayrakdar Pasha became the new *grand vezir*.

BESIEGED WITHIN AND WITHOUT

Ottoman reliance upon autonomous provincial *ayan*s and *emir*s to govern outlying areas of the empire could promote stability at one moment and provide opportunities for rebellion and European intervention at another. In the late eighteenth-century Balkans, for example, before Sultan Selim III's ascension to the throne, a noticeable number of Albanian elites with local roots commanded bands of brigands and often acquired provincial appointments from the Ottoman authorities. They were relied upon to maintain political and military control, as well as playing a role in the tax collection system, enabling tax farmers to extract revenue from the peasantry through "subcontracted" local notable intermediaries who themselves were tax-exempt. The most famous of this ilk was an Albanian brigand named Tepedelenli Ali Pasha, who gained various provincial Ottoman appointments in southwest Rumelia in the 1780s, ultimately becoming the Ottoman *sancakbeyi* of Ionnina (Janina) who accumulated significant economic and political power. From the late eighteenth century this "lion of Albania," as he was called, ruled with an iron fist over much of Albania, Macedonia, Epirus, Thessaly, and the Morea as an almost independent state for over thirty years. However, he eventually fell into disfavor with the Ottoman administration. From the sultan's point of view, he became dangerous due to his fomenting of rebellions and his friendly dalliances with Britain and France, the latter of which soon threatened the empire directly with the invasion of Ottoman Egypt in 1798. It would fall to Sultan Selim III's successor to finally deal with Ali Pasha of Janina as an internal threat to provincial stability by declaring this Ottoman-appointed guarantor of provincial order a dangerous rebel. But not before relying upon another Albanian to restore order disturbed by the French intrusion into Egypt.

While Selim III was still on the throne, international entanglements driven in part by diplomatic linkages with European powers and the Ottoman sense of a need to adhere to conditions set out in alliances (and Ottoman expectations of the same for European powers!) pulled the Ottomans into wars that exacerbated domestic disturbances. The Napoleonic Wars and their ripple effects are a case in point. First, Napoleon's invasion of Ottoman Egypt with an expeditionary force and their defeat of the Mamluks at the Battle of the Pyramids in July 1798 was intended to create a way to interrupt British trade routes to India (Figure 10.2). Though combined Ottoman and British forces eventually ousted the French forces by 1801, tensions between Muslims and Christians in Egypt were exacerbated by this action. More significantly the Sublime Porte dispatched a military officer in command of an Albanian unit, Mehmed Ali Pasha, to Cairo to restore order in the aftermath. By 1805 Mehmed Ali had assumed the governorship of Egypt. He embarked upon a rapid modernization program of his own there that included wiping out the remnants of the Mamluk elite once and for all in a bloody massacre at the Citadel in 1811 to establish a firm grip on power. Ultimately his ambitious rule resulted in Egypt becoming a semi-independent state, and a direct challenge to the Ottoman government itself by the mid-nineteenth century.

In 1804, defiant Janissaries owing little allegiance to the Ottoman state disrupted the autonomy enjoyed by the Serbian province of Smederevo (on the Danube, southeast of

Figure 10.2 *Battle of the Pyramids,* 1798. Artist: Baron Antoine-Jean Gros, 1810.

Belgrade) by killing the local leaders, causing an uprising there. Meanwhile, the French, posturing against Russia and pushing into Dalmatia, encouraged the Ottomans to dismiss their Danubian *voivode*s without the requisite consent from Russia. Russian forces were deployed to Moldavia and Wallachia; the Ottomans blockaded Russian ships from the Dardanelles, and declared war on Russia in 1806. Serb rebels, seeing an opportunity to demand independence and assuming Russian support would be forthcoming, refused to submit to Ottoman authority and continued their rebellion. When the Treaty of Bucharest was signed in 1812 ending hostilities between the two empires, the Ottomans were freed up to put down the Serbian rebellion the same year. Although this was not initially a nationalist uprising, within a few years another would start that did have more clear separatist leanings.

As these international and domestic crises of the late eighteenth and early nineteenth centuries occurred, the Ottomans faced an indigenous extremist movement, the first of its kind in the empire, which challenged Ottoman sovereignty internally as the rightful Muslim leadership – the puritanical Wahhabi movement, which emerged in the Arabian Peninsula initially around the 1770s. Arabia had never been very controllable, particularly in the tribally organized hinterlands; the desert terrain was difficult. Southern coastal Yemen was only nominally better. The Hijaz area on the western coast of the peninsula was the location of the holy cities of Mecca and Medina; the Ottomans designated the prestigious *sharif*s of Mecca (who claimed descent from the Prophet Muhammad) as custodians of the holy sites under Ottoman authority. Named after its founder, Muhammad b. ʿAbd al-Wahhāb (from the more conservative *Hanbali* Islamic legal school), the Wahhabi sect based its rigid interpretation of Islam after traditionalist Ibn Taymiyya (b.1263–d.1328), who wrote during the tumultuous era of the Mongol invasions (and who partly inspired

Kadizadeli conservatism in earlier Ottoman centuries, see Chapters 7 and 8). According to this view, which the Wahhabis enforced with violent severity, Muslims had strayed from the true path of Islam: all of Islamic civilization that had emerged after the Prophet's lifetime was considered a negative innovation, *bid'a* in Arabic, a violation of the spirit of the religion and a distortion of Islam that could only be rectified through purification and a return to the ways of the Prophet in his time. Sufi orders, tombs of saints, any ornamentation on tombs or mosques, for example, were all considered heretical idol worship. Even orthodox Ottoman Muslims were horrified by this harsh interpretation of Islam. The Wahhabis viewed the Ottoman *ulema* as functionaries who distorted the word of God – heretics in their eyes – which was worse than paganism. The Wahhabis affiliated themselves with a formidable tribal prince in Arabia, 'Abd al-Azīz b. Muhammad b. Al Sa'ud (r.1765–1803), and his son, Sa'ud b. 'Abdul-Azīz b. Muhammad Al Sa'ud (r.1803–1814). Though Muhammad b. 'Abd al-Wahhāb died in 1792, his sect's teachings were firmly entrenched in Sa'ud tribal mentality by the end of the century. And the Sa'ud tribe was a force to be reckoned with – almost a mini-state, they plundered areas of Arabia and were pushing north.

In 1798, as the *sharif* of Mecca's fighters were being defeated by Wahhabi-Sa'ud forces (Map 10.2), Napoleon's expedition invaded Egypt, adding to the perception of the Ottomans as weak in the face of the infidel. In 1802 the Wahhabi-Sa'ud partnership sacked the Shi'a holy site of Karbala (Shi'ites were considered heretics by them as well). In 1803 they occupied Mecca for a time, they sacked Medina and even damaged the Prophet's tomb in 1805, they retook Mecca in 1806 and plundered whatever they considered idolatrous – tombs, shrines, etc. They were able to harass or block the pilgrimage route between 1805 and 1807, a certain affront to the Ottoman state's status as Muslim custodians of the holy sanctuaries. Sa'ud b. 'Abdul-Azīz b. Muhammad Al Sa'ud audaciously substituted his name in the Friday prayer (*khutba* in Arabic) for Ottoman Sultan Selim III's, insulting the Ottoman house: mention of one's name in this way was traditionally symbolic of claiming political legitimacy in Islamic history.

Once the Ottomans had ousted the French from Egypt in 1801, they were able to turn attention to the Wahhabi challenge to their sovereignty. Mehmed Ali Pasha had stabilized Egypt and in 1811 the Porte entrusted him with the campaign to subdue the Wahhabis, with his son Ahmed Tosun in command of the forces on the ground. Mecca and Medina were liberated from the Wahhabis by 1813. Sa'ud b. 'Abdul-Azīz's son, Abdullah b. Sa'ud, continued to lead tribal forces after his father died in 1814; by 1818 Ottoman forces commanded by Mehmed Ali's eldest son İbrahim forced the surrender of the Wahhabis at the Sa'uds' so-called capital of Dariyya in Central Arabia. Abdullah b. Sa'ud was captured in 1818, sent to Constantinople, beheaded and put on public display in the Hippodrome. İbrahim Pasha became governor of the Hijaz. It would not be the last policing campaign assigned to Mehmed Ali Pasha with his son İbrahim, and the Ottomans would later regret their empowerment of the Pasha in Egypt. A new era of engagement with the West, inaugurated with Napoleon's invasion, and the question of legitimacy to rule, forced upon the Ottoman state by the Wahhabis, illustrated the challenges to come for the empire as the nineteenth century wore on. Ottoman flexibility to adapt to changing circumstances

pushed the empire's ability to govern to the limit, and ultimately, to more internal unrest and international conflict.

LOSING EGYPT

Napoleon's invasion of Egypt in 1798 is often viewed as a watershed event in Middle East history, as it was the first foreign invasion in the modern era that struck an Islamic heartland so directly. Egypt was a rich and vital province of the Ottoman Empire, known as the Ottoman "breadbasket" because it supplied much of the empire's grain, and because control over Egypt anchored the Indian Ocean-Mediterranean Sea trade in Ottoman hands after Sultan Selim I's 1517 conquest of the Mamluk Sultanate. While Napoleon's forces only remained for roughly three years, with Napoleon departing even sooner than his troops, the effects of this short occupation echoed throughout the following centuries. First, one could argue

Map 10.2 Wahhabi Conquest and Conversion, Early Nineteenth Century.

that while this was a violent irruption of Europe into the Islamic world that had not happened since the crusades, it was also a moment of direct introduction of Western culture to the region. After the departure of the French, Ottoman rule in Egypt in the near future would be dominated by a Francophile Ottoman elite who patterned many of their strategies for developing Egyptian state and society on European models. Second, while France had for the most part been an ally of the Ottoman Empire since the sixteenth century, this action pulled Britain into cooperation with the Ottoman military against French forces. The British, concerned for the threat to their prized colonial possession of India, would from this moment onwards have a vested interest in engaging in the Eastern Question in order to pursue Britain's imperial aims in the region and resist French intervention when warranted. Third, Napoleon's invading forces were not just military in nature. The expedition was one in which he was also accompanied by an army of around 160 scholars and scientists who came to Egypt to study it – its ancient and modern history, its culture and civilization, its natural history, flora, and fauna, all cataloged in a massive study entitled *Description de l'Égypte* that was published serially a decade or so later. Here is where archeologists and historians mark the beginnings of modern Egyptology, with the discovery

of Egypt's Rosetta Stone leading to the deciphering of hieroglyphics. The discovery of Pharoahnic Egypt also assisted in stimulating a preoccupation with "the East" among French and other European artists and painters who attempted to capture the "exotic" lands of the Islamic Middle East with a new genre, that of Orientalist art portraying the region as backward and barbaric to justify foreign imperialist claims. The style flourished in Europe throughout the nineteenth century. Artists need not even have set foot in the Ottoman Empire to have felt both compelled and able to capture the "Oriental essence" of the Middle East in their paintings, its desert landscapes, its saber-wielding Bedouin on camels, its Oriental despots – the sultans, and their erotic harems of slave women. The European Romanticism movement combined with Orientalism to create a similar genre in Western literary circles, all of which shaped European public opinion regarding the Muslim "terrible Turk."

The other consequence, mentioned earlier, was triggering the arrival of Mehmed Ali Pasha in Egypt in 1801 to restore order on behalf of the Ottoman state (Figure 10.3). Of Albanian or Greek ethnicity, once Mehmed Ali was granted the governorship of Ottoman Egypt, he embarked upon an aggressive plan to centralize and modernize the country through a series of military and educational reforms, and industrial initiatives designed to grow the economy through a focus on agricultural management of sugar production and textiles such as cotton. He established an Arabic press that eventually published the first government newspaper (in 1828). The religious scholar, Rifāʻa Rāfiʻ al-Ṭahṭāwī, sent to Paris in 1826, returned after several years to play an important role in developing Egypt's new education system that emphasized language instruction and translation as a way to study and reconcile Western ideas and Islam. Mehmed Ali established a shipyard and built up a modern navy. He established a new army, the *Nizâmiye*, or "Ordered Army," modeled along European lines, by forcibly conscripting the Egyptian peasantry. In 1811 he used this army to violently eradicate the last of the Mamluk *emir*s, many of whom were from households who had accumulated wealth as powerful tax farmers and sub-provincial Ottoman governors. They were a challenge to his singular authority. Mehmed Ali's Egypt became an Ottoman "regional policeman" – his forces were used to quell the Wahhabi rebellion in Arabia starting in 1811, and an expedition into the Sudan was also embarked upon using this new military arm in 1820. Mehmed Ali's services and his modern army would be called upon again by the Ottoman Sublime Porte in 1821 when an uprising in Greece (strengthened and supported by philhellenism in Britain) threatened Ottoman sovereignty there. The outcome would be devastating for the prestige of the empire when, in 1827, combined Ottoman and Egyptian fleets were sunk at Navarino Bay by a coalition of British, French, and Russian naval forces aiding the Greek insurrection.

But the worst was yet to come, when the servant challenged the master: Mehmed Ali's army actually turned north and invaded Ottoman Syria in 1831, seizing control of the Ottoman Levant for over a decade to enlarge his domains. The army reached all the way to Konya in Anatolia; his son İbrahim Pasha governed Ottoman Greater Syria until roughly 1840. Ottoman armies failed to dislodge his forces on several occasions, and the Syrian population started rebelling against the centralizing reforms of their Egyptian overlords. The

intervention of foreign powers is what ultimately compelled Mehmed Ali to withdraw from Ottoman Greater Syria. A deal was struck due to European pressure – from Great Britain, Russia, Austria, and Prussia – in which the Ottoman sultan granted Mehmed Ali hereditary governorship of Egypt in return for his forces leaving Syria. The post was conferred upon him by 1841. A broken man back in Cairo, he lapsed into senility and died in 1849 but his descendants, eventually known as the Egyptian *khedive*s (a title granted by the Ottoman sultan in 1867) ruled as the royal family in Egypt until Nasser's Revolution in 1952. Mehmed Ali Pasha had shaped the future of Ottoman Egypt with his revolutionary modernization program and had threatened the sovereignty of the Ottoman Empire itself. Egypt would progress on a separate trajectory from the rest of Ottoman territories from his reign onwards. After an Egyptian national uprising was quelled by British forces who landed in 1882, Egypt, still nominally a province of the Ottoman Empire, was governed in practice as a British colony.

OTTOMAN REFORM AMID CRISES

Figure 10.3 Mehmed Ali Pasha in Egypt.

Mahmud II (r. 1808–39) ascended the Ottoman throne in his early twenties during domestic and international crises that converged upon the Ottoman Empire simultaneously. He had been brought to power by the rebellion and the murder of his cousin Sultan Selim III, followed by a coup against his brother, Mustafa IV, who at one point had ordered Mahmud II's pre-emptive execution as well (he in fact had his brother Mustafa IV executed after securing the throne!). The ability of the Janissaries and the *ulema* to dictate political fortunes of sultans and *vezir*s had been duly and violently demonstrated. Central authority over the Balkan provinces and over provincial areas of the empire in general had deteriorated and foreign interventions such as Napoleon's invasion of Egypt would only become more frequent. Sultan Mahmud II's *grand vezir*, Bayrakdar (or Alemdar) Mustafa Pasha, attempted to rein in wealthy provincial notables who controlled affairs on the ground by drawing up the "Charter of Alliance" (*Sened-i İttifak*) in September 1808 in which the financial and military obligations of the *ayan*s and the political relationship between them and the Ottoman state were defined. Designed as a way to combat Janissary and cavalry resistance to checks placed on their power through notables' promises to support the sultan, in the end it failed to do more than provoke a bloody Janissary revolt in the capital that resulted in a huge loss of life and fires that destroyed sections of the city. And meanwhile the empire was still at war with Russia in 1808. The cessation of hostilities ultimately resulted in the loss of eastern Moldavia (Bessarabia) to Russia, and autonomy for Serbia by 1815. Ottoman pragmatism would have to resurface yet again to weather these storms and survive in the modern era.

As a young yet more worldly prince, Mahmud II had taken a keen interest in European institutions. The time spent with his cousin in the palace, the deposed Sultan Selim III, before he was murdered, probably assisted in Mahmud II's recognition that reforming and modernizing the empire was paramount to its survival (Figure 10.4). To improve the quality of diplomatic personnel, a Translation Office of the Sublime Porte was established around 1821 not only to eventually replace the Imperial *Divan* translatorship, but to provide training for a cadre of Muslims who would become familiar with foreign languages in order to serve the state. Prior to the Greek rebellion that started in 1821, there had been a heavy reliance upon Ottoman Greeks in this capacity.

The young sultan became known for decisiveness and a willingness to seize the initiative in the face of various crises at hand, both internal and external. Like Mehmed Ali's destruction of the Mamluk households in Egypt, Mahmud II struck at some of the more formidable provincial lords who resisted his efforts at recentralization, whether in Iraq, or more famously in northern Greece in 1820, with the pacification of the Albanian Tepedelenli Ali Pasha of Janina (mentioned earlier). Dismissing him from his appointed post, Tepedelenli Ali Pasha stirred revolts against the state and made contact with the *Filiki Eteria* ("Society of Friends"), a secret revolutionary organization comprised of Greeks from several regions founded in 1814 in Odessa to establish an independent Greek state by rebelling against the Ottoman Empire (more about that shortly). Besieged by Ottoman forces, he surrendered and was killed in 1822, but the offensive he led sparked a Greek rebellion against Ottoman authority starting in 1821 that blossomed into sectarian (Muslim/non-Muslim) violence in the Danubian Principalities, the Morea, and in Ottoman cities (including the capital), putting a definitive end to the Charter of Alliance with provincial *ayan*s.

Before long this uprising transformed into a nationalist rebellion with separatist aims, based upon the notion of a kind of Greek renaissance, with Greek identity grounded in ancient heritage, a shared history, religion, ethnicity, and language. With some Greeks dreaming of a resurrected Byzantine Empire if the Ottoman state were to collapse, a coordinated movement between three Greek populations gave the rebellion teeth: the Greeks of Odessa on the Black Sea who founded the "Society of Friends" and were influenced by the ideas of the European Enlightenment and the French Revolution, a portion of the elite Ottoman Greek Feneriot community of Constantinople who dominated the patriarchate there and who served as *voivode*s in the principalities, and the Greek population residing in what is today Greece proper. An armed revolt broke out in the Danube region and in the Peloponnesus. The Ottomans executed the Greek Orthodox patriarch in Istanbul and many Greeks fled. British public opinion, being firmly philhellenic, idealized ancient Greece as the foundations of Western civilization and was sympathetic to the Greek cause. When Sultan Mahmud II dispatched Ottoman and Egyptian fleets to quell the rebellion, European fleets came to the Greek rescue at Navarino in 1827. Russia had its own interests in supporting a Greek empire's resurrection and also declared war on the Ottomans in 1828. When the smoke had cleared, Greek independence was forthcoming by 1832 (Figure 10.5) with an agreement for Russian withdrawal and European protection over what was a truncated Greek state – the source of later Greek grievances and assurance there

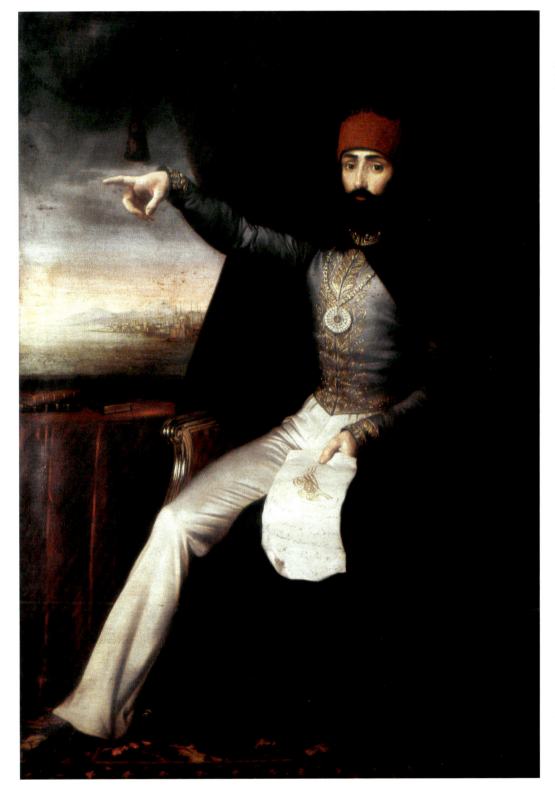

Figure 10.4 Ottoman Sultan Mahmud II in Western Garb.

Figure 10.5 *Grateful Hellas*, 1858. Greece personified as a woman, with revolutionaries who participated in the Greek War of Independence.

would be future Greek claims to other areas. While many Greeks returned to Istanbul, reinvigorating the Feneriot community after independence, it was also a moment for the Armenian community of Constantinople to have their renaissance – Orthodox and Catholic Armenians were recognized as separate *millet*s around this time. They ran many of the city's cottage industries and factories, whether paper, gunpowder, munitions, etc. Greeks became less trusted after this; Armenian translators and interpreters for the Ottoman government became integral to Ottoman diplomatic efforts at home and abroad due to their linguistic abilities and cultural orientations toward Europe.

France, whose population had been divided over supporting Greek independence and was remorseful over not having acted earlier against the Ottoman attempt to suppress militarily the Greek rebellion, would soon choose to act decisively against the Ottomans elsewhere in the Mediterranean. In the current European political climate highlighting new definitions of freedom and liberty, the Greek independence struggle and the demands for abolition of slavery were conflated with the Muslim barbarity of the Ottoman Turks. The Ottoman slave trade and its corsairs centered in Algiers, it was argued, kidnapped good Christian women and young girls, transporting them to the slave markets of Istanbul to supply Turkish harems and endure the unthinkable. An opportunity to exploit the situation as a distraction at home by the domestically unpopular French king began by 1827: his French Consul was sent to exact repayment of an old debt from the *dey* of Algiers. When the Consul was insulted with the famous strike of a flyswatter, an apology was insisted upon that was not forthcoming. In response, and despite debate at home regarding the legitimacy of this action, in 1830 France invaded and occupied Algiers, with one supportive French publication in Paris claiming there would now be "the start of a new era for world civilization."[1] France gained a colony in the former North African Ottoman province.

Upon ascending the throne in 1808, Sultan Mahmud II had approached the undertaking of a military reform effort in a more gradual manner than had his reforming predecessor, Selim III. Mahmud II was heavily influenced by rival Mehmed Ali's rapid modernization

Figure 10.6 Sultan Mahmud II's "Triumphant Soldiers of Muhammad" (*Asâkir-i Mansure-i Muhammediye*).

projects in Egypt and his dispatching of study missions to Europe. A modern army like Mehmed Ali's *Nizâmiye* that would be capable of facing the Russian military machine had to be formed, and was first contemplated by the sultan while war in the east with Qajar Iran (from 1820 to 1823, starting over border incursions) was still winding down. But demonstrating a more cautious approach to reforms than his predecessor, he recognized the need to have his reforms officially sanctioned by members of the religious *ulema* and Janissary officers while also appealing to the more traditional religious sentiments of the Ottoman Muslim population at large for his reorganization of military forces to succeed. After a meeting of ministers, the initial edict proclaimed the establishment of a new army corps as a "modern Muslim army" (according to a *fetva* issued by the şeyhül-islâm demanding soldiers study both military science and religion), which drew its personnel in part from the Janissaries. Mahmud II's new Ottoman force replacing the muddied and corrupted Janissary Corps would not be called New Troops, but a more culturally amenable name with echoes of earlier Islamic heritage, the "*Asâkir-i Mansure-i Muhammediye*" – the "Triumphant Soldiers of Muhammad" (Figure 10.6). Non-Muslims would not serve in this new army. The troops would not be trained directly by foreigners, but by a Muslim officer corps who first received instruction from French and Prussian army officers and British naval staff after being sent to Europe to study.

Not long after the first Western-style drills by this new armed force took place, the Janissary soup cauldrons could be heard in the city being overturned as their sign of mutiny. The resentful Janissaries were rebelling, but this time their efforts to start a mass revolt in the streets failed; the sultan and his loyal forces were ready. Mahmud II unfurled

the Standard of the Prophet (kept in the Relics room of the palace), and the "Auspicious Event" (*Veka-yı Hayriye* as it is known in Ottoman history) had begun: as the Janissaries blockaded themselves in their barracks, troops with guns and heavy cannons fired on it and on those coming out into the square, finishing off the Janissaries in about thirty minutes – some 6,000 were killed; thousands more fled and tried to recede into the civilian population, only to be hunted down later – perhaps another 5,000 of them. The abolition of the Janissaries was complete. Their barracks was razed, the word *Janissary* erased from Ottoman parlance, in 1826. The *Bektaşi* Sufi order that was so closely linked to the Janissary Corps would also be under assault. Now considered too heterodox in its traditions by more orthodox Sunnis because of borrowing "heretical" elements from Shi'a Islam, Christianity, and shamanism, the order was banned, its sufi masters were "re-educated" or executed, its properties were confiscated by the state, forcing resolute adherents underground to practice their rituals. Other sufi orders not affiliated with Janissaries, however, were allowed to flourish at the same time. Ironically this extermination of the Janissaries also had economic consequences. Many of the Janissaries who were eliminated had by this time also become involved in various business enterprises as shopkeepers, café and tavern owners, and could be said to have started to form an entrepeneurial middle class.

An education system had to be inaugurated to support this reorganized military as a European fighting force, which built upon precedents established during Sultan Selim III's reformist era. A naval academy opened in 1828, the Imperial Military Academy was inaugurated in 1831, with curriculum taught by the army and navy engineering school graduates. A military sciences war college was established in 1834. French was the language of instruction at these academies, generating a class of Ottoman elites, officers, and bureaucrats well-versed in European intellectual currents and cultural attitudes. These schools in effect created a new generation who would push for further reforms in the future – a pattern that was repeated throughout the nineteenth-century Ottoman Empire: expanding the education system produced graduates who demanded more change.

Reform in the sphere of military affairs affected medical reform. European medical literature that had filtered into the empire starting in the seventeenth century and continued into the nineteenth combined with previous Islamic practices as part of the modernization process. An imperial medical school was opened in 1827, the School of Surgery in 1832 (they merged in 1839). Military hospitals were founded in Istanbul that employed modern Western medicine. Soon to follow were government-established medical schools to train doctors and state hospitals to treat Ottoman citizens. Private modern hospitals (called *hastanes*) were also founded by Muslims and non-Muslims. The Ottoman government would send medical students to Europe to study. Research laboratories led to the use of vaccines. An Ottoman quarantine system to try to stem the spread of disease was put in place in the 1830s – in 1831 to screen Black Sea ships, in 1835 at Çanakkale and other ports.

Sultan Mahmud II implemented a series of reforms not solely as a response to Western contact, but also to address newly created internal circumstances that threatened the stability of the empire. The two were interconnected as Western powers increasingly

intervened in Ottoman affairs in the nineteenth century. His reform efforts, most of which occurred during wars (i.e., with Russia), rebellions (i.e., Wahhabis in Arabia, Serbians, the Greek revolt), and losses of Ottoman territory (i.e., France seizing Algiers in 1830) had several purposes beyond, for example, placating the British to get their assistance in ousting Mehmed Ali's forces from Greater Syria (though many reform-minded bureaucrats at this time pushed for the Ottoman Empire to "catch up" to Ottoman Egypt). Reforms were designed to create a modern military capable of defending against foreign aggression while remaining loyal to the sultan's will, to generally increase revenue extracted for the central government, to streamline and make more efficient the bureaucracy, and to redefine aspects of Ottoman state and society. These initiatives, all of which continued to be goals of reform efforts in the decades following his reign, were intended to modernize the Ottoman Empire but were imposed from above, leaving subjects of the empire to remain subjects – not citizens – at the start of this process. This conception of ruler and ruled, however, would begin to be rethought in the mid-nineteenth century.

With this in mind, a modernized bureaucracy was organized with independent branches of the military (*seyfiye*), judiciary (*ilmiye*), and civil administration (*kalemiye*) that started to resemble European government structures. The first modern census was conducted in 1830–1 to establish taxation procedures as well as to lay groundwork for implementing a military draft for his new troops and reserve corps. New units within the army were formed and officer ranks were delineated. The *timar* system was formally abolished in 1831 and professional cavalry units were created, allowing for taxation to be better regulated as well, though tax farms endured. The Translation Office that had been created in 1821 became a bureaucratic department out of which by the 1830s would come many ministers and reformers of the future. Initially staffed by many Ottoman Greeks, after Greek independence the office became dominated by Armenians and Muslims. This office played a role in producing more capable Ottoman diplomats to staff foreign postings in the recently reinvigorated staffing of embassies abroad after a period of neglect between 1811 and 1830. They were the conduits of westernization who transmitted European culture and thought to their Ottoman comrades; several of them would spearhead the *Tanzîmât* reform era of the next decades. To curb the power of the religious class, in 1826 the Ministry of Religious Endowments was created, restricting the *ulema*'s ability to control *vakf* trusts. New Ottoman ministries of the Interior, Justice, and Treasury were founded around 1836.

To transform traditional offices of the Ottoman administration into modern ministries required reorganizing the Sublime Porte of the *grand vezir*, who was now the Ottoman prime minister. The chief scribe of the Imperial Council became the foreign minister, with a diplomatic corps trained in French in civil service schools to staff the foreign ministry. New consultative councils were established, a military council in 1837, and two others, one more legislative in nature (the Consultative Assembly of the Sublime Porte), the other judicial (the Supreme Council of Judicial Ordinances), by 1838. Mahmud II's reorganization created a cabinet of sorts, eventually known in 1839 as the Council of Ministers, the *Meclis-i Vükela*, which decentered the *grand vezir*'s position temporarily. An official

state gazette was founded, the first newspaper in Ottoman Turkish, *Takvîm-i Vekâyi*, in 1831, shortly after a French language newspaper called *Moniteur ottoman* began publication. A modern postal service was created in 1834. In 1838 the ban on confiscation of private property and extrajudicial exile and/or execution of officials was enacted to replace the more arbitrary punishments meted out in the past. New police and firefighting forces for urban areas were formed and eventually fell under the supervision of the Ministry of the Interior. Sultan Mahmud II's first dramatic reforms of the government were a blueprint from which to organize more ministries in subsequent sultans' reigns.

Sumptuary laws in the Ottoman Empire that dictated dress codes for ethnoreligious orientations and class distinctions had been in place for centuries and were enforced or ignored depending upon the whim of an individual sultan (or his close associates). Now the wool fez was introduced, intended to equalize the status of Ottomans in officialdom and among the general population. Whereas Mahmud II's new army was already sporting a fez as their headgear with cloth wrapped around it, by 1829 the civil servants of the empire were also required to wear the fez. Some sources claim there was an expectation that the religious class would abandon the wearing of turbans, but that Mahmud II's headgear demand of the *ulema* was less successful; others state that the *ulema* was not actually required to wear the fez, and they continued to wear their turbans to indicate status. Nonetheless, more conservative elements of society disliked this headgear, as it was associated with Balkan Christians (though it originated in the North African Maghreb, or Morocco). The fez only became widespread among the general population later.

Sultan Mahmud II himself donned Western dress and was an enthusiast of European styles and culture: architecture, music, fashion, etc. all mimicked those of the French, Italians, and Viennese. He was seen on horseback with Western-style saddle and stirrups. The Italian musician Giuseppe Donizetti "Pasha" (d. 1856) introduced European music to Mahmud II's court and his new military force as an imperial music instructor and Italian opera aficionado and promoter while residing in Constantinople from 1828 until his death. In this rapidly changing Ottoman capital city, women were becoming more visible in public than before, some donning European-style clothing. Lavish balls to host European diplomats served champagne and brandy in Western fashion. New technologies were also starting to make their appearance in Istanbul – British steamships appeared on the Bosphorus; construction began on the famous Galata Bridge that spanned the Golden Horn; more modern hospitals and quarantine facilities to deal with plague and cholera were established.

NATIONALISM GERMINATING

Sultan Mahmud II seems to have made an effort to appeal to non-Muslims in the Ottoman Empire for several reasons and in various ways. Influenced by the ideals of "Western progress," yet recognizing the dangers of overstepping Islamic religious bounds, he carefully straddled the two by couching secular reforms in terms of the critical need for

modernizing the Ottoman Empire to resist Western military encroachment. Clearly the rebellions resulting in Greek independence and Serbian autonomy had made the sultan keenly aware of the potential for more territorial losses in the Balkans if more Christian populations were to rebel with European support, or if they defected to Austrian or Russian empires (both of which occurred). Mehmed Ali Pasha's invasion and occupation of Syria made the sultan recognize the necessity to acquiesce to British wishes for reform if the Ottomans wanted to secure Ali's withdrawal. In this regard, the abolition of sumptuary laws, the permitting of new churches to be built in the empire, and allowing non-Muslims to enroll in many of the modern educational institutions newly founded during his reign were among the sultan's efforts to lessen the sense of subordination non-Muslims had experienced – to keep them in the Ottoman Empire. However, the attraction to ideas of nationalism would ultimately be more than the Ottoman Empire could bear. Since the American and French revolutions, new ways of defining one's identity had made their way into many areas of the world in which people had been merely subjects of an empire.

Nationalist awakenings boiled over nowhere more than among non-Muslim Ottoman peoples in the Balkans. The geographic and intellectual connections between them and western Europe, with its new notions of nationhood, made this region the epicenter in a series of centrifugal forces pulling the empire apart. Non-Muslims increasingly viewed themselves not as one particular *millet* or another in the traditional Ottoman sense, but now as distinct national communities, each with its own shared history, culture, language, religion, and ethnicity. Complicating matters further was the ethnoreligious makeup of the borderland areas of the Balkans, in which ethnically Slavic Serbs followed an Orthodox Christian rite and generally had Russian encouragement for their actions, while the ethnically Slavic Croatians, Catholic in faith, more closely identified with the Habsburgs of Austria. Ethnically Slavic Muslims, heavily concentrated in Ottoman Bosnia, had brethren caught in the middle in some Christian-dominated areas. Uprisings here frequently started as resistance to harsh taxation demands made by the state or to abuses by its representatives, for example, and then transformed into nationalist rebellions against Ottoman authority more generally. The first Serbian revolt of 1804 began this way, with tacit Russian support; the second in 1815 managed in 1817 to secure some autonomy for Serbia as a newly declared principality with a national council and a hereditary Serbian prince at its head.

While these rebellions predated the Greek uprising, the Greek revolt was the first successful episode in this narrative of nationalist unrest that resulted in the creation of a new nation-state, protected by European powers (Britain, France, Bavaria) and Russia. This achievement was won also through the inauguration of intercommunal violence in the name of constructing a homogenous polity: to make Greece fully Greek required the expulsion or massacres of thousands of non-Greeks. A pattern of ethnic cleansing and the creation of refugees and mass migrations was repeated frequently as a consequence of the empire's slow dissolution. The underlying causes of these rebellions and the sectarian violence that ensued must all be understood in the proper context of these domestic, financial, and political tensions between and among the ruling class and their subjects, as well as from European interventions in Ottoman affairs on behalf of non-Muslim populations.

ETHNORELIGIOUS NATIONALISM AND ITS DISCONTENTS IN OTTOMAN LANDS

Historian Benedict Anderson proposed in his 1983 groundbreaking work, *Imagined Communities: Reflections on the Origin and Spread of Nationalism*, a theory of nationalism that could be applied to peoples in the Ottoman Empire quite readily. Ottoman subjects generally identified themselves through a religious understanding within a dynastic realm prior to the nineteenth century: in other words, within the Ottoman Empire, its population typically defined themselves as Muslim or non-Muslim, with additional layers of identity to varying degrees based upon family, clan or tribe, geographic area (neighborhood, village, or region), Sufi order, class or profession, linguistic familiarity, race or ethnicity. But with the introduction of Western ideas of nationhood, two types of nationalist ideology developed that were not mutually exclusive, and in the case of the Ottoman Empire could often both be seen to have influenced new notions of identity in the nineteenth and twentieth centuries. In "civic nationalism" – an idea emanating from the French Revolution – "citizens," not "subjects," are equal under the law, and have certain inalienable rights, including civic participation in the nation (i.e., the vote), but also have duties to the nation's defense (i.e., military conscription). The paradigm of "organic" or ethnic nationalism, sometimes called the German model of "blood and soil," implies that the nation is comprised of people who share in some characteristics considered inherent – particularly racial or ethnolinguistic heritage, often but not always geographically delimited as well, that sets them apart from other groups similarly defined. One could argue that the ideal of civic nationalism is inclusive in nature, whereas organic nationalism is exclusive. Religious affiliation can continue to play a role in both kinds, however. In both types, Anderson argues, the phenomenon of "print-capitalism" foments nationalist consciousness: the appearance of a didactic press in which readers' identities are shaped through literary production instructing them as to who they are, and with whom they belong as a people.

One aspect of this construction of a national identity is the need to resurrect or even create out of thin air a "national past," a "national mythology," a tangible antiquity that can be emphasized to illustrate the uniqueness of one's history. In the nineteenth century, if a people had an antiquity that could be readily discerned, and because their current existence implied a continuity with that past as a people, this past combined with their continuity granted them the right to assert nationhood – and by extension, then, entitlement to self-determination, independence, and possibly territorial claims as well. With this framework in mind, a people's understanding of itself as a nation had certain radical implications that were a destructive force for an empire such as the Ottoman one in the nineteenth century. For example, the Ottoman Greek population embraced its heritages of ancient Greece and Byzantium as well as its ethnoreligious history and culture. Eventually a successful separatist agitation against the Ottoman dynasty was conducted, resulting in an independent nation in 1832, with territorial claims in southern Europe that were satisfied through European (philhellenic) support for their nationalist agenda (think of Lord Byron). Serbia followed in

subsequent decades, their national myth being one related to the destruction of the Serbian kingdom by the Ottomans in 1389 at Kosovo. The pharoahs of Egypt who so strongly attracted the imaginations of European archeologists in the nineteenth century became Egypt's antiquity; the Egyptian peasantry, the Arabic-speaking "*fellahin*" who continually inhabited the countryside as waves of invaders came and went through the centuries, were the rightful owners of a future country of Egypt.

As the nineteenth century wore on in the empire, more separatist nationalist movements formed and rebelled against Ottoman sovereignty. Most of these movements occurred in connection with foreign power intervention on behalf of one group or another, as the Ottoman state struggled to hold its territories and peoples together through reforms, enticements, and violence. The various ethnoreligious nationalisms that emerged in the Balkans perpetuated their view of throwing off the "Ottoman yoke of oppression" in the nineteenth century far into the twentieth century. Non-Muslims tended to embrace nationalist ideologies first; Muslim Arabs, Turks, Kurds, etc. tended to remain loyal to the Ottoman state much longer due to the cultural and historical connections these Muslim populations felt in being part of an Islamic Ottoman Empire. Nonetheless, the seeds of Arab, Turkish, and Kurdish nationalisms were all beginning to sprout by the late nineteenth and early twentieth centuries.

But within non-Muslim communities, not everyone was attracted to the idea of independent nationhood. Often elite individuals of a non-Muslim *millet* had much to gain by remaining loyal to the Ottoman authorities, a fact not wasted on Ottoman officialdom. For example, Konstantinos Mousouros (b.1807–d.1891) was an Ottoman Greek born in Constantinople to a Feneriot family with origins in Crete. Known in Turkish as Kostaki Musurus Bey (Pasha as of 1867), after serving as governor of Samos, he then occupied the post of Ottoman ambassador to Greece (in Athens, 1840–7), ambassador to Austria at Vienna (1848), then ambassador to Britain at London (1851–85), while jointly to Belgium (1861–75) and the Netherlands (1861–77). A worldly Ottoman diplomat who did not know Ottoman Turkish but communicated in fluent French, he translated Dante's *Inferno* into Greek in the early 1880s. Musurus Pasha served the Ottoman state and was often at odds with the Greek nationalists who despised him. He was a "Renaissance man" who "had staked his life and career on advancing the interests of the Ottoman state," who mediated British financial and political arrangements with the empire, and was distraught over the rebellions and sectarian/state violence flaring in Ottoman lands in the nineteenth century.[2] Intercommunal strife, nationalist uprisings, the Ottoman state's responses to them, and the atrocities associated with both sides became more numerous and more severe as the century wore on, yet there were always Ottoman individuals who felt an affiliation with multiple identities – as Ottomans, as Muslims or non-Muslims, as an ethnolinguistic group, etc. depending upon circumstances.

THE CRISES CONTINUE: REFORM AND REPERCUSSIONS

Though Mahmud II has been hailed as a reforming sultan, the effects of his recentralization program also had dire consequences for many subjects of the Ottoman Empire, whether due to the direct effects of his fiscal and military policies, or the knock-on effects of rebellions, European involvement in domestic affairs, and internecine strife in the provinces. Nor did his reforms prevent further crises from developing after his reign. In fact a repetitive cycle of crisis and reform persisted throughout much of the nineteenth century. When he died in 1839, Mehmed Ali's occupation of Syria was ongoing, and France had already seized Algiers nine years earlier. He would not live to witness unrest in Serbia explode into a riot against taxes around 1841, which would be harshly put down by Albanian Muslims, increasing sectarian tensions there.

After Sultan Mahmud II's death in the summer of 1839, his son Abdülmecid I (r. 1839–61) was enthroned as a teenager. Months later, in November, the first official decree of the era called the *Tanzîmât*, the "Reordering" (*c.* 1839–76), was announced. The young Abdülmecid I first presided over its promulgation as sultan, followed by his brother and successor, Sultan Abdülaziz I (r. 1861–76). But the real architects of these reform initiatives were three members of the bureaucratic elite: first Mustafa Reşid Pasha (b. 1800–d. 1858), a pro-British official who served in the Foreign Ministry, then Mehmed Amin Ali (b. 1815–d. 1871) and Mehmed Fuad (b. 1815–d. 1869) Pashas, who had both emerged out of the Translation Bureau of the 1830s, when it had become primarily Muslim. Their exposure to European ideas had a direct impact upon this first edict, the *Hatt-ı Şerif* of 1839 (the Imperial Rescript of Gülhane), which was proclaimed in a Topkapı Palace garden by Reşid Pasha in the presence of various Ottoman and foreign dignitaries before being read aloud in public squares across the empire and published in *Takvîm-i Vekâyi*. They were clearly influenced by the *Declaration of the Rights of Man and of the Citizen*, the French National Assembly statement of 1789 that was heavily influenced by Marquis de Lafayette and by the American envoy to France, Thomas Jefferson. The Ottoman statesmen, fluent in French, would have read this declaration in the original.

The parallels between the French and Ottoman proclamations are undeniable. The French declaration expresses that men are free and equal in rights, that liberty, property, and security are natural rights. These rights are guaranteed by the rule of law, which protected one's freedom of expression and one's property; the rule of law prohibited the arbitrariness of arrest and/or imprisonment. It also delineated the responsibilities of citizens – a new concept here – to the nation, the homeland. Citizens had the right and the obligation to participate in governance; thus "all sovereignty resides essentially in the nation." These responsibilities included supplying soldiers for a military force to protect the nation, with the demand equitably distributed among the population, as well as fair taxation according to means. The Ottoman Gülhane Edict echoed these points, though they were imbedded within a text that reiterated the past glory of the Islamic Ottoman Sultanate and the importance of adhering to *şeriat* (Islamic law) for the realm to survive. Perhaps this explains in part why Sultan Abdülmecid I chose to revive and adopt the

titles of "Commander of the Faithful" (*Amir al-Mu'minin*) and "caliph" for himself. The concept of citizenry was somewhat muddled in the Ottoman decree because the notion of citizenship was still in its infancy in the empire, and not yet embraced by the statesmen promulgating this initiative. The three main points do resemble the French statement, however, and were as follows: the guarantee to promise "our subjects perfect security for life, honor, and property"; "a regular system for assessing taxes"; "an equally regular system for the conscription of requisite troops and the duration of their service."[3]

The main provisions of this decree were carried out to varying degrees throughout the empire. The rule of law would ensure the prosperity of the realm by guaranteeing individuals their security and entitlement to a public hearing if arrested. Fair taxation meant the abolition of tax farms, to be achieved only in part by 1840. This proviso also implied a form of equality unheard of in Islamic empires until now: all Ottomans, Muslims and non-Muslims, were to pay taxes according to means; in theory the *jizya* tax on non-Muslims was to be officially abolished, though in reality it persisted in places. Universal conscription to replace arbitrary drafting of soldiers would have limits on service of four to five years. The latter two provisions provoked the most tension in society, as this new concept of equality deconstructed two guiding principles in place for centuries in Islamic societies that had preserved the subordination of non-Muslims to Muslims: the *jizya* tax, and the proscription against non-Muslims bearing arms and serving in the military. For the first time in history, creating equality between Muslims and non-Muslims on the basis of law was being attempted by a Muslim state. The introduction of the fez first to Ottoman officials in 1829 and then more generally into the population was an attempt to visibly erase distinctions between Ottoman subjects. The societal consequences of this new ideology of equality violently disrupted the empire at its foundations for the next century.

The Gülhane Rescript of 1839 and the subsequent *Hatt-ı Hümâyun* decree of 1856 which reiterated and expanded upon the former were promulgated in the context of several factors. First, in the face of ethnoreligious nationalist feelings beginning to emerge among non-Muslim minorities, it was an attempt to hold the multinational empire together by offering non-Muslims legal equality. The Gülhane decree was the first attempt to cultivate a broader notion of national solidarity among all its Ottoman subjects in a doctrine called "Ottomanism." The Ottoman state attempted to implement reforms to bind the multiethnic, multireligious society together at the very moment when the forces of nationalism were causing peoples to identify themselves as distinct from one another, pulling the empire apart. Ottomanism would be conceived as a love for the Ottoman homeland, loyalty to the dynasty, the belief in the viability of the empire to maintain its Islamic character while respecting the rights of all its people (not quite understood as citizens yet, but as subjects with rights), and undertaking modernization to survive in the contemporary world. Second, resolution to the crisis with Mehmed Ali required assistance from European and British powers to oust his forces. Europe and Britain in turn had exerted pressure on the Ottomans to reform, in the name of concern for the welfare of Ottoman non-Muslims.

The second decree, issued at the end of the Crimean War (1853–6), further emphasized non-Muslim equality and guaranteed their equal participation in all facets of Ottoman

life. This decree inched toward a sense of subjects as citizens; it was also designed to alleviate European pressures on the Ottoman Empire related to non-Muslim communities, in the aftermath of the Crimean War ignited by French and Russian claims as protectors of their respective Catholic and Orthodox Christian communities. But also underpinning this new and disruptive "culture of sectarianism,"[4] were several features of mid-nineteenth-century Ottoman relations between Muslims and non-Muslims: the new principle of Ottoman legal equality between them was enacted while the *millet* system that set apart ethnoreligious Ottoman communities had not been abolished, creating a sociopolitical contradiction exacerbated by Western missionary intervention, dictating and encouraging these distinct and separate communal, proto-national identities (see Chapter 4). The result was a paradox – of *millet* organization and religious legal equality fueling new levels of violence among communal sects. In an environment of awakening nationalist consciousness, it was perhaps a most dramatic error in policy-making regarding minorities in the empire that the state embraced the notion of equality for all Ottomans without abandoning the *millet* system. In the minds of minorities, too, the benefits reaped as a *millet* endured alongside newfound equality.

European imperialism came in several forms. Previously, victory in wars against the Ottomans allowed for the seizure of more territory through treaty arrangements. By the nineteenth century, Western or Russian intervention occurred through support for separatist movements fomenting among the Ottomans' non-Muslim populations, most of which first arose in the Balkans. European powers sometimes intervened on behalf of a particular ethnoreligious community and its interests. European imperialism also manifested through the insistence on and the commercial manipulation of the Capitulations granted to Western nations. French and English merchants had already become permanent fixtures in port cities and trade hubs in previous centuries (England from the sixteenth century; France, which from the eighteenth century had overtaken English trade in the Levant); to their Ottoman non-Muslim protégés – their employees, guides, and interpreters who worked for them and who were also often granted foreign citizenship – were now extended the same Capitulatory privileges that benefitted the foreign nationals themselves. The influx of European-made products with favorable trade duties was detrimental to local Ottoman cottage industries as well as to many Muslim merchants who did not reap the same Capitulatory exemptions as their non-Muslim compatriots in the service of Europeans. In fact by the mid-nineteenth century local non-Muslim merchants (particularly in the Levantine silk industry) with connections to French capital and international trade networks had been able to profit more than their Muslim and European counterparts due also to tax exemptions and access to cheap local labor. And added to commercial gain afforded to expatriates and their charges from the Capitulations was now the inclusion of judicial extraterritoriality in those agreements, so that legal proceedings against a foreign individual were to be heard in consular, "mixed" courts in which the non-Ottoman government could influence rulings. *Berat*s – patents or tax-exemption licenses issued by the Ottoman government to foreign embassies employing *dragoman*s (interpreters) – were increasingly being sold off to Ottoman non-Muslim subjects who then profited from these privileges.

The combination of ethnoreligious and nationalist sentiments bubbling over, the *Tanzîmât* reform decrees removing communal barriers to provide equality for non-Muslim minorities in the Ottoman Empire, and the favorable economic privileges gained by non-Muslim Ottoman merchants and employees of Western governments was a recipe for societal tensions culminating in bloody sectarian violence in several areas of the empire. Non-Muslims had experienced newfound wealth and economic status in an Islamic state whose Muslim population in many cases perceived themselves as having been negatively affected by the reforms and the unfair Capitulatory arrangements that benefitted Ottoman Christians. In Ottoman Lebanon and Greater Syria for example, a diverse region and center of Levant trade, ethnoreligious strife broke out repeatedly between (Maronite) Christians, Druze communities, and Muslims. Due in part to the disruption caused by the withdrawal of Mehmed Ali's forces in 1841 in which İbrahim Pasha had backed one faction or community against another during the ten-year occupation, the *Tanzîmât* reforms further exacerbated tensions there. At a time when disputes over control of the holy sites in Jerusalem and Bethlehem between the French-backed Catholic priests and the Russian-backed Orthodox clergy had flared up again in the 1840s, conflict between Maronites (supported by the French) and Druze (backed by the British) was also brewing in the 1840s. A massacre of Christians by Muslims in Aleppo in 1850, and a Maronite rebellion against Druze overlords in the 1860s led to a sectarian civil war and bloody riots in Damascus. Ultimately the Ottoman solution to this troubled area was a new political arrangement agreed upon in 1861 with European consent: the *Mutasarrifiyya* of Mt. Lebanon in which the governor of this single district would be a non-Lebanese Christian (Catholic). Added to his position in 1864 was an administrative council to assist in managing the district that was comprised of twelve members from among the ethnoreligious communities – four Maronite Christians, three Druze, two Greek Orthodox, one Sunni, one Shi'a, and one Greek Catholic.

Ottoman reform and modernization was also intended to generate recognition among the European powers, Britain, and Russia of the empire's status as a viable modern polity that respected the rights of its inhabitants and protected private property. To this end, adhering to international law and signing economic and political treaties were understood to be binding contracts, even though they were often agreed upon while the Ottomans were in the midst of a critical situation (e.g., Mehmed Ali's occupation). When Sultan Mahmud II signed the 1829 Russo-Ottoman Treaty of Edirne, among the provisions was allowing Russia access to areas of Moldavia and Wallachia. He signed the Hünkâr İskelesi Treaty in 1833, which protected Russia by forbidding foreign warships from passing through the Dardanelles if Russia was attacked; during the *Tanzîmât* era, the Straits Convention of 1841 stipulated foreign warships were not allowed to pass through the Bosphorus and Dardanelles in peacetime. The 1838 Anglo-Ottoman Treaty of Baltılimanı reconfirmed Britain's favorable Capitulatory status in the Ottoman Empire; as the single most destructive trade agreement, it banned government monopolies and allowed British commercial agents into the Ottoman interior, flooding the market with British goods and eroding Ottoman Muslim wealth. Under pressure from Britain and its pursuit of banning

the slave trade, in 1846 the slave market in Constantinople was closed, and the Ottomans came under increasing pressure to cease the slave trade of Circassians and Black Africans. The Ottoman ban on the African slave trade was eventually enforced by 1857, though the slave trade of Circassians (mainly women) continued.

In any case, the *Tanzîmât* reforms were intended to modernize Ottoman state institutions, to create new ones when needed, and to strengthen its authority with its own subjects across the empire. In some cases the result was a weakening of the empire against outside forces. Domestically the program included economic and political reforms such as a rural survey to establish better taxation and revenue collection, new commercial codes put forth in the 1840s, and improvements in agricultural and manufacturing technology. A supreme council of sanitation with international representatives was established in 1839 in Istanbul to oversee Mediterranean quarantine. The first telegraph lines opened during the Crimean War in the 1850s and the system was expanded in the 1860s. In need of new policing, surveillance, and firefighting forces after the destruction of the Janissaries and a weakening of guilds, both of which had traditionally maintained order, local gendarmeries, based on French models, to assist in preventing crime, a new criminal court system, and the empire's first modern penal code were created in 1840. Spy reports from informants circulating in the streets and among the many coffeehouses, *hamam*s, mosques, etc. of Constantinople to hear the latest news, gossip, and potential dissent made their way to a chief of police, and from there, to the *grand vezir*, up to the sultan himself, in order to gauge public opinion. Further modifications of the penal code were made in 1851, and again in 1858 with the promulgation of an imperial Ottoman penal code. Between 1869 and 1876 a modernized Ottoman civil legal code, the *Mecelle*, was drafted, the codification of which was based on Islamic law adhering to *Hanafi* interpretation, the official legal rite of the Ottoman Empire.

The new penal code of 1840 was revolutionary in defining former behavior among Ottoman state officials who misused their office or who accepted "gifts" in new ways – as "corruption" or "accepting bribes," which required criminal prosecution and punishment. As part of a strategy to centralize the fiscal administration, *Tanzîmât* reformers hoped to curb the abuses in the countryside conducted by provincial governors, tax farmers, and local notables through legal and financial regulation. It was perhaps overambitious to eradicate the widespread corruption in the provinces. The new tax system, with its centrally appointed tax collector (*muhassıl*), was designed to replace tax farms but was not implemented in all areas (e.g., it excluded the Balkans where Albanian governors presided as well as Arab and Kurdish territories); in some cases tax farms reemerged after having been suspended, despite the appointment of a tax collector. Corrupt individuals were not often brought to heel legally in provincial districts. However, the peasantry, both Muslim and non-Muslim, who bore the oppressive tax burdens or *corvée* (forced labor) at the hands of provincial elites, was taught this new meaning of corruption. There were frequent petitions to the central authorities by rural communities complaining of such abuses and demanding the state use its *Tanzîmât* legal instruments to rectify the unbearable situation of the peasantry.

The *Tanzîmât* reforms opened a new era in educational reform, with inspection of Ottoman schools commencing in the 1830s. The reorganization of the education system started with the establishment of the Ministry of Education in 1847. A teacher training college for boys, the *Darülmuallimin*, was opened in 1848. Educational reforms of the nineteenth century, which included the introduction of public education and Western-style primary schooling, were intended to cultivate a class of officials to serve the state administration. In 1859 a mixed (Muslim and non-Muslim) civil service school was founded. With cooperation of the French, the mixed Galatasaray Imperial School was opened in 1868. The first schools for girls opened in 1858, and in 1863, the first middle-level schools and a primary teacher training college for girls opened. Regular oversight of schools occurred by the 1860s and the Public Education Regulations (1869) organized Ottoman education further, making primary and secondary education compulsory for boys and girls, standardizing the curriculum, and defining the four levels as *sıbyan*, *rüsdiye*, *idadiye*, and *sultaniye*, corresponding to primary, middle ("preparatory"), and two high-school levels. Non-Muslim minorities could still run their own schools or they could attend the state schools attended by Muslims. More schools at the primary, middle, and high-school levels were established throughout the *Tanzîmât* era of the 1860s–70s, providing education in secular subjects for boys. Girls had their own *sıbyan* schools, with their own curricula. Girls received a basic education and skills related to "household duties"; the *rüsdiye* grade was the highest level they could attend. Another teacher training college for girls opened in 1870, which trained teachers (male and female) how to teach girls in the bottom two grade levels. The goal of establishing an Ottoman university to parallel European institutions of higher learning took several attempts before succeeding – initial efforts were as early as the mid-1840s and a university of sorts, a *Darül-Fünûn* to train civil servants, did appear in 1873. But the official founding of the Ottoman Imperial University (Istanbul University today) finally occurred in 1900 (Figure 10.7).

Many reforms were intended to reorganize the relationship between state and citizens on an individual basis. Communal taxes were to be commuted and taxes were now to be assessed and collected from individuals instead; tax farms did persist despite the 1839 rescript abolishing them. In 1843 new military regulations were announced, based upon French and Prussian models. Universal conscription meant every male eligible due to age and health was to serve, but done by drawing lots determining regular service or reserve. Another census of male household heads was done in 1844 for purposes of recruitment, though the accuracy of such data was questionable due to the difficulty of collecting information, the possibility of men fleeing an area, etc. By around 1845 there were Christians serving in the Ottoman navy, though neither party was satisfied with the new arrangements whereby both Muslims and non-Muslims served in the military. Non-Muslims were permitted to send substitutes to serve in their place according to the conscription law of 1848. While there are records of non-Muslims having enlisted during the Crimean War, from 1855 non-Muslims were allowed to purchase an exemption from military duty called a *bedel* – in a way replacing the *jizya* (Muslims could also pay for an exemption). In 1869 another reform of military organization occurred; in 1870 a review of conscription policy clarified the exemption

Figure 10.7 Ottoman Imperial University (Now Istanbul University). The building pictured housed the Ministry of War until the university was relocated there in 1923.

payments (the first real universal conscription law was not enacted until 1908).

In 1858 a new agrarian code was announced; the same year an Ottoman land law was promulgated that altered significantly the previous understanding of land rights in the Ottoman Empire. Landowners now had to register ownership with the state, and were obligated to pay certain assessed taxes and perform military service. This new law created new problems: in the shift from communal to private landownership, land historically occupied by peasants who may have tilled the land for generations was now registered to one individual – often a literate village notable who may or may not have actually lived on that land but could register his name on the title deed, and sell it if desired. Absentee landlordism led to future disputes in some areas of the Ottoman Empire where peasants resided and worked land without owning it, particularly if the absentee owner chose to sell it to a third party, as sometimes happened in Palestine in the twentieth century. As a consequence of the emergence of Jewish nationalism known as Zionism in the late nineteenth century (partly as a response to pogroms occurring in eastern Europe and Russia), Jewish immigration to Ottoman Palestine increased with the "first Aliyah" around the late 1870s. The Jewish National Fund, established in 1901 to purchase land for Jewish settlement, sometimes resulted in this problematic relationship on the ground between the newly arriving Jewish immigrants and the Palestinian Arab peasantry who had farmed the land for generations without being able to claim legal private ownership.

THE CRIMEAN WAR, REFUGEES, THE YOUNG OTTOMANS

There was a limit on Ottoman acquiescence to foreign demands, however, regarding treaty arrangements and interventions on behalf of non-Muslim communities. Coming on the heels of an uprising in Vidin (Bulgaria) in 1850 and Ottoman concessions made there, the conflict between France and Russia over the rights to the holy sites of their respective ecclesiastical clients (Catholics and Orthodox) heated up again in the early 1850s, and a flurry of diplomatic efforts by the Ottomans and the British to resolve the situation came to naught. Ultimately Russia demanded to be recognized as the protector of Ottoman Orthodox Christians; when the Ottomans did not agree, Russia mobilized its army for war and occupied the Danubian Principalities. The Ottomans, believing their custodianship

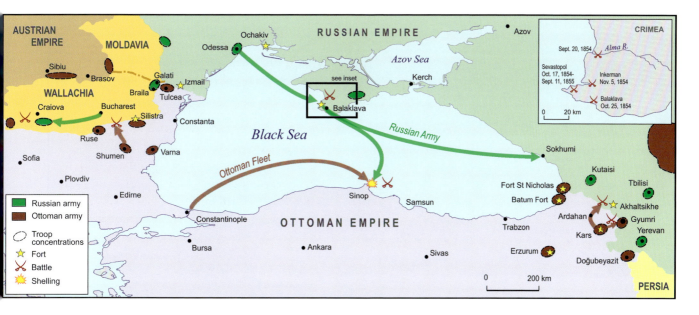

Map 10.3 Crimean War (1853–6).

over Orthodox Christians for centuries had been augmented by the *Tanzîmât* reforms guaranteeing equality for all its peoples, declared war on Russia in the fall of 1853. The theater of war moved to the Crimean Peninsula and northeastern Anatolia after the Russian Black Sea fleet destroyed Ottoman ships at Sinop. The British and French, fearing Russian force could overwhelm the Ottomans, disrupt the balance of power, and resolve the Eastern Question to their detriment, dispatched British and French fleets to the Black Sea in 1854 to fight on the Ottoman side against Russia (Map 10.3). The Crimean War continued until 1856 when Austria, now in occupation of the Danubian Principalities, issued an ultimatum to Russia to sue for peace. Stunningly, the dispute in Jerusalem and Bethlehem between the two Christian sects over keys to churches, the placing of a Catholic silver star on the Church of the Nativity (reportedly stolen by Orthodox priests), and control over pilgrims' access to the sites had led not only to Catholic priests and Orthodox monks beating each other with crosses and bibles in the Holy Land, but to this dramatic international incident as well.

The Treaty of Paris was signed in 1856, ending the Crimean War. The Black Sea was demilitarized by agreement of both Russian and Ottoman empires, and Russia renounced claims to areas around the Danube delta, Bessarabia, and northeastern Anatolia. A level of autonomy was granted to the Danubian Principalities falling under Ottoman authority. The Ottoman Empire was officially recognized as part of the Concert of Europe, its territorial integrity guaranteed by the Allied powers and foreign non-interference promised, in the same year the Ottomans had promulgated the *Hatt-ı Hümâyun*. European intervention in the Ottoman Empire continued, however, in the form of an increase in Christian missionary efforts: proselytizing, lobbying on behalf of non-Muslim communities, and the opening of missionary schools in various places in the empire resulting from the 1856 Edict. Promises would not be kept.

The Crimean War had intensified another modern problem for the Ottoman Empire: refugees (Map 10.4). Muslims (and Cossacks, and even Bulgarians who had been settled in

Map 10.4 Refugees Entering Ottoman Lands, c. 1850s–60s.

the Crimea) had already fled from the ravages of wars with Russia, becoming Ottoman refugees in the first half of the nineteenth century. But the Crimean War exacerbated the plight of many more. The first refugees in the 1850s were forced out of the Crimea, and were settled in the Balkans, around the Danube region. The Ottoman Refugee Code of 1857 stipulated that families and groups with only a minimum amount of capital received plots of state land, and exemptions from taxes and conscription obligations for six years if they settled in Rumelia, for twelve years if they settled in Anatolia. Refugees and immigrants were promised freedom to practice their faith and construct places of worship. They did have to agree to cultivate the land and not sell or leave it for twenty years to prevent speculation. In 1860 the Refugee Code became the Refugee Commission, administered under the Ottoman Ministry of Trade to deal with the Tatars, Circassians, and Turkic Muslims expelled from the Crimea and Russia – Abkhazians, Chechnyans, Dagestanis, etc. from the western Caucasus (mainly Sunni Muslim) fleeing from lands conquered by

the Russians north and west of the Black Sea, as well as thousands of non-Muslim immigrants from Hungary, Bohemia, and Poland. As they fled and retreated into Ottoman lands, about one-third were killed or died; those who survived were resettled in areas of Rumelia and Central Anatolia. The estimates are somewhere between 500,000 and 600,000 Tatars and about a million other Caucasian Muslims resettling in the Ottoman Empire between 1855 and 1864.

The post–Crimean War period, the 1860s, marks the second half of the *Tanzîmât* era in which the Ottoman Empire continued on its path of reforms and responses to crises. With the death of Sultan Abdülmecid I, his brother Sultan Abdülaziz I (r.1861–76), the first sultan to travel to Europe and Britain in 1867, presided over the introduction of more reforms by statesmen Ali and Fuad Pashas. In 1863 a maritime code was promulgated. The sultan had a particular interest in building up the Ottoman navy, at tremendous expense. New provincial regulations were enacted in 1864 to reorganize and develop the provinces across the empire as *vilayet*s with more clearly defined offices and hierarchy. This new arrangement would ultimately exaggerate sectarian tensions further in ethnoreligiously mixed areas of the empire. In 1867 the ban on Circassian slavery began to be enforced sporadically and into the 1870s slavery in general was reduced. By 1868 the former Supreme Council was split into the Council of State (*Şûrâ-yı Devlet*), with many new commissions to oversee legislative and administrative functions of the government, and the Council of Justice, which oversaw judicial affairs as dictated by the new law code in effect. Both councils included non-Muslim representation as a way to revise how the "antiquated" *millet* system functioned; members of these communities were divided in their enthusiasm for reforms, with the former heads of the *millet*s preferring the status quo that guaranteed their elite status, while others supported the ability to have more direct input concerning their affairs. In 1873 the first rail track was laid.

The Ottoman state had avoided borrowing internationally until the onset of the Crimean War. Their first foreign loan was taken out in 1854, during wartime. Further borrowing from this time onward to stabilize the Ottoman financial situation resulted in a vicious cycle of loans, wars, war debt, and more foreign borrowing, until by 1875, in combination with the exorbitant spending by the Ottoman sultan and administration, the Ottoman coffers were empty – bankruptcy was officially declared and the Ottomans could not pay their creditors. Ironically Sultan Abdülaziz I (r.1861–76) had been in a bit of a rivalry with *Khedive* Ismail in Egypt, whose extravagant lifestyle and spending on palaces also bankrupted Ottoman Egypt in 1875. Egypt had been wealthy through the 1850s–60s, but even selling the shares of the recently opened Suez Canal (1869) to the British and French, whose commercial and strategic interests in Egypt were heightened by the new waterway connecting Britain to its prized colonies of India, Australia, and New Zealand, did not stave off bankruptcy for the *khedive*. Ottoman bankruptcy would soon be another avenue for imperialist intervention into the Ottoman Empire for European powers.

The modernizing reforms of the *Tanzîmât* era introduced by senior Ottoman bureaucrats did not satisfy everyone who demanded change in the empire. In 1865 a group of young Ottoman intellectuals, most of whom had been educated in the secular institutions

intervention in the empire by European states and Russia illustrated the government's inability to protect its borders. Insistence on fiscal and judicial Capitulatory privileges continued; foreign governments or Christian missionaries continued to intervene on behalf of Ottoman minority communities when it suited their interests.

NOTES

1 *Le Constitutionnel* (July 2, 1830), quoted in Gillian Lee Weiss, *Captives and Corsairs: France and Slavery in the Early Modern Mediterranean* (Stanford: Stanford University Press, 2011), 109.
2 Christine M. Philliou, *Biography of an Empire: Governing Ottoman in an Age of Revolution* (Berkeley: University of California Press, 2011), 170, 172.
3 Halil İnalcık, trans., "The Imperial Rescript of Gülhane," in *Sources in the History of the Modern Middle East*, ed. Akram Fouad Khater (Boston: Houghton Mifflin Co., 2004), 12–14. Translated from the Ottoman Turkish source in *Takvim-i Vekayı* 187 (15 Ramazan, 1255 *hijiri*/1839 CE). Reproduced as facsimile in *Tanzîmât I* (Istanbul: Maarif Matbaasi, 1940), following p. 48.
4 See Ussama Makdisi, *The Culture of Sectarianism: Community, History, and Violence in Nineteenth-Century Ottoman Lebanon* (Berkley: University of California Press, 2000).

SELECTED READINGS

Ahmad, Feroz. "Ottoman Perceptions of the Capitulations 1800–1914." *Journal of Islamic Studies* 11, no. 1 (2000): 1–20.

Akarlı, Engin. *The Long Peace: Lebanon, 1861–1920*. Berkeley: University of California Press, 1993.

Aksan, Virginia H. "The Ottoman Military and State Transformation in a Globalizing World." *Comparative Studies of South Asia, Africa and the Middle East* 27, no. 2 (2007): 259–72.

Aksan, Virginia H. *Ottoman Wars, 1700–1870: An Empire Besieged*. London: Pearson Longman, 2007.

Anderson, Benedict. *Imagined Communities: Reflections on the Origin and Spread of Nationalism*. Revised edition. New York: Verso, 1991.

Arslan, Aytuğ, and Hasan Ali Polat. "Travel from Europe to Istanbul in the 19th Century and the Quarantine of Çanakkale." *Journal of Transport & Health* 4 (2017): 10–17.

Badem, Candan. *The Ottoman Crimean War, 1853–1856*. Leiden: E.J. Brill, 2010.

Brewer, David. *The Flame of Freedom: The Greek War of Independence, 1821–1833*. London: John Murray, 2001.

Burçak, Berrak. "Modernization, Science and Engineering in the Early Nineteenth Century Ottoman Empire." *Middle Eastern Studies* 44, no. 1 (2008): 69–83.

Chatty, Dawn. *Syria: The Making and Unmaking of a Refugee State*. New York: Oxford University Press, 2018.

Cole, Juan. *Napoleon's Egypt: Invading the Middle East*. New York: Palgrave Macmillan, 2008.

Davison, Roderic H. *Reform in the Ottoman Empire 1856–1876*. Princeton: Princeton University Press, 1963.

Eldem, Edhem. "Ottoman Financial Integration with Europe: Foreign Loans, the Ottoman Bank and the Ottoman Public Debt." *European Review* 13, no. 3 (2005): 431–45.

Fahmy, Khaled. *All the Pasha's Men: Mehmed Ali, His Army and the Making of Modern Egypt*. New York: The American University in Cairo Press, 1997.

Findley, Carter V. *Bureaucratic Reform in the Ottoman Empire: The Sublime Porte, 1789–1922*. Princeton: Princeton University Press, 1980.

Findley, Carter V. *Ottoman Civil Officialdom: A Social History*. Princeton: Princeton University Press, 1989.

Glenny, Misha. *The Balkans: Nationalism, War, and the Great Powers, 1804–2011*. New York: Penguin Books, 2012.

Gondicas, Dimitri, and Charles Issawi, eds. *Ottoman Greeks in the Age of Nationalism: Politics, Economy, and Society in the Nineteenth Century*. Princeton: Darwin Press, 1999.

Goodwin, Godfrey. *The Janissaries*. London: Saqi Books, 1997.

Hathaway, Jane. *The Arab Lands under Ottoman Rule 1516–1800*. London: Pearson Education, Ltd., 2008.

Hanioğlu, M. Şükrü. *A Brief History of the Late Ottoman Empire*. Princeton: Princeton University Press, 2010.

Al-Jabartī, ʿAbd al-Raḥmān. *Napoleon in Egypt: Al-Jabarti's Chronicle of the French Occupation*. With introduction by R.L. Tignor. Princeton: Wiener, 1993.

Kafadar, Cemal. "Janissaries and Other Riffraff of Ottoman Istanbul: Rebels without a Cause." In *Identity and Identity Formation in the Ottoman World*, edited by Baki Tezcan and Karl Barbir, 113–34. Madison: University of Wisconsin Press, 2007.

Karpat, Kemal. "Ottoman Views and Policies towards the Orthodox Christian Church." *Greek Orthodox Theological Review* 31 (1986), 131–55.

Kasaba, Reşat. "The Enlightenment, Greek Civilization and the Ottoman Empire: Reflections on Thomas Hope's Anastasius." *Journal of Historical Sociology* 16, no. 1 (2003): 1–21.

Kasaba, Reşat. *The Ottoman Empire and the World Economy: The Nineteenth Century*. New York: State University of New York Press, 1988.

Kırımlı, Hakan. "Emigrations from the Crimea to the Ottoman Empire during the Crimean War." *Middle Eastern Studies* 44, no. 5 (2008): 751–73.

Kırlı, Cengiz. "Coffeehouses: Public Opinion in the Nineteenth Century Ottoman Empire." In *Public Islam and the Common Good*, edited by Armando Salvatore and Dale F. Eickelman, 75–97. Leiden: E.J. Brill, 2004.

Kırlı, Cengiz. "Tyranny Illustrated: From Petition to Rebellion in Ottoman Vranje." *New Perspectives on Turkey* 53 (Fall 2015): 3–36.

Kreiser, Klaus. "Turban and Türban: 'Divider between Belief and Unbelief': A Political History of Modern Turkish Costume." *European Review* 13, no. 3 (2005): 447–58.

Makdisi, Ussama. *Artillery of Heaven: American Missionaries and the Failed Conversion of the Middle East*. Ithaca: Cornell University Press, 2008.

Makdisi, Ussama. *The Culture of Sectarianism: Community, History, and Violence in Nineteenth-Century Ottoman Lebanon*. University of California Press, 2000.

Mardin, Şerif. *The Genesis of Young Ottoman Thought: A Study in the Modernization of Turkish Political Ideas*. New edition. New York: Syracuse University Press, 2000.

Ochsenwald, William. "The American Revolution: A 19th Century Turkish View." *Middle East Journal* 30 (1976): 439–42.

Owen, Roger. *The Middle East in the World Economy 1800–1914*. New York: I.B. Tauris, 1993.

Philliou, Christine M. *Biography of an Empire: Governing Ottoman in an Age of Revolution*. Berkeley: University of California Press, 2011.

Quataert, Donald. "Janissaries, Artisans and the Question of Ottoman Decline." In *Workers, Peasants and Economic Change in the Ottoman Empire 1730–1914*, 197–203. Istanbul: The Isis Press, 1993.

Republic of France. *Declaration of the Rights of Man*. National Assembly of France (August 26, 1789). https://avalon.law.yale.edu/18th_century/rightsof.asp.

Al-Sayyid Marsot, Afaf Lutfi. *Egypt in the Reign of Muhammad Ali*. New York: Cambridge University Press, 1984.

Schull, Kent F. "Comparative Criminal Justice in the Era of Modernity: A Template for Inquiry and the Ottoman Empire as Case Study." *Turkish Studies* 15, no. 4 (2014): 621–37.

Schull, Kent F. *Prisons in the Late Ottoman Empire: Microcosms of Modernity*. Edinburgh University Press, 2014.

Somel, Selcuk Aksin. *The Modernization of Public Education in the Ottoman Empire 1838–1908: Islamization, Autocracy, and Discipline*. Leiden: E.J. Brill, 2001.

Tas, Latif. "The Myth of the Ottoman Millet System: Its Treatment of Kurds and a Discussion of Territorial and Non-Territorial Autonomy." *International Journal on Minority and Group Rights* 21 (2014): 497–526.

Toledano, Ehud R. *Slavery and Abolition in the Ottoman Middle East*. Seattle: University of Washington Press, 1998.

Toprak, Zafer. "Modernization and Commercialization in the Tanzîmât Period: 1838–1875." *New Perspectives on Turkey* 7 (1992): 57–70.

van den Boogert, Maurits H., and Kate Fleet, *The Ottoman Capitulations: Text and Context*. Rome: Istituto per l'Oriente C.A. Nallino, 2003.

Weiss, Gillian Lee. *Captives and Corsairs: France and Slavery in the Early Modern Mediterranean*. Stanford: Stanford University Press, 2011.

Yaycioğlu, Ali. *Partners of the Empire: The Crisis of the Ottoman Order in the Age of Revolutions*. Stanford: Stanford University Press, 2016.

Yeşil, Fatih. "Looking at the French Revolution through Ottoman Eyes: Ebubekir Ratib Efendi's Observations." *Bulletin of the School of Oriental and African Studies* 70, no. 2 (2007): 283–304.

Zürcher, Erik Jan. "The Ottoman Conscription System, 1844–1914." *International Review of Social History* 43 (1998): 437–49.

ELEVEN

AT EMPIRE'S END

In a historical moment in which problems or crises in a nation or empire were often expressed in anthropomorphic terms, Europeans as well as Ottoman elites were known to have expressed their view of maladies in the Ottoman body politic in this manner. The second half of the nineteenth-century Ottoman Empire was summed up in a phrase coined by Russian Tsar Nicholas I in 1853, when he described the Ottomans as the "Sick Man of Europe," and the epithet stuck (Figure 11.1). Ottoman Arab intellectual, teacher, and official Sâṭî ' al-Ḥuṣrî similarly used the metaphor of human ailment to describe the empire in a lecture he gave in Istanbul in 1913 about the progress of German and Japanese nations. He emphasized the importance for ethnoreligious communities in the empire to embrace a shared Ottoman-Islamic heritage to generate patriotism and achieve modernity, remarking that

> in the course of borrowing and imitating European civilization – we do not behave in earnest, with consistency ... we have ignored (the country's) prosperity and cultural refinement ... we behave like a sick person that frequently changes the doctor's treatment and the method of care, and does not adopt any medical regime and treatment unless a crisis happens or recurs.... We resemble not a person trying to walk and swim among the floods of civilization, (but) as (someone) stricken, meeting a fate of being dragged behind the current's whims while we want to stop motionless in these torrents.[1]

The Ottoman "body" of the late nineteenth and early twentieth centuries tried to cure itself with more reforms and a revolution, but the "doctors" – Ottoman statesmen – could not successfully treat the symptoms of the "sickness" – the traumas of Western imperialism and intervention, devastating wars and territorial losses, and an epidemic of nationalisms that erupted into divisiveness and sectarian bloodshed. Territorial losses and population fluctuations vary in the sources. But roughly speaking, the Ottoman Empire from Sultan Süleyman I's reign until the early nineteenth century spanned roughly 3 million square kilometers,

Le Petit Journal

Le Petit Journal — 5 CENTIMES — SUPPLÉMENT ILLUSTRÉ — 5 CENTIMES — ABONNEMENTS

Le Petit Journal agricole, 5 cent. ~ La Mode du Petit Journal, 10 cent.
Le Petit Journal illustré de la Jeunesse, 10 cent.

On s'abonne sans frais dans tous les bureaux de poste

Dix-neuvième Année — DIMANCHE 18 OCTOBRE 1908 — Numéro 935

LE REVEIL DE LA QUESTION D'ORIENT
La Bulgarie proclame son indépendance. — L'Autriche prend la Bosnie et l'Herzégovine

Figure 11.1 The "Sick Man of Europe" Being Dismembered.

and according to unreliable census records (1831), had a population somewhere between 25 and 30 million people. By 1914, the empire had been reduced to about 1.3 million square kilometers (roughly 42 per cent); the population decreased somewhat, to about 21 million (due to territorial losses in the densely populated, mainly non-Muslim Balkans, war casualties, disease, or emigration).[2] In 1830 the Muslim population made up about 75 per cent of the population; in 1914 Muslims were 81 per cent of the total.[3] The main concentrations of the population were around coastal areas, port cities, and river waterways.

As had happened so many times before, a new sultan ascended the Ottoman throne amid domestic and international crises. Sultan Abdülhamid II's accession late in the nineteenth century was no exception. When Sultan Abdülaziz I was deposed in 1876, his nephew, Murad V, the eldest son of Abdülmecid I, was placed on the throne by the cabinet elites who had conspired to carry out a coup. In 1875 a revolt in Herzegovina against excessive taxation had broken out which spread into Bosnia and became an intercommunal war when the Serbs tried to expand into Bosnia, forcing Austria and Russia to intervene. The mood in the empire at the time among the Ottoman population, both Muslim and non-Muslim, was frustration and anger — whether due to the changed relations between these two sectors of Ottoman society, the vulnerability of the empire due to its financial indebtedness, or to the ability of European powers to encroach upon Ottoman territory militarily and politically, dictating terms to the empire concerning non-Muslim rights. Anticipating the promulgation of an Ottoman constitution, the co-conspirators expected Murad V to assist in achieving their goal. But he only lasted three months in office before it was determined that he was unfit to rule. Who they thought was another pliable sultan was enthroned in his place: Murad V's younger brother, Abdülhamid II (r. 1876–1909). He disappointed constitutional reformers with his astute ability to put in place centralizing measures through autocratic means and ultimately resist true political reform of the Ottoman system. He outlasted many of them, reigning for over thirty years using propaganda, a network of informants and spies, and the power of exile (and sometimes execution) over political activists and dissidents. He survived domestically inspired deposition and assassination attempts until he was finally deposed in 1909. He was known as the "Red Sultan" for his responsibility in the violent intercommunal episodes that took place during his reign, earning European condemnation as the

epitome of the "terrible Turk." But he was not opposed to reform – technical modernization, expansion of the education system, particularly primary schools for girls as well as boys, were some of his progressive achievements. Ottoman flexibility to adjust to new circumstances endured where science and technological modernization were concerned, but became constrained politically as the European imperial noose tightened around the Ottoman neck, and ethnoreligious divisions pulled at the empire's social fabric.

CHANGES IN OTTOMAN LIFESTYLE

The Ottomans had never been immune to the influences of other cultures and civilizations: the success and longevity of the empire was surely due in large part to the dynamism generated through the early synthesis of Turco-Mongol, Arabo-Persianate-Islamic, and Byzantine traditions. As early as the fifteenth and sixteenth centuries, Chinese porcelains and Japanese lacquerware had made their way into the Ottoman Empire. Ottoman miniature paintings by court-patronized artists that accompanied manuscripts in the sixteenth century were a synthesis of Sino-Mongol and Persian influences with Turkish artistry. Proximity to and sustained contact with Europe in the latter centuries of the empire, and particularly in the late nineteenth century, created a conduit to the Ottoman dynasty and palace, and to Ottoman urban elites, for the importation of everything from scientific discoveries and intellectual currents, to fashions, architectural styles, and musical tastes.

Much of this importation from Europe centered around the idea of social and technical modernization as symbolic of a society's progress, and so was often embraced more enthusiastically by those sectors of the Ottoman population whose outlooks were influenced by Western science, or who were educated in Europe or in the many new Ottoman government schools founded during the *Tanzîmât*, which cultivated a modern bureaucratic elite. It became important among Ottoman ruling circles to be seen by the West as "civilized." This trend became particularly obvious during the Young Turk era of the late Ottoman period (*c.*1908–18), when many individuals in this movement adhered to anti-religious, secular, Social Darwinist and Positivist ideologies as the way for the empire to modernize its state and society in order to survive in the modern world. But new technologies had already been introduced to the empire earlier in the nineteenth century that made life more comfortable for city dwellers, or more efficient – and which enabled the state to gain more centralization – such as clocks, railways, steamships, and telegraphs. Construction of the funicular rail line in Constantinople (known today as *Tünel*) connecting Pera (Beyoğlu) at the top of the hill and Galata (Karaköy) down at the waterfront of the Golden Horn began in 1871 and was opened in 1875. A handful of newspapers and journals founded mainly by private individuals were published in Ottoman cities. Books were translated, novels were written, despite generally very low literacy rates among the general population in the empire. Elites, both men and women who actually possessed and enjoyed the new phenomenon of leisure time, spent their time picnicking in parks, or attending plays

Figure 11.2 Constantinople c.1890s. View from Eminönü side of the bridge in the Old City toward the neighborhoods of Karaköy and Beyoğlu.

performed in reading salons or in newly constructed theaters. Cultural fads included the use of Western-style furniture and European glassware. Life in Constantinople resembled other European cities: the coexistence of modern features with traces of the traditional, the benefits of technology, and the drawbacks of congestion (Figure 11.2).

PRECURSORS TO SECTARIAN VIOLENCE AND MASS MIGRATIONS

As had been the pattern in previous reform eras, new policies went hand in hand with crises destabilizing the empire. The 1870s were no different: continued environmental disasters in Anatolia, including floods, droughts, disease, and famine, occurred at the same time

that uprisings flared in the Balkans. As the Herzegovinan and Bosnian unrest continued, in April of 1876, shortly after the accession of Sultan Abdülhamid II, a popular rebellion erupted in Bulgaria, on the heels of a Bulgarian national awakening that had included the establishment of a revolutionary committee in 1869 and official recognition by the previous sultan in 1870 of a Bulgarian Orthodox Church, independent from its former Orthodox Christian Patriarchate. Despite the Ottoman authorities having been informed of the rebellion ahead of time, many Muslim civilians were massacred at the outset. The Ottoman state response was severe: regular troops and Circassian Muslim irregulars called "*başıbozuks*" ("broken-headed" or fanatic), most of whom were refugees who had been settled in the Ottoman Balkans after expulsion by Russia in the 1860s, put down the uprising brutally. Shortly after the April uprising in Bulgaria started, in early May the Razlovtsi Insurrection among a small group of Bulgarians in Ottoman Macedonia also broke out and was suppressed. Estimates vary on the number of non-Muslims killed in these events, with sources claiming anywhere between 3,000 to 30,000 casualties, though French and British sources reported around 12,000–15,000 Bulgarians killed. In late June of 1876, Montenegro and Serbia declared war on the Ottoman Empire.

The Bulgarian atrocities, as they came to be known in Europe, captured international attention, and inflamed the Christian West despite dramatic loss of life among Ottoman Muslims in the Balkans and a general lack of sympathy for the suffering of Muslim refugees that had been forced out of the Russian Empire after the Crimean War. Apparently much of the news of the Bulgarian massacres reached European embassies in Constantinople by June of 1876 through Bulgarian students at Robert College (the American college founded in 1863 by Christopher Robert, a wealthy American philanthropist, and Cyrus Hamlin, a missionary devoted to education). Faculty members there wrote to the British Ambassador and to Istanbul correspondents at *The Times* and the *Daily News*. Former British Prime Minister William Gladstone, hoping for a comeback after his 1874 election defeat, used these violent incidents to stir up British public opinion in his favor by publishing a pamphlet in September of 1876 entitled *The Bulgarian Horrors and the Question of the East*, based upon British eyewitness accounts. His racist sensationalism, an excerpt of which is below, found a captive audience:

> Let me endeavour very briefly to sketch, in the rudest outline, what the Turkish race was and what it is. It is not a question of Mahometanism simply, but of Mahometanism compounded with the peculiar character of a race. They are not the mild Mahometans of India, nor the chivalrous Saladins of Syria, nor the cultured Moors of Spain. They were upon the whole, from the black day when they first entered Europe, the one great anti-human specimen of humanity. Wherever they went a broad line of blood marked the track behind them; and as far as their dominion reached, civilisation disappeared from view.[4]

European pressure on the Ottoman Empire intensified. Russia mobilized amid the violence (the Serbian–Ottoman and Montenegrin–Ottoman Wars were ongoing to 1878), declaring

war in April 1877. It was a Russo-Ottoman War on both sides of the Black Sea – a Russian invasion of the Danube region in June 1877, and conflict east, in the Caucasus, lasting until early 1878. Russia occupied Plovdiv, Bulgaria, and temporarily seized Ottoman Edirne, the symbolic second capital, in January 1878. This sufficiently startled Britain into posturing to defend the Ottoman Empire militarily, and Russia agreed to seek an armistice with the Ottomans. Britain surrendered its contempt for what it considered past Ottoman barbarity, replacing it with a strategic interest in balancing the Eastern Question against Russia; the British papers published caricatures such as an "allegorical war map" entitled *The Avenger*, demonizing the Russian tsar as the aggressor in the Russo-Turkish War of 1877–8.

THE OTTOMAN CONSTITUTION AND PARLIAMENT

For Ottoman bureaucrat modernizers possessed of the spirit of the *Tanzîmât* such as the experienced Midhat Pasha (b.1822–d.1883/4?), who had implemented successful provincial reforms while governor of the newly established Danube Province from 1864 until 1868, followed by a governorship in Baghdad for five years, the moment was ripe for instituting the most ambitious reform initiative. The new sultan was consumed with the Balkan crises, and the empire was susceptible to British insistence on reform. The sultan announced there would be an Ottoman constitution and parliament; Midhat Pasha headed a commission comprised of civil officials, *ulema*, and military officers charged with drafting the constitution, and he was appointed *grand vezir* just before its promulgation on December 23, 1876. It was a constitution of compromise that guaranteed monarchical authority to the Ottoman dynasty, with the sultan also recognized as caliph. Islam was declared the empire's official religion and Turkish the official language, although freedom of worship was to be protected across the empire. Among the many provisions delineated here, modernized taxation and equality for all before the law were reiterated, and significantly, the constitution provided for a partially elected bicameral legislature. The president and the members of the Senate were to be appointed by the sultan for life while the Chamber of Deputies would be elected every four years. Ottoman Parliament's first session occurred in March 1877 amid much international press coverage; subsequent Ottoman parliamentary sessions were covered for example by British papers (Figure 11.3). This was the first constitution in the Muslim world to establish a parliamentary assembly.

This constitution was modeled mainly on the Belgian constitution of 1831, with French and Prussian constitutions also consulted during its preparation, though adjusted for the Ottoman Empire. There were articles that allowed the sultan, as a constitutional monarch, to exercise certain executive powers to limit legislative, parliamentary authority and would prove detrimental very soon after the promulgation of the Ottoman constitution in 1876: one article guaranteed the sultan the right to exile anyone considered (in rather open-ended terms) "dangerous" to the Ottoman government, another to appoint and dismiss ministers, and another to prorogue the Chamber of Deputies and call for new elections. The "father of the Ottoman constitution" himself, Midhat Pasha, would experience these executive powers

firsthand, when weeks after the constitution's promulgation he was exiled to Italy (Brindisi). As the San Stefano preliminary treaty negotiations were about to take place ending the war with Russia, Sultan Abdülhamid II suspended the constitution and the parliament, in February of 1878. The first constitutional experiment in the Ottoman Empire was over, less than two years after its introduction – the Ottoman constitution and parliamentary assembly would not be reinstated for thirty years. This modern moment of Ottoman political flexibility to confront and adapt to current exigencies was halted, its trailblazers stymied.

A SITTING OF THE NEW TURKISH PARLIAMENT AT CONSTANTINOPLE.

Figure 11.3 Ottoman Parliament, Depicted in *The Graphic* (April 7, 1877).

Midhat Pasha returned to the Ottoman Empire and became governor of Syria in November of 1878, where he continued his reform efforts in that province until, frustrated by the lack of progress he desired, he tried to resign several times. He was officially dismissed from that office and transferred to Aydın in 1880. The sultan's paranoid distrust of this experienced reformer ultimately resulted in having Midhat Pasha arrested in 1881, put on trial for the murder of Sultan Abdülaziz (it had previously been declared a suicide), convicted, exiled to the Arabian Peninsula, and there executed in 1884 by order of the sultan. This was the first of the sultan's many measures intended to maintain a firm hold on power and keep political reform at bay. Autocracy would define his lengthy reign. Would other Ottoman reformers be able to pick up the torch and regenerate the Ottoman spirit of flexible governance?

The question of why Western powers demanded constitutional reform of the Ottoman Empire speaks to larger questions beyond merely the belief in promoting liberal democracy worldwide – true liberal democracy being an exaggeration of the realities of this particular century in any case. European concern for protection of rights for the empire's non-Muslim communities has already been pointed out. Even more importantly, from an imperialist, Orientalist, global economic and political perspective, Western powers now had a considerable stake in the Ottoman economy. The ability to facilitate trade and investment, and a political structure that could guarantee Ottoman stability, that could protect private property and allow for capitalism to thrive in the empire, would benefit all interested parties. In this regard the rule of law, of constitutionalism, was the measure of "civility" in the nineteenth-century world. A polity that could assure European powers of its government's ability to carry out this significant duty – the protection of private property – would be respected as such and considered a state in the international order. To not have the ability to do so would be considered "uncivilized." It would in fact be a pretext for interference in domestic politics and the demand for extraterritoriality: i.e., to intervene on Ottoman subjects' behalf. The notion of "white man's burden" came into play here, as the Western attitude was basically that of "governing those who could not govern themselves." It went

hand in hand with theories of racial hierarchy that were prevalent at the time, such as those espoused by the French sociologist Gustave Le Bon, in which humans were ranked in a system of "superior" races (i.e., Indo-Europeans meaning Caucasians or Aryans), "average" races (e.g., Turks, Japanese), and "primitive" races (e.g., Africans). This Western attitude was also connected to the theory of Social Darwinism elucidated by British social philosopher Herbert Spencer, whose famous phrase "survival of the fittest" he applied to human societies, as a way to understand the political consequences of the hypothesis of evolutionary differentiation of species first developed by Charles Darwin. For Europeans, the Ottomans simply had not evolved to the same level of civilization. Thus in an era of colonial expansion, either Western intervention to deliver constitutional reform was necessary, or the "uncivilized" were to be colonized. France had already seized Algiers by 1830; the British had taken control of the Gulf and the port of Aden in Yemen by 1839. There would be more imperialist seizures of Ottoman territory in the near future.

SAN STEFANO, THE TREATY OF BERLIN: BALKANS LOST, REFUGEES GAINED

The agreement resulting from the San Stefano negotiations signed in March of 1878 had destructive consequences for the Ottomans and was renegotiated slightly in the subsequent Treaty of Berlin later in 1878 (Map 11.1). From the former, the Ottoman Empire lost its Balkan lands – most of its non-Muslim populations. Initially Bulgaria would be autonomously governed, but, though limited, Macedonia was included in its territory. Bosnia and Herzegovina also were to become autonomous. Romania, which had been established in 1861 from the principalities of Wallachia and Moldavia, was to receive more territory and become independent. Serbia and Montenegro were also to become independent (the Serbian Orthodox Church had become independent of the Orthodox Patriarchate in 1879). In the East, Russian-occupied areas of eastern Anatolia and the northwest Caucasus were to fall under Russia's control. For Armenian revolutionaries swayed by the wave of nationalism sweeping the empire, this area claimed by Russia was seen as part of the future site of an Armenian nation-state, and certain to affect Ottoman-Armenian actions and fortunes in the coming decades. The Treaty of Berlin in 1878 reiterated most of the same arrangements, but Austria-Hungary was granted control over Bosnia and Herzegovina instead, causing the officially Catholic empire to have a mixed Slavic population of Catholics (Croatians), Orthodox (Serbs), and Muslims (Bosniaks). The ethnoreligious, nationalist tensions in these newly acquired territories, both of which Austria-Hungary would officially annex in 1908, would have catastrophic repercussions for Austria-Hungary (and the world) in the twentieth century. Russia's gains in the East at San Stefano would be reversed by the Treaty of Berlin; they would not retain eastern Anatolia, but they did wrest southern Bessarabia from the Ottomans, as well as a hefty war indemnity. The Ottomans granted Cyprus to Britain in 1878 in exchange for an annual payment and the promise of military assistance if needed.

Map on image labels:

AUSTRIA-HUNGARY

occupied, 1878
annexed, 1908

BOSNIA

SERBIA

ROMANIA

1878

1878

BULGARIA

1878

E. RUMELIA

autonomous, 1878
to Bulgaria, 1908

1878

Austrian
occupation
1878 - 1909

1878

ITALY

RUSSIAN
EMPIRE

CASPIAN SEA

BLACK
SEA

1878

OTTOMAN
EMPIRE

1881

1912

autonomous, 1898
to Greece, 1908

CRETE

RHODES

CYPRUS

occupied by Britain, 1878
annexed, 1914

IRAN

MEDITERRANEAN SEA

to Italy, 1912

1912

LIBYA

EGYPT

occupied by British, 1882
made British Protectorate, 1914

Ottoman Territorial Losses
between 1878 and the Beginning
of the Balkan Wars in 1912

m. 50 100 200 300 400

k. 100 200 300 400 500 600

The Russo-Ottoman War in 1877–8 and post-war settlement by 1878 with the Treaty of Berlin triggered another dramatic consequence for the Ottoman Empire: again, the forced migration of Circassians, Abkhazi, Abaza, Chechnyans, and other Caucasian groups escaping Russian expansion and carnage there, as well as thousands of Muslims from the Balkans who were forced to flee the sectarian violence and the newly nationalist, non-Muslim nation-states slowly taking shape in eastern Europe. Between 1876 and 1896 more than one million refugees poured into Constantinople from the Balkans, southern Russia, and the Caucasus as borders were redesigned, including or excluding Muslims and non-Muslims. The city was overwhelmed with homeless, destitute Muslim newcomers (Figure 11.4). Muslim refugees from these borderland regions were resettled in Anatolia and the Ottoman provinces of Greater Syria (Map 11.2). The Commission on Immigration oversaw the management of any international aid for refugees (mainly missionary in nature at this time) to the Ottoman Empire. The influx of Muslim refugees and the loss of much

Map 11.1 Ottoman Losses,
1878–1912.

Figure 11.4 Muslim Refugees in the Aya Sofya Mosque after 1877–8 War.

of the Ottoman non-Muslim population that inhabited the Balkans generated a dramatic demographic shift in the empire. It would not be the end of ethnoreligious strife involving Muslims and non-Muslims, but starting in the late nineteenth century, violence played out also in Anatolia, particularly in the East.

SULTAN ABDÜLHAMID II, AUTOCRAT MODERNIZER

Sultan Abdülhamid II's (Figure 11.5) lengthy reign could be described as one of absolutism at home and pan-Islamic solidarity abroad. Assuming the title of "Caliph of all Muslims," he wielded it like a weapon at foreign powers in occupation of Muslim populations, particularly after 1881 when France assumed control over Tunisia as a protectorate, and when Britain landed occupying forces in Egypt in 1882. Ostensibly for a short term the British occupation was to restore order after an Egyptian nationalist uprising starting in 1879 led by a military officer, Ahmed 'Urabi, attempted to oust the *khedive*s from power and failed. The Ottoman sultan dispatched an agent to some African leaders to foster support for his status as caliph, and sent members of the religious *ulema* class to various areas in Asia to promote the Islamic faith and his role as the international Muslim community's spiritual head. In late 1889, after the Japanese emperor had earlier sent gifts in friendship to the Ottoman sultan in an effort to encourage diplomatic relations between the two "citadels" on each side of Russia, he reciprocated the favor by dispatching a frigate named *Ertuğrul* to

Post 1877–8 Russo-Ottoman War
and Treaty of Berlin

▨	Ottoman Empire in 1800
- - - - -	Modern Borders

Another forced migration of Circassians, Abkhazi, Abaza,
Chechnyans, & other Caucasian groups forced to move to
Anatolia & Ottoman provinces of Greater Syria.

0 250 500
miles

Map 11.2 Flow of Muslim Refugees after 1877–8 War.

Japan to deliver gifts and offers of friendship to the Japanese. The ship was plagued with logistical problems from the start and ultimately sunk in a typhoon off the Japanese coast when it departed for home in late 1890. But the frigate managed to stop at many Muslim ports of call along the Asian coastline during its eleven-month journey to Japan – including port cities in British-controlled India, in the Dutch East Indies, etc. The local newspapers there reported on the immense pan-Islamic enthusiasm for the ship's arrival among the Muslim populations, and on the sense of concern foreign occupying governments had for this show of solidarity with the Ottoman Empire being expressed in their colonies. Russian Muslims such as the Tatar Muslim political activist, journalist, and traveler from Russia Abdürreşid İbrahim frequently expressed his support for the sultan as caliph of Muslims in his many publications, most of which were shut down by the Russian authorities. He and other Turkic Muslim exiles from the Russian Empire found refuge in the Ottoman Empire as an alternative to living under the autocracy of the tsar.

Figure 11.5 Sultan Abdülhamid II (r. 1876–1909).

As Abdülhamid II promoted his role as sultan-caliph publicly, he increasingly withdrew to his more contemporary Yıldız Palace, built in the nineteenth century, and only ventured out on certain occasions. After a few assassination and coup attempts early on in his reign, the sultan came to view all liberal ideas and movements as subversive to his rule and threatening to the very existence of the Ottoman Empire. They had to be suppressed, through the use of informants and spies to expose his enemies, through rigorous censorship of the press, including a ban on any perceived political criticism and on specific words which he ordered to be redacted, and through the means of arrests, exile, or even execution of political activists and dissidents.

In the nineteenth century and after, the coffeehouse was a place to buy a cup and gain access to the many newspapers made available by the cafés that purchased subscriptions to them. It mattered not if one was illiterate, for the exciting news of the empire and the world was often read aloud in the café to those not literate, sometimes in dramatic fashion, such as reports of the *Ertuğrul* shipwreck, or when descriptions of Japan's sinking of the tsar's Russian fleet at Tsushima in 1905 during the Russo-Japanese War roused the pan-Asian sentiments of a captive Ottoman audience. By this time the coffeehouse was also a site of surveillance by a paranoid Sultan Abdülhamid II. Worried of its potential as a meeting place for political scheming and revolution, there were informants frequenting coffeehouses to listen in on conversations not just to measure public opinion, but now to root out political threats to his regime.

The sultan's increasing reliance upon Islamism as the primary form of identity for the Ottoman Empire encouraged a societal response in which religion came to be a bulwark against modernization because of its perceived association with westernization and European imperialism. Nonetheless, reform and modernization of institutions and infrastructure did continue. Education at the primary level was exponentially expanded, with the founding of more new schools and provisions for training teachers. Railroads and telegraph lines reached further into the corners of the empire, making for improved transportation and communications, whether to move goods, people, military forces, or information across the Ottoman realm. The palace published its own mouthpiece, a newspaper called *Malûmât*, to disseminate officially sanctioned information. Legal judiciary reform efforts included an attempt to partially limit the Capitulations that had become so damaging to Ottoman sovereignty.

Between 1881 and 1893 an extensive Ottoman census was conducted in which the number of persons in a household (including women) were counted. The pre-1877 war population was estimated at around 29 million, whereas the census, taking into account the loss of populations in the Balkans and north Africa (other Arab provinces were not included in the census) resulted in a tabulation of somewhere between 17.4 and 20.4 million. Although this census still left much to be desired in terms of accurate population statistics,

it was a major effort to take an accounting of the empire's peoples; the use of identity papers (called *nüfus tezkeresi* or *cüzdanı*) by citizens was required by the government to carry out various tasks needing record-keeping. By 1884 the Ottomans also recognized the importance of preserving their heritage as part of becoming a modern polity: the Ottoman state declared itself the owner of all antiquities. The Ottoman Antiquities Law stated that all artifacts found in legal excavations within Ottoman lands now belonged to the Imperial Museum and could not be removed to another country.

Despite the institutional modernization that continued during this era, the empire was not without persistent problems. In 1881, an armed uprising broke out and was put down in Albania. Financially, with the declaration of Ottoman bankruptcy in 1875, European powers forced a resolution that required the establishment of the Ottoman Debt Commission in 1881. This public debt administration was staffed by European and Ottoman personnel; those foreign countries owed collected their Ottoman debts via several means, including imposing excessive interest rates that held the Ottomans in perpetual financial ruin, or being granted certain industry monopolies – salt, tobacco, silk, etc. – which both helped and hurt the local Ottoman economy. Not only was the empire fiscally besieged from the outside, but ideologically, one could argue, the Ottomans were trapped between the external forces of progressive political ideas on the one hand, and detrimental realpolitik on the other. Ottoman parliamentary democracy was being undermined from outside: Austria-Hungary and Russia, the imperialist monarchies, still possessed international might and pressed at Ottoman borders; France and Britain, the "liberal democracies," did not always assist or defend the Ottomans, they supported ethnoreligious minorities in the empire, and/or seized Ottoman territories for themselves.

In this Concert of Europe, Germany now seemed the least provocative foreign power and the best ally against the Ottoman Empire's possible dismemberment. And Germany was happy to oblige, as a more restrained newcomer to colonial and imperial actions in the region who looked to the Ottomans as a possible counterweight to Russian and Austro-Hungarian ambitions. There had already been relations between Prussia and the Ottoman Empire in the 1830s when Sultan Mahmud II received military officer Helmuth von Moltke to advise and assist in reforming the Ottoman military. But it was after the Congress of Berlin in 1878 that Imperial Germany took a deeper interest in Ottoman fortunes. By 1882, several German officers had been sent to the empire to assist in military reform, and in 1883 Colmar Von der Goltz began teaching at the Ottoman military academy. Military, banking, and trade relations between Germany and the Ottoman Empire deepened. Railway construction was dominated by German companies, as was much of the infrastructure development in the empire. Kaiser Wilhelm II visited Istanbul for the first time in 1889, and again in 1898, amid much pomp and circumstance. A fountain given by him to the sultan in the Sultanahmet district of the capital commemorates Kaiser Wilhelm II's appearance and proclamation to be a friend of the world's 300 million Muslims. The kaiser made a third visit in 1917 (during World War I). The relationship between Ottoman and German empires had been secured – and reached dramatic heights in the twentieth century.

Ottoman domestic troubles would continue in the 1890s, and the state responses to these challenges were severe and often violent. In what was left of the Ottoman Balkans,

the "Macedonian Question" centered around conflicting claims to the area comprised of the Ottoman provinces of Kosovo, Salonika, and Manastir by Bulgarian, Greek, and Serbian separatists. Ethnoreligious violence among these groups as well as with Ottoman state-backed Muslims spiraled into what was a Macedonian civil conflict in the 1890s requiring Russian and Austrian intervention that did not quell the unrest. Macedonia would in fact be the site of the future Ottoman Revolution to reinstate the constitution in 1908. Agitation on the island of Crete by nationalists there led to the Ottoman-Greek War of 1897 when Greece attempted to annex it forcibly by sending an army there and into Macedonia. With German support, the Ottoman army suppressed the revolt and defeated invading forces. But Crete became autonomous in 1898, and officially became a part of Greece in 1908.

In the East, ethnic strife was occurring in six provinces populated by semi-nomadic Kurdish tribes and an Armenian landed peasantry with ties to Russian Armenians. Eastern Anatolia was the historical location of the Armenian Kingdom and later Armenian principalities that had endured waves of imperial invasions since ancient times, whether Persians, Romans, Byzantines, or Seljuk Turks, with the continuous existence of an Armenian population inhabiting cities and engaged in farming and trades. During the *Tanzîmât* era the Armenian *millet*, whose patriarch in Constantinople had been their communal head, formulated a reform of their political structure to allow for broader participation in Armenian affairs. This was not a "constitution" per se in 1860, and was revised in 1863 as a government-sanctioned regulation providing for a central assembly to administer affairs of the Armenian *millet*. This "national assembly" more closely linked the influential Armenian community of Constantinople with the Armenian peasantry in Anatolia. The current hostilities in the East had been fueled by several factors: first, the influx of Circassian Muslim refugees who had been expelled from the Russian Empire and settled in Anatolia had disrupted the region. Second, the Armenian population of the Russian Empire, and by extension a segment of the Ottoman Armenian community, had been deeply influenced by the ideas of nationalism and socialism now on the ascent in the nineteenth century. Two revolutionary Armenian organizations were founded – the *Hnchak*s in 1887 and the *Dashnak*s in 1890, both of whom were attracted to the idea of separate nationhood and were willing to embrace armed resistance against the Ottoman state as a means to an end. Witnessing the results of sectarian violence in the Balkans, which provoked Western intervention on non-Muslims' behalf, they hoped to achieve the same outcome through attacks on Muslims in eastern Anatolia.

The 1878 Treaty of Berlin made it apparent that Western powers were interested in the fate of the Armenians. Sultan Abdülhamid II tightened his control over the Armenian community and its institutions through various means, administrative, discriminatory, and repressive. He turned to his auxiliary gendarmes – armed *Hamidiye*, irregular cavalry units created in 1890 from local Sunni Kurdish tribes – to patrol the provincial areas and suppress the unrest that had erupted in 1892 between revolutionary Armenians and Muslims in eastern Anatolia (Figure 11.6). Kurdish tribes possessed a history of resistance to Ottoman central authority as well as friendly relations peppered by occasional tensions with the settled Armenians. The creation of this *Hamidiye* militia was (unsuccessfully) intended to also pull the independent-minded Kurds into the Ottoman fold. When sectarian violence

Figure 11.6 Kurdish *Hamidiye* Unit.

exploded between Armenians and Muslims in 1893, the rather non-national, lawless mercenary nature with which some Cossack-like *Hamidiye* units operated, however, soon turned into horrific massacres of Armenians between 1894 and 1896. Named the Hamidian massacres for the complicity of the sultan, scenes of violence broke out between Armenians and Turkish authorities in Erzurum and Yozgat over suspected arms caches in churches, while in Sasun the conflict over taxes led Armenians to rebel against Kurdish tribesmen and Ottoman authorities. There Armenians were slaughtered. Attempts by British officials to enact reforms to protect the Ottoman Armenians came to naught. Violence spilled over into vigilante Muslim mobs attacking Armenians in the Ottoman capital in 1895, as well as across many other cities of eastern Anatolia. The killing continued to spread in the East in 1896; late that summer, a band of revolutionary *Dashnak*s stormed the Ottoman Bank in Istanbul in the name of the "Armenian nation," threatening to blow it up unless their demands were met for the massacres to stop, prisoners to be released, and reforms to be enacted. They were eventually evacuated to France, but not before the mobs in Constantinople continued to massacre Armenian civilians while Ottoman authorities looked on.

Though European officials and civilians were appalled at the violence many personally witnessed, perpetrated by the "terrible Turk" against the Armenians, and though foreign ambassadors put forth a lengthy reform plan, before long the massacres were forgotten, subordinated to the greater imperial concerns of Western governments for preserving the Ottoman Empire. Control over the fate of orphans from these events became a competition between the surviving Armenian community, Ottoman state orphanages, and Christian missionary institutions. Actual concern for the orphans' lives was debatable, based upon mortality records. Some Westerners blamed the Armenians, accusing them of provoking the Ottoman state and masses, thus deserving their fate. Estimates of Armenians killed are somewhere between 80,000 and 300,000. But the Armenian Question would go unanswered in the 1890s, setting the stage for more bloodshed in the next century. The Ottoman government's propensity for flexible responses amid such acute challenges as rising sectarian strife had rapidly dwindled by the late nineteenth century.

THE YOUNG TURK MOVEMENT, NATIONALISM, AND REVOLUTION

The political opposition which fomented against Sultan Abdülhamid II and his absolutist rule in the latter decades of the nineteenth century and into the twentieth needs to be seen within the context of not only his internal centralization policies, but also from the effects of Muslim migration out of the Russian Empire, the development of nationalist ideologies among both non-Muslims and Muslims, and the dire sense of an impending dissolution of the Ottoman Empire if Western intentions were not seriously resisted. The narrative of the Young Turk movement involves all of these factors. But at the outset, it must be understood that the term "Young Turks" was a phrase coined by European powers – "*jeune Turquie*" – to describe a broad political opposition movement against the sultan that was in favor of the reinstatement of the Ottoman constitution and the restoration of an Ottoman parliament. The movement was comprised of a diverse segment of the Ottoman population. The Young Turks were not merely Muslim Turks – they were Muslim and non-Muslim, they were Turks, Arabs, Greeks, Albanians, Circassians, Armenians, Kurds, and others who were influenced by Young Ottoman thought, but were typically more secular in their outlooks than their Young Ottoman precursors. They were products of the modern school system and the military who emerged as a new, educated middle-class intelligentsia, heavily influenced by the modernization taking place in Europe and in Meiji Japan.

Nationalism among the Muslims of the empire, and indeed among the Turkish segment of the population, manifested quite late in the Ottoman Empire. For Muslims, their allegiance was to the sultan as a Muslim sovereign and caliph in the late nineteenth century, as well as to the Ottoman Empire itself. Loyalty to this most long-lived and powerful of Muslim polities, a "community of believers" in its most basic sense, went relatively unquestioned until the issue was forced by the turn of the twentieth century. With the advent of secular political thought among the Young Turks, identity for many Muslims (as well as non-Muslims) in the empire came to be more complicated to define. An individual could have multiple, layered identities – as Ottoman, as Muslim, as Turk, Arab, Albanian, or Kurd for example. However, by the latter half of the nineteenth century, the ethnoreligious affiliation of a person with a particular community began to be constructed with more emphasis upon one's ethnicity, as modern definitions of nationalism relied more strongly on race as a primary determinant. This tendency manifested first among non-Muslims – initially among Christians in the Balkans. Armenian revolutionaries followed suit, though non-Muslims with close linkages to the Ottoman state (such as Feneriot Greeks or Armenian elites of Istanbul), felt a simultaneous attachment to both their Ottoman as well as their ethnoreligious identities, as Ottoman Greeks or as Ottoman Armenians. Generally speaking, Ottoman Christian communities, with the exception of most Christian Arabs (until the twentieth century), had developed political aspirations of independent nationhood, and did not embrace the idea of an Ottoman federation.

In the case of Ottoman Turks in the Young Turk movement, their narrative of nationalist consciousness must begin with an acknowledgment of the impact of Turkic Muslim

exiles from Russia and the pan-Turkist ideologies they brought with them when they found refuge in the Ottoman capital. In the mid-nineteenth century, a pan-Slavic movement arose in Russia after the Prague conference of 1848 with Russia's state-sponsored attempts to Russify its Muslim population. A rival "pan-Turanist" movement emerged among some Turkic Muslims – *Turan* being the Persian word for "Turkistan." Pan-Turanism of the mid-late nineteenth century was the belief in the racial-linguistic unity and future greatness of Ural-Altaic peoples (including Hungarian Magyars, Estonians, Finns, Turks, Tatars, Mongols, Manchus, and Tungus) stretching from Hungary, across Ottoman lands, to Central Asia and Siberia. The renowned Hungarian Orientalist and linguist Árminius Vámbéry, an advisor to the British Foreign Office, can be given much credit for promoting this idea of pan-Turanism in the late nineteenth century. But the actions on the ground – Russia's Christianization and Russification policies – stimulated the rise of a slightly more limited ideology of "pan-Turkism" formulated by Crimean Tatar and Turkic Muslim elites in Russia. For them, the unification of the race of Turkic peoples was based upon physical traits and culture, a shared common language, and connecting to the Ottoman *Turkish* Empire with its symbolic, spiritual authority. They expounded upon these proto-nationalist ideas of pan-Turkism by publishing newspapers, books, and treatises. The Crimean Tatar İsmail Gaspıralı (b.1851–d.1914) was among the first to explicate pan-Turkism in his Bahçesaray paper *Tercüman*. The founding of a secular school there (as part of his involvement in the "*usul-u cedid*" – "new method" education movement) was to teach a reformed curriculum that included a modernized Turkic language. Other Turkic Muslim intellectuals also traveled, migrated, or were exiled from the Russian Empire to Europe or to the Ottoman Empire where they continued to promote pan-Turkist ideas. Individuals such as the Caucasus Tatar Ali Hüseyinzade (b.1864–d.1941), Volga Tatar Yusuf Akçura (b.1876–d.1935), and Azeri Turk Ahmet Ağaoğlu (b.1869–d.1939) encouraged Turkish language reform in their publications as they made contact with and had an influence upon Ottoman members of the Young Turks. In combination with the secular, modernizing outlook of particular Ottoman individuals within the broader Young Turk movement, pan-Turkist ideology would eventually, by the first decade of the twentieth century, metamorphosize into a more exclusive form of Turkish nationalism in the Ottoman Empire.

A group of students at the Military Medical Academy in Constantinople first founded a secret political society in 1889 called the Ottoman Union Committee, which opposed Sultan Abdülhamid II's authoritarian regime. The founders were all Muslims. Soon more clandestine cells of this organization sprung up in other imperial academies. Known informally as the Young Turks, they held meetings, drew up plans for a more official organizational structure, and recruited members of the Ottoman bureaucracy and the religious class into their ranks in the early 1890s despite efforts by the state to suppress their activities. Some fled to Europe or to Cairo where they established local branches and published newspapers. Non-Muslims joined and contributed to the organization as well. Ahmed Rıza Bey (b.1858–d.1930), an Ottoman educator, activist, and reformer devoted to Auguste Comte's Positivism who had moved to Paris, joined the movement. Rıza's influential interpretation of Positivism, as a member of Comte's philosophical, secular "Religion

of Humanity" that emphasized individual moral virtue, demanded Ottoman order and progress be achieved through non-violent means and an evolutionary process uninterrupted by European colonialism. The Ottoman society came to be known as the Committee of Union and Progress (CUP), with Rıza publishing its views in two journals, *Meşveret* and *Mechveret Supplément Français* starting in 1895. Even members of the sultan's family joined the opposition and moved to Europe, including the brother-in-law of the sultan, Damad Mahmud Celaleddin Pasha, and his son, the sultan's nephew, Prince Sabaheddin Bey.

More branches of the CUP were established across the empire – in the Balkans and in British-controlled Cairo. But the CUP, as a kind of umbrella organization, splintered amid conflict among its members in Europe, Cairo, and in the empire over differences in reform strategies, whether to solicit British intervention to overthrow the regime, and how inclusive of non-Muslims the opposition would be. An attempted coup to overthrow the sultan in 1895 failed. Some CUP members were exiled, but other members who had been in exile returned to the Ottoman Empire after accepting promises of reconciliatory reform by the sultan. The CUP was temporarily defunct while Prince Sabaheddin Bey's group organized the "Congress of Ottoman Liberals" in Paris in 1902 and established itself as the "Ottoman Freedom-Lovers Society." They held a second congress in 1907. This congress and society favored British assistance in conducting a coup and included Armenian and Greek activists and intellectuals. Ahmed Rıza's faction rejected foreign involvement and increasingly embraced Turkist ideas and claims to lead, fracturing the opposition further and increasingly stressing the Turkish character of the Ottoman state, implying the Turks' right to dominate and govern. There had already been mutual distrust between the latter faction and the Armenians due to events of the 1890s – the Armenian takeover of the Ottoman Bank and the massacres of Armenians that followed. By 1907 Dr. Bahaeddin Şakir, a prominent Young Turk leader, managed to bring together the Turkist faction with revolutionary branches of the Ottoman Freedom-Lovers Society that had been established in Salonika among army officers and state officials the previous year. This CPU (Committee of Progress and Union), soon to revert the name back to CUP, would come into the open and conduct a revolution in the summer of 1908 that started in Salonika with a mutinous Macedonian military corps (Figure 11.7). The sultan was compelled to announce the reinstatement of the Ottoman constitution of 1876 and the reopening of parliament; elections were held and the Chamber of Deputies convened again.

The Young Turk Revolution of 1908 released an undeniable initial optimism in the Ottoman Empire among many sectors of the Ottoman population. Many believed that they would now experience the freedoms and opportunities guaranteed in the constitution, with a voice in parliament to guide their modern nation – their Ottoman nation. Whether in Constantinople among both Muslims and non-Muslims, in Salonika in the Balkans, or in the Arab provinces such as Jaffa in Palestine, the mood was celebratory (Figure 11.8). After years of press censorship and the shutting down of newspapers by the Ottoman authorities for their alleged seditious publications, the publishing industry boomed as new papers and journals of various genres were founded across the cities of the empire to disseminate international and domestic information of interest. Virtually overnight the number of new Arabic language publications in cities like Damascus, Aleppo,

Beirut, Jerusalem, Haifa, and Baghdad expanded exponentially between 1908 and 1909. More papers and journals in Ottoman Turkish appeared, including several Young Turk papers. But this expectant enthusiasm would not last. The Young Turk movement had transformed into the Committee of Union and Progress, which became, after the revolution, an open political party with headquarters in Salonika (until that city was lost in 1912). CUP branches were established all over the empire. The CUP ran candidates in elections and came to dominate the Senate and the administration as the "Unionist" government, becoming, within a short time, to the great disappointment of many, an authoritarian regime possessing centralized control over the empire. The Young Turk Revolution in 1908 did not inaugurate the liberal reform movement that had been anticipated.

What did the Young Turk CUP stand for? Their ideology can be generally summed up as having the following characteristics: comprised of educated elites, they were, for the most part, Social Darwinists. They read and embraced the theories of Herbert Spencer, Gustave Le Bon, and German philosophers of the nineteenth century (e.g., Ernst Haeckel), which led to evolutionary implications of Darwin's differentiation of species for the Ottoman Empire– that the Ottomans could "evolve" to the level of other modern nations provided Europeans ceased their interference in the process. In terms of the class system, the theory implied their (the CUP's) right to rule over the ignorant Ottoman masses who could not be trusted to have a real voice in governing. As the elite, they were the "more evolved" members of Ottoman society. The Young Turks were often not only secular-minded, but actually anti-religious. Some, like Ahmed Rıza, were devoted Positivists. They were typically Western-oriented and educated in Europe, but felt the frustration of knowing the West did not see them as equals – thus they possessed an animosity toward European imperialism. They inherited the patriotism of the Young Ottomans who preceded them, desiring to save the empire from destruction. To this end, capitalism was the system they believed would maintain the economic viability of the Ottoman state. Significantly, there

Figure 11.8 Palestinians Celebrating the Revolution in 1908, Popularly Known by the Arabs as *al-Hurriyya*, in Front of the Government Offices of the Grand Serai in Jaffa.

was a subtle Turkish nationalist orientation among some important members of the movement who would become the powerful decision-making Central Committee of the CUP. Influenced by the pan-Turkism of Turkic exiles from Russia, they developed a very racialized understanding of nationhood that became more pronounced in the twentieth century. The Tatar Muslim exile from Russia Yusuf Akçura published his famous "Üç Tarz-ı Siyaset" ["Three Types of Policy"] in the Young Turk journal *Türk* out of Cairo in 1904, in which he described Ottomanism, Islam, or Turkism as the three available ideological underpinnings for the Ottoman Empire to embrace in order to survive in the modern world. The best alternative, he surmised, was Turkish nationalism based on Turkic ethnicity (race). His essay would be reprinted again in Istanbul as a pamphlet in 1912, solidifying for the Young Turk CUP regime their commitment to a Turkish nationalist orientation among its leadership.

Contributing to all of these traits was Young Turk idealization of modern Japan as a role model for sociopolitical reform; technological, science-based modernization; and building a national consciousness in the empire, before and after Japan's defeat of the Russian Empire in 1905. The sultan and the Sublime Porte had been intrigued by the possibility of making a friendly alliance with Meiji Japan since the exchange of gifts between the sovereigns in the 1880s and the frigate *Ertuğrul*'s ill-fated journey to East Asia that ended in shipwreck and death for most of its crew in 1890. The survivors had been returned to Istanbul aboard Japanese warships, amid much public display of affection and curiosity by the masses in 1891. From that time until around 1910, open and clandestine negotiations between government officials, journalists, businessmen, and private citizens of both countries continued, endeavoring to establish more formal Ottoman-Japanese relations. Their efforts came to naught. The Japanese insisted on being granted Capitulatory privileges in Ottoman lands as their Great Power counterparts had received; Ottoman statesmen, wary of the detrimental effects of such agreements, resisted this demand, subtly delaying responses to Japan's overtures. Eventually the Japanese, immersed in their own colonial activities in East Asia in the early twentieth century, lost interest in establishing a formal alliance. Nonetheless, as German diplomats discussed in communiques, and as Ottoman Turkish and Arabic newspapers reported, the Young Turk Unionists continued to look to Japan for ideas of how to govern in the early years of their regime, whether it meant staffing military personnel in overseas diplomatic posts as the Japanese had done, or employing Japanese naval advisers in place of the British and French, whom they had come to trust less.

THE RUSSO-JAPANESE WAR (1904–1905) AND ITS IMPACT

The Russo-Japanese war had a tremendous influence upon many peoples in the world, particularly in Asia and Africa where the experience of Western imperialism and/or colonization had been a painful reminder of the "weaknesses" of those societies placed lower on Gustave Le Bon's racial-civilizational hierarchy. It was viewed as the first modern war in which the "East" was victorious over the "West," it was a victory for a constitutional monarchy, Meiji Japan, over an autocratic Russian Empire ruled by a tsar, and it was a triumph of a small, independent, new nation-state over an antiquated, multiethnic, multireligious empire. The lessons were not lost on many civilian and military officials, political activists, journalists, and even the general population of the Ottoman Empire who rejoiced at Japan's defeat of the Ottoman archenemy, Russia, in 1905 (including many Arab Christians. Balkan Christians affiliated with Russia seemed to have been the exception to this enthusiasm for Japan, as there are Ottoman archival records that mention churches conducting prayer services for Russia during the war).

Newspapers across the empire had covered the news of the war on a daily basis with front-page examinations of each side's military personnel, their naval and land forces, battle tactics and outcomes, etc. (Figure 11.9).[5] The sultan had even dispatched an Ottoman military officer to Manchuria to witness the war directly and report on it. Excitement over Japanese successes, which included the sinking of the Russian fleet at Tsushima, led Ottoman military officials to study Japan's modernization of its armed forces. Ottoman writers published books about the "secret of Japan's success" in Ottoman Turkish and in Arabic, which included explorations of Japanese history, culture, religion, political institutions, modernization policies, and Japan's ability to have revised its Unequal Treaties (like the Capitulations) previously signed with Western powers. Modern Japan inspired Arabic poetry hailing the role of Japanese women, or the martial, samurai qualities of the Japanese soldier and official. Books on Japanese child-rearing were to teach Ottomans how to instill patriotism in their children from a young age. Information about this little isolated nation far off in East Asia distilled its way into Ottoman society among those less literate through the coffeehouse culture of reading newspapers aloud to those present. The Japanese, it was believed, had modernized their nation and overturned the racial hierarchy that favored Indo-European races over the rest, without losing their eastern essence. The Ottomans would certainly be able to do the same, argued many Young Turks, provided Europe stopped its imperialist, interventionist behavior. In fact, when two Unionist representatives of the Ottoman government met with British officials to discuss forging a new alliance in late 1908, they did not describe the empire as the "Sick Man of Europe," but instead declared themselves "the Japan of the Near East" and suggested the British would be well-served to deal with them.[6] The CUP held a conference in 1911 in which Comte Léon Ostrorog discussed "La renaissance du Japon." For the Young Turks and many others in the Ottoman Empire, modern Japan represented a role model for achieving modernity that was at once Western-oriented yet not Western-inspired; modern and independent, yet (they believed) not imperialist like the West. Japanese modernity solved a paradox for

those intellectuals and activists striving to save the empire from destruction while remaining true to their Ottoman-Islamic roots. The trope of modern Japan was a powerful metaphor that was often based upon more fiction than fact by Ottoman writers. The Japanese themselves, interested in achieving Great Power status in the international arena, also promoted this image. The idealization of this model of Japan's "non-Western" modernity endured long after the Ottoman Empire's demise in the twentieth century.

The pan-Islamic, pan-Turkist Tatar Muslim Abdürreşid İbrahim continued to lobby for this pan-Asian relationship by traveling across the Muslim world and to Japan on several occasions. He would return to the Ottoman Empire and publish his travelogue in Ottoman Turkish, *Alem-i İslam ve Japonya'da İntişar-ı İslamiyet*, around 1910. He eventually ended up in Japan in the interwar era, presiding over the opening of the first mosque in Tokyo in 1938. He died there in 1944 while publishing war propaganda for the Japanese in 1944.

Figure 11.9 Japanese Admiral Tōgō, Hero of the Russo-Japanese War.

THE COMMITTEE OF UNION AND PROGRESS IN POWER

Sultan Abdülhamid II was initially left on the throne after the revolution in July of 1908 inaugurated the second constitutional period of the Ottoman Empire. The Young Turks had restored the constitution and parliament, and fair elections took place in late 1908. But there were already cracks in the movement that had brought these events to fruition, between a nationalist faction, an Islamist faction, and a liberal faction among the Young Turks. Some non-Muslim organizations had demanded ethnoreligious quotas for the Chamber of Deputies seats. Laborers conducted strikes, demanding improvements to

their working conditions. In the middle of the chaos of the revolution, Bulgaria declared independence in October 1908. Austria-Hungary annexed Bosnia-Herzegovina the same month. More of the Balkans had been lost. The increasing power of the CUP, now an official political party, alienated many who founded new political parties. The CUP sponsored cultural activities and community events in an effort to promote its reform program emphasizing secular science, liberty, and Ottoman unity through Ottomanism that could supplant sectarian identifications and gain political support at home. CUP branches were established across the empire at a mass level which did not, however, translate into more participation in government by members. Decision-making and policy formulation remained in the hands of a cabal of civilian and military individuals, shrouded in some secrecy, who eventually controlled all cabinet appointments – Dr. Bahaeddin Şakir and Dr. Nâzım, described as having "Turkist" proclivities; Talaat Bey, the deputy for Edirne after 1908 and organizer in Salonika; two military officers, Enver Bey and Cemal Pasha; Mehmed Cevid Bey, who was the minister of finance, and Ahmet Kemal Bey (known as Kara Kemal), who handled internal CUP governance and managed some Ottoman social programs. Sociologist Ziya Gökalp, known in historiography as the architect of Turkish nationalism, also became part of the CUP Central Committee. He wrote ideological treatises explicating the Ottoman nation as a synthesis of Turkish culture (the foundation), Islamic heritage (the source of morality), and Western civilization (the technological basis for successful modernization).

Frustration over what looked to be the emergence of a one-party government, with the CUP Central Committee pulling the strings behind the scenes, led to an attempted countercoup in Istanbul among military personnel and religious students in April 1909. Known as the 31 March Incident (due to the different calendar used at the time), it was put down quickly by an "Action Army" of military units from Salonika led by Mahmud Şevket Pasha who restored order and declared martial law. The CUP leaders forced the deposition of the Sultan Abdülhamid II in late April 1909, replacing him with his more pliable brother Mehmed V Reshad (r. 1909–18). The CUP executed perpetrators of the countercoup. From this time onward the CUP decided to clamp down upon any dissent against their administration.

Interestingly, the sultan's deposition led to addressing the question of slavery in the empire once again; it had been forgotten about since Midhat Pasha had attempted unsuccessfully to enact anti-slave trade policies in the 1870s. Over 600 female slaves in the palace were slowly manumitted in 1909 after demands made by their families, and other Circassian slaves began to petition the Interior Ministry for their freedom based upon the tenets of the Ottoman constitution promising freedom for all.[7] Contradictions between the şeriat and the Ottoman penal code in relation to the right to possess slaves, however, muddled the Ottoman parliament's response to the abolition of slavery, so that a ban on the slave trade did not result in the manumission of currently held slaves in households. Slavery quietly continued to exist until the empire's dissolution.

The revised constitution drafted in the summer of 1909 placed power in the hands of the parliament and cabinet. The sultan now merely approved their decisions. They passed

the restrictive Law of Strikes and the Press Law to further cement the Central Committee's authoritarian hold on power. They purged from office or excluded anyone seen as potentially disloyal to the Unionist regime. In July 1909 military service was made compulsory for all Ottoman citizens regardless of sect, much to the dismay of many Christians (those who were wealthy enough could still buy their way out or flee to another country) and Muslim religious students and others who had been exempted previously. The Young Turks resisted demands by Christians that they be allowed to serve in their own distinct units, seeing this request as un-Ottoman. In August of 1909, the government passed the Law of Associations, which banned ethnically based political parties. Ironically the faction that ultimately came to dominate the CUP gave the Unionist government an increasingly Turkish nationalist tone to their centralizing policies at others' expense after 1909. The optimism among Armenians, Greeks, Albanians, Arabs, and others in the immediate aftermath of the revolution turned to disappointment, frustration, and more ethnoreligious activism with more damaging consequences for the empire in the early twentieth century.

ARABISM AND THE NAḤDA

Although the emergence of nationalism among the Muslim population of the empire did lag behind that of the Balkan Christian and Armenian communities, there can be no doubt that a cultural awakening occurred among various Muslim communities in the late nineteenth century. Most of these movements did not begin as separatist in nature, but were instead expressions of ethnolinguistic identity among Muslims who still felt an affinity for the Ottoman Empire as an Islamic power that could acknowledge and protect such difference – even as the world around them changed and nationalist movements severed Ottoman territories. For the Kurds, most uprisings to date had been over state attempts to implement centralizing controls, which mainly tribally organized Kurdish groups resisted. Not until the twentieth century did a more developed nationalist movement among Kurds result in rebellions with demands to establish a Kurdistan state in eastern Anatolia. For the Albanians, their desire was for autonomy within Ottoman rule to protect their population from Greek and Serbian expansionism from the 1878 crisis (the Russo-Ottoman War) onward. Segmented into Catholic, Orthodox, and Muslim Albanian sects, their internal religious divisions and proximity to irredentist Balkan Christian states ultimately meant their awakening in the early twentieth century. An Albanian insurrection in 1910 resulted in declaring independence in 1912 (after the first Balkan war) to establish stability through Albanian nationhood.

The Arabs of the Ottoman Empire deserve particular attention, as the second largest population, almost on par with the Turkish population after the loss of most of the Balkan Christians in the late nineteenth century. A cultural awakening among Ottoman Arab elites in the empire began to percolate in the mid-nineteenth century, with what scholars call the *naḥda* – a renewed awareness of the Arabs' contributions to pre-Ottoman Islamic

civilization combined with a nineteenth-century literary movement highlighting Arab achievements. After all, Muhammad the Prophet was an Arab, the Qur'an was in Arabic, the leadership of Arab caliphs spread the faith in the early Islamic conquests, and Arab dynasties presided over the flourishing of arts and sciences during the period of high Islamic civilization. Ottoman Greater Syria (today the region which includes modern Syria, Lebanon, Palestine-Israel, and part of Jordan) contained the urban, intellectual centers where Arabic literary societies and reading salons sprang up and produced Arabist thought. Both Christian and Muslim Arab elites were involved in the rediscovery of Arab heritage and the publishing of Arabic dictionaries and grammatical studies, biographies of noted Arab historical figures, newspapers and journals, historical novels, etc. in which they defined the Arabs as a people and a culture for their community while still adhering to the belief in the viability of the Ottoman Empire as an Islamic polity. Christian Arabs, many of whom were influenced by Western thought, viewed the achievements of Islamic civilization as their cultural possession as much as it belonged to Muslim Arabs. They were more apt to base their communal identity upon their ethnicity, language, and culture – a shared Arabo-Islamic past as Arabs.

Arab participants in the *nahda* did not initially endorse separatism from the Ottoman Empire. They merely hoped to gain recognition within the empire for the special place of the Arabs as the founders of Islamic civilization. Many Syrian-Arab Christians, such as novelist and newspaper editor Jurjī Zaydān (b.1861–d.1914), departed for British-controlled Egypt in the late nineteenth century to publish papers and journals articulating these views in a freer environment.

Prior to the *nahda*, the *salafi* movement (*salaf* means ancestors in Arabic; in this case, "pious [Arab] ancestors") had erupted earlier in the tribally organized Arabian Peninsula with the extremist Wahhabis who had caused much disruption for the Ottomans. Wahhabi radicalism was not appealing to most of the Arab population further north in Greater Syria. But the movement did generate thinking about the need to contemplate Islam's place in the Ottoman Empire, which led to later Islamic modernist ideas concerning the reconciliation between Islam and modern (Western) science and knowledge. Some of these Arab *salafi* thinkers had also fled to Cairo in the late nineteenth century (e.g., Rashīd Ridā, b.1865–d.1935), where they published their ideas in the pages of the press. At the turn of the twentieth century, the effects of the Arab cultural awakening, the *nahda*, dovetailed nicely with the ideas of a new generation of *salafi* thinkers into a more politicized ideology of Arabism in which Arab intellectuals, journalists, and activists began to contemplate more than just a demand for cultural recognition of the Arabs' contributions. As early as 1901 a Syrian Arab named 'Abd al-Rahmān al-Kawākibī (b.1855–d.1902) published a literary treatise, part of which was entitled "The Excellences of the Arabs," in which he extolled the virtues of the "true Arabs" – the Bedouin in Arabia whom he romanticized as being the purist of Muslims, untainted by outside influences. His essay ultimately was a subtle challenge to the Ottoman Sultan Abdülhamid II's claims to be "Caliph of all Muslims" despite the sultan's attempts to cultivate support by maintaining some prominent Arab figures at court. Other Arab *salafi* thinkers also opposed the idea of the caliphate resting

SYRIAN CHRISTIAN JURJĪ ZAYDĀN'S LAST POPULAR HISTORICAL NOVEL, *SHAJARAT AL-DURR* (1914)

Jurjī Zaydān authored histories of Arabic literature and Islamic civilization, as he understood them to be a part of his Arabo-Islamic heritage. He endeavored to educate readers of his newspaper, *al-Hilāl* (published in Cairo from 1892 to 1914) through the serialization of the new Arabic literary genre of the novel. He wrote twenty-three historical novels. *Shajarat al-Durr* ["Tree of Pearls"], the medieval queen of Egypt in the thirteenth century, was the subject and title of his last (1914), which drew a rich picture of harem life, womens' relationships, political intrigue at the end of the Ayyubid dynasty founded by Saladin, and the founding of the Mamluk Sultanate by Baybars. Below is an excerpt.

Shajarat al-Durr reclined on an ebony couch richly upholstered in patterned brocade. The terrace on which mistress and slave now sat, and which belonged to one of the many palaces that Al-Salih had built on his Garden Island, overlooked a vast expanse of the Nile. This islet was the most beautiful of the verdant patches of green that sat like jewels in the great river between Old Cairo and Al-Jazira. Many a king of old had made it his pleasure-garden. It was Al-Salih who moved his royal seat there from the Citadel, where his predecessors had resided and from whence they had ruled. On this island he built a magnificent fortress that became known as the Fortress of the Measure, in reference to the ancient Nilometer nearby. It was also known as the Garden Fort or the Salihiyya Fort. Numerous palaces, mosques, and naval workshops had formerly existed on the site,

and it was home to the famous pavilion that the Fatimid Sultan, Al-'Amir bi Ahkamillah, had built for his concubine. The Good King demolished all these structures and raised the Fortress in their place, expending a vast fortune in the process. The palaces and mosques that he caused to be raised rested upon great columns and arches fashioned from the venerable granite and marble taken from the ancient ruins surrounding the city. He planted orchards with flowering trees of all kinds, and he erected sixty towers for his armories and for grain and sundry foodstuffs against the possibility of a Frankish siege, for the Franks were intent on invading Egypt in those days. So lavish was he in constructing this fortress that each one of its stones was said to be worth a whole dinar. The King himself had supervised its construction, and when it was completed he moved his womenfolk and his slaves there, as well as his Mamluk horsemen, their number reaching one thousand hardy warriors. Finally, outside the walls he built a vast zoological garden in which he gathered all sorts of savage beasts – lions, for instance, and tigers. Tree of Pearls was Al-Salih's favorite concubine, and when she gave birth to a son, the King drew her even further into his confidence. Being a woman of surpassing astuteness and intelligence, she acquired great influence over the King and so, when he was killed in Mansura in 1249, she carefully concealed his death from the populace and ruled in his stead, signing decrees and military commissions in his name, for the war against the Crusaders still raged. Her secret she

confided to none but the leading princes and commanders of the army. 'Izz al-Din Aybak the Turk was her most particular confidant, for there was love between them....

Shajarat al-Durr was dressed in a simple garment and wrapped in a silk shawl. She sat gazing abstractedly at the Nile, while all around, nature lay perfectly still. The breeze had died down but for a few puffs that now and again stirred up her long dark hair, which she had gathered into an insouciant mass that tumbled luxuriously around her shoulders. She was not a woman like other women. She had both the courage and the ambition of the greatest of men. If once she resolved on a course of action, she paid not the slightest heed to any obstacles placed in her path. She knew well how to conquer, by any and all means necessary. Her handmaiden Shwaykar was, like her mistress, of Turkish origin, but still in the flower of youth. Tree of Pearls loved her dearly. She was the eager repository of her mistress's little secrets, for the great lady trusted her in spite of the native cunning that made her loath to reveal her thoughts to a living soul. It was for this cunning that the Mamluk princes feared and respected Tree of Pearls. She had conquered their hearts with her grace and she now commanded their awe and admiration with her indomitable will.[8]

in the hands of Ottoman Turks, whom they pointed out lacked the Qurayshi genealogical origins required to assert a legitimate claim to the position. Arguing for a political reorientation back to an Arab caliphate was dangerous business, however. Al-Kawākibī was mysteriously poisoned.

More secular Arab elites in the Ottoman provinces typically chose to align themselves with the liberal principles of the Young Turk movement, and with the revolution in 1908. They enthusiastically published newspapers and journals explicating Arab identity to their community in the most didactic way – telling their readers *who* the Arabs were and are, reminding them of their shared history, culture, and language. By 1909, however, some of these Arab newspaper editors and political activists (Christian and Muslim) were already expressing disillusionment with the new Unionist government and its seemingly authoritarian nature. They critiqued the CUP and its lack of sincerity in reforming the empire according to the principles it had originally espoused. When the Unionists chose to purge officials deemed disloyal to the regime after the counter-coup in 1909, what was in reality a tactical expulsion based upon political differences and opposition to CUP centralization came to be interpreted by many in the Arab provinces as discriminatory "Turkification" policies aimed at removing non-Turks – Arabs – from their posts. Additionally, in a time and place in which language was a defining feature of identity, there were articles in the original 1876 constitution that were not altered, which also contributed to the view of Turkification: the original constitution had stipulated that Ottoman Turkish was the official language. Deputies in parliament were required

to have, within four years, some ability in Ottoman Turkish. The CUP inserted an additional article insisting Ottoman Turkish language be compulsory in elementary school education, and that it be the language of instruction for secondary and higher educational institutions. Although the curriculum of the civil service college, the *Mülkiye*, was in Ottoman Turkish and included Arabic, Greek, Armenian, or Albanian language training for students who would staff posts in certain provincial areas, the state required Ottoman Turkish to be used in all courts. In the early years of the Unionist government, these issues began to polarize the Arab and Turkish political elites of the empire. Turkish cultural and literary societies sprung up that emphasized Turkish linguistic identity, the culture, the character, and the Turkish genius of founding the Ottoman Empire. Pan-Turkist influences of Turkic Muslim exiles from Russia over the Unionists had become stronger, and a journal called *Genç Kalemler* ("Young Pens") was published by one of these societies between 1910 and 1912 that endorsed purifying the Ottoman language by purging Arabic and Persian words and grammar. They advocated the use of a new, authentic Turkish literary language, which they dubbed *yeni lisân*, or "new language."

Some Arab individuals continued to support the idea of an Ottoman empire, albeit as a kind of federated sultanate that respected its various ethnoreligious communities. Others became more vocal in the pages of their presses, demanding the Unionist regime make good on its promises and truly reform the Ottoman Empire along the lines of a liberal, decentralized state, which provoked strong responses from the administration. Publications were censored. Newspapers were shut down. More Arab writers and editors fled (to Europe, or to Egypt, where you could critique anyone but the British occupation forces!). Not until 1913 did the Unionists introduce reforms allowing Arabic to be used in law courts and in instruction in schools, except for the higher educational *sultaniye*s, as a way to placate local Arabs in the provinces. By then, many of the more vocal Arabists in Greater Syria had determined that there would be no possibility of a Unionist government that respected its Arab population. The Ottoman Empire, it appeared, was going to be molded into an Ottoman *Turkish* Empire, with Turks ruling *over* other ethnoreligious communities. More Arabs fled the empire; others remained, forming clandestine societies and agitating. By 1915–16 some Arab journalists and activists would be arrested, convicted, and executed for what was believed by the Unionists to be their subversive Arab nationalist views during a vulnerable moment – wartime.

The Ottoman quest to achieve modernity to survive in the world seemed to have released a host of contradictions in the latter years of the empire. As early as the *Tanzîmât* era of the mid-nineteenth century, state-led reforms aimed at redressing shortcomings in Ottoman policies and administration, military performance, and educational institutions stimulated a backlash among the Young Ottomans who were at once both progressive, patriotic constitutionalists demanding democratic participation, as well as anti-secular activists who resented the arbitrary nature of these reforms and the Western Christian imprint on them. Meanwhile to Ottoman bureaucrat reformers and

NON-HUMAN ANIMALS IN THE MODERN URBAN SPACE

The pursuit of modernity in the late Ottoman Empire affected the lives of non-human animals as much as it did those of its peoples. Dogs (and cats) who survived on the scraps of human settlements were owned by no one individual in particular. Evidence of street dogs in Ottoman villages and cities who were often cared for compassionately by a certain neighborhood's inhabitants also served as the garbage removal system, devouring refuse in the streets and alleys (Figure 11.10). But with urban overcrowding due to rural migration to cities in combination with new ideas about what was considered "modern," dogs in cities came to be seen as filthy, unclean disease-carriers in competition with humans over urban public space. Their treatment at the hands of the Ottoman government worsened.

Concern over Istanbul's street dogs reflecting poorly on Ottoman civility and tarnishing the empire's reputation as modernized (since, it was believed, stray dogs were not a feature of European cities) led to citywide roundups of street dogs to be forcibly removed by the Ottoman authorities. During Sultan Mahmud II's reign (r. 1808–39), an attempt to cull dogs in Istanbul by taking them to an island had failed because the ship was caught in a storm and the dogs swam back to shore; another roundup was carried out during Abdülaziz's reign (r. 1861–76). Dr. Abdullah Cevdet, Young Turk editor of *İctihâd* who was an anti-religious, avid westernizer, published a pamphlet in 1909 entitled *The Dogs of Istanbul* (*İstanbul'da Köpekler*) in which he virulently encouraged the extermination of street dogs as an expression of modern progress, frightening readers with stories of their impurity and of rabid dogs biting passersby. Perhaps that

is why in 1910, a roundup occurred in which the dogs were transported to Sivriada, an island in the Marmara Sea (Figure 11.11) where they eventually starved, cannibalized, and all perished, much to the horror of many of Istanbul's Muslim residents (according to several European accounts, Ottoman Christians were less sympathetic to the plight of

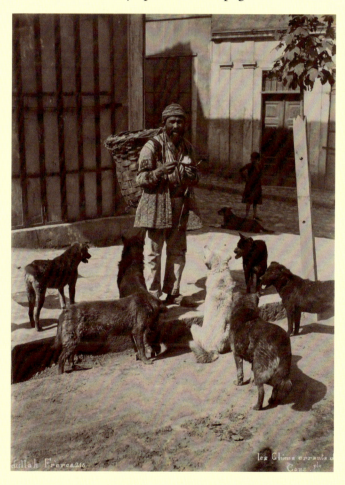

Figure 11.10 Street Dogs in Constantinople.

Figure 11.11 Street Dogs Relocated to Hayırsız Ada (Sivri Island) in the Marmara Sea.

stray dogs). In 1912 the Society for the Protection of Animals was founded in Istanbul to prevent animal abuse, and street dogs came to be seen in a more positive light by 1913 in Istanbul's newspapers and magazines, perhaps due to membership in the organization of several prominent Ottoman statesmen – General Mahmud Şevket Pasha and *Grand Vezir* Said Halim Pasha.

foreign observers alike, whose intentions were based on either strategic Ottoman state or European imperial interests, these same *Tanzîmât* reform efforts were perceived as liberal and forward thinking. A generation later, leaders of the Young Turk movement who aimed to reinstate the constitution and to (eventually) remove an autocratic sultan from power possessed an elitist, Social-Darwinist, subtly nationalist platform that would quietly exclude from its ranks those whom they deemed too ignorant (the masses), too superstitious (the religious *ulema* and students), or too untrustworthy (Armenians). Though the CUP publicly encouraged Ottomanism as a patriotic doctrine to elicit loyalty to the empire, their private communications reflected animosity toward Arabs for example, whom they called "dogs of the Turkish nation."[9] The Young Turk Revolution was said to be a victory for "liberty, freedom, and justice," yet in the post-revolution, post-countercoup second Ottoman constitutional era, the CUP regime was increasingly authoritarian and repressive in striving to maintain power amid internal

and international pressures. They passed laws to curtail resistance, censored the press, arrested, exiled, or had executed individuals whom they suspected of opposition to their rule. They understood the military as the backbone of the CUP's rightful claim to political authority in an era in which an "armed nation" was necessary for the empire's survival. When in November of 1911 a new political party called the *Liberal Entente* formed out of various opposition parties that had previously been disbanded, and posed a serious challenge to the hegemony of the CUP, the Unionists manipulated the 1912 elections (called the "Big Stick elections") through means of intimidation, arrest, and outright corruption of the process, which resulted in a parliament that met irregularly after this point and was relatively uninfluential and ineffective in governing. Ottoman flexibility, which had answered challenges in the past, gave way to inflexible responses by the state – exclusion, political suppression, and brute force to preserve empire – and violent sectarian strife in society. It was a changed world, all in an unfolding climate of regional, and soon global, war.

NOTES

1 Sâṭî Al-Ḥuṣrî, "Japonya ve Japonlar," *Büyük Milletlerden Japonlar, Almanlar*, Konferans Kütüphanesi (İstanbul: "Kader" Matbaası, 1329/1913), 34–7. Translated by Renée Worringer. In *The Modern Middle East: A Sourcebook for History*, eds. Camron Michael Amin, Benjamin C. Fortna, and Elizabeth Brown Frierson (Oxford: Oxford University Press, 2007), 439.

2 Halil İnalcık and Donald Quataert, eds., *An Economic and Social History of the Ottoman Empire*, (Cambridge: Cambridge University Press, 1994), 777–97.

3 Gábor Ágoston and Bruce Masters, *Encyclopedia of the Ottoman Empire* (New York: Facts on File, 2009), 469.

4 Cited in Norman Itzkowitz, "The Problem of Perceptions," in *Imperial Legacy: The Ottoman Imprint on the Balkans and the Middle East*, ed. L. Carl Brown (New York: Columbia University Press, 1996), 33–4.

5 Turkish writer Halide Edip Adıvar mentions naming her child after Tōgō in *Memoirs of Halidé Edib* (New York: Arno Press, 1972), as did many enthusiastic Ottomans after the war.

6 Grey Papers, PRO, FO 800/184A and 185A, 13 November 1908.

7 Ceyda Karamursel, "The Uncertainties of Freedom: The Second Constitutional Era and the End of Slavery in the Late Ottoman Empire," *Journal of Women's History* 28, no. 3 (2016): 148–9.

8 Jurjī Zaydān, *Tree of Pearls, Queen of Egypt*, trans. Samah Selim (Syracuse: Syracuse University Press, 2012), 4–5.

9 Dr. Nâzım Bey to İshak Sükûti in 1901, *Papers of Bahaeddin Şakir Bey*, quoted in M. Şükrü Hanioğlu, "The Young Turks and the Arabs before the Revolution of 1908," in Rashid Khalidi, Lisa Anderson, Muhammad Muslih, and Reeva Simon, eds., *The Origins of Arab Nationalism* (New York: Columbia University Press, 1991), 31.

SELECTED READINGS

Berkes, Niyazi. *The Development of Secularism in Turkey*. Montreal: McGill University Press, 1964.

Brummett, Palmira. "Dogs, Women, Cholera, and Other Menaces in the Streets: Cartoon Satire in the Ottoman Revolutionary Press, 1908–11." *International Journal of Middle East Studies* 27, no. 4 (November 1995): 433–60.

Commins, David Dean. *Islamic Reform: Politics and Social Change in Late Ottoman Syria*. New York: Oxford University Press, 1990.

Çelik, Zeynep. *The Remaking of Istanbul: Portrait of an Ottoman City in the Nineteenth Century*. Berkeley: University of California Press, 1986.

Deringil, Selim. *The Well-Protected Domains: Ideology and the Legitimation of Power in the Ottoman Empire, 1876–1909*. London: I.B. Tauris, 1998.

Devereux, Robert. *The First Ottoman Constitutional Period: A Study of the Midhat Constitution and Parliament*. Baltimore: Johns Hopkins Press, 1963.

Gökalp, Ziya. *Turkish Nationalism and Western Civilization: Selected Essays of Ziya Gökalp*. Edited and translated by Niyazi Berkes. London: Allen & Unwin, 1959.

Gündoğdu, Cihangir. "The Animal Rights Movement in the Late Ottoman Empire and the Early Republic: The Society for the Protection of Animals (Istanbul, 1912)." In *Animals and People in the Ottoman Empire*, edited by Suraiya Faroqhi, 373–95. Istanbul: Eren Books, 2010.

Hanioğlu, M. Şükrü. *A Brief History of the Late Ottoman Empire*. Princeton: Princeton University Press, 2010.

Hanioğlu, M. Şükrü. *Preparation for a Revolution: The Young Turks, 1902–1908*. New York: Oxford University Press, 2001.

Hanioğlu, M. Şükrü. *The Young Turks in Opposition*. New York: Oxford University Press, 1995.

Al-Ḥuṣrî, Sâṭî. "Japonya ve Japonlar," [Translated title]. Translated by Renée Worringer. In *The Modern Middle East: A Sourcebook for History*, edited by Camron Michael Amin, Benjamin C. Fortna, and Elizabeth Brown Frierson. London: Oxford University Press, 2007. Lecture originally given at the East Theatre in Istanbul. Reprinted in *Büyük Milletlerden Japonlar, Almanlar*. Konferans Kütüphanesi, İstanbul: "Kader" Matbaası, 1329[o]/1913.

İnalcık, Halil, and Donald Quataert, eds. *An Economic and Social History of the Ottoman Empire*. Cambridge: Cambridge University Press, 1994. See esp. chap. 30, "Population," of vol. 2, "1600–1914."

Itzkowitz, Norman. "The Problem of Perceptions." In *Imperial Legacy: The Ottoman Imprint on the Balkans and the Middle East*, edited by L. Carl Brown, 30–43. New York: Columbia University Press, 1996.

Kabakcı, Enes. "[Extended Abstract] An Example of Reinterpretation: Ahmed Rıza's 'Positivism,'" *Turkish Journal of Sociology* 3, no. 28 (2014): 59–71.

Karamursel, Ceyda. "The Uncertainties of Freedom: The Second Constitutional Era and the End of Slavery in the Late Ottoman Empire." *Journal of Women's History* 28, no. 3 (2016): 138–61.

Karpat, Kemal H. "Ottoman Population Records and the Census of 1881/82–1893." *International Journal of Middle East Studies* 9, no. 3 (October 1978): 237–74.

Kasaba, Reşat. *A Moveable Empire: Ottoman Nomads, Migrants, and Refugees*. Seattle: University of Washington Press, 2009.

Kasaba, Reşat, ed. *Turkey in the Modern World*. Vol. 4 of *The Cambridge History of Turkey*. New York: Cambridge University Press, 2006.

Kayalı, Hasan. *Arabs and Young Turks: Ottomanism, Arabism, and Islamism in the Ottoman Empire, 1908–1918*. Berkeley: University of California Press, 1997.

Khalid, Adeeb. *The Politics of Muslim Cultural Reform: Jadidism in Central Asia*. Berkeley: University of California Press, 1998.

Klein, Janet. *The Margins of Empire: Kurdish Militias in the Ottoman Tribal Zone*. Stanford: Stanford University Press, 2011.

Landau, Jacob M. *Pan-Turkism: From Irredentism to Cooperation*. Bloomington: Indiana University Press, 1995.

Le Bon, Gustave. *The Psychology of Peoples*. New York: G.E. Stechert and Co., 1924. Reprinted English edition of *Psychologie des foules* [*The Psychological Laws of the Evolution of Peoples*]. Paris: n.p., 1895.

Lewis, Bernard. *The Emergence of Modern Turkey*. Oxford: Oxford University Press, 1968.

Mandel, Neville J. *The Arabs and Zionism Before World War I*. Berkeley: University of California Press, 1976.

Melson, Robert. "A Theoretical Inquiry into the Armenian Massacres of 1894–1896." *Comparative Studies of Society and History* 24, no. 3 (July 1982): 481–509.

McCarthy, Justin. *The Ottoman Peoples and the End of Empire*. London: Bloomsbury Academic, 2001.

Ostrorog, Comte Léon. *Conférence sur la Renaissance du Japon*. Istanbul: Ahmed İhsan, 1327/1911.

Pears, Edwin. *Forty Years in Constantinople, The Recollections of Sir Edwin Pears 1873–1915*. 1st ed. London: Herbert Jenkins Limited, 1916.

Pinguet, Catherine. "Istanbul's Street Dogs at the End of the Ottoman Empire: Protection or Extermination." In *Animals and People in the Ottoman Empire*, edited by Suraiya Faroqhi, 353–71. Istanbul: Eren Books, 2010.

Reynolds, Michael A. *Shattering Empires: The Clash and Collapse of the Ottoman and Russian Empires 1908–1918*. New York: Cambridge University Press, 2011.

Rogan, Eugene L. *Frontiers of the State in the Late Ottoman Empire*. New York: Cambridge University Press, 1999.

Shissler, Holly. *Between Two Empires: Ahmet Ağaoğlu and the New Turkey*. New York: I.B. Tauris, 2003.

Suny, Ronald Grigor. *"They Can Live in the Desert but Nowhere Else": A History of the Armenian Genocide*. Princeton: Princeton University Press, 2015.

Toledano, Ehud R. *Slavery and Abolition in the Ottoman Middle East*. Seattle: University of Washington Press, 1998.

Üngör, Uğur Ümit. *The Making of Modern Turkey: Nation and State in Eastern Anatolia, 1913–1950*. Oxford: Oxford University Press, 2011.

Washburn, George. *Fifty Years in Constantinople and Recollections of Robert College*. 1st ed. Boston & New York: Houghton Mufflin Company, 1909.

Wishnitzer, Avner. *Reading Clocks, Alla Turca: Time and Society in the Late Ottoman Empire*. Chicago: University of Chicago Press, 2015.

Worringer, Renée, ed. *The Islamic Middle East and Japan: Perceptions, Aspirations, and the Birth of Intra-Asian Modernity*. Princeton: Markus Wiener Publishers, 2007.

Worringer, Renée. *Ottomans Imagining Japan: East, Middle East, and Non-Western Modernity at the Turn of the Twentieth Century*. New York: Palgrave MacMillan, 2014.

Worringer, Renée. "Rising Sun over Bear: The Impact of the Russo-Japanese War upon the Young Turks." In *"L'ivresse de la liberté: la evolution de 1908 dans l'Empire ottoman" The Euphoria of Liberty: The 1908 Revolution in the Ottoman Empire*, edited by François Georgeon, 454–85. Paris: Peeters Publishers, 2012.

Worringer, Renée. "'Sick Man of Europe' or 'Japan of the Near East'?: Constructing Ottoman Modernity in the Hamidian and Young Turk Eras." *International Journal of Middle East Studies* 36 (May 2004): 207–30.

Zilfi, Madeline C. *Women and Slavery in the Late Ottoman Empire*. New York: Cambridge University Press, 2010.

Zürcher, Erik Jan. *The Unionist Factor: The Role of the Committee of Union and Progress in the Turkish National Movement 1905–1926*. Leiden: E.J. Brill, 1984.

TWELVE

THE EMPIRE AT WAR

By the first decade of the twentieth century, in the midst of the social and political upheaval of the 1908 Young Turk Revolution and aftermath described previously, the Ottoman Empire had become a shadow of its former self in terms of territory (Map 12.1). European and Russian empires had already seized former Ottoman provinces in the Balkans, North Africa, the Black Sea coast, and the Caucasus. Some nationalist movements in the ethnoreligiously diverse Balkans had succeeded in breaking away from Ottoman control to establish their own fledgling states, often with boundaries still fluid and under dispute by their equally newborn, nearby neighbors. More threats to Ottoman territorial integrity manifested elsewhere. Tribal rebellion in Yemen from the early 1900s was settled in 1911 with a treaty recognizing Zaydi (Shi'i) autonomy under the leadership of the charismatic Imam Yahya. But from 1911 onward, the Ottoman Empire was continually mobilized and at war, a fact that cannot be overlooked when examining the policy choices of the CUP leadership and the general sense of the empire being under siege from all sides. In that year, 1911, Italy invaded the last bastion of Ottoman sovereignty in North Africa – Tripoli and Cyrenaica (Libya) – conducting a short war as a first step toward resuscitating an Italian neo-Roman empire in the Mediterranean. Units of Ottoman guerrilla fighters traveled to Tripoli to defend the province (including CUP member and military officer Enver Pasha and another young officer, Mustafa Kemal), which only triggered more Italian aggression. Italy occupied the Ottomans' Mediterranean island of Rhodes and the Dodecanese islands in the Aegean.

THE OTTOMANS LOSE EUROPE

As soon as an agreement was reached allowing Italy to retain its gains in Tripoli and the evacuation of the Dodecanese (though Italy did not evacuate those islands), a larger crisis pulled Ottoman attention north, to the Balkans. "Encouraged" by Russia, whose imperial adversaries in eastern Europe were Germany and Austria-Hungary, a Balkan League was formed of Montenegro, Serbia, Bulgaria, and Greece, who all opposed Ottoman Turkish rule in

Map 12.1 Ottoman Losses of Territory.

Macedonia and, each having their own territorial claims to Macedonia, looked for a pretext to declare war. Lack of Ottoman reforms there was it. The Balkan League rightly assumed the Ottomans were in a vulnerable moment, having just fought a brief conflict with Italy. The First Balkan War began when Montenegro declared war on the Ottoman Empire in October 1912; declarations by the other members of the Balkan League soon followed. The Bulgarian army was held off by Ottoman forces at the Çatalca Line just outside Istanbul in 1912, but eventually Edirne, the historic second capital of the Ottoman Empire, was lost temporarily in March 1913. In November 1912 Greek forces had accepted the surrender of Salonika, previously the headquarters of the CUP, from the Ottoman commander of the garrison just before Bulgarian forces reached the city. With the conflagration happening directly to the east, Albania declared independence from the Ottomans in December 1912. Albania received the

Balkan Wars, 1912–1913

- Taken by Bulgaria
- Taken by Greece
- Taken by Serbia
- Taken by Montenegro
- Taken by Romania

AUSTRIA-HUNGARY

RUSSIA

ROMANIA

• Bucharest

BLACK SEA

•Belgrade

SERBIA

BULGARIA

MONTE-NEGRO

• Sofia

Retaken by the Ottomans
↙ 1913

•Üsküdar

Kumanova

Kirk Kilise

ALBANIA
Independent
1913

Manastir

Edirne

• Lüleburgaz

Catalca

• Istanbul

Salonica

ITALY

Yanya

OTTOMAN EMPIRE

GREECE

• Izmir

Athens •

MEDITERRANEAN SEA

Dodecanese Islands
To Italy, 1912

sanction of the Great Powers once they realized the Ottomans had lost Macedonia, the last real Ottoman foothold in Europe. Albanian independence was officially recognized with the Treaty of London signed in May 1913. Shortly thereafter, in June of 1913, Bulgaria started the Second Balkan War by attacking its League allies over dissatisfaction with the Macedonia settlement. In response they (and Romania) declared war on Bulgaria (Map 12.2). As the front lines

Map 12.2 Balkan Wars, 1912–13.

fluctuated between warring Balkan states, forced conversions from one Christian Orthodox church to another played a role in determining nationhood and thus claims on territory.

The Second Balkan War from June to August 1913 among the Balkan League members offered the Ottomans an opportunity to recapture Edirne – which they did – but when the dust settled and the Treaty of Bucharest and that of Istanbul were signed in 1913, the Ottoman Empire lost Macedonian Salonika to Greece forever. Bulgaria lost its initial war gains. Kosovo, with its Albanian Muslim and Christian populations, was ceded to Serbia and Montenegro despite having been a center of the Albanian nationalist awakening. The Serbs, with their historic claims to Kosovo dating back to their loss to the Ottomans in 1389, violently suppressed an Albanian Muslim rebellion there in 1913. Purges of "non-national" Muslims in the Balkans relied upon starvation, disease, rape, massacre, and forced exile to create national realities on the ground. Over a quarter of the Balkan Muslim population died in the Balkan Wars. Another influx of Muslim refugees from former Ottoman Balkan territories that had been lost to newly formed Christian nation-states inundated the beleaguered and much reduced territory of the Ottoman state. Rumelia, one of the Ottoman heartlands for centuries, was lost forever, with the exception of Edirne and eastern Thrace.

CUP CRISIS MANAGEMENT AND THE COMING OF THE GREAT WAR

Just before the outbreak of the First Balkan War, amid the unease and perceived corruption of the recent Ottoman elections, the Italo-Ottoman War, and tensions in the Balkans, an Ottoman mutiny among some army commanders in Albania forced the CUP from power temporarily, allowing the opposition, the Liberal Union, (the *Entente Libérale* mentioned earlier) to form a new cabinet. Gazi Ahmed Muhtar Pasha (b.1839–d.1919), a decorated Ottoman war hero of various campaigns in the 1870s including the Russo-Ottoman War in 1877–8, was appointed *grand vezir* and dissolved parliament (with its CUP-dominated Chamber of Deputies due to corrupt elections) in August. The outbreak of the First Balkan War in October 1912 surprised his cabinet and created turmoil in the empire. The CUP saw its opportunity to reassert political control: led by military officer Enver Bey (soon to be Pasha), they conducted a *coup d'état* in January 1913 (known as the "Bab-ı Alî raid"), forcing Gazi Ahmed Muhtar Pasha's resignation and the disbanding of his cabinet at gunpoint in order that the CUP could form a new one. The poor defense of the empire in the Balkan conflict and the impending loss of Edirne in March 1913 loomed, solidifying the CUP's hold on government as potential *Turkish* saviors of the Ottoman Empire. General Mahmud Şevket Pasha, leader of the Action Army in 1909 that had suppressed the countercoup (see Chapter 11), was appointed the new *grand vezir*, but he was assassinated in June of 1913. Said Halim Pasha, a grandson of the famous ruler of Egypt Mehmed Ali, was installed as the new *grand vezir* in 1913, a post he held until 1917.

Members of the new CUP cabinet known as the "triumvirate" would now assume complete control of the Ottoman government bureaucracy and military. They led the Ottoman Empire down a path from which there was no return: to an alliance with Germany and world war in 1914, to state-inspired, state-conducted violence against any dissent, to genocide against Armenians and Assyrians, and ultimately, to the demise of the empire altogether. Ismail Enver Pasha (b.1881–d.1922) became minister of war in early 1914. Mehmed Talaat Pasha (b.1874–d.1921), a telegraph and postal worker who was the Edirne deputy, became minister of the interior and minister of finance (and eventually *grand vezir* in 1917 during World War I). Military officer Ahmed Cemal Pasha (b.1872–d.1922) became minister of public works in 1913, minister of the navy in 1914, and governor of Syria in 1915, commanding the 4th Ottoman army against British forces in Sinai and Palestine (Figures 12.1, 12.2, and 12.3). This triumvirate governed with an iron fist until 1918. They would be held responsible for some of the most glaring errors in judgment, the costliest policy choices, and the most tragic episodes in Ottoman history that occurred at the end of the empire.

Figure 12.1 Enver Pasha.

The Ottoman Empire was in desperate need of a Great Power ally to assist in stopping the hemorrhaging of Ottoman territories. Wars and refugees had drained Ottoman finances and the economy was in a shambles. By 1914 the Ottomans had been stripped of the majority of their European lands, and what now remained of the empire was its heartland of Anatolia, and the Arab provinces from Greater Syria to Iraq, delimited by Russia and Persia in the east, and British-occupied Egypt at the Sinai Peninsula from 1906. Britain was not interested in any alliance with the Ottomans other than to preserve its positions in the Middle East. British treaty arrangements at the end of the nineteenth century with several Arab sheikhdoms in eastern Arabia had promised protectorate status to those on the Persian Gulf coast (e.g., the 1899 treaty with the al-Ṣabāḥ tribe in the area of today's Kuwait). The British were concerned for German involvement with the Ottoman Empire in the region – German engineers had advised on the Hijaz Railway project started in 1900 to connect Damascus to the holy cities (the rail line to Medina was opened in 1908 but never reached Mecca). Plans for a more collaborative German-Ottoman project, the Berlin-Baghdad railway, started in 1903 which, when completed, would easily be able to transport Ottoman and German troops east. The project was interrupted during World War I and only resumed in the 1930s; the Berlin-Baghdad railway was completed only in the 1940s.

British protection over their prized colony of India was their main strategic concern, so that maintaining control over the Suez Canal as an open shipping and communications lane via their occupation of Egypt, and relationships with the sheikhdoms around the Persian Gulf, were of prime importance. Adding to the significance of the Persian Gulf and southern Arabia, a British concession for oil exploration and

Figure 12.2 Cemal Pasha.

Figure 12.3 Mehmed Talaat Pasha.

production in Persia had been signed with the Persian Shah in 1901. In 1908 oil had been struck and started pumping in Masjid-i Suleiman, about 250 km or 155 miles north of the Persian Gulf. Winston Churchill's decision to shift the British Royal Navy from coal to oil power in 1911 cemented British intentions to maintain this foothold in Arabia. The Arabian Peninsula had, by the 1913–14 Anglo-Turkish Conventions, been divided into a British sphere of influence in the south, and declared Ottoman territory in the unwieldy desert hinterlands of the central Arabian Peninsula, the Najd; although in reality the tribal leader 'Abd al-'Azīz b. Sa'ūd was the de facto ruler on the ground and had been made its hereditary governor. The Ottomans could only truly claim authority over the coastal Hijaz region of Arabia, but even there, the Young Turks in 1908 had appointed as custodian of the holy cities of Mecca and Medina the Hashemite descendants of the Prophet Muhammad, the influential *Sharif* Husayn, *emir* of Mecca (Figure 12.4) and his sons, who maintained order in the region and oversaw the smooth orchestration of Muslims on pilgrimage. The British were not interested in allying with the Ottomans beyond their conventions guaranteeing this regional influence.

Past German involvement with the Ottoman Empire had in part been welcomed because of their late arrival on the imperialist scene. Germany was seen as the lesser imperial evil (as opposed to Britain, France, Russia, and Austria-Hungary), as well as perceived as having the best military in Europe. Several other factors made Germany the natural power with whom the Ottomans sought a formal alliance: the kaiser's royal visits; the Germans who advised on developing Ottoman infrastructure; the German military personnel who assisted in the training and reorganization of the Ottoman army, such as General Limon von Sanders, who was appointed inspector-general over the first Ottoman army; and the increase in German civilian activities (e.g., building schools and hospitals; establishing various social, commercial, and cultural associations) in the empire. The Ottomans actually had approached the other powers as well, but had been turned down. Nor were German officials initially very enthusiastic about allying themselves with the Ottoman Empire. Several, including General von Sanders himself, had expressed reservations concerning the political and military liability of a treaty with the Ottomans. The German position would change with events of 1914 and the Austrian pressure placed on Germany to consider an Ottoman alliance that might, for Austria's sake, also include Bulgaria.

The Kingdom of Serbia, still seething from Austria-Hungary's annexation of Bosnia-Herzegovina in 1908, had pan-Slavic nationalist aspirations fueled by having gained more territory in the settlement at the end of the Balkan Wars. Resenting Vienna's perpetuation of political and economic controls over Serbia, relations were tenuous between the two, and in June of 1914 a Bosnian-Serb nationalist assassinated Crown Prince Archduke Franz Ferdinand, heir to the Austrian throne, in Sarajevo. This act was the catalyst for either establishing new treaties between powers, or for triggering the defensive clauses of international alliances that had already been put in place – ultimately resulting in the Great War, or World War I, in 1914. A month after the assassination, in July, Austria-Hungary declared war on Serbia. Serbia was allied with Russia, which then pitted Russia against the Habsburgs. Germany's alliance

with Austria-Hungary formed the Central Powers, and the Triple Entente of Russia, France, and Britain (the Allied Powers), meant the two sides were at war by early August.

For the Ottoman Empire, anxiety over any war among the Great Powers was based upon fears of Russian annexation of Ottoman territory. In the Ottoman CUP triumvirate, Enver and Talaat Pashas were the pro-German faction who wanted an alliance with Germany. In late July 1914 they and *Grand Vezir* Said Halim Pasha sent a proposal to the German ambassador in Istanbul. Cemal Pasha preferred France, the Ottomans' major creditor in 1914, or Britain as a second choice (his experience with British assistance in conducting naval reform while minister of the navy perhaps had an effect upon his viewpoint). But when the French refused an Ottoman appeal, and Britain reneged on an agreement for several battleships sold to the Ottomans, the Ottomans and Germany signed a secret alliance at the beginning of August which later included Austria. Germany promised it would protect Ottoman territorial integrity should Russia attack the Ottoman Empire. Though the CUP triumvirate had gotten its German defensive treaty, there were Ottoman officials still divided on whether or not to join the Central Powers. Once the treaty was signed, Enver Pasha declared a state of armed neutrality and called up a military mobilization of the empire that stunned the general population. Even more shocking, days later, Enver, Talaat, and *Grand Vezir* Said Halim Pashas secretly proposed to the Russian mission in Istanbul an alliance if Russia would guarantee Ottoman territorial integrity, support Aegean islands reverting back to Ottoman control, and relinquish Russian support for reforms among the Armenian communities in eastern Anatolia. In return they would dismiss all German personnel and sever the relationship with Germany, but the Russian foreign minister rejected the offer.

Figure 12.4 *Sharif* Husayn of Mecca, Nineteenth Century.

Most Ottomans still hoped for neutrality during the coming conflict, but it was to be short lived. German warships (the *Goeben* and *Breslau*) that had harassed the Triple Entente's ships and ports in the Mediterranean fled into Ottoman waters (with Enver Pasha's secret approval) with British and French fleets in hot pursuit. Once the two ships entered the Dardanelles, Britain claimed it a breach of Ottoman neutrality. Clever Ottoman pragmatism won the day: in a bit of blackmail, while also boosting the power of the Ottoman navy, the Ottomans forced Germany to concede several demands so as not to lose their German ships outright. Germany was forced to support abolition of the Capitulations that had been so damaging to the empire, and to back redressing Ottoman territorial claims in the Balkans, in islands in the Aegean, and in eastern Anatolia. In return, a "sale" of the German ships to the empire was concocted, thus arguing to the British that neutrality had not been violated. As the war heated up in Europe in the fall of 1914, Germany pressed the Ottomans to open fronts against Russia in the east and Britain across the Suez Canal, in Egypt. The Ottoman government unilaterally abrogated the Capitulations in September

of 1914 and levied new taxation demands against foreign residents, Ottoman citizens, and on certain commodities, to boost the treasury. In October 1914 the Ottomans closed the Dardanelles to Allied shipping traffic. Ottoman plans to conduct maneuvers in the Black Sea became muddled orders (in part again due to Enver Pasha's rogue actions) and eventually a surprise attack on Russia's Black Sea fleet was carried out in late October 1914. The effect was a declaration of war by Russia against the Ottoman Empire and the immediate invasion of Russian troops into the Ottoman Caucasus frontier to secure a buffer zone in Ottoman territory. The Ottomans repelled the Russian advance, but in the less than two weeks before the offensive paused, it cost many lives on both sides, with little accomplished.

Despite not all members of the CUP having been in favor of joining the war effort on the side of the Central Powers, the official Ottoman declaration of war against the Triple Entente powers took place on November 2. Britain officially recognized Kuwait as an independent protectorate the next day, annexed Cyprus, and declared war on November 5. Indian units, which had already been dispatched to Bahrain in the Persian Gulf, were now ordered to the Shatt al-Arab waterway area in southern Iraq the day after that to secure the Anglo-Persian oil refinery, tanks, and pipeline there before moving ahead to besiege Basra. The Ottomans' potential Achilles heel – a large-scale, multifront war – had begun.

THE OTTOMAN EMPIRE, WORLD WAR I

November of 1914 was a month of mobilizing war strategies, military personnel, munitions, and popular support through nationalist propaganda or a spiritual call to arms, to varying effect. The British and French began with a bombardment of the Dardanelles, hoping to pry open the way to Constantinople, as part of a larger European view of Ottoman weakness and the ease with which they believed the Ottoman Empire would be quickly knocked out of the war. At the same time, the Ottoman sultan's *şeyhül-islâm* proclaimed a *jihad* against the Triple Entente in mid-November. There were mistaken assumptions on both sides: the Allies assumed they could easily penetrate the straits' coastal defenses. The Ottoman state, using this call to *jihad* to mobilize its own Muslim populations, believed a call for a Holy War might destabilize the Entente's war effort from within by fomenting rebellion among the millions of colonized Muslims in British India, French North Africa, and tsarist Russia who would rise up against their infidel rulers. It was also hoped that the final outcome of this war, secured by the Ottoman-German military alliance, would yield the Ottoman reclamation of lands lost in the Balkans, the Aegean and Mediterranean seas, North Africa, and in eastern Anatolia.

These assumptions did not materialize. The Ottomans strengthened their shore defenses of the straits with Ottoman and German artillery, reinforced coastal positions with infantry units, and mined the straits, so that the British admiralty was compelled ultimately to request ground troops for an amphibious assault in the spring of 1915. Contrary to Ottoman expectations and Western fears (particularly among the British) of

an enthusiastic, international Muslim response to the call for *jihad*, it did not happen. The British declared Egypt a protectorate in December of 1914. They deposed *Khedive* Abbas Hilmi and placed the eldest prince, Husayn Kamil, (both descendants of non-Egyptian Mehmed Ali) on the throne in hopes of having an Egyptian monarch more amenable to British aims. But overall Egyptians themselves did not engage in the conflict; an Egyptian nationalist rebellion did not occur until 1919. Abdürreşid İbrahim, the anti-Russian, Tatar Muslim activist who was in Ottoman lands, went first to the eastern front in order to coordinate Muslim efforts against the Russians at the start of World War I. He then traveled to Europe as a member of the Ottoman intelligence services called the *Teşkîlât-ı Mahsûsa* to attempt to recruit Russian Muslim prisoners of war held in Berlin into an anti-Russian fighting force for the Ottomans. But overall the Ottomans would be disappointed in the lack of Muslim solidarity against the Triple Entente. European empires similarly had overreacted to what they believed was going to be overwhelming "Muslim fanaticism" overthrowing their colonies.

In retrospect, the Ottomans performed better in this multifront war than was expected – however, there were some disastrous errors in judgment at the outset by the ruling triumvirate and Unionist government concerning war strategy that cost the empire dearly. Much blame is often assigned to Enver and Cemal Pashas for their miscalculations. Enver Pasha, as minister of war, dispatched Cemal Pasha to Greater Syria to lead the Suez-Sinai campaign against the British in November of 2014. In the same month the British decided to winter their colonial ANZAC troops in Egypt (Figure 12.5). The Ottoman

Figure 12.5 Australian 9th and 10th Battalions, Mena Camp, Near Pyramids with Kangaroo, the Regiment Mascot. Many Australian units brought kangaroos and other Australian animals with them to Egypt. Some were given to the Cairo Zoological Gardens when the units went to Gallipoli.

TEŞKÎLÂT-I MAHSÛSA, OR THE "SPECIAL ORGANIZATION" AND OTTOMAN IRREGULARS IN WORLD WAR I

Mystery surrounds this organization, and scholars dispute the date of its establishment as well as its purposes, though they all agree that the ambitious military officer and member of the CUP, Enver Pasha, was a key actor associated with initially organizing this secret intelligence and security service. Sources indicate that the group of paramilitary volunteers first became active around 1911 as part of an organized resistance force against the Italians in North African Tripoli. The group, led by Enver Pasha, who carried out the Bab-ı Alî raid that ousted the Liberal Union cabinet in 1913 seems also to have been part of the Special Organization, which became a more official entity in 1913. The *Teşkîlât-ı Mahsûsa* was also active against Bulgarians and Greeks in western Thrace during the Balkan wars, especially with the Ottoman reconquest of Edirne from Bulgarian forces and the Ottoman establishment of the short-lived Provisional Government of western Thrace after the Second Balkan War (treaty arrangements dictated that Ottoman forces evacuate western Thrace and the territory revert back to Bulgaria). In August 1914 *Teşkîlât-ı Mahsûsa* was transformed into an official organization connected to the Ottoman Ministry of War, and was known to be active against the British in Egypt and Iraq. Scholars describe how the Special Organization sought to "... foment insurrection against imperialist European powers, or to prepare the local Muslim population for guerilla fighting, and also to raise Muslim political consciousness against colonialism in Libya, Afghanistan, the Central

Asian khanates, as well as against the British-led insurgency in Arabia and Russian activities in the Caucasus."[1] "... It was a multi-purpose special volunteer force led by professional officers ... to foment insurrection in enemy territory, fight guerillas and insurgents in friendly territory, conduct espionage and counterespionage, and perform other tasks unsuited to conventional military forces."[2]

Teşkîlât-ı Mahsûsa has been implicated in the Armenian genocide. Given the complex nature of Ottoman military forces in eastern Anatolia during the Great War as regular army units or irregulars (and some of which were both) like gendarmes, the provincial, rural police force; the tribal cavalry of Kurds and Circassians; and paramilitary volunteers typically from outside the empire, as well as the proliferation of *çeteler*, local gangs of violent mercenaries and brigands who operated independently, the responsibility for committing the atrocities and massacres of the Armenians is often unclear. Commanded by Dr. Bahaeddin Şakir in late 1914, a man known for his anti-Armenian attitudes and major role in the genocide, the Special Organization was later accused of having carried out massacres of Armenians during the genocide starting in 1915. However, military historian Edward Erickson argues that the *Teşkîlât-ı Mahsûsa* mainly served in a conventional capacity in the Caucasus from December 1914 to the end of 1916. After Enver Pasha's military debacle at Sarıkamış, when distrust of Armenian intentions intensified and

military-related killings of Armenian soldiers increased, paramilitary forces were also unleashed upon the Armenians – Muslim Turks, mounted Kurds, Bedouin tribesmen, prisoners and violent criminals released by the state, embittered Muslim refugees from the Balkans and the Caucasus, angry mobs from local villages, all participated.

In October 1918 the CUP government collapsed and the *Teşkîlât-ı Mahsûsa* was officially liquidated.

contingent in Iraq, comprised in part of Arab tribal units who were not necessarily loyal to the Ottoman authorities, did not last long against the British forces landing at the Shatt al-Arab. The Ottomans abandoned Basra by November 21, withdrawing to regroup for the coming defense of Baghdad. Enver Pasha, eager to recapture in eastern Anatolia what the Ottoman Empire had lost to Russia in 1878, led a disastrous offensive into the Caucasus against Russia at the head of the 3rd Army starting in December of 1914. Believing such a victory would inspire Muslim solidarity across Central Asia, to Afghanistan and India, Enver's reckless campaign at the start of winter decimated the 3rd Army. Culminating in the battle for Sarıkamış (northeast of Erzurum) from the last days of December to early January 1915, the failed Ottoman campaign entailed massive losses of Ottoman soldiers due not just to those killed in combat, but to exposure, starvation, and disease (typhus and dysentery). Cemal Pasha's Suez Canal offensive against the British started about a month later, in January 1915, and his defeated forces were in retreat by February.

The devastating loss at Sarıkamış was a humiliating defeat for Enver Pasha and the Ottomans. It was also a moment in which tensions with Armenians had reached a point of no return. Anti-Armenian attitudes manifested among Enver and other military officers commanding Ottoman forces in the east. Armenians were caught between the needs of two empires – Ottoman and Russian – each wanting Armenian loyalty and collaboration in their war effort. Armenian volunteers and deserters from the Ottoman army served in Russian units. Armenians in Ottoman uniform were increasingly distrusted and more frequently shot by their Ottoman comrades, while the Armenian civilian population in eastern Anatolia became trapped in the conflict around them, with no choice guaranteeing their survival. The Ottoman defeat at Sarıkamış fueled anger over the Armenian presence in the Ottoman Empire. No longer the "*millet-i sadîka*," the "loyal *millet*," the Armenians were now overwhelmingly being viewed as a subversive element in the empire's midst, a people encouraging Western intervention in the Ottoman Empire in order to facilitate their national aspirations for a homeland in Anatolia. In a time of war, they would be dealt with as such in due time.

These early Ottoman defeats at the hands of the Allies emboldened the Entente to undertake the Gallipoli offensive in 1915 in which it was assumed a quick assault to liberate

World War I

⟨ **British and Russian Advances**

⟨ **Ottoman Advances**

⟨ **Centers of Rebellion**

✗ **Major Battles**

A Bayburt	H Bitlis-Maraş
B Erzurum	I Nablus
C Köprüköy	J Gaza
D Sarıkamış	K Suez
E Eleşkirt	L Ctesiphon
F Kigi	M Kut al-Amara
G Malazgirt	

Map 12.3 The Ottoman Empire in World War I.

the Dardanelles Straits would open the way to occupying Constantinople and removing the Central Powers' Ottoman ally from the war altogether (Map 12.3). The defeats had the opposite effect upon the Ottoman Empire's military resolve; nonetheless the mood in the empire in early 1915 was grave. The Allies had miscalculated in their war effort, and the Gallipoli campaign, starting with naval operations in February of 1915, was one of the most disastrous defeats inflicted upon British, French, and ANZAC forces during the conflict in terms of loss of life and loss of prestige. Blunders in conducting landings, the underestimation of Ottoman defenses, the difficulty in clearing mines, errors in predicting the Ottoman army's determination to defend their empire at all costs from a foreign invasion that

threatened the capital and the Anatolian heartland itself, and in general British arrogance about Allied abilities and Ottoman weaknesses, made for a dramatically failed campaign. The initial March 18 attempt by the Anglo-French battle fleet to penetrate the Dardanelles ended with the reduction of its strength "by one-third in a single day's action with no significant damage inflicted on Ottoman positions."[3] Back in Europe, the Triple Entente decided a ground assault on Gallipoli was now required. Russia had chosen not to invade toward Constantinople via the Black Sea and Bosphorus Straits. The Allied landing took place in the early hours of April 25, but German General Limon von Sanders and the Ottoman commanders were prepared with trenches, barbed wire, machine guns, and artillery batteries. It was an unwinnable assault that devolved into a stalemate of trench warfare. Despite this, the British, ANZAC, and French forces continued the campaign for nine months, with a tremendous loss of life on all sides (Figure 12.6).

The Gallipoli campaign of 1915 came to generate what could be called a seminal moment in the "coming of age" of new nations and national identity. For the Ottomans, and the primarily Turkish troops defending the Dardanelles, repelling the Allied forces was a much-needed victory and one that reinvigorated the Ottoman war effort after initial setbacks on several fronts. It made a war hero of Colonel Mustafa Kemal. If the Ottoman Empire had not been understood as a state possessed by the Turks before, solidifying a Turkish sense of pride and identity beyond broader Ottoman affiliations, this battle certainly drove the point home with the eventual withdrawal of the Allies. Additionally, the ANZACs also made the realization that they were more than merely expendable human capital coming from the colonial outposts of the British Empire. Their coming of age was of a new sense of Australian and New Zealander nationhood, countries with their own interests, which could and did diverge from that of mother England. Recognition among the soldiers on both sides of the Gallipoli campaign of the absurdity of war, and the newfound respect each side had for their counterparts' suffering, boredom, and desperation in the trenches, merely feet away from one another, generated a bond that is still felt today with the commemoration ceremonies held on the Peninsula annually among Turks, Australians, and New Zealanders. As bullets literally fused in mid-air due to the massive munitions exchanges that took place between adversaries, cease-fires were called and adhered to in order to take time to recover fallen comrades. Photographs, cigarettes, and food were sometimes exchanged in cautious fraternization between ANZACs and Turks in the opposing trenches. To the ANZACs, the Ottoman soldiers were jovially referred to as "Johnny Turk" or "Jacko."

Meanwhile the Mesopotamian campaign had continued after the Ottoman retreat toward Baghdad. An initial British victory at Kut al-Amara in 1915 with the Anglo-Indian

Figure 12.6 Ottoman Soldiers on the Gallipoli Peninsula in 1915.

IRFAN ORGA'S *PORTRAIT OF A TURKISH FAMILY*

Irfan Orga (b.1908–d.1970) (Figure 12.7) was born into an upper-class Ottoman family in Istanbul. His father and uncle were killed in World War I. He later became a Turkish fighter pilot, officer, and author who wrote in English after immigrating to the UK. His memoir depicts Turkish family life in late Ottoman and early Republican-era Turkey; the excerpts reproduced below recount the harshness of life during World War I in the capital.

Figure 12.7 Irfan Orga, at the War College, 1928.

The world seemed suddenly full of the word and the noise of women weeping. All down the street news had begun to arrive of sons and brothers and fathers who had been killed at the front. There were no heated arguments now with the street sellers. The women wearily bought what they could afford; the young boys went off to join their fathers in the fighting, and the street was given over to the dribbling babies and the dogs and the ever ravenous cats. Each waking day brought fresh news from the front, of the appalling casualties we were suffering; and the Red Crescent trains came faster and thicker than ever, bringing the wounded and dying to Istanbul. There was not a woman in the little street but had someone at the front, even the widow downstairs, whose only son was away. Food was scarcer than ever, even if one had the money to buy it; and the Bourse noir [Black market] flourished unchecked, and people dropped in the streets for lack of nourishment. My grandmother had been in the habit of sending storable foods to us, but she stopped this practice. My mother would make soups for us from a handful of lentils or dried peas, or serve plain boiled haricot beans, conserving such precious items as rice and flour or olive oil for the leaner times just around the corner....[5]

In the midst of their talking, my mother came in, looking so odd, so disheveled, that my heart gave a lurch of fear. "What is wrong?" cried the widow in dismay, and my mother replied in the new, hard voice that she always seemed to use nowadays. "I am past wondering what is right and what is wrong. To live nowadays is to bear insults from everyone. At the Government departments they treat us like vermin, or tell us how fortunate we are that we have given a man to the war. I hunt bread every day, running from one baker's shop to another, and, in the end, what do I get? A piece of hard black bread that I would be ashamed to feed to the animals. The crowds push and kick and snarl with rage, and all decency seems to

be gone from humanity – " Her voice broke and I thought she was going to cry, but she controlled herself, a faint furrow appearing between her delicate brows, almost as though she were wondering what she was talking about. She put out a hand to steady herself, and her face became very white, deadly white, so that the cheekbones were thrown into high relief, and the nose appeared sharper and more pinched. "Did anything unusual happen this morning?" roared my grandmother. "Plenty!" retorted my mother. "When you are a woman and alone in the world, you have to grow used to insults. This morning I tried several shops for bread; at last I found one open and joined the queue to take my chance with the rest. Just as I had handed my money and taken the bread offered to me, a woman beside me snatched it from my hand, saying that it was hers and that she had given her money first. I snatched it back again, and so the battle started. She was like a wild animal. She fought and kicked and screamed and pulled my veil from my face, saying only the rich wore veils and that I had no right to queue for bread when the poor needed it worse than I did. My veil!" my mother repeated, horrified. "Before all those people she pulled aside my veil, as if I were a prostitute, and then she called me one! Me! In front of all those people! I thought the world would fall on top of me. I tried to get away from her, but she had hold of my skirt and I was afraid she would tear that from me too. Two men interfered and gave me back the bread, and I ran away from that dreadful place with my veil all torn and the people shouting after me in the streets. They thought I was a bad woman and that I had been fighting with another bad woman! Oh, such disgrace! To think I should live to see the day that I should fight for such a thing – " She held up the piece of dry black bread.... That evening [my grandmother] prayed in her loud, rumbling voice

for her sons who were dead, for my grandfather, for my mother and us children.... After dinner was over, my grandmother illogically expressed a desire to visit the little mosque to pray, saying that she wanted me with her. We started out into the black night, I pleasantly fearful and excited. My grandmother carried a lighted candle in a sort of storm lantern, and I could clearly see another candle glowing on the tomb of the holy man. We walked swiftly, for the night was bitterly cold, and when we came abreast of the window in which rested the tomb, my grandmother sternly bade me pray for the soul of the holy man. She opened her hands to the sky, palms upward in the Moslem fashion, and I did the same thing....

One day my mother and I went to Beşiktaş, some distance from our home. I have forgotten the reason we went but remember the occasion, for it was the first time I had ever seen the sultan, Mehmed Reshad. In the main street of Beşiktaş, soldiers were marching and a band played military music, while the police were roughly keeping back the curious crowds from the royal route. We waited to see the sultan, and the cavalry came first, mounted on their high-stepping Arab horses. As far as I can accurately remember, they wore blue jackets with brightly shining brass buttons, scarlet trousers, and great tall calpacs on their heads, with flowing white plumes. They pranced toward us, their uniforms making a splash of welcome color in all that drab humanity, and their spurs clinked and jingled and gleamed in the watery sun. A carriage came after the cavalry, drawn by elegant, aristocratic horses, and dimly, through the windows, we caught a glimpse of a small old man with a little white beard. He was in uniform, many medals marching across his breast. A great loyal cry went up from the people, half of them in rags, a deep-throated rumbling roar of welcome. "Padişahım çok yaşa!" ["Long Live my Sultan!"] they roared,

and then he was past us, and other voices took up the refrain. Even when the carriage had finally disappeared from sight, the echoes of the cheering crowds came back to us. Then the quiet streets grew quieter, for the people had dispersed, and my mother and I continued on our journey. Mother had found work to do in these days. The widow, true to her word, had obtained sewing for her from her patron in the Kapalı Çarşı. The money was pitifully small, and nowadays the salon was eternally littered with made and unmade work: the never ceasing whirr of the sewing machine dominated all else. So the winter passed.... Somehow or other life was readjusting itself: we had become used to bad food and not enough of it, and my grandmother did the marketing and I now hunted for bread. But the soft, early days of spring changed all that again. One had already learned that security was a fragile thing, sensitive to the first cold breath, yet one could not learn to accept this with finality. That spring of 1916 overrides all other memories and carries its scars to this day. Sewing for my mother came to a sudden, abrupt end, for the patron of the Kapalı Çarşı explained that there was no more work for anyone, that the Government had bought all the available materials for the Army. He said that an Army sewing depot had been opened behind the Gülhane Park and that anyone applying there would be given work to do.... "Well, you will not!" roared my grandmother ... "What is the use of talking like that?" demanded my mother wearily. "We have so little money and the children must be fed. Can we see them going hungry because of our pride?"[6]

No matter how the women of my family tried to stave off poverty, it came eventually; and this time it was the real, unadulterated thing. There was either nothing left to be sold or, more correctly, what was left was unsalable, for though the carpets and furniture were very fine, the price they would have brought would only have been sufficient to keep us for a matter of months. And all prices had dropped considerably; all prices, that is, except the price of food. And this still continued to soar. Even had she been disposed to sell them, my grandmother's jewels were useless. The people wanted food, not jewelry, as the dealers took pains to point out when they offered a few lire for genuine stones worth hundreds. There seemed to be no way out of this impasse, and eventually my mother had to leave us and go to the Army depot behind the Gülhane Park.... My grandmother did the marketing, leaving us three children to look after ourselves. She would return with the shopping bag pitifully empty, for the money she had bought only the most meager supplies. It seemed to us that we had lived forever on lentils and cabbage soup and the dry, black apology for bread. Yet although our stomachs revolted against this diet, we were always so hungry that we would wolf down the tasteless, insipid mixtures almost with relish. Up and down the length of the street continued to come the fateful news of the dead or dying or wounded relatives. Fresh sickness broke out, for the people were starving; and they were likely to continue starving unless they bought from the Bourse noir, but who in that poor street was capable of raising sufficient money to buy from the Bourse noir? One day my grandmother took us to see my mother.... The building was old and dirty, and we went up a long, tortuous flight of broken wooden stairs, making a great deal of noise ... into a large, gloomy room where many women sat working at their machines.... It was the first time we had ever visited her here, and I was shocked by the dirt and the meanness and the poverty-stricken air of the place. My mother looked tired; her eyes were red-rimmed and her hands faintly soiled. All the fastidiousness

in me was revolted, and I felt impotent, childish rage that my mother should have to work in a place like this ... she said to my grandmother: "It would have been better not to have brought the children here"... My grandmother's face was cold and obstinate. "They will die with hunger if they stay much longer with me," she declared. "I am old and I can do with little food if necessary, but these are young and keep demanding, demanding – "....[7]

My mother was still at the Army sewing depot, and my grandmother looked after the little house. One day I went with her to market, but we could not buy anything. The shops were shuttered and closed, the few that remained open having only a little Indian corn for sale and rotten vegetables. Flour was treble its normal price, black and sour-looking, giving off an acrid smell. My grandmother looked at what she had bought and at the few remaining coins in her hands, then said in amazement: "This is the first time I have ever come back from market with money still left in my hand!" And that day we ate sour bread and soup that tasted like salt water. Then came a succession of days when only olive oil, much adulterated, could be poured over our ration of bread and I became so weak I was even unable to walk. I remember that I lay most of the day in the salon, faint with hunger and unable so much as to move a limb. Muazzez was with me, sitting on the carpet and whimpering that she was hungry, but I was far too lightheaded to pay much attention to her. Not until dusk did my grandmother return from some long trek she had made into the hills. She gave us bread, fresh, almost white bread, and quartered raw onions, and butter that was rank, but it made no difference to our appetites. We ate until we could eat no more, and Muazzez went to sleep where she was, stretched out on the carpet, and no one cared because she was not in bed.

My grandmother sat by the window, crying and talking to herself, as was her habit nowadays. "There is no food anywhere," she said. "For the first time in years I have money in my pocket, and there is nothing to buy with it...."[8]

imperial aims, whether to repopulate cities as a path to prosperity, or to stabilize unruly areas of the empire whose inhabitants were otherwise harder to control. In the modern era, however, this pattern had more ruthless national, sectarian aims. Nowhere would the Armenians be allowed to constitute more than 5–10 per cent of the total population. This goal would be achieved through brutal means.

Ottoman fears of Allied penetration into Cilicia (in central southeastern Anatolia) and potential Armenian collaboration there caused the first efforts at deportation of Armenians by the state in February and March of 1915. Foreshadowing the violence against Armenians to come, years before this, the attempted countercoup in 1909 against the CUP had also spilled over into pogroms against Armenians in Cilician Adana in which somewhere around 20,000 Armenians were massacred by mobs and Ottoman soldiers alike, their homes destroyed. Interestingly, the Arab grand shaykh of the respected Sunni

Figure 12.8 Armenians in Cattle Cars.

religious institution, al-Azhar University in Cairo, Sālim al-Bishrī (who held the position from 1909 until his death in 1916) issued a *fetwa* (an Islamic juridical ruling on a particular subject) in 1909 after hearing of the events in Adana. Countering a *fetwa* supposedly issued by a Turkish *müfti* urging the violence, al-Bishrī harshly condemned the perpetrators of the massacre and the Ottoman authorities who encouraged it as not behaving as Muslims, of violating the covenant of God, the pact with the non-Muslim *ahl-dhimma*, and thus of transgressing the tenets of Islam.[9] It would not be the last time that an Arab religious figure of significant status would demand of the Ottomans that treatment of the Armenian Christians conform to the promises made to *dhimmi*s according to the laws of Islam.

Also in March 1915 the provincial governor of Van, Cevdet Pasha, initiated policies that incited violence against Armenians in villages around Lake Van. An Armenian uprising in the city of Van to resist Ottoman forces lasted for weeks and was a bloody battle. Russian troops invaded to support the Armenians and seize whatever Ottoman territory they could. Muslims were evacuated from Van by May, but by summer the Ottomans had forced a Russian retreat. Thousands of Armenians withdrew with the Russians while the two imperial armies continued to fight over Van. The Ottomans' initial loss of Van, however, seems to have hardened the Unionists' resolve to rid the empire of those whom they considered subversive internal enemies – the non-Muslim Armenians.

While government orders were said to be given (not written) for the deportation of Armenians from war zones only, on April 24, 1915, literally as the Allied Gallipoli offensive was also about to begin, the political, cultural, and intellectual head of the Ottoman Armenian community, its elites in Istanbul – writers, merchants, educators, some of whom were even political officials such as parliamentary deputies, and many of whom were members of the Armenian National Assembly that had been established to govern the Armenian *millet* starting in 1863 – were rounded up, transported out of the capital, marched into the countryside, and massacred. This event and other deportations and massacres of Armenians from areas of Anatolia, which may or may not have been actual war zones, reflected the sinister nature of the deportations. Cattle cars were used to transport Armenian deportees (Figure 12.8). The temporary *Tehcir* Law allowing confiscation of Armenian property claimed it would be recorded in registers so that, upon conclusion of the war, it would be returned to rightful Armenian owners. This process never materialized. Property was redistributed to Ottoman Muslims or Muslim refugees from earlier conflict zones in the Balkans and the Caucasus, to assist in creating what would become a post-war Turkish middle class. From this moment, a state-orchestrated liquidation of the Armenian population of the Ottoman Empire between 1915 and late 1917 was systematically conducted through official policy as well as through "unofficial encouragement": the disarming of Armenian males in the military who became military laborers and were eventually executed; men in Armenian villages were rounded up, separated from their families, and massacred. Women, children, and the elderly were marched away from their settlements with nothing, robbed, tortured, raped, starved, massacred, preyed upon by mounted Kurdish *Hamidiye* units,

Turkish mercenaries, gendarmes ostensibly sent to guard the Armenians on the move, criminals intentionally released from Ottoman prisons, or resentful Muslims in mobs, eager to seek their revenge for previous violent sectarian episodes or who blamed Armenians for the empire's misfortunes (Figure 12.9). Forced conversions occurred but did not necessarily guarantee an Armenian's survival. Ottoman officials who refused to carry out such orders were threatened with dismissal and/or execution – of which there were such instances. The Armenians were deported to the southeast, often through Aleppo, to concentration camps set up in areas around the Syrian desert near Deir az-Zor, where many who had survived the deportations and marauding subsequently died of disease and starvation (Map 12.5).

Figure 12.9 Armenians Marched through Harput to a Prison in Nearby Mezire by Armed Turkish Soldiers, 1915.

Muslims did hide their fellow Christian brethren, sometimes out of kindness and kinship, at other times, for profit, by receiving bribes from Armenians who had sold their belongings before being forced to depart. Kurdish tribes with *Alevi* leanings in the Dersim area (southeast of Erzurum) had a reputation for resisting the Ottoman state's infringement on their independence. They had close ties to local Armenians and helped them flee to Russian territory after sheltering them from the reach of the Ottoman authorities. Armenian women were often seized and taken into harems. Armenian children were taken or adopted and raised as Muslim. *Sharif* Husayn, the Arab *emir* of Mecca (whose sons were the military commanders of his Arab Revolt against the Ottoman garrisons in Arabia since its irruption in 1916, to be discussed shortly), must have been informed of the plight of the Armenians; he was certainly sympathetic to their suffering at the hands of the Ottomans. He promulgated an Islamic decree in 1917 that was likely directed toward Arab tribal leaders in the desert areas of Syria and Iraq in which he implored them to behave compassionately, as honorable Muslims. Implicit in this statement is a subtle indictment of the Ottoman state's brutality and un-Islamic treatment of the Armenians:

> What is requested of you is to protect and to take good care of everyone from the Jacobite Armenian community living in your territories and frontiers and among your tribes; to help them in all of their affairs and defend them as you would defend yourselves, your properties and children. And provide everything they might need whether they are settled or moving from place to place, because they are the Protected People of the Muslims (Ahl Dhimmat al-Muslimīn) – about whom the Prophet Muhammad (may God grant him His blessings and peace) said: "Whosoever takes from them, even a rope, I will be his adversary on the day of Judgment." This is among the most important things we require of you to do and expect you to accomplish, in view of your noble character and determination....[10]

Map 12.5 (following page) Deportation Routes and Massacre Sites.

The 1915 Armenian Genocide in the Turkish Empire

This map illustrates three prevailing aspects of the 1915 Armenian Genocide: the deportations, the massacres, and the concentration camps. The deportations affected the majority of Armenians in the Turkish Empire. From as far north as the Black Sea and as far west as European Turkey, Armenians were forcibly removed to the Syrian desert. From the onset the deportations were marked by atrocities. At select sites, large-scale massacres were carried out. The survivors were dispersed across Syria, Iraq, and as far south as Palestine (see inset), where they were left in inhospitable places. Starvation, thirst, and epidemic diseases destroyed vast numbers of those confined to these places of concentration. The deportees in many concentration camps were eventually killed through further massacres. As this map demonstrates, the total effect of the policies of the Turkish government was the mass destruction of the Armenian people.

Produced by the Armenian National Institute (ANI) (Washington, DC) and the Nubarian Library (Paris). © ANI, English Edition Copyright 1998.

ARMENIAN NATIONAL INSTITUTE

www.armenian-genocide.org

Legend:

- ● centers of massacre and deportation
- ○ principal points of transit
- ▫ subsidiary points of deportation
- ■ principal destination points of deportation
- ····· boundaries of the eastern provinces
- ⊗ concentration camps
- → principal routes of deportation
- ┼┼┼ rail lines

WAR AND THE ARMENIAN GENOCIDE

SHOGHER TONOIAN'S SURVIVOR TESTIMONY, VILLAGE OF VARDENIS

On the day of [the Feast of] Vardavar, 1915, the Turkish askyars brought Chechen brigands from Daghestan to massacre us. They came to our village and robbed everything. They took away our sheep, oxen and properties. Those who were good-looking were taken away. My aunt's young son, who was staying with me, was also taken away, together with all the males in the town. They gathered the young and the elderly in the stables of the Avzut Village, set fire and burned them alive. Those cattle-sheds were as large as those of our collective farms. They shut people in the stables of Malkhas Mardo, they piled up stacks of hay round them, poured kerosene and set on fire. Sixty members of our great family were burned in those stables. I do not wish my enemy to see the days I have seen, lao! Only I and my brother were saved. From the beginning, they took away the young pretty brides and girls to Turkify them and also they pulled away the male infants from their mothers' arms to make them policemen in the future. The stable was filled with smoke and fire, people started to cough and to choke. Mothers forgot about their children, lao! It was a real Sodom and Gomorrah. People ran, on fire, to and fro, struck against the walls, trod upon the infants and children who had fallen on the ground.

... What I have seen with my eyes, lao! I don't wish the wolves of the mountain to see! They say that, at these distressing scenes, the Turkish mullah hung himself. During that turmoil the greatest part of the people choked and perished. The roof of the stable collapsed and fell upon the dead. I wish I and my little brother had been burned down in that stable and had not seen how sixty souls were burned down alive. I wish I had not seen the cruel and ungodly acts of those irreligious people. The

Armenians of the neighboring villages of Vardenis, Meshakhshen, Aghbenis, Avzut, Khevner and others were burned in the same manner in their stables. I do not wish my enemy to see what I have seen. There was a very old woman among us. Those who knew her called her Polo, Arshak's mother-in-law. She was about one hundred years old. When smoke began to enter the stable, she gathered the children and made them lie on their faces, their nose and mouth on the ground, then she made their mothers lay on them. She made my brother also lie on the ground. She took off her apron, covered him with it and pushed me to lie down on my brother and not let him get up, even if he cried. May God bless her soul.

That woman said: "Lao, what's the use of crying, we must act so that from each house one boy remains alive and comes out of the fire, so that their hearth is not extinguished, so that they may tell the world the acts of these godless and ruthless Turks. People, don't get disappointed, don't lose your head, be staunch in your belief. God is great; He shall open a door." I covered my brother with my body. Fallen on his nose and mouth in the dirt of the stable, the poor boy was not able to breathe, he wanted to come out. He cried and cried, he cried so much that he fainted and calmed down. When the roof of the stable collapsed, the flame and the smoke escaped from the opening, and air penetrated in the stable.

I and my uncle's daughter, Areg, took my unconscious brother by the arms and legs and, treading on burned logs and corpses, we came out through the breach. There we saw the Turkish soldiers dancing in round, swinging and striking their sabers and singing merrily "Yürü, yavrum, yürü!" (Dance, my child, dance! – Turk.). Up to this day that song resounds in my ears. That dance, lao, should never be danced in an Armenian house;

that's the dance of the ruthless, godless, wild beasts. Fascinated with the dance they did not see us. I put my brother on my back and ran away. I escaped and entered the nearby reeds. When dark fell I took my brother and ran away. How far did I run, or where, I don't know? Suddenly I saw people coming toward us. I took my brother and hid under the shrubs. Then I heard those people speaking Armenian. I ran and joined the group....[11]

AN ARAB BEDOUIN, BASHIR AL-SAADI, RAQQA

In 1915, I was 14 years old. I was a shepherd grazing the animals of our people on the bank of the Euphrates River, near Rakka. I saw groups of people – tired, exhausted, in rags, half-naked, who came to our areas.

Later, I learned that the Turkish government had deported them from their homeland and had driven them to the Syrian deserts.

Those Armenian exiles had walked under the guard of Turkish gendarmes for days, without knowing where they were going. They left their relatives by the roads. These were unable to walk and many of them had been killed by the Turks.

I and my cousins used to go to the desert on our camels and, seeing their miserable state, helped them by milking our camels and giving them the milk to drink instead of water. They were so emaciated and weak that all of a sudden they fell down on the ground and died like sheep.[12]

Figure 12.10 The Armenian Genocide. Armenian woman kneeling beside dead child in field "within sight of help and safety at Aleppo."

The American Committee for Armenian and Syrian Relief, founded in 1915 with the assistance of foreign missionaries and consuls in the empire, distributed aid and food to Armenian refugees; renamed the American Committee for Relief in the Near East in 1918, it provided assistance in resettling the many surviving Armenians across some of the new Arab nations founded after the war.

The debate still rages as to whether what happened to the Armenians constituted a genocide. Armenian diaspora communities, survivors (and their descendants), and many scholars today argue that it was undeniably a genocide, a crime against humanity, a systematic attempt to annihilate "in whole or in part, a national, ethnical, racial or religious group..."[13] The argument for genocide relies on the thorough and systematic nature in which the deportations were carried out, the violent, sectarian nature of the eradication of Armenians (and Assyrians) from Anatolia, the testimonials of survivors, records of other eyewitness accounts, and documentary evidence. Ethnic cleansing of the Armenians by an Ottoman regime whose ringleaders were vehement secular Turks was a modern by-product of racially defined Turkish nationalism; the Unionist architects of the genocide merely employed Islamic identity as a convenient tool to motivate mobs to commit sectarian murder. Foreign diplomats and Christian missionaries directly witnessed the atrocities and the violence. Foreign newspapers reported widely on what was happening to Christians in the Ottoman Empire. Post–World War I war crimes trials that were held by the remnants of the Ottoman government and the Allies in occupied Istanbul (until they were suspended in 1920) left court transcripts recently unearthed by scholars that prove the culpability of the Unionist government in specifically ordering policies resulting in a genocide.

The government of the Turkish Republic, however, and indeed still many people understand what happened not as a genocide, but as the unfortunate events of wartime mobilization, emphasizing the fact that massacres were perpetrated by both sides, that foreign attacks on several fronts occurred simultaneously, and that over the course of the war more Ottoman Muslims were killed than Armenian Christians. Even the exact number of Armenians killed is hotly debated. It falls somewhere between 500,000 and 1.5 million, depending upon which side's figures are being presented. The Turkish Republic's official statements deny a genocide on various grounds, arguing that what it calls the "alleged genocide" was merely the consequence of war; that there were radical Armenian nationalists who were a subversive element endangering the empire in a time of war; that many Armenians chose to leave with the Russian withdrawal; that the Ottoman government only wanted to remove Armenians from war zones (though the historical record indicates otherwise); that no official orders were given but that uncontrollable sectarian violence was a natural outcome of the wartime situation. Turkey condemns many of the foreign accounts of the genocide by pointing out the Orientalist, racist tone expressed toward Muslims and Turks in these Westerners' memoirs (such as that of Henry Morganthau, cited at the beginning of this book), though it does not negate their witnessing of atrocities and massacres nor some of the damning statements made to them by members of the Unionist triumvirate who orchestrated the genocide.

SECRET DEALS, THE ARAB REVOLT

The onset of World War I not only triggered the international alliances pulling the Great Powers into war, but it also put in motion efforts to carve up the Ottoman Empire that would solve the Eastern Question once and for all after the war concluded. Russia, Britain, and France secretly signed the Constantinople Agreement in March 1915 granting Russia control of the Bosphorus and Dardanelles straits, the city of Istanbul as a free port, and what was left of Ottoman Europe (eastern Thrace), in return for British and French "spheres of influence" over new states to be created in what was the Ottoman Middle East. The Allied failure at Gallipoli impeded the execution of this agreement. Meanwhile, *Sharif* Husayn, Hashemite *emir* of Mecca, was in a delicate position between the Ottoman demand for loyalty from him as their appointee, and the British desire to create a fifth column inside the empire that could disrupt the possibility of the sultan's call for *jihad* to be effective. His son Prince Abdullah (future King Abdullah of Transjordan) subtly investigated British attitudes toward Arab aspirations. Once *Sharif* Husayn determined the Unionists were interested in getting rid of him, another son, Prince Faysal (future king of Iraq), went to work making contact with both the Unionists (to discern Ottoman motives) and with Arabist societies in Greater Syria who contemplated seeking independence from the Ottomans, but who did not want to set in motion the possibility of foreign rule replacing the Turks either. The result was first, the Damascus Protocol of 1915, which laid out Arabists' territorial demands to be presented to the British for an independent kingdom in return for an Arab revolt. Second, the Husayn-McMahon Correspondence, a series of letters exchanged between *Sharif* Husayn and the British high commissioner in Egypt between 1915 and 1916, which reiterated that an Arab revolt against the Ottoman Empire would be carried out to tie down Ottoman troops in Arabia in exchange for a post-war independent Arab caliphate headed by *Sharif* Husayn. Boundaries of this future Arab kingdom were intentionally left ambiguous, with the British cautious to consider their earlier treaties with Arab sheikhdoms and wanting their strategic positions in the Persian Gulf to be protected.

In complete contradiction to the Husayn-MacMahon letters, the British and French signed the secret Sykes-Picot Agreement in 1916 (with tacit Russian approval) in which the Ottoman Empire was to be divided into direct areas of colonial control and indirect areas of influence by European and Russian powers. Already recognizing the potential conflict that could ensue concerning the "Holy Land" and various religious sites in Ottoman Palestine, particularly around Jerusalem, the agreement labeled that district an "Allied condominium," which implied the future establishment of an international administration in an area considered sacred to Muslims, Christians, and Jews (Map 12.6). Previous conflict between Catholic and Orthodox Christians, and more recently the influx of Jewish immigrants from eastern Europe to the region, made this arrangement all the more imperative. Nonetheless, the British complicated the picture even further by also issuing the Balfour Declaration in 1917, which promised the Zionist movement "the

The Sykes-Picot Agreement, 1916

establishment in Palestine of a national home for the Jewish people ..., it being clearly understood that nothing shall be done which may prejudice the civil and religious rights of existing non-Jewish communities in Palestine...."[14] In the same month, the Bolshevik Revolutionaries overthrew the Russian tsar in 1917. Russian forces withdrew from the war, and the revolutionaries, seizing papers from the previous Russian regime, published a copy of the Sykes-Picot accord in *Pravda* and *Isvestia*. The news reached the British papers shortly thereafter in late November. This was how the Arabs finally discovered the British betrayal of support for Arab independence. These agreements, all contradictory promises made to gain temporary allies, foment dissent against the Ottomans, and preserve British, French, and Russian interests, were at the expense of Arab aspirations for independent nationhood in the aftermath of the war.

But before this news came out, starting in 1915, Ottoman military commander Cemal Pasha had already started exiling Christian and Muslim Arab intellectuals and activists

Map 12.6 The Sykes-Picot Agreement, 1916.

Figure 12.11 Prince Faysal and Lawrence at Guweria during the Arab Revolt.

belonging to Arabist secret societies in Greater Syria whom the Unionists considered to be a dangerous element in their midst. In part due to starvation, and in part due to Cemal's ruling Greater Syria with an iron fist throughout the duration of the war, the majority of the Arab population there did not rise in revolt. His punishment for anyone belonging to Arab secret societies had escalated – from exile to arrest for treason, torture, and execution by hanging, carried out in Beirut and Damascus in May 1916.

The terms of the Sykes-Picot Agreement not having been made public yet, the Arab Revolt began in Arabia in June of 1916 under the leadership of *Sharif* Husayn and his sons. The British had dispatched T.E. Lawrence, the famous "Lawrence of Arabia" – a young, knowledgeable intelligence officer who had met Prince Faysal previously – to investigate what the British could do to support the Arab Revolt without stirring up too much anti-British resentment. The decision was made to supply cash and arms, but no troops. The Arabs were eventually able to control the Hijaz; they harassed the Hijaz railway and conducted guerrilla warfare against Ottoman positions. A two-pronged assault on Ottoman Syria was launched from the Arab Hashemite forces (with Lawrence's famous participation) on one side (Figure 12.11) and the British campaign up from Sinai and Palestine on the other in 1916. Hashemite forces entered the port of Aqaba in July of 1917. The Anglo-Indian forces of the Mesopotamian campaign had already reached Baghdad. British forces initially failed at Gaza but General Edmund Allenby, the commander of the Egyptian Expeditionary Forces, reached Jerusalem in December 1917, a month after the revelations about the Sykes-Picot Agreement had come to light in the Russian papers. Even Cemal Pasha's appeals to cease aiding the

British after their betrayal did not dissuade the Hashemites from continuing the Arab Revolt and progress into Syria. Allenby's forces, the Australian Mounted Division, and the Arabs of the revolt led by Prince Faysal and Lawrence entered Damascus victoriously on October 1, 1918. The Ottoman Middle East and much of the empire's Arab lands were lost. It was now a matter of Ottoman survival in Anatolia, as the tide turned for the Allies.

GREAT WAR ENDS, ANATOLIAN WAR CONTINUES; THE POLITICAL AFTERMATH

With the departure of Russian troops from eastern Anatolia following the Russian Revolution, the Armenian forces were left to fight the Ottomans, and by 1918 Ottoman armies had retaken much of the territory. The systematic genocide of the Armenians had tapered off, but from 1918 into the 1920s, Armenians, Turks, and Kurds all continued to fight and kill one another. Signing the Treaty of Brest-Litovsk in March of 1918 established peace with the new Bolshevik Russia and restored to the Ottomans three eastern provinces lost to the empire in 1878 – Kars, Ardahan, and Batum, which the Ottomans annexed officially in August 1918. The Ottoman military had performed well in multiple fronts of the war, much to the surprise and frustration of the Allies, but ambitious plans to continue the momentum in the east, again led by Enver Pasha, would prove another fatal error at a moment in which the Central Powers were losing ground in Europe. Russian, Armenian, Ottoman, and Azeri interest in controlling Baku on the Caspian Sea, with its considerable oil reserves, had created competition. An Ottoman-Azeri alliance was signed in June of 1918. Enver Pasha chose to push into the Caucasus with forces to "liberate" Baku by September 1918, squandering troop strength there, just a month before the significant Ottoman losses to the British in Palestine and the Allied entry into Damascus in October 1918. Combined with the successful Anglo-Indian Mesopotamian campaign the year before, the collapse of the southern front signaled the turning tide in the war against the Ottomans.

Mehmed VI Vahideddin (r. 1918–22) became the last Ottoman sultan, enthroned in July of 1918, in the midst of Enver's Baku offensive. When the Unionist cabinet (with Talaat Pasha as *grand vezir*) resigned in October of 1918, Bulgaria had already capitulated the month before, and a new Ottoman government negotiated for peace aboard the British ship *Agamemnon*. The Unionist leadership fled aboard German vessels to Odessa and eventually arrived in Berlin. The Mudros Armistice was signed on October 30, 1918, and the Allies sailed up the Dardanelles to occupy Istanbul in November. The British forces continued to push into oil-rich Mosul for another two weeks after the armistice was signed, creating a political stumbling block during further peace negotiations because the Ottomans insisted it was not included in the armistice. And though Mosul had been allotted to the French according to the Sykes-Picot Agreement, a deal was struck with the French to grant

Mosul to the British while the French gained Syria and Lebanon. It was an arrangement officially recognized by Woodrow Wilson's newly founded League of Nations in January of 1920, effectively erasing any Ottoman claims to the region and legitimating the post-war Mandate system that would be put in place to guarantee British and French colonial hegemony as laid out in the Sykes-Picot Agreement – design and control of the Middle East (and elsewhere) – for decades to come.

In 1919 post-war developments occurred apace. The preliminary meetings of the victors in war met in early 1919. The Paris Peace Conference, with its Supreme Council members Britain, France, Italy, and the United States (Japan possessed a secondary status), resulted in the Treaty of Versailles, signed in June 1919. In April 1919 the feeble Ottoman government in Istanbul decided, particularly at American and British insistence, to hold military tribunals for war crimes committed against the Armenians. The prosecution held the Unionist regime completely responsible, while the defense of those on trial was that they could not control the violence of the mob, the Muslim masses. Court-martials resulted, though only a few death sentences of those found guilty were actually carried out. The primary perpetrators – the triumvirate, Dr. Bahaeddin Şakir and others, were convicted and sentenced to death in absentia. By 1920, with other events consuming the Ottomans in Anatolia, the trials lapsed and were eventually suspended. Nonetheless Armenians got their revenge: Talaat Pasha was assassinated in 1921, shot dead at point blank range in Berlin by an Armenian survivor; the assailant was acquitted by the German court. Dr. Bahaeddin Şakir was also assassinated in Berlin in 1922. Cemal Pasha met an assassin's bullet in 1922 in Tiflis (Tbilisi in modern Georgia). Enver Pasha, never having relinquished his ambitions in the East, was killed in Central Asia fighting the Bolsheviks in 1922.

Europe's plans to parcel off Anatolia were also gaining momentum in early 1919, with Sykes-Picot serving as the initial blueprint. In April and May of 1919, Italy invaded and occupied southwestern Anatolia to enlarge its vision of another Roman Empire. Greek forces landed at Izmir in May of 1919, and, with the sanction of the Allies, moved to occupy more of western Anatolia from there, ushering in yet another round of intercommunal violence as the Greeks advanced east. In May of 1919 Mustafa Kemal, war hero at Gallipoli and an officer at several fronts during the war, was appointed general inspector and sent to Samsun to oversee the demobilization of the Ottoman army. Given the somber, defeated mood in occupied Istanbul, and the multiple invasions of Ottoman Anatolia by foreign powers, Mustafa Kemal's nationalist desire to free what was left of the empire from being completely parceled off and colonized led him to disobey orders. Escaping to inner Anatolia, he launched the Turkish nationalist movement with remnants of the Ottoman army, regrouped and willing to fight what became known as the Turkish War of Independence, from 1919 to 1922.

In the summer of 1919, at the same time in which the American King-Crane Commission traveled to non-Turkish (Arab) areas of the former Ottoman Empire to investigate the post-war political wishes of the peoples there, several Turkish nationalist

The Turkish War of Independence, 1919-23

Legend:

Retained by French	Retained by Italians
French Occupation	Italian Occupation
French Claims	Italian Claims

Retained by British	Armenia
British Occupation	Armenian Claims

Georgia	
Georgian Claims	

Greece in 1914

Greek Invasion Furthest Extent

Allied Occupation

1923 Borders

1914 Borders

Map 12.7 Treaty of Sèvres.

congresses were held in the hinterlands of Anatolia, which resulted in the adoption of a Turkish National Pact recognizing the aims of Kemal's nationalist movement in January of 1920 (a Turkish Grand National Assembly held in Ankara would replace the former Ottoman parliament). While the political and military landscape began to shift in Anatolia, the San Remo Conference held in April of 1920 resulted in the Treaty of Sèvres, a treaty the Turkish nationalists vehemently rejected and ultimately defeated militarily (Map 12.7). This treaty was to grant Cilicia and Alexandretta in southeastern Anatolia to France; Italy would retain the Dodecanese Islands and acquire southern Anatolia (around Antalya and Konya). Izmir and western Anatolia would go to Greece, and some of Thrace would fall under a Greek administration. The Dardanelles and Bosphorus straits and the Sea of Marmara would be declared international waters, and Istanbul would be a commercial "free zone" within a curtailed Ottoman state. A Kurdistan would be created in eastern Anatolia, though boundaries were ambiguous

Map 12.8 Turkish War of Independence, 1919–22.

and overlapped with Armenian claims. The newly founded Armenian Republic (in May 1918) in the Caucasus and the diaspora Armenian communities demanded large areas of eastern Anatolia and Cilicia, to which US President Wilson initially agreed. Ottoman Turkey would be restricted to northwest and north central Anatolia only; the Capitulations which had been abolished by the Young Turks would be re-enacted; Ottoman commercial interests (railroads, coal mines, and other industries and infrastructure) would be placed under European control. The Ottoman army would be reduced to merely a gendarmerie.

Turkish nationalists led by Mustafa Kemal's vision for a modern Turkish nation-state found a way to resist challenges to their aspiration (Map 12.8). Turkish and Bolshevik mutual interest in limiting the Armenian Republic's demands resulted in an agreement that pacified the Turks' eastern frontier with Russia, thus thwarting Armenian aims there. The newfound "friendship" with the Bolsheviks produced the Turks' first arms supplier to use against foreign occupiers to the west. The Turkish army then pushed back the occupying forces, again fighting multiple adversaries at once – major Greek offensives in the west and Armenian forces in the Caucasus in 1920–1, forcing Italian and French evacuations by 1922, and eventually driving back the Greek occupation in 1922. The Turkish recapture of İzmir became the last dramatic scenes of carnage when the city was lit afire and burned to the ground, with its primarily non-Muslim civilian population trapped at the waterfront, many choosing to leap into the sea or to escape the bloodshed and the inferno aboard overloaded lifeboats (Figures 12.12 and 12.13).

Figure 12.12 Burning of Smyrna (Izmir), September 1922.

Figure 12.13 Smyrna Dock, 1922.

Figure 12.14 Mustafa Kemal
Atatürk.

A cease-fire with the Turkish army was concluded with the Armistice of Mudanya in October of 1922. The Ottoman Empire could be said to have slowly faded from view, overshadowed by the Allied occupation of the capital in 1918 and the Turkish nationalist movement achieving militarily what the Ottoman administration could not. The Turkish Grand National Assembly assumed more legitimate power over events in 1922, and in November, the decision was made to officially abolish the political office of the Ottoman Sultanate. Temporarily maintaining the spiritual office of the caliphate, a new caliph was chosen from the Ottoman dynasty, Abdülmecid II (r. 1922–4), just as the last Ottoman sultan, Mehmed VI Vahideddin, departed for Malta on a British ship. The Conference of Lausanne ensued for weeks and resulted in the Treaty of Lausanne in July 1923, which overrode the former Sèvres Treaty. The Turks had won their nation: on October 29, 1923, the Turkish Republic was declared, with war hero Mustafa Kemal as its first president (Figure 12.14). He was soon to be known as Atatürk, "father of the Turks." The Ottoman Caliphate was abolished by the Grand National Assembly in March 1924. The new Turkish Republic, led by Atatürk, embarked upon a rapid and dramatic program to create a modernized, secular, Western-oriented Turkish nation in Anatolia, built upon the ashes of Ottoman defeat and destruction. The Ottoman past was to be forsaken.

NOTES

1 Yücel Yiğit, "The *Teşkilat-ı Mahsusa* and World War I," *Middle East Critique* 23, no. 2 (2014): 160.

2 Edward J. Erickson, "Reexamining History: Armenian Massacres: New Records Undercut Old Blame," *Middle East Quarterly* 13, no. 3 (Summer 2006): 69.

3 Eugene Rogan, *The Fall of the Ottomans: The Great War in the Middle East* (New York: Basic Books, 2015), 141.

4 "Annexe D: Statistical Analysis of the racial elements in the Ottoman vilayets of Erzeroum, Van, Bitlis, Mamouret-ul-Aziz, Diyarbekir, and Sivas: drawn up in 1912 by the Armenian Patriarchate at Constantinople," in Viscount Bryce, *The Treatment of Armenians in the Ottoman Empire: 1915–16. Documents presented to Viscount Grey of Fallodon, Secretary of State for Foreign Affairs* (London: HMSO, 1916).

5 Irfan Orga, *Portrait of a Turkish Family* (New York: Macmillan, 1950), 140. Reprinted by permission of Eland Publishing Ltd. Text and Afterword © Ates D'Arcy-Orga, 2011.

6 Orga, *Portrait of a Turkish Family*, 165–9.

7 Orga, *Portrait of a Turkish Family*, 177–8.

8 Orga, *Portrait of a Turkish Family*, 189.

9 Shaykh al-Azhar Sālim al-Bishrī, "Condemnation of the Adana Massacre (1909)," https://ballandalus.wordpress.com/2015/04/22/condemnation-of-the-adana-massacre-1909-by-shaykh-al-azhar-salim-al- bishri-d-1916/.

10 Sharif of Mecca, "The Hashemite Royal Court, Decree issued in 1917 by the Sharif of Mecca for the Protection of Armenians," from Harut Sassounian, comp., *The Armenian Genocide: Documents and Declarations 1915–1995* (Glendale: 80th Anniversary of the Armenian Genocide Commemorative Committee, 1995), 62–3.

11 "Shogher Tonoian's Testimony 1901, Mush, Village of Vardenis," *The Armenian Genocide: Testimonies of the Eyewitness Survivors*, testimony 9 (Yerevan: "Gitoutyoun" Publishing House of NAS RA, 2011), 98–9, accessed at The Armenian Genocide Museum-Institute Foundation, http://www.genocide-museum.am/eng/Shogher-Tonoyan-eng.php.

12 "Bashir Al Saadi's Testimony, 1901, RAQQA," Verjine Svazlian, *The Armenian Genocide: Testimonies of the Eyewitness Survivors*, testimony 303 (Yerevan: "Gitoutyoun" Publishing House of NAS RA, 2011), 498–9. Accessed at The Armenian Genocide Museum-Institute Foundation, http://www.genocide-museum.am/eng/Bashir-El-Saadi-eng.php.

13 The 1948 United Nations Convention on the Prevention and Punishment of the Crime of Genocide defines genocide as consisting of "(a) Killing members of the group; (b) Causing serious bodily or mental harm to members of the group; (c) Deliberately inflicting on the group conditions of life calculated to bring about its physical destruction in whole or in part; (d) Imposing measures intended to prevent births within the group; (e) Forcibly transferring children of the group to another group." UN General Assembly, Resolution 260 A (III), Convention on the Prevention and Punishment of the Crime of Genocide, (December 9, 1948), https://www.un.org/en/genocideprevention/documents/atrocity-crimes/Doc.1_Convention%20on%20the%20Prevention%20and%20Punishment%20of%20the%20Crime%20of%20Genocide.pdf.

14 *The Balfour Declaration*, November 2, 1917, British Library Add MS 41178 A, http://www.bl.uk/manuscripts/FullDisplay.aspx?ref=Add_MS_41178_A.

SELECTED READINGS

Akçam, Taner. *From Empire to Republic: Turkish Nationalism and the Armenian Genocide*. New York: Zed Books, 2004.

Akçam, Taner. *A Shameful Act: The Armenian Genocide and the Question of Turkish Responsibility*. Translated by Paul Bessemer. New York: Metropolitan Books, 2006.

Akçam, Taner. *The Young Turks' Crime against Humanity: The Armenian Genocide and Ethnic Cleansing in the Ottoman Empire*. Princeton: Princeton University Press, 2012.

Akın, Yiğit. *When the War Came Home: The Ottomans' Great War and the Devastation of an Empire*. Stanford: Stanford University Press, 2018.

Aksakal, Mustafa. "'Holy War Made in Germany?' Ottoman Origins of the 1914 Jihad." *War in History* 18, no. 2 (2011): 184–99.

Aksakal, Mustafa. *The Ottoman Road to War in 1914: The Ottoman Empire and the First World War*. Cambridge: Cambridge University Press, 2008.

Anscombe, Frederick. *The Ottoman Gulf: The Creation of Kuwait, Saudi Arabia, and Qatar*. New York: Columbia University Press, 1997.

Astourian, Stephan. "The Armenian Genocide: An Interpretation (in Historiography)." *The History Teacher* 23, no. 2 (February 1990): 111–60.

Bloxham, Donald. *The Great Game of Genocide: Imperialism, Nationalism, and the Destruction of the Ottoman Armenians*. New York: Oxford University Press, 2005.

Erickson, Edward J. *Gallipoli: The Ottoman Campaign*. Barnsley, UK: Pen & Sword Military, 2010.

Erickson, Edward J. "Reexamining History: Armenian Massacres: New Records Undercut Old Blame." *Middle East Quarterly* 13, no. 3 (Summer 2006): 67–75.

Fewster, Kevin, Veciji Başarın, and Hatice Hürmüz Başarın. *Gallipoli: The Turkish Story*. Sydney: Allen & Unwin, 2003.

Fromkin, David. *A Peace to End All Peace: The Fall of the Ottoman Empire and the Creation of the Modern Middle East*. New York: Henry Holt and Company, 1989.

Hanioğlu, M. Şükrü. *A Brief History of the Late Ottoman Empire*. Princeton: Princeton University Press, 2010.

Kasaba, Reşat. "Izmir 1922: A Port City Unravels." In *Modernity and Culture from the Mediterranean to the Indian Ocean, 1890–1920*, edited by Leila Fawaz, C.A. Bayly, and Robert Ilbert, 204–39. New York: Columbia University Press, 2001.

Kent, Marian, ed. *The Great Powers and the End of the Ottoman Empire*. London: Frank Cass, 1996.

Khalidi, Rashid, Lisa Anderson, Muhammad Muslih, and Reeva Simon, eds. *The Origins of Arab Nationalism*. New York: Columbia University Press, 1991.

Lewy, Guenter. *The Armenian Massacres in Ottoman Turkey: A Disputed Genocide*. Salt Lake City: The University of Utah Press, 2005.

Nezir-Akmeşe, Handan. *Birth of Modern Turkey: The Ottoman Military and the March to World War I*. New York: I.B. Tauris, 2005.

Rogan, Eugene. *The Fall of the Ottomans: The Great War in the Middle East*. New York: Basic Books, 2015.

Safi, Polat. "History in the Trench: The Ottoman Special Organization – Teşkilat-ı Mahsusa Literature." *Middle Eastern Studies* 48, no. 1 (January 2012): 89–106.

Sassounian, Harut, comp. *The Armenian Genocide: Documents and Declarations 1915–1995*. Glendale: 80th Anniversary of the Armenian Genocide Commemorative Committee, 1995.

Suny, Ronald Grigor. *"They Can Live in the Desert but Nowhere Else": A History of the Armenian Genocide*. Princeton: Princeton University Press, 2015.

Suny, Ronald Grigor, Fatma Müge Göçek, and Norman M. Naimark, eds. *A Question of Genocide: Armenians and Turks at the End of the Ottoman Empire*. New York: Oxford University Press, 2011.

Tokay, Gül. "Austro-Ottoman Relations and the Origins of World War One, 1912–14: A Reinterpretation." *Perceptions Journal of International Affairs* 20, no. 2 (Summer-Autumn 2015): 39–58.

Yığıt, Yücel. "The *Teşkilat-ı Mahsusa* and World War I." *Middle East Critique* 23, no. 2 (2014): 157–74.

THIRTEEN

EPILOGUE: OTTOMAN LEGACIES AND TURKEY'S GHOSTS

The last decades of the Ottoman Empire's existence were a tragic end to a vast and long-lived empire that seemed for centuries to have adjusted to economic, military, and social changes in the world, while also retaining its internal flexibility to manage and survive domestic crises. The longevity of the Ottoman dynasty itself speaks to this adaptability. Enduring as it did for over six hundred years, the ability of a sultan and his household to exert political authority evolved over time. The sultans of the first half of the empire's existence carried out a more direct role in decision-making and the leading of campaigns. Post-Süleymanic sultans (with a few exceptions) increasingly became the symbol of Ottoman sovereignty rather than the executors of real political and military power. The deposition or even execution of an Ottoman sultan at various times in the latter centuries of the empire never resulted in the overthrow of the dynasty entirely, however. It resulted in merely the replacement with another member of the royal family on the throne, as if to keep sacrosanct Ottoman dynastic entitlement to rule while more pragmatic arrangements for the actual administration of the empire fell to other individuals or groups that could be the custodians of Ottoman imperial authority. Changes in global trade routes, the transformation of warfare technology, the effects of climate, domestic political rebellions, scientific and philosophical discoveries, all of these factors posed significant challenges to the Ottomans, yet the empire adjusted, reoriented, survived.

So what happened at the end of the Ottoman Empire's lifespan that proved insurmountable? Was it merely that Ottoman flexibility in the last decades of empire failed? Could the Ottoman Empire simply not adjust to the demands of the modern world, falling behind in modernization that eventually sealed its fate? This is too simple an explanation, one that demeans what was actually an impressive ability by the Ottomans to carry on amid a constant stream of wars and territorial losses, environmental calamities, economic disadvantages caused by detrimental, antiquated agreements with other states or empires, and perhaps also by the very fact of its location as a coveted crossroads between Europe and Asia. This made the empire a vulnerable target for intervention by foreign interests, with

its vast and ethnoreligiously, culturally diverse territorial domains that reached across what are now over forty different countries today – across the Middle East, North Africa, the Balkans, and the Caucasus. The Ottoman Empire was unlike Japan, for example, which benefitted from its relative homogeneity and its remote geography. Tucked away in the far reaches of East Asia, the Japanese islands developed, modernized, and for the most part remained free from much of the Western interference that came to define the late Ottoman era. The Ottoman Empire was geographically connected to – as well as a constant actor in and involved with – Europe, Africa, and Asia. More directly affected by external forces, Ottoman survival relied upon political and cultural adaptability as changes in the world manifested.

Examples of Ottoman flexibility and pragmatism have been explored in previous chapters, whether it was the Ottoman policy of acceptance of difference creating a relatively stable coexistence among various ethnic and/or religious groups, or the accommodation between orthodox Sunni Islam and mystical Sufism despite some moments of hostility toward heterodox forms of religious practice, or the flexibility the Ottoman state demonstrated in organizing fiscal policies across the immense expanse of the empire based upon the practicality of employing pre-existing precedents in different regions. Ottoman tolerance for difference among the various non-Muslim *millet*s was an acceptable societal arrangement in the pre- and early modern eras when in fact it allowed minority communities more autonomy and less discrimination than was the case in Europe. Taxation, land tenure, and military forces were managed through the use of *timar*s in one time and place in Ottoman lands, and through tax farms by often autonomous provincial elite notables in another, depending on need and achievability. If one takes the notion of the Ottoman Empire as a "provisioning organism," this organism, at its height, had to be flexible across climatic, geographic, demographic, and economic variances in order to acquire and redistribute provisions to armies on campaign and the general population in urban centers while also extracting revenue – from rural agricultural settlements and elsewhere. Despite the complexities of these demands over time and place, the Ottoman Empire did endure, albeit a very changed polity in the twentieth century from what it had been before.

Perhaps what can be said is that by the late nineteenth and early twentieth centuries, it was the world that had become less flexible, so that the Ottoman tendency toward pragmatism and adaptable means to function in this changed world was no longer as feasible. The demand for legal equality between communities in the Ottoman Empire (made both domestically and internationally) began to supercede the willingness on the part of minorities to accept the second-class citizenship implicit in the very *millet* arrangements that emphasized ethnoreligious difference underpinning proto-national identities in the Ottoman Empire. Whereas sociocultural autonomy and economic power without political equality had been sufficient to placate non-Muslims in the past, this was no longer a satisfactory societal structure according to principles in this "new world order." The Ottomans attempted to redress the issue with the *Tanzîmât* decrees reshaping the state's

relationships with its peoples in terms of taxation, conscription, and law. Both Muslim and non-Muslim provincial notables far from the political center sometimes continued to enjoy their autonomy and ignored *Tanzîmât* edicts, compelling the state to either excuse the defiance, or resort to brute force to suppress it.

So the Ottoman administration did try to adapt in the nineteenth century – but in a more rigid, inflexible world of binding political alliances and ruthless international economic competitions; of institutional reform not organically Ottoman in its origin, but in many cases, introduced out of insistence from outside and amid threats to Ottoman sovereignty; and during the introduction of innovative intellectual currents that could be said to be restricting how Ottomans understood themselves and their fellow members of Ottoman society, since now "difference" contained within it the seeds of separatism from the empire, and not coexistence within it. The modern world, and specifically the hegemony of a Western-inspired modernity, constricted the possibilities the Ottomans could explore to survive in this new reality. Institutional reforms from the *Tanzîmât* era onward, implemented from above and based upon Western patterns as they were, perhaps precluded other possible avenues of reform for the Ottomans that may have better satisfied those elements within the empire who instead rebelled, demanded their own styles of reform, and through conflict became independent in the mid-late nineteenth and early twentieth centuries.

What is meant here by an "inflexible world," for example, is the coercive nature of the Capitulations in the latter decades of the empire, which restricted Ottoman economic independence and devastated local industries, and incidentally also heightened ethnoreligious differences among Ottoman subjects due to perceived (and real) commercial advantages being extended to non-Muslims. The obligation by the empire to abide by the financially burdensome terms of the European-controlled Ottoman Debt Administration after Ottoman bankruptcy was declared in 1875 merely exacerbated the dire fiscal crisis and prevented the state from ever unshackling itself from its debt-induced condition. The economic consequences of these constraints over the last decades of the empire's existence only served to place a stranglehold on the Ottoman administration's ability to make policy choices independent of Western demands. These demands typically did not consider the Ottoman Empire's well-being, but instead were European considerations of the Eastern Question and how to benefit their interests. Combined with this was the deepening relationship and eventual alliance made with Germany, followed by the ambitions of the CUP triumvirate that soon dragged the empire into World War I on the side of the Central Powers, creating wartime mobilization and even less Ottoman flexibility in governing. Tremendous Ottoman resources and manpower were funneled toward the war effort, the populace had to be kept in line, sent to the front to fight, and any dissent was dealt with severely.

Two examples of the negative effects elicited by the pressure on the Ottoman state to conform to Western forms of modernity may suffice to further illustrate the point. First, the Ottoman state's compulsion to want to forcibly settle and contain pastoral

nomadic groups in certain areas of the empire stemmed from both the need to increase economic productivity in a climate of fiscal crisis, as well as a kind of state-projected "Orientalist" attitude toward Bedouin and nomads as primitive and barbaric, at a time when the empire needed to project an image to the West as "civilized." Striving to tempt or to coerce nomadic tribes into accepting a life of settled cultivation often resulted in costly rebellions for the empire, however, in terms of military manpower and resources. Second, methods of dealing with orphans in the Ottoman Empire had traditionally been through the social structure of the *millet* system – in other words, orphans were often cared for by the particular community from which they originated, in an informal kind of response to the child's loss of parents, or if they were the product of an unwanted pregnancy, etc. But with the introduction of state-run orphanages as an element of Western-style institutional modernization in the empire, as well as the involvement of Christian missionary foundations in the empire operating among its non-Muslims (whom the missionaries hoped they could convert to Catholicism or Protestantism provided they indoctrinated them early enough), the competition between the Ottoman state, the *millet*s, and the missionaries over controlling orphans became a cruel and inflexible scenario for the children who were supposed to be helped. The Ottoman state became engaged in a rather impractical effort to deal with orphans that actually witnessed high mortality rates of these children.

Arriving alongside the Ottoman state's insistence on introducing Western forms of political organization in the nineteenth century, which disrupted the traditional order, came that most destructive ideology to the social fabric of the Ottoman Empire starting in the early nineteenth century and culminating at the turn of the twentieth: the attraction to nation-state nationalism among significant portions of the Ottoman population. The advent of nationalism in Europe eventually unleashed similar forces informing identity among Ottomans. Minorities who had previously identified themselves as members of this or that *millet* within the larger Ottoman polity, and as Ottomans first, now often understood themselves as part of a distinct Serb, or Greek, or Bulgarian, or Armenian, nation; one's faith still figured heavily into these identities. These *millet*s continued to reap the benefits of being separate communal groups when it suited, creating a sociopolitical duality within the empire that was to the ultimate detriment of the Ottoman ability to govern and maintain social stability. That customary Ottoman tolerance toward communal *millet*s and the *Tanzímât* Ottoman declarations of legal equality coalesced, enabling non-Muslim ethnoreligious communities to envision themselves as legitimate nation-states deserving of self-determination. They were followed thereafter by Muslims (Arabs, Albanians, Kurds, Turks) as well. To retain some flexibility in governing the empire, the ruling authorities had attempted to promote Ottomanism as a form of Ottoman nationalism by appealing on this basis of equality for all its citizens. But Ottomanism ultimately failed altogether, subordinated to more readily discernible ethnoreligious identifications that were more universally understood in the new global order of the twentieth century. The inclusive Ottoman principle of tolerance

for difference and the view of diversity in the empire as a positive attribute were over-come by the ideology of nation-state nationalism, an inflexible, often violent internal force in the Ottoman Empire that compelled the state to respond or adjust accordingly. And when those holding the reins of power in the twentieth century fully embraced a Turkish nationalist ideology themselves, their exclusivity resulted in the harshest acts of inflexibility – the almost complete elimination of non-Turkish, non-Muslim Ottoman peoples from Anatolia.

The former border regions of the late Ottoman Empire – the Balkans, the Caucasus, and eastern Anatolia – all inherited the sectarian and ethnonational tensions described above. Designated in contemporary historiography of the modern era as "shatterzones" for their location at the intersection of warring Habsburg, Russian, and Ottoman empires, which had "crashed together like tectonic plates,"[1] they were "zones of coexistence and multi-ethnicity, but also of violence and devastation" when nationalists wanted to "replace diversity and hybridity with fixed borders."[2] These tensions, a prominent legacy of the late Ottoman Empire, still bubble under the surface and occasionally boil over into conventional wars in the current era. In the Balkans, perceived unredressed territorial grievances led to the Bosnian War from 1992 to 1995 between Serbs, Croats, and Muslims; Kosovo still remains a contested area between Serbs and Albanians. In the Caucasus (and the Crimea), Azerbaijan, Armenia, Georgia, and Russia all vie for territorial control and resources, with a resurgent Russia most recently annexing Crimea and staking claims in Ukraine.

In the post–World War I settlement of the Middle East in which European powers established Mandate states with newly drawn borders, most of which reflected no consideration for the demography or relevancy of the peoples residing there, Ottoman residue in the region created several characteristics. First, similar to post-war Balkan historiography concerning the centuries of Ottoman rule in the region, the Ottoman era in the Arab Middle East (1517–1918) came to be seen negatively also among Arabs, as merely "centuries of the oppressive yoke of the Ottoman Turks." Only recently has this attitude subsided somewhat in the Balkans and the Middle East, rectified by multilingual Ottomanists' scholarship revising nationalist historiographies of the earlier twentieth century with more nuanced historical understanding. Some cultural reconciliation is also taking place between peoples and countries (though among the general populations the attitudes are still mixed).

Second, the Ottoman Empire's role as a preeminent Sunni power in the world ended with its dissolution in World War I, but the idea of a central authority embodied in the Ottoman sultan-caliph of Muslims endured, generating questions that soon resurfaced about the future viability of the caliphate. In British India, Muslims founded the "Khilafat Movement" immediately after World War I in an attempt to determine the leadership of the Islamic community. When Republican Turkey's President Atatürk officially abolished the caliphate in 1924, the question was made all the more urgent in the 1920s. Conferences were held to discuss the issue. The long-lived political idea of a caliph of Muslims that

had been kept alive by the Ottoman Empire entered a new phase of controversy. At that time, a new competition emerged over who could assume the symbolic post, which also involved political leadership within the Arab world more specifically – between the head of the royal family in Egypt (the non-Egyptian *khediv*al descendant King Fu'ad I), the tribal chief 'Abd al-'Aziz b. Sa'ud in the Arabian Peninsula, and *Sharif* Husayn of Mecca all having been political players in the late Ottoman era. The latter two both claimed to be the rightful "king of the Hijaz"; their rivalry, entwined with the caliphate debate, spilled over into armed conflict. These early twentieth-century divisions, and before that, Mehmed Ali Pasha's severing of Ottoman Egypt from the empire in the mid-nineteenth century, set a precedent for non-unity among Arab states throughout the twentieth century. And the resurrection of a Muslim caliphate still has traction in the world today, witnessed most recently by Islamic State (ISIS/ISIL/DAESH) leader Abū Bakr al-Baghdādī's claim to be caliph in 2014.

There are other legacies of the Ottoman era perhaps less obvious: the pattern of Ottoman reform starting in the late eighteenth century and continuing into the twentieth was conducted first in the military, whether among Ottoman forces in the empire proper, or in Ottoman Egypt with Mehmed Ali Pasha's modernization of his army. As a consequence of this reform emanating from the military in terms of education and the adoption of science and technology, there was a long-lived tendency in Egypt and the Republic of Turkey, as well as in the post–World War I Ottoman Middle East, for the modernizing political leadership in these countries to be from among a former Ottoman military officer class, and for the military to remain a feature of domestic politics. In newly created Mandate states – in Iraq and Syria for example, some of these leaders even led revolts against the European Mandate authorities. Similarly, the tradition of a centralized state with autonomous actors in more remote areas – the structure of Ottoman provincial governance – tended to survive into the modern era in many nations that were formerly Ottoman domains. Other Ottoman political arrangements endured: in Lebanon's case as a French Mandate in the interwar era, the confessional political configuration was maintained after World War I as a modified version of the Ottoman *Mutasarrifiyya* of 1861. It is still in existence today, as are its lingering political tensions. Subsequent adjustments to this confessional political system have been made since Lebanese independence to account for population and demographic change, but this is still not satisfactory to many of Lebanon's inhabitants.

The lengthy history of the Ottoman Empire and its message of reliance upon flexibility and adaptability illustrated the success inherent in a polity that embraced difference and tolerance. Ultimately this Ottoman policy of coexistence became antiquated due to two factors: first, it rested upon a notion of inherent inequality that was no longer acceptable to many non-Muslims in the empire and to European powers supporting these minorities. Second, the hegemonic Western nation-state system emphasizing ethnolinguistic (and religious) homogeneity and territorial claims of nationhood as the global organizing principle prevailed over multiethnic, multireligious empires. Although the attempt was made in the turbulent mid-nineteenth century by the Ottoman state to reform sociopolitical relations between disparate Muslim and non-Muslim communities under the umbrella

of an inclusive Ottoman nation, it was unsuccessful. Perhaps if the Ottomans had been allowed to adapt more organically, in their own way over time, with a form of coexistence between diverse Ottoman peoples that truly incorporated equality while respecting difference, a very different result might have ensued. Nonetheless, the Ottoman Empire's traumatic dissolution illustrates the inevitability of weakness when societies confront adversity with exclusionary and xenophobic attitudes. The Ottoman Empire can teach us this profound lesson today.

TURKEY'S GHOSTS

The establishment of the modern Turkish Republic after the final demise of the Ottoman Empire was an achievement that had not been without tremendous cost. The horrible loss of life in Anatolia was due to the realities of war – casualties on the battlefields, massacres, disease, starvation were all contributing factors (Map 13.1). Nor was the newly founded Turkey without lingering "ghosts" of the Ottoman past. The distrust of minorities that started in the nineteenth-century Ottoman Empire persisted into post-Ottoman Turkey. Previous centuries of Greek and Turkish coexistence in the Ottoman Empire had been overshadowed by the frequent intercommunal hostilities with one another in the nineteenth century and wars in the twentieth: the Greek war for independence from the Ottoman Empire from 1821 to 1829, conflict again during the Balkan Wars, and again in Anatolia during the Turkish War of Independence. The Treaty of Lausanne included a final attempt to sever their shared Ottoman history with the official and mutually agreed-upon, yet harrowing population exchanges between neighboring Greece and Turkey from 1923 to 1926, the first of its kind in the modern era designed to "nationally" homogenize both countries. Ironically, nationality was based upon religious affiliation in this exchange. About 900,000 "Greeks" – that is, Greek Orthodox Christians in Anatolia (excluding Istanbul) who had lived there for generations, many of whom spoke Turkish or who were actually Turkish in ethnicity, were compelled to move to Greece proper. Approximately 400,000 "Turks" – that is, Balkan Muslims in the Greek state who had resided in Greece for generations, perhaps spoke only Greek and who may have been Greek in ethnicity, were labeled Turks, and relocated to Anatolia. There was persistent distrust of these new immigrants in both countries. Simmering ethnoreligious national tensions boiled over in Istanbul in the 1950s with riots against the remaining Greek community there. Only around 2,000 Greeks who are citizens in Turkey remain today. Cyprus was another Greek-Turkish hotspot in which rivalry over control of the island nation resulted in an international crisis with the Turkish invasion of 1974, the hostilities of which are only now beginning to ease there. The consequences of such violent disruptions and the tensions between Turkey and Greece would be felt for decades, and are only now beginning to subside, almost two hundred years after the establishment of a Greek nation-state independent from the Ottoman Empire.

Map 13.1 Mortality in Anatolia, 1912–22.

Legend:
- Gained 50%
- Percentage Lost: 5–15
- 15–25
- 25–35
- 35–45
- 45+

The lack of resolution between the Turkish government and those demanding Turkey recognize the "Armenian issue" as a genocide (including Assyrians, who only number about 5,000 in Turkey today) is like a festering wound that continues to plague modern Turkey's domestic politics and damages Turkey's international standing in the world. Today the population of Armenians in Turkey, who mainly reside in Istanbul, is somewhere around 60,000. A continual reminder of Turkey's denial occurs every year, drawing attention worldwide, and not by accident: as Armenians commemorate the genocide on Armenian Genocide Remembrance Day, April 24, coincidentally, on April 23 in Turkey, National Sovereignty Day commemorates Atatürk's founding of the Grand National Assembly. Additionally, on April 25, ANZAC Day honors the fallen with ceremonies at Gallipoli, which typically involve Turks as well as Australians, New Zealanders, British, and French. While the academic community is gradually coming to terms with the tragedy through annual conferences and diligent scholarship bringing together Turkish, Armenian, and foreign narratives of the last years of empire, the Turkish government, perhaps worried that demands for reparations may follow, and denying that Turkey could have been born on such a sin (what modern nation has not?), continues to refuse acknowledgment of events as a genocide.

Ottoman Anatolia had been 80 per cent Muslim before the wars; now the Turkish Republic is 98 per cent Muslim (Map 13.2). The Kurds, fellow Muslims, were left without a state, as the abrogation of the Sèvres Treaty and the terms of the Lausanne Treaty meant there would be no Kurdistan established in the territory allotted to the Turkish Republic. The Kurds, deemed "mountain Turks" by the Republican government, were thus left with minority status in several states of the Middle East – in Turkey, Persia (Iran), and the Mandate states of Syria and Iraq. Kurdish uprisings in eastern Turkey in the 1920s and 1930s were met with brutal government suppression, both militarily and culturally. After the failed Kurdish Shaykh Said revolt in Turkey in the 1920s, about 10,000 Kurds fled to

Black Sea
Trebizond
Erzurum
Van
Sivas
Ankara
Bursa
Afyon
Karahisar
Konya
Diyarbakir
Adana
Antep
Izmir
Sea of Marmara

1912
Others
Armenians
Greeks
Muslims
1922
Total

Syria to join other Syrian Kurds there. But the ongoing war between the Turkish government and the Kurdish people over their national demand for their own homeland has had serious political implications inside Turkey – with the state dismissing academics (and others) from positions, and arresting and/or imprisoning those who express any support for Kurdish rights. Outside Turkey, the conflict with the Kurds has destabilized the region even further today, due also to both parties' involvement in the civil war that has raged in Syria from 2011, and the advent of DAESH (ISIS/ISIL) in Syria and Iraq.

Turkey's Ottoman ghosts such as these are powerful legacies, whether overt or veiled. But ethnic Greeks, Armenians, and Kurds are not Turkey's only "ghosts." The largest minority group in Turkey, the non-Sunni *Alevis* understood to be the descendants of the Sufi-oriented *kızılbaş*, who could possibly make up as much as 15–25 per cent of its total population, have had their existence denied, they have been discriminated against and persecuted at times. And there are two more non-ethnonational, "invisible" legacies troubling the post-Ottoman Republic of Turkey that are residues of the former empire: first, the still evident sociopolitical divide that exists between a secular, often Western-oriented elite and a more religious sector of the populace, is a rift that crosses urban and rural lines, and still simmers just beneath the surface of post-Ottoman Turkish society, often spilling over into the open as political protests, demonstrations, and sometimes violent unrest. Turkey is still in the midst of deciding who it is, and who "Turks" are – European? Or Middle Eastern? Ethnic Turks, or multiethnic citizens of Turkey? Islamists or secularists? These uncertainties have created plenty of current anxiety and societal conflict today, threatening Turkey's fragile democracy. The second legacy was initially that of army involvement in Turkish politics as the "guardians of the state" that are traceable back to the Ottoman era of military-driven, top-down reform efforts. The near-century of this "deep state" military influence seemed to have finally been broken by the regime of Erdoğan's

Map 13.2 Demographic Change in Anatolia's Population, 1912–22, by Religion.

Justice and Development Party (*Adalet ve Kalkınma Partisi*, or AKP) between 2007 and 2011, only to be replaced by an increasingly authoritarian AKP leadership hindering the establishment of real justice, freedom, and liberty in Turkey with its crackdown on dissent. These are Turkey's "ghosts" that continue to haunt the direct inheritor of the Ottoman Empire.

NOTES

1 Peter Holquist, "Forms of Violence during the Russian Occupation of Ottoman Territory and in Northern Persia (Urmia and Astrabad): October 1914–December 1917," in *Shatterzones of Empires: Coexistence and Violence in the German, Habsburg, Russian, and Ottoman Borderlands*, eds. Omer Bartov and Eric D. Weitz (Bloomington: Indiana University Press, 2013), 335.
2 Marc Jansen, review of *Shatterzones of Empires*, eds. Omer Bartov and Eric D. Weitz, *East/West Journal of Ukrainian Studies* 2, no. 1 (2015): 171.

SELECTED READINGS

Adanır, Fikret, and Suraiya Faroqhi. *The Ottomans and the Balkans: A Discussion of Historiography*. Leiden: E.J. Brill, 2002.

Bartov, Omer, and Eric D. Weitz, eds. *Shatterzones of Empires: Coexistence and Violence in the German, Habsburg, Russian, and Ottoman Borderlands*. Bloomington and Indianapolis: Indiana University Press, 2013.

Brown, L. Carl. *Imperial Legacy: The Ottoman Imprint on the Balkans and the Middle East*. New York: Columbia University Press, 1996.

Choueiri, Youssef M. *Modern Arab Historiography: Historical Discourse and the Nation-State*. Rev. ed. New York: Routledge Curzon, 2003.

Dressler, Markus. *Writing Religion: The Making of Turkish Alevi Islam*. Oxford: University of Oxford Press, 2013.

Makdisi, Ussama. "Ottoman Orientalism." *American Historical Review* 107, no. 3 (June 2002): 768–96.

Maksudyan, Nazan. *Orphans and Destitute Children in the Late Ottoman Empire*. Syracuse: Syracuse University Press, 2014.

McCarthy, Justin. *The Ottoman Peoples and the End of Empire*. London: Bloomsbury Academic, 2001.

Poulton, Hugh. *Top Hat, Grey Wolf, and Crescent: Turkish Nationalism and the Turkish Republic*. New York: New York University Press, 1997.

Provence, Michael. *The Last Ottoman Generation and the Making of the Modern Middle East*. New York: Cambridge University Press, 2017.

Shankland, David. *The Alevis in Turkey: The Emergence of a Secular Islamic Tradition*. New York: Routledge Curzon, 2003.

Todorova, Maria Nikolaeva. *Imagining the Balkans*. Rev. ed. Oxford: Oxford University Press, 2009.

GLOSSARY

Abbasid Caliphate Islamic dynasty in Baghdad and empire presiding over the Middle East *c.*750~1258

aga/ağa title of a civil leader or military commander, especially for eunuchs

ahdname the actual written treaty granting privileges to foreign powers

ahl-dhimma "People of the Pact," non-Muslims who recognize Muslim political authority

akıncı/akıncılar Ottoman raiders who "flow" over area

Akkoyunlu "white sheep" Turkic tribespeople on the eastern Ottoman frontier, mainly Sunni

Al-Andalus Islamic Spain

Al-Azhar University Islamic institution established by the Fatimids; today a center of Sunni learning

Alevi contemporary Turkish Shi'i descendants of the non-Sunni Muslim *kızılbaş*

amân Islamic guarantee of security to traveler

amir/emir Muslim military commander controlling a province or territory

appanage term describing territories of an empire divided and governed by family members circa the Mongol and Seljuk eras

Arabism proto-Arab nationalist movement in the nineteenth century recognizing Arab cultural contributions to Islamic and Ottoman civilization

arquebus a primitive matchlock-type firearm

Ashina/Aşina name of ancestral wolf in Turkic folklore; name of Turkic clan Asia Minor/Anatolia territory that is today the Republic of Turkey

askeri term denoting military, used to describe Ottoman ruling class

ayan provincial notable

azab locally levied infantryman

bailo Venetian representative to the Ottoman state in Constantinople

başdefterdar chief Ottoman finance minister

başıbozuks Ottoman irregulars; mercenary warriors

bay'a Muslim oath of allegiance

Bayram Ottoman religious festival or holiday

BCE before common era, before year 1 (formerly known as BC)

bedel exemption from Ottoman military duty that could be purchased mainly by non-Muslims

bedestan covered market

Bedouin nomads mainly in the Arabian Peninsula

berat diploma of appointment; a kind of exemption license issued by Ottoman state to foreign parties or their employees

bey Turkic chieftain, governor, or noble

beylerbeyi provincial governor-general

beylik Turkic territory or principality

Buyid Indo-Iranian Shi'ite temporal rulers while Sunni Abbasid Caliph resided in Baghdad *c.* mid-tenth–mid-eleventh centuries; supplanted by Seljuks *c.*1055

caique small, oared boat frequently used on the Bosphorus Straits; imperial *caiques* used for royal ceremonials

caliph Islamic rulers after the prophet Muhammad's death; "successor"

Capitulations, or *imtiyazât* economic trading privileges granted to foreign powers by the sultan

CE common era, from the year 1 (formerly known as AD)

Circassian Sunni Muslims from the northwest Caucasus region, most of whom were expelled by Russia and emigrated to Ottoman lands

clientage relying upon other groups as buffer

concubine female captives in war or slaves sent to the harem of a household (i.e., the sultan's palace)

damad title denoting Ottoman imperial son-in-law

Dar al-Harb "Abode of War": territory not under Muslim rule

Dar al-Islam "Abode of Peace": territory under Muslim rule

darül-şifa hospital (pre-nineteenth century)

devşirme slave recruit system; a periodic levy on non-Muslims in Ottoman lands

dhimmi non-Muslims who are subordinated to Muslim rule and agree to abide by conditions set forth

Divan Ottoman Imperial Council (the sultan's cabinet)

dönme Jewish followers of Sabbatai Zvi who converted outwardly to Islam while still practicing Judaism

dragoman translator; interpreter

Druze splinter subsect of Shi'ism who developed into a minority community

Fatimid Ismaili Shi'ite dynasty established in N. Africa/Egypt *c.* tenth century who were rival claimants to the Abbasid Caliphate

fermân Ottoman royal decree

fetva/fatwa Islamic legal opinion

fiqh the science of Islamic jurisprudence

gaza/gazi Islamic term to describe raiding culture/participants in raiding for plunder

genocide the extermination of a population or race of people

ghulam slave (from Persian)

Gökturks/Kökturks name of pre-modern "Blue" or "Sky" Turk Empire in Central Asia

Golden Horn inlet waterway from Bosphorus Straits in Istanbul

Hagia Sophia/Aya Sofya the first spelling was used in the Byzantine era while the second was/is used in the Ottoman and Republican Turkey eras

hamam bathhouse

Hamidiye armed Kurdish tribal cavalry units formed by Sultan Abdülhamid II in the late nineteenth century

han/khan inn or caravanserai to house traveling merchants

Hanafi the Sunni Islamic legal school that predominated in the Ottoman Empire

Hanbali one of the four main Sunni Islamic legal schools

haseki favorite consort of the Sultan

Hashemites Qurayshi descendants of the Prophet Muhammad, e.g., *Sharif* Husayn of Mecca, whose descendants are today the royal family in Jordan

hastane modern Ottoman hospital (*c.* nineteenth century ~)

hijri Islamic calendar, year 1 starting with the Prophet Muhammad's emigration to Medina in 622 CE

historiography the study of historical writing

ikta' an administrative land grant delegating fiscal rights over state land in earlier Islamic empires, often to army commanders; taxes were to be paid to treasury but often were not

Ilkhanids the thirteenth-century Mongol appanage in Western Asia founded by Chingghis Khan's grandson Hülegü, which became a dynasty centered in Persia

iltizâm tax farms auctioned to highest bidder (*mültezim*) to collect revenues on Ottoman state's behalf with no military obligation required

imamate Shi'ite understanding of political authority, which differed from the Sunni Caliphates

Ismaili Sevener Shi'a subsect

jizya poll tax levied upon non-Muslims to demonstrate subordination to the Muslim ruler in exchange for communal autonomy

kadı Islamic judge

kadiasker Ottoman military judge and official

kadırga oared galley

kafes part of Topkapı Palace where princes were held

kaftan the ornate silk outer garment of the sultan or elite members of the *askeri* class symbolizing power and authority

kânûn secular, "man-made" law

kanunname Ottoman legal code made known through proclamation or decree

kapıkulu "slave of the Porte" (Ottoman slave recruit)

kapılar pasha households who increasingly monopolized Ottoman government posts

kapudan pasha Ottoman naval admiral

Karakoyunlu "black sheep" Turkic tribespeople on the eastern Ottoman frontier, with Shi'a leanings

kaza Ottoman judicial districts

kazf Islamic legal term for sexual slander

khan, khağan Central Asian title meaning "ruler"

khanate a political entity and territory ruled by a khan

khutba mention of ruler's name in Friday prayer as symbol of authority

Khwarazmshahs Persianate Sunni dynasty of Turkish *mamluk* origin who ruled in areas of Central Asia and Persia until the Mongol invasion of the thirteenth century

kızılbaş Turkic tribesmen in eastern Anatolia adhering to Shi'ite Islam

külliye mosque complex

kuriltai Turco-Mongol tribal assembly

kütüphane library

lala statesman/tutor who accompanied crown princes to their provincial postings to assist in governing

latitudinarian allowing latitude, especially in religion; showing no preference among varying creeds/forms of worship.

Levant refers to the Eastern Mediterranean area of the Middle East that today comprises Syria, Iraq, Lebanon, Jordan, and Palestine/Israel.

levend **or** *sekban* hired or conscripted armed infantry from local peasantry

Little Ice Age defined as the dramatic weather pattern of the fourteenth to nineteenth centuries, its effects of famine and rebellion were most severely felt in the Ottoman Empire in the sixteenth to eighteenth centuries

mahalle local neighborhood, typically in an urban area

malik "king"

malikâne Ottoman lifetime tax farm (implemented *c.*1695)

mamluk "slave" (from Arabic); came to mean slave soldiers who could become militarily and politically powerful in Islamic empires

Mamluk sultanate in Egypt founded by slave commander in the thirteenth century; endured until the nineteenth century

mangonel a kind of military catapult or siege engine

Maronite Arab Christians mainly in Lebanon who recognize the authority of the Catholic pope

Mecelle Ottoman legal civil code of the nineteenth century

medrese Islamic school teaching religious and other subjects

mektep-i sıbyan a kind of elementary school

miri state land possessed by the sultan

müderris Islamic teacher or instructor

müfti learned Islamic jurisprudent

mukataa tax farm generating revenue not from state land, but from trade commodities (i.e., silk, grain, wine, sheep, etc.); values determined by weight scales

müsellem unpaid cavalry in non-combat military roles

Mutasarrifiyya Ottoman political subdivision established in Mt. Lebanon in 1861

naḥda Arabic literary renaissance of the mid-nineteenth century

nahiye political district of a *sancak*

nakkaşhane sultan's official "studio" for artists and chroniclers

nişancı head of the Ottoman chancery

Nizari "assassins"; Shi'i Ismaili sect that founded a state in the late eleventh century in Persia and Syria within the Sunni Seljuk Empire and carried out dramatic assassinations of Seljuk officials

ocaklık labor provided by villages, required during wartime mobilization

Oğuz name of Turkic tribe or the individual who founded it

Orientalism the underpinning of scholarship on "the East" or "Orient" originally carried out by Western scholars that imagined and depicted "non-Western peoples" in particular, often exoticized, ways.

Ottomanism nineteenth-century notion of Ottoman patriotism/love of homeland and loyalty to dynasty

padishah "emperor" (from Persian)

pasha high Ottoman political or military official's rank

polygeniture shared rule by a tribe or family rather than by only one individual

Quraysh the tribe from which the Prophet Muhammad was descended

re'aya term from Arabic meaning "the flock" – those who are ruled

reis ul-kuttab chief of Ottoman scribes

revisionist historian scholars who challenge previous historical ideas or theories

Rumelia the region of southeastern Europe known as the Balkans

Safavid Shi'ite dynasty in Persia, founded in 1501 out of the Safavi Sufi order in Ardabil

salafi conservative belief in recreating the era of the "pious Arab ancestors" (the Prophet Muhammad and the first four caliphs)

sancak Ottoman sub-province

şehnameci official Ottoman court historian

Seljuk branch of the Turkic Oğuz tribe who founded a large empire in Persia, the Levant, and shared a frontier in Anatolia with the Byzantines *c.* the eleventh century

şeriat (*shari'a*) the corpus of Islamic religious law based upon the Qur'an, the Sunna of the Prophet Muhammad, and the legal jurisprudence (interpretations and commentaries) generated by Muslim scholars

şeyhül-islam highest-ranking position in the Ottoman *ulema*

sharif title denoting descent from the Prophet Muhammad

Shi'ite followers of several subsects of Islam who argue the Prophet Muhammad had designated Ali as his political successor (caliph) to lead the community; rule would be inherited by the Prophet's family in a line of imams, thus seeing Sunni caliphs as illegitimate. Shi'ites are minorities in the Islamic world today.

shûra consultative assembly or tribal council

sikka the minting of coins as a sign of Muslim political legitimacy and authority

sipahi Ottoman cavalryman granted a *timar*

sultan Quranic term meaning "power, authority"

Sunni Muslims who believe the Prophet Muhammad wanted the community to select the next caliph after his death rather than establishing a familial dynasty, though eventually subsequent caliphates became hereditary and dynastic. Sunnis comprise the majority in the Islamic world today.

sürgün forced resettlement by Ottoman authorities

tâ'ife sect

Tanrı **or** *Tenggri* Turco-Mongol sky god

Tanzîmât "reorganization": Ottoman reform era from 1839 to 1876

tekke Sufi lodge

timar land grant to Ottoman *sipahi* cavalrymen

transhumance the practices of nomadic pastoralists migrating on semi-regular routes with their animals

trebuchet medieval siege engine

Turanism belief in a Turkic race and homeland stretching from eastern Europe across the Asian continent

Turkism proto-Turkish nationalist proclivities celebrating Turkish cultural contributions

ulema Muslim religious class

Umayyad Caliphate Islamic dynasty in Damascus and empire presiding over the Middle East *c.*661–750 CE

umma Arabic word meaning "community of believers"

Uskoks Slavic Christian anti-Ottoman militias

Üzbek Turkic dynasty founded in Central Asia

valide sultan queen mother

vakanüvis official court historian as of the seventeenth century

vatan homeland or country

vezir administrator or minister; government official

vilayet Ottoman province

Vlach Balkan Slavic nomadic pastoralists, mainly Orthodox Christian

voivode local Balkan notable recognized by Ottoman state as semi-autonomous governor

wagenburg war wagon defensive arrangement, often in circle (*tabur*)

waqf/vakf/evkaf pious endowment designed to provide for the society's general welfare

Xiongnu ancient Turkic tribe

yaya medieval era Ottoman infantryman

yurts nomadic tents

Yürük nomadic tribespeople (mainly Turkic)

zina Islamic legal term for adultery or fornication considered illicit

CREDITS

MAPS

2.1 *The Map Project*, MESA. Courtesy of Dr. Justin McCarthy.

2.2 *The Map Project*, MESA. Courtesy of Dr. Justin McCarthy.

2.3 *The Map Project*, MESA. Courtesy of Dr. Justin McCarthy.

2.4 *The Map Project*, MESA. Courtesy of Dr. Justin McCarthy.

2.5 *The Map Project*, MESA. Courtesy of Dr. Justin McCarthy.

3.1 *The Map Project*, MESA. Courtesy of Dr. Justin McCarthy.

4.1 Constantine Plakidas/CC BY-SA 4.0; https://creativecommons.org/licenses/by-sa/4.0/deed.en.

4.2 Copyright © Swanston Map Archive Limited. All rights reserved.

4.3 *The Map Project*, MESA. Courtesy of Dr. Justin McCarthy.

5.1 *The Map Project*, MESA. Courtesy of Dr. Justin McCarthy.

5.2 Copyright © Swanston Map Archive Limited. All rights reserved.

6.1 Courtesy of Howard Wiseman.

6.3 *The Map Project*, MESA. Courtesy of Dr. Justin McCarthy.

9.1 Chamboz/CC BY-SA 4.0; https://creativecommons.org/licenses/by-sa/4.0/deed.en.

10.1 *The Map Project*, MESA. Courtesy of Dr. Justin McCarthy.

10.2 *The Map Project*, MESA. Courtesy of Dr. Justin McCarthy.

10.3 Adapted from Flappiefh/CC BY-SA 4.0; https://creativecommons.org/licenses/by-sa/4.0/deed.fr.

10.4 Courtesy of Dawn Chatty.

11.1 *The Map Project*, MESA. Courtesy of Dr. Justin McCarthy.

11.2 Courtesy of Dawn Chatty.

12.1 *The Map Project*, MESA. Courtesy of Dr. Justin McCarthy.

12.2 *The Map Project*, MESA. Courtesy of Dr. Justin McCarthy.

12.3 *The Map Project*, MESA. Courtesy of Dr. Justin McCarthy.

12.4 Adapted from https://en.wikipedia.org/wiki/Six_vilayets#/media/File:Six_Vilayets_ethnic _groups.png.

12.5 Reproduced by permission of the Armenian National Institute.

12.6 *The Map Project*, MESA. Courtesy of Dr. Justin McCarthy.

12.7 *The Map Project*, MESA. Courtesy of Dr. Justin McCarthy.

13.1 Courtesy of Dr. Justin McCarthy and Bloomsbury Academic, an imprint of Bloomsbury Publishing Plc.

13.2 Courtesy of Dr. Justin McCarthy and Bloomsbury Academic, an imprint of Bloomsbury Publishing Plc.

FIGURES

0.1 *People of Different Countries* (New York: Mahlon Day, 1837). Courtesy of the American Antiquarian Society.

0.2 Anonymous, *The Lustful Turk: Scenes in the Harem of an Eastern Potentate* (1828?), 49.

6.5 The Picture Art Collection/Alamy Stock Photo.

6.6 CBL T 413.113v and CBL T 413.114r. © The Trustees of the Chester Beatty Library, Dublin.

6.7 Topkapi Palace Museum, Istanbul, Turkey/Sonia Halliday. Photographs/Bridgeman Images.

7.1 Hamam, or Turkish bath, about 1809. Anonymous Greek artist. © Victoria and Albert Museum, London.

7.2 CBL T 439.9r. © The Trustees of the Chester Beatty Library, Dublin.

7.3 *Surname-i Hümayun*, H.1344, fol. 123b. Reproduced by permission of the Presidency of the Republic of Turkey, Presidency of National Palaces Administration.

7.4 Pitt Rivers Museum, Oxford, UK/Bridgeman Images.

7.5 Heritage Image Partnership Ltd/Alamy Stock Photo.

7.6 The Holy Caravan in the Şem. Syria. Between 1860 and 1900. Courtesy of the Library of Congress Prints and Photographs Division, https://www.loc.gov/item/2004671967/.

7.7 *Hünername*, H.1523, fol. 207b. Reproduced by permission of the Presidency of the Republic of Turkey, Presidency of National Palaces Administration.

7.8 The Camel Corps at Beersheba. 1915. Courtesy of the Library of Congress Prints and Photographs Division, https://www.loc.gov/resource/ppmsca.13709/?sp=36.

7.9 Courtesy of Sir Terence Clark.

7.10 Family posing on doorsteps, photographer unkown. 1890. Pierre de Gigord Collection. The Getty Research Institute. Courtesy of the Getty Open Content Program.

7.11 History/Bridgeman Images.

7.12 Adobe Stock/hikrcn.

8.1 History/Bridgeman Images

8.2 Selimiye Mosque Edirne/Turkey. © Enver Şengül.

8.3 Courtesy of the author.

8.4 Talikizade, *Şehname-i Mehmed Han*, H.1609, fols. 68b-69a. Reproduced by permission of the Presidency of the Republic of Turkey, Presidency of National Palaces Administration.

8.5 Adobe Stock/mehmet.

8.6 Lebrecht Authors/Bridgeman Images.

9.1 Håkan Henriksson (Narking)/CC BY 3.0. https://creativecommons.org/licenses/by/3.0/deed.en.

9.2 Photo © Luisa Ricciarini/Bridgeman Images.

9.3 The Picture Art Collection/Alamy Stock Photo.

9.4 From copy of Enderunlu Fazıl's *Hubanname ve Zenanname*. From Hamadeh, *The City's Pleasures*, xv. TY 5502, fol. 78a. Courtesy of Istanbul University Rare Works Library.

9.5 Levni, *Sûrnâme-i Vehbî*, A.3593, fols. 93a, 47a, and 126a. Reproduced by permission of the Presidency of the Republic of Turkey, Presidency of National Palaces Administration.

9.6 Levni, *Sûrnâme-i Vehbî*, A.3593, fol. 73b. Reproduced by permission of the Presidency of the Republic of Turkey, Presidency of National Palaces Administration.

10.1 "Der Sultan ertheilt begleitet von den Grossen des Reichs, bei der Heerschau des neuorgnisirten Fussvolks der Massouris und Cambaradjs, den Paschen Befehle" (1806). \ *Prints, Drawings and Watercolors from the Anne S.K. Brown Military Collection*. Brown Digital Repository. Brown University Library. https://repository.library.brown.edu/studio/item/bdr:233586/.

10.2 Campaign of Egypt © Photo Josse/Bridgeman Images.

10.3 Reproduced by kind permission of the Trustees of the Mohamed Ali Foundation and of the University of Durham.

10.4 Universal Images Group/Art Resource, NY.

10.5 The Picture Art Collection/Alamy Stock Photo.

10.6 From Mahmud Şevket Paşa, *Osmanlı Teşkîlât ve Kıyâfet-i Askeriyyesi*, Vol. 2 (Istanbul: War Office Press, 1325/1909).

10.7 Carriages and passers-by on Beyazit Square in Istanbul, anonymous, Neue Photographische Gesellschaft (possibly), 1900–9. CC0 1.0.

11.1 PD/https://commons.wikimedia.org/wiki/File:Le_Petit_Journal_Balkan_Crisis_(1908).jpg.

11.2 Kara-Keui (Galata) and view of Pera, Constantinople, Turkey, *c.*1890–1900. Courtesy of the Library of Congress Prints and Photographs Division.

11.3 Private Collection/Look and Learn/Illustrated Papers Collection/Bridgeman Images.

11.4 Tornai Gyula – Refugees in the Gallery of the Hagia Sophia Mosque After Amadeo Preziosi. Painters/Alamy Stock Photo.

11.5 Universal Images Group/Art Resource, NY.

11.6 © SZ Photo/Scherl/Bridgeman Images.

11.7 UtCon Collection/Alamy Stock Photo.

11.8 From *Before Their Diaspora: A Photographic History of the Palestinians, 1876–1948*, by Walid Khalidi. Courtesy of the Library of the Institute for Palestine Studies.

11.9 PD From Arabic magazine from Cairo, Jūrjī Zaydān, al-Hilāl (15 April 1904). Original caption: "Admiral Togo, commander of the Japanese fleet in the Far East."

11.10 *Les chiens errants de Constantinople*. Abdullah Frères, 1880. Pierre de Gigord Collection. The Getty Research Institute. Courtesy of the Getty Open Content Program.

11.11 Photograph: Jean Weinberg, Pierre de Gigord Koleksiyonu. PD/L'illustration, 16 July 1910.

12.1 History/Bridgeman Images.

12.2 Chronicle/Alamy Stock Photo.

12.3 History/Bridgeman Images.

12.4 Everett Collection Inc/Alamy Stock Photo.

12.5 Lines of the Australian 9th and 10th Battalions at Mena Camp, looking toward the Pyramids. Image C02588. Courtesy of the Australian War Memorial.

12.6 Turkish soldiers in a covered shelter at Kanle Sirt. Image A02599. Courtesy of the Australian War Memorial.

12.7 Photo © Ateş Orga. Reproduced by permission.

12.8 Courtesy of the Shoah Foundation.

12.9 FLHC 1F/Alamy Stock Photo.

12.10 Courtesy of the Library of Congress Prints and Photographs Division, https://www.loc.gov/pictures/item/2006679122/.

12.11 Lowell Thomas Papers, James A. Cannavino Library, Archives & Special Collections, Marist College, USA.

12.12 HMS Iron Duke and the Great Fire of Smyrna, 1922. © Illustrated London News Ltd/Mary Evans.

12.13 Topical Press Agency/Stringer/Getty Images.

12.14 History/Bridgeman Images.

GENEALOGICAL CHARTS

0.1 Adapted from Halil İnalcik with Donald Quataert, eds., *An Economic and Social History of the Ottoman Empire, 1300–1914* (Cambridge: Cambridge University Press, 1994), xvii.

8.1 Adapted from "Sultans and Valide Sultans of the Sixteenth and Seventeenth Centuries," in Leslie Peirce, *The Imperial Harem: Women and Sovereignty in the Ottoman Empire* (New York: Oxford University Press, 1993), 288. Reproduced by permission of Oxford University Press.

INDEX

Page numbers for illustrations appear in *italics*.

Abbas Hilmi, 317
Abbasid Caliphate, map, *28*
Abbasid dynasty, 27
Abbasid Empire, and emirates, 29
Abbasids, 29–30, 31
'Abd al-'Aziz b. Sa'ud, 314, 350
'Abd al-Raḥmān al-Kawākibī, 299, 301
Abdülaziz I, 260, 269, 276
Abdülhamid I, 234, 239, 241
Abdülhamid II ("Red Sultan"), *286*
 accession and deposition, 276, 297
 and Armenians, 288, 289
 as autocrat, 281, 284, 286
 constitution and parliament, 280–1, 292
 liberal ideas and surveillance, 286
 opposition to, 290, 291, 292
 overthrow, 292
 pan-Islamic solidarity and as "Caliph of all
 Muslims," 284, 285–6, 299
 reforms, 280, 281, 286, 287
 rule and reign, 276–7, 286
 and Young Turks, 296
Abdullah Cevdet, 303
Abdülmecid I, 260–1, 269
Abdülmecid II, 342
Abdürreşid İbrahim, 285, 296, 317
Adalet ve Kalkınma Partisi, or AKP (Justice and
 Development Party), 354
Adana events, 327–8
administration
 centralization and bureaucracy under Süleyman
 I, 128–9, 140–2, 153
 fiscal administration and policy, 153–4, 218
 foundations under Mehmed II, 85–7, 128, 137, 153
 by *grand vezirs*, 205–6
 modernization and reforms, 255–6, 264, 286, 287
 of provinces, 56–9, 151–4, 222
 terminology, 57
 See also governance
Afshar dynasty, 225
agrarian code, 266
ahdname, 86
Ahmed (prince), 116, 118
Ahmed Cemal Pasha. *See* Cemal Pasha
Ahmed I, 190, 200–2

Ahmed II, 218, 219
Ahmed III
 ascension, 220
 circumsicion of four sons, 227, *229*
 consumption and opulence in capital, 226–8
 deposition, 225, 230
 festival of 1720, 228, *228*, *229*
 rule and reign, 221–2, *223*, 226
Ahmed Rıza Bey, 291–2
akıncıs, 56, 57
Akkoyunlu tribal confederation, 93
Albania, 103, 105, 310–11
Albanian elites in Balkans, 244
Albanians, 298
Alevi-Bektaşi Turkmen, 119
*Alevi*s in Turkey, 353
Algiers, 152, 252
amân, 86
ambassadors, 219–20, 224, 241–2
 See also diplomacy
Anatolia
 administration, 57
 agricultural problems, 193
 alliances, 51–3
 Armenians in, 90, 92, 282, 288–9, *289*, 322, *323*
 arrival of Turks, 35, 37
 beylik (principality) of Osman (*see* principality in
 Anatolia [*beylik*])
 beyliks in, 37–8, 39–40
 Celali rebellions, 193, 196, 203
 in Civil War, *73*
 cultural mix and milieu, 35
 destruction by Ottomans, 9–10
 division of post–WWI, 338, *339*–40
 expansion of Ottomans, 47–9, *48*, 56
 historical background (pre-Osman), 30–5
 mortality, 351, *352*
 population and size changes, 352, *353*
 and resettlement, 100, 168
 in WWI, 319, 337
Anderson, Benedict, 258
Anglo-Ottoman Treaty of Baltılimanı (1838), 263
Anglo-Turkish Conventions (1913–14), 314
animals (non-human)
 in daily life, 169–74

animals (non-human) (*continued*)
 hierarchy, 169–70, 173–4
 in modern cities, 303–4
Ankara, description of districts, 162–3
antiquities, ownership by state, 287
ANZAC forces and troops (Australia-New Zealand
 Army Corps), 5, 317, *317*, 320, 321
Arabia and Arabian Peninsula
 control and rule, 245, 246, *247*
 post–WWI, 338
 in WWI, 314, 334, 335–7, *336*
Arabic, in Turkish language, 16
Arabism, 299
Arab Revolt, *336*, 336–7
Arabs in Empire
 contribution to Ottoman civilization, 298–9
 and CUP, 301–2
 and legacy of Empire, 349–50
 and *naḥda*, 298–9, 301
architecture, 140, 142, 224, 226
Arif Çelebi, *62*
Armenian genocide, *328*, *332*
 actions and atrocities, 328–9, 333, 337
 background, 322–3, 327–8
 denial in Turkey, 333, 352
 deportation routes and massacre sites, *329*
 survivors accounts, 331–2
 and *Teşkîlât-ı Mahsûsa*, 318–19
 war crimes tribunals, 338
Armenian Kingdom, 288
Armenian Republic, 340
Armenians
 in Anatolia, 90, 92, 282, 288–9, *289*, 322, *323*
 destruction by Ottomans, 9
 as ethnic group by *vilayet*, *323*
 massacres pre-genocide, 289, 327–8
 nationalism, 288–9
 and professions, 166, 252
 reforms in *Tanzîmât* era, 288
 renaissance in Empire, 252
 and Treaty of Berlin, 282
 in Turkey, 352
 and WWI, 319, 322–3, 327–33, 337
Armistice of Mudanya, 342
art and artists, 144–5, 148, 248
artillery of Ottomans, 109, 112
"*Asâkir-i Mansure-i Muhammediye*" ("Triumphant
 Soldiers of Muhammad") corps, *253*, 253
A-Shih-Na branch, 24–5

Asia Minor, 31
askeri class (imperial ruling elites), 16, 60, 129, *179*, 224
Atatürk, Mustafa Kemal, 10, 342, *342*
 See also Mustafa Kemal
Australians, *317*
Austria-Hungary, 282
ayan-emir system, 222
*ayan*s (urban notables), 222, 244, 249
Aya Sofya mosque, 82, *82*, *83*, 284
Ayyub al-Ansari tomb, 83
Ayyubid dynasty, 33
*azab*s (infantrymen), 108, 111

Bab-ı Alî raid, 312, 318
Bahaeddin Şakir, 292, 318, 323, 338
Balfour Declaration (1917), 334–5
Balkan League, 309–12
Balkans (Rumelia)
 in Civil War, *73*
 expansion of Ottomans, *48*, 48–9, 56, 76–7, 131
 local governance, 244
 loss by Empire, 282, 283–4, 309–12
 Muslims in, 100, 283–4, 312
 nationalism, 257, 259, 349
 territory management in expansion, 99–100, 102
 troubles in 19th century, 279–80, 287–8
 wars of early 20th century, 309–12
Balkan Wars (First and Second), 310, *311*, 311–12
bankruptcy of Empire, 269, 287, 347
Barbarossa (Barbaros, Khayr ad-Din / Hayrettin),
 111, *112*, 142, 143, *143*, 152
bathhouses (*hamam*s), 160, 163, *164*
battle formations of Ottomans, 108, 109, *110*
Battle of Çaldiran against Ottoman Sultan Selim I, *122*
Battle of Kahlenberg, *217*
Battle of Lepanto, 185, *186*
Battle of Mohács, 132
Battle of Petrovaradin, 223
Battle of the Pyramids, 244, *245*
Battle of Zenta, 219, *219*
Bayezid (son of Süleyman I), 149, 154
Bayezid I
 defeat at Ankara, 49, 71
 expansion of Ottomans and raids, 48, 49
 firearms use, 66
 marriage and alliances, 51
 naval fleet, 111
 as ruler, 49
 sons and power struggle, 71, 72, *72*, 73–4

and succession, 54, 55, 71–4, *72*, 76–7
title, 52
Bayezid II
 and Cem, 107, 113–14
 deposition by Selim, 116
 diplomatic tactics, 113–14
 naval fleet, 112, 113
 rule and reign, 107
 and Safavids, 116
Bayrakdar (or Alemdar) Mustafa Pasha, 249
Bayt al-Hikma institute, 29–30
bedel, 265
Bedreddin, Sheikh, 74, 75–6
Bektaşi Sufism, 167, 254
Belgrade, 131–2, 218, 223, 225
Bellini, Gentile, 95, *95*
*berat*s, 262
Berlin-Baghdad railway, 313
beylerbeyi (governor-general), 57
beylerbeylik (or *vilayet*), 57–8
beylik of Ottomans. *See* principality in Anatolia
 (*beylik*)
beyliks (fiefdoms), 37–8, 39–40, *48*
"Big Stick elections," 305
birds of prey, 171, 173
Bishrī, Sālim al-, 328
Black Sea and region, 135, 203, 225, 234, 267
Blue Mosque, 201, *201*
Bodin, Jean, 199
Bolshevik Russia, 335, 337, 340
Bonneval, Comte de, 231
Book of Travels (*Seyahatname*), 160, 161–3
borderlands, 13, 42–3, 151–2, 153
Bosnia, 63, 103
Bosphorus, freezing over, 193, 196
boys, 176–7, 178, 264
Britain
 and Arabia in WWI, 314, 334, 335, 336–7
 Bulgaria and Balkans, 279, 280
 and Egypt, 247, 249, 284
 interests in early 20th century, 313–14
 in regime overthrow, 292
 surrender at Kut al-Amara, 322
Buda (Hungary), 132
Bulgaria, 279, 311–12
Bursa, 39, *40*, 85
Busbecq, Ogier Ghiselin de, 199
Byzantine Empire, 26, *33*, 78
Byzantium, 30, 32–3

Çaldıran battle, 119, *122*
caliph as central authority (caliph of Muslims)
 Abdülhamid II as, 284, 286, 299
 Süleyman I as, 123, 142, 144, 145
caliphate of Muslims, 123, 280, 301, 342, 349–50
camel military corps, *174*
camels, 169–70, *170*
canals, 140, 185
Candide (Voltaire), 230–1, 232–3
cannons, use by Ottomans, 79–80, 109, 112
capitalism, 184
Capitulations (*imtiyâzât*) and Capitulatory privilege,
 86–7, 184, 213, 223, 262, 347
 in WWI, 315–16, 340
Capsali, Moses, 90
Catherine the Great, 233, 234
Caucasus, 234–5, 319
Celali rebellions, 193, 196–7, 203, 208
Cem, 107, 113–14
Cemal Pasha (Ahmed Cemal Pasha), 313, *313*, 315,
 317, 319, 335–7, 338
cemeteries, 179, *179*
census of late 19th century, 286–7
Central Powers, in WWI, 315–16
ceremonial palanquin (*mahmal*), 170, *170*
Chamber of Deputies, 280
"Charter of Alliance" (*Sened-i İttifak*), 249, 250
children, and education, 177–8, 264
China, 23, 24
Christians
 in Byzantium, 32–3
 cruelty from Ottomans, 8
 description by Turks, 4
 holy sites management, 224
 and Luther, 199
 marcher lords, 52
 military service, 298
 outnumbered in Empire, 123
 protection by Russia, 234
chronicles, as sources, 14, 35, 37, 42
*çift*s, 59
Circassian Corps, 123
"Circle of Justice," 30
circumcision festival of Sultan Ahmed III's sons,
 227, *229*
citizenship concept in Empire, 261, 262, 270
civic nationalism, 258
civil legal code (*Mecelle*), 264
Civil War, *73*

climate and natural disasters, 192, 193, 196, 197
coffee, 163–4
coffeehouses, 163, 164–5, *165*, 286
coinage debasement, 192
Committee of Union and Progress (CUP)
 actions as government, 293, 296–8, 301, 305–6,
 313
 and Arabs in Empire, 301–2
 Armenia and genocide, 322, 328, 333, 338
 collapse of government, 319, 337
 coup against (countercoup), 297, 301, 327
 decision-makers and policy formulation, 297
 loss of power and coup d'état, 312
 on Ottoman nation, 3
 reforms, 297, 301, 302
 "triumvirate" control and rule, 312, 315, 317,
 333, 338
 and Turkish language, 301–2
 and wars, 313–16
 and WWI, 315, 316, 317, 335–6
 and Young Turks, 292, 293–4, 295, 298
Concert of Europe, 267, 287
concubines, and succession, 54, 55
Constantine (emperor), 30, 81
Constantinople
 conquest by Mehmed II, 78, 79–83, 99
 consumption and opulence under Ahmed III,
 226–8
 crisis of 17th century, 203–4
 and Crusades, 32–3, 78
 districts description, 161–2
 diversity post-siege, 88–93
 and expansion of Ottomans, 49
 invasions over time, 78
 life in WWI, 324–7
 map in 15th century, *80*
 modernization, 278, *278*
 naval shipyard, 111
 palace, 84–5, *85*
 population, 92–3
 practices and policies, 85–7
 rebellions, 231
 refugees in late 19th century, 283, *284*
 remaking as capital by Mehmed II, 82–5
 as renewed capital under Ahmed III, 226–7
 repopulation, 84
 in Roman Empire, 30
 siege, 79–83, *80*
Constantinople Agreement (1915), 334
constitution

models for, 280
 promulgation and outline of provisions, 280
 reinstatement, 292, 296
 revision of 1909, 297
 suspension, 281
 Turkish as official language, 280, 301–2
 and Western powers, 281–2
constitutional reforms, 276, 280, 281
consultative assembly of Selim III, 241
core and periphery countries, 184
corsairs, 142, 143
Cossacks, 212, 215
Council of Justice, 269
Council of Ministers (*Meclis-i Vükela*), 255
Council of State (*Şûrâ-yı Devlet*), 269
countercoup against CUP, 297, 301, 327
court historians (*şehnameci* or *vakanüvis*), 14, 148
court records, and history, 15
courts, 141–2, 264
Crete, 205, 206, 288
Crimea, 105–6, 225, 233–4, 267, 291
Crimean Khanate, 234
Crimean War, 267, *267*, 268
crimes, punishment for, 177
criminal court, 264
crown princes, life and succession process, 54–6,
 149, 151, 189–90
Crusades, in Anatolia and Middle East, 32–3, 78
culture
 assimilation, 29–30
 dislike by *ulema*, 230, 242
 and Egypt's loss, 247
 milieu in Islam, 29–30
 mix and milieu in Anatolia, 35
 and modernization, 277–8
 Ottoman influence in Europe, 228, 230
 western influences, 212, 228, 230, 233, 256, 277–8
CUP. *See* Committee of Union and Progress
Cyprus, 185, 282, 351

daily life. *See* life in Empire
Damad Mahmud Celaleddin Pasha, 292
Damascus, 337
Damascus Protocol (1915), 334
Danube and region, *216*, 222–3
Danubian Principalities, 223
Dar al-Harb, 29
Dar al-Islam, 28
Dardanelles Straits, in WWI, 5, 315, 316, 321
death, in daily life, 179

decline, as view of history, 12

"defensive modernization" reforms, 241–3

Deneç, Erol, *36*

devşirme recruit system, 61–3, *62*, 64, 65, 67, 87, 137, 221, 241

*dhimmi*s. *See* non-Muslims

diet, in daily life, 173

diplomacy
 ambassadors, 219–20, 224, 241–2
 and European empires, 113–14, 219–20, 223–4
 and Translation Office, 250, 255

Diu (Gujarat), 113, 123, 133

Divan-i Hümayun (Imperial Council), 137, 140, 142

Dodecanese islands, 309

dogs
 in cities, *303*, 303–4, *304*
 for hunting, 170, *172*, 173, *175*

domestic slavery, 28, 60

*dönme*s ("converts"), 208

dowries (*mahr*), 175–6

Dream of Osman Gazi, The, *36*

dress code, 233, 255

drink, in daily life, 161–2

early modern era transformation, overview, 183, 184–6, 189, 190, 192, 200, 206–8, 211–12

Eastern Question, 224–5, 247, 267, 280, 334, 347

"East, the," in western art and science, 247–8

Ebu Su'ud, 129, 141, 204

economic transformations, 184, 347

Edebali's daughter, 51

Edirne
 in Balkan Wars, 310, 312
 as capital or palace, 47, 85, 212, 220
 capture by Russia, 280
 in interregnum, 72, 77
 and Mehmed IV, 205, 212

"Edirne Incident," 220–1

education
 for children, 177–8, 264
 in medicine and military, 254
 and reforms, 254, 265, 271

Eğer siege, 192, *194–5*

Egypt
 bankruptcy, 269
 Britain in, 247, 249, 284
 and İbrahim Pasha, 123, 138, 246
 importance to Empire, 247
 invasion by Napoleon, 122–3, 244, 246, 247
 loss of, 247–9

 and Mehmed Ali, 244, 246, 248–9
 nationalism, 259
 and Selim I, 122–3
 and WWI, 317

Egyptian *khedive*s, 249, 284

Egyptology, 247–8

elections, 293, 296, 305

elective chieftaincy, 37

elite
 consumption and opulence under Ahmed III, 226–8, 230
 life in Empire, 159–60
 western influences, 212, 228, 230, 277–8
 See also specific elite

embassies of Empire in Europe, 241–2

emir, as term, 29, 52

*emir*s, 222, 244

Emir Sultan Mosque (Bursa), *40*

engineering plans and projects, 140, 185

Enlightenment ideas and reforms, 240

Entente Libérale (Liberal Union) party, 305, 312

Enver Pasha (Ismail Enver Pasha), *313*
 in CUP and as minister of war, 312, 313, 315, 317, 319
 eastern ambitions, 337, 338
 Teşkîlât-ı Mahsûsa, 318

environment, impact on history, 13

Epic of Sheik Bedreddin (Hikmet), 75–6

equality (of subjects) as law, 261–2

Erickson, Edward, 318

Ertuğrul frigate, 284–5, 294

ethnic (or organic) nationalism, 258

ethnoreligious communities, and daily life, 160, 165, 166–7

ethnoreligious nationalisms in Empire, 258–9, 262–4, 290, 348–9

eunuchs, 61

Europe (WWI and after)
 loss by Empire, 309–12, *310*
 negative effects of pressure on Empire, 347–8

European empires
 and Armenian violence, 289
 and bankruptcy of Empire, 269, 347
 and Capitulations, 86, 184, 347
 and decline of Empire post-Süleyman I, 198–200
 and diplomacy with Ottomans, 113–14, 219–20, 223–4
 and Eastern Question, 224–5, 247, 267, 280, 334, 347
 embassies of Empire, 241–2

European empires (*continued*)
 and Empire in 16th century, *128*, 131
 and Empire in 17th century, 200, 211–12
 and Empire in late 19th century, 287–8
 imperial boundaries, 223–4
 imperialism forms, 262
 and reforms in Empire, 263–4, 266–7
 view of Turks, 199
 See also specific countries or events
Europeans in Empire, 224
Evliya Çelebi and *Book of Travels* (*Seyahatname*), 160, 161–3
expansion of Ottoman Empire. *See* Ottoman Empire expansion
Eyüp district (Constantinople), and ascension ceremonial of sultan, 84, 154–5

falcons and falconry, 170, *172*, 173, 175
family, 175, *176*
family pictures, *176*
Fatih Mosque, 85
fetwa after Adana events, 328
Feyzullah Efendi, 220–1
fez headgear, 255
Filiki Eteria ("Society of Friends"), 250
Finkel, Caroline, 213
firearms or gunpowder weapons use, 59, 66, 80–1, 108–9
First Balkan War, 310, 312
fiscal administration and policy, 153–4, 218
flexibility of Empire
 failures, 190, 192, 197, 350
 overview through history, 17–18, 345–7, 350–1
 at specific times, 42–3, 68, 95, 137, 151
food, in daily life, 161–2
forced resettlement (*sürgün*), 99–100, 102, 168, 218, 323, 327, 347–8
Fourth Latin Crusade, 78
France, 223, 228, 230, 247, 252, 260, 261
Franz Ferdinand, 314
fraticide in succession, 55, 72, 87, 190, 191, 201
frontier(s), 13, 42–3
funerary tradition for sultan, 190

Galata (Pera), *84*
 in Constantinople siege, 80, 81, 82–3
 daily life, 161–2, 165
 demography, 92, 165
Galata Tower, *84*

galleys (*kadırgas*), 111, 112, *112*
Gallipoli
 and naval power, 111, 112
 in WWI, 5, 319–21, 334
gazi, as term, 42
Gazi Ahmed Muhtar Pasha, 312
"*gazi* thesis" or narrative, 11–12, 41
gender, 15, 17, 175, 176
genealogical chains, 52
Gennadius Scholarius, 89, *89*
Georgia, 234–5
Germany, 287, 313, 314–15
Germiyan principality, 37
ghulam system, 28
girls, and education, 178, 264
Gladstone, William, 279
glossary, 355–60
Gökalp, Ziya, 297
Göke ship, *113*
Göktürks (or Köktürks) clan, 25
Golden Horde (Kıpçak Khanate), 34
Golden Horn Arsenal, 111
Golden Horn at Constantinople, 81, 84
governance
 in provinces, 151–4, 244
 and Süleyman I, 137, 140–2
 terminology, 57
 See also administration
Grand Bazaar (*Kapalı Çarşı*) construction, 85
Grand National Assembly, 342
*grand vezir*s
 administration of Empire, 205–6
 examples as ruling elite, 137, 138–40
 family succession, 205–6
 origins and power, 140
 residence and office, 224
 role, 55
 See also specific *grand vezir*s
Grateful Hellas, *252*
graveyards, 179, *179*
Greater Syria, 283, 299, 317, 319, 334, 336
Great Seljuk Empire, 31, *32*
Great Turkish War, 215
Great War. *See* World War I
Greece
 insurrection and independence, 248, 250, 252, *252*, 257
 population exchange with Turkey, 351
Greek Orthodox Church, 89

Greeks
 professions in Empire, 166, 250
 rebellion and nationalism, 250, 252, 257, 258, 259, 351
 in Turkey, 351
Gujarat, 123, 133
Gülhane Edict (*Hatt-ı Şerif* or the Imperial Rescript of Gülhane), 260–1
"Gunpowder" empires of Islam, 127, *129*
gunpowder weapons use, 59, 66, 80–1, 108–9
Györ fortress, 215

Habsburg, 113, 127, 185
 conflicts with Ottomans, 127, 132, 142, 190, 192, 206, 215, 218, 223
Hagia Sophia Church, 81–2
Halil, 51
Hamidiye militias and units, 288–9, *289*
Hamidian massacres, 289
Hanafi school, 141
harem of sultan, 190
harems, description and stereotypes, 8, *9*
haseki (favorite concubine/chief consort), 190, 191
Hatt-ı Hümâyun, 261
Hatt-ı Şerif (the Imperial Rescript of Gülhane or Gülhane Edict), 260–1
healthcare, 178–9, 254
Hijaz region, 246, 247, 314, 336
Hikmet Ran, Nâzım, 75–6
historiography of Ottomans, 11–13, 15–16, 41–3, 349
history overview
 centralization and peripheral areas, 13
 current studies, 16–17
 early views by Westerners, 11–12
 flexibility and adaptability of Empire, 17–18, 345–7, 350–1
 government records and archives, 14–15
 interpretation by Ottoman historians, 11–12, 41
 and language, 16
 nationalist views from Atatürk, 9–10
 periodization, 12
 and projections back in time, 14, 35, 41–2, 52
 revisionist views, 9–10
 sources (*see* sources for history)
Holy caravan, 170, *170*
Holy Land, management, 224
Holy League, 185, 215, 217, 219
"Holy Roman emperor" title, 144
homosexuality, 176–7

horses, 171, *172*, 173
hounds. *See* dogs
Hourani, Albert, 222
human hierarchy theories, 282
Hungary, 131–2, 215, 219, 222–3
Hünkâr İskelesi Treaty (1833), 263
hunting, 169, 170–1, *172*, 173
Hürrem. *See* Roxelana
Hurriyya, al- (Young Turk Revolution), 292–3, *293*, *294*
Husayn Kamil, 317
Husayn-McMahon Correspondence, 334

Ibn Battuta, 39
Ibn Qutayba, 30
Ibn Taymiyya, 245–6
İbrahim I ("Deli" [or "Crazy"] İbrahim), 203, 205
İbrahim Müteferrika, 230, 231
İbrahim Paşa (16th century), 64, *64*
İbrahim Pasha (16th century)
 and Capitulations, 184
 helmet for Süleyman, 144
 life and rise, 137, 138
 and Red Sea interests, 123, 133
 and Roxelana, 149
İbrahim Pasha (18th–19th century), 230, 246, 248
identity
 and daily life, 165–9
 national identity, 258, 290–2, 321, 348
ikta' system, 153
Ilkhanids and Ilkhanid Mongols, 34–5
illustrated manuscripts, *144*, *146–7*, 148
iltizâm system (land tenure taxation), 153, 218
Imperial Council (*Divan-i Hümayun*), 137, 140, 142
imperial scriptorium (*nakkaşhane*), 148
Indian Ocean, 123, 133
institutionalization of Empire, 128–9, 271
interregnum, 49, 72, 103
Ionnina (Janina), 244
Iraq, 133
İsa (prince), 72
İskendername chronicle, 53
Islam
 in Arabia, 245–6
 courts, 141
 and crisis of 17th century, 204
 cultural milieu, 29–30
 and early Turks, 25, 26, 27–8, 41
 as Empire responsibility, 124, 133, 349–50

Islam (*continued*)
 holy cities, 124, 245, 246
 and Mamluk Sultanate, 123–4
 pan-Islamic solidarity of Abdülhamid II, 284,
 285–6, 299
 restrictions in 18th century, 233
 rise and expansion, 26–8
 rulership theories, 30
 and slavery, 28–9
 succession in, 26
 and Süleyman I's titles, 144, 145
 Sunni-Shi'i divide, 26–7
 and Wahhabi movement, 245–6
Islamic "Gunpowder" empires, 127, *129*
Islamic law (*şeriat* law), 87, 141, 260
Islamic millennium celebrations, 189
"Islamic modernists," 270
Islamism, 286
Ismail Enver Pasha. *See* Enver Pasha
İsmail Gaspıralı, 291
Ismail / Ismâ'îl / İsmail (shah), *117*
 battle against Selim, 119, 120
 letters with Selim, 119, 120–1
 in Safavid state and empire, 116
 status, 116, 119
Istanbul
 administrative practices and policies, 85–7
 architectural development, 224
 as capital, 212
 as Constantinople, 82
 life in WWI, 324–7
 population, 92–3
 remaking as capital of Ottomans, 82, 83–5
 repopulation, 84
 See also Constantinople
Istanbul University (was Ottoman Imperial
 University), 265, *266*
Italy, 309
Ivan IV, 135
İzmir (Smyrna), 340, *341*

Jaffa, 292, *294*
Janissaries and Janissary Corps (*yeni çeri*), 65, *66*
 challenges to authority and rebellions, 155, 192,
 203, 242, 249, 253–4
 changes in role, 221, 231
 corruption, 204, 221
 description and role, 61, 63, 64–6, 67–8, 87
 elimination, 254

 firearms, 109
 in military formations, 108
 power and influence on sultan, 65, 68, 87, 155,
 221, 249
 and reforms, 253
 and Sufism, 67, 167, 254
"Janissary recruitment in the Balkans," *62*
Japan, 284–5, 294–6, 346
Jerusalem, 124
Jews and Jewish communities, 89–90, 91–2, 166, 266
jihad against Triple Entente, 316, 317
jizya (or head or poll) tax system and obligations,
 86, 88, 218, 261
judges (*kadıs* or *kazıs*) in Islamic courts, 141
judicial system in 16th century, 141
Justice and Development Party (*Adalet ve Kalkınma
 Partisi*, or AKP), 354
justice praxis in principality, 53
Justinian, Emperor, 78–9, *79*

Kadizadeli movement, 204–5, 206
Kadizade Mehmed Efendi, 204
kadı (officials), 151
kadı registers, 15
Kamianets-Podilskyi fortress (Kamenets Fortress),
 212, *214*
Kantakouzenos, John, 40
Kantakouzenos faction, 39–40, 51
kânûnnâme (legal code/statutes), 87, 128, 141, 176–7
*kânûn*s (dynastic laws/legal decrees), 87, 129, 141
kapıkulu slaves and elites ("slaves of the Porte"), 60,
 63–4, *64*, 66–7, 112–13
kapudan pasha (naval grand admiral), 142
Karaman *beylerbeylik*, 57, 93, 196
Kara Mustafa Pasha, 215–16, 217
Katip Çelebi, 205
*kaza*s, administrative practices, 58
Kemal Reis, 112, *113*
khan, as term for rulers, 52
Kingdom of Serbia, 314
Kınık tribe, 25
Kıpçak Khanate (Golden Horde), 34
Kırghız, and early Turks, 25
kızılbaş (or "redheads"), 115–16, *117*, 119, 120
kızlar ağası (chief black eunuch), 190
Klis fortress, 132
Knights Hospitallers of St. John, 107, 131, 135
knowledge assimilation, 29–30
*köçek*s, 176, *177*

Köktürks (or Göktürks) clan, 25

Konstantiniyye, 82

Köprülü, Mehmed Fuad, 11–12, 41

Köprülü family dynasty, 205–6, 215

Köprülü Fazıl Ahmed Pasha, 206, 212

Köprülü Mehmed Pasha, 205–6

Köprülüzade Fazıl Mustafa Pasha, 206

Korkud (prince), 116, 118

Kösem Sultan (Mâh-Peyker Sultan), 191, 201–2, 203, 205

Kosovo, 312

Kurds and Kurdistan, 152, 153, 288, *289*, 298, 352–3

kuriltai (tribal elders assembly), 54

Kutadgu Bilig (*Wisdom of Royal Glory*), 53

Kut al-Amara, 321–2

lala, and succession, 54, 55

land grants, 35, 37, 52, 56, 57, 59

land law and rights reforms, 266

land management systems, 153

language
 diplomacy and foreign languages, 250, 255
 history and changes, 16, 42
 official language, 280, 301–2

law
 codification, 128, 129
 Islamic (or *şeriat*) law, 87, 141, 260
 land law, 266
 legal code/statutes (see *kânûnnâme*)
 policies in Constantinople, 87
 secular, 141, 271
 and Süleyman I, 141–2

Law of Associations, 298

"Lawrence of Arabia" (T.E. Lawrence), 336, *336*, 337

Lazarević, Stephen, 51

League of Nations, 338

Lebanon, 263, 350

legal code/statutes. See *kânûnnâme*

leggings-makers, *166*

legislature, in constitution, 280

Leopold I, 215, 218

"Levantine diplomacy," 113

levend infantry and militias, 109, 111, 231, 233–4, 241
 See also *sekban*s infantry and militias

Levni, *228*

Liberal Entente (Liberal Union) party, 305, 312

life in Empire
 animals in, 169–74, 303–4
 description challenges, 159–60

 and ethnoreligious communities, 160, 165, 166–7
 and identity, 165–9
 and modernization, 277–8
 for non-elite, 174–9
 in public spaces, 160–5
 and tribal identity, 167–9
 in WWI, 322, 324–7

literary renaissance of 19th century, 270

Little Ice Age, 193

loans (international) to Empire, 269

Lokman, 130

"long" nineteenth century, 240

Long War, the, 192

losses of territory in Empire, 216, 282–3, *283*, 309–12, *310*

Louis XIV, 215, 218

Luther, Martin, 199

Macedonia, 288, 309–10, 311, 312

"Macedonian Question" and conflict, 288

Machiavelli, Niccolò, 199

Mahfiruz, 202

Mahmud I, 225, 230, 231

Mahmud II, *251*
 administrative reforms, 255–6
 ascension, 243, 249
 death, 260
 decision-making and initiatives, 250, 255
 reforms, 250, 252–6, 260
 treaties, 263
 and Western culture, 256

Mahmud Şevket Pasha, 297, 312

malik, as term for rulers, 52

malikâne (lifetime tax farms), 154, 218, 222

Malta, 135, 185

Malûmât newspaper, 286

Mamluk *emirs*, 123, 248

mamluks and *mamluk* slavery, 29, 60

Mamluk Sultanate and dynasty
 description, 33
 and Islam, 123–4
 power, 106
 and Safavids, 121–2
 and Selim I, 118, 121–3
 war with Ottomans, 114

Mandate states/system, 338, 349, 350

manuscripts, work on, *145*

marcher lords, 52, 59

Marj Dabiq battle, 122

marriage, 51, 137, 175–6, 226
Mecca and Medina, as holy cities, 124, 245, 246
medicine and medical care, 178–9, 254
Mediterranean
 battles and campaigns, 111, 112, 132, 135, 142,
 185–6
 in early modern era, 183
 naval fleets, 112, 114
*medrese*s schools, 178
Mehmed Amin Ali Pasha, 260
Mehmed Fuad Pasha, 260
Mehmed I (prince/sultan), 72–4
Mehmed II, *89, 95*
 administration practices and policies, 85–7, 128,
 137, 153
 as art patron, 148
 in Balkans, 77, 103, 105
 Constantinople conquest, 78, 79–83, 99
 death and achievements, 94–5
 empire map, *94*, 106
 expansion of Empire, 93–5, 99, 106
 and fratricide, 55, 79, 86
 naval fleet, 112
 policies and laws, 85, 87, 88, 89, 92
 remaking of Constantinople, 82–5
 as ruler, 77, 79
 succession of, 106–7
 vision of Empire, 53, 77, 79
Mehmed III, 56, 106, 190, 192, *194–5*
Mehmed IV
 ascension, 203, 205
 campaigns, 212, 215
 court in Edirne, 205, 212
 overthrow, 215, 218
 rule and reign, 205–6
Mehmed V Reshad, 297, 325–6
Mehmed VI Vahideddin, 337, 342
Mehmed Ali Pasha, 244, 246, 248–9, *249*, 252–3
Mehmed Talaat Pasha, 313, *314*, 315, 338
Mehmed Nazım, 323
Mehmed Sokullu Bridge, *188*
Mehmed the Conqueror ("*Fatih Mehmed*"), 82–3, 93
"Mehterhâne," *67*
*mektep-i sıbyan*s schools, 177–8
men, 163, *164*
 See also gender
Mesopotamia, in WWI, 321–2
Mevlevi "Whirling Dervishes," *167*
Mevlid, 189

Midhat Pasha, 280–1, 297
military academies, 254
military bands (*mehter*), 66, *67*
military conscription, 261, 265
military legacy of Empire, 353–4
military organization and weapons, 108–9
military reforms
 and Germany, 287
 in modern era, 231, 234
 in 19th century, 239, 241, 242, 252–4, 255, 265–6,
 350
military service, 298
military strategies of Ottomans, 108–9, 112, 192
millet, as term, 88
millet system, 88–9, 90, 160, 346, 348
 in reforms, 257, 259, 262, 269
Mimar Koca Sinan, 188
Mimar Sinan Pasha, 140, 142, 186
miniature paintings tradition, 145, 148, 171, *228*, 277
ministries, modernization, 255–6
mobility in Empire, 68
modern era transformation, overview, 211–12, 218,
 219–22, 223–4, 226, 230–3, 235, 239
modernists in 19th century, 270
modernization
 in Constantinople, 278, *278*
 "defensive modernization" reforms, 241–3
 negative effects of pressure on Empire, 347–8
 and reforms, 248, 254–6, 263–5, 269–72,
 286, 287
 and westernization, 241, 256–7, 277–8
 and Young Turks movement, 277, 290
Moldavia, 103, 223, 249
Mongol Empire map, *34*
Mongols, in Anatolia and Middle East, 32, 33–5
Montagu, Mary Wortley, 8
Montesquieu, 199–200
Morean War, 218
Morgenthau, Henry, description of Turks, 4, 9
Mosul, 337–8
Mouradgea d'Ohsson, Ignatius, 199, 241
Mousouros, Konstantinos (Kostaki Musurus Bey),
 259
Mudros Armistice (1918), 337
*müfti*s, 141
Muhammad b. 'Abd al-Wahhāb, 245, 246
mukataa collection, 153
Murad I, 40, 47–9, 51, 54, 55, 60
Murad II, 74, 76–7

Murad III
 celebrations as distraction, 189
 reign and power, 186, 189, 190, 192
 siege of Eğer, 192
 succession, 56, 149
 weaponry, 109
Murad IV, 203, 204
Murad V, 276
Mural I, 111
Musa (prince), 72
Muscovy, 135, 212
müsellem cavalry, 108
music, 230
Muslim and non-Muslim relations
 changes in history, 17
 and equality as subjects, 262, 263, 350
 and flexibility of Empire, 17, 346–7, 350–1
 sectarian violence, 250, 263
Muslim caliphate, 123, 280, 301, 342, 349–50
Muslim empires, and Empire, 129
Muslim "Gunpowder" empires, 127, 129
Muslims
 Abdülhamid II as Caliph of all Muslims, 284, 285–6, 299
 caliphate, 123, 280, 301, 342, 349–50
 death traditions, 179
 marriage, 175
 in military, 253
 nationalism within Empire, 290, 298
 in New Order Army, 241, 242
 as population, 276, 352
 predominance in Empire, 123
 as refugees, 267–8, 283–4, 285
 and slavery, 63
 in state apparatus and officials, 140
 trade and reforms, 262–3
 in WWI, 316, 317
Mustafa (prince, son of Süleyman I), 149, 154
Mustafa (prince, the "false" Mustafa), 73–4
Mustafa Ali, Gelibolu, 198
Mustafa Bayrakdar Pasha, 243
Mustafa I, 201, 202, 203
Mustafa II, 219, 220
Mustafa III, 231, 233, 234
Mustafa IV, 243, 249
Mustafa Kemal
 as Atatürk, 10, 342, *342*
 post–WWI nationalism, 338, 339
 in WWI, 9–10, 321

Mustafa Reşid Pasha, 260
Mutasarrifiyya of Mt. Lebanon, 263
Mu'taşim, al-, 29

Nadir Khan, 225
Nadir Shah, 121, 225, 230
nahda (cultural awakening) of Arabs, 298–9, 301
*nahiye*s, 58
Na'ima, Mustapha, 14
Nakkaş Osman, 130
Nakkaş Sinan Bey, 95, *95*
Namık Kemal, 270
Napoleon, invasion of Egypt, 122–3, 244, 247
Napoleonic Wars, 244
nasihatnâme ("mirror for princes") literary genre, 198, 205
nation
 Ottoman nation, 3, 323
 in propaganda of CUP, 3
 and reforms, 261–2
national identity, 258, 290–2, 321, 348
nationalism
 in Armenia, 288–9
 in Balkans, 257, 259, 349
 in Egypt, 259
 ethnoreligious, 258–9, 262–4, 290, 348–9
 germination and rise, 256–7, 259
 Greeks, 250, 252
 and identity, 258, 290–2, 348
 and Jews, 266
 of Muslims within Empire, 290, 298
 negative effects on Empire, 348–9
 and Ottomanism, 261–2, 348
 post–WWI movement, 338–9, 340–1, 349
 in Serbia, 257, 258–9
 theory and types, 258
 WWI in Empire, 323
 Young Turks movement, 290–1, 294, 298
national solidarity (Ottomanism), 261–2, 348
nation-state nationalism. *See* nationalism
natural and climate disasters, 192, 193, 196, 197
naval academy, 254
naval battles
 at Constantinople siege, *80*, 81
 in Mediterranean, 111, 112, 132, 135, 142, 185–6
naval forces of Ottomans
 corsairs, 142, 143
 early forces, 110–13, 114–15, 142

naval forces of Ottomans (*continued*)
 foreign help, 110, 111
 ship building, 112, 114
New Order Army (*Nizâm-ı Cedid*), 241, 242, *242*
newspapers and news, 286, 292–3
New World discoveries, 113
Nicopolis battle, 49, *50*
"Nine Years War" (War of the Grand Alliance), 218
Nizâmiye ("Ordered Army"), 248
Nizâm-ı Cedid ("New Order") corps, 241, 242, *242*
nomads
 lifestyles, 167–8
 and origins of Turks, 23–4
 political power in, 54, 58
 sürgün (forced resettlement), 99–100, 168, 347–8
 and written history, 14
non-elite. See *re'aya*
non-Muslims (*dhimmi*s)
 in Bulgarian uprising, 279
 equality of subjects as law, 261–2
 identity, 290
 jizya tax system and obligations, 86, 88
 management post-siege, 88–9
 in military, 265
 and "*millet* system," 88–9, 257, 259, 262
 outnumbered in Empire, 123
 in reforms of Mahmud II, 256–7
 relations with Muslims (*see* Muslim and
 non-Muslim relations)
 slavery, 28–9, 61, 63
 in state apparatus, 137
 and trade, 86, 88
North Africa, 152
"Northern Arc" of Ottoman Empire, 106, 212, 215
Notaras, Loukas, 82
Nurbanu Sultan, 191
Nurettin Bey, 322

Oğuz Khan and Oğuz lineage, 23–4, 25, 35
open succession, 53–6
Orga, Irfan, *324*, 324–7
organic nationalism, 258
Orhan (son of Osman), 39–40, 51
Orhan (uncle of Mehmed II), 79
Orientalist art, 248
Orientalist scholarship and "Orientalists," 5, 8, 12
Orkhon Inscriptions, 25
orphans and orphanages, 348
Orthodox population in Empire, 234
Oruç Reis, 143

Osman (Osman Gazi / Ghazi or Osman Bey)
 alliances and marriage, 51
 ancestors and lineage, 35, 37, 51, 130
 death, 39
 dream of, *36*, 36–7
 early territory, *38*
 first conquest, 35
 as founder of principality, 5, 37
 as ruler, 37–9
Osman II, 202–3, 205
Osman III, 231
Ottoman Antiquities Law, 287
Ottoman *beylik*. See principality in Anatolia (*beylik*)
Ottoman Caliphate abolition, 342, 349
Ottoman chronicles, as sources, 14, 35, 37, 42
Ottoman Debt Commission, 287
Ottoman dynasty
 death traditions, 179
 family confinement, 56
 family tree, *1*
 resiliency in crises, 221, 345
 succession in, 53–6, 148–9, 151
 sultans and *valide sultan*s, *202*
Ottoman Emirate. *See* principality in Anatolia (*beylik*)
Ottoman Empire
 and balance of power in Europe, 224–5
 in civilization and human hierarchy, 281–2
 daily life (*see* life in Empire)
 decline post-Süleyman I, 197–200
 description and understanding, 5, 8–10
 diversity post-siege, 88–93
 downfall start, 212
 in early modern era transformation, 183, 184–6,
 189, 190, 192, 200, 206–8, 211–12
 end and dissolution, 342, 345–6, 351
 in European empires, *128*
 expansion (*see* Ottoman Empire expansion)
 flexibility (*see* flexibility of Empire)
 geographic extent, 346
 losses of territory, *216*, 282–3, *283*, 309–12, *310*
 in modern era transformation, 211–12, 218,
 219–22, 223–4, 226, 230–3, 235, 239
 nationalism theory and examples, 258–9
 and "Northern Arc," 106, 212, 215
 population and size changes, 275–6, 286–7
 pre-Napoleon (1795), *243*
 reforms (*see* reforms in Empire)
 revisionist history, 9–10
 as "Sick Man of Europe," 275, *276*
 and "Southern Tier," 106, 124

as Turkish Empire, 323
See also specific topics, events, and people
Ottoman Empire expansion
 in Anatolia *beylik*, 47–9, *48*, 56–7
 by Mehmed II, 93–5, 99, 106
 by Selim I, 114–19, 121–4
 by Süleyman I, 128, 129, 131–3, 135, 136–7, 142
 as world empire, 6–7, *48*, *94*, *115*, *136*
"Ottoman Freedom-Lovers Society," 292
Ottoman-Greek War, 288
Ottoman-Habsburg Treaty of Edirne (1568), 185
Ottoman Imperial University (now Istanbul
 University), 265, *266*
Ottoman interregnum, 49, 72, 103
Ottomanism (national solidarity), 261–2, 270, 348
Ottoman-Mamluk War, 114
Ottoman nation, 3, 323
Ottoman Prime and Foreign Ministry Archives,
 14–15
Ottoman Sultanate abolition, 342
Ottoman Turkish language, 16
Ottoman Turks
 description and identity, 4–5, 9
 early territory, *38*
 genealogical chains, 52
 justice system, 53
 nationalism and identity, 290–1
 See also principality in Anatolia (*beylik*)
Ottoman Union Committee, 291–2
Ottoman-Venetian wars, 112, 114

Pachymeres, Georgius, 38
Palace. *See* Topkapı
Palaeologus faction, 51
"pan-Turanist" movement, 291
pan-Turkism ideology, 291, 294, 302
"paradigm of decline" view of history, 12
Paris Peace Conference, 338
Parliament, 280, 281, *281*
pasha households (*kapılar*) in "Edirne Incident,"
 220–1
"Patriotic Alliance," 270
patriotism to Empire, 270
Patrona Halil Rebellion, 230
peasants, in provincial administration, 59
Peirce, Leslie, 191
penal code of 1840, 264
Pera. *See* Galata
periphery and core countries, 184
Persia, 30, 116, 119, 225, 314

Peter the Great, 223
piracy and pirates, 111, 143
Piri Reis, 123
Podolia region, 212, *214*, 219
Poland, 212
Polish-Lithuania Commonwealth entente, 212, 219
political power
 "Circle of Justice" theory, 30
 and "Edirne Incident," 220–1
 legitimacy in principality, 51–3
 Ottomans link to Seljuk Turks, 52
 in provinces, 56–9, 244
 and succession, 53–6
 in tribal-nomadic entities, 54, 58
poll tax, 218
polygeniture, 54
Porte (or Sublime Porte), 224, 255–6
Portuguese expansion and trade, 113, 114, 123, 133
power, political. *See* political power
power symbols, 52
prebendal right, 57, 58
Prince Faysal, 334, *336*, 337
principality in Anatolia (*beylik*)
 alliances, 51
 authority reinstation after Timur, 71, 73–4, 76–7
 borderlands and frontiers, 13, 42–3
 in Civil War, *73*
 cultural mix and milieu, 35
 debates about, 40–1
 early Turks, 35, 37
 emergence, 5, 12, 37
 expansion, 47–9, *48*, 56–7
 flexibility, 42–3
 historical background (post-Osman), 35–40
 historical background (pre-Osman), 30–5
 historiographical conclusions, 41–3
 and Ilkhanids, 35
 in interregnum, 49, 72, 103
 justice praxis, 53
 legitimacy of power, 51–3
 link to Seljuk Turks, 52
 Murad I as ruler, 47–9, 60
 naval power and fleet, 111
 Orhan as ruler, 39–40
 Osman as founder, 5, 37
 Osman as ruler, 37, 38–9
 and other *beyliks*, 37–8, 39–40
 power struggles and succession of Bayezid I,
 71–4, 76–7
 provincial administration, 56–9

principality in Anatolia (*beylik*) (*continued*)
 religion, 41
 rulership terminology, 52
 ruling class, 60
 sources and projections back in time, 42, 52
 and Venice, 74, 75
printing press, 230, 231
privatization in fiscal matters, 222
professions, 166, 250, 252
Prophet Muhammad, 26, 51, 78, 189
prostitution, 177
Protestants, 132
provinces
 administration, 56–9, 151–4, 222
 corruption and taxation, 264
 governance, 151–4, 244
 postings of sultans' sons, 54–5, 56, 149, 151,
 189–90
"provisioning organism," 137, 346
provisioning system of Empire, 137, 168, 192–3, 196,
 213, 346
Prussia, 233
public spaces, and daily life, 160–5
publishing industry, 292–3

racial hierarchy theories, 282
Radu (Drakul), 104, 105
railway of Hijaz, 287, 313
railways, 287, 313
Rami Mehmed Pasha, 220–1
raptors (birds of prey), 171, 173
re'aya (non-ruling classes or non-elite), 16, 109, 174–9
"Reception of Ibrahim Paşa," *64*
"Red Apple" (*kızıl elma*) as symbol, 78, 79
Red Apple riddle, 77–8, 79
Red Sea, 123
Reformation, 132
reforms in Empire
 and Abdülhamid II, 280, 281, 286, 287
 in administration and bureaucracy, 255–6, 264,
 286, 287
 in Armenia, 288
 constitutional reforms, 276, 280, 281
 and CUP, 297, 301, 302
 decrees and edicts, 260–2, 263
 "defensive modernization," 241–3
 and education, 254, 265, 271
 in Egypt, 248
 ethnoreligious issues, 240, 262–4

 and institutional dualism, 271
 and international law, 263–4
 medicine and medical care, 254
 military (*see* military reforms)
 and modernization, 248, 254–6, 263–5, 269–72,
 286, 287
 and non-Muslims, 256–7
 opposition by young Ottomans, 269–71
 overview in 19th century, 239–40, 241, 302,
 304–5
 rebellions against, 242–3
 and religion, 240
 state-led, 239, 241, 250, 252–3, 269–70
 success debate, 271–2
 in taxation, 218, 222, 261, 264, 265
 See also Tanzîmât reforms and era
Refugee Code / Refugee Commission, 268
refugees into Empire, 267–9, 283–4, *284*
 movements, *268*, *285*
regicides, 203, 205
religion
 breakdown in Constantinople, 92
 and clothing, 166
 and daily life, 160, 165, 166–7
 diversity in Empire, 88, 89–90, 92
 and genealogical chains, 52
 holy sites in Empire, 124, 245, 267
 and medicine, 179
 millet system, 88, 160, 262
 and nationalism, 258
 population exchange Greece-Turkey, 351
 printing ban, 230
 and reforms, 240
 and resettlement, 100
 and Süleyman I's titles, 144–5
 See also specific religions
"Reordering, the." *See Tanzîmât* reforms and era
residential quarters (*mahalles*), 165
Rifā'a Rāfi' al-Ṭahṭāwī, 248
rights (personal/human), 260, 270
river fleets, 114
Roman Empire, 30
Rome, 94–5
Roxelana (Alexandra Lisovska, renamed Hürrem),
 56, 148–9, *149*
royal hunt tradition, 170–1
rulership
 Islamic theories, 30
 terminology, 52

Rumelia. *See* Balkans (Rumelia)

Rumelia (Europe) in 14th century, 57

Rumeli Hisarı ("Rumelian Castle" or *Bogaz kesen*), 79, *81*

Rûm Seljuk Empire, 31–2, *33*, 34

Rûm *vilayet* (province), 57

rural daily life in Empire, 159, 160, 167–9

Russia
 Bolshevik Russia, 335, 337, 340
 conflicts with Ottomans, 219, 223, 233–5, 245, 250, 266–7, 279–80, 283
 and Empire in WWI, 315, 316, 334, 335, 337
 modernization and expansion, 223, 225–6, 233
 and "pan-Turkism" movement, 291
 rights and provisions in Empire, 234
 and treaties, 263, 282

Russo-Japanese War, 295–6

Russo-Ottoman Treaty of Edirne (1829), 263

Russo-Ottoman War, 223, 280, 283, *285*

Russo-Turkish War, 280

Rüstem Pasha, 137

Rycaut, Paul, 199

Sa'adabad Palace, 227, *227*, 230

Saadi, Bashir al-, 332

Sabaheddin Bey, 292

Sabbetai Zvi and movement, 206, *207*, 207–8

Safavid dynasty/empire and state
 borderlands management, 151–2, *153*
 collapse and occupation, 225
 conflict with Ottomans, 119, 121, 133, 135, 189, 192, 203
 Empire map, *118*
 and Mamluk Sultanate, 121–2
 and Selim I, 109, 117, 118–19, 120
 Sufism, 116, 119

Safî ad-Dīn, 116

Safiye Sultan, 191

Said Halim Pasha, 312, 315

salafi movement, 299, 301

Salah ad-Din (Saladin), 33

*sancakbeyi*s, 57, 59

*sancak*s, 57–8

San Remo Conference (1920), 339

San Stefano negotiations, 281, 282

Sarıkamış battle and debacle, 318–19

Sâṭi ' al-Ḥuṣrî, 275

Sa'ud b. 'Abdul-Azīz b. Muhammad Al Sa'ud, 246

Sa'ud tribe, and Wahhabis, 246

scribal class, 197–8

sea, 110, 113–14

sea power. *See* naval forces of Ottomans

Second Balkan War, 311–12

"Second Edirne Incident," 242

şehnameci or *vakanüvis* (court historians), 14, 148

*sekban*s infantry and militias, 109, 192, 197, 208
 See also *levend* infantry and militias

Selim (prince), 116, 118

Selim (son of Süleyman), 149, 154

Selim I (Yavuz Selim, or "Selim the Grim" / Selîm)
 actions and expansion of Empire, 114–19, 121–4
 and Egypt, 122–3
 hunt, *172*
 letters with Ismail / Ismâ'îl, 119, 120–1
 and Mamluk Sultanate, 118, 121–3
 naval power, 114
 and Safavids, 109, 117, 118–19, 120

Selim II ("Selim the Sot"), 139, 154–5, 185, 186

Selim III, *242*
 ascension, 239, 240, 241
 campaigns, 244
 deposition and murder, 243, 249
 interests, 240–1
 reforms, 239, 241–3

Selimiye Mosque, 186, *187*

Seljuk (ruler), conversion to Islam, 25

Seljuks of Rûm Empire, 31–2, *33*, 34

Seljuk Turks
 early history, 25, 30–1
 Great Seljuk Empire, 31, *32*
 link to principality, 52
 as power and sultans, 31, 52

sema ceremony, 167

Şemâ'ilnâme manuscript, 130

Senate, in constitution, 280

seniority principle in succession, 56, 191, 201

Serbia, 244–5, 249, 257, 258–9, 314

Şeref, Abdurrahman, 14

şeriat law (Islamic law), 87, 141, 260

Seven Years War, 233

sexuality, in daily life, 176–7

şeyhül-islâm position, 141, 190

Shah Rukh, 71

Shajarat al-Durr ("Tree of Pearls") novel, 300–1

Sharif Husayn and sons, 314, *315*, 329, 334, 336, 350

sheep as livestock, 168–9, 173

shepherds, *101*, 168, *169*

Shi'a and Shi'ites, 26–7, 119, 133

Shi'ism, conversion in Persia, 116, 119
ship building, 112, 114
Shogher Tonoian, 331–2
"Sick Man of Europe," 275, *276*
sieges. *See* specific sieges
siege tactics of Ottomans, 108
silk embargo, 129
silkworms and silk, 173–4
*sipahi*s (cavalrymen), 58–9, *60*
Sivriada/Sivri island, 303, *304*
Skanderbeg (George Kastrioti), 103
slave-origin individuals, 58, 63–4, 137, 140
slavery
 abolition, 177, 297
 acquisition of slaves, 29, 60–1
 "collection" method (or *devşirme*), 61–3, *62*, 64,
 65, 67, 87, 137, 221, 241
 and Islam, 28–9
 for non-Muslims, 28–9, 61, 63
 trade and ban in 19th century, 252, 265
 traditional form, 28, 60
slave soldiers and armies
 Janissaries as, 61, 63, 64, 87
 kapıkulu as, 60, 63–4
 loyalty of, 66–7
 and *mamluks*, 29, 60
Smederevo province, 244–5
Smyrna (İzmir), 340, *341*
Social Darwinism, 282, 293
Söğüt land grant, 35, 37, 52
Sokollu Mehmed Pasha, *135*
 biographic details, 137, 139–40
 death of Süleyman I, 139, 154
 plans for Empire influence, 185–6
sons
 in slavery and *devşirme* system, 61–3, *62*
 and succession, 54–5, 56, 149, 151, 189–90
sources for history
 archives and government records, 14–15
 from China, 23, 24–5
 on daily life in Empire, 159, 160
 early sources, 11, 14, 35
 and language, 16, 42
 and projections back in time, 14, 35, 41–2, 52
 reliability, 14, 35, 37
"Southern Tier" of Ottoman Empire, 106, 124
spice trade, 113, 123, 133
state apparatus and officials, 137, 140
Straits Convention (1841), 263

street or stray dogs, *303*, 303–4, *304*
study mission to Europe, 228, 230
Sublime Porte (or Porte), 224, 255–6
Sublime Porte building, 224
succession
 dynastic succession, 53–6, 148–9, 151
 fraticide in, 55, 72, 87, 190, 191, 201
 seniority principle, 56, 191, 201
 sons (as crown princes), 54–5, 56, 149, 151,
 189–90
 struggles in 17th century, 200–3
 system changes, 148–9, 151, 189–90, 191, 201
 wives and concubines in, 54, 55
 See also specific rulers' succession
Suez Canal, 140, 185, 319
Sufism
 and alliances, 51
 description, 41
 in early Turks and nomads, 41
 of Janissaries, 67, 167, 254
 of Safavids and *kızılbaş*, 116, 119
 sects as identity, 166–7
Sufi wandering dervishes (*baba*s), 41
Süleyman (Bayezid I's son), 72
Süleyman (Orhan's son), 40
Süleyman I, or Süleyman "the Magnificent," *130*
 actions and expansion of Empire, 128, 129,
 131–3, 135, 136–7, 142
 administrative centralization and bureaucracy,
 128–9, 140–2, 153
 arts and patronage, 145, 148
 ascension, 124, 127, 129
 as caliph, 123, 142, 144, 145
 campaigns, 131–7, *134*, *135*
 concurrent rulers and powers, 127–8, 130, 131,
 136
 courts and law, 141–2
 death, 135–6, 139, 154
 decline of Empire afterwards, 197–200
 eastward expansion, 133, 135
 empire map, *136*
 funeral procession, *146–7*
 and governance, 137, 140–2
 as *kânûnî* ("the lawgiver"), 129, 141
 marriage, 56
 naval force, 111, 142
 and provinces, 151–4
 state apparatus and officials, 137–40
 succession, 56, 148–9, 151, 154–5, 189

titles of power and prestige, 142, 144–5, 148
 westward expansion, 131–3, 135
Süleyman II, 215, 218
Süleymaniye Mosque inscription, 145
Süleymannâme, 62, 64
"Sultanate of the Women," 149, 191
sultan(s)
 ascension ceremonial, 84, 87
 and constitution, 280
 family tree, *1*
 portraits in *Şemâ'ilnâme*, 130
 as term for leader, 52
 See also specific sultans
sumptuary laws, 233, 255
Sunnis, 26–7, 133, 349–50
Supreme Council, 255, 269
sürgün (forced resettlement), 99–100, 102, 168, 218,
 323, 327, 347–8
Surname-ı vehbi, 67
surveillance by Abdülhamid II, 286
Sykes-Picot Agreement, 334–5, *335*, 336, 337–8
Syria, 248–9, 263
Szapolyai, John, 132

Tanzîmât reforms and era (the "Reordering")
 and Armenia, 288
 description and provisions, 260–1, 302, 304
 and diplomats, 255
 impact and goals, 263, 264–5, 269–70, 271–2,
 346–7
Tatars, 105–6, *134*, 135
taverns, in daily life, 161–2, 165
taxation systems and collection
 reforms, 218, 222, 261, 264, 265
 for wars, 196
 See also specific taxes
tax farms, 153–4, 218, 222, 264
technology, in modernization and reforms, 256,
 264, 277
Tepedelenli Ali Pasha (Ali Pasha of Janina), 244, 250
Teşkîlât-ı Mahsûsa (intelligence service), 318–19
31 March Incident, 297
Thököly, 215
tiles from Kütahya area, *58*
timars, 59, 218, 222
Timur (or Tamerlane), 49, 52, 71, 73
tobacco use, 164
Tōgō (Admiral), *296*
Tonoian, Shogher, 331–2

Tonyukuk Inscription, 25
Topkapı (Palace), *85*
 construction, 84–5
 power and intrigues, 189–90
 regicides and oustings, 203, 205
 slave-origin individuals, 63–4
 sovereigns and seclusion, 87
 and succession, 56, 149, 189–90
trade
 and Capitulations, 86–7, 184, 213, 223, 262, 347
 expansion with Empire, 93
 in Istanbul, 85–7
 with Muscovy, 135
 and Muslim merchants in reforms, 262–3
 non-Muslims, 86, 88
 by sea, 114
 spice trade, 113, 123, 133
 with Venice, 74, 86, 93
tradespeople guilds, 166
Translation Office, 250, 255
Transylvania (or *Erdel*), 103, 219
Treaty of Berlin (1878), 282–3, *283*, *285*, 288
Treaty of Brest-Litovsk (1918), 337
Treaty of Bucharest (1812), 245
Treaty of Bucharest (1913), 312
Treaty of Constantinople (1700), 219
Treaty of Edirne (1444), 77
Treaty of Edirne (1568), 185
Treaty of Edirne (1829), 263
Treaty of Istanbul (1913), 312
Treaty of Jassy (1792), 234–5
Treaty of Karlowitz (1699), 219, 220, 224
Treaty of Küçük Kaynarca (1774), 234
Treaty of Lausanne (1923), 342, 351
Treaty of London (1913), 311
Treaty of Paris (1856), 267
Treaty of Passarowitz (1718), 223
Treaty of Sèvres (1920), 339, *339*
Treaty of Sistova (1791), 223
Treaty of Versailles (1919), 338
Trebizond empire, 93
tribal identity, and daily life, 167–9
Triple Entente (Allied Powers), in WWI, 315–16,
 334–5
Tripoli, 135, 152, 309
"triumvirate" control and rule of CUP, 312, 315,
 317, 333, 338
Tu-chüeh (or *Türkî*) tribal confederations, 23–4
Tuğs (horsetail standards), 52, *53*

Tulip Age (or Era) ("*Lâle Devri*"), 226–8, 233
tulips and tulip-breeding, 226
Tunis, 142, 152, 186
Turcology, 12, 41
Turhan Sultan, 203, 205
Turkey
 first president, 10, 342
 and minorities, 351–3
 nationalist history, 9–10
 as Republic, 342, 351
Turkish, as official language in constitution, 280, 301–2
Turkish Empire, 323
Turkish Republic, 342, 351
Turkish War of Independence, 338, *340*
Turks
 arrival in Anatolia, 35, 37
 description and stereotypes, 4, *8*, 8–9, 248
 folk traditions, 24–5
 Islamization process, 25, 26, 27–8, 41
 migrations and conquests, *24*
 origins, 23–5
 sea knowledge, 110
 view from Europe, 199
 view of Christians, 4
 See also Ottoman Turks; Seljuk Turks
"Turquerie," 228, 230

"Üç Tarz-ı Siyaset" ("Three Types of Policy"), 294
ulema (religious class)
 dislike of Western culture, 230, 242
 and education, 178
 headgear, 255
 power and influence, 205, 249
 and Süleyman I, 140–1
Umayyad Caliphate map, *27*
Umayyads overthrow, 26, 27
unigeniture, 54
universities, founding, 264
Urban (cannon-founder), 79–80
urban daily life in Empire, 159–60
Uyghurs, 25
Üzbeks, 116
Uzun Hasan, 93

*vakf*s (charitable works/pious endowments), 149, 150, 178
*valide sultan*s (queen mothers), 55, 190, 191, *202*
Van (Armenia), 328

vassals, and territory management, 48–9, 51, 102–6
Venice
 and Albania's Ottomans, 103
 *bailo*s and reports on Empire, 198, 199
 and *beylik*, 74, 75
 and naval battles, 111, 112
 and Süleyman I, 132–3
 trade with Ottomans, 74, 86, 93
 wars with Ottomans, 93, 112, 114, 132–3, 205
Vienna sieges, 132, 211, 215–18, *217*
vilayet (or *beylerbeylik*), 57–8
Vlachs and expansion, 100, 101–2
Vlad III Drakul, *104*, 104–5
*voivode*s and *voivodate*s, 102–3, 104
Voltaire, 230, 232–3

wagenburg and *tabur* battle formation, 109, *110*
Wahhabi sect and challenge, 245–6, *247*, 248, 299
Wallachia, 103, 104–5, 223
Wallerstein, Immanuel, 184
War of the Alpujarras, 185
War of the Grand Alliance ("Nine Years War"), 218
warriors, and land grants, 56, 57, 59
weaponry of Ottomans, 108–9
 See also firearms
weather conditions, 193, 196
westernization
 among elites, 212, 228, 230, 256, 277–8
 as modernization, 241, 256–7, 277–8
Western powers, and constitution of Empire, 281–2
"Whirling Dervishes," *167*
"white man's burden" notion, 281–2
Wilhelm II, 287
Wilson, Woodrow, 340
Wittek, Paul, 11–12, 41
wives, and succession, 54
wolf, in origin myths, 24–5
women
 in daily life, 163, 175, 324–7
 influence, 15, 17
 role in society, 175
 See also gender
world systems theory and Empire, 184
World War I (WWI), *317*
 in Anatolia, 319, 337
 Arabia and Arab revolt, 314, 334–7, *336*
 Armenia and genocide, 319, 322–3, 327–33, 337
 and Capitulations, 315–16, 340
 CUP in, 315, 316, 317, 335–6

daily life in capital, 322, 324–7
declaration of war, 316
division of Empire, 334–5, 337–40
Empire in, 315–22, *320*, 337
nationalism and national identity, 321, 323
nationalist movement post-war, 338–9, 340–1
neutrality of Empire, 315
onset and alliances, 314–15, 334
Ottoman soldiers, *321*
peace negotiations and post-war developments, 337–8
Teşkîlât-ı Mahsûsa, 318–19
Wu-Sun people, 24

Xiongnu tribe, 24–5

Yakub, 54, 55
yaya foot soldiers, 108
Yedikule fortress ("Seven Towers"), 84
Yemen, 133, 203
yeni çeri. *See* Janissaries and Janissary Corps
yeni lisân ("new language"), 302
Yirmisekiz Mehmed Çelebi Efendi, 228

Yıldız Palace, 286
Young Ottoman intellectuals, and opposition to reforms, 269–71
Young Ottoman Society, 270
Young Turk Revolution (*al-Hurriyya*), 292–3, *293*, *294*
Young Turks movement
cracks in, 296–7
and CUP, 292, 293–4, 295, 298
description and aims, 290, 291, 293–4, 304
identity as pan-Turkist ideology, 290–1
and Japan, 295–6
and modernization, 277, 290
and nationalism, 290–1, 294, 298
as political party and government, 293
Yürüks tribespeople, 99–100, 168
Yusuf Akçura, 291, 294

Zarfati, Isaac (Yitzhak Tzarfati), letter to Jews, 90, 91–2
Zaydān, Jurjī, 299, 300–1
zina crimes, 176–7
Zionism, 266